KU-351-928

# Children, Television and the New Media

*A Reader of Research and Documentation in Germany*

## Edited by Paul Löhr and Manfred Meyer

UNIVERSITY
OF LUTON

*p*

press

TELEVIZION

A publication of the
Internationales Zentralinstitut für das
Jugend- und Bildungsfernsehen (IZI)
Munich 1999

**British Library Cataloguing in Publication Data**
A catalogue record for this book is available from the British Library

ISBN: 1 86020 567 4

This is No. 13 of
COMMUNICATION RESEARCH AND BROADCASTING
A publication series of the Internationales Zentralinstitut für das
Jugend- und Bildungsfernsehen (IZI)
Address:     Bayerischer Rundfunk
              Internationales Zentralinstitut
              D – 80300 München
Telephone:  +49 89 5900 2140
Fax:          +49 89 5900 2379
E-mail:      IZI@brnet.de
Homepage:  www.izi.de
Head:       Paul Löhr
Series Editor: Manfred Meyer

791. 45013 LOH

Published by
University of Luton Press
Faculty of Humanities
University of Luton
75 Castle Street
Luton
Bedfordshire LU1 3AJ
United Kingdom
Telephone: +44 (0) 1582 743297; Fax: +44 (0) 1582 743298
e-mail: ulp@luton.ac.uk
website: www.ulp.org.uk

Copyright © 1999 University of Luton Press, all rights reserved.
Unauthorised duplication contravenes applicable laws.

Cover reproduction by Sarah Shrive, University of Luton Press
Typeset in Palatino
Printed in Great Britain by Whitstable Litho, Kent, UK

# Contents

# Preface

This book is a collection of selected articles from *TelevIZIon*, a specialised journal of the *Internationales Zentralinstitut für das Jugend- und Bildungsfernsehen*, whose initial letters appear in the title of the journal.

*TelevIZIon* is an organ of topical interest published by the IZI and designed to take up problems relating to media research and present national and international developments in the field of children's and young people's television. The subjects are selected after a constant sifting and evaluation of the relevant literature, which is collected on the IZI's own database.

The journal is published twice a year in German and is directed at producers of children's and young people's programmes in broadcasting stations, students and scholars and at the large numbers of those who, for professional or private reasons, are interested in children's and young people's interrelation with the media, especially the broadcasting media: this includes parents, teachers, educators and other experts in questions relating to children and young people as well as those working in this field in the churches, political parties and institutions engaged in youth welfare and youth protection.

It has turned out more or less automatically that the so-called New Media have expanded this complex of problems to such an extent that they have come into direct contact with the children's and young people's everyday world of experience and have moved, literally, into their living rooms and bedrooms: their own radios and televisions, Walk– and Discman, audio and video cassette recorders and – in recent years increasingly and inexorably – computers with their opportunities for games and communication, their incentives for learning and an expansion of experience.

The individual issues of *TelevIZIon* deal with a particular theme. The journal is available free of charge to subscribers, and frequently individual theme issues – often together with earlier numbers – are sent on request, if they are not out of print. The articles in the issues already out of print can now be accessed on the Internet (*www.izi.de*); in future this will apply to all articles.

Meanwhile the journal is well known to and accepted by media researchers and programme producers in German-speaking countries. The issue on the theme of 'Children's Channels' (1/1995) played an important part in the introduction of the 'Kinderkanal', a thematic channel exclusively for children, set up jointly by the public-service broadcasting corporations ARD and ZDF.

A measure of the current interest in a theme was frequently the number of copies that was requested apart from the subscriptions on certain themes as a result of press reports or recommendations. Occasionally whole seminars at universities and further education institutions for teachers and educators were provided with material. Large numbers of the issues dealing with the themes 'Media Competence' (1/1998), 'Youth and the Media' (1/1997), 'Music on Television for Young People' (2/1996) and 'Multimedia for Children' (1/1996) had to be reprinted, as the Bavarian Ministry of Education wanted to distribute them to all schools in Bavaria.

In the course of the years, the feedback indicated to us which formats have best satisfied our clientele's need for information: for example, the basic description of a problem connection with documentation of the most important relevant literature; the select annotated bibliography on themes dominating discussions; the brief outline of current or planned research projects, as far as possible prior to the time-consuming completion of the detailed volumes of reports and tables; the reflective essay; the interview with decision-makers or other people involved.

Why now this anthology of selected articles within the framework of our English language series 'Communication Research and Broadcasting'? This, too, we believe, can satisfy a requirement that has arisen, as many years of experience have shown. In keeping with its original remit as an international clearing house, the IZI lives from contacts with foreign colleagues and partner institutes. These contacts result not least from our association with the major events and institutions in the area of children's and young people's television: with the Prix Jeunesse International, the prestigious award presented at the headquarters of the Bavarian Broadcasting Corporation in Munich every two years for the best children's and young people's television programmes, with the World Summit on Children's Television, and with the specialised bodies of the EBU for children's and educational programmes in Geneva and the institutions supported by the EU in Brussels, such as the European Children's Television Centre (ECTC) in Athens.

Inevitably we received many requests in these matters for concise information and documentation on our special themes for the German-speaking area, above all on the current state of research and on the latest programme projects, in other words for precisely that type of information we regularly offer in our journal. It therefore seemed obvious to present the most important contributions to our journal to Anglo-American experts in the form of an anthology. Most of them have been given in translation as

they were printed – sometimes only slightly abridged or revised. The only article to be updated is that by Tobias Gehle on children's use of the Internet, as the author was of the opinion that much of the old version had been made obsolescent by subsequent developments.

Another exception is the contribution by Friedrich Krotz of the Hans Bredow Institute in Hamburg. His report was not published in our journal; but in this volume it is a useful addition to the description of the English part of an international comparative study presented in *TelevIZIon* by Sonja Livingstone, the initiator of the large-scale project, and by her colleagues; Krotz sums up the findings of the part studies carried out in Sweden, Flanders and Germany, which were not available when we published the first results from England in our journal in 1997.

The collection of texts presented here cannot and does not claim to reflect the latest developments in production and research in Germany, nor is it our intention to attempt to present a systematic approach to the themes. This volume should be regarded rather as a kind of longitudinal section, a mirror image, so to speak, of the multifarious facets of an approach to stimulate discussion and thought on areas of interest which, we believe, have occupied or are still occupying committed experts in Germany in the last decade.

The above-mentioned criteria – acceptance of the main themes and journalistic formats – were very important for selecting the texts collected here as well. To mention just a few examples: the works by Schmidbauer and Löhr constitute overviews of the main themes such as 'TV kids as new socialisation types', 'Children and the media market', 'Youth media and youth scenes', young people online' or 'Music video for young people'. Gehle gives a survey of how children relate to the Internet, Schmidbauer analyses their relation to depictions of violence on the television screen, Vogelgesang reports on 'Adolescent media behaviour'.

Examples of annotated compilations of literature or select bibliographies constitute contributions to the themes 'The child's processing of visual information', 'Children's news on television' or 'Cartoons'.

Whenever possible, new research approaches and projects have been reported on – frequently in advance or as the publication of the first results. Examples of this are the short reports on current studies by Stefan Weiler (on the television behaviour of computer kids), by Karin Böhme-Dürr (on children's reactions to children's news), by Helga Theunert and Bernhard Schorb (on children's reactions to violence shown on television; on their perception of violence in cartoons), Maria Borcsa and Michael Charlton (on young people's handling of action films) or by Birgit van Eimeren and Brigitte Maier-Lesch (on adolescents' political interests and their use of current affairs programmes).

Lastly, the essays or basic reflections of Jan-Uwe Rogge, Ben Bachmair, Jo Groebel and Arne Wilander also have to be mentioned. An especially successful example of the category 'interview' is the

conversation with three young people on their media-fed music preferences.

There still remains a word of acknowledgement to our translators: our thanks are due to Geoffrey P. Burwell and John Malcolm King – who divided up the work – for having always given of their best to put the texts, which were occasionally quite difficult and broke new terminological ground, into their mother tongue.

Finally, we owe thanks to Rosemarie Hagemeister and Dieter Grassberger from the IZI and, in particular to Sarah Shrive from the University of Luton Press. It was due to their tireless diligence and attentiveness that this compilation of rather heterogeneous texts and table formats could be finalised in a way that came up to the necessary standard.

*Manfred Meyer*                                                    *Munich, August 1999*
*Paul Löhr*

# 1: Do Children Need Television?

# Do children need television?

*Bruno Bettelheim*

Looking at history, we can hardly be surprised that parents, educators, and our other moral overseers are greatly worried about the damage television is doing to all of us, and particularly to our children. Moralists, by nature, have a tendency to worry about and decry the newest dominant form of popular entertainment. In Plato's ideal state, all imaginative literature was to be banned because of the bad influence it supposedly exercised, although this same literature has been admired ever since its creation as one of the proudest achievements of man.

Smoking, congregating in coffee-houses, dancing – each in its turn was thought to corrupt the young. Neither operas nor music halls escaped severe censure. Even such masterpieces as Goethe's 'The Sorrows of Young Werther' were blamed for having caused a wave of suicides (although in 18th-century Germany no records were kept from which one could have ascertained whether suicides had indeed increased).

Any new form of mass entertainment is viewed with considerable suspicion until it has been around for some time. It usually becomes accepted once people realise that life goes on in the same haphazard way as before. Then a newer entertainment medium becomes the focus of the same concerns. When I was a child, all kinds of evil influences were ascribed to the movies; today these influences are ascribed to television. When I was a young man, comics were denounced because they supposedly incited the innocents to violence.

Even then, however, it was acknowledged that children were not all that innocent. It was known that they harbour angry, violent, destructive, and even sexual fantasies that are far from innocent. Today as well, those who evaluate the impact of television on children ought to understand truly what children are all about, and not maintain Victorian images of how perfect children would be if only they were not exposed to bad influences, or condemn as evil anything that children greatly enjoy.

Despite all the concern and the innumerable articles about what television does to our children, hard facts are few and difficult to come by. We know as little about the topic as my parents' generation knew about what movies did to us. My parents worried about children spending so

3

much time in the dark movie palaces – castles where we lost ourselves in dreams as often as our meagre finances permitted. At least television does not require the child to go out or spend most of his allowance on tickets.

One of the movies' attractions, though we were unaware of it, was that they helped us escape from our parents' watchful eyes at home, and from other children's competition at play. Watching a film, we daydreamed of being as successful in life and love as its hero or heroine. We participated in exciting fantasies that made our humdrum (if not outright unpleasant) existence that much more bearable. We returned to everyday life restored by having seen the movie – often not just once, but a second or even third time, when ushers permitted it.

Our children manage to do the same thing, right in their homes, and no usher prevents them from watching over and over again what is essentially the same programme. They are neither bored nor stultified; all of us need to dream the same daydream until we have had our fill of it. In the public debate on the effects of television on children, the fact that television programmes provide material for daydreams is so much taken for granted that it is hardly discussed. There seems little doubt that most of us need to engage in daydreams – the more frustrating reality is for us, the greater is our need.

Although we wish to see young children's lives free of troubles, they are in fact filled with disappointment and frustration. Children wish for so much but can arrange so little of their own lives, which are so often dominated by adults unsympathetic to their priorities. That is why children have a much greater need for daydreams than adults do. And because their lives have been relatively limited they have a greater need for material from which to form daydreams.

In the past, children saturated their imaginations with folk tales, myths, and Bible stories. There was plenty of violence and crime in Old Testament stories and fairy tales. There is a lot of cruelty, enmity within the family, homicide, even patricide and incest in Greek drama and Shakespeare's plays. This suggests that people have always needed a fare of violent fantasies as an integral part of popular entertainment.

Among the concerns about television's effects on our children, none is greater than that it may induce them to violence. Probably none has been more thoroughly investigated. I personally dislike watching violence on the screen, and would be favourably impressed with broadcasters if they restrained their desire to exploit it. But I cannot deny that as long as it is not vicious or cruel – which it very often is – it holds a certain fascination.

Many children not only enjoy aggressive fantasies. but also need them. They need material for aggressive and retaliatory daydreams in which they can vicariously act out their hostile feelings without hurting close relatives. While the very young child may beat up a doll (thinking all the while of the new baby who stands in his way), or lash out at a parent, the slightly older child can no longer afford to express his aggression so directly. In

4

healthy development, the child soon moves to daydreams in which not he, but some imaginary stand-in, discharges his anger against another distant and imaginary figure. That is why it is so gratifying to children when a cartoon shows a helpless little animal, such as a mouse, making a fool of much bigger and more powerful animals.

For a 1976 study on television violence, violent cartoons were shown to both normal and emotionally impaired children. The latter, being unstable, were expected to be more vulnerable to the cartoons' influence. But after watching the violent scenes, most children in both groups were less chaotic and expressed their aggression, if at all, in a less random fashion than they had displayed before the viewing. Having acted out aggressive feelings vicariously, in fantasy, as they watched, most of these children had less need to act aggressively in reality.

On the other hand, some of the seriously disturbed children became more violent after watching the cartoons. Some youngsters do get ideas about how to act aggressively from what they see on the screen, which they then may attempt in reality. The decisive factors are not the types of events shown on the screen but the child's own personality (which is formed in the home under the parents' influence), and to a much smaller degree the child's present situation.

For normal children as well, television offers a wide variety of models to fantasise about and try out, as if for size. Children tend to dress, walk, and talk like the television characters they admire. Whether this helps or hurts a particular youngster seems to depend on which television figure he emulates. And this is determined much more by his personality and the problems he faces at the moment than by what is shown on the screen.

As Wilbur Schramm and other researchers recognised more than two decades ago: 'The chief part television plays in the lives of children depends at least as much on what the child brings to television as on what television brings to the child'. And the younger the child is, the more this is so.

In an experiment reported in 1978 second graders viewed a programme and then were asked to retell its story so that 'someone who has not seen it would know what happened'. In response the children strung together random occurrences, showing no recall of relationships among the events they had observed. But children several years older were able to recall fairly well what they had seen. Thus, the younger the child, the less responsive he is to the actual content of the programme; he responds to it in terms of his inner life.

Only the child whose emotional life is barren, or whose conditions of life are extremely destructive, will 'live' in the world of television programmes. Doing so may be preferable to facing his actual life, which could lead him to give up all hope, or to explode into violence against those who make his life miserable.

In fact, most children seek refuge at times in television-fed fantasy, although they do not permit it to engulf more than a very limited part of

5

their lives. Television is truly an ideal medium for the purpose of fantasising because it permits the child to return immediately from the fantasy world to real life, and also to escape as quickly into the television world when reality becomes too much to handle. All it takes is turning a knob.

We ought to remember how restricted children's lives have become. It used to be possible to let children roam all by themselves for much of the day, or in the chance company of other children. They used to play somewhere in the neighbourhood, in an empty shack, or wander the woods and fields. There they could dream their own daydreams, without parents nearby demanding that they use their time more constructively.

Today, for our children's security, we cannot permit them to fend for themselves in that way. Yet, to grow up well, every child needs time and space to be himself. Watching television gives him this chance. Being able to choose the programme that will spark and feed his dream has become a way for the modern child to exercise his self-determination, an important experience in growing up.

Oddly enough, in the dizzily active world of television fiction, one kind of movement is in short supply: personal growth. The child needs to learn from his experiences and to grow because of them. This is why the child is best served by programmes that show how characters' experiences change them – in personality, in outlook on life, in relationships with others, in the ability to cope better with future events. Not only children's programmes but also adult programmes watched by children should avoid using stock characters who remain predictably the same.

Even such an exceptional programme as *All in the Family* was centred around main characters who never changed and never learned, no matter how obvious the lessons of past episodes. In this, as in many other programmes of less merit, the good guys learn as little from their experiences as do the bad guys. Even after the most incredible events, characters remain the same as before. But growth and development, and images of such growth, are what the child needs if he is to believe that he himself can grow. He needs to fantasise about how he will change, learn, and become a better person because of what life has taught him.

Not only do television characters fail to learn from their experiences, but no matter how severe their difficulties, their creators always provide them with simple, easy, instantaneous solutions, as simple as those promised by commercials. Using a particular brand of hair spray guarantees success in life and love; ingesting a pill does away with all our worries. Programmes and commercials alike mislead the child by making it appear that there is, or ought to be, an easy solution to every problem he encounters, and that there must be something wrong with him, his parents, and society, if these so readily available answers are withheld from him.

In this respect even public television's educational programmes are misleading. Whether *Sesame Street* or *Nova*, they create the illusion that one

6

will easily and immediately become well educated. And whether the child is promised popularity by toothpaste commercials or knowledge by public broadcasting service, he is encouraged to believe that he will succeed effortlessly. He does not, of course, and becomes dissatisfied with himself and society.

A large part of the problem is inherent in the medium. To hold viewers' attention, television programmes have to simplify matters and cannot follow the arduous process required for a person to gain knowledge. Some programmes do tell how slow and difficult progress is, but hearing that said makes little impression on the child when characters on the same programme can usually solve the greatest difficulties in 30 or 60 minutes.

Television is, after all, a medium best suited for entertainment; it does not readily lend itself to the balanced judgement, to the consideration of all the pros and cons of an issue. We should not expect of this medium what is contrary to its nature. The information received from television programmes will always tend to be one-sided, slanted, and simplified. This is why a young child will not truly learn by watching even the best programmes – even those designed for his age. His life experience is too limited. Adults or older adolescents can bring their accumulated life experience to watching television, which permits them to adopt the proper perspective. The child needs adult help to do so.

There is hardly a programme from which a child could not learn a great deal, provided some responsible adult does the necessary teaching. Even violent programmes are no exception, provided the child is not so anxious or angry that he is completely overwhelmed by what he watches. It is very important for children to develop the right attitudes toward violence, and closing one's eyes to its existence can hardly be considered the most constructive attitude. Every child needs to learn what is wrong with violence, why violence occurs, and how he ought to deal with it.

What is necessary is for parents to explore with the child what he, all on his own, made of what he saw and heard. We must let the child tell us what he got from the programme, and start from there in helping him sort out which impressions came from within himself and which from the programme, which were good and which were not, and why.

We should blame neither our children nor television if the reason they watch it is that we, their parents, are not very interested in spending time with them. We ought to consider that the more time we spend with them, the less time they will be watching. The more time we devote to talking with them about what they have watched, the more intelligent and discriminating viewers our children will become. The fact remains that our personalities and values will have much more effect than television in shaping our children and their outlook on life.

# European TV kids in a transformed media world: Findings of the UK study

*Sonia Livingstone, Moira Bovill and George Gaskell*

**Background**

This paper[1] describes a multinational project on children's and young people's use of old and new forms of media and communications.[2] The project aims to chart and interpret the current uses and meanings of new media among young people aged 6–17 years old in several European countries, using a combination of qualitative and quantitative techniques.[3]

It was originally conceived as a forty year update on *Television and the Child* (Himmelweit *et al.* 1958), a seminal British 'effects' study, which played a key role in subsequent policy formation. During the 1950s, Himmelweit compared the lives of children with and without television, and before and after a television was acquired in their home. When updating a project from the 1950s to the 1990s there are inevitably both similarities and differences in research focus and design. The present research, like that of *Television and the Child*, coincides with the introduction of new media into children's and young people's lives and aims to be relevant both to academic research and to public policy debates.

In many European countries there are debates about one or more aspects of the new media and information technologies – concerning provision, access, cost and regulation. There are also concerns about the impact of the media on reading, identity formation and civic participation. To facilitate comparisons, each of the national teams collaborating in the present research is following a common conceptual framework and methodology, albeit with variations to fit the national context.[4]

The international perspective will allow us to examine the consequences of the uneven diffusion of technological innovations, together with national variations in the adoption and assimilation of these innovations within different cultural contexts. It will also allow us to address the internationalisation of the media themselves, by asking questions about the emergence of European or even global identities or cultures as the media cross national frontiers. However, the present paper focuses on selected findings from the project being conducted in Britain.

## Focus of the project

While in historical terms, 40 years ago is very recent, in terms of media history forty years ago is a different world. In the early days of research on media use by children and young people, television barely existed. Indeed, when Hilde Himmelweit began her study on *Television and the Child*, even the social segmentation between children, young people and adults was different – now we have teenagers and an almost autonomous youth culture. And since those days, Himmelweit's 13- to 14-year-olds have become one of the more problematic market segments for broadcasters, neither child nor adult, who tend to turn away from television towards other activities.

Reflecting subsequent developments in academic theory, the main focus of our project is not on media effects but rather on the meanings, uses and impact of media in the lives of children and young people. Furthermore, the present project coincides with a dramatic expansion and diversification of media forms. While to some extent, such diversification means that we must address more fragmented – or segmented – audiences than the mass audience of the early days of television, it also raises crucial questions of social exclusion as inequalities in access and availability of media and information lead to the emergence of the so-called information rich and information poor.

## What do we mean by new and old media?

To focus our thoughts on what's new in the media, we identified the following four categories of change. First, and most simply, we are seeing the *multiplication of personally owned media*. In other words, media familiar to us all are being used in new arrangements of space and time as households come to possess multiple televisions, telephones, video recorders and computers.

Second, there is a rapid *diversification of the forms of familiar media*, particularly of their contents, resulting in local and global, general and specialised television channels, in diverse kinds of computer and computer/video games. This diversification encourages the multiplication of goods, for as new forms of media come onto the market, families upgrade their existing goods, and thus the older forms are passed down, typically, from parents to children, or from living room to bedroom.

Third, there is the more technologically radical *shift towards convergent forms of information services*, as media, information, and telecommunications services become interconnected. Thus children and young people have access to new kinds of telephone services, teletext, CD-Rom and Internet resources, some of which are still fairly limited but are nonetheless expanding rapidly. In our interviews with children, we found many children who, despite the current limitations of these media, were still frequent users, keen to try out what is new.

Fourth and last, the most radical change of all, and one which is still more promised than actual, is the *shift from one-way, mass communication*

*towards more interactive communication* between medium and user. Technologies currently in development or now coming onto the market include the Internet, teleshopping, interactive games/television and video-on-demand.

Thus we have adopted a very inclusive definition of 'new media' to include all those media which were not part of the upbringing of the parent generation and so which they have had to find, or are having to find, a means of accommodating in their practices and routines as parents. All of these changes demand that researchers rethink their research questions in the field of children, young people and the new media environment. How much these changes represent new opportunities or dangers is still to be determined.

### The issue of displacement

A common question regarding social change is that of displacement. Children's options have widened from comics, books and cinema, to include first radio, then television, and now computer games. Inevitably the introduction of each new medium tends to raise questions of displacement: have books been displaced by television? Are computers now displacing television? However, if one can show that people either have increased leisure time or increasingly participate in simultaneous, possibly more casual, leisure activities, one can suggest that new forms of media or leisure supplement rather than displace older forms.

Some historical evidence would seem to suggest that this may indeed be the case. Fischer (1994) found evidence both for increased private leisure and for increased public, participatory leisure – not an increase of one at the expense of the other. He also showed how over the past century, despite the rise of commercialised leisure, there is no evidence for the commensurate loss of informal leisure (although, it has to be admitted, good historical data on this is sparse). However, other scholars suggest that displacement may have occurred. Putnam (1995) discusses the erosion of participation in civic organisations in post-war America because of mass mediated leisure, while Brake (1990) discusses the growth, in Britain, of youth culture as a form of leisure in which informal activities become incorporated with the commercial sphere through consumption-oriented leisure.

In reality the issue of displacement cannot be satisfactorily answered in any project without a longitudinal component enabling us to compare behaviour before and after the acquisition of the potentially displacing activity. While this was possible for Himmelweit's study, it is no longer practicable in a complex multimedia environment. It seems plausible that particular shifts in patterns of leisure are not to be accounted for simply by changes in the available media technologies but in terms of shifts in the socio-cultural context. Thus we stress the importance of locating the analysis of any one medium or leisure activity within the broader media,

or leisure, environment. Rather than the somewhat piecemeal approach common in the research literature of studying children's use of one medium in isolation from their use of other media or with little consideration for their wider social context, we regard the uses and meanings of any one medium as defined significantly through its relationship with the other media and non-mediated leisure activities that are available to a particular child in their socio-cultural context.

Lest we appear to be studying the whole of children's and young people's lives, for the purposes of our project we have located the screen at its core, for 'the screen is likely to become the site of a multimedia culture in which telecommunications, computing and video intertwine' (Silverstone, 1996). The project seeks to identify how the meanings and uses of the screen are contextualised, for particular audience groups, first in relation to non-screen-based media, then in relation to non-mediated leisure opportunities and then, wider still, in relation to broader socio-cultural factors.

## Estimating changes: the continuing dominance of television

How are children's and young people's uses of media changing as the media environment itself is changing? Notwithstanding popular speculation about the pace of technological change, there are dangers in both overestimating and underestimating the pace and significance of the changes in media and information technologies. While ever more domestic technologies come onto the market, it remains likely that children's and young people's lives are more constant and that many of the apparent changes may be superficial.

For example, despite the diversification of media forms, our surveys of British children and parents show that television still dominates the leisure hours and interests of children and young people in the 1990s.[5]

- Nine out of ten children watch television every day or almost every day.
- Television is identified most often when asked which media they would miss most.
- Television is named most often when asked what they talk about with friends.
- For parents, 'watch television' is the most frequent activity they share with their child.
- 'Watch television' is identified as the most common leisure activity from a wide range of activities.

Comparing our initial findings with those from Himmelweit's *Television and the Child* forty years ago, it seems that a number of characteristics of children's viewing have remained constant, despite public speculation and the beliefs of many parents and teachers. Children preferred to watch adult programmes then as now. How much children view, then and now, tends to follow their parents' viewing habits. Parents then and now encourage their children to watch television to give them, the parents, some peace. In the

1950s children were not glued to the box, but television was finding a place in their lives in a more complex way, and the same would seem to be the case for most young people nowadays as they incorporate into their daily lives the new kinds of media available to them.[6]

Nonetheless, with a longer time frame the changes are indisputable. We are moving from a print to a visual culture, from a mass audience to a more segmented audience, from a receptive to an interactive audience (itself a problematic concept): these are significant changes of which the explanation and implications are more difficult.[7]

## Effect of new leisure media

There seems little doubt that the new information and communication media will play an increasing role in the lives of children and young people, potentially affecting their socialisation, leisure, education, social and political knowledge, family life and work opportunities. Thus television's role at the top of the hierarchy of leisure activities is threatened by the growth of such new leisure media as computer and video games and the Internet. When we asked children in our research which one medium they would choose if they wanted excitement or to stop feeling bored, they were as likely to choose a computer game as television. Children's comments in the qualitative phase of our study testify to the attraction of the interactive nature of such games and the feelings of mastery and control that they can provide.

Early results from a recent survey of European young people[8] would suggest that three times as many British teenagers as German teenagers have games machines. Young people in Britain compared with their European counterparts in Germany, France and Italy are also the least likely to agree that video games machines are 'just a fad'. While the British are more likely to own games machines, those who use them from whichever country claim to spend around 5 hours a week doing so. As the key comparison appears to be percentage penetration, one wonders whether the penetration in Germany will increase or whether there is some cultural constraint in Germany (eg parental opposition, the dominance of English, price) or, conversely, some reason why British teenagers adopted these machines in such greater numbers.

## Children's optimism about new forms of media

Not only may television become just one among a number of leisure options for children, but television is itself undergoing rapid changes. Television is expanding from a few to many channels, from national to global channels, and it is converging with computer technologies to form Internet or web TV, video on demand, interactive television, and so forth. In our project, when we asked children what changes they thought might be coming, the evidence suggests that while adults may be reluctant, fearful or sceptical of change, children are not only aware of the

12

developments which may lie ahead, but are positive about their potential for change. For example, when asked to draw their ideal bedroom in the year 2000, children described a media-marketing dream:

I've got a cinema screen. That's cinema films – a cupboard full to the top – you can't get in. A TV here and this is your desk thing or whatever. That's a video games and computer cupboard. That's a bank cell with loads of money. That's little bit in the middle with all the TV computer hi-fi and these are telephones all around my bed and TV all round the edge. ....This is all cable ... And these speakers are everywhere round the room everywhere you look. So it's soundblaster sound. (Boy, 10-11)

**Figure 1: Child's Ideal Bedroom in the Year 2000**

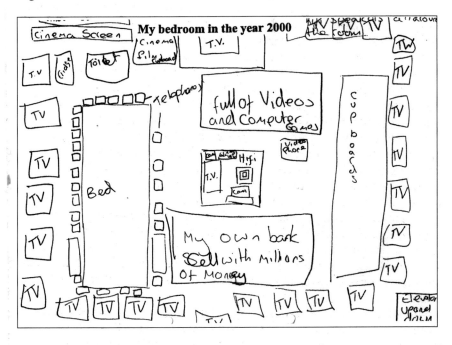

**Social and individual uses of media**

It is often suggested that newer forms of screen-based media are serving to isolate children from their families and friends. Many households now possess multiple television sets, and even video recorders, and an increasing diversity of media equipment such as computers and games machines. This potentially fragments the family audience. In addition, the new interactive multimedia possibilities (although they have barely entered children's lives at present) provoke fears that old sociable uses of media are being displaced by newer more individual uses and that this in itself is negative in its consequences. Once again from our current data we suggest that the picture is not so simple.

Focusing on television, how do children describe their viewing? Conscious of trying not to impose our assumptions on our respondents, we first asked children to draw themselves watching television. We were surprised to find that about half the children chose to draw themselves watching television alone, often in their bedrooms. This would seem to mark a radical shift from the image of television as the family hearth, replacing the dinner table perhaps, but at least a social focus in the centre of family life. Yet many other pictures showed children comfortably ensconced in their living rooms, watching with their parents and siblings suggesting the changes since the first introduction of television some forty years ago may not be so radical.

**Figure 2: Child Watching Television Alone**

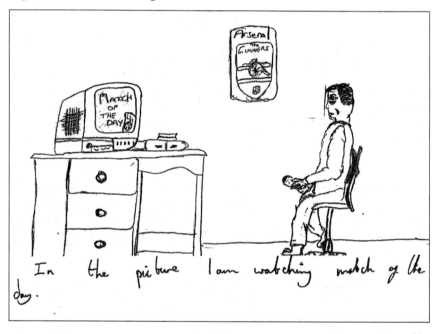

Of course, children's drawings may reflect actual, or preferred, viewing habits. In our survey we asked both questions (Table 1), revealing several interesting discrepancies between actual and preferred viewing. Clearly, children would like to be able to watch alone far more than they actually can at present. This would seem to be strongly motivated by the desire to escape from co-viewing with siblings and with parents. In all age groups, but particularly amongst teenagers, more than are presently doing so would like to watch with friends.

The interest in being more often with friends was repeated when we asked about experiences and preferences for playing computer games.

However, there were other interesting differences. In contrast to their experience with television, more children were playing computer games on their own than would opt to do so given the choice. Almost two thirds mostly play computer games alone: far fewer (four out of every 10) say they enjoy playing this way most.

Table 1: **Reported actual and preferred viewing habits** (by age, N=719)

| AGE | 10-11 | 12 | 13-14 | 15-16 |
|---|---|---|---|---|
| % saying they watch television for more than half the time | | | | |
| Alone | 17 | 16 | 32 | 30 |
| With sibling | 59 | 59 | 50 | 39 |
| With mother | 50 | 62 | 40 | 40 |
| With father | 35 | 50 | 33 | 27 |
| With friends | 7 | 10 | 6 | 1 |
| % saying they enjoy watching television most | | | | |
| Alone | 31 | 39 | 46 | 44 |
| With sibling | 19 | 12 | 12 | 13 |
| With mother | 16 | 20 | 6 | 6 |
| With father | 5 | 1 | 3 | 3 |
| With friends | 16 | 19 | 19 | 31 |

So, television is revealed as a family activity, which a substantial minority of children would prefer to do alone, while playing computer games is a solitary activity which satisfies the largest proportion although a substantial minority would prefer to play with friends.

**Loss of public freedom**
This increasing desire to be alone or with friends, away from the family, is a recurring theme. Children's and young people's responses to us about their wider leisure context showed clearly that domestic media are secondary in interest to children's primary desire to be with friends. Thus the main division in the way children think about their leisure distinguishes between inside and outside their home. This apparently simple distinction is strongly invested with a variety of meanings important to children and their parents. Going out, or being outside, is generally preferable, even for the youngest children. It is seen as offering independence, worthy of exploration, with exciting potential for the unexpected. Outside places are also seen as fundamentally social, for these mean being outside with friends. (Unlike their parents, children rarely talk about going out on family trips.) Children seemed to be at their brightest and most confident when talking about going out.

15

However, going out is heavily defined by parent-imposed rules of access which often restricts where children can go and with whom. These rules were highly salient to children, and included

- spatial restrictions (eg only visit this street, only cross certain roads, only cycle a certain distance);
- temporal restrictions (eg be back by 7 p.m., only go out after homework is completed, only go somewhere at the weekend);
- financial restrictions (going out often requires entrance fees, transport costs; children tended to prefer organised places to hanging around parks, town centres etc);
- social restrictions (eg only visit certain known children, you can't go to certain public places, etc).

Particularly for the younger children interviewed, 'outside' often means the immediate locale, and hence the specific features of that locale may be very important to the child (eg is their street a cul-de-sac where they can play safely? Is there a park nearby?).

By contrast, staying inside is seen as what you do when you have to or when friends are unavailable. Social interaction is one of the most regulated areas of home life for children. Parents restrict telephone use because of the cost, parents, when watching television in the living room, decide on programmes, parents restrict friends visiting (who, when). In consequence, 'inside' is rarely preferred by children as it tends to offer parasocial interaction (with television, music) rather than real social interaction (for children strongly favour interaction with friends over that with family, and even siblings are frequently seen by children as irritants to be avoided rather than as chosen companions). In other respects, however, 'inside' is seen as relatively free – an unstructured, non-restrictive space with few rules, costs or difficulties. Home is comfortable and familiar if also somewhat boring.

To a certain degree at least, parents' views are the opposite of those of their children. For parents, maybe especially in Britain, outside the home is seen as fundamentally unknown and unsafe as a locus for their children's leisure. There are exceptions where, despite general fears of traffic, strangers or 'unsuitable' friends, somewhere may be both knowable and safe, and parents restrict their children's access to the outside world to these kinds of places.[9] This is not to say that parents are happy about the situation, and many are strongly nostalgic about the freedom which they experienced as children themselves, regretting the many rules which they feel obliged to impose on their children's freedom outdoors.

The distinction between staying in and going out is encapsulated in our survey when we asked children which three things they would like to do on a really good day or which three things they would most likely find themselves ending up doing on a really boring day (Table 2).

Table 2: **Activities for a good day and a boring day**
(N=719, 10- to 16-year-olds)

|  |  | Good day (%) | Boring day (%) |
|---|---|---|---|
| OUT | go to cinema | 41 | 2 |
|  | see friends | 39 | 6 |
|  | play sport | 35 | 7 |
|  | go out to club | 18 | 4 |
| HOME | watch television | 14 | 41 |
|  | play computer game | 15 | 19 |
|  | read a book | 5 | 28 |

While for children staying inside is clearly far less attractive than going out, it is seen by parents as fundamentally known and safe. Even if in practice they do not know what their children do or watch on television in their bedrooms or even in the living room, home is seen as knowable and controllable.[10] Thus, unlike their children, parents do perceive the home to be rule-governed to some degree – in terms of what is watched and when, when and where computers can be used, etc – and home is also seen by parents as sufficiently full of interesting and challenging activities for their children.

**The rise of bedroom culture**

The *Teenagers Europe* study shows that multi-set households are most common in Britain. Almost four in ten teenagers live in homes with four or more sets, whereas in Germany almost three in ten live in single-set homes; Italy and France fall somewhere in between (Table 3).

Notwithstanding anxieties from the parent generation concerning children becoming isolated from friends and family, being too lazy to tear themselves away from the screen to play a sport, read a book or practice a hobby, in our own survey of 1310 children and young people aged 6–17, we found that two thirds have their own television set in their bedroom and that personal ownership of other media is also substantial (Table 4).

Some would argue that British television is better than that available in other countries. However, we suggest that the biggest influence on children's viewing habits are the restrictions placed on their access to the outside world. Parents are perhaps disproportionately afraid to allow their children similar freedoms to those which they enjoyed as children and which, perhaps, are available for children in other countries. Not only are children not allowed out but, even when they are, our evidence indicates they find few resources tailored to their needs. In our main survey (n=1310 respondents, 6- to 17-year-olds) two thirds of those sampled said that there was not enough for them to do in their area. In Britain, we suggest, there is an impoverished concept of public provision for leisure activities for children and young people.

Table 3: **Number of sets in household**
(Base: all watching television; N=9905)

|  | TOTAL | Britain | Germany | Italy | France |
|---|---|---|---|---|---|
|  | % | % | % | % | % |
| One set | 16 | 7 | 29 | 15 | 9 |
| 2 sets | 30 | 23 | 42 | 32 | 20 |
| 3 sets | 32 | 32 | 20 | 42 | 37 |
| 4+ sets | 20 | 37 | 8 | 11 | 28 |

Table 4: **What do children have in their own bedroom?**
(N=1310 respondents aged 6-17)

| Children have in own bedroom: | (%) |
|---|---|
| books | 64 |
| television set | 63 |
| games machine | 33 |
| video recorder | 21 |
| PC computer | 10 |
| cable/sat.-connection | 5 |
| PC with CD-ROM | 4 |

It is therefore no surprise that the *Teenagers Europe* study found that British teenagers spend the most time watching TV – around four hours per day (Table 5):

Table 5: **Average hours watched**
(Base: all watching television; N = 9905)

|  | TOTAL | Britain | Germany | Italy | France |
|---|---|---|---|---|---|
| Weekdays | 3.2 | 4.0 | 2.5 | 3.1 | 3.5 |
| Saturdays | 3.2 | 4.3 | 3.0 | 2.5 | 3.0 |
| Sundays | 3.1 | 3.7 | 3.0 | 2.9 | 2.8 |

Fifteen-year-old girls in a rural area complained: 'There's nothing to do really ...'cos they've just gone and closed down the (club).' – 'Can't go down there no more.' – '(It was) a disco.' – 'For our age.' – 'But there's nothing here now.'

In circumstances when opportunities for socialising outside the home are, or are seen to be, problematic, parents are increasingly providing their children with a well equipped, individual space for media use – the bedroom. They are doing so, we might reasonably conjecture, by way of compensation and for reasons unconnected to the media: fear for their

18

children's safety because of crime and traffic, combined with a lack of available, safe, publicly funded communal facilities. Given the restrictions on exploration and independence outside, children and young people are being given a new place – safe and known in parents' terms, exciting and personal in children's terms – for their leisure, namely the bedroom.

While other social changes, from central heating, smaller family size, and continual upgrading of domestic technological goods all have their part to play, here we have a new kind of place for children's leisure, which has been little explored to date. Significantly, the way to make a bedroom a place of interest, sociability, exploration, excitement and independence, is to fill it with media: televisions, video recorders, computers, CD-players, all of which are making their way into more and more, younger and younger children's bedrooms in Britain.

Children's expectations are growing commensurately. As we saw earlier, there is a strong desire among children to watch television alone more frequently than is possible with the set in the living room, and the bedroom may also provide that safe space where children can see their friends. The growth of a market for personal ownership of television sets, videos and computers is thus multiply determined, resulting in what might be termed the privatisation of leisure. This privatisation does not necessarily mean that social contacts are being replaced with social isolation, but rather, these media can offer new means for social interaction, indicating a potential shift from family to peer contexts for domestic media use.

Increasing numbers of children are now able to invite their friends home to see their new computer or to listen to music with them in their bedrooms. When we interviewed children in their bedrooms we were struck by the way in which teenagers in particular had used the space to express their individuality. Posters, special collections, colour schemes, together sometimes with a defiant, anarchic untidiness and 'Keep out' notices, marked off the territory clearly from the rest of the home.

Buchner (1990) describes how the study of childhood in West Germany draws on the concept of the *Normalbiographie* (standardised biography) – ie the normative, socially approved structural characteristics, which previously governed the life course of children. Although for some, childhood still follows such traditional forms, the '*Normalbiographie*' is no longer applicable to the lives of many modern children and young people whose lives are destandardised and increasingly individualised. In view, for example, of the changing structure of family life many children are engaged in a struggle to establish a modern version of such a biography for themselves.

A decreasing commitment to the previously normative traditions of family life has been noted, together with a parallel drift towards individualisation processes. The life stage of childhood is for many no longer uniform and socially predetermined – it is marked by biographical independence. Every child is increasingly expected to behave in an

19

individualised way and to make choices for or against particular biographical variants. This development is described as the *biographisation* of the life course and is actualised in the way in which children and young people establish lifestyles for themselves and assert areas of independence.

The importance of bedroom culture for this process of individualisation is clear. Büchner (1990, p. 78) notes:

..... examples of such areas of independence might include deciding individually what to buy, planning and managing space and time, the selection and shaping of 'leisure careers', determining media consumption patterns, displaying personal tastes, or choosing appropriate modes of communication and social activities.

### Developmental trajectories

This emergence of what we might term the mediatised, or even hi-tech, bedroom as a child-centred and private space has its own developmental trajectory. In our interviews, we found that up to about nine years old, children strongly prefer the main family spaces for playing, seeing friends, watching television, and so forth, especially when family is present. This contrasts with teenagers who also like to use the space and facilities of the living room, but mainly when their family is absent. Children younger than about nine years, and especially boys, are relatively uninterested in 'bedroom culture', seeing it merely as a convenient place to sleep and store toys, while in middle childhood, children start to want personal ownership of media for mainly pragmatic reasons (comfort, own choice, no interruption). However, after about 11 years old, young people want personal ownership of media for social-psychological reasons (privacy, independence, identity, socialising and conspicuous consumption).

This more personalised use of media in the bedroom is also structured temporally. For example watching television in the bedroom is least common in the mornings before school: only 15 per cent of those children who have a personal television say they usually do so at that time. On the other hand, almost a third of those with their own sets watch in their bedrooms after they come home from school, in the early evening and after 9 o'clock, when British 'watershed' restrictions (designed to protect children from unsuitable viewing) end.

### Wanting to be older

Something which has not changed is children's near-universal desire to be maybe just two years older, to have access to the opportunities and facilities which they are constantly being told they are too young for. The children we interviewed saw growing up, reasonably enough, as a series of hurdles to be crossed between their current restrictions and independence and freedom.

In fact, the terms we use to describe our respondents convey different assumptions and access different moral debates. There is no single term to

20

describe people between the ages of birth and 18 (if, indeed, that is when adulthood starts). 'Child' – usually singular – is often taken to mean dependent, incomplete even, and hence vulnerable and in need of protection. Conversely 'youth' – now plural – are often seen as deviant, out of control, different, so that we become in need of protection from them. Shall we call a 12-year-old a child, a youth, a young person or an adult? All this is not just a matter of semantics: rather the difficulties with the terms reflect cultural uncertainties and tensions over childhood: what is a child? When do children become adult? Are teenagers different? These uncertainties over the boundary between childhood and adulthood were clearly salient to the parents and the children we interviewed.

> Interviewer: 'Tell me, boys, what is it like being six years old?'
> Boy, 6:     'Nice, but I'd like to be 10 years old, I always do.'
> Interviewer: 'How will it be different being 10 years old to being six years old?'
> Boy, 6:     'Because you can stay up later.'
> Interviewer: 'And what would be the point of staying up later, what do you want to do?'
> Boys, 6:    'So we can watch TV.' – 'And play computers.' – 'And put videos on.' – 'And so you could go to more places, so you could go from Basingstoke to India to...'

This desire to be older has implications for their media use, for they partly see the media as something which occupies their time when they cannot do what they would really like to: go out, be independent, have money, etc. Much media content targeted to them thus seems patronising, as they resent reminders of what adults consider appropriate for their age, and so they prefer media intended for older people or those which blur the boundaries between child and adult (as with the teen soaps, where teenagers act like adults, or comedy shows, where adults act like kids).

They also seem to mark their own development in terms of personal ownership of goods. In Britain at least, equipping the child's bedroom is providing a new kind of personal space – space for socialising, as well as for the consumption of media goods in a market which had seemed almost saturated, especially by vastly multiplying the demand for television sets, video recorders, computers and telephones.

## Conclusions

We suggest that the traditionally conceived boundary between public and private is a key boundary for both children and their parents. Each conceives both public and private spaces in very different ways and access to these spaces is much contested. This in itself is not new, though the apparent continued importance of 'going out' for even quite young children confounds many public anxieties about the hypnotic attractions of the media.

However, it has been noted by others that the particular nature of the media themselves complicate this boundary, for the media introduce public

meanings, public representations into the traditionally private space of the family living room, supposedly usurping the fireplace, the dining table, and the family conversation in the process. As a result, there is some public lamentation that traditionally valued public spaces – the town square, meeting halls, and so forth are becoming depopulated. Arguably, the participation of children and young people in such spaces has never been valued, or even permitted, but nonetheless, the growing centrality of the media in family life has been blamed for such a loss of the public sphere.

The suggestion that the public sphere is becoming a virtual one, reconstituting itself across a nation through the sum total of family discussions around the television set, complicates further the boundary between public and private. Yet even this notion, of family talk around the television, may be a flawed one. For through the concept of 'bedroom culture', we have suggested that the diversification and personalisation of domestic media is drawing up a new kind of public/private boundary.

In short, the boundary marked by the domestic front door is so problematic for families that, motivated also by other factors operating within the home, there is now another boundary, this time marked by the bedroom door. In this paper, we have begun to map out some of the meanings, and the associated age trajectory, of this new public/private boundary.

It has, for example, important repercussions for parental mediation. Parents are devoting more attention to regulating which media are located where, and possibly less to when each medium may be used. This greater focus on spatial as opposed to temporal boundaries means that, although parents remain concerned about the media content (particularly for new forms of media), in practice this is increasingly difficult for them to regulate, not least because of the proliferation of equipment.[11]

> Father: ' ... they would just disappear and the next thing you know you hear a TV come on in another room ... We can kick them into their bedrooms and tell them to get an early night because they're worn out from some other activity ... We don't actually know the TV's going on in another room ... and they do – the TVs go on. So I've had to go in those rooms at midnight. The TVs are flickering away in two different rooms.'

From the point of view of the children and young people we interviewed, on the other hand, it would seem that overcoming the obstacles placed between themselves and their friends is of primary importance. The media are thus meaningful through their relation to social interaction with friends:

- They may facilitate this interaction (somewhere to go out to, something to talk about, something to do together);
- They may simulate this interaction or offer mediated interaction, when face-to-face contact is restricted (whether via the telephone, the Internet, or the parasocial interaction of watching soap operas);

- They may compensate for the absence of social interaction (although it seems unlikely they will displace it unless restrictions are imposed by parents).

As a final comment, we note that the present conclusions may reflect a very British picture, in terms of the parental preoccupation with public safety and hence in terms of the equipment provided for children's bedrooms. For further analysis, we must await the outcome of our comparative study.

## References

Brake, M. (1990). Changing leisure and cultural patterns among British youth. In L. Chisholm, P. Büchner, Heinz-Hermann Krüger and P. Brown (Eds), *Childhood, youth and social change: a comparative perspective*. London: Falmer Press.

Büchner, P. (1990). Growing up in the 1980s: Changes in the social biography of childhood in the FRG. In L. Chisholm, P. Büchner, Heinz-Hermann Krüger and P. Brown (Eds.), *Childhood, youth and social change: a comparative perspective*. London: Falmer Press.

Fischer, C. S. (1994). Changes in leisure activities, 1890-1940. *Journal of Social History*, (Spring), pp. 453-475.

Hillman, M., Adams, J. and Whitelegg, J. (1990). *One False Move .....: a study of children's independent mobility*. London: Policy Studies Institute.

Himmelweit, H. T., Oppenheim, A. N., and Vince, P. (1958). *Television and the Child: An Empirical Study of the Effect of Television on the Young*. London and New York: Oxford University Press.

Home Office (1994). Children as victims of Crime, by type of crime 1983 and 1992 (ie abductions and gross indecency). Home Office, cited in 'Central Statistical Office – Special Focus on Children 1994'. Government Publications.

Livingstone, S. M. and Gaskell, G. (1995). Children, young people and the television screen. In F. Guglielmelli (Ed), *Reinventing television: the world conference*. Paris: Association Television et Culture.

Miles, I., Bessant, J., Guy, K., and Rush, H. (1987). IT futures in households and communities. In R. Finnegan, G. Salaman, and K. Thompson (Eds), *Information technology: social issues. A reader*. UK: Hodder and Stoughton.

Morley, D. and Silverstone, D. (1990). Domestic communication technologies and meanings. *Media, Culture and Society*, 12(1), pp. 31-56.

Neuman, W. R. (1991). *The future of the mass audience*. Cambridge: Cambridge University Press.

Putnam, R. D. (1995). Bowling alone: America's declining social capital. *Journal of Democracy*, 6, pp. 65-78.

Silverstone, R. (1996). *Technologies, texts and discursive spaces: notes towards the interactive*. Paper presented at the 46th Annual Conference of the International Communication Association, Chicago.

## Notes

1   The German version of this article appeared in TelevIZIon 10/1997/2, pp. 4-121.

2   The project described in this paper, *Children, Young People and the Changing Media Environment*, is conducted in association with the Broadcasting Standards Commission and is supported financially by the Leverhulme Trust, the British Broadcasting Corporation, the Independent Television Commission, Yorkshire/Tyne Tees Television, British Telecommunications plc. and the Advertising

Association. It is part of a multinational project, *Children, Young People and the Changing Media Environment* (directed by S. Livingstone and G. Gaskell at LSE) with financial support from the Broadcasting Standards Commission, the Youth for Europe Programme (EC-DGXXII), and the European Science Foundation. Earlier versions of this paper were presented to the conference, *Les Jeunes et Les Médias Demain*, GRREM/UNESCO, Paris April 1997, and will appear in Italian in 'Problemi dell 'Informazione', E. Menduni (Ed.).

3    We interviewed children from 6 to 16 in small groups at schools from different locations around the country, asking a variety of open-ended questions about their media use. We also visited homes around the country, interviewing both the children (including some of those interviewed at school) and, separately, their parents, again asking diverse questions about their media use and family practices. Lastly, we interviewed some children who were specifically identified as 'early adopters' of new media (Internet users, cybercafé users). In all, we interviewed some 250 children. This was both preceded and followed by the use of national survey methods with parents and children. The project aims and methods are described in detail in Livingstone and Gaskell (1995).

4    The teams involved are from Britain, Denmark, Finland, Flanders, France, Germany, Italy, Israel, The Netherlands, Sweden and Switzerland.

5    Source: surveys conducted via the BBC's Television Opinion Panel (Children's Panel, 7-16 year olds, n=719; Adult Panel, n=830).

6    What strikes us more strongly on re-reading *Television and the Child* is the way social science has changed, so that many of the theoretical assumptions with which Himmelweit and colleagues approached their study are not shared by researchers today.

7    Neuman (1991) questions whether we are really seeing the end of the mass audience, suggesting that audiences are conservative, expressing a desire for new technical opportunities but not actually taking them up when they become available. Somewhat similarly, Miles *et al.* (1987) list a multiplicity of factors likely to inhibit the diffusion of such social innovations as new media/informatics.

8    Preliminary results released by Euroquest MRB of *The Teenagers Europe* survey of youth aged 11- 19. This was carried out in Germany, Italy, France and Britain in May and June 1997. Results will be available from Euroquest MRB London or Paris from December 1997.

9    In our survey 30 per cent of parents of children aged 6 to 17 thought the streets around where they lived were not safe for their child: only 5 per cent thought this had been the case when they were a child. Consequently, 31 per cent said their child spent very little time outdoors without adult supervision. British parents' fears may not be entirely unfounded. Home Office statistics (1994) reporting on the numbers of children who were victims of crime report twice as many cases of gross indecency with a child in 1992 compared with 1983 and a fourfold increase in the number of child abductions. Similarly Hillman et al (1990) noted that over three quarters of German primary school children came home from school on their own, compared with only a third of English juniors. In respect of all six variables studied – permission to cross roads, to come home from school alone, to go other places than school alone, to use buses to go out after dark and to use their bicycles on the roads – German children were far less restricted than their English counterparts.

10   It is worth noting that parents in Britain expect a responsible television industry and value policies in place to protect children such as the 9 p.m. 'watershed', as well as operating their own policies such as enforcing bedtime.

11   Cf. Morley and Silverstone (1990) on this double significance of media – as consumer goods and as conveyers of meanings.

# European TV kids in a transformed media world: Findings from Germany, Flanders and Sweeden

*Friedrich Krotz*

## Introduction

Audiovisual media, in particular radio and television, have a formative impact on our society. People's everyday life and culture, interaction and identity are shaped to a growing extent by media referentiality. Childhood and youth today are media childhood and media youth (Baake *et al.* 1990a, 1990b). This fact of life has been examined, analysed, conceptualised, explicated and grasped by a host of theories and research projects with a social and communications sciences orientation.

State-of-the-art communication technology, fibre optic cables and digitalisation, computers and new data services, telecommunications and digital television have created a new type of media that is currently institutionalising itself in everyday life and society. Compared with the 'old' media, the use and acceptance so far of this computer-mediated communication can still, by and large, be described as limited. However, in the long term at least, new interpersonal communication environments will emerge and, concomitantly, new types of interaction and communication with far-reaching implications for society and its institutions as well as for each individual person (Krotz 1995, 1997, 1998).

Nevertheless, there is one major difference between the advent of computer-mediated communication and that of radio and television in previous decades: audiovisual programme media established themselves through the adults who purchased and used the corresponding equipment. In the case of computer-mediated communication, merely buying the equipment is an insufficient prerequisite for usage. Rather, new competencies and a change in existing communication habits are also essential. Along with groups of specialists, therefore, it is above all children and young people today who use computer-mediated communication in everyday life and leisure time.

The way they see it, the media that adults classify as new are not new at all, but simply a further type of available media. They use them because they seem useful for certain applications – just like any other media. Children and young people do not have to change their media habits and cultural practices to do so, since they are the ones who develop them in the

first place. If computer-mediated communication as a new brand of mediated communication does change everyday life and society, and, consequently, people as communicative beings, this will occur in the long term during the course of a socialisation via which children and young people develop into a society that modifies accordingly. One presumably significant factor in this context is the fact that children and young people have fun with computers and, for example, enjoy playing computer games – and it is here too that they differ from adults.

A major gap in research exists in this context: cross-cultural studies have not yet been conducted that compare the usage and significance of radio and television in different culture areas, neither with respect to children and young people, nor with respect to the emergence of new media environments that assimilate old and new media.

With this in mind, the Hans Bredow Institute for Media Research in Hamburg decided to participate, within the frame of an international project network, in an initiative launched by Sonia Livingstone and George Gaskell from the London School of Economics to conduct a comparatively orientated research project on how children and young people deal with new and old media. The network, set up in 1996, includes research teams from Denmark, Flanders, Finland, France, Israel, Italy, the Netherlands, Sweden, Switzerland and Spain.

Its more or less official name is 'Himmelweit revisited': during the 50s, Hilde Himmelweit, a former professor at the London School of Economics, and her team, along with Wilbur Schramm (1961) in the USA and Gerhard Maletzke (1959) in Germany, took a creative and differentiated look at the role of audiovisual media in the life of children and young people. During Himmelweit's studies (1956) of BBC television, broadcasting permission was also granted to Britain's first commercial channel, so she dynamically extended her research to take this into account. In view of the rapidly changing media landscape, communication researchers today would also be well-advised to demonstrate similar flexibility.

### Project objectives

With a cross-cultural and communications sciences orientation, the project network sets out to explore how children and young people aged between 6 and 17 use audiovisual media. The central question is: How do children and young people use the old and the new and, above all, the audiovisual media and what does this mean for them? Although this was examined in a separate study for each individual country the studies were designed in joint coordination and their findings are currently being evaluated and presented cross-culturally.

The core of the European comparison is a representative survey in each country that determines the individual media environments as well as the extent and nature of their usage and significance in the everyday life and leisure time of children and young people. The surveys focused on the

extent to which the 'new' (ie computer-based) media are part of the everyday life of children and young people and whether the level of penetration of computer-mediated communication can be empirically confirmed at all within the frame of a representative study. The societal conditions and consequences for media development in the everyday life of children and young people are also taken into account, for example, the question of gender-specific differences in usage and perception. The surveys also examine which knowledge and competence gaps emerge between which groups and how significant these gaps are.

In addition to the quantitative study, a series of preparatory or back-up qualitative studies was conducted in almost all countries, some of them with differing approaches: observations of how children and young people deal with computers, group discussions involving specific age, gender and educational groups, explorative participation in projects at school, and expert discussions. Their aim is to enable, at least to a certain degree, the identification of a variety of cultural backgrounds and interpretative patterns and their consultation for interpretation.

A first joint report by all project teams was published in the European Journal of Communication at the end of 1998. A further publication evaluating the different findings in all project team countries is planned for 1999.

This is not the place, of course, for a complete overview of these findings. Rather, some of the results will be reported and a number of theses relating to the subject of children and young people and the Internet thus made plausible. The focus is not on the effects of media content or media forms of presentation, but on the impact of the existence of computer-mediated communication and, first and foremost, of the Internet on everyday life of children and young people. The more complex evaluations are bypassed and comparative findings from Flanders and Sweden consulted instead.

Flanders and Sweden were selected as comparative countries for several reasons. First, the research teams there show an interest in aspects similar to those of interest to the German team. Second, there are reasons relating to content, in particular the fact that experience is important in intercultural comparisons. From a global perspective, the countries are similar in many respects, especially with regard to their broadcasting system and media tradition.[2] From the perspective of each individual country, however, they are at the same time quite different in terms of their historical, cultural, social and political conditions. On the one hand, therefore, the selection simplifies a comparison, whereas, on the other hand, it indicates that interesting differences are to be expected which are rooted in respective cultural traditions.

In the following, however, a number of surveying differences should be taken into account when considering the comparisons presented. Although the questions asked were by and large identical in all countries,

27

not all questions were asked in each one. Furthermore, there were different sampling methods and interview situations. In Germany, 1253 children and young people between the ages of 6 and 17 were interviewed in an in-house survey that was representatively selected according to region, age, gender and type of school. Only the children in the age groups 6–7, 9–10, 12–13 and 15–16, however, were included in the comparative evaluation presented here; these age groups were chosen for the international comparison on account of difficulties relating to the different school systems. For the German sample, this means 830 respondents, of whom 55 per cent are male and 45 per cent female. The breakdown of this sample according to age groups is as follows: 20 per cent six to seven year-olds, 25 per cent 9- to 10-year-olds, 27 per cent 12- to 13-year-olds, and 27 per cent 15- to 16-year-olds.

The figures for Flanders, on the other hand, are based on 1,000 interviews with children and young people between the ages of 6 and 17 that were conducted in various schools according to type and region. The Swedish survey of 1600 children and young people was also conducted in schools that were additionally differentiated according to the character of their residential location, but only children from classes 1, 3, 4, 5, 7 and 9 were interviewed. These differences are rooted in the varying financing frames for the individual project teams and should be taken into account when assessing the findings.

This is particularly significant in the following for the breakdown of aggregate figures relating to class. In the Flemish and Swedish surveys, the respective social class was laid down for the respectively interviewed school class as a whole. In the German survey, one parent of every second child was interviewed and the disposable household income selected as an individually assignable criterion of class. Due to these differences in surveying methods, the findings relating to class affiliation can only serve as indicators and not as exactly comparable criteria.

Strictly speaking, these different conditions are quite a problematic basis for a comparison. However, in view of the given financial restrictions, bearing in mind the different scientific and research traditions in the field of communication sciences and taking into account the differing goals of the institutions that provide the financial support in the countries concerned and the differing interests of the researchers involved, the findings are nevertheless useful. Or, to put it another way: there are currently no better findings in a converging Europe. 'Better' studies would presumably require a much greater 'lead-in' and a similar financing frame for all projects.

**Computer equipment and media usage time in comparison**
I would like to begin at this stage with some data on the number of PCs with CD-ROM and Internet connections at the disposal of children and young people and on the average time they spend using the most important media.

28

Table 1: **Computer facilities with CD-ROM in own room or in the home as a whole**[3]

|  | In own room | | | In home as a whole | | |
|---|---|---|---|---|---|---|
|  | FL | DE | SW | FL | DE | SW |
| PC without CD-ROM | 16 | 6 | 6 | 60 | 15 | 18 |
| Male | 18 | 7 | 7 | 64 | 18 | 14 |
| Female | 14 | 5 | 5 | 57 | 12 | 16 |
| By class: |  |  |  |  |  |  |
| Lower | 15 | 11 | 6 | 58 | 14 | 15 |
| Middle | 13 | 3 | 4 | 61 | 12 | 16 |
| Upper | 20 | 8 | 7 | 60 | 23 | 16 |
| PC with CD-ROM | 9 | 14 | 12 | 47 | 39 | 43 |
| Male | 13 | 19 | 22 | 51 | 44 | 52 |
| Female | 5 | 7 | 7 | 43 | 33 | 42 |
| By class: |  |  |  |  |  |  |
| Lower | 8 | 9 | 14 | 46 | 27 | 40 |
| Middle | 7 | 13 | 15 | 49 | 36 | 55 |
| Upper | 12 | 17 | 15 | 46 | 58 | 55 |
| Modem/ISDN | 3 | 1 | 7 | 32 | 9 | 28 |

Table 1 shows the extent to which computers have moved into the homes and rooms of children and young people in all three countries. With an across-the-board aggregation of all respondents, one of the findings is that the dynamics of the media environments of children and young people in Europe, or at least in the countries under review here, has developed along similar lines. It is also clear, however, that this statement conceals substantial differences between the individual countries. The Germans are, when it comes to technical equipment with PCs, the tail enders in the homes as a whole, but front runners for PCs in the children's own rooms. This statement does not aim to stimulate any battle of the nations or propagate greater effort to establish Germany as a business location – rather, the question raised is whether the development is something that could be classified as typically German.

The level of available computer equipment varies in all countries when set in relation to the gender of the child surveyed. In general, access for girls to a computer and the associated communicative facilities in their own rooms or in the home as a whole is more seldom than for boys. What is more, the differences in social class with respect to computer ownership are particularly pronounced in Germany. In comparison with the other countries, the access of German children to the Internet via a modem or an ISDN connection could almost be described as rare.

The dissimilarities regarding PC availability must be interpreted against the background of varying historical, societal and cultural differences. It comes as no surprise, therefore, that Swedish society, with its

much greater orientation to equality, ensures a more balanced distribution of access to computers than German society. It should also be taken into account, however, that the new media and computer-mediated communication meets with very different media traditions in individual countries and is thus embedded in different ways in the everyday life of the children. The differences in the time spent using respective media presented in Table 2 are an indicator of this aspect.

Table 2: **Average time spent using different media**[4]
(in minutes per day)

| Media | Flanders | | Germany | | Sweden | |
|---|---|---|---|---|---|---|
| | All | Users | All | Users | All | Users |
| TV | 106 | 106 | 101 | 104 | 134 | 138 |
| Video | 17 | 19 | 16 | 19 | 43 | 45 |
| Radio | 66 | 68 | 57 | 68 | | |
| CDs, audiocassettes | 49 | 50 | 49 | 55 | | |
| Books | 15 | 18 | 16 | 19 | 18 | 22 |
| Comics | 11 | 13 | 6 | 11 | 10 | 13 |
| Magazines | 9 | 11 | 8 | 13 | 11 | 13 |
| Newspapers | 5 | 7 | 5 | 11 | 9 | 10 |
| Computer/video games | 12 | 20 | 23 | 38 | 38 | 46 |
| PC  (not for games) | 14 | 14 | 8 | 19 | 28 | 35 |

Table 2 indicates considerable usage in all countries of the media as a whole, but very differing degrees of usage for individual media. On average, German and Flemish children watch less television and use VCRs much less frequently than children in Sweden. The time spent reading books and other print media is roughly the same in all countries, although there is a more widespread usage of comics in Flanders and to a lesser extent in Sweden. Computers are used for a longer period in Germany and Sweden than in Flanders. One very striking finding is the fact that twice as much time is spent playing computer games in Germany than for other PC activities, whereas this ratio is markedly smaller in the other countries.

A more detailed breakdown of the differences in computer time than the one shown in the table reveals that, in Germany's case, the differences tend to be lower depending on the respective social class and greater between the sexes. Whereas boys and girls from Germany use computers to a comparable extent for writing and other non-game activities (approximately 20 minutes per day), boys with PCs spend almost 50 minutes more and girls only 18 minutes more per day playing computer games. On the other hand, almost one in three of the girls from Germany at the time the survey was conducted had a Tamagotchi, but less than one in four of the boys. The computer games industry, which has realised this

limited marketability of its products, can be expected to change this situation very soon, albeit with different computer games for each of the two sexes.

Doing something because it's exciting is one of the motives most frequently named by children and young people. Television and video are primarily, and with the highest percentage figures, used for this reason, followed in the ranking by computer games. Whereas the audiovisual 'run-only' media are apparently often switched on because kids are bored, this is less frequently the case for computer games. The same can be said at a much lower level with respect to using the Internet: the possibilities of entertaining digital communication are exciting for children, and the fun they have using them is where they differ from the average adult.

As an interim summary, it is fair to claim that computers have established themselves to an equal extent in all three countries in the homes and rooms, the time budgets, and the fields of interests of children and young people. Below the general level, however, differences emerge between the countries that are rooted in the different cultural contexts of media usage. These differences become even clearer if the assessment is not limited to subgroups that are not aggregated across-the-board and segregated along sociodemographic variables.

Rather, the factor and cluster analysis studies on type formation to which reference can be made here show two kinds of differentiating tendencies (cf. for greater detail Johnsson-Smaragdi *et al.* 1998): First, specific subgroups are developing among children and young people within individual cultures that can be characterised by specialist patterns of media usage. To a certain extent, for example, reading is no longer tied to the primary usage of books, periodicals and newspapers, but also runs parallel to the usage of computers. And, secondly, the countries compared here differ with respect to the varying patterns of media usage as well as the size and nature of the groups that orientate their activities to these patterns.

## The Internet in the everyday life of German children and young people

In the following, the focus will be on a more detailed description of how children and young people deal with the Internet. As the figures for Germany are, on the whole, too small in this context, the comparative figures for Flanders and Sweden are only mentioned in the text and not incorporated into the tables. Table 3, of course, is just a snapshot of a rapidly developing and changing landscape. It comes as no surprise that knowledge and usage grow with age, at least in almost all of the response categories selected. It is also clear that gender-specific differences exist.

The figures for Flanders and Sweden are naturally much higher here too. 74 per cent in Flanders and 91 per cent in Sweden have heard about the Internet and 22 per cent and 41 per cent respectively have already

used it themselves. The Swedish figures indicate that more young people have actually used the Internet than just watched it, whereas the pattern is the other way round in Flanders and Germany. The degree of familiarity with e-mail is also much greater in the two other countries than in Germany.

Table 3: **Internet – Familiarity and Usage**[5]

| | All | By gender | | By age | | | |
| --- | --- | --- | --- | --- | --- | --- | --- |
| | | Boys | Girls | 6–7 | 9–10 | 12–13 | 15–16 |
| Heard about the Internet | 66 | 70 | 61 | 14 | 55 | 87 | 95 |
| Not heard about | 34 | 30 | 39 | 86 | 45 | 13 | 5 |
| Base: All those who have already heard about it (N=550): | | | | | | | |
| Already used it myself | 17 | 21 | 10 | | 4 | 13 | 29 |
| Only watched | 21 | 22 | 20 | 25 | 24 | 21 | 20 |
| None of these | 64 | 59 | 71 | 75 | 72 | 67 | 55 |

The response to the question where and on what occasion children and young people first came across the Internet reflects, if the figures are broken down according to age, the growing action spaces that are also important for their encounter with the Internet (Table 4). Strikingly often, they find access via friends, male and female, and thus via the peer group culture, but these figures were markedly lower in Sweden and Flanders (30 per cent in Flanders, 35 per cent in Sweden). In Germany, on the other hand, the parents tend to be less important for familiarity with the Internet.

If the significance of the peer group culture is combined with the great interest in excitement and adventure and the significance of computer games, it is fair to conclude that the difference between the generations in Germany is relatively substantial – or, to put it another way, with respect to the media environment, the socialisation of children and young people in Germany is quite different from what it was for today's adults.

Table 4: **Internet usage: Locations of Internet access in per cent**[6]

| | All | By gender | | By age | | | |
| --- | --- | --- | --- | --- | --- | --- | --- |
| | | Boys | Girls | 6–7 | 9–10 | 12–13 | 15-16 |
| At home | 24 | 20 | 29 | 50 | 31 | 25 | 17 |
| At father's or mother's place of work | 8 | 9 | 6 | 17 | 7 | 8 | 8 |
| At a friend's home | 42 | 43 | 41 | 17 | 52 | 37 | 45 |
| At school | 16 | 14 | 22 | | 3 | 14 | 23 |
| At an Internet café | 12 | 14 | 8 | | 7 | 11 | 16 |
| At a library | 3 | 2 | 3 | | 3 | 2 | 3 |
| Somewhere else | 14 | 19 | 5 | 17 | 10 | 19 | 13 |

A further interesting fact in an intercultural comparison, however, is that only 3 per cent of the children and young people in Flanders are also familiar with the Internet from school, but 10 per cent from public libraries. In Sweden, as many as 44 per cent had already used the Internet at school and 16 per cent in public libraries. In Flanders only 9 per cent and in Sweden only 4 per cent first became familiar with the Internet in an Internet café. It looks as if the public poverty in Germany forces children and young people keen on finding out about the Internet to use their own initiative to organise in an Internet café the acquisition of an educational competence that is so important for the future. Particularly for girls, libraries and schools would obviously be important in this respect in order to catch up on deficits caused by parental prescripts. Girls already mention schools and libraries as a location of experience with the Internet more frequently than boys.

It is not the Internet as such that is important, however, but certain services that children use or that they regard as meaningful. Table 5 shows which services these are. The percentages relating to how girls use the Internet are higher with respect to e-mail, usage of newsgroups and designing their own homepages, whereas other activities, in particular 'surfing', tend to be male activities.

Even though these are only very small case figures they are nevertheless theoretically plausible. Generalising the associated action interests, self-presentation via a homepage, the participation in informal discussion groups, and, above all, the sustainment of interpersonal relations tend to be female activities. Instrumental activities, on the other hand, in which an interpersonal *vis-à-vis* tend to be unimportant, such as testing new software and the usually non-committal discussion in chat rooms, are a domain of male Internet usage. This can be combined, of course, with the thesis that girls are more strongly orientated to communication than male children and young people.

Social class and/or household income also play a significant role when it comes to knowledge about the Internet and the way it is used. Whereas only 53 per cent of the children and young people with low household incomes have heard about the Internet and only 14 per cent had come across it at home, the corresponding percentages for respondents with high household incomes are 77 per cent and 47 per cent respectively. This makes it clear that friends and school can play a particularly substantial role for, in particular, lower-class children and young people with respect to familiarisation with computer-mediated communication. It should be pointed out that, in an international comparison, children and young people in Sweden make use of all Internet services more frequently than in Germany, whereas the Flemish children and young people concentrate on surfing, searching for information, and games.

## New media and new and old inequalities

Computer-mediated communication opens up a communication space that becomes equally important for leisure time, everyday life, culture and society (Krotz 1995; Beck and Vowe 1997; Neverla 1998). Among other things, it extends the previous spectrum of available types of communication by adding a new, third kind: alongside interpersonal communication and the reception of standardised and prestructured products, computers also enable interaction with so-called intelligent software. The chief examples of this both open and framed communication are computer programmes in chat boxes or MUDs, which appear and act as independent persons, and the world of computer games.

Table 5: **Type of Internet usage: What did you do on the Internet?**[7]

|  | All | By gender | | By age | | | |
|---|---|---|---|---|---|---|---|
|  |  | Boys | Girls | 6 – 7 | 9– 10 | 12-13 | 15-16 |
| Surf | 44 | 54 | 25 | 20 | 25 | 32 | 60 |
| Download software | 10 | 12 | 5 |  | 7 | 4 | 15 |
| Play games | 23 | 24 | 19 | 40 | 29 | 30 | 15 |
| Chat groups | 13 | 16 | 7 | 7 | 9 | 18 |
| Newsgroups | 7 | 5 | 10 |  |  | 11 | 7 |
| Search for information | 8 | 9 | 5 |  |  | 8 | 17 |
| E-mail | 17 | 14 | 22 | 20 |  | 16 | 23 |
| Write/design my own homepage | 5 | 3 | 9 |  |  | 7 | 6 |
| Something else | 19 | 19 | 19 | 40 | 36 | 20 | 11 |

New media have a general appeal for children and young people on account of their versatility of application (but also due to the associated possibility of creative use). Whereas adults often seem to deal with the computer in their leisure time as if they were tinkering with a radio, children and young people enjoy playing games and the possibilities of this third kind of communication encounter. This element of play and the enjoyment involved marks a decisive difference between this younger group and the adults who face computers in their working environment.

The question raised here relates to the nature of the integration of new media into future society and the generation gap these media create. Let us summarise a number of the empirical findings on this aspect which highlight how dealing with computer-mediated communication in Germany differs from the way it is dealt with in other countries: the availability of computers and the Internet strongly depends on gender and class. The peer group and facilities such as Internet cafés are particularly important in this context, whereas parents, school and public libraries play a comparatively minor role. A further empirically striking feature is the particularly high percentage of time German young people who own computers spend playing games. And, finally, the new media not only

perpetuate old inequalities but also produce new ones, insofar as, for example, access to computers and the Internet and the way they are handled depend on parents and their fears and attitudes.

If the thesis is forwarded that people's communication environments have a formative impact on their development a possible generation gap is not restricted to the fact that children find the new media easier to handle and take them for granted, whereas adults in Germany tend to do so more hesitantly. Rather, they also use them in a different way, and it is because of this and their emotional involvement that different social characters and identities will emerge in future (cf. also Turkle 1998). In this sense, the difference between adults and children runs even deeper in Germany, since the tendency there to entrust these forms of communication to the peer group culture of young people is particularly pronounced.

Viewed from the perspective of societal integration, however, such a tendency does have its problems. The introduction of new media also requires the background of experience of the older generation. Particularly in view of the host of temptations computer-mediated communication holds in store, and in view of the growing commercialisation of the Internet too (McAllister 1996), a balanced exchange between old and young people, in which the one side contributes its experience with communication, culture, society and economic factors and the other side adds its competence in dealing with the new equipment and thus enjoying its use, would be important.

This, admittedly, presupposes critical self-query on the part of the adults and a self-critical willingness that is not tied down to authority – a capability that would appear to apply to differing degrees in different countries. It might even indeed be quite un-German, and this could be one explanation for the fact that computer-mediated communication via the Internet is not as widespread in Germany as in other countries.

Media competence is a buzzphrase often used in discussions on the basic qualifications for dealing with PCs and the Internet (cf. Kubicek *et al.*, 1998). This has to be provided inter alia by societal institutions intended for this purpose – the public libraries and schools, especially since gender- and class-specific differences are manifest when dealing with computer-mediated communication. This raises the question of society's responsibility for ironing out such inequalities and ensuring a more integrative introduction of the new media to society.

The fact that the public libraries in Germany, which, after all, could also reach the adults, hardly play a role in this respect on account of their dried-up financial resources is no surprise. Schools too, however, as emancipatory institutions of socialisation have also all too obviously failed to offset these problems. Only about a quarter of the girls and 38 per cent of the boys have so far come into contact with computers at school. The figures would not seem to be too high in an international comparison, particularly since gender- and class-specific deficits are identifiable here.

And only eight per cent of the boys and seven per cent of the girls have actively encountered the Internet and/or e-mail at school.

In Germany, the opinion prevails in many parts of society that children and young people use too many audiovisual media and do so in the wrong way. Biographies today, however, are media biographies, and everyday lives are everyday media lives; not just for children, but for everyone. If the institutionalisation of the new media remains, on the one hand, entrusted to the market and, on the other hand, to the peer group culture and society's institutions opt out of their responsibility, this will produce results as well as conflicts that merely go to reinforce the sorry state of affairs. In this respect, we can only learn through intercultural research: the Swedes and the Flemings do a better job.

## References

Baacke, D., Sander, U. and Vollbrecht, R. (1990a): Lebenswelten sind Medienwelten. *Lebenswelten Jugendlicher*, Vol. 1, Opladen.

Baacke, D., Sander, U. and Vollbrecht, R. (1990b): Lebensgeschichten sind Mediengeschichten. *Lebenswelten Jugendlicher*, Vol. 2, Opladen.

Beck, U. (1986): *Risikogesellschaft*. Frankfurt am Main: Suhrkamp.

Beck, K. and Vowe, G. (1997): *Computernetze – ein Medium öffentlicher Kommunikation?* Berlin: Wissenschaftsverlag Volker Spiess.

Ferguson, M: (1992): The mythology about globalisation. In: *European Journal of Communication 7*, pp. 69-93

Hans-Bredow-Institut (ed) (1998): *Internationales Handbuch für Radio und Fernsehen*. Vol. 98/99. Baden-Baden, Hamburg: Nomos.

Himmelweit, H. T., Oppenheim, A. N. and Vince, P. (1958): *Television and the child. An empirical study of the effect of television on the young*. London: Oxford University Press.

Johnsson-Smaragdi, U., D'Haenens, L., Krotz, F. and Hasebrink, U. (1998): Patterns of old and new media use among young people in Flanders, Germany and Sweden. In: *European Journal of Communication*, 13, pp. 479-510.

Krotz, F. (1995): Elektronisch mediatisierte Kommunikation. In: *Rundfunk und Fernsehen 43(4)*, pp. 445-462.

Krotz, F. (1997): Hundert Jahre Verschwinden von Raum und Zeit? Kommunikation in den Datennetzen in der Perspektive der Nutzer. In: Vowe, G., Beck, K. (ed): *Computernetze – ein Medium öffentlicher Kommunikation?* Berlin: Spiess, pp. 105-126.

Krotz, F.(1998): Digitalisierte Medienkommunikation.: Veränderungen interpersonaler und öffentlicher Kommunikation. In: Neverla, I. (ed): *Das Netz-Medium. Kommunikationswissenschaftliche Aspekte eines Mediums in Entwicklung*. Opladen: Westdeutscher Verlag, pp. 113-136.

Kubicek, H. *et al.* (ed) (1998): *Lernort Multimedia. Jahrbuch Telekommunikation und Gesellschaft 1998*. Heidelberg: R. v. Decker.

Maletzke, G. (1959): *Fernsehen im Leben der Jugend*. Hamburg: Hans-Bredow-Institut.

McAllister, M. P. (1996): *The commercialisation of American culture. New advertising, control and democracy*. Thousand Oaks: Sage.

Neverla, I. (ed) (1998): *Das Netz-Medium. Kommunikationswissenschaftliche Aspekte eines Mediums in Entwicklung*. Opladen: Westdeutscher Verlag.

Schiller, H. I. (1989): *Culture, Inc.: The corporate takeover of public expression*. New York.

Schramm, W. (1961): *Television in the lives of our children*. Stanford: Stanford University Press.

Turkle, S. (1998): *Leben im Netz. Identität in Zeiten des Internet*. Reinbek nr. Hamburg: Rowohlt.

# How a child experiences reality

## Educational parameters of environmental acquisition beyond the influences of the media[1]

*Jan-Uwe Rogge*

### Stage-managed realities

On the way (not only when travelling!) to school, when going wild at home or playing active games at kindergarten children experience the reality of life. Physical experience curtailed by exaggerated care and concern impairs developmental processes in children's perception of reality that cannot be offset by the 'stage-managed reality' of television.

Children need television. This is the way Bettelheim put it a few years ago – without intending to provoke. Neither was this a criticism levelled at the know-all manner of cultural pessimism, but rather a serious allusion to the significant symbols and situations contained in realities staged in the media that appeal to children, fascinate and excite them, supplement (and enhance) their everyday lives with fictive, imaginative dimensions or can help them cope with inner real-life conflicts. Interpreting the significance attributed by the child to television programmes as a sign of a constructive-productive way of processing and coming to terms, as a way of coping with problems and as creative regression – Bettelheim was not the only one to describe this. Discerning phenomenological approaches as well as interaction and structural analyses of children's media consumption have revealed that the encounter with the symbolism produced by the mass media can be supportive for children if set in the context of immediate and communicative reality acquisition.

I know about the objections and concerns aroused by such statements: for example, the allusion to the growing incidence of heavy viewing by children who are more and more frequently referred to media activities and who lack emotional care. But anyone who has anything to do with precisely these children in various working contexts – for example, in an advisory or child care capacity – soon realises that a plain ban on media consumption or an abstract reference to alternative possibilities does not help them in any way.

Media products cannot represent the sole starting point for work aiming at communication competence with such children; the latter has to start out from the child's ecological system, its everyday experiences and the worlds it lives in. Anyone who associates only the media with the catch

38

phrase 'second-hand reality' loses sight, with a media-centred perspective (in the broadest sense of the term), of central structural parameters, which have a sustained influence on current childhood, on adolescent's emotional and psychic state and their communication culture.

Doubtless, media have both a quantitatively and a qualitatively significant function in children's everyday lives; doubtless the reality transmitted via the media plays a (sometimes too) dominant role in specific ecological and social systems – and not only in the case of children. But as is borne out by many research projects on children's activities, direct learning activities, for example games, do not cease to have effect. Grasping concepts comes via grasping objects; the concept is developed until primary school age, as the result not of abstract thinking but of active confrontation with the world.

## The disappearance of childhood
The directly active acquisition of the immediate surroundings and the environment has changed in the past few decades: the existence of things ranks above their materialisation, the production process. Buying and consumption render the production of one's own objects virtually superfluous. If I can purchase everything, production loses its appeal. The pressing of a button supersedes physical effort, the facade and the beautiful appearance of the design make it difficult to look behind them.

But children do not thrive on the world of glamour, superficial beauty and prefabricated experiences. Anyone who possesses the perspicacity and the opportunity for close observation (and not only a perspective seeking to corroborate one's own interpretation models) will discover how children oppose the sometimes incomprehensible components of a media- and industrially formed reality with their own means of grasping reality, with their movement and loudness, with their wish for unambiguity and independence.

There is no experience without friction – when there is no resistance, it will be sought. Adults often find such resistance a nuisance; creativity is praised when it does not create any trouble or a mess. Children's playing is seen positively when it is nice, quiet and well-behaved, when it conforms to and does not contradict the norm; media learning behaviour is, too, when the child sits quietly, signalling the need for explanation, attention, inner involvement and understanding.

By no means do I wish to paint an idyllic picture of childhood today or to tone down the influences on children surrounded by the media; but, on the other hand, it is a gross simplification, a mechanistic perspective to ascribe the commercialisation and functionalisation of children, even the 'disappearance of childhood' – a subject of unhistorical speculation not only among critics of our civilisation – solely to the influences of the media. Criticism of the media is not made any more plausible by exaggerated allegations, and yet it makes the headlines and governs everyday knowledge about the media.

Someone who reflects closely on the structural change of childhood, on the worlds in which children live, on what children experience, interpret and re-interpret as reality, or on what is discussed as the disappearance of childhood realises that a line of argumentation based on the media overrates the significance of the media and their effects, and at the same time neglects or ignores the other socialisation influences – and consequently the influences capable of forming the child's view of reality and the child's development potential.

In the various projects I have carried out in kindergarten and primary schools over the past few years[2] a number of education problems and development-related disorders have emerged in children that could only partly or marginally be explained by media-related activity; on the contrary, they were linked to problem constellations that studies in the field of communications research or media literacy hardly take into consideration in their categorisations.

In these projects I focused my attention not only on children who had considerable contact with media in their everyday lives or who were experts at handling the range of media services on offer. In fact, I was more concerned with observing the socialisation conditions of the children who attributed less importance to the media – the result of an educational approach based on regimentation and supervision – who, on the contrary, experienced a great degree of practical support and (too many) emotional demands, whose learning environment was stimulating and who were permitted considerable scope for their own activity.

Medical, therapeutic, psychological and pedagogical care, support and prevention measures sometimes assume incalculable dimensions; however, despite increasing concern about the growing child, the quality of the child's living conditions does not necessarily improve. The psychologisation and pedagogisation of childhood – just to name these two fields – also have their drawbacks: care becomes too much care and ends up in children being constantly and continually observed without their being left to their own devices. Demands become pressure; not the child's abilities and wishes are decisive but the adult who seeks self-fulfilment via the child. Children are not trusted very much; children and their attempts to actively internalise the world are constantly waylaid by well-meant or even regimental advice, a pedagogical programme, a learning goal, a curriculum. Experts give advice, parents follow suit. This superficially dispels the parents' uncertainty, which is in turn transferred to the children.

By means of several representative everyday situations I wish to refer to the drawbacks of exaggerated care, pedagogical and psychological supportive measures, concentrating on the segments which superficially have nothing or only a little to do with the use of the media, but which are nevertheless able to influence the heart of the child's relationship with the reality they experience and already have experienced:

40

- acquisition of time and space;
- repressed corporeality due to lack of movement;
- culture- and civilisation-induced perception disorder and
- psychosomatic disorders caused by excessive pressure.

### Children, time and space

Mario, five-and-a-half-years of age, attends kindergarten; he is – according to his teachers there – 'easy to handle'. He knows about the effect he has on adults and shows off a little with his likeable nature. Mario's parents take an intense interest in their son; pedagogically he receives a wide range of support. His everyday rhythm is one of regularity and a clear sequence of events. Mario plays, works diligently, allows himself hardly any breaks, constantly reaches his physical and intellectual limits. It is therefore no wonder that he sometimes seems 'stressed', sometimes far away. Spontaneity is alien to him; instead he has a strong tendency to plan everything in advance. Mario cannot bear frustration; he wants to 'do everything right'.

In the evening Mario 'is completely whacked', as his mother puts it. He does not co-operate, he retires to his room, he 'is contrary and is not at all amenable', he does not respond to his parents' offers to have a chat or play a game. The evening meal is ruined by his resistance; he just plays with his food, 'moans about the meal or wreaks havoc', his father reports. 'We try so hard', say the parents.

This 'trying so hard' can be seen in the course of the day's events: in the morning Mario goes to kindergarten ('We chose the best one here!'), also on Monday and Wednesday afternoons. His mother is at work on these days. The kindergarten offers a sports and physical exercise programme. On Tuesdays Mario attends a recorder course at a music school with his friend Robert; on Thursdays he goes with a group of children – accompanied by their mothers – to a nearby adventure playground. Friday is reserved for a shopping trip with his mum. Mario's Dad is responsible for organising the weekend: 'I want to do things better than when I was a kid. I was left on my own. Mario must have a better childhood.'

On the basis of my analysis of over 900 5- to 11-year-olds' daily programmes – and of a few other studies – it was possible to ascertain a few general tendencies:

1.  Children experience and read the grammar of their environment and immediate surroundings using their individual experience of time and space. Children are more and more frequently strapped into the straitjacket of a timetable. In the child's experience of time a functional experience of time predominates, a schedule and organisation geared to objective situations. Increasing demands (from requirements to pressure) – frequently communicated via the parents' exigent attitudes ('Our children should have a better life!') – often involve the necessity of a precise schedule for the day's events to reconcile the vast variety of interests – particularly when there are several children in the family.

41

The mothers are their children's time-organisers, chauffeurs who drive their children from place to place. For many children individually organised and experienced time is frequently a rare good: cyclical experience of time is often interpreted (by parents) as boring, doing nothing or idleness. Children have to fight for time to spend on their own activities; they sometimes have difficulty finding activities to occupy such time.

2.  Children learn how to handle special areas: areas for playing, letting off steam, being loud, painting, splashing about, modelling plasticine, etc. Spontaneous acquisition of space is a more difficult process: the street outside, usually paved or tarred and very busy, and even the speed limit, if at all observed, severely restrict the children and their activities. The wild meadow, the park, the forest are a long way away. Activity in functional areas involves the organisation of time. If playing grounds are not available in the neighbourhood it means appointments or a long drive.

3.  The problematic spontaneous acquisition of space affects bodily contact, self-discovery, movement and the related development of autonomy and self-esteem. When activity spheres become more confined and planned-aimless expeditions more difficult, even impossible, not only does active acquisition of the environment become difficult but also the need for movement is also curtailed, thus creating the necessity for educationally oriented physical exercise programmes. To the same degree that the transport from one functional location to another becomes important to cater for movement as well as the journey through time and space the fascination of the area in between wanes.

**Ways and movement**

The autonomous organisation of a way to a certain place in terms of experiencing time and space entails consequences that are not always spectacular and immediately apparent: namely the changes experienced on the way to school or kindergarten:

Mark, when he was almost six, insisted on going to kindergarten and returning home on his own. Eventually his mother consented because two of his friends went with him. Mark describes the situation as follows: 'In the morning things went very fast. We wanted to be there for breakfast. The atmosphere at our kindergarten's nice and cosy. On the way home we always took our time. Talking and things. Getting up to loads of tricks. It was best when it rained. Jumping into puddles. Or in summer – there were some cracks in an old wall where you could always see some lizards lying in the sun. Or when we had a bit of money we went to Auntie Klara's to buy some chewing gum.'

One year later Mark attends the primary school in the town closest to home; in the mornings he is picked up by the neighbour and taken home

at midday by his mother: 'The atmosphere there isn't nice at all. We have to be quiet, can't tell each other any stories any more because my Mum's always listening. And she keeps on asking, non-stop: 'How was it today? What's your homework?' That really gets on your nerves. But soon I'm allowed to go on my bike. I'm looking forward to that, to being on my own again at last.'

No doubt more and more children go to school or kindergarten on the school bus due to the nature of the school's network. But at the same time mother taxi drivers take their children to school in the morning and pick them up again at midday. The same applies to kindergarten. The car journeys are intended to spare the children the way there and back. The changes in the way to school brought about by technological advance affect the children's feeling for time and space and have a lasting influence on their physical exercise and feeling for nature. The car and the school bus mean that the way to school and back is always travelled in the same period of time. Car journeys especially – sometimes superfluous from the child's point of view – encroach on children's acquisition of reality and experience of space:

- The autonomous way to school is generally accomplished more rapidly and intensely so as not to miss the beginning of lessons. The child walks faster, crosses areas more intently; perception is usually more cursory. Being punctual means experiencing a functional time organisation, which children have to learn.
- The drive to school generally offers less scope for experiences; it is more regimental, more comfortable and linked to appointments. The mechanisation of the journey to school often means an extension of the child's upbringing in the home: the journey to school is subject to closer scrutiny and analysis.
- On the way home the child can stroll at its leisure, it can take its time. It stops, has a look around, sees many things that it overlooked in the morning. It takes another way round, discovers something new or familiar, digests the day's experiences at school, curses teachers and other pupils, concocts new tricks and pranks, makes friends and confronts enemies.
- Scuffles and fights are just as much a part of the journey to school as the growing – particularly recently – destructive violence experienced among pupils. Whereas a disciplined sense of time was required on the way to school, on the journey back the child can make the most of its own subjective time cycles.
- The way to school – on foot or by bicycle – involves an individually determined and created acquisition of immediate surroundings and environment. Even the hostile conditions of the barren concrete deserts of some suburban estates are not able to stifle completely the child's wish to plan its time and space autonomously, but they do severely inhibit it.

- The technical mode of dealing with journeys is based on rationalisation, the quest for the shortest time possible. Time regimentation forms are on the increase: schedules and appointments are becoming important. In many families time management tops the list of discussion topics.

Those who impose restrictions on ways restrict walking and standing, going wild and jumping, climbing and balancing. Moving and perceiving, thinking and feeling are closely intertwined. Anyone who walks, runs or races, experiences sensory impressions with the whole of their body. Children become acquainted with their body and environment through movement. The way to school in the rain is not the same as in bright sunshine: the way itself affords experiences different to those with friends; a stone wall is an invitation to balance on top of it; a bush is an invitation to break off a branch to make a pistol; the lowered level-crossing barrier is a challenge for a race; standing in front of the barrier is a chance for the child to recover its breath and to guess where the train could be going to; the red light unmistakably indicates the need to adhere to sensible rules.

Following ways also means experiencing borders, feeling resistance, withdrawing, breaking away. Movement and the development of the ego are closely related. Distances covered in a motorised vehicle and consequently not *dis-covered* by the children influence their state of mind. Of course, the school organisation requires school buses, co-ordination of schedules, the fast coverage of distances. And there are ways to school that are dangerous, definitely needing constant parental support. But anyone who reflects on the destruction of children's acquisition of space, on the impulsiveness in the child's urge to move must also consider, among other things, the micro-world of the way to school, the transformation of which has certain effects.

Of course, it would be superficial to describe such change as a technical problem. The phenomenon of children being driven by their parents to school can be associated with pedagogical patronising and influence, with safety and protection. The more a child is not trusted or permitted to do things, the more it will tend towards the image of a child in need of help, a mentally immature child. It will be incorporated in an educationally attractive programme, which is demanding, however not necessarily geared to the child's but to the parents' needs.

Two more small situations illustrate the connection between second-hand reality, restricted physical exercise and educational influence.

- Mother says to Juliane: 'Listen, don't run about so much at kindergarten otherwise you'll start sweating again'. And when leaving, she turns to the teacher and says: 'When Juliane romps around, she gets sweaty and catches a cold. She gets ill so easily.'
- When I want to go with a group of kindergarten children out into the open air, Pia holds me tightly by the hand and says sadly: 'Today I can't go out. I've got my silk shoes on and they'll get dirty. Mum told me to be careful.'

44

These two situations can raise a smile, they can cause a shaking of heads, even amazement. Anyone who has anything to do with kindergarten and school teachers knows that such situations are no exception. Interventions in the child's physical exercise caused by inappropriate clothing are not the rule, but they are on the increase. Children come in clothing that does not match the occasion. The child's urge for movement is subtly suppressed – not even consciously by the parents. Many parents are unaware of the consequences of such suppression.

Anyone who restricts physical experiences over a long period of time impairs developmental processes. While swaying to and fro on the swing, while running, jumping and balancing children experience the feeling of weightlessness, the thrill of speed, of dexterity and strength. The child shows what it can do; it achieves mental command through physical mastery. Failures are part and parcel of the process. They reveal limits, can encourage – or discourage. Security of movement and growing self-esteem are inter-related, likewise restricted opportunities for physical exercise and little confidence in oneself and others. Identity is developed, social relationships are created, via movement. And it is by no means a co-incidence that clumsy children whose movement is impaired are often isolated in the group.

### Perception disorders

Cornelia, four years old, stands out because of her motor clumsiness. I would like to illustrate this with two situations:

- Cornelia climbs onto a table, extremely clumsily. She has great difficulty in co-ordinating her arms and legs. Once she has climbed onto the table, she lets herself fall like a sack of potatoes, crashing onto the carpet where she lies motionless. She is not able to cushion the impetus of the jump and despite the pain she starts climbing all over again.
- The little girl cannot put her clothes on when the kindergarten group goes outside. And she is unable to wear clothes suited to the occasion (eg the weather). As a result she runs out into the snow – if one is not careful – in stockings or into the cold rain with only a T-shirt on.

The list of situations could be continued. One important thing is that the situations are not isolated examples but should be viewed in an overall context. In order to interpret accurately the situations described I asked the parents for their assistance.

Cornelia is physically and organically healthy. Her motor and perception-related disorders are ascribable to cultural, ie educational, causes: they are the expression of a certain style of upbringing. Cornelia's mother is an excessively caring 'high-performance mother':

- The sentences Cornelia often hears are: 'Watch out!', 'Be careful!', 'Wait! I'm just coming'. Then there are expressions like 'Don't get yourself dirty!' and 'Don't break everything!'

- During Cornelia's playing or motor activities her mother is present, always ready to give her – literally – a helping hand. Her mother does everything she can to protect Cornelia from bad experiences. Cornelia is spared everything; Cornelia experiences – without any television – cultural hospitalism.

- This also applies to Cornelia's contact with the reality of the outside world. When it rained she was not allowed to go out into the garden or she wore, in accordance with her mother's instructions, clothing that was not very appropriate or restricted her in her movements. Her mother's comment: 'But I only meant the best for her. Nobody looked after me, nobody was ever there to dry my tears. And then I always had to run around in rags; everyone laughed at me'.

Movement disorders can indicate a disorder in the meaning-attribution processing of stimuli in the central nervous system: stimuli that are registered by the sensory organs and then sent on to the central nervous system are not processed or inadequately processed there. Symptoms of this disorder may assume many forms: motor restlessness, a high level of distractibility, aggression towards others and oneself, concentration problems, rapid fluctuation of interest, inordinate sense of anxiety and insecurity, lack of self-confidence, disorders of the fine motor system and the gross motor system and a lack of attentiveness, etc.

The causes of such perception disorders are manifold: as numerous studies have already proved, they can be due to organic causes. These highly complex bio-genetic connections cannot be discussed at length in this context. Perception disorders can also be due to psychic reasons: for example, constantly excessive or low demands, the result of mental stress or an emotional disorder in the parent-child relationship. Children with perception disorders are quite often the symptom bearers. They adopt the (primarily stabilising) role of a child with an apparent behaviour disorder within a tense family system. Further causes of behaviour disorders are related to the child's culture and civilisation, eg the consequences of a lack of physical exercise, imposed education ideals and norms geared more to parental notions and less to the child's level of development.

The latter applies to Cornelia. An overprotective style of education prevents physical self-discovery; the low demands placed on the child in its experience of bodily contact lead to disturbances in the child's movements and the co-ordination of its various sensory activities. Cornelia becomes a problematic child that her mother has to look after. Pedagogical and therapeutic assistance are required to eliminate perception disorders: Cornelia went on to attend psychomotor courses, accompanied by a short-term family therapy, in which Cornelia's mother was encouraged to 'let go' of her daughter, thus giving her more self-confidence.

## Final remarks

Education difficulties and problems, the disappearance of reality and the senses – in an overall review of the child's daily life – can only partly be ascribed to the problem of media technology. Contact with and suffering from realities are also the consequence of a complex enculturation and civilisation process. Communication science and media pedagogy research should now focus on the latter more than ever before. Anyone wishing to illustrate and change critical constellations associated with media consumption must not simply gaze intently at the media. They must think and act in terms of the overall context, starting with the child and its environment. Not only will their perception become keener, but their relationship with the child will also be more complex and intensive. Changed realities and the transformed acquisition of realities also require a review of pedagogical modes of activity. A productive configuration of reality, decisive and transformational activity are not possible when children are confined to a pedagogically protected reservation.

## Notes

1    The original version of this article appeared in *TelevIZIon*, 5/1992/2, pp. 8-13 and in *Medien praktisch* -/1992/3, p. 4-8.

2    The study is based on various communication pedagogy projects I have conducted in the past few years, for example in Lower Saxony, in the rural district of Reutlingen and in various Austrian educational establishments. The results of the counselling activities can be read in: Rogge, Jan-Uwe: *Kinder brauchen Grenzen*. Reinbek b.Hamburg: Rowohlt Taschenbuch Verl. 1993.

# TV kids – new socialisation types?

## Michael Schmidbauer and Paul Löhr[1]

Children who behave differently from previous generations are called by scientists new socialisation types.[2] Is this due to their upbringing? Fathers, as models for their children, are no longer of any use, mothers are often domineering and helpless. This raises the question as to whether *Knight Rider, Alf, Pumuckl* or *Logo* now assume educational duties as a necessary response to children's needs, abilities wishes and opportunities.

### 1. Children's use of television

Current data on coverage, utilisation and viewing duration as well as programme preferences again reveal what was repeatedly ascertained in previous years: children display a high level of dependence on television and award top marks to programmes offering plenty of variety, excitement, fun and action. At present this mainly applies to programmes addressing the child audience such as *Knight Rider, Alf, Batman, He-Man* and *A-Team*. Programmes specially designed for them (*Hallo Spencer, Sesame Street, Die Sendung mit der Maus, Pumuckl*) are also included in this list, but in the case of young children these programmes rarely occupy the top positions in the rankings.

### 2. The Socialisation Process

In order to illustrate the main criteria determining children's relationship with television programmes, it would be wise to relate the child programme evaluations to the social and psychic conditions influencing the children's everyday life, awareness and behaviour. The first step in this procedure is to elucidate the context that is decisive for the children's socialisation: the parent-child relationship (seen here only in the context of the so-called complete family). Second, the key features must be elaborated that characterise the children's socialisation process, on the one hand, and the extra-family institutions intervening in this process, on the other.

#### 2.1 The parent-child relationship

The parent-child constellation is initially determined by the current mother-father relationship, for the parents' relationship with these children is strongly influenced by the customary transfer of the child's care to the

mothers and by the fathers' reserve, usually turning into aversion, concerning household and family duties. Moreover, the parent-child relationship is characterised by a contradiction  arising from 'child-centredness', typical of the modern family.

On the one hand, the meaning of life and the marriage relationship is meant to be safeguarded by the strong emotional bond with the child, the loosening of which – as the child grows older – (psycho-) logically has to be opposed by the parents. On the other hand, the parents want to guide their child towards independence and assertiveness in the interests of the child's development and future perspectives. It is clearly difficult to reconcile the two tendencies – of a strong bond and independence.

'Independence' does in fact seem to be impeded by the 'strong bond'. Family sociologists therefore advocate the thesis that the care constantly devoted to children since babyhood (despite different class-specific and everyday life emphases) frequently lowers their chances of breaking away from relationships in a 'normal' fashion and of gaining independence based on security. It is also assumed that a 'familialisation' process based on considerable devotion entails serious problems for the children especially when they are no longer tied to the 'natural' dependence relationship with their parents and to a narrowly restricted sphere of activity defined by the parents.

It goes without saying that the problems become even more acute when the children reach adolescence and emotional detachment from their parents. What also has a lasting effect on the child-parent relationship is the phenomenon that children from a very early age live not only in the family sphere but also in the public and commercial world – ie in two worlds, whose influence on the children can hardly be offset or controlled by the parents. The parents' efforts to strengthen the bond with their children, on the one hand, and their independence, on the other, take place within a framework that confronts children with (frequently changing) non-family contexts. This means that children leave the familiar close environment at an early age, entering – particularly via education and consumption – the sphere of influence of non-local rules of behaviour overlapping those of the family. These provide children at an early age with guidelines for autonomous behaviour, independent of parents.

The current parent-child relationship is thus subjected to an 'individualisation phase'. This tendency, which asserted itself after the Second World War, brings about living conditions and forms of awareness that make individuals increasingly dependent on themselves, 'liberating' them from firmly established ways of life and contexts. They are reflected in the many views, directions, living conditions and perspectives affecting – via the above mentioned fields of education and consumption (media!) – the parent-child relationship and the children in particular.

Especially children experience the breaking up of the social environment and cultural traditions. No longer can they simply rely on

secure guidelines mainly conveyed by the family. They are expected to fulfil new integration requirements, to attain more independence, and to assume at an early age a pivotal role in organising their lives and becoming the initiators of their social relationships. For children this means opportunities for the individual organisation of their lives but it also involves risks. The actual outcome depends mainly on the way the child-parent relationship and the extra-family socialisation institutions intervening in this relationship permit children to develop their individual and social identity.

## 2.2 Socialisation mechanisms and a 'new socialisation type'

Due to its 'child-centredness' the modern ('complete') family can be described as a parent-child 'symbiosis', which mainly consists of the development of the child/children and, linked to this development, a meaningful fulfilment of the parents' lives. The parent-child symbiosis therefore provides the framework for the children's socialisation process and for conveying to them forms of perception and interpretation, patterns of needs and emotions, knowledge and behavioural concepts.

### 2.2.1 The concept and the plausibility of the 'new socialisation type'

The past few years have witnessed the discussion of the thesis that under the influence of the parent-child symbiosis a 'new socialisation type', a 'new social character' has developed among children – both boys and girls.[3] To describe and explain the 'new socialisation type' particular psychoanalytical categories and theorems have been consulted, which define the 'new social character' as a consequence of the parent-child symbiosis.

The starting point of the thesis is the assumption that, due to the social processes of change that have taken place since the late 1950s, the parents' social position and psychic disposition have dramatically changed and that traditional thinking, emotional and behavioural orientations have been fundamentally called into question. This has had two main effects on the parent-child relationship, it is argued: first, the family position of the father has been undermined and hence his ability to act as the decisive 'identification object' in the child's socialisation process. Secondly, the mother, subjected to the insecurity of social changes, on the one hand, and to the 'weakness' of the father, on the other, has been manoeuvred into a dominant role within the family and above all within the socialisation process.

In the concept of the 'new socialisation type' this maternal dominance is said to manifest itself particularly in the first year of the child's life as a very intense mother-child symbiosis. The close mother-child relationship is indispensable for the infant's development during this phase – referred to as the primary-narcissist phase. The *excessive* intensity of the relationship causes the child, however, to cling to the (primary-narcissist) relationship

50

with its mother and the fantasies associated with her in the following development stages, too. The child is thus encouraged, also beyond the primary-narcissist phase, to make the goals of its life self-reference, immediate satisfaction, protection and security fantasies, defence mechanisms against being abandoned and offended, and to 'imbue' its further personality development with these elements.

The first plausible element of the 'new socialisation type' concept is the portrayal of the father image. The 'weak father' described is in fact an empirical fact. Without any doubt the economic and political dynamism that has strongly influenced the (Federal) German society of the past 25 years has filled a large number of fathers with uncertainty, drastically upsetting their social domain, and thus causing long-term effects. This applies to both the professional sector and the civic domain. These burdens, failures and uncertainties affect the father's role and his behaviour in the family. Uncertainty, self-doubt, an unstable educational approach grow – with consequences for the children's personality development, which is also characterised by instability, inconsistency and uncertainty.

The second plausible element of the 'new socialisation type' concept is the portrayal of the mother-child symbiosis arising almost naturally from the bio-psychic nature of the mother-child dyad – in the primary-narcissist phase. An intensification and a prolongation of the symbiosis comes about when the mother exhibits the following reactions, induced by the stresses and uncertainties resulting from her family role or her double family-career role: when she reacts to her anxiety about being inadequate – related to the demands of life in general and to the demands coming from the child in particular – with an over-affectionate mode of behaviour.

Both types of reaction result in a mutual relationship compulsion on the part of the mother and the child and in the child's internalisation of a 'grandiose' mother image that constantly promises intimacy, satisfaction of needs and protection. This mother image, usually assuming the form of a subconsciously active imago, then accompanies the child beyond the primary-narcissist phase, constantly directing it to a longing – associated with the mother imago – for self-centredness, protection, security and immediate satisfaction.

The third plausible element of the 'new socialisation type' concept is the thesis that the 'weak' father sees himself confronted with a consolidated mother-child dyad which, due to his 'weak position', he can now relate only to passively and without any commitment to his 'male' protector-cum-leader function. The effect of his behaviour is two-fold: on the one hand, he intensifies the mother's relationship with the child, elicits its clinging to the 'grandiose' mother image and creates an additional strain on the mother, frequently triggering aggression and anxiety. On the other hand, he undermines his – already impaired – ability to offer the child an 'object' suitable for occupation, identification and (super-ego) development purposes.

51

Another notable feature is the fact that the 'new socialisation type' reveals not only a 'narcissist component'; this type also harbours – precisely because of this component – aspects that can help him or her to achieve a kind of 'psycho-structural flexibility'. Despite all the stressed-stressful conditions of his or her formative process he or she has neither to subordinate himself – or herself – to an authoritatively consolidated, rigid parent-child structure ('weakness' on the part of the parents) nor does he or she have to fit in with a character form valid for life – conveyed via a structure of this kind and legitimised mainly by the 'strength' of the father.

The 'new socialisation type' can therefore be described as an absolutely contradictory character: the tendency towards self-centredness; the fear of being abandoned, offended and of a delay in satisfaction; the longing for protection and security; the detachment from adult authority; the reservations concerning 'identification persons' – these properties are always connected with the opportunity arising from them. This not only consists in the fact that the 'new socialisation type' lives in a more flexible, less authoritatively regulated psycho-social environment. He or she is also offered opportunities for development that can dissolve the bond with the mother imago and combat the unstable identification with the 'weak' parents.

An important role is played not least by the question as to whether the parents – despite their 'weakness' and the special 'bond' with their child linked to this weakness – are 'strong' enough and the family structures open enough to promote the use of such opportunities. Furthering the latter is particularly important for children over six, when the process of coming to grips with these development opportunities begins to play a most significant role – primarily in terms of the expression of needs and interests, the adaptation to human relationships and the identification with a ('school') task.

### 2.2.2 The status of extra-family socialisation institutions

The older children become the more clearly they perceive how their parents' (still remaining) real power and vigour, stimulating the process of identification, gradually wanes. This means a noticeable decline in the parents' ability to act convincingly as 'representatives' of societal reality and as transmitters of binding, indisputably valid orientations, knowledge and social obligations. From the age of six or seven children begin to turn to extra-family spheres and allow 'access' by extra-family institutions. Initially, children are attracted by peer groups understood to be a 'social uterus'.

A vital role is also played, however, particularly by institutional 'contact opportunities' (consumption, media), when they correspond to the children's 'narcissist component' and relieve them of problems in their processes of self-reference, occupation of objects and identification. Such opportunities are particularly important from the time when children

have to struggle with anxieties and failures, depressive and aggressive tendencies caused by pressures stemming from performance at school and alienation, by their consequences for family socialisation conditions. The children's relationship with extra-family assistance and relief institutions means that the development of the child's ego is substantially shifted away from family and school to be taken over by these institutions themselves.

*2.2.3 Children's action-determining themes and their relationship with the television programme*
In the context – and as a result – of socialisation conditions children develop specific spheres of needs and behavioural aspects that are manifested in 'themes'. These themes represent for the children the principal characteristics of their everyday situation and *any aspect that determines their actions*. The themes are action-determining inasmuch as they express relatively long-term, constantly iterative, subconscious or conscious scenes related to the children's current phase in life – and consequently to their needs and abilities, wishes and opportunities but also to the resistance encountered.

The children's concrete themes arise from the psycho-dynamic and social conflicts characterising their situation within and outside the family: the acquisition of the sex and age role, the confrontation with the parent-child relationship, the positioning in the network of extra-family influences, particularly expectations and anxieties concerning peers and school. These themes are therefore directed at

- the development of forms that provide for the satisfaction of individual needs as well as the ability to cope with expected fears and failures (school!);
- the development of cognitive, emotional and social-moral abilities required in and outside the family;
- the identification with the sex role and the autonomy tendencies related to the age role;
- the rapprochement with points of reference for extra-family role opportunities, normative orientations and 'world images'.

These themes are joined by one more that does not however possess a quality of its own. Rather, it accentuates a significant feeling for life. This emphasis implies that children not only take in their action-determining themes but also want to be treated in a particularly playful, imaginative, 'purpose-free', 'trial-feasible' manner.

Due to the socialisation conditions described, children cannot 'handle' these themes in a framework characterised by unproblematic identification with parents and self-evident recognition of authority, indisputable orientations and binding behaviour guidelines. Nowadays children must come to terms with the themes in a situation that confronts them with at least three problems:

1. They have to confront the restricted and constantly reduced identification and model quality of their parents and the partial substitution of this quality by parental (particularly maternal) 'over-protection'.
2. Children have to face a school situation exposing them to a 'gentle' but still relentless system of thoroughly regimented performance demands, in which the children's family socialisation parameters are not a subject of open discussion but which still put in a tacit appearance.
3. Children have to come to terms with the *contradictory* form of their character (owed to the transformation of societal and family conditions), which is both self-centred and adaptable, which rejects authority and is in need of protection, which is reluctant to take decisions and yet in search of a purpose, which is easily offended and yet receptive and open.

The demands implied by the above-mentioned themes and the contradictory nature of the approach to these themes very soon cause children to waver: between frustration, resistance and withdrawal, on the one hand, and the search for identity and loving care, on the other. In this process they constantly look for means of assistance that can support their identity, afford them stability and relieve stress. Their purpose is to replace what parents and adults in kindergartens and schools are allegedly unable to provide – namely reliable guidelines signalling 'warmth and security', accompanied by a play, fantasy and fun approach to 'the serious side of life' that simultaneously lessens the pressure created by the latter.

This assistance is evidently offered by the television programme and its transmission of experiences, emotions, interpretation patterns, fields of knowledge, and wishes. If the degree and intensity of children's television use are accepted as proof of this phenomenon, one thing is clear: children avail themselves of television reception, contact with television experiences and television symbolism as a self-evident activity in the course of everyday events and experiences. The television programme not only complies with action-determining themes; it also quite clearly tallies with the special psycho-dynamic nature of socialisation and the children's character form conveyed in this process.

But this does not yet answer the question of how the connection between the television programme and children's themes is realised in concrete terms and in individual cases – and of whether the television programme is *development-conducive* or *development-inhibitive* (or both) for children. The two questions, which cannot be answered without an appraisal of the television programme (actually received by children), will be further examined in the following section with reference to examples.

### 3. Children's relationship with the television programme

What form is assumed by the connection between the television programme and action-determining themes? What are the consequences

for the children's 'handling' of the themes? Now follow a few comments on four programmes 'relevant to children' and the studies available on them:

### 3.1 Alf – *Handling personal needs*

The first of the action-determining themes introduced above will now be resumed: the acquisition of forms of orientation and action affording children a satisfactory way of handling their needs. An important element of this theme: the acquisition of such forms of orientation and action by learning is characterised by two factors. On the one hand, the learning process includes the previously mentioned 'self-centred' inclination on the part of the children to avoid any delay in satisfaction and to reap opportunities for satisfaction without any big 'ifs and buts'. On the other, this process bears the strain of the contradiction arising from the societal changes in the mother and father figures. This is expressed in the fact that children follow their parents' guidelines with little conviction, frequently reluctantly – but at the same time they view their parents as being the vital guarantors of protection and guidance.

The series *Alf* appears to be a television programme that embraces the previously referred to implications of this theme and, by means of a playful, imaginative pastiche of the 'emergency situation', reduces the pressure involved in the confrontation with the acceptance and rejection of children's needs. Clearly the funniest episodes in the programme for the kids are those when *Alf* voices his needs and attempts to fulfil them without any respect for other people's rules, usual customs and conventions. He undermines the restrictions he is subjected to by making fun of adults' double moral standards, their ignorance and unreflecting adaptation, by refusing to let them have any impression on his amazing knowledge and skills.

This makes it easy for kids – both girls and boys – to identify with *Alf*. They regard him as a childlike friend, who breaks the rules of family life, who refuses to follow orders, lives according to his own ideas and is not an 'obedient' child. The kids are happy to see that role obligations and the interpretations of needs – envisaged by parents and other adults – are not sacrosanct, but have to be queried and justified when criticised (transfer to the school situation!). What seems to be particularly important for children is that doubt and criticism are always put forward by the one concerned and offered for discussion (in the family) – and that the one concerned does not lose any esteem, protection and security from the other members of the family.

Children, by identifying with the way *Alf* sets an example of spontaneous self-reference and the right to question educational rules and contents, role obligations and the interpretation of needs, evidently feel they have been raised to a 'superior' position. However, as *Alf*'s activities usually end up in medium-sized catastrophes, such feelings of superiority

are subject to severe limitations. This is also probably the 'main problem' of the series. Children, it is true, with their action-determining theme can 'join in' *Alf*'s activities and 'work on' important aspects of these themes in their confrontation with *Alf*'s comings and goings. But in the final analysis, they are led up to a certain point in every programme where any form of spontaneous self-reference, any reasoning based on questioning and doubt come to a sudden, frequently 'speechless' ending – namely to the point where the 'tacit compulsion' of the catastrophe restores (normative) situations to the order they assumed before their being called into question.

### 3.2 Logo – *the acquisition of competence for the construction of reality*
The following section reviews the children's theme related to the acquisition of cognitive, emotional and social-moral skills enabling them to cope with rules and events inside and outside the family. This theme also derives its special importance from specific consequences of children's socialisation conditions: in view of the 'weakness' of parents and teachers as models and identification figures children find it difficult to accept their instructions as compulsory. The outcome is a clash between the children's inclination to consider their own well-being as the main criterion and the necessity to accept well-founded learning and performance requirements that are, in many cases, neither personally relevant nor personally rewarding.

The longing for protection and security consequently prompts the children to avoid every possible uncertainty, which is inevitably attached to learning processes and the respective changes in the cognitive, emotional and interactive sphere. The wish for a withdrawal into the realm of play, fantasy-cum-imagination and adventure may result in the children pushing aside anything that is earnest, worthy of reflection and threatening.

The fact that there are a number of programmes that feel a true commitment to an intentional transmission of cognitive, emotional and social-moral competencies to children is a great advantage of the German, particularly the ARD/ZDF television programme for children. The dilemma of such channels is known: the programmes they offer, aimed at giving children emancipated support, explanations of the reality around them and the opportunity to grow up in the world, are not very enthusiastically received by their intended audience. Could this also be due to these ambitious programmes often levelling their sights way above the attitudes and knowledge of the child audience? And to the possibility that they do not in fact consider the factors mentioned above, that accompany children in their acquisition of skills and confrontation, with reality? This question is reviewed in the context of the ZDF children's news programme *Logo*.

Three problem areas will be discussed in connection with *Logo*:
1. The first point is the way the programme is presented and the distance maintained by the presenter from the events depicted. Both aspects

56

confront children with an 'elevated' information and interpretation authority with which they cannot enter any relationship or confrontation and cannot establish any fulfilling identification. Consequently they are granted hardly any opportunities to relate to the orientation, identification and authority problems typical for their socialisation process and to find support for their attentiveness – which is therefore always precarious and unstable.

2. The second point is the form in which the news in *Logo* is presented. The quality of this form gives rise to the following concern: this method of processing information can familiarise children with hardly any *concrete* historical processes, *concrete* societal conditions that characterise and illustrate the people presented in the news as behaving 'meaningfully'. It is probably difficult for the children to discern among the news reports explicitly developed points of reference with which they and their ability to understand can associate and from which they can integrate the items described into their cognitive, emotional and social-moral frame of reference. This in turn could give children the impression that the news has nothing to do with their own situation, with their own sphere of experience – an appraisal that is likely to create not only reluctance and aversion in the children, but also confusion and a lack of direction.

3. The third point is that especially the political contributions – in the narrow sense of the term – make children very insecure, for they never fail to confront them with an obligation to question and possibly re-organise their knowledge, their emotional structure and their moral orientation. Furthermore, the ensuing uncertainty is usually not offset by unequivocal, precise, visual and textual information of a limited scope; on the contrary, it is frequently aggravated even further by a disproportionate abundance of information.

A summary of the three points indicates one obvious assumption: on the one hand, children are keen to accept the *Logo* programme in the sense that they seek an explanation of reality and wish to understand the world; on the other, *Logo* elicits the tendency on their part to withdraw and look the other way.

### 3.3 Hallo Spencer *and* Pumuckl *– the urge for autonomy and the gender role*

This section reviews the children's theme focusing on their handling of their sex role and the associated urge for autonomy and independence. How children associate this theme with certain television programmes will be illustrated with reference to two individual case studies.[4] The studies were carried out with two 6-year-olds: Nicole, who prefers *Hallo Spencer* and Paul, who prefers *Meister Eder und seinen Pumuckl*. Both examine the demands and requirements involved in the acquisition of a sex role and the urge for age and parent-related independence and autonomy. Both are

directed mainly against the (over-) protective 'embrace' and refusals practised by the parents.

The individual case studies illustrate the connection children make between the programmes and their themes; they show very clearly and concretely the specific socialisation character of this connection. In both Nicole's relationship with *Hallo Spencer* and Paul's relationship with *Pumuckl* it becomes strikingly clear how the children integrate their television experiences into the situation of their private lives and accordingly interpret them. They use the programmes to project the experience of their everyday situation and their handling of its demands (identification with the sex role, detachment from parents, independence) into television figures and their actions. In this way children obtain the opportunity to 'symbolise' their expectations, anxieties, wishes, hopes, and aggressions and to make them comprehensible and acceptable – also for themselves.

The studies do however also raise the question of how children handle the television programmes – especially when the discussion is extended to other programmes, not only *Spencer* and *Pumuckl*. One thing is clear: children 'bend' the television stories to suit their present situation and the themes that are on their minds or worry them.

On the other hand, two aspects must be borne in mind. First, the children's psychic structure and social environment may be so problematic that even a programme with the best intentions and designed to foster their development does not reach them, even confuses them or guides them in an unhelpful direction. Second, children are served a range of programmes whose 'autonomous nature' cannot be simply dismissed. Children are not only pushed into a pre-fabricated framework, usually they are also confronted with a programme choice – if all the programmes children consume are included – which is by no means adapted to the aim of fostering their development. The danger therefore exists that the programme reception in the first and in the second case does not in fact proceed along the lines of an active, reflective examination of internal and external realities and of 'fantasising to cope with life' but as an escape into a world of illusion in which children (can) lose themselves. This problem is well illustrated by the following example.

### 3.4 Knight Rider – *orientation towards views of the world*[5]

The children's fourth action-determining theme named is the rapprochement with points of reference for extra-family role opportunities, norms and views or conceptions of the world. This theme is mainly characterised by the intervention on the part of institutions outside the family – school, the consumer market (in particular the media) – in the parent-child relationship. Particularly the media intentionally address the children's theme and its socialisation-specific 'slant': they offer a host of normative points of reference and aspects of the world view (good/bad, right/wrong), frequently presented in a way and quality that cannot be offered in the family, nor at school.

The media also make it possible for children, on the one hand, to elude parental 'intervention' in the handling of their themes and, on the other, to compare the orientation and identification relationship with their parents whom they experience as being 'insecure'. And the media provide children with points of reference and aspects in an (entertainment) form that relieve the pressure exerted on them by the whole subject. The quality and the (possible) consequences of such activity by the media – namely, which normative points of reference and aspects of world view the media offer their form and their consequences – will be discussed with reference to the example of *Knight Rider*, a programme children highly appreciate.

*Knight Rider* is apparently so popular with children because the structure of the plot in the series and the structure of the characters featured are very skilfully adapted to children's (normative) interpretation and evaluation abilities (as well as their wishes and anxieties). *Knight Rider* is a hero that can be characterised with just a few normative references. He knows no fear; he masters every dangerous situation; he acts according to specific, very straightforward modes of behaviour; he presents the world and its protagonists in a highly schematic contrast of 'good and bad'.

*Knight Rider* thus presents an ideal identification object for children who experience themselves and their ego development as problematic, often worrying and who cannot cope with the normative demands governing their needs and behaviour (or who are quickly deterred by them). *Knight Rider* shows clearly, casually and like a friend which way to go. In the process it appeals to children's important wishful fantasies, particularly their longing for the unconditional fulfilment of their wishes, for praise and security, for a clearly defined division between what is 'good' and what is 'bad'.

The quality of the series outlined above also harbours its serious problem: as it is known, the series is not a pedagogical event that seeks – by addressing children's interpretation and evaluation capacities – to take them beyond this development stage and its cognitive, emotional and social-moral content. Admittedly, the construction principle and the contents of the series address action-determining aspects of the children's everyday situation and can be integrated and interpreted by children in this sense, but at the same time the series features a cliché, unreal, manipulated image of the world, society, technology and people that is hardly likely to exert a beneficial influence on the development of the child.

## Notes

1   The German version of this article appeared in *TelevIZIon* 5/1992/2, pp. 17-23. This article is based on a study by Schmidbauer and Löhr (1992) on 'Television children – New Socialisation Types?' published by the Prix Jeunesse Foundation.

2   Cf., among others, Ziehe 1979; Rolff and Zimmermann 1985.

3   This context does not allow further analysis of gender-specific tendencies and differentiations: cf. chapter B/I in the original version of the study (Note 1).

4   Cf. Charlton, Dörler and Neumann-Braun 1986; pp. 91 ff..

5   Cf. Theunert *et al.* 1992.

# 2: *Children's Television in Transformation*

# Children in the media market of the Nineties[1]

*Michael Schmidbauer & Paul Löhr*

Leisure for children means involvement with the media. Television has long been one of their favourite leisure-time activities, but, of course, they also listen to radio, records, CDs and cassettes, read books and comics and enjoy themselves playing computer games. What children are offered by this market, how they handle it and which (commercial) interests are pursued by programme suppliers is described in detail on the basis of new data.

## 1. Children among the media: coverage, time budgets, costs and preferences

According to the 1993 Statistical Year Book, in 1991/92 there were some 6.1 million children aged between 6 and 13 living in (a reunited) Germany. 49 per cent of them were girls and 51 per cent boys. A good 90 per cent of the children were members of so-called 'intact families' (married couples with child/ren). In 1991/92 there were about 8 million such families with children below the age of 18.

If it is assumed that 'active everyday life', the waking hours of 6- to 13-year-olds, amounts to between 13 and 15 hours, 50 to 60 per cent of them is taken up by school and homework. Of the remaining time almost half is spent watching television. That means: television constitutes children's favourite occupation in the time not spent on school and homework. Although in surveys the children state that their preferred activity is playing (indoors and outdoors), if we look at what they really do it emerges that occupying themselves with television ranks first – and 'playing', 'meeting friends' and 'being together with parents and siblings' are to be found in the positions that follows. (Table 1; Klingler and Windgasse, 1994, p. 3).

It can be seen that the table not only shows how dominant watching the television programme is, but it also makes it clear that the time spent in front of the television set considerably exceeds the time they spend on other media (radio, sound-recording media, books, magazines, newspapers). If the children's individual media-related activities are added up, it becomes quite clear to what extent the media (Charlton and

Table 1: **The frequency of individual leisure activities among 6- to 13-year-olds** (in %, 1990, representative sample)

| Activity | Every day/almost every day |
|---|:---:|
| Watching television | 82 |
| Playing outdoors | 73 |
| Meeting friends | 55 |
| Playing indoors | 53 |
| Being together with family | 51 |
| Listening to the radio | 46 |
| Listening to records, CDs, cassettes | 46 |
| Spending time with animals | 38 |
| Reading books (not school books) | 32 |
| Reading comics | 21 |
| Watching videos | 12 |
| Playing video/computer games | 9 |
| Reading magazines | 9 |
| Reading newspapers | 7 |

Neumann-Braun, 1992, pp. 101 ff.) as a whole dominates the structure of the children's activities. This is the tendency with all children, independent of their age, sex- and stratum-specific characteristics. However, individual deviations can be observed:

- As their age increases, the girls' and boys' interest in television programmes, books, comics, newspapers, magazines, computer/LCD games and particularly in audio media grows noticeably.
- Girls devote themselves to books, sound-recording media and magazines more intensively than boys and spend less time on television programmes and videos.
- Children from the better educated middle and upper classes attach rather more importance to reading newspapers and books and going to the theatre as they get older.

Since it is the electronic media that interest children most, it is no surprise that at an early age they already own equipment which provides them with access to what these media have to offer ( Glogauer, 1993, p. 12).

That the extent of such ownership also depends on the children's age and social stratum is obvious: especially their possessing their own television sets and (game) computers clearly goes up with increasing age and a higher position on the scale of social ranking. But even if the children do not have their own equipment, they can always resort to a large arsenal of media hard- and software on which their parents spend DM 140 each month (family of an employed person with a middle income) to DM 190 (families of employees and civil servants with a higher income). Table 3 shows what this arsenal looks like related to the German households (*Media Perspektiven* 1993, pp. 70, 82, 86).

Corresponding to the many opportunities for children and the media to come together, the media therefore reach far into the age group of the 6- to 13-year-olds (Groebel and Klingler 1991, p. 639).

Table 2: **Equipment owned by 6- to 10-year-olds**
(in %, 1993; representative sample)

| Equipment owned by | 6 to 8 year olds | 9 to 10 year olds |
|---|---|---|
| Radio | 52.4 | 61.9 |
| Radio recorder | 75.4 | 51.9 |
| Television | 15.5 | 34.0 |
| Video recorder | 5.5 | 14.0 |
| Children's computer | 21.3 | 28.8 |
| Walkman | 42.1 | 62.5 |
| Game Boy | 11.3 | not surveyed |

Table 3: **Equipment and means of communication in German households**
(in %, 1993, representative sample)

| Persons from households with | % |
|---|---|
| at least one TV set | 98.5 |
| of these | |
|    one TV set | 70.9 |
|    two or more TV sets | 27.6 |
|    colour TV | 96.8 |
|    with remote control | 89.1 |
|    portable set | 7.2 |
|    with videotext | 41.7 |
| Mini-TV/Watchman | 2.8 |
| At least one radio | 98.2 |
| Stereo-set (with record and CD player, cassette recorder) | 68.8 |
| Video recorder | 49.1 |
| Personal computer | 16.7 |
| Car radio | 75.4 |
| Telephone | 82.9 |
| At least one newspaper | 85.0 |
| At least one magazine | 75.0 |

Table 4: **The media reach in the case of 6- to 13-year-olds**
(in % per weekday, 1990, representative sample)

| Media | Mon-Sun |
|---|---|
| Television | 84 |
| Video | 8 |
| Records, cassettes, CDs | 24 |
| Radio | 34 |
| Reading (books/newspapers/magazines) | 32 |

How long the children are occupied with the media every day is illustrated by the measure of the so-called use time and time of stay. The use time, which – as a statistical value – refers to users *and* non-users, indicates the time which the children devote to the media (Groebel and Klingler, 1991, p. 642).

Table 5: **Media use time of 6- to 13-year-olds**
(in minutes per weekday, 1990, representative sample)

| Media | Mon-Sun, 5-24 hours |
|---|---|
| Television | 110 |
| Video | 7 |
| Records, cassettes, CDs | 20 |
| Radio | 27 |
| Reading (books/newspapers/magazines) | 20 |

On the other hand, the time of stay, which takes into account the *respective* users only, illustrates how long the children have actually spent with the relevant media product on the relevant set date (of the survey).

Table 6: **Media time of stay of 6- to 13-year-olds**
(in minutes per weekday, 1990, representative sample)

| Media | Mon-Sun, 5-24 hours |
|---|---|
| Television | 133 |
| Video | 87 |
| Records, cassettes, CDs | 82 |
| Radio | 82 |
| Reading (books/newspapers/magazines) | 64 |

While the media coverage does not show any age, sex and strata-specific features, their influence on the use time and time of stay clearly emerges. With increasing age the time the girls and boys spend with the media rises continuously. It is the older children who spend most time on television and video programmes, although the latter are only used by a

66

small group (see Table 5). Somewhat less time is devoted to television and video programmes by girls and those children who attend secondary modern and grammar schools and come from higher social strata. They invest the time thus gained to read books, newspapers and magazines and listen to radio (music) programmes.

The individual media products and the relationship to their respective child audience is dealt with below. Then items offered by the media will also be included that have either been integrated into the general categories (comics under 'magazines') or not mentioned (computer and LCD games, video films). On the other hand, the areas 'newspapers' and 'books' as well as 'cinema and theatre programmes' cannot be considered systematically and in detail, since at present no data to speak of are available for them.

## 2. The programme market and the child audience[2]

Children's extensive media interest identifies them as participants in a market which promises a demand for programmes running into millions, therefore sales of programmes also running into millions and, with the sales, advertising opportunities running into millions.[3] It is true, the supply of media offered to the children clearly cannot be just reduced to such market calculations. Especially in many *official* children's programmes transmitted by the ARD and ZDF, factors that used to be labelled 'educational and cultural remit' are still important. Nevertheless, it cannot be disputed that to a very considerable extent the market and financial imperatives determine the production and marketing of all the media that children encounter (and accept).

But that is hardly surprising, since the child audience is regarded, on the one hand, as a profitable group of consumers and buyers, and, on the other, as a promising target for advertising: it is known that 6- to 13-year-olds dispose of DM7–9 billion (some believe DM 16 billion or more) every year (pocket money, gifts of money, savings), of which it is estimated 70 per cent is spent on the media, ie on both programmes *and* equipment (Schmidbauer, 1993, p. 15; Institut für Jugendforschung 1993, p. 4). From that point of view it cannot be inappropriate to investigate the contours and structures of the 'child-relevant' media market and at the same time to find out how this market handles a clientele whose situation of needs and development does not actually exist to be turned into the instrument for the economics of programmes and advertising.

### 2.1 Television programmes
The part played by television in everyday life can be seen from the reach of the television programme and from the children's viewing behaviour.

### 2.1.1 Reaches and use habits[4]
At the beginning of the nineties 63 per cent of 6- to 13-year-olds were reached by television. Of this age group 82 per cent sat in front of the TV

screen 'every day/almost every day' – the children from the new federal states of Germany being clearly over-represented with a figure of 93 per cent. The daily television use by children *in fact* reached by television (= time of stay on a set day of the investigation) amounted to a good 160 minutes, somewhat less on weekdays and somewhat more at weekends.[5] The daily prime viewing time of 6- to 13-year-olds was between 6.00 p.m. and 9.00 p.m. (Mon – Thurs, Sun) and between 6.00 p.m. and 10.00 p.m. (Fri, Sat). At these prime times 1.2 million children (Mon–Thurs, Sun) and 1.7 million (Fri, Sat) were sitting in front of the television. Of the children who used television roughly 40 per cent were average viewers (one to two hours a day), 30 per cent were heavy viewers (three hours a day), 15 per cent excessive viewers (four hours a day) and 10 per cent light viewers (less than 40 minutes a day).[6]

It has to be said in addition to the data given:

- First, 10 per cent of 6- to 13-year-olds (who use and *do not* use television) are likely to be non-viewers.
- Secondly, it is likely that while watching television other things were also done (additional activity).
- Thirdly, probably many programmes were only partly seen by the children, as the parents very often switch over to 'their' programme.
- Fourthly, programme consumption by the children, especially boys, from the lower social stratum is likely to be much greater than by those from the middle and upper strata, in which fewer heavy viewers are also to be found. (Schmidbauer and Löhr, 1991, pp. 30 ff.)

The programme on which most of the children who watch television are well informed in advance by broadcasting programme guides (65 per cent), parents (30 per cent) and friends (21 per cent) is always watched at home – often alone, sometimes with friends or parents. The latter are the most important role models as far as the children's television behaviour is concerned. 15 per cent of the average viewers and nine per cent of the heavy viewers are 'never alone' when they sit in front of the television; 67 per cent of the average and 72 per cent of the heavy viewers do not have to ask their parents for 'permission to watch television' (Klingler and Windgasse 1994, p. 5). The parents usually show very limited interest in their children's relationship to watching television, although they are certainly aware that their children are more and more turning into an evening programme audience.

The parents rarely impose any restrictions on access and hardly any limits on selection that are 'non-negotiable'. However, during the adult programme time most of the children have to do without their television enjoyment if their parents, especially their father, want to see something else. Programme-related conversations with their parents are invariably very limited in time and hardly intensive. But in the peer group the programmes received, especially their emotionally charged parts, are evaluated with all the more vehemence and involvement – not least on

account of the chance to turn an intimate knowledge of a programme into a gain in status and prestige.

### 2.1.2 The programmes offered

If the children's and 'child-relevant' programmes are examined, it is its rapid expansion, mainly due to the commercial stations, that is so striking. The fact that this enlargement does not express itself in the volume of programmes that are explicitly transmitted as children's programmes is obvious: regarding the overall programme in 1993, on the ARD 9.2 per cent of the transmission time was taken up by children's (and adolescents') programmes, on the ZDF 5.8 per cent, on SAT.1 3.1 per cent and on RTL 5.7 per cent. (Krüger and Zapf-Schramm, 1994, p. 114). In the case of PRO 7 the figure is likely in the meantime to be well above six per cent.

What the programme expansion has actually brought (and will continue to bring) the children first becomes particularly clear when the children's programmes are reviewed that were transmitted on one typical weekday and at a typical weekend.[7] Compiling these programmes, one would have to include two types of programming: those programmes that are *officially* aimed at children, and those programmes – whether explicitly described as children's programmes or not – which on account of the way they are produced and/or their repeatedly documented success have to be conceded an obvious 'child-relevance'.

It is well known that children additionally watch other programmes clearly intended for adults (Saturday evening entertainment, crime series). Their attraction for children is clearly recognisable if one looks at those programmes which are, in fact the most-used programmes of the 6- to 13-year-olds (see Table 9).

### 2.1.3 Programme preferences

Which television programmes do the children especially appreciate from this assortment, in which higher quality is being increasingly pushed out by the mass of animated cartoons, action stories and family idylls? (Klingler and Windgasse, 1994, p. 4)

Those programmes are always accepted that belong to the genres of 'fiction', 'entertainment' and 'advertising' and with their mixture of suspense and relaxation, family idyll and adventure, action and fun, gags and a dash of violence obviously appeal to the child audience (Heidtmann, 1992, pp. 82 ff.).

This general finding has to be differentiated by sex- and age-specific considerations:

- The programme preferences of girls and boys differ in that the girls are far less interested than boys in programmes full of action, violence and science fiction and more in family series and shows.
- The interest, especially of boys, in action, violence and science fiction (and also in advertising) develops more strongly the older they get.

- The older children (both boys and girls) show considerably less interest in animated content.
- The younger children (both boys and girls) prefer to watch programmes that are specially directed to them.

Table 7: **The 10 programme genres preferred by the 6- to 13-year-olds and their sex-specific acceptance**
(in %; criterion 'often watched', 1990 ; representative sample[8]

| Genres | Total | Boys | Girls |
|---|---|---|---|
| Animated cartoon | 66 | 66 | 65 |
| Advertising | 48 | 45 | 48 |
| Children's programme | 38 | 36 | 39 |
| Humorous films, | | | |
| Silent films | 37 | 41 | 32 |
| Programme with (real) animals | 37 | 38 | 36 |
| Action films | 34 | 43 | 25 |
| Quiz and shows | 33 | 31 | 35 |
| Science fiction | 28 | 36 | 20 |
| Western | 25 | 33 | 16 |
| Family series | 23 | 15 | 30 |

As the bulk of the programmes 'accepted' by the children is nowadays chiefly (and in profusion) provided by commercial stations, it does not come as a surprise that the programmes offered by the commercial stations RTL, SAT.1 and PRO 7 are considered far more attractive by the children than those of the public service organisations ARD and ZDF duo (Darschin and Frank, 1993, p. 99.).

How that and the preferences sketched above for specific programme genres is concretely reflected in the children's viewing habits is vividly shown in a documentation registering the programmes favoured most strongly by the 6- to 13-year-olds in a selected programme week (Klingler and Windgasse, 1994, p. 11; Glogauer, 1993, p. 50).

Table 8: **The average viewing time of children according to television stations** (Monday to Sunday, in minutes per day, 1993, representative sample)

| Stations | Viewing time |
|---|---|
| ARD | 13 |
| ZDF | 10 |
| ADR Third Programmes | 5 |
| Sat.1 | 12 |
| RTL | 27 |
| Tele5/DSF | 1 |
| Pro 7 | 20 |
| Others | 18 |

To do this 6- to 13-year-olds were asked about the broadcasts they had watched between the 6th and 12th September 1993. Table 9 illuminates the following facts in particular:

- Although ARD and ZDF rank first in the sections '6 a.m. to 7 p.m.' and '7 p.m. to 6 a.m.', the two stations score only a very moderate success with children as a whole: ARD and ZDF are represented in the list by two programmes each, but PRO 7 by 26 and RTL by 8 programmes.

- It is especially noticeable to what extent family and 'relationship' comedies dominate: *Unser lautes Heim, Herzbube mit zwei Damen,* and *Gute Zeiten, schlechte Zeiten.* This means that series take centre stage – especially with the girls – in which it is primarily a matter of relations between the generations and the sexes as well as – and this applies especially to the obviously very successful series with children *Unser lautes Heim* – the children's efforts to gain autonomy, finding (sex) roles and forming their identity.

- It is also noticeable how attractive action films (*Zwei ausser Rand und Band, American Wildcats* and *Zwei wahnsinnig starke Typen*) and cartoon series (*Disney Club; Familie Feuerstein; Dink, der kleine Saurier; Katts and Dogs* and *Cap Candy*) are to children, especially to boys. This, first, is likely to be an expression of children's desire for programmes that make life easier and release them from the constraints of everyday life. And, secondly, the preference for action and cartoon films shows that these evidently have no difficulty in connecting up with their cognitive, emotive and moral abilities to perceive and process.

That appears to basically come about by the children being able to relate films and series, with their simple and easily understandable psychological and sociological orientation (successful struggle of the heroes against the rigours of the 'world', a clear dualism of right and wrong and a clear-cut division of good and evil), to their own developmental problems (forming an identity, social responsibility). An additional attraction is that everything that is shown to the children maintains a strong, unrealistic accent, which arises, in the cartoon series, from their obvious artificiality and, in the action films, from their slapstick trimmings, easily recognisable exaggeration and so-called 'humour' .

There are probably two reasons for an advertising programme being named twelve times in the children's 40 favourite programmes. One of them is likely to result from advertising programmes being extremely popular with children. They are appreciated by them just as much for their entertainment as for their explanation of reality: 53 per cent of the 6- to 13-year-olds deliberately watch advertising programmes 'every day/almost every day'; in the case of the 13-year-olds it is as much as 61 per cent.

The children are attracted both by the perceptually salient design (short spots, cutting pace, acoustic and visual effects, music, slogans and advertising jingles) and by the easily understood messages of the commercials, which, moreover, usually take place in areas they are familiar with (family, play, leisure).

Table 9:  **The 20 most-used programmes of the 6- to 13-year-olds**
(Programme week 6th to 12th September 1993; representative sample)

| Programme Ranking | Transmission Date | | | Title of programme | Length in minutes | Children watching in mill | in % |
|---|---|---|---|---|---|---|---|
| 1. ARD | Sat | 11.09.1993 | 16.05 | Disney Club | 84 | 0.64 | 10 |
| 2. PRO7 | Tue | 07.09.1993 | 18.55 | Straßenflirt | 24 | 0.62 | 9 |
| 3. PRO7 | Wed | 08.09.1993 | 18.55 | Unser lautes Heim | 23 | 0.59 | 9 |
| 4. PRO7 | Wed | 08.09.1993 | 18.24 | Herzbube mit zwei Damen | 24 | 0.56 | 9 |
| 5. PRO7 | Thu | 09.09.1993 | 18.57 | Unser lautes Heim | 22 | 0.55 | 8 |
| 6. PRO7 | Tue | 07.09.1993 | 18.24 | Herzbube mit zwei Damen | 24 | 0.54 | 8 |
| 7. PRO7 | Wed | 08.09.1993 | 18.07 | 'Block of advertisements' | 6 | 0.53 | 8 |
| 8. PRO7 | Wed | 08.09.1993 | 17.54 | Familie Feuerstein | 24 | 0.51 | 8 |
| 9. PRO7 | Wed | 08.09.1993 | 18.36 | 'Block of advertisements' | 6 | 0.51 | 8 |
| 10. ARD | Sat | 11.09.1993 | 17.29 | Spot Fernsehlotterie | 0,4 | 0.49 | 8 |
| 11. RTL | Sat | 11.09.1993 | 09.14 | Beverly Hills Teens | 10 | 0.49 | 7 |
| 12. PRO7 | Fri | 10.09.1993 | 18.56 | Unser lautes Heim | 23 | 0.49 | 7 |
| 13. RTL | Sat | 11.09.1993 | 09.39 | Dink, der kleine Saurier | 23 | 0.48 | 7 |
| 14. PRO7 | Thu | 09.09.1993 | 18.26 | Herzbube mit zwei Damen | 24 | 0.48 | 7 |
| 15. PRO7 | Tue | 07.09.1993 | 18.34 | 'Block of advertisements' | 6 | 0.47 | 7 |
| 16. PRO7 | Fri | 10.09.1993 | 17.54 | Familie Feuerstein | 24 | 0.47 | 7 |
| 17. PRO7 | Fri | 10.09.1993 | 18.25 | Herzbube mit zwei Damen | 24 | 0.46 | 7 |
| 18. RTL | Sat | 11.09.1993 | 11.51 | Katts and Dogs | | | |
| 19. ARD | Sun | 12.09.1993 | 08.24 | Disney Club | 84 | 0.45 | 7 |
| 20. RTL | Sat | 11.09.1993 | 08.45 | Camp Candy | 23 | 0.45 | 7 |

The other reason for the high priority given to commercials in the children's favourite programmes is probably due to something quite different. It is likely to be a consequence of the fact that children, because of their intensive use of the programmes of the commercial channels, are swamped by commercials before, during and after the programmes to such an extent that they simply cannot escape them if they want to see a particular non-commercial programme from beginning to end.

### 2.2 The programmes of the audio media
It should be remembered that children's occupation with the programmes of the audio media such as radio, records, cassettes or CDs ranks high in their leisure-time pursuits

Table 10: **The 6- to 13-year-olds' occupation with programmes of the audio media**
(criterion 'daily/almost daily', in %; 1990, representative sample)

| | All respondents | Boys | Girls | 6-9 | 10-13 |
|---|---|---|---|---|---|
| Listening to the radio | 46 | 44 | 47 | 36 | 56 |
| Listening to CDs, records, cassettes | 46 | 42 | 50 | 39 | 53 |

That means that half of the 6- to 13-year-olds devote themselves continuously to radio, cassette and CD programmes. Here the older ones – because of their preference for music programmes – are more strongly represented than the younger children and the girls more interested than the boys (Klingler, 1994, p. 15). It is important to note that the overwhelming majority of the age group have their own access to the programmes: 60 per cent of the 6- to 13-year-olds own a radio, 65 per cent a cassette recorder and 50 per cent a Walkman (Lukesch 1989, p. 50; Hansen and Manzke 1993, p. 17; Glogauer 1993, p. 12).

### 2.2.1 Coverage and use habits

At the beginning of the nineties radio reached 28 per cent, and records/cassettes and CDs 23 per cent of the six to 13-year-olds (per day). Each day the children listened on average to radio for 23 minutes and to records/cassettes/CDs for 19 minutes – the girls rather longer than the boys and the older children quite a lot more than the younger ones.

Table 11: **Duration of radio and sound-recording media use by the 6- to 13-year-olds** (in minutes per day; 1990, representative sample)

|  | All respondents | Boys | Girls | 6-9 | 10-13 |
|---|---|---|---|---|---|
| Listening to the radio | 23 | 22 | 25 | 16 | 31 |
| Listening to records, cassettes CDs | 19 | 15 | 23 | 17 | 22 |

While there is a clear television prime-time for TV consumption by the children, listening to the radio and occupying themselves with records, cassettes or CDs is spread out over the day. However, here, too, – and this applies equally to boys and girls, to younger and older children – small 'peaks' can be observed: thus at 7.00 a.m., 1.30 p.m. and between 6.30 p.m. and 7.30 p.m. for listening to the radio, and at 2.00 p.m. and 8.00 p.m. for listening to records, cassettes or CDs – the latter applying especially to the girls.

It has to be stressed with regard to the area 'radio' that half of the 6- to 13-year-olds tune in themselves to the radio programme they receive (25 per cent of the 6- to 7-year-olds and 71 per cent of 12- to 13-year-olds); on the other hand, 39 per cent listen to the programme that someone else has switched on: in the case of the 6- to 7-year-olds it is 58 per cent and the 12- to 13-year-olds 22 per cent (Klingler, 1994, p. 15).

### 2.2.2 The programmes offered

It is important to mention that since the eighties the ARD radio programme has run down its official children's programme and today 'productions intended for children ... (make up) less than one per cent of

the overall programme' (Heidtmann 1992, p. 58). There are therefore hardly any ARD stations which provide a children's programme regularly or several times a week. The exceptions here are Radio Bremen (RB) and the Bayerischer Rundfunk (BR) and Saarländischer Rundfunk 3 (SR) (Rogge, 1990, pp. 100 f.).

Table 12: **The children's radio programme of the Bayerischer Rundfunk** (week from 10th to 16th May, 1994)

| | |
|---|---|
| Bayern 1 | daily 7.55-8.00p.m.: Betthupferl |
| Bayern 2 | Mon-Fri 6.55-7.00p.m.: Betthupferl |
| Bayern 2 | every Sunday 7.30-8.05a.m.: Der Sonntagswecker |
| Bayern 2 | daily 2.00-2.30p.m.: various children's programmes |
| | 10th May: Das Kaleidoskop |
| | 11th May: Der Notenschlüssel |
| | 12th May: Hoheit Wiebke oder Drache auf dem Baum - play |
| | 13th May: Fortsetzung folgt...: Wenn man Märri Schimmel heißt - story |
| | 14th May: Vor unserer Tür - Kinder im Gespräch |
| | 15th May: Der weisse Täuber - story |
| | 16th May: Don Quichote - play |

If the ARD children's programme is examined in its totality (including the RB, BR and SR programmes) three things become immediately noticeable: firstly, most of the programmes are tailored to younger children; secondly, spoken programmes clearly dominate; and, thirdly, children's radio programmes are placed at very unsuitable times. All three factors restrict quite considerably – as will be shown in the next section 'Programme preferences' – the attractiveness of the broadcasts for the 6- and especially for the 9- to 13-year-olds. Added to this is the fact that the content of the programmes – if the RB, BR and SR programmes are left aside – is not exactly breathtaking, but is exhausted in 'trivial good-night stories or childish artificial fairy tales' (Heidtmann, 1992, p. 58).

More attractive, it seems, are, those programmes broadcast by the commercial radio stations and also many ARD stations in competition with them: general 'pop music carpets' interspersed with 'chat' and advertising. This, too, is documented in the section 'Programme preferences'. It may be conjectured that this fact can explain why many families with children under the age of 14 hold the regional and local commercial radio in such high esteem, although it does not provide any programmes that are specially aimed at children (Bergmann and Kiefer, 1992, pp. 317 ff).

But within the sound-recording media market there is quite a considerable segment whose range of products is clearly intended for the 6- to 13-year-olds. At the beginning of the nineties 25 million sound-recordings worth DM 175 million were being sold on this child-relevant

sub-market per year. It is true, the development of the market has been stagnating somewhat in the meantime – above all because of the competition from the low-priced videos and an increase in television programmes. Nevertheless, children still constitute an important focus of the recording industry, in particular as customers that from the age of 12 or 13 promise to become a target group for pop music productions that guarantees turnover.

The child-relevant sound-recording market is at present dominated by three groups who together account for over 90 per cent of sales (Heidtmann, 1992, pp. 65 ff.) These are BMG Ariola-Miller (Bertelsmann with a 40 per cent market share and their labels Ariola express (*Der kleine Vampir, Garfield, Die Schnorchels*) and Europa (*TKKG, Masters of the Universe, Knight Rider, Regina Regenbogen*); the Polygram Group (Philips) with a market share of 20 per cent and the label Karusell (*Alf, Disney productions*); the ITP Ton- und Bildträger GmbH with a 10 per cent market share and their label Kiosk (*Benjamin Blümchen, Bibi Blocksberg*) as well as CBS/Sony (*Mein kleines Pony*), EMI Electrola (*Pumuckl*) and the Munich company Polyband (*MASK*), which together also make up a 10 per cent market share. The market leaders reckon that 40,000 pieces of the first sale of the productions have to be sold.

What swept the board in the last 10 years were the series *Benjamin Blümchen* (the adventures of a talking elephant who, full of child-like innocence, roams through the world of humans) and *TKKG* (the adventures of a group of child detectives), each with about 70 instalments and total sales of DM 30 million records/cassettes (Spielzeug-Markt 1992, p. 2).

Table 13: **Market-leading sound-recordings (records and cassettes) 1991**

| Series title | Label | Market share in % |
|---|---|---|
| Benjamin Blümchen | Kiosk | 15.4 |
| Bibi Blocksberg | Kiosk | 9.1 |
| TKKG | Europa | 5.6 |
| Walt Disney | Karussell | 5.3 |
| Kinderlieder | Karussell | 5.2 |
| Knight Rider | Europa | 4.6 |
| Ghostbusters | Karussell | 3.1 |
| Fünf Freunde | Europa | 3.1 |
| Teenage Mutant Hero Turtles | OHHA/Karussell | 3.0 |

The sound-recording programmes can be arranged into genres according to their contents (Heidtmann, 1992, pp. 68 ff.; Hansen and Manzke, 1993, p. 18, 20):

● The funnies (eg *My Sister Clara, Pumuckl, Barbar the Elephant, The Little Vampire, Bibi Bocksberg, Alf, The Simpsons*)

- The fantastic adventure (eg *Regina Rainbow, Ghostbusters, Teenage Mutant Hero Turtles, Masters of the Universe, He-Man, Airwolf*)
- The crime story (eg *TKKG, Five Friends, Scotland Yard, Knight Rider, James Bond*)
- The girls' story (eg *Hanne and Nanni, Barbie, Wendy*)
- The area 'music and songs for children' (including children choirs, children's hit parades, classical music programmes like *Peter and the Wolf*, environmental songs)

That the above-mentioned productions have such a great market success is due in the main to three facts. First, the productions mostly constitute 'cribs' of popular TV series; secondly, the productions are launched onto the market at an immense advertising expense (television, comics); and, thirdly, the productions are usually put on sale as low-priced offers in shopping centres, self-service markets and department stores (Hansen and Manzke, 1993, p. 19).

*2.2.3 Programme preferences*
The available results make it obvious that for the majority of the 6- to 13-year-olds – both for boys and girls, for younger and older children – the radio is first and foremost an entertaining musical instrument which is used 'while doing homework in the afternoon', 'while reading comics or magazines', 'while playing' as a 'secondary medium', as 'musical background', as an 'accompanying medium'. Sixty-four per cent of the age group would rather listen to music than spoken programmes; only three per cent are genuine 'verbal fans' (as few as one per cent of the 12- to 13-year-olds). That means that pop music programmes – by no means aimed at children – come top of the children's preferred radio genres (Rogge, 1982, pp. 490 ff.).

With regard to the 10- to 13-year-olds, this applies especially when other predominantly music programmes not directed at children are taken into account, like 'request programmes' or 'magazine programmes with music and chat'. That the music programmes have such outstanding importance for children is likely to be due to the fact that:
- 'music ... (is based) on specific body experiences, because the rhythm of the music makes you feel your body ...; thus this music can contribute to compensating for emotional shortcomings, satisfying one's own needs or expressing cultural behaviour styles' (Rogge, 1988, p. 526);
- especially in the case of older children '... listening on the side ... (becomes) a condition for psychological well-being, ... (supports) emotional composure – which in turn is a prerequisite for concentration and learning achievement' Baacke, 1990, p. 17.

Second on the scale of interest, not only for boys and girls but also for all age levels, is advertising (Klingler, 1994, 18). This is then followed by – frequently belonging to the programme for adults – news, programmes to join in and guessing games for the 10- to 13-year-olds

(boys and girls), fairy tales for the 6- to 9- year-olds (boys and girls) and sports reports for the 10- to 13-year-old boys (see Table 14).

Table 14: **Radio genres preferred by the 6- to 13-year-olds** (criterion 'often listened to; in %, 1990, representative sample)

| Genres 10–13 | All respondents | | Boys | Girls | 6-9 |
|---|---|---|---|---|---|
| Music programmes | 57 | 54 | 60 | 43 | 69 |
| Advertising | 22 | 19 | 24 | 18 | 25 |
| Request programmes | 15 | 11 | 18 | 7 | 22 |
| Magazine programmes with music and information | 14 | 12 | 15 | 6 | 21 |
| Programmes to join in (also for adults) | 13 | 10 | 16 | 6 | 19 |
| Sports reports | 13 | 21 | 5 | 5 | 20 |
| News | 12 | 12 | 11 | 5 | 16 |
| Guessing games (also for adults) | 11 | 10 | 12 | 4 | 16 |
| Children's programmes | 10 | 9 | 12 | 6 | 14 |
| Fairy tales | 9 | 8 | 9 | 12 | 4 |
| Crime, adventure | 6 | 7 | 6 | 4 | 8 |
| Informational programmes | 5 | 5 | 5 | 1 | 5 |
| School radio | 2 | 2 | 2 | 2 | 3 |

It looks rather different in the case of preferences which the children show for record, cassette and CD programmes (Klingler, 1994, p. 19). Here it is not a liking for musical programmes but other kinds that dominates. The 12- to 13-year-olds, however, are an exception, as their preference for musical programmes stands out clearly: 29 per cent of the 6- to 13-year-olds would rather listen to music, but 69 per cent to other programmes; in the case of the 12- to 13-year-olds, however, 59 per cent prefer music to other programmes. The children answered the question as to which non-musical programmes they occupied themselves with as shown in Table 15.

Table 15: **The children's preferences for sound-recording programmes** ('non-music', in %; 1990, representative sample)

| Genres | All respondents | Boys | Girls | 6-9 | 10-13 |
|---|---|---|---|---|---|
| Fairy tales | 35 | 29 | 40 | 51 | 17 |
| Children's stories | 37 | 32 | 43 | 55 | 18 |
| Adventure | 41 | 48 | 34 | 44 | 39 |
| No answer | 0 | 1 | 0 | 0 | 1 |

It can be clearly seen that the girls' interest centres on children's stories and fairy tales such as for example *Benjamin Blümchen*, *Bibi Blocksberg*, *Pippi Langstrumpf*, *Barbie*, and that of the boys on adventure programmes, eg

*Turtles, He-Man, Knight Rider,* but also *Benjamin Blümchen,* who sometimes reveals an adventurous side to himself (Hansen and Manzke, 1993, pp. 18 ff.).

'Children clearly prefer radio play series that emphasise entertainment. The experiences of heroes in series offer diverse variations of what listening children do not find in their real world. They can therefore hardly evade the fascination of these figures; they are strong, sometimes omnipotent, superior to adult antagonists and infringe prohibitions. The one-dimensional portrayal of the characters is understandable when listened to for the first time and is strengthened by the caricatured, easily identifiable voices. The plot is straightforward, without flashbacks, with suspense situations that can be easily grasped and the expected happy ending. The rapid change of short sequences conveys the impression of uninterrupted action.' (Heidtmann, 1992, p. 72) But it can also be clearly recognised that the interest in 'non-musical sound-recording programmes' drops off considerably as age increases – only the 10- to 13-year-old boys are still fairly interested in adventure stories.

What children especially appreciate about sound-recording programmes (80 per cent of these, by the way, are presents from parents and grandparents) has, however, not only something to do with the content and forms offered (Hansen and Manzke, 1993, p. 21). It also appears to result more from the fact that the programmes, because of their technical accessibility, are assigned a certain 'practical use function', which children evidently like to put into effect – and in which nowadays – referring to the enjoyment of cassettes – the ever-present Walkman, as we all know, plays an important part. (Vollbrecht 1989, pp. 101 ff.)

Rogge (1988) observed:

'Seen from the children's angle, on the one hand, the spatial and temporal availability of sound-recording media account for their attraction; records and cassettes provide a chance to withdraw at a point in time of their own choosing. Listening to them together with friends provides an occasion for conversations, guarantees an exchange of views and ensures the same taste; their individual use dispels boredom, creates moods or serves to bridge over or compensate for periods of doing nothing or bad feelings.

But what use children make of the sound-recording media depends not only on the spatial, temporal and situational setting but also on their media experiences and psycho-social situation. Children use sound-recording media against the background of specific communication needs and interests, or put in other words: children rarely listen consciously to a record or cassette from beginning to end, but a perception, an association, based on their own experiences prevails. Certain scenes or passages are listened to over and over again, others, because they are not interesting, are not perceived at all. For this reason alone a preference exists for those sound-recording media which make expectations come true (Rogge 1988, p. 526).

Table 16: **The 6- to 13-year-olds' occupation with the printmedia** (criterion 'daily/almost daily', in %; 1990)

| Genre | All respondents | Boys | Girls | 6-9 | 10-13 |
|---|---|---|---|---|---|
| Reading books | 32 | 24 | 40 | 26 | 38 |
| Reading comics | 21 | 21 | 20 | 17 | 24 |
| Reading magazines | 9 | 7 | 12 | 5 | 14 |
| Reading newspapers | 7 | 8 | 7 | 2 | 12 |

## 2.3 Magazines and comics

Magazines,comics, newspapers and books are apparently less important to the 6- to 13-year-olds than television, radio and sound-recording programmes (Klingler, 1994, p. 15). It can be clearly seen that their occupying themselves with the printmedia – especially with newspapers – is age-dependent and is not pursued more intensively until they reach the age of 10 to 13 (see Table 16). Here it is especially the girls who reveal that for them reading books (school books are not included) has considerable importance (Lukesch *et al.*, 1989, p. 156). As already noted, the subjects 'books' and 'newspapers' are not included below, as there are no useful data to be found on them. (Sommer, 1994, pp. 86 ff.)

### 2.3.1 Coverage and use habits

When mention is made below of magazines and comics there are four categories that are considered:[10]

- (free) advertising magazines (eg *medi + zini, Hallo* or *Marc & Penny*)
- children's magazines (eg *Popcorn, Salto, Treff , Bravo*)
- comics (eg *Micky Maus, Garfield, Wendy, Clever & Smart*)
- illustrated magazines (eg *Stern, Brigitte* (girls), *ADAC-Motorwelt* (boys) or radio and TV programme guides like *Hörzu* and *TV Hören+Sehen*.)

To determine how far these products reach into the group of the 6- to 13-year-olds[11] is rather difficult in that there are no accurate data for the coverage of advertising magazines and illustrated magazines/programme guides.[12] If the unreliable figures on advertising magazines and the illustrated magazines/programme guides are combined it can be conjectured that the advertising magazines – the two best known chemists' products *medi + zini* and *junior* have a circulation of 3.1 million copies per issue – reach about 30 per cent of the 6- to 13-year-olds and the illustrated magazines/programme guides between 2 per cent (*Stern*) and 13 per cent (*Hörzu*).[13]

In the case of the children's magazines, for which reliable data are available (Schüler-Mediaanalyse, 1993, p. 10; Bauer-Verlag, 1993, p. 55) the coverage ranges between 3 (*Treff*) and 12 per cent (*Popcorn*) and for the comics, for which there are also usable findings, between 5 per cent (*Conny*), 21 per cent (*Micky Maus*) and 36 per cent (*Micky Mouse-Kombi Plus,* which is a combination of *Micky Maus, Donald Duck, Garfield* and *Wendy*).

With regard to comics and children's magazines there is the following

picture broken down into age, sex and school type, which, however, does not reflect the situation of the 6- to 13 but of the 7- to 15-year-olds. In Table 17 the following are considered as comics: *Conny, Donald Duck, Fix und Foxi, Garfield, Micky Maus, Tom & Jerry* and *Wendy*. Children's magazines mentioned are *Popcorn, Salto, Treff* and *Yps* (*Schüler-Mediaanalyse*, 1993, p. 10)

Table 17: **The reach of children's magazines and comics** (according to sex, age and school type, in %; 1993, representative sample)

| Readers per issue currently | | | | | | | | | | |
|---|---|---|---|---|---|---|---|---|---|---|
| | | Sex | | Age groups | | | School type | | | |
| | all | Boys | girls | 7-9 | 10-12 | 13-15 | Prim'ry | Second'ry | Middle | Grammar |
| Sample | 2808 | 1441 | 1366 | 958 | 955 | 895 | 958 | 732 | 481 | 578 |
| Conny | 5.3 | 1.5 | 9.2 | 3.8 | 7.0 | 5.1 | 3.8 | 6.7 | 7.3 | 4.6 |
| Donald Duck | 13.1 | 16.3 | 9.6 | 14.1 | 12.6 | 12.4 | 14.1 | 14.4 | 11.8 | 10.1 |
| Fix und Foxi | 8.9 | 10.3 | 7.5 | 11.1 | 9.4 | 6.1 | 11.1 | 10.0 | 8.4 | 4.9 |
| Garfield | 6.4 | 6.7 | 6.1 | 5.6 | 7.0 | 6.4 | 5.6 | 8.0 | 6.5 | 5.2 |
| Micky Maus | 21.6 | 25.4 | 17.6 | 23.4 | 25.8 | 15.2 | 23.4 | 21.8 | 19.3 | 20.9 |
| Popcorn | 11.9 | 11.3 | 12.5 | 2.5 | 10.2 | 23.7 | 2.5 | 16.1 | 19.5 | 14.8 |
| Salto | 3.5 | 4.2 | 2.8 | 3.6 | 3.7 | 3.2 | 3.6 | 4.6 | 2.2 | 2.8 |
| Stafette | 3.0 | 3.1 | 2.8 | 1.4 | 4.1 | 3.3 | 1.4 | 3.4 | 2.2 | 5.6 |
| Tom und Jerry | 6.9 | 8.3 | 5.5 | 10.2 | 6.6 | 3.8 | 10.2 | 7.4 | 5.0 | 2.3 |
| Treff | 2.8 | 2.6 | 3.1 | 0.9 | 3.9 | 3.7 | 0.9 | 3.9 | 3.5 | 4.2 |
| Wendy | 7.6 | 2.3 | 13.2 | 5.3 | 10.2 | 7.2 | 5.3 | 9.0 | 8.9 | 8.7 |
| Yps | 5.7 | 7.9 | 3.5 | 6.1 | 6.6 | 4.3 | 6.1 | 5.9 | 5.9 | 5.1 |
| Micky Maus-Kombi | 33.6 | 34.7 | 32.5 | 33.8 | 38.7 | 28.0 | 33.8 | 35.1 | 32.6 | 32.6 |
| Micky Maus-Kombi plus | 36.3 | 37.7 | 34.8 | 35.9 | 41.4 | 31.3 | 35.9 | 38.1 | 35.8 | 35.5 |

According to this, *Micky Maus* – both alone and in combination with other comics – clearly has the greatest reach (*Micky Maus; Micky Maus Kombi* = Micky Maus, Donald Duck, Wendy; and *Micky Maus Kombi Plus* = Micky Maus, Donald Duck, Wendy, Garfield). But *Popcorn*, too, which sees itself not as a comic but a kind of *Bravo* for young teenagers, is doing well, ranking only just behind *Donald Duck*.

The extent to which the children's magazines and comics are used depends considerably on whether and how these products can prevail over the competition from television and audio programmes (Heidtmann, 1989, pp. 255 ff.) The chances of doing so are especially good when:
- the use of children's magazines and comics does not require a lot more time and attention than occupying themselves with television and audio programmes;
- the children's magazines and comics offer entertaining (more rarely informational) material, which is either not to be found in the competitive media or which constitutes a useful addition or another media version, eg magazines, comics, records, cassettes and CDs accompanying TV series (Glogauer, 1993, pp. 106 ff.).

80

## 2.3.2 The programme offered

The category with the largest circulation of print media directly aimed at children consists of the advertising magazines published by chemists, retail stores and hospitals, savings banks and insurance companies. As the magazines often come out irregularly, have different sizes of circulation and are rarely documented in media statistics, it is hardly possible to obtain data to help describe precisely what is offered by these customer magazines. Heidtmann (1992, p. 6) gives the following circulation figures for 1991 (see Table 18).

Table 18: **The circulation of the leading children's advertising magazines** (per issue in Germany, 1991)

| Titles of magazines | Circulation | Number of issues per year |
|---|---|---|
| medi+zini (chemists' shops) | 2.033,000 | 12 (free) |
| junior (chemists' shops) | 1.082,500 | 12 (free) |
| Hallo (savings banks) | 250,000 | 10 (free) |
| Schlaukopf (chemists' shops) | 197,000 | 12 (free) |
| jojo (AOK) | 150,000 | 6 (free) |
| Marc & Penny (co-operative banks) | 100,000 | 12 (free) |

The advertising magazines deliberately adopt the format of the usual children's magazines and comics. They provide instructions for modelling, jokes, book tips and some short, profusely illustrated texts on nature, animals and health. Almost all of the magazines contain comic strips in which product-related figures are always romping around (*Wummy* from Elephant shoes; *Lurchi* from Salamander shoes; *Knax* from the savings bank magazine).

The 'genuine' children's magazines have to be satisfied with a slightly lower circulation – if *Bravo* and *Bravo Girl* are left aside, which, although frequently read by the 12- to 13-year-olds (especially girls), do not have any decisive importance for younger children. As Table 19 shows, the Bauer-Verlag (even if *Bravo* and *Bravo Girl* are not considered) is the front runner in the children's magazine market (Heidtmann 1992, p. 8).

Apart from the Bauer-Verlag, the Medien-Verlagsgesellschaft has also gained a considerable market share with its magazine *Mädchen* (Girls) – which in view of the great interest in reading shown by older girls is not particularly surprising. By a wide margin, they are followed by the comic-like magazines *Bussi Bär* and *Dumbo*, which – like *Goldbärchen* and *Glücksbärchis* – are preferred by the younger children (especially boys). Weaker still is the market position of the publishers of back-up material for TV series (*Sesamstrasse, Hallo Spencer, Kermit*) and entertaining and informative titles like *Treff* or *Stafette*.

In the case of both the advertising and children's magazines it can be seen that children are extremely interested in comics. This is also expressed in the sales of magazines which can be described as comics 'in the narrower sense' and are generally sold through kiosks, department stores

and supermarkets. At present three publishing groups share about 90 per cent of the German comic sales and have divided up almost the entire market for children's comics among themselves: the Ehapa, Bauer and Bastei publishing houses. Market leader in the branch is the Ehapa-Verlag, which puts over 70 million comics onto the German and foreign market each year. (See Table 20; Ehapa-Verlag, 1992, p. 10; see also Heidtmann, 1992, p. 19 f.).

Table 19: **Circulation of children's magazines sold**
(per issue in Germany, 1991)

| Magazine title (publisher) | Circulation |
|---|---|
| Bravo (Bauer) | 1.310,600 |
| Bravo Girl (Bauer) | 891,000 |
| Mädchen (Medien-Verlagsgesellschaft) | 669,600 |
| Bussi Bärl (Bauer) | 322,000 |
| Dumbo (Ehapa) | 250,000 |
| Yps mit Gimmick (Gruner & Jahr) | 150,000 |
| Goldbärchen (Condor / Bauer) | 140,000 |
| Sesamstraße (Condor / Bauer) | 140,000 |
| Glücksbärchis (Condor / Bauer) | 130,000 |
| Rätselclub für Kinder (Bavaria Comic) | 130,000 |
| Treff (Velber) | 130,000 |
| Hallo Spencer (Bastei) | 100,000 |
| Kermit (Bastei) | 100,000 |
| Stafette (Sebaldus) | 100,000 |

Table 20: **Ehapa-Verlag: Circulation of comics sold**
(per issue in Germany, 1991)

| Comic title | Circulation | Issues per year |
|---|---|---|
| Micky Maus | 700,000 | 52 |
| Wendy | 322,000 | 26 |
| Die tollsten Geschichten von Donald Duck | 245,000 | 12 |
| Garfield | 238,600 | 12 |
| Mickyvision | 234,400 | 26 |
| Donald Duck | 194,600 | 26 |
| Dagobert Duck | 175,000 | 26 |
| Mein kleines Pony | 125,000 | 12 |

Two series of comics important for the publisher (and apparently eagerly read by the children) are not listed in the Ehapa catalogue, because they do not appear regularly: *Lucky Luke* and *Asterix*. The latter has a first edition of no less than between two and three million copies; they are, however, not only related to child readers.

The second largest publisher of comics is the Bauer-Verlag with its sub-contractors Pabel-Moewig, Condor and Junge Welt (previously an East German publishing house). The most successful contenders in the

Bauer publications are *Fix und Foxi* and *Clever & Smart*, followed by the comic edition of a TV series which has been very popular with children (*Turtles*). While in recent years *Tom & Jerry* have suffered rather badly, the girls' comic *Jenny* and Herman van Veen's *Kwak* have held up well (see Table 21).

Table 21: **Bauer-Verlag: circulation of comics sold**
(per issue in Germany, 1992)

| Comic title | Circulation | Times published per year |
|---|---|---|
| Fix und Foxi | 322,600 | 52 |
| Teenage Mutant Hero Turtles | 250,000 | 12 |
| Clever & Smart, 1.Edition | 200,000 | 6 |
| Jenny | 200,000 | 12 |
| Mosaik | 200,000 | 12 |
| Alfred J. Kwak | 185,000 | 12 |
| Tom & Jerry | 175,000 | 12 |
| Clever & Smart, 2.Edition | 165,000 | 6 |
| Clever & Smart, 3.Edition | 140,000 | 4 |
| Thundercats | 125,000 | 6 |

The third position in the group that dominates the market is taken by the Bastei-Verlag. Apparently the Bastei-Verlag, on the one hand, relies on girls' comics (*Vanessa, Conny*), and, on the other, on material which can be combined with the latest TV and sound-recording products (*Benjamin Blümchen, Bibi Blocksberg*). The publishing house has had some success with the latter – in spite of the considerable competition from television, record, cassette, CD and video programmes (see also Heidtmann 1992, p. 19 f.).

Table 22: **Bastei-Verlag: circulation of comics sold**
(per issue in Germany, 1992)

| Comic title | Circulation | Published per year |
|---|---|---|
| Spukgeschichten | 180,000 | 26 |
| Vanessa | 180,000 | 26 |
| Conny | 170,000 | 26 |
| Benjamin Blümchen | 140,000 | 26 |
| Bibi Blocksberg | 130,000 | 26 |

If we sum up the responses given on the publishing houses' productions it seems that the comics can be put into five genres:
- the funnies, which (directed equally at girls and boys) all present 'getting-into-trouble-and-out-again' stories and which are based on the principles of 'good wins over bad' and 'malicious joy at the person taken in' ( eg *Micky Maus, Donald Duck, Garfield, Fix und Foxi, Tom & Jerry*);
- the semi-funnies, which represent a mixture of funnies and adventure and are aimed at a readership of boys rather than girls (eg *Clever & Smart, Lucky Luke, Tim & Struppi*);

- the adventure comics, which appeal primarily to boys (eg *Teenage Mutant Hero Turtles, Die echten Ghostbusters, He-Man, MASK, Transformers*);
- the ghost comics, which interest girls more (eg *Gespenster-Geschichten, Spuk-Geschichten, Vanessa, Die Freundin der Geister*);
- the girls' comics, which offer partly love stories (eg *Conny, Jenny, Wendy*), and partly fantasies (eg *Regina Regenbogen, My little Pony*).[14]

### 2.3.3 Programme preferences

Children's magazines, comics and advertising magazines are also used by children primarily for entertainment and passing the time. Here it is interesting that the children's magazines – in contrast to both television, radio and sound-recording programmes – are additionally used in quite a noticeable way to impart knowledge and experience reality. It is astonishing how intensively children devote themselves to the print media. In Table 23 it is made quite clear how great the probability is for any page to be opened and looked at or read by children, in this case 7- to 15-year-olds (Schüler-Madiaanalyse, 1993, p. 30).

It is remarkable what a high level – above all with increasing age and growing development of the cognitive abilities – the reading connection to children's magazines and comics has reached. The figures for *Salto* and *Yps*, which lag somewhat behind, are likely to be accounted for by the fact that the technology information presented in *Salto* and the quality of *Yps* – too demanding for 6- to 13-year-olds – hamper or prevent their being read intensively.

Table 23: **Index on the use intensity regarding any page**
(in %, 1993, representative sample)

Readers per page

|  | | Sex | | | Age groups | | | School type | | |
|---|---|---|---|---|---|---|---|---|---|---|
|  | all | Boys | Girls | 7-9 | 10-12 | 13-15 | Primary | Secondary | Middle | Grammar |
| Sample | 2808 | 1441 | 1366 | 958 | 955 | 894 | 958 | 732 | 481 | 578 |
| Conny | 92.3 | 79.4 | 94.4 | 90.8 | 92.7 | 92.9 | 90.8 | 94.8 | 89.5 | 93.3 |
| Donald Duck | 94.1 | 95.0 | 92.4 | 94.0 | 94.6 | 93.6 | 94.0 | 91.3 | 95.9 | 96.5 |
| Fix & Foxi | 91.5 | 91.5 | 91.3 | 93.9 | 90.3 | 88.6 | 93.9 | 89.2 | 89.9 | 90.9 |
| Garfield | 92.3 | 92.8 | 91.7 | 91.3 | 91.6 | 94.0 | 91.3 | 93.8 | 92.2 | 95.6 |
| Micky Maus | 93.1 | 93.8 | 92.1 | 93.4 | 94.1 | 90.9 | 93.4 | 92.1 | 94.3 | 93.8 |
| Popcorn | 89.7 | 90.8 | 88.6 | 76.0 | 86.8 | 92.6 | 76.0 | 91.1 | 90.0 | 90.6 |
| Salto | 81.0 | 80.3 | 82.1 | 73.8 | 85.7 | 84.2 | 73.8 | 84.6 | 88.5 | 84.4 |
| Stafette | 84.9 | 84.6 | 85.2 | 74.5 | 86.8 | 87.2 | 74.5 | 82.6 | 80.1 | 92.1 |
| Tom und Jerry | 91.7 | 92.0 | 91.2 | 92.0 | 92.0 | 90.1 | 92.0 | 92.2 | 91.7 | 88.2 |
| Treff | 89.5 | 84.1 | 94.2 | 90.1 | 92.0 | 86.5 | 90.1 | 91.0 | 87.4 | 89.9 |
| Wendy | 93.8 | 89.4 | 94.6 | 91.7 | 94.2 | 94.9 | 91.7 | 93.4 | 92.9 | 96.8 |
| Yps | 88.8 | 89.2 | 87.7 | 88.0 | 90.5 | 86.9 | 88.0 | 89.4 | 92.5 | 85.0 |
| Micky -Kombi | 92.8 | 93.2 | 92.2 | 92.7 | 93.5 | 91.8 | 92.7 | 90.5 | 94.2 | 95.0 |
| Micky - Kombi-plus | 92.6 | 93.2 | 91.8 | 92.3 | 93.2 | 92.0 | 92.3 | 91.0 | 93.9 | 94.7 |

Table 24: **The composition of the child readers of children's magazines and comics** (according to sex, age and school attended; in %, 1993)

| Readers per issue currently | | | | | | | | | | |
|---|---|---|---|---|---|---|---|---|---|---|
| | all | Boys | Girls | 7-9 | 10-12 | 13-15 | Primary | Secondary | Middle | Grammar |
| Sample | 2808 | 51 | 49 | 34 | 34 | 32 | 34 | 26 | 17 | 21 |
| Conny | 148 | 15 | 85 | 24 | 45 | 31 | 24 | 33 | 24 | 18 |
| Donald Duck | 367 | 64 | 36 | 37 | 33 | 30 | 37 | 29 | 15 | 16 |
| Fix & Foxi | 251 | 59 | 41 | 43 | 36 | 22 | 43 | 29 | 16 | 11 |
| Garfield | 179 | 54 | 46 | 30 | 38 | 32 | 30 | 33 | 17 | 17 |
| Micky Maus | 606 | 60 | 40 | 37 | 41 | 22 | 37 | 26 | 15 | 20 |
| Popcorn | 334 | 49 | 51 | 7 | 29 | 64 | 7 | 35 | 28 | 26 |
| Salto | 99 | 62 | 38 | 35 | 36 | 29 | 35 | 34 | 11 | 16 |
| Stafette | 83 | 54 | 46 | 17 | 47 | 36 | 17 | 30 | 12 | 39 |
| Tom und Jerry | 194 | 61 | 39 | 50 | 32 | 18 | 50 | 28 | 12 | 7 |
| Treff | 79 | 47 | 53 | 11 | 48 | 42 | 11 | 36 | 21 | 31 |
| Wendy | 213 | 15 | 85 | 24 | 46 | 30 | 24 | 31 | 20 | 24 |
| Yps | 161 | 70 | 30 | 37 | 40 | 24 | 37 | 27 | 18 | 18 |
| Micky - Kombi | 944 | 53 | 47 | 34 | 39 | 26 | 34 | 27 | 17 | 20 |
| Micky - Kombi plus | 1020 | 53 | 47 | 34 | 39 | 27 | 34 | 27 | 17 | 20 |

Table 24 – again without the category 'advertising magazines' – reveals from the composition of the readership in what way children (again the 7- to 15-year-olds) are attracted by children's magazines and comics according to their sex, age and the type of school they attend and to the interest thus resulting from that.

From the table it can be gathered that

• girls prefer the girl-related comics *Wendy* and *Conny* and the boys *Yps*, *Donald Duck*, the magazine *Salto* (with its bias towards technology), *Tom & Jerry* and *Micky Maus*;

• the girls are principally less interested in comics but rather more in magazines like *Popcorn* and *Treff* than the boys;

• as age increases the preference for comics declines among the boys, but slightly increases among the girls in view of *Conny* and *Wendy*;

• the magazines *Popcorn* and *Treff*, whose subjects are strongly related to the transition between childhood and adolescence, are read by both boys and girls as they increase in age, while attending a 'higher' type of school (secondary modern, middle or grammar school) is apparently unimportant;

• attending a 'higher' type of school, however, considerably contributes to children distancing themselves from comics, especially the simplest kinds (*Fix und Foxi, Tom & Jerry*).

## 2.4 Computer and LCD games

Below only computer and LCD games will be examined. Gaming machines, 'stand-alone' games and those that used to be gathered together under the heading 'video/tele games' (a combination of console, television set and game cassette) will not be included. On the subject of 'gaming

machine games' (arcade games) there are no – for this context – useful data; and stand-alone games like video/tele games are not very important compared with computer games and the new generation of LCD games (*Game Boy, Game Gear*).

### 2.4.1 Coverage and use habits

In the scale of leisure-time pursuits, children's involvement with computer games ranks quite low. In 1991 9 per cent of the 6- to 13-year-olds devoted themselves to these games 'daily/almost daily' and 21 per cent 'at least once a week'. The time spent on them per game amounted to 30 minutes on average (Kingler and Windgasse, 19994, p. 3; Glogauer, 1993, p. 53 f.).

The bulk of the players are likely to be boys, even though apparently many girls take part in LCD games like, for example, *Game Boy* and *Game Gear* (Glogauer, 1993, p. 67). The 11- to 13-year-olds are especially interested. The reason for this is probably that, on the one hand, – because of their cognitive development – they have no difficulty in coping with the mental and emotional demands of even complicated games, and, on the other, – because of their integration into the context of their peers – they can make optimum use of the social opportunities of the games (eg cooperation and competition with their peers). That the boys, who are equipped to an above-average extent with (home) computers, devices for video games and hand-held video games, have a lead here over girls of the same age is well known (Lukesch *et al.*, 1989, pp. 119 ff.) This can no doubt be mainly put down to the absence of technology in girls' socialisation, which becomes especially visible regarding computer and LCD games (Heidtmann, 1992, p. 128).

### 2.4.2 The programme offered

The main feature of computer and LCD games is that the events of the game take place on a screen in the form of a film-like sequence of happenings. Their possibilities and patterns are fixed by rules and can be influenced by the player by means of a figure, which is directed by using an input device (computer keyboard or joystick). The programme thus kept up by the players 'has the appearance of an animated-cartoon-like happening, like a world in a film – only with the decisive difference that I can influence what happens in this world by my actions. The impression of a film is supported by the background music and sounds. The player does indeed find himself in a film world. Gradually he learns to find his way around in this world and to assert his right to remain in this world by his skilful action.' (Fritz, 1987, p. 168).

While in 1985 only five per cent of German households possessed a home or personal computer, by 1990 the rate had risen to 20 per cent. In 1993, probably about 30 per cent of the 6- to 13-year-olds lived in a household in which there was at least one home or personal computer. According to the statistics, there are supposed to be 50 game programmes

per computer and household on average.[15] No wonder, since every year thousands of new games are offered for sale: for the Commodore VC 64 alone over 20,000 games were created. On the German market some 10,000 games were available in 1994, 90 per cent of which were sold by three companies: Ariolasoft (Bertelsmann), Rushware (Micro-Handels-GmbH Maxwell) and US Gold.

At the beginning of the 90s the market for electronic games was stirred up by the Japanese companies Nintendo and Sega introducing a new generation of miniaturised game computers (hand-held games) which are fitted with an LCD monitor and loudspeakers. They resemble small hand-held television sets and are provided with accessories that enable them to be networked for several players. The base unit costs about DM 300 and a game module in the form of an (exchangeable) plug-in card (the game programme) between DM 50 and 100. The market leader is Nintendo Game Boy, followed by Sega's Game Gear. In 1991 over two million Game Boys were sold in Germany.

The scenarios realised in both the computer and LCD games are all dominated by sports, war and fighting, adventure and simulation games. In contrast to the 'old' video games, in the technically more sophisticated computer and LCD programmes not only extensive (and talking) chains of acts and action are offered but also, as a result of the better resolution of the picture, visual refinements and astonishing reality regarding landscapes, buildings, interiors and figures. The game programmes can – according to their (mainly technical-cognitive) level – be described as 'button games' or 'brain games'. In the case of the button games it is mainly a matter of skill, powers of concentration, rapid response and tenacity. On the other hand, the brain games call for strategic considerations, language proficiency, spatial orientation, a good memory and logical and interactive thinking (Fritz, 1989, p. 179). 'Button games' are to be found especially among the sports, fighting and shooting programmes, 'brain games', on the other hand, among the simulation programmes.

When the selection of games is categorised according to the individual programmes the following picture emerges (Swoboda 1990, p. 16):

- Sports and reaction games which call for concentration, skill and mental agility and are designed to spur the players on to achieve 'record performances', eg *Summergames, Wintergames* (Ariolasoft); *Game-Gear-Golfspiel* (Sega); *Motorcross* (Nintendo);
- Programmes to cope with a whole array of different simulations - from car driving and flying to economic processes and military campaigns, eg *Autosimulator* (Ariolasoft), *Flightsimulator* (US Gold), *Balance of Power* (Microsoft);
- War, fighting and shooting games, in which 'opponents', weapons, facilities etc have to be 'wiped out', eg *Uridium* (US Gold), *Raid over Moscow* (US Gold);

● Adventure, fantasy and role games, which offer a constellation of scenes and stories that the players can decide how to change and develop, eg *Super Mario Land* (Nintendo), *Ghostbusters* (Sega), *Quack Shot* (Sega), *Gargoyle's Quest* (Nintendo);

● Games that are based on television series and films, eg *Batman, The Simpsons, Spiderman, Teenage Mutant Hero Turtles, E.T., Star Wars, Robocop*).

As varied and (for children) interesting as the game programmes may be, a considerable problem has arisen with their appearance on the market. This consists of the fact that, with the supply of computer and LCD games quite a few programmes have come onto the market that glorify war, are pornographic and fascistic (Benz, 1989, pp. 224 ff.; Heidrich, 1991, pp. 48 ff.). Many of these sorry efforts have been prohibited for sale by the German Inspection Office (*Bundesprüfstelle*) and some have been confiscated.[16]

Table 25: **Prohibited fascistic computer games, 1991**[17]

| Titles | Year of publication | Confiscated |
|--------|--------------------|-------------|
| Adolf Hitler | 1991 | |
| Anti-Türken-Test | 1987 | 1987 |
| Ariertest | 1988 | 1989 |
| Clean Germany | 1988 | |
| KZ-Manager | 1989 | 1990 |
| Nazi-Demo | 1989 | |
| Proud to be a German | 1990 | |
| Sieg Heil | 1988 | |
| The Nazi | 1988 | |
| 10 Foltertips | 1989 | |

*2.4.3 Programme preferences*

Like other media programmes, computer and LCD games are much appreciated by children when they provide action-packed, adventurous happenings full of suspense, but also call for 'coolness' and 'cleverness' and enable them to test their own powers of reaction and to survive in the face of competition (Lukesch *et al.*, 1989, pp. 126 ff.).

Four qualities that are very often encountered, at least in the successful game programmes, are assessed as being especially attractive: the reduction of complex plot situations to clarity and intelligibility (good/evil; friend/foe), the technology involved, the reality of what is displayed and the refinements for controlling the picture. It also seems to be exceptionally important that children experience the game device as a partner who functions for them as an active, responsive player and helps to allow them to experience the game as a procedure, which – at least for a brief time – seems to be more exciting and intensive than reading any book or watching any film. In the case of the LCD games there is also the additional fact that the children are in a position to use them – as hand-

held games – at any time and without the least inconvenience (Swoboda, 1990, p. 17).

That most children occupy themselves with games in order to fill in breaks and/or to bridge over periods of boredom cannot therefore be interpreted as if it were a matter of indifference to the children what they do to fill in breaks and/or bridge over periods of boredom (Spanhel, 1987, p. 108). The reverse seems to be the case: the children turn to the computer or LCD game precisely at such seemingly unoccupied and boring moments because they – for whatever reasons – cannot muster up any activity, involvement with reality or an ability to act, which in the games is obviously so easy to realise.

> In the video game ... the player is to a certain degree given the chance to exert influence. In the shape of a figure that 'determines the plot' he can enter this 'world on a wire' 'without risk', explore it and make it evolve by his actions. The video player becomes a 'videonaut', who with the help of his 'electronic representative' can make this 'world' navigable for himself and pass on this experience to other 'videonauts'. Seeing and hearing, he penetrates the 'world' that is made for him, investigates its 'secrets' and proves himself with his skills. (Fritz, 1989, p. 168)

## 2.5 Video programmes[18]

Occupying themselves with video programmes (feature films, animated cartoons, series known from TV, fairy tales, special interest videos) is not of such great importance in the everyday lives of the 6- to 13-year-olds as with television, radio or sound-recording programmes. Even so, the influence the video programmes have on the children should not be underestimated, as is shown by the debate that has been going on for years on the consumption of action, violence and horror films recorded on video.

### 2.5.1 The coverage and use habits

As has already been stated above, 12 per cent of the 6- to 13-year-olds occupy themselves 'every day, almost every day' and 30 per cent 'at least once a week' with (recorded, borrowed or bought) video films (Brosius and Schmitt, 1990; Klingler and Windgasse, 1994). It should not be overlooked that it is precisely under the criterion 'daily/almost daily' that the younger children – especially if they are boys – have a clear lead, with their preference for fairy tales, animated cartoons or TV series (Klingler and Windgasse, 1994; see Table 26).

It is known that children have easy access to the video recorder: 5 per cent of the 6- to 8-year-olds and 14 per cent of the 9- to 10-year-olds own their own video recorder; there is one in every other German household (49.1 per cent; Glogauer, 1993, p. 12; Media-Perspektiven: Basisdaten 1993, p. 70). If there is neither of these opportunities, video films are watched at the houses of friends or relatives. Thus about 45 per cent of

the 12- to 13-year-olds watch videos at home, and 41 per cent turn to their friends (Lukesch *et al.*, 1989, p. 54).

Table 26: **Occupation of the 6- to 13-year-olds with video programmes** (criterion 'daily/almost daily', in %; 1990, representative sample)

| Respondents | % of the respondents that watched videos daily/almost daily |
|---|---|
| All respondents | 12 |
| Girls | 9 |
| Boys | 14 |
| 6- to 9-year-olds | 14 |
| 10- to 13-year-olds | 10 |

The children are almost exclusively interested in pre-recorded cassettes; cassettes on which, for example, television programmes have been recorded are of little importance to them. The children get hold of video programmes

- by resorting to their parents' holdings of cassettes (it is obvious that in this case they consume only videos for adults);
- by recording television programmes (this happens on a larger scale only in the case of the 12- to 13-year-olds);
- by using cassettes from friends;
- by borrowing cassettes from video libraries (which is difficult today, since the majority of the video libraries do not serve children because of the Children and Young Persons Act – *Jugendschutzgesetz* – amended at the beginning of the 90s);
- by borrowing videos from public libraries (which are all rather poorly equipped and often not with the appropriate videos required by children);
- by buying cassettes (their continual drop in price, in some cases to the lowest price level, being an important incentive);
- and by being given cassettes mainly by parents and relatives as presents.[19]

It is therefore not surprising that some of the children already possess their own video library, in which a large number of (illegally) copied or borrowed programmes are to be found apart from those they have bought or been given: 23 per cent of the 12- to 13-year-olds have such a collection consisting of 20 cassettes on average (Lukesch *et al.*, 1989, p. 54).

*2.5.2 The programme offered*
One of the main features of the current video market is a considerable decline in the lending business. The reasons for this are chiefly the tremendous expansion of private television and the flooding of the market with feature films and series of every kind. On the other hand,

the sales of pre-recorded cassettes, which nevertheless still rank behind the lending business of video libraries, have risen – even if this trend seems to be stagnating at the moment (Heuzeroth, 1993, p. 386).

Table 27: **Turnover on the video market 1990 to 1992** (in millions of DM)

| Year | Lending | Sales | Total |
|------|---------|-------|-------|
| 1990 | 1009 | 300 | 1309 |
| 1991 | 1001 | 640 | 1641 |
| 1992 | 900 | 580 | 1480 |

It was particularly the video libraries that were hit by the decline in the lending business, as the increase in sales did not have a positive impact on them but on the other outlets, such as shopping centres or department stores (Media Perspektiven; Basisdaten, 1993, p. 69). The majority of cassettes sold on the German market come from the USA and southern Europe. They are sold not through video libraries, but especially through department stores, supermarkets, discount shops, mail order firms and book clubs for between DM 10 and 20 (Heuzeroth, 1993, p. 386; Tab. 28).

Table 28: **Channels of distribution for cassettes that are sold** (in %, 1992)

| | |
|---|---|
| Department stores/ supermarkets/discount | 20 |
| Shopping centres | 18 |
| Mail order | 15 |
| Book clubs | 15 |
| Electrical shops | 15 |
| Video libraries | 7 |

Because of their low prices the cassettes can compete very successfully with other media (especially books), since in the assortment of low-priced cassettes the latest film hits are offered for sale sooner and more often. It is known that the major American film companies make 20 per cent of their earnings from video licences. Thus, in only a few months, in Germany 600,000 *Susi und Strolch* videos and from autumn 1991 to spring 1992 1.5 million *Arielle* videos (both films by Buena Vista/Disney) were sold (Heidtmann, 1989, p 101).

The so-called official Video Programme Index, published annually and obtainable at any well-run video library, contains more than 16,000 titles to buy or borrow for 1992. Of these 52 per cent can be assigned to the category 'feature (and cartoon) films' and 43 per cent to 'special interest' (the latter is, however, of little importance for children). A break down into genres produces the picture that follows in Table 29.

It can be noticed that the genre 'children' in the category 'feature films' takes a position well in the middle (some 1,000 programme

91

cassettes belonging to this genre are expected for 1992: feature films, animated cartoons, series). But the far more surprising finding is that this category (plus adolescents' films) has the largest share of the turnover in cassettes bought and borrowed on the German market with 40 per cent. (Heidtmann, 1992, p 102).

Table 29: **Video titles by genres**
(in %, 1992)

| Genres | Share | Genres | Share |
|---|---|---|---|
| Feature films of these | 52 | Special interest of these | 48 |
| Action | 18 | Music | 18 |
| Comedy | 17 | Education | 14 |
| Children | 15 | Documentary | 13 |
| Crime | 11 | Sport | 12 |
| Drama | 9 | Business | 9 |
| Entertainment | 5 | Help for life | 8 |
| Science fiction | 5 | Hobbies | 6 |
| Adventure | 5 | Travel | 6 |
| Western/war | 4 | Medicine | 5 |
| Horror | 4 | Culture | 5 |
| Classics | 4 | Language | 4 |
| Soft pornography | 3 | | |

If one looks at the most successful videos bought and borrowed in 1992, there were eight (pseudo) children's films among the 10 most successful videos that were bought and four among the 10 most successful videos that were borrowed (Heuzeroth, 1993, p. 385).

It is clear how the Disney Corporation – above all with its subsidiary Buena Vista – dominates the German market for video cassettes that are sold; on the market for videos that are borrowed it is the American company CIC. It is with these companies that, especially in the German children's video sector, firms like Bertelsmann (UFA, Europa), Taurus-Video (Leo Kirch), Polyband, Polygram (Kiosk), Ocean-Music and Atlas AV have to compete. For the most part they distribute – with the exception of the Verlag Atlas AV, which deals in high-quality children's films – animated cartoons. The products are made either in Japan or Taiwan or are marketed as revivals of other media products (television and radio series, sound-recording programmes).

The four most important subject areas of the animated cartoon films, which today have an 80 per cent share of the children's video products, are: stories (*Benjamin Blümchen*); science fiction (*Oskar, die Supermaus, Captain Harlock, Teenage Mutant Hero Turtles, MASK*; fairy tales and sagas *König Drosselbart*; and series accompanying toys *Regina Regenbogen, Mein kleines Pony*. Added to these are the well-known hits like *Asterix, Das letzte Einhorn* or *Der König und der Vogel*.

The (non-animated) fiction films rank second in the list of children's video products, making up 15 per cent. These are in particular Disney

productions and Astrid Lindgren films, which are distributed under the labels Taurus Video and Europa. These are joined by some famous children's films like *Metin* or *Rosi und die grosse Stadt*. And finally in third place, with 15 per cent, are the puppet, marionette and cut-out films.

It is clear that the children's video films mentioned do not cover everything the children find interesting in the video selling and borrowing market. As in the case of the television or radio programme, the children here, too, quickly leave the area 'devoted' to them and look for attractive material elsewhere. On the video market there are not many barriers they have to overcome, since one-third of all the available videos are accessible from the age of 6 and a further third from the age of 12. The fact that over and beyond this children get hold of video films that are not meant for them has already been mentioned: access to the videos (bought of borrowed) in the possession of parents, older relatives or friends makes this possible.

### 2.5.3 Programme preferences
The reason for children occupying themselves with video programmes can quickly be summed up (Lukesch *et al.*, 1989, pp. 104 ff.; Heidtmann, 1992, p.105). Children find such programmes attractive;
- because they endow figures known from television and existing as toys with a new and different life;
- because they can be bought at pocket-money prices;
- because they provide easy and low-cost access to the latest cinema hits that are being talked about;
- because they encourage children to watch films together;
- and because they make it possible to watch a certain presentation at any time and to see a favourite film or an especially funny or spine-chilling sequence that can be repeated.

It is through videos, as indicated above, that they can easily get hold of films for adults, which have not been passed by the voluntary control commission of the German film industry (FSK) as suitable for showing to children. (These videos are sometimes even copies of banned or confiscated material.) Thus five years ago, as part of a representative survey, it was ascertained that 19 per cent of the 12- to 13-year-olds had seen banned material and five per cent confiscated video films – though girls and children from higher social strata and types of school were less involved (Lukesch *et al.*, 1989, p. 74).

The following banned films that were viewed and thought to be especially attractive were: *Gesichter des Todes* (Faces of Death), *Nightmare – Mörderische Träume* (Murderous Dreams; was later confiscated); *Freitag, 13th, Mad Max, City Cobra, Rambo II, Rückkehr der Ninja* (Return of the Ninja); *Planet der Schrecken* (Planet of Horror), *Horror-Hospital, Im Wendekreis des Söldners* (In the Tropic of the Mercenary). The 12- to 13-year-old viewers named the films that were confiscated: *Lebendig gefressen*

(Eaten up Alive), *Man Eater, Tanz der Teufel* (Dance of the Devils), *Ein Zombie hing am Glockenseil* (A Zombie hung on the Bell Rope).

Such findings are not only encountered among the older children, though they can also be observed among the 9- to 10 year-olds. In 1992 a survey was carried out with primary school children from large cities (424) and country towns (377) which was not, however, based on a systematic representative sample. One hundred and eight (city) and 35 (country town) children replied that they had viewed banned and/or confiscated films (Glogauer 1993, p. 75). Here, too, girls and children from higher social strata were not so strongly represented as boys and members of lower social strata (see Table Table 30).

Table 30: **Banned/confiscated video films viewed by 9- to 10-year-olds** (1992; unsystematic random selection)

| Titles of Banned videos | Number of responses | | |
|---|---|---|---|
| | Total | Boys | Girls |
| Zombie | 25 | 20 | 5 |
| Bruce Lee | 19 | 14 | 5 |
| Ninja | 14 | 12 | 2 |
| Draculas Ende | 13 | 5 | 8 |
| Frankenstein | 11 | 6 | 5 |
| Rambo III | 10 | 9 | 1 |
| Rambo II | 8 | 7 | 1 |
| Die Werwölfe | 8 | 7 | 1 |
| American Fighter | 6 | 5 | 1 |
| Kung Fu | 6 | 2 | 4 |
| City Cobra | 4 | 3 | 1 |
| Die Fliege II | 3 | 2 | 1 |
| Tanz der Teufel II (The Fly) | 3 | 1 | 2 |
| Der Dämon | 2 | 2 | 0 |
| Freitag der 13. | 2 | 0 | 2 |
| Platoon | 2 | 2 | 0 |
| Der Terminator | 2 | 2 | 0 |
| Das Omen | 1 | 0 | 1 |
| Spookies | 1 | 1 | 0 |
| | | | |
| **Titles of confiscated videos** | | | |
| Tanz der Teufel I (Dance of the Devils) | 24 | 14 | 10 |
| Nightmare I | 8 | 7 | 1 |
| Ein Zombie hing am Glockenseil (A Zombie hung on the Bell Rope). | 1 | 1 | 0 |

It can be assumed that while viewing banned or confiscated video films it is often less the content that counts than the chance to get into a clique by viewing the films or to undergo a test of courage with one's friends. At the same time, however, on no account should the tremendous impact of violence, inflicted on young children whilst viewing this kind of film, be ignored, – irrespective of the reasons (psychological and social) why children may turn to such films.[20]

94

## 3. Concluding remarks

Even though the time in which children occupy themselves with the media is considerable, their involvement with the media constitutes only *part* of children's everyday world. But it is one part that, in the meantime, is quite considerable in size and of which the influence on the children can by no means be taken lightly. What is especially problematical about the situation is not, however, that the children see themselves confronted now by this or now by that offer of the media. But, rather, it results from the fact that the children get caught up in the maelstrom of an 'arrangement of multimediality', which is rightly described as the *media-compound system* (Hengst, 1991, p. 191). That means: the children are drawn into a network of media presentation facilities and are subjected to a web of media messages, which they can resist only with difficulty, because of the forces of attraction at work on all sides.

How the interlocking media system comes into being as far as content is concerned is obvious. It happens by a media message (story, plot) or parts of it (main figures, plot scenarios, emblems) being presented and brought to them in various programme vehicles, in the form of a television and video programme, magazine article, comic, clothing, toy, computer game and even food or bed linen (Hengst, 1991). According to this there is talk of a *media-compound system* when

- a 'script' (plot, story) or individual elements of it are available in different media at the same time;
- the script is launched by a leading medium (usually a TV series or cinema or video film);
- at least one audio-visual medium and one print medium are combined with each other;
- and the individual script presentations are mutually dependent on one another, ie are promoter and advertising medium for each other.

That the media areas presented here are linked up in the way that has been outlined should have become clear. But it should also have become clear that such a *mediamix* system, if it pursues commercial ends directly or indirectly, influences the children in a way that an individual medium certainly does not achieve.

## References

Baacke, D. (1990). Zur Industrialisierung des Hoerens durch das Radio. (The industrialisation of listening to the radio.) *Medien und Erziehung*, 34(1), pp. 13-17.

Bauer-Verlag (ed) (1993). *Kinder- und Programmzeitschriften. Medien – und Konsumdaten von 6- bis 14jährigen Kindern.* (Children and TV guides. 6- to 14-year-old children's media and consumption data.) Hamburg: Bauer-Verlag.

Benz, Wolfgang (1993). KZ-Manager im Kinderzimmer. Rechtsextreme Computerspiele. (Concentration camp managers in the child's room. Radical right-wing computer games.) In W. Benz (ed), *Rechtsextremismus in der Bundesrepublik.* Frankfurt, Main: Fischer Taschenbuch Verlag, pp. 224-231.

Berg, K. and Kiefer, M.-L. (eds) (1992). Massenkommunikation Bd.4. *Eine Langzeitstudie zur Mediennutzung und Medienbewertung 1964-1990.*

(A longitudinal study into media use and media assessment 1964–1990.) Arbeitsgemeinschaft der ARD-Werbegesellschaften (ed). Baden-Baden: Nomos.

Brosius, H.-B. and Schmitt, I. (1990). Horrorvideos im Kinderzimmer – wer sieht sie und warum? (Horror videos in the child's room – who sees them and why?) *Rundfunk und Fernsehen*, 38(4), pp. 536-549.

BPS-Report (1991), 14(6), pp. 29ff. German Federal Inspection Office (Bundesprüfstelle für jugendgefährdende Schriften), Bonn (ed).

Charlton, M. and Neumann-Braun, K. (1992). *Medienkindheit – Medienjugend. Eine Einfuehrung in die kommunikationswissenschaftliche Forschung.* (Media childhood – media youth. An introduction to communication science research.) Munich: Quintessenz-Verlag.

Darschin, W. and Frank, B. (1994). Tendenzen im Zuschauerverhalten. Fernsehgewohnheiten und Fernsehreichweiten 1993. (Viewer behaviour trends. TV habits and TV coverages 1993.) *Media Perspektiven*, (3), pp. 98-110.

*Daten zur Mediensituation in Deutschland. Media Perspektiven, Basisdaten 1993.* (Data on the media situation in Germany. Media perspectives, basic data 1993.) Frankfurt a.Main: ARW 1993.

Ehapa-Verlag (ed) (1992). *Fruehe Markenpositionierung. Neues ueber Kinder und Marken.* (Early brand positioning: news about children and brands.) Stuttgart: Ehapa-Verlag.

Fritz, J. (1989). Videospiele – ein problematisches Freizeitmedium? (Video games – a problematic leisure-time medium?) In J. Fritz (ed), *Spielzeugwelten*. Weinheim *et al.*: Juventa, pp. 165-215.

German Federal Inspection Office (Bundersprüfstelle für jugendgefährende Schriften), Bonn (ed) (1991), 14(6), pp. 29 ff.

Glogauer, W. (1993). *Die neuen Medien veraendern die Kindheit. Nutzung und Auswirkungen des Fernsehens, der Videospiele, Videofilme u.a. bei 6 bis 10jaehrigen Kindern und Jugendlichen.* (The new media change childhood. Use and effects of TV, video games, video films in 6- to 10-year-old children and young people among others.) Weinheim: Dt.Studien Verlag.

Groebel, J. and Klingler, W. (1991). Kinder und Medien 1990. Erste Ergebnisse einer Vergleichsstudie in den alten und neuen Bundeslaendern. (Children and media 1990. First results of a comparative study in the new and old federal states.) *Media Perspektiven*, (10), pp. 633-648.

Hansen, L. and Manzke, G. (1993). *Hexen und Monster im Kinderzimmer. Ergebnisse einer Befragung zum Gebrauch von Kinder-Hoerspielkassetten. Spiele zum Hoeren.* (Witches and monsters in the child's room. Survey results on the use of children's radio play cassettes.) Remscheid: Rolland.

Heidtmann, H. (1989). Lektüre – Kontrahent audiovisueller Medien? (Reading – the audio-visual media's opponent?) *Buch und Bibliothek*, 41(3), pp. 252-256.

Heidtmann, H. (1992). *Kindermedien*. (Children's media.) Stuttgart: Metzler.

Heidrich, J.J. (1991). Krieg als Software. Computerspiele – alte und neue Tendenzen. (War as software. Computer games – old and new trends.) *Medien praktisch*, (1), pp. 48-49.

Hengst, H. (1990). Szenenwechsel. Die Scripts der Medienindustrien in der Kinderkultur. (Change of scene. The scripts of the media industries in children's culture.) In M. Charlton *et al.* (ed), *Medienkommunikation im Alltag.* Munich *et al.*: Saur, pp. 191-209.

Heuzeroth, T. and Mueller-Neuhof, K. (1993). Video – Grenzen des Wachstums erreicht? (Video – maximum growth limits already reached?) *Media Perspektiven*, (8), pp. 380-387.

Klingler, W. (1994). Was Kinder hoeren. Eine Analyse der Hoerfunk – und Tontraegernutzung von 6 bis 13jaehrigen. (What children listen to. An analysis of 6- to 13-year-old children's radio and sound media use.) *Media Perspektiven*, (1), pp. 14-20.

Klingler, W. and Windgasse, T. (1994). Was Kinder sehen. Eine Analyse der Fernsehnutzung von 6- bis 13jaehrigen. (What children watch. An analysis of 6- to 13-year-old children's TV use.) *Media Perspektiven*, (1), pp. 2-13.

Krüger, U.M. and Zapf-Schramm, T. (1994). Programmanalyse 1993 von ARD, ZDF, SAT.1 und RTL. (1993 programme analysis of ARD, ZDF, SAT.1 and RTL.) *Media Perspektiven*, (3), pp. 111-124.

Lukesch, H., K.-H. Kischkel, A. Amann, S. Birner and M. Hirte *et. al.* (ed) (1989). *Jugendmedienstudie. Verbreitung, Nutzung und ausgewaehlte Wirkungen von Massenmedien bei Kindern und Jugendlichen. Eine Multi-Medien-Untersuchung ueber Fernsehen, Video, Kino, Video- und Computerspiele sowie Printprodukte.* (Youth media study. The propagation, use and selected effects of mass media by children and young people.) Regensburg: Roderer.

Lukesch, H., Kaegi, H., Karger, G. and Taschler-Polacek, H. (1989). *Video im Alltag der Jugend. Quantitative und qualitative Aspekte des Videokonsums, des Videospielens und der Nutzung anderer Medien bei Kindern, Jugendlichen und jungen Erwachsenen.* (Video in young people's everyday life. Quantitative and qualitative aspects of video consumption, playing videos and the use of other media by children, youth and young adults.) Regensburg: Roderer.

Rogge, J.U. (1982). Pop- und Schlagermusik fuer Kinder. (Pop and hits for children.) *Buch und Bibliothek*, 34(6), pp. 490-495.

Rogge, J.U. (1988). Zur Bedeutung und Funktion des Radios und des Kinderfunks im Alltag von Kindern. Ein Forschungsueberblick. (The meaning and function of radio and children's radio in children's lives. A research overview.) *Media Perspektiven*, (8), pp. 522-528.

Rogge, J.U. (1990). Wege und Mühen zu einer Hoerkultur fuer Kinder. Zu den Programmen des Kinderfunks. (The struggle for a children's listening culture. Children's radio programmes.) *Medien und Erziehung*, 34(2), pp. 97-107.

Sander, U. (1989). Kino und Jugend. (Cinema and Youth.) In E. Gottwald *et al.* (Ed.) *Alte Gesellschaft – Neue Medien*. Opladen: Leske u.Budrich, pp. 111-123.

Schmidbauer, M. and Löhr, P. (1991). *Fernsehpaedagogik. Eine Literaturanalyse.* (TV pedagogy. A literature analysis.) Internationales Zentralinstitut fuer das Jugend- und Bildungsfernsehen, Munich (ed). Munich *et al.*: Saur.

Schmidbauer, M. and Löhr, P. (1993). *Gewaltdarstellungen in Fernsehprogrammen - ihre Auswirkung auf Fuehlen, Denken und Handeln von (Grundschul)kindern.* (Portrayals of violence – their effect on (primary school) pupils' emotions, thoughts and actions.) Internationales Zentralinstitut fuer das Jugend- und Bildungsfernsehen, Munich (ed). Munich: IZI.

Schmidbauer, M. (1993). Teil I: Programmangebot. Televisionaere Lieblingsspeise mit Werbe-Ingredienzen. (Part I: the programme range. Television favourites with advertising ingredients.) *Televizion*, 6(2), pp. 14-19.

*Schueler-Mediaanalyse* (1993). (Pupils' media analysis) Gottschaller, E. (ed), Institut fuer Jugendforschung, Markt- und Meinungsforschung, Munich (ed). Munich:

IJF.

Sommer, M. (1994). *Die Kinderpresse in der Bundesrepublik Deutschland. Angebot, Konzepte, Formen, Inhalte.* (Children's press in Germany. Output, concepts, forms and contents.) Hamburg: Kovac.

Spanhel, D. (1987). *Jugendliche vor dem Bildschirm. Zur Problematik der Videofilme, Telespiele und Homecomputer.* (Young people in front of the screen. The problems of video films, video games and home computers.) Weinheim: Dt. Studienverlag.

Strobel, H. (1993). Kinderfilm und Kinderkino in der BR Deutschland. (Children's films and children's cinema in Germany.) In H. Twele (ed) *Kinderkino in Europa.* Frankfurt, Main: BJF, pp. 9-16.

Swoboda, W.H. (1990). Game over. Computerspiele im Medienalltag von Jugendlichen. (Game over. Computer games in young people's everyday media lives.) *Medien praktisch,* (2), pp. 13-18.

Vollbrecht, R. (1989). Der Walkman und das Ende der Aufklaerung. (The portable stereo and the end of the Enlightenment.) In E. Gottwald *et al.* (ed) *Alte Gesellschaft - Neue Medien.* Opladen: Leske u.Budrich, pp. 101-110.

## Notes

1   The German version of this article appeared in *TelevIZIon* 7/1994/1, pp. 8-28.

2   The remarks made in this chapter refer to the programme market. The *equipment* market, above all of importance for the area of the electronic media, is largely left out of the considerations.

3   Here 'programmes' is used to refer to all media communiqués: television and radio broadcasts, newspaper and magazine articles, video and film programmes, record, cassette and CD recordings, computer games, book contents and plays.

4   The data given below on reach and viewing behaviour relate to all children living in German households. As nowadays 90 per cent of the German population can receive *RTL*, 89 per cent *SAT.1* and 70 per cent *PRO 7*, no distinction will subsequently be made between households with and households without cable and satellite connection. To this and the data that follow see Darschin and Frank, 1994, p. 98; Klingler and Windgasse, 1994, pp. 4, 8).

5   The use measurement refers only to children who watch television on a fixed day. If the use duration is calculated in relation to all children living in television households the daily use time is reduced to 106 minutes. It seems appropriate, however, to regard such use figures only as rough estimates of the time children actually spend watching television. In a very detailed case study Klingler and Windgasse have found out the time which a 'normal' 11-year-old girl with her own television set and living in a three person cable household in fact spends watching television on a Sunday (26.9.93) between 8.00 + 12.00 and 18 + 23 hours: the time is exactly eight hours 35 minutes and 44 seconds (cf. Klingler and Windgasse, 1994, p. 12).

6   As to heavy viewers and excessive video users, cf. Glogauer, 1993, pp. 16 ff.

7   In the original German version programmes for children and programmes of relevance for children are listed for a typical weekday (Monday, 9th of May) and a typical weekend (7th/8th of May 1994).

8   If the 10 favourite genres are related to girls only, the categories 'entertainment series' (30 per cent) and 'pop music broadcasts' (28 per cent) would have to be supplemented and the categories 'science fiction' and 'Western' removed; if the 10 favourite genres are related to boys only, the category 'sport' (28 per cent) would have to be supplemented and the category 'family series' removed.

9   Coverage does not relate to the boys' or girls' buying records, cassettes or CDs but to their listening to them (cf. Klingler, 1994, p. 14).

10  Cf. Sommer, p. 89 ff. and footnote 8. The estimates made by Sommer of form/content of the children's press and how children handle it largely correspond to references given subsequently. As this text is primarily geared to data-related documentation, it is not possible here to properly acknowledge Sommer's detailed comments with their analysis of the audience, form and content.

11  Here, too, the coverage does not refer to the buyers of the products but to the 'readers per issue'.

12  Cf. also Bauer-Verlag 1993. The coverage survey within the framework of this study, however, is based only on an unsystematically made and therefore unrepresentative selection.

13  Cf. Heidtmann, p. 6. Here it should not be forgotten that the coverage of television programme announcements/television supplements – irrespective of whether mediated by programme guides,

illustrated magazines or newspapers – is far greater (between about 60 and 75 per cent – cf. Klingler and Windgasse, p. 12 and Bauer-Verlag, 1993, pp. 55 ff.).

14  As cross-generation series, *Asterix* and *Peanuts*, which also has a large circulation, have not been included in this compilation.

15  BPS-Bulletin, ie the bulletin of the German Federal Inspection Office (Bundesprüfstelle – BPS)

16  Cf. the reports of the Federal Inspection Office (Bundesprüfstelle) of the previous years.

17  Cf. *BPS-Report*, 14/1991/6, pp. 29 ff..

18  As no usable quantitative material is available for the area 'children and children's films' and neither use and preference data nor references to market analysis are to be found on this sector, the subject has not been considered here. The little that is available on the area 'children's cinema' in the way of programme descriptions and reception conjectures can be read up in Heidtmann (1993), Kindermedien, p. 43 ff.., and Strobel, H.: Kinderfilm und Kinderkino in der Bundesrepublik Deutschland. In: Twele, H. (ed): Kinderkino in Europa, Frankfurt am Main: Bundesverband Jugend und Film e.V., 1993, p. 9 ff.

19  Cf. Heidtmann, 1992, pp. 99 ff.; Lukesch, 1989, pp. 54 ff.

20  In the present context this issue cannot be pursued further – cf. Schmidbauer and Löhr. 1993.

# Computer kids are avid TV viewers[1]

*Stefan Weiler*

Broadcasts for children and young people which were put into the programme of German TV stations in the mid-90s have little in common with their predecessors in the 80s. Computer shows and computer future clubs for children and adolescents are in fashion with programme suppliers. Interactivity is the common denominator that is aimed at and the big attraction to get young people in front of the television screens. Sequences adapted to MTV and VIVA, video clip-like jingles accompanied by techno music, raging steady cam tracks, extremely cool presenter-types with a vocabulary taken from the 'Dance-Trance' and 'cyberspace' scene are the features of these 'mega-', 'cyber-' 'hyper-programmes'.

Although the formats are presented differently, the contents of the new programmes are very similar. What is offered are computer games, Game Boys, video games and background information on high technology, in the shrunken format of the computer's user interface.

### What is the aim of computer broadcasts on television?

How are computer broadcasts integrated into the children's leisure-time activities? Does their reception strengthen the trend towards an increase in the media equipment in the children's room or does the skilful use of commercials even persuade them to acquire computer products via the screen?

The commercial blocks before, during and after these shows together with the 'messages' cleverly integrated into them by resourceful market strategists indicate that the latter certainly give top priority to children as an economic factor and trend-setters when including them in their planning. Added to this is the fact that events and contents of different media are being linked up with one another to an increasing extent. Events are initiated, as can be shown by the example of 'dinomania'.

Are these new types of broadcasts accepted by children and young people and is there a demand for such programmes? In order to proceed any further it is first necessary to collect precise information about the motivations and situations which result in the consumption of the media

or events. The media environment and the children's biographical details provide the first leads. For this reason concentrating on a sub-group of the children interviewed, the so-called computer-kids, i.e. those with exclusive access to computers or special skills in handling computers, was preferred to a more general presentation.

The results of this report contain findings of selected partial random samples of the complete DINOFON panel of children which was set up by the ZDF Media Research in 1993 and expanded in 1994. In all,

- 662 children's answers were included in the random sample, 330 boys (50 per cent) and 332 girls (50 per cent);

- 286 (43 per cent) were from the 6- to 9-year-old age group, 194 (29 per cent) were 10 to 11 and 182 (28 per cent) 12- to 13 years old;

- 175 children (26 per cent) were identified as fans of commercial channels, while 236 (36 per cent) preferred the private broadcasters; 76 (12 per cent) turned out to favour both broadcasting systems, and 166 (25 per cent) showed no preferences.

**Electronic media in the children's room**

Let us take a look into a children's room in the year 2000. A large-scale screen integrating computer, television, telephone and radio is what first catches the eye. Hundreds of CD-ROMs, which can be used for programmes, music and virtual games, provide an opportunity to immerse oneself interactively in virtual reality. Three sets of a 'data overall', the new fashion trend among adolescents, in the colours 'blue-screen-blue' is hanging in the shiny chrome wardrobe. The cyberspace goggles help to find answers to the geography homework.

Now back to the reality of 1994. What does the computer or media reality look like in children's rooms today? The way to the 'young person's domicile in 2000' no longer seems far off, since even today the children possess an astonishing array of audio-visual media equipment:

- out of 662 respondents over three-quarters (79 per cent) listen to their favourite music on their own Walkman or cassette recorder (N=520);

- over three-fifths (63 per cent) switch their way through the radio channels on their own radio (N=420);

- almost half play video games (48 per cent) or with Game Boys (N=318) without being interrupted by their parents;

- almost one-quarter (24 per cent) can afford a stereo-set (N=156) and make use of a record (22 per cent) or CD player (N=144) undisturbed by their parents;

- one in five children (20 per cent) has a chance to surf the TV channels in his own room (N=132);

- 15 per cent of the children already have exclusive access to a computer (N=96).

Of course, there are also a few children who have to organise their free time without electronic media. It is possible, however, to make out even more who can choose between several electronic media in their private lives. 26 children were identified who came very close to the vision of the twenty-first century. They possess for their exclusive use all the media asked about and previously introduced into the discussion. These 4 per cent can be expected to take the step beyond the year 2000. They are closely followed by a further 84 (12 per cent) adolescent owners of computer, Walkman and Game Boy (see Fig. 1).

**Figure 1: Media ownership (exclusive)**
(Base: N = 662 6- to 13-year-olds, in %)

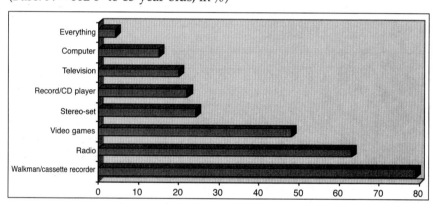

These figures are valid as a whole. If the factor of age is introduced into the evaluation, a rise in this trend can be observed as age increases. It was especially the young people over 12 years of age who possessed an astonishing number of TV sets of their own (36 per cent). Over half in this age group owned video games and Game Boys, and this also applies to radios and CD players. The sex-specific different ownership of media, already suspected, turned out to be old hat. Almost three times as many boys (N=67) as girls (N=25) have a computer. The situation is rather different when we look at the shared use of PCs among siblings or joint ownership. For almost exactly as many girls (N=56) as boys (N=68) have an opportunity to use a computer with siblings (see Table 1).

It is especially the older children that have access to a PC. Over 40 per cent of those over the age of 12 have a computer in the household. This distribution, however, simply reflects the ownership situation of the parents. The likelihood that the father (37 per cent) uses a computer at work or privately at home is almost twice as great as that the mother (15 per cent) owns her own PC. Most of the older children share one with one or several siblings; only to a very limited extent do relatives act as computer partners.

Table 1: **Computer ownership according to demographic data and broadcasting system preference**

(Base=662 children between 6 and 13 years of age, in %)

| | Sex | | Age | | | Broadcasting system preference | | | | |
|---|---|---|---|---|---|---|---|---|---|---|
| | Boys | Girls | 6-9 years | 10-11 years | 12-13 years | Public service | Private stations | Both | None | All |
| No | 58 | 75 | 74 | 64 | 58 | 62 | 67 | 65 | 68 | 67 |
| With siblings | 21 | 17 | 16 | 22 | 20 | 22 | 14 | 17 | 22 | 19 |
| Alone | 21 | 8 | 10 | 14 | 22 | 11 | 19 | 18 | 10 | 15 |
| Total | 100 | 100 | 100 | 100 | 100 | 100 | 100 | 100 | 100 | |
| | (n=330) | (n=332) | (n=286) | (n=194) | (n=182) | (n=175) | (n=236) | (n=76) | (n=166) | (n=662) |

## Who owns a computer?

How can children who have their own computer be typologically characterised? An analysis of variance furnished important findings. As shown, it is essentially age and class that determine computer ownership. The older the children and the better off the parents (p=.000), the greater is the probability that computer sound can be heard coming from the children's room. The computer-owning children receive DM 5.15 (about US$2.90) pocket money a week, while their less privileged peers get almost DM 8 (US$4.50) less a month.

A computer owner is usually an only child. If several children live in one household there is less probability of their possessing a computer of their own. Here the question arises as to whether computer activity as a hobby plays a kind of sibling-substitute role. That does not seem to be the case, as these only children tend rather to maintain friendships with other children and to more people to talk to who appreciate their problems. Their environment is also strongly determined by the fact that the parents are more frequently available and devote more time to their children. Children with access to a computer have a greater opportunity to conduct discussions with friends or parents. The thesis that involvement with PCs reduces social contacts cannot, therefore, be supported.

## The television set as the origin?

How does it come about that children want to play or calculate with computers at all, which, provided with their joystick and mouse, usually occupy the best place in the children's room? If there are other electronic media in the children's room the likelihood that there will also be a computer there increases many times over. If a child can surf through the TV channels with his own remote control the ownership of a PC is four times more probable (p=.000). This also applies to their own video games for the Game Boy (p=.002), to a lesser extent to stereo sets (p=.002), radios

(p=.032) or record/CD players (p=.016) as well as to Walkmen (p=.043). The computer comes at the end of a chain of electronic media – one reason for this being its high price. Everything begins with the first acquisition of audio-visual media.

Print media, apart from instructions for computer use and game descriptions, play a smaller part in the lives of computer kids. That means that books but also story cassettes – more important for younger children – show just as little influence on the ownership of a computer as the access to people to talk to.

## The interest of the parents

It is not just the mere presence of audio-visual equipment but also the frequency of use that determine computer ownership and the desire to experience virtual worlds or just to calculate on the computer and to write on a keyboard.

Interestingly, not only the frequency with which children (p=.015) and parents (p=.039) use television but also their preferences for a broadcasting system reveal highly significant findings. It can be unequivocally stated that the children who own computers are those who frequently watch television. The greater the TV consumption, the more probable it is that a PC can be found in the children's room. The same applies to their parents. Their television consumption correlates with that of their offspring. The more frequently they watch television, the more their children are inclined to use computers.

But which programmes they watch is also important. Computer kids' parents still prefer public service channels, while their children favour the private companies. The reasons for this reversal in the system preference is to be seen in these children's search for exciting programmes, which they think they are more likely to find on commercial channels like RTL, RTL2 and PRO 7. They have become part of what the Bamberg sociologist Gerhard Schulze (1992) termed the excitement and 'experience scheme'.[2] Computer kids can therefore be found in an environment of high television consumption and an increased use of multimedia. Both parents and children are seen to be more than interested in and receptive to the media and media activities.

## Games around the clock?

What are the soundblaster-supported sounds that will be spreading through the children's rooms in the year 2000? The scenario of a cabled and networked children's room touches upon not only the mere availability but also the fears raised by the volume of time and use of home PCs. A loss of reality through the daily consumption of games and simulation is just one of the possible horror visions that are feared as a result of excessive use of computer games. These fears are not altogether unfounded, as the

following findings underscore, since besides other media occupations it is chiefly declining creative activities, such as a musical training, that serve to provide time to dip into the computer world (see Table 2).

Table 2: **Computer use according to demographic data and broadcasting system preference**

(Base=218 children with access to a computer from the total sample of 662 children between 6 and 13 years of age, in %)

|  | Sex | | Age | | | Broadcasting system preference | | | | |
|---|---|---|---|---|---|---|---|---|---|---|
|  | Boys | Girls | 6-9 | 10-11 | 12-13 | Public | Private | Both | None | All |
| Quite seldom | 20 | 30 | 16 | 43 | 20 | 27 | 21 | 15 | 30 | 24 |
| A few days a week | 58 | 50 | 62 | 55 | 57 | 47 | 56 | 70 | 57 | 55 |
| 1-2 hours every day | 22 | 20 | 22 | 22 | 23 | 25 | 24 | 15 | 13 | 21 |
| Total | 100 | 100 | 100 | 100 | 100 | 100 | 100 | 100 | 100 | 100 |
|  | (N=136) | (N=82) | (N=73) | (N=70) | (N=75) | (N=59) | (N=77) | (N=27) | (N=53) | (N=218) |

Anyone who has a computer does not necessarily use it every day. Among the 218 children those have also been taken into account who share a PC with siblings or who are allowed to use their parents' computer. Altogether the inclusion of shared users doubles the number of those with access to a computer to 40 per cent (N=218). In the answers on daily use and for several hours (N=46) or, more seldom, only sporadic use in the week (N=172) only one-fifth (21 per cent) turned out to be 'obsessive' users. But the ranks of the excessive users are recruited solely from the circles of computer owners. This means almost every other child with a PC in the children's room switches it on every day.

In this group, too, the boys made up the majority of daily users (N=30). Girls (N=16) turned out to be rather sporadic users, who spread their leisure-time interests more than boys. Age – as was to be expected on account of the different cognitive level of development – determines the duration of occupation with the medium. The over 10-year-olds use their PC far more frequently than those who are younger. This increase applies in particular to those who watch television more frequently (p=.008) and prefer private channels.

The more television a child watches and the more strongly it prefers private companies, the more extensive is its use of the PC. It therefore seems that experience-orientation lies at the centre of leisure-time activities. Approximating to the results on computer ownership, here a similar television use frequency can also be observed in children and parents.

105

The experience previously gained from electronic equipment allows conclusions to be drawn on the time spent in front of the PC as well. Owning a Walkman or a Game Boy increases the probability of daily PC use. The competence acquired on the Game Boy or other electronic equipment is immediately applied to the PC. The children grow out of the Game Boy age and into the computer age, without, however, neglecting their old familiar game equipment to any extent. It can therefore be concluded that computer use in the environment of an extended media use takes place as a kind of additional activity.

The PC is fitted into the daily course of events without demanding much time from the other media activities. Leisure-time turns into media activity, and television and Game Boy become the catalyst of the PC. The problems of this orientation show up clearly when factors of creative occupations, like, for example, learning to play a musical instrument, are included. Here it shows that frequent occupation with the computer considerably decreases the probability and the wish to learn to play a musical instrument (p=.008).

**Who helps with the computer?**

No doubt every PC user is familiar with the desperate conversations with a friend and expert on the cussedness of the computer. That also applies to children, in spite of their own undisputed ingenuity in handling electronic equipment. Who accepts responsibility for the children entering and being accompanied on their daily excursions into the world of computers? Who supports them before and after their activity?

Four (N=175) out of five children who said they shared the use of a computer are and were supported in their activity. In the case of younger children it is mainly the parents who give them a hand, while the school plays a minor part. This changes in the course of their computer career. Special knowledge is imparted, on the one hand, by friends and siblings or, later, by the school. Here the time factor plays a large part.

The more time a member of the family can find for the children, the more help he/she can provide. As parents usually have less spare time than siblings, it is chiefly the latter who are the people the older children talk to (47 per cent). This does not mean, however, that they are neglected by their parents, for it is mainly the father (37 per cent) who helps the children (52 per cent), both in giving computer advice and in the general use of television, especially since as a rule it is this group of helpful parents which apparently takes more time for its computer children.

It is particularly the only child who is given 'First Aid' in discussions about television content and computer use. This is especially so with younger parents under 40, the generation of the first 'computer children', who had access to computers early on in connection with their work and socialisation. If for any reason the parents do not help, siblings and close friends are consulted. If they cannot give any assistance, comics (p=.018)

106

and music (p=.013) become alternative authorities. Younger children seek compensation in story cassettes.

## Games – nothing but games?

The sound reveals the player. There is boxing, slamming, running, shooting and motorcycle and car racing. The world is simulated to the accompaniment of extremely lifelike sounds. Other variants of PC use betray the user less and are not so frightening for the observers. For drawing, painting, programming or word processing are generally associated with greater creativity in handling the computer.

But which activities dominate? Is it mainly playful elements that draw the young users to their PCs, or perhaps painting and drawing programs? Who programs, calculates with the computer or writes his texts on the screen? In all, computer games for children offer the greatest attraction. This applies in particular to the younger ones (66 per cent). Drawing and, surprisingly, calculating also prove to be a greater attraction for the under 10-year-olds than writing texts or programming, which appeal more to the older children (see Table 3).

Table 3: **Computer use, activities**
(multiple answers)

| Games | 55% | (N=202) |
|---|---|---|
| Painting, drawing | 9% | (N=32) |
| Writing text | 18% | (N=66) |
| Learning programs | 5% | (N=19) |
| Programming | 4% | (N=16) |
| Calculating | 7% | (N=25) |
| Music | 2% | (N=6) |

Entry takes place through games and programs for drawing and painting and switches to more creative activities with the PC in the course of the 'computer career'. This applies above all to the over 10-year-old children. Video and computer games remain interesting, however, if the parents have less time for their children and have less formal education and a lower income.

More demanding activities with the computer are the reserve of the better educated. That means that even in handling computers differing ownership conditions (of the parents) show up as well as their differing competences (knowledge gap). The less parents can and want to occupy themselves with their children, because they are too taken up with their work, the more the children turn to computer games and away from 'playing' with its actual possibilities.

A further indication of the parents' importance for the children's handling of the medium more creatively is shown in the finding that children who say they have someone to talk to also exercise more demanding activities on the computer (p=.069). This applies especially when this contact person is supportive in matters relating to the subject of the PC (p=.006).

In addition to the home, the school also proves to be an authority for the older children which is decisive for a critical attitude towards handling the media. Children who enjoy going to school carry out more demanding activities on the computer. And also important is the finding that: good pupils play less and learn more.

If there are a lot of books in the children's room and the children have fun reading, computer games are put on a back-burner and interest is focused on learning programs and word processing programs.

### Computer kids and the dual television system

As stated above, the possession of a television set turns out to be the variable which makes media consumption and the ownership of other media most likely. This applies not only to the frequency of television use (p=.000) – to guarantee both parents and children an undisturbed and exclusive programme consumption – but also to all other forms of media ownership (see Table 4).

Table 4: **The importance of owning a television for further media equipment**

| Medium | Significance (TV ownership) |
|---|---|
| | (P=) |
| Game Boy/video game | .000 |
| Owning a computer | .000 |
| Owning a radio | .005 |
| Owning a stereo set | .000 |
| Record/CD player | .000 |
| Walkman/cassette recorder | .031 |
| Telephone use | .000 |

*Print products —the exception*

The opposite results apply to print products, since children with their own television generally possess fewer books than their contemporaries. Reading is less important, and creative activities or training artistic talents are rare. Attending school tends to be rejected by frequent viewers. This finding is again underscored by the fact that these pupils decline to name any favourite subjects.

## Declining creativity

Children who own a television of their own are not so active creatively as their contemporaries who consume less television. They also have less time to do so, for when children have their own television they spend almost three times as much time watching it as those without a television. That they clearly prefer private channels applies to them as well. This is also shown consistently in the case of the computer kids who have generally become fans of RTL, SAT 1 and PRO 7. Almost one in five children discloses that he watches only private channels (19 per cent), while only one in 10 (11 per cent) outs himself as an exclusive viewer of public service television. Their parents, on the other hand, still represent the traditional preference for public service programmes (21 per cent). But here, too, the commercial stations are catching up (17 per cent).

This trend is reversed if the PC is used together with siblings. Almost one in four children claims to watch mainly ARD and ZDF. Individual users can therefore be characterised as more likely to be experience-orientated television consumers. If the competence of the children on the computer is consulted the station preferences level off with a tendency towards the public service broadcasting system. In the same way differences in the computer use of supporters of different systems can be found. Children who prefer the public service channels tend to use their PC for writing, and their contemporaries with a partiality for commercial television, for programming.

## Fun and experience through comedy

Consuming television and owning a television set were defined as important quantities for computer ownership and the mode as well as the duration of activities at the computer. But what does a day in front of the television look like, and which programmes and contents are preferred by the computer kids?

If the namings of favourite programmes in the overall television output are taken into consideration, the following picture results according to a categorised evaluation (see Table 5).

Computer owners are distinguished by a strong interest in comedy programmes, such as the *Cosby Show*, game shows and crime thrillers. Children who grow up at home without a PC prefer special children's programmes, for example the ZDF's *Kinderstudio*, *Bim Bam Bino* and the like as well as animated cartoons (*Trick 7*) in addition to action and teenager series (*Beverly Hills 90210*). Computer kids on the whole favour lighter forms of entertainment.

So that an evaluation can be made, the highest percentage of the children's namings of their favourite programmes will now be presented. The preference for animated cartoons, comedy and age-group-specific

programmes – for the younger ones the *Sendung mit der Maus* and the older ones *Beverly Hills 90210* – are reflected in the categorised presentation of the children's favourite programmes (see also Table 5).

Table 5: **Favourite Programme categories in relation to PC ownership**

| Favourite categories | Computer ownership % | |
|---|---|---|
| | Exclusive | No |
| Comedy | 16.4 | 8.1 |
| Crime thrillers | 3.9 | 1.2 |
| Children's programmes | 18.8 | 28.6 |
| Animated cartoons | 18.8 | 23.4 |
| Feature films | 3.9 | 3.3 |
| Animals/science/ politics | 2.3 | 2.2 |
| Action/teenager programmes | 21.9 | 23.4 |
| Game show | 3.1 | 1.6 |
| Television film | 1.6 | 0.7 |
| No answer | 9.4 | 7.4 |

The characters and contents of animated cartoons are mostly based on exemplars taken from both real fictional films and comics. The readiness to accept these figures rises with increasing age and television consumption. Frequent viewers are therefore often also avid comics readers and comics programme fans. This applies in the same way to the computer kids (see Table 6).

## The Game Boy user as a preliminary phase to the computer kid

If the answers on favourite programmes are distinguished according to less and more frequent computer use, considerable differences are revealed. Whereas the less frequent users watch teenager programmes like *Beverly Hills 90210* and comedy programmes, but also the *Sendung mit der Maus*, the daily users show a preference for action programmes *Parker Lewis* and public service children's programmes such as the series *Es war einmal...* or the *Kinderstudio*.

It can be seen that computer kids need exciting programmes, but also educational broadcasts such as *Kinderstudio*. This tendency is underlined by the Game Boy as a preliminary phase or substitute for a computer of one's own among the less well-off children. Here, too, the Game Boy children opt for action programmes and teenager series. The frequent viewers with their own television in their room show a marked preference for *Beverly Hills 90210*, *Bill Crosby* and *Parker Lewis*. Game Boy and computer users reveal parallels in their programme use. Both turn out to be an audience for action series. Their interest is focused on thrills and adventure.

Table 6: **The children's favourite programme** (N=662)

| Programme titles | % |
|---|---|
| Disney Club (ARD) | 8 |
| Bill Cosby Show (PRO 7) | 8 |
| Beverly Hills 90210 (RTL) | 6 |
| Sendung mit der Maus (ARD) | 5 |
| Parker Lewis (PRO 7) | 5 |
| Kinderstudio (ZDF) | 4 |
| Bim Bam Bino (KABELK) | 3 |
| Smurfs (ZDF) | 3 |
| Freunde fürs Leben (RTL) | 3 |
| Garfield and his Friends (PRO 7) | 3 |
| Gute Zeiten, schlechte Zeiten (RTL) | 3 |
| Löwenzahn (ZDF) | 3 |
| Pippi Langstrumpf (ZDF) | 3 |
| Trick 7 (PRO 7) | 3 |
| No answer | 12 |

**Game Boy and video games**

The hand-held computer games described as a preliminary phase to computer games or computer ownership, on the market as Game Boy or generally as video games in every form, frequently offer the purchasers to a certain extent the thrill of a genuine computer game. For this reason findings on the use habits and users of this preliminary form of computer game should be included in the overall analysis (see Table 6).

As already stated in the case of computer ownership, it is especially boys who possess Game Boys or video games (N=177). It is also clearly shown that these games are designed mainly for older children or adolescents and are used by them. Over three times more children over the age of 12 (N=104) say they own a Game Boy than do the 5- to 7-year-olds (N=32). The excitement they prefer is found by this group chiefly on the private channels (60 per cent) and less on the public channels (37 per cent).

In contrast to the computer-owning children, this also applies to the parents of the 'Game Boy kids'. The latter are to be found for the most part among the heavy television viewers and infrequent readers with less formal education. So Game Boy or video games constitute the less expensive counterpart, the computer substitute, so to speak, for lower income parents, the cheap equivalent to the home PC. They get an average

pocket money of DM 4,38 (US$2.50), about one Deutschmark less a week than the computer kids, although far above average. 'Game Boy kids' represent a preliminary phase to the computer kids with regard to their finances as well.

Table 7: **Ownership of Game Boy and video games, number of games, according to demographic data and broadcasting system preference** (Base = 662 children between the ages of 6 and 13, in %)

| | Sex | | Age | | | Broadcasting system preference | | | | All |
|---|---|---|---|---|---|---|---|---|---|---|
| | Boys | Girls | 6-9 yrs | 10-11 yrs | 12-13 yrs | Public service | Private stations | Both | None | |
| No | 46 | 58 | 64 | 55 | 43 | 59 | 40 | 47 | 63 | 52 |
| Yes | 54 | 42 | 36 | 45 | 57 | 41 | 60 | 53 | 37 | 48 |
| | 100 | 100 | 100 | 100 | 100 | 100 | 100 | 100 | 100 | 100 |
| Total | (N=330) | (N=332) | (N=286) | (N=194) | (N=182) | (N=175) | (N=236) | (N=76) | (N=166) | (N=662) |
| Over five | 31 | 15 | 18 | 28 | 25 | 13 | 32 | 17 | 22 | 23 |
| video games | (N=102) | (N=48) | (N=51) | (N=54111) | (N=45) | (N=22) | (N=76) | (N=13) | (N=37) | (N=150) |

Analogously to computer ownership, owning a Game Boy increases the probability of possessing other media, although to a lesser extent. Game Boy owners like to read comics, watch television longer – which they are allowed to do by reason of their greater age – and often use a television together with siblings (p=.049).

These results are also confirmed by the data on the average ownership of Game Boys or video games per child. Even so, 26 per cent of the video players say they own from 7 to as many as 95 games. This applies more to boys than girls, to the older children rather than the younger ones and to those who prefer private broadcasting three times more frequently than to the fans of public service stations. The parents, most of them younger than average and supporters of RTL, RTL2 or PRO 7, share their children's predilections.

The chronological chain of media ownership can be arranged in an order that is also roughly based on the age structure of the owners. It begins when they enter the Walkman/Game Boy/video game age and continues with the acquisition of a computer. Class-specific features are just as decisive as television use.

A look into the children's room now shows that it is already well furnished with media equipment. Multi-media are materialising in the adolescents' rooms and (media) environment:

- Almost all children own an electronic medium, one in seven their own computer and 4 per cent even the whole range.

- Entering the virtual world occurs when the first audio-visual equipment is purchased, continues by playing with the cheap Game Boy and, in the absence of any 'better' alternatives for the time being, ends with the home computer.

- The world of the PC and computer language is made accessible by means of games. These can first be tested for their excitement content with the help of the cheap Game Boy and later upgraded graphically and interactively with the PC.

- The more creative part of the computer can be and is first made use of after a playful phase and overcoming initial fears. That is why games and game broadcasts come mainly at the beginning of the computer career.

- The older children, however, tend to continue to shift to more creative activities, but still continue to sock and daddle. They are usually supported by their better educated and better-off parents, who as a rule spend more time with their offspring.

- While the parents remain faithful to public service stations, their children prefer the programmes of the commercial channels. But it can be said of both that they are keen media consumers.

It can therefore be concluded for the programme-maker that computer programs are on the upturn and also have good chances of becoming firmly established in the overall programme – but not inevitably for all broadcasts of this kind. What is called for is excitement and action. If the children are not provided with that there is a risk that even programmes of that kind will meet with outright rejection.

## Notes

1   The German version of this article appeared in TelevIZIon 7/1994/2, pp. 37-43.
2   Schulze, Gerhard: *Die Erlebnisgesellschaft*. Frankfurt am Main: Campus 1992.

# Children's television in transformation? Something is going on in children's bedrooms[1]

## Ben Bachmair

It is apparent that children's television has begun to move in Germany: *Der Kinderkanal* (children's channel), a joint effort of the ARD and ZDF, and Nickelodeon as well as further two digital children's channels on DF1 'in the background' are signalling fundamental changes. How is all that to be assessed? Children's programmes, broadcast round the clock so to speak, are, of course, something many had wanted,[2] not least to provide children with an appropriate and reliable service at viewing times that best suited them.

But there are still some open questions, which point more to long-term changes. How, for example, is the development of thematic channels to be judged? Is it not more a case of the children's channels, as the pioneers of this development, speeding up this fragmentation of television as we know it? Will the beleaguered children's sector not result in new genres, which, although they comply with the children's viewing behaviour – mquick comic and video mixtures without any comprehensible narrative sequence, banal series, indiscreet chat-shows, embarrassing playback shows with children – tend to worry thoughtful adults?

Susanne Müller, the experienced head of the ZDF's Department for Children's Programmes and the ZDF's co-ordinator for the public service *Kinderkanal* already mentioned, believes, irrespective of this development, that in the end 'nothing is really new' that is appearing all over the place on the TV screen for children. What is changing and with what momentum? In summer 1997 media scientists and programme producers met at Kassel University to discuss these problems at a workshop on the current situation of children's television.[3] The aim was to sound out how programme offers for children, their reception and integration into their everyday life change, and into which general development children's television is integrated.

The following argument on this: the familiar form of television is undergoing a transformation, which can be seen from the change in the organisation (full programmes vs. thematic channels), from new genres, from the integration of television into multimedia arrangements and from the recipients' new patterns of viewing behaviour (eg zapping). Probably the dynamics of mass communication as a whole are changing.

Responsible for all this is both technological and the cultural development. Thus multimedia are resulting from the overlapping of computer, telephone and screen media. At the same time media and objects of consumption are becoming sources of everyday aesthetic symbolism which are becoming increasingly important for social cohesion and/or the demarcation of social environments.

The dynamics can be recognised by the examples of children's television or children as the target audience of television. Since children's television – with its move towards thematic channel structure – is currently changing and at the same time much attention is being paid to the relationship of children and television, children's television and children as television users are obvious indicators of the further development of television and mass communication. Simultaneously, as the development of the media changes so does the cultural framework of reference of and for childhood.

How can the dynamics of change be approached by reasoning? Hans-Dieter Erlinger (1995) has documented the history of children's television as part of the special research area and in doing so given priority to a systematic study and ordering of the programmes offered. Because market and cultural dynamics have intervened in the relationship between man and the media, television is also being developed by its users.[4] So how far, to ask quite pointedly, is television already integrated into individual media and event arrangements? Both children's bedrooms and music scenes and their styles are opening our eyes to this development and showing how the new form of mass communication will function.[5]

## 1. Children's bedrooms – a typical example of subjective media and event arrangements

If we visit 9-year-old Jonas in his room our eye is immediately caught by two posters hanging above his bed. One shows the heroes of the year and the other the *Power Rangers*. Of course, there are many more things as well: dinosaurs, a collection of minitoys from chocolate eggs and little toy figures from McDonald's. Asked about the posters, he begins to talk:

*Interviewer (I)*: And who are those characters in the posters?

*Jonas (J)*: Those in the poster are the heroes in 1996.

*I*: And what is that?

*J*: Well, these are, these here, for example, all heroes and these two are the silliest, they are the Undertakers.

*I*: And who are they?

*J*: Oh, they fight with each other. They throw each other on the ground till one is knocked out. Then they sort of jump onto the man's stomach and so on.

*I*: I see. And you find that silly.

*J*: Yes. I don't like that very much. And I have seen, I've seen a film with Hulk Hogan. He was a bit brutal as well, but only a bit. I watched him at grandma's. Yes. And then I think they're all good.

I: You watch more television at grandma's than at home, then?

J: I suppose I do.

I: And who is that? *Power Rangers*?

J: Yes. Actually I wanted to go and see the film at the cinema, but then it was sold out, and then I got a poster from my parents. And I bought that from Limit (magazine for 8- to 12-year-olds, published by Ehapa. ed.). That's *Power Rangers* as well.

I: And what do they do?

J: Well, they fight for what's good, fight monsters and that sort of thing.

I: I see.

J: And they are sort of one-eyed moles.

I: They look funny. Where do they live then?

J: They live high up somewhere, on a huge mountain. But here they are wearing masks. So that's only the suit. Without it they look much better. Yes. And he's just joined them because they needed help, and he, I've forgotten what he's called, their leader, brought him into the territory and gave him a suit and weapons.

I: Did you see that on television?

J: Yes, I often see it on television. Well, that's not coming any more. But I often used to see it on television.

I: Tell me some more about it.

J: Yeah, well, what can I say, well, these two are really dumb, they pretend to be stupid, and then they went to visit the baddies, and then they fought for them, but then they turned stupid again and then they went away. Yes. And that's all I know really.

I: But you like it, don't you?

J: Yes. I look at other series, like *Captain Planet* and...

I: And which series do you like best?

J: Um, well, let me think about that. I like *Power Rangers* best actually. Yes. 'Cos the others are always series with painted, they're all painted. This is real. They're real things, real figures.

I: With proper actors?

J: Yes. I can't say any more about the *Power Rangers* actually, because that's all I know about them.

I: Do you like boxing as well, because there's a boxing poster hanging up there?

J: Hm. Yes. It's not very good, but I like Henry Maske more. I have another poster of him here, but it's lying down there.

I: And in this heroes picture? They aren't just sportsmen, are they?

J: No. Well, these three are sportsmen and those three as well and those aren't, they make films, sort of action films.

I: Do you know a film they take part in?

J: No, not really. Well, I did see a bit of one once. By Arnold Schwarzenegger, but I was only allowed to look at it for a bit. And

otherwise I only have this one here, it's new, but I've known Sylvester Stallone for some time.

*I*: And what do you know where Sylvester Stallone has taken part?

*J*: Well, I only know one *Terminator* film, and I have another by him, I don't know when his birthday is, I have another sort of poster with him on it, and yes, and then I have a small picture of him. And of others as well. Of the *Power Rangers* as well. And of a wrestler as well and...

*I*: So you're fond of Sylvester Stallone?

*J*: Yes. I've got a picture of him too. And of the footballers as well. Yes.

*I*: And why do you like Sylvester Stallone?

*J*: Yes, because, well, I can't really describe it, because he makes good films. Well, better than, er, Arnold Schwarzenegger, because in his films there is always someone dead at the beginning and with him it always takes a bit of time. I've found out from my parents that he made a film and nobody died in it. It was a kind of quiet film.

*I*: But you've never seen one of his films, or have you seen one?

*J*: Hmm (*shaking head*). They're all for children over 12.

*(Interview and research conducted by Anke Piotrowski and Britta Albrecht.)*

Jonas uses the two posters to order and assess films and series. What is astonishing is his statement at the end of this part of the conversation on Stallone and Schwarzenegger, who for him merge into the same type of man and whose films he has never seen. So with the aid of the posters he orders not only his primary film experiences, but also, and in the same thematic context (strong, wild men), the secondary hearsay experiences. Only when asked does he distinguish between primary and secondary experiences ('They're all for children over 12'). The two posters supply him with the metalevel so that he can occupy himself with the media that are presumably thematically relevant for him. He can talk about these media after he has ordered them according to his assessment.

He begins with a genre classification, heroes and *Power Rangers*. The heroes poster lists figures from the area of sport. He formulates straightaway as an introduction that the wrestling stars the Undertakers and Hulk Hogan are problematic in sport ('...and these two are the silliest, they are the Undertakers'; '...Hulk Hogan. He was a bit brutal as well, but only a bit'). For brutal Hulk Hogan, who fits into the genre of sport far better than the weird figure of the Undertaker, he has even looked for somewhere where he is undisturbed and yet safe watching them, at his grandmother's.

Besides the Heroes of the Year there is a poster of the *Power Rangers*, which he obviously prefers. It is true, he does not explain the relationship between the heroes and their sport context and the *Power Rangers*. (Probably it is the fighting, and perhaps also the transformation motif in *Power Rangers* and wrestling.) He does, however, make some distinctions in the case of the *Power Rangers*: cinema and television version, the fight between good and evil as part of the plot, scene of the action, figures and

their clothing. In spite of his detailed knowledge (eg the fantasy area with the huge mountain/the two idiots from that part of everyday adolescent life, the 'normal level' of adolescents' everyday life that belongs to the transformation in the *Power Rangers*), he plays his cards close to his chest when the interviewer wants to hear more. He then corrects the idea that the heroes poster shows not only sportsmen but also a mixture of prominent sportsmen and action actors.

This short excerpt from the conversation only comes about because he has hung up posters to help him to condense primary and secondary media experiences thematically and in doing so to sound out genres for their structure and connections. Out of the posters planned as merchandising products he makes a 'primary medium'[6] for himself with an integration and reflection function that is important for him. He connects the two posters, with nothing in common apart from merchandising, in his subjective, thematic perspective. Hanging up the two posters is certainly also possible from the genre perspective. Personal themes (fighting, men...) plus genre programmes certainly make it advisable to hang both these posters on the wall.

What does Jonas do when he hangs up posters and thinks about them? It is qualitatively certainly something different from media reception. In his room Jonas arranges media like the posters and much else besides, adds his media experiences to them as a reflective performance and in this way mixes for himself a kind of 'text of his own' which he explains in the interview with the help of the objects in his room.

Further on in the interview he reports on, for example, his SuperNintendo and the games he has to play on it. Thus he relates that he vies with older boys on who has the most games. But he also borrows games from them. Then he sits down on his bed-settee and fetches one soft toy after the other that are lying around on his bed. He has, as he says, twenty of them, which he all calls by the name he has given them, with the exception of the lion. Finally he shows a Tyrannosaurus rex which he has begun to build with his father. To do this he has a building kit. But he also has a happy families card game with dinosaurs. It is only the film he has not yet been allowed to see. Part of Jonas's textual arrangement made up of the games, media and leisure-time pursuits are, of course, also his clothes, with which he maybe shows how important sport and also his music style (Michael Jackson or rap) are to him.

So what the media market has to offer children like him he arranges to fit his own room. The room is his form of appropriation and organisation, for both objects and experiences.[7] He allocates them their place, and can then, as with a text, bring out the elements of his media arrangement by way of explanation. In relation to television experiences, the secondary media of the posters are already in the textual form in which they can be lexically called up and evaluated.

## 2. 'Formation of meaning' as the essential dynamics of mass communication

Jonas's bedroom becomes a personal text which is fed out of the symbolic sources of our society and which at the same time also functions as a medium of communication. If this statement is generalised, one arrives at Pierre Bourdieu's (1991) insight into symbolic forms[8] which in a society make possible and structure the social organisation of classes and strata, today new social forms of integration and demarcation. In the logic of symbolic forms our society is beginning to change, increasingly more than with the hitherto familiar mechanisms of political and large-scale industrial measures. Thus culture is given a decisive function, although no longer in the categories of education or advanced civilisation, but in those of everyday aesthetics.

Everyday aesthetics is, so to speak, the generic term or the metalevel which functionally unites the symbolic sources of our society. Gerhard Schulze (1992) has systematically given the reasons for and empirically explained this cultural dynamics in his book *Die Erlebnisgesellschaft* (the experience society). In his context, 'functionally' means: as life-world components (*Lebensweltbausteine*) of subjective arrangements of media, goods and events which may assume, for example, the form of a child's bedroom.

When the relationship between man and the media changes, new models are required to explain it. A concept like that of the formation of meaning (Bedeutungkonstitution) reacts to the novel ways of integration and fragmentation of our society.[9] 'Multimedia' and 'individualisation' are the key terms for this in the on-going public discussion. Thus at present it can be seen that television will lose its function as a leading medium. A look back at cultural history puts this in the right perspective by showing that what is happening to television is what radio and various print media have already survived.

What is the course of this development? In democratic industrial societies those 'things' have gained acceptance that promised individual freedom and helped to bring it about. This is a fundamental part of individualisation, in which people shape their individual lives through the experience of consuming, ie of individually disposing and consuming. That is more than shaping the course of one's personal life. What people have to 'provide' today is the construction of a life-world for which they are individually responsible.[10]

This construction of a life-world takes place in a perspective of egocentric experience,[11] which, in keeping with the trend of economic changes, uses symbolic components. A pair of jeans, for example, defines its practical value not only as an article of clothing, but also as a brand which proclaims thrift or a feeling for quality or association with a style of music. It is in this sense that Jonas uses the space provided by his family to shape his world. In this connection not only do his current life-themes have an essential function in shaping it, but he also turns to members of his

119

family (action films at his grandma's, dinos with his father) and his friends (cinema, probably the *Power Rangers*, and heroes).

That elements of different media by no means have merely an enrichment function is in keeping with the current trend, namely to achieve free disposal in a complex contradictory world. The media, like commercial quarries, supply, so to speak, the symbolic building material to construct an individual life-world. People's essential and individual achievement in shaping it is here the formation of meaning, namely by individually and meaningfully arranging the very varied array offered by the media. There is maybe a wrestling fan sitting in Jonas's class who thinks Hulk Hogan is 'super' or 'sweet'. The Kelly fans, who would love to go sailing into the freedom of the intact family idyll on the Irish houseboat, show the female specialists of *Caught-in-the-Act* (a very successful boy group band at the moment) their demarcation with, for example, the appropriate prints on their T-shirts. What the media, goods and services offer thus become a symbolic building-block that can be linked up.

At this point it would be advisable to argue formally and to use the term medium with limitations. Media in the trend to integrate multimedia have the function of text-like components which then link people up with their textual arrangements. Thus Jonas uses his room not only as a traditional space in a middle-class home, but he also turns it into a text to attach himself to a social relationship; at the same time he takes his bearings from the guidelines offered by the media and consumption. This is a form of reflexivity in order to make sure (in a post-modern way, so to speak) of social guidelines, contradictions and options, which – in his own individual experience perspectives – is actually 'what it is all about'.[12]

## 3. On the way to a new model of mass communication

With the key words 'formation of meaning', 'experience orientation' and 'everyday life aesthetics' a history of the theory of mass communication continues to be written which has found it very difficult to look below the simple surface. It is quite enjoyable to leaf through the theoretical recollections of James Halloran (1990) on the Prix Jeunesse research. Thus the first study in 1965 dealt with 'Television experience patterns in children and juveniles'.[13] It looked at information on television reception by children: What happens in the recipients with the stimuli of television, how do different viewers react to programmes produced for them? This was like the producers' question: 'How do we get the message across?' Only after that was the research question also directed at the programme-makers and 'scrutinised' their 'intentions and assumptions' (Keilhacker 1965, p. 13 f.). In this way the intentionality of a mass communication organised by and with the media was made the focus of attention.

Then the Prix Jeunesse research opened itself up for the complex integration of television into society by asking about the role of television in the socialisation of pre-school children. The viewing behaviour of the

children was not considered in isolation, but in relation to other individuals, groups and sequences. Television was regarded – especially inside the family – as 'one of several connected influences on the development of the child' (Hömberg 1978, p. 14). After that the producers' side of the communication process conveyed by the media was looked at anew: How do the programme-makers see their viewers, their task, their aims? How can they implement their ideas in the broadcasting organisations?

The conceptional development first ran, therefore, over a kind of model of 'influencing' the viewers. It was a matter of measuring the appropriate viewer variables, the aim being also to set up the 'process of influencing' appropriately with regard to the media. Only comparatively late did it become clear that in this way the 'relationship between television and viewer was being taken out of its social context' (Hömberg 1978, p. 25).

Now, at the latest with models of television as a form of social action,[14] the way was also open to a mass communication which, then as now, was beginning to break away from the organisation of mass communication by the media. At that time reception began to guide mass communication.

Today the media are becoming one of many sources of symbols. The charts and audience ratings, hitherto regarded as indispensable on account of their clarity, have in the meantime lost importance as measurements of mass communication, because the 'gravitational poles' of mass communication – media/recipients – have shifted. The reception data are meant to make the pole of 'reception' transparent, since it is the source of the dynamics. To make it clear what is involved here, a model of the formation of meaning that explains this new 'gravitational field' is perhaps quite helpful.

Formation of meaning refers to the central social activity in a culture dominated by the media and consumption. Thus individualised social and cultural activities assume that people individually give their own meanings to media and other sources of symbols. The processes of sensibly shaping the everyday world by the recipients are thus based on individual selection and interpretation of all media or whichever are available or sought after. In the times before television, of course, people in industrial societies in many different ways produced their life-world as their own everyday life and as their own world of interpretation.

The penetration of more and more areas of life by the media and linking media with goods and services by means of advertising is, however, turning, for example, television pictures in all their variants, from film to MTV, into an all-round symbolic building material of the everyday world. This symbolic material is being individually acquired by people, namely

(a) in the perspective of the course of their own lives and subjective themes;
(b) related to the existing or desired social environment;
(c) with the media, related to one another, forming the relevance framework;
(d) in the perspective of what is arranged in the respective text.

This (a) sensible perspective, (b) concrete social and (c) intertextual formation of meaning is only one functional connection in one's own

everyday occurrences which in the 'reflective risk society' (Beck 1986) means in the last analysis building up and maintaining one's own life-world.

With the categories of the formation of meaning and everyday aesthetics it is possible to imagine a 'new' mass communication of a society based on individualisation. On the basis of children's bedrooms, that may look like an academic exaggeration of simple everyday phenomena. But, as in *Alice in Wonderland*, a complex, new, perhaps also – as defined by Huxley – a brave new world is opening up. Here the sociologists are leading the debate. Ulrich Beck's or Tony Giddens's contributions, especially the idea of reflexivity, are very encouraging. In the contradictions of societal structures, in the construction of a life-world for which individual responsibility has to be taken and in enforced fragmentation, there are also new forms of emotional and rational penetration of what is happening around us, with us and caused by us. The children are certainly showing us quite naturally how to do this.

The public debate, with an eye on technological innovation, is using multimedia as a model, and this looks harmless, but only at first sight. If we take a second look something basically new is revealed – a change of major significance. Fragmentation will, among other things, oust television from its key media function. But before that happens, there are several intermediate stages, namely, within the cultural framework of reference of television among the broadcasters and of watching television among the viewers.

## 4. From the contradiction between television and subjectivity to the stylistically integrating scripts

The culturally determined fragmentation, from individualisation to multimedia, goes hand in hand with new forms of integration. Such integration mechanisms are emerging in children's culture. The question is now about which new integration mechanisms can already be discerned and how they will shape the development of children's television.

Ever since Philippe Ariès (1978), at the latest, it has become clear that 'childhood' is not a constant, but something that accordingly arises in the dynamics of a society and its culture. Neil Postman (1983) has drawn his theoretical conclusions from this and maintains that a society dominated by television also creates its own typical picture of childhood. He believes that television with an openness lacking any distance or its talkativeness is depriving children of the protective phase of a sheltered upbringing which is important for them, and is exposing them defencelessly to an adult world.

The relationship between children, their culture and television is certainly more complex and is based on mechanisms different from those of disappearing barriers. The Bremen sociologist Heinz Hengst assumes that both children and television encounter cultural lines of development in their activities. Thus subsequent to the age of enlightenment there is a 'middle-class education and development project' which conflicts with an 'autonomy project' and turns 'against helplessness and dependency' and

122

also against 'the excessive expectations of the middle-class education project' and against the 'childhood constructions determined by the middle-class picture of childhood'. The education project is future-orientated, while the autonomy project is orientated to the present.[15]

The market, or the media market, can side with one or the other 'project', more with the educational task or more with supporting the autonomy and independence of childhood. When Nickelodeon links its logo with 'Give children a voice' it is clearly placing itself on the side of the autonomy project – a thought that would have been unthinkable for the various children's hours from the early days of television.[16] Postman's arguments are, in the last analysis, also based on this education project.

The British research project 'Children's Media Culture' by Buckingham, Jones and Kress (1998) looks at the power of television to define the respective ideas of childhood. The ways in which television people or parents or journalists do this are such familiar categories as broadcasting time, viewing duration etc, although questions are once again asked about their cultural content. The findings promise to be interesting, since here it is a matter of using broadcasting routines, time allotted etc to disclose the basic cultural pattern into which children's television has been embedded from the 1950s until today.

What began relatively simply in the early times of television is meant to become transparent in its cultural logic. Thus the broadcasting time is one of the means of social regulation and a way of defining the concept of 'child'.[17] One of these is how the broadcasts intervene in the mother-child relationship. It was thus clear for the BBC programmes in 1956 that young children watched television at home with their mothers. In 1956 children's television was integrated into the programmes for housewives. Children were part of a kind of women's and mothers' time slot in the family organisation. Thus the BBC was broadcasting *Watch with Mother* from 10.45 to 11.00 a.m. in 1956 – and still doing so in 1966. After it there was a station break during midday. As expected, there is no longer a schedule like the one in 1956. The genres regarded and broadcast as suitable for children are also changing analogously.

In addition to the fundamental ideas of children's subjectivity in the 'education' or in the 'autonomy project' that structures childhood, there is, according to Heinz Hengst, a mediation context (Vermittlungszusammen-hang) that likewise creates structures. Thus media and consumption companies (Konsumunternehmen) take up everyday trends and connect them with their economic intentions. To this end they condense and generalise everyday events to create 'scripts' which the recipients then also adopt together with programmes, merchandising items, suitably styled clothing or settings for plots, for example, for sports equipment.

Of course, children's television, too, is integrated into this mediatory interaction of 'economic strategies and everyday practices'. Their distinguishing feature is the following: 'The media and consumer industries

process sub-cultural scripts to create 'style packages' for a global audience. In doing so they bring out age- and generation-specific aspects which are put into concrete terms and modified by children on a local level in the circle of their peers.'[18] Linking children's culture with sport is typical of this. *Streetball*, for example, is presented as a structure of stylistically integrated body movement, of fashion, sports venues, fan articles and, of course, media as well, from the special interest magazine to the cinema film or advertising.[19]

In this way the script *Streetball* (that is or was basketball without a club and fixed rules) came about in dense conurbations as a game of fast movement and continual negotiating. In Germany Adidas, for example, took up the script and marketed it together with regional sports shops and ARD radio stations. Tens of thousands came to 'Streetball Competitions', but in the meantime it is a sport script that is being phased out.

The scripts will probably not only decide on the success of television stations with children, they also function as an important means of integrating programmes. Thus the two children's channels *Nickelodeon* and *Der Kinderkanal* of ARD and ZDF are almost indistinguishable in their orientation to the 'autonomy project'. Whether *Pippi Langstrumpf* or *Pete & Pete*, they always come out on the side of the children. Probably this fundamental common interest of the two channels also provides the motivation to design changeable logos in a creative way. The logos are only very different at first sight: with the common orientation to the subject model of the 'autonomy project' they not only adopt the creativity of their young viewers, but consistently side with the children as creative television viewers. On the basis of the definition of childhood there is no competition whatsoever between the channels.

In the logic of the mediation model it is, however, clear that marketing arguments generalise this creativity and subject orientation to create viewer bonding. The reception orientation of marketing plus siding with the children's independence and individuality leads not only to a clearly recognisable label, which every kind of fashion advertising needs as well, but with the station logos there also arises a new and amusing minigenre.

There are, however, also stylistically recognisable differences, which mark the various main areas when the children's channels are integrated into scripts. That is somehow connected with whether the grannies are meant to enjoy viewing and the young mothers are given the security of not only being present at the 'autonomy project' but also, looking to the future, of doing something for the 'education project' of their children when they choose to watch a children's channel.

Scripts with an emphasis on creativity or tacit educational philosophies lead beyond that to new genres or favour the repeat of old familiar material. Clubs like the *Tigerenten Club*, lifestyle magazines like *Bravo-TV*, talk- or game-shows arise in the 'mediatory connection' of everyday life, media, goods and event venues, which in the marketing strategy offices are always created with their sales value in mind, and which then result in

condensed scripts whose styles and themes fit in with everyday life. Probably, in addition, programme areas that integrate are an important aid on the part of the programmes to adjust to diverse scripts and thus to everyday patterns typical in their themes and styles.[20]

It can also be foreseen, of course, that the trends in everyday life result in new scripts which from the outset are designed for multimedia. Examples here are *Hugo* on Kabel 1[21] or the Internet projects of RTL2, ARD, ZDF, Nickelodeon, Kinderkanal etc. Because mediatory connections, especially under the risk conditions of the individualisation of everyday life, are only partially calculable with regard to strategy, there is still much movement remaining in the cultural development of children's television.

## References

Aries, P. (1978). *Die Geschichte der Kindheit.* (The history of childhood.) Munich u.a.: Hanser.

Bachmair, B. (1996). *Fernsehkultur: Subjektivität in einer Welt bewegter Bilder.* (Television culture: Subjectivity in a world of moving images.) Opladen: Westdeutscher Verlag.

Beck, U. (1986). *Risikogesellschaft. Auf dem Weg in eine andere Moderne.* Frankfurt a. M.: Suhrkamp.

Bourdieu, P. (1991). *Zur Soziologie der symbolischen Formen.* (Towards a sociology of symbolic forms.) Frankfurt a. M.: Suhrkamp.

Bourdieu, P. (1989). *Die feinen Unterschiede.* (The refined differences.) Frankfurt a. M.: Suhrkamp.

Brown, J., Dykers, C., Steele, J. R., White, A. B. (1994). Teenage Room Culture. Where Media and Identities Intersect. *Communication Research,* 21(6), pp. 813-827.

Buckingham D. , Jones, K., Kress, G. (1999) Children's Media Culture: Education, Entertainment and the Public Sphere. A study of changing assumptions about children as a media audience. Research officers: Hannah Davies, Peter Kelley. Institute of Education, University of London

Deutsche Bischofskonferenz, Zentralstelle Medien (ed) *et al.* (1998). *Debatte Kinderfernsehen. Analyse und Bewertung von TV-Programmen fuer Kinder.* (Debate on children's television. Analsyis and assessment of TV programmes for children.) Berlin: Vistas.

Erlinger, H.-D., Boell, K., Grewenig, S., Hecker, G., Heimes, P., (eds) (1997). *Kinder und der Medienmarkt der 90er Jahre. Aktuelle Trends, Strategien und Perspektiven.* (Children and the media market of the 90s.) Opladen *et al.*: Westdeutscher Verlag.

Erlinger, H.-D., Esser, K., Hollstein, B., Klein, B., Mattusch, U. *et al.* (eds) (1995). *Handbuch des Kinderfernsehens.* (Handbook of children's television.) Konstanz: Ölschläger.

Erlinger, H.-D. (1997). Traditionelle Genres lösen sich auf, Programmflächen entstehen. Paper presented at the working conference 'Kinderfernsehen im Umbruch' (unpublished manuscript). Kassel

Fink, Hans (1997), Interaktive Programme. (unpublished manuscript) 'Kinderfernsehen im Umbruch'. Kassel.

Halloran, J. D. (1990). *A quarter of a century of Prix Jeunesse research.* Munich: Prix Jeunesse Foundation.

Hengst, H. (1997). Erscheinungsformen und Funktionszusammenhänge der aktuellen Kinderkultur'. Paper presented at the working conference 'Kinderfernsehen im Umbruch' (unpublished manuscript). Kassel.

Hengst, H. (1996). Kinder an die Macht! Der Rückzug des Marktes aus dem Erziehungsprojekt der Moderne. (Children to the power.) In H. Zeiher, P. Büchner and J. Zinnecker (eds), *Kinder als Außenseiter? Umbrüche in der gesellschaftlichen Wahrnehmung von Kindern und Kindheit.* Weinheim: Juventa, pp. 117-133.

Hickethier, K.( 1995). Die Anfänge des deutschen Kinderfernsehens und Ilse Obrigs Kinderstunde. In H.-D. Erlinger *et al.* (eds): *Handbuch des Kinderfernsehens.* Konstanz: Ölschläger, pp. 129-141.

Hömberg, E. (1978). *Vorschulkinder und Fernsehen. Empirische Untersuchungen in drei Ländern.* (Preschool children and television.) Munich: Saur.

Jacobi, R. and Janowski, H.N. (1998). Programmbericht des Runden Tisches 'Qualitätsfernsehen für Kinder'. (Report on the round table meeting 'Children's television in transformation') In *Deutsche Bischofskonferenz, Zentralstelle Medien* (ed) Debatte Kinderfernsehen. Berlin: Vistas, pp.13-18.

Keilhacker, M. and Vogg, G. (1964). Television experience patterns in children and juveniles – illustrated by the prize-winning programmes of the Prix Jeunesse 1964. Research report. Munich: IZI. (Schriftenreihe des IZI, Heft 1.).

Kress, G. (1997). How does television constitute childhood? Paper presented at the working conference 'Kinderfernsehen im Umbruch' (unpublished manuscript). Kassel.

Moss, G. (1996). Wie Jungen mit Wrestling umgehen. (How boy deal with wrestling.) In B. Bachmair and G. Kress (eds), *Höllen-Inszenierung Wrestling. Beiträge zur pädagogischen Genre-Forschung.* Opladen: Leske and Budrich, pp. 161-184.

Postman, N. (1983). *Das Verschwinden der Kindheit.* (The Disappearance of Childhood.) Frankfurt a. M.: S. Fischer.

Schulze, G. (1992). *Die Erlebnisgesellschaft. Kultursoziologie der Gegenwart.* (The Experience Society.) Frankfurt a. M.: Campus.

Schütz, A. (1974). *Der sinnhafte Aufbau der sozialen Welt. Eine Einleitung in die verstehende Soziologie.* Frankfurt a. M.: Suhrkamp (Original English version 1932).

Steele, J. R. and Brown, J. D.(1995). Adolescent Room Culture. Studying Media in the Context of Everyday Life. *Journal of Youth and Adolescence,* 24(5), pp. 551-576.

Teichert, W. (1972). 'Fernsehen' als soziales Handeln. Zur Situation der Rezipientenforschung: Ansätze und Kritik. (Television as social action.) *Rundfunk und Fernsehen,* 20(4), pp. 421-439.

Teichert, W. (1973). Entwürfe und Modelle zur dialogischen Kommunikation zwischen Publikum und Massenmedien. *Rundfunk und Fernsehen,* 21(4), pp. 356-382.

## Notes

1   The German version of this article appeared in *TelevIZIon* 10/1997/2, pp. 13-19.

2   Cf. the so-called 'Kölner Thesen zum Kinderfernsehen' (Cologne theses on children's television) in Jacobi and Janowski 1998, p. 17.; Deutsche Bischofskonferenz 1998.

3   'Kinderfernsehen im Umbruch I' (Children' television in transformation.), Workshop on June 27-28. 1997; organised by Universität Gesamthochschule Kassel; Internationales Zentralinstitut für das Jugend- und Bildungsfernsehen (IZI), Hessische Landesanstalt für Privaten Rundfunk (LPR Hessen), Chairmen: Ben Bachmair, Paul Löhr.

4   Cf. Erlinger 1997, pp. 13 ff. and pp.101 ff.; Bachmair 1996.

5   Cf. Bachmair 1997.
6   Cf. Moss 1996.
7   Cf. Brown *et al.* 1994; Steele and Brown 1995.
8   Cf. Bourdieu 1989, 1991.
9   Cf. Bachmair 1996, p. 16.
10  Cf. Schütz 1974.
11  Cf. Schulze 1992.
12  Cf. Beck 1986.
13  Cf. Keilhacker 1965.
14  Cf. Teichert 1973, 1974.
15  Cf. Hengst 1996.
16  Cf. Hickthier 1995.
17  Cf. Kress 1997.
18  Cf. Hengst 1997, p 4.
19  Cf. Bachmair 1996.
20  Cf. Erlinger 1996.
21  Cf. Fink 1997.

# 3: Internet and Multimedia

# Taking off for the virtual world[1]

## Jo Groebel

When one day many children can click themselves into the virtual world, it could mean that their identity and integrity are at jeopardy. In this new environment everyday realities are done away with. New worlds are emerging. Passing from Philip's simple 'Newtopia' for video-text users to the digital cities in Internet on to the highly sophisticated and imaginative Kymer Land of the software entrepreneur 'Worlds Away', one can cross every border and leave the old atlas on the bookshelf. What most entertainment and 'edutainment' offers have in common is that they start out from a simulation of the known world, where one takes part in a game as an individual with one's old identity, goes shopping, meets other people – everything in an electronic ambience 'reconstructed' from the physical environment.

But more and more new architectures and new languages are being developed in the multimedia systems, similar to the way film became a cultural form in its own right with D. W. Griffith. This time, however, the consequences could be even more far-reaching: one's own person as an active participant will be constructable. In Internet the textual self-portrayal allows the attribution of any qualities one wishes: in the more sophisticated virtual reality systems one can equip oneself with a new outer appearance. The often quoted intelligent 'agents' in the digital network become almost perfect deputies, a 'second ego' one can tell one's wishes to, which it then proceeds to fulfil: for example, selecting articles from the newspaper, communicating with other people at deferred time intervals.

What seems to be utopia has already come about: at a virtual reality workshop I saw the digital 'customer' who appeared in human form, who autonomously carried out quite intelligent negotiations with a similar-looking digital 'salesperson' about the benefits, disadvantages and the price of a product and who 'purchased' it for its main character... automated, mind you. Although this development may seem very utopian, frightening or even promising to some people, the most important question at the end of the day is still which function these technical opportunities offer the user, for it is he or she who decides what to do with them and what not. Consequently, the discussion on the possible risks cannot be directed at the

technology itself but must focus on the contents and the forms in which it is used. The recently reported case in the Netherlands of an 'Internet addict' is not a criticism of the system, but suggests that in this case someone obviously suffered deprivation in his physical environment.

## Children and young people

The previously mentioned development of personal identity is a critical area in this context, particularly for children and young people. So far we have assumed that the role is developed by direct social comparison, in the family, by the observation of others, also by genetic predisposition; in any event the degree of freedom left for taking personal decisions seems to be limited in this case.

The increase in space and social mobility has already brought about many changes, but fixing identity at the click of a mouse could entail much greater repercussions: an ego constructed to produce the super hero of one's wishes, or an existence as a spoilt princess become so realistic that any awareness of the fictive component recedes into the background.

Naturally, fairy tales and adventure stories also supply identification opportunities, but the new technologies are able to construct a 'perfect' environment right down to touching it (by means of electronic 'touch gloves'), in which it is just as possible to wander around as in the spatial environment. Problems could arise

- in the lack of competitiveness between the 'real' role models of real social comparison;
- in the isolation of and withdrawal from the immediate environment;
- in the lack of structure and continuity of only situational identities;
- in the emergence of 'digipathy', a world of its own devoid of ethical orientational standards.

In contrast, some new positive opportunities emerge:

- creative experimentation of identity, empathic role games;
- the transformation from the role of a passive consumer to that of an active co-producer of a new environment, ie a 'prosumer';
- the globalisation and democratisation of communication and of the search for information in identity development;
- the emergence of new forms of art and culture.

But it will be possible to lower the risks and to promote the opportunities involved if the relationship with the spatial and social environment is maintained – not least by school and the traditional mass media, which continue to play an important role – and if a 'real' exchange of experience and social comparison can take place. And of course media competence must be developed further and be put into practice at last – not as a discussion by a panel of experts or as the theme of a seminar or congress.

The development of identity is however not the only multimedia aspect that is important for the younger generation. In Utrecht we are endeavouring to describe the future for other subjects, not from the

132

technology standpoint but on the basis of the psychological and social processes involved. To avoid fumbling around in futurological fog, we wish to define a few fundamental dimensions associated with known behaviour and thought patterns but which open the eyes for future developments. Besides identity the following should be briefly mentioned:

## Intensification

The often quoted knowledge gap is just one example to show that the increasing number of technological opportunities for the individual user create more and more options: individual interests and needs can be more perfectly addressed and catered for. In this way homogeneous digital groups are created across the globe, social distances in the concrete neighbourhood grow. Furthermore, the speed and intensity of sensory impressions continue to increase.

## Involvement

In order to actually access people via the media – with regard to more competition, more individual design – the pressure is growing to find stimuli capable of arousing attentiveness. Media messages often end up in mere 'atmospherics'. But once the user has been successfully addressed, the interaction can develop into a 'relationship' by means of 'involvement'. This process is also promoted by the fact that structures and signposts are sought in the jungle of multimedia stimuli: involvement and 'confidence' figures from classical media have a function to fulfil here. Just as Donald Duck advanced from cartoon status to the television screen, the 'Mouse' – already available on CD-ROM – will also probably feature in 3-D space.

## Integrity

The integrity of the information could prove to be the real challenge. How dependable, how reliable is the information digitally transmitted to us, bearing in mind that we have no opportunity to verify its sources? Which authorities are responsible for giving us complete, comprehensive information? Not the imposition of bans, but the promotion of respectable information authorities recognised by all will be one of the most important tasks for society and politics.

In total, both new and old media varieties will form the future. Whether in the commercial sector, in the form of universal services or as public-service broadcasting, the suppliers will (have to) join in this development: the need for orientation and structure is sufficiently large to grant adequate space to familiar and well-established genres of classical children's and young people's TV and radio – in a new guise.

## Note

1    The German version of this article appeared in *TelevIZIon* 9/1996/1, pp. 38-39.

# Children on the Internet[1]

*Tobias Gehle*

Storm, a girl only 12 years of age, already owns three houses. Exotic pets jump around there, across tables and sofas: a cuddly toy frog named Jasper and Callie the cat, who prefers to be called by her name and gets grumpy when simply called 'cat'. Storm has also got a friend: Rachel, who is 13. She even has her own castle, which she keeps on filling with new pieces of furniture. Storm and Rachel are just two average American girls. They romp and roll in cyberspace, their possessions are virtual, their home is *'MOOSE Crossing'*, a fun world built from bits and bytes. What sounds like an absurd prophecy of some distant future is already the reality of 1998: kids meet other kids in simulations of the real world on the Internet.

But can Internet in Germany already be taken seriously as a medium for children? Online media seem still to play a minor role in 6- to 13-year-olds' free-time. Let us look at the findings of media research.

**Where are the children?**

Media scientists have not yet examined the young surfer generation's connectivity and user profiles in depth. Although the first surveys revealed certain trends, a commercial study, conducted in spring 1998 by three major publishing houses, shows that in Germany less than one percent of all children aged 6- to 13 use the Internet (KidsVerbraucherAnalyse 1998). The connectivity is extremely low among primary school children. Only 0.3 per cent of the kids younger than 11 use online media. In the 11- to 13-age group two per cent are on-line.

At school, pupils seldom have any contact with the Net. Online activity is often restricted to the older pupils. At home only a few children can avail themselves of a computer connected to the Internet, the reason being that in Germany online media are most frequently used for professional purposes (Eimeren, Oehmichen and Schröter 1997). On the other hand, only a little over one quarter of grown-ups and adolescents over the age of 13 who have an Internet connection at home and who use Internet for the reasons of private pleasure, live in households with children under the age of 14 (Typologie der Wünsche Intermedia 1998).

A regional survey carried out by the *Medienpädagogischer Forschungsverbund Südwest* with 800 children and young people between the age of 12

and 17 shows: the largest section of child and adolescent users are aged between 14 and 16; 11 per cent of 12- to 13-year-olds are 'connected', which at first sight seems to be a rather high proportion (Feierabend and Klingler 1997). But these results are put into a different perspective once the question as to the frequency of Internet use is asked: only half of the 'on-liners' are regularly out and about on the Internet (at least once a week). Gender-specific differences are marginal. Kids use the Internet most for sending electronic messages (e-mails), for listening to sound and video files, for chatting and playing on the Net. The authors would like to point out, however, that very few children regularly use the applications referred to above (Feierabend and Klingler, 1997,p. 23 f.).

An online survey, conducted at the University of Dortmund, including 301 respondents aged 6 to 13, confirms that children younger than 11 are rarely on the Net.[2] It also points out that boys by no means use online media more frequently than girls. Quite the opposite is the case: there were more female than male respondents, girls going online slightly more regularly than boys. About one quarter of the children go out onto the data highway almost every day, one third once or twice a week. One child in two usually goes online at home, only three in ten at school.

These results are based on an online questionaire filled in by the children on the WWW. As the children voluntary participated in the survey and the sample was not recruited actively, the empirical findings cannot be regarded as representative (Batinic and Bosnjak 1997; Schmidt 1997).

Most children are familiar with visual online content, which can be found in the World Wide Web: graphics, photos and video-clips. Two thirds of the respondents had already sent an e-mail, before filling in the online questionnaire, 60 per cent had listened to music or sound files. Just over half had read stories and news on the Net, fewer than one child in two was experienced in chatting and only two in five had played online games. When asked to rate the different services and contents of the Internet, children awarded the highest marks to communicative services such as e-mail and Internet Relay Chat (IRC).

### German-language online services for children

What can cyberkids expect when going for a trip down the data highway? First, apparently the range of German-language on-line services, specially adapted to the target group of 6- to 13-year-olds, is still rather feeble compared to the mass of English online services (Aufenanger 1997; Schumacher 1997). But there's something brewing in the digital jungle: three years ago it was possible to count the non-commercial offers on four hands – excluding educational sites. As of November 1998 *Blinde Kuh*, the only search engine for German-language children's pages in the Net, alone registers more than 1000 addresses.[3]

Most Internet offers directed at the target group of 6- to 13-year-olds are located on the World Wide Web. The graphic design of the pages is fair

to middling. Some pages are designed with great care, others consist of heaps and heaps of text. Many pages are in content terms rather poor, quite a few only consist of links to other children's pages, which also contain only links. Ambitious multimedia forms of presentation such as audio and video recordings are few and far between; but there are some interesting projects here and there. Most pages for children are the result of private initiatives. The number of homepages of public institutions, private organisations and agencies is constantly on the increase, however. The commercial sector is still quite feeble.

In the following section I would like to classify systematically the German-language variety of offers for children on the Internet. Besides the World Wide Web I have included applications such as Internet Relay Chat and newsgroups. I am only interested here in offers designed specially for children, which do not pursue any commercial goals and which have not been set up primarily for educational use at or for school. The aim of this compilation is not to provide a complete description of the most important offers – this would be obsolete very soon. It is rather my intention to illustrate the various ways children can use the Internet in their free-time. I include English-language services when a corresponding German-language offer does not (yet) exist.

### The Internet – market-place for contact opportunities

Internet's appeal lies in its directness. At breakneck speed messages can be dispatched from one end of the world to the other. Children can communicate or even celebrate virtual parties, either in real or at deferred time. The most popular form of real-time discussion is Internet Relay Chat. Via a special programme the users call up an IRC server, where they – as in the case of CB radio – can meet people on various channels. Those who want to can open up their own chat room, fence it off from uninvited guests and have a private chat with one or several friends.

The non-profitmaking American organisation *Kidsworld* maintains several IRC servers, reserved for kids and young people under 17. The honorary personnel of *Kidsworld* make sure that no adults creep in.[4]

The installation and configuration of the chat software (client) requires considerable time and effort, however. This explains why more and more suppliers are switching to the direct installation of chats on their Internet pages, using small java software programmes. Chats of this kind can be found on the pages of the *Schulweb* (schools' web)[5], in the *Schulnet* (schools' net) of Langenscheidt publishers,[6] in *Kindernetz*,[7] (the kids' net) offered by the German broadcasting company Südwestrundfunk (SWR), and on the homepage of *Fun Online*.[8]

### MUDs

The virtual worlds initially referred to constitute a sophisticated variant of real-time contact on the Net; in their simplest form they consist solely of

words: MUDs (multi-user dungeons). All communication takes place on the level of pure text; areas are described with brief sentences and demand a high degree of abstraction on the part of the 'muddie'.

In the final analysis, MUDs are nothing but huge computer programmes, usually running on university computers, which users call up by means of special software via Internet. Those promenading through these worlds of words sometimes live thousands of miles apart. Originally MUDs were on-line adventure games, where the participants, synchronically with other players from all over the globe, used to defeat repulsive fabulous creatures, fight their way through worlds of fantasy, having to collect experience points in order to climb up the player hierarchy to the level of a wizard. In the original MUDs – which still comprise the majority today – the wizards have the exclusive right to open up new areas and to re-programme the world.

There is one difference between this and 'MOOSE Crossing',[9] a textual on-line world for children in English language, initiated by Amy Susan Bruckman in 1995, then a member of staff at Massachusetts Institute of Technology (MIT), and now working at the Georgia Institute of Technology. 'MOOSE Crossing' is a MOO (an object-oriented MUD), allowing all the logged-in participants to create objects such as virtual pets, swimming pools or underground tunnels (Bruckman 1997; Schindler 1997). By september 1998 about 300 children, mostly between 7 and 12, had undertaken an expedition into this world and were extremely creative on the way.

Bruckman sees 'MOOSE Crossing' as an interactive learning environment, where children co-operating with other children can learn basic programming knowledge and train reading and writing skills. The research scientist spent many months observing several children during their expeditions into MUD and her conclusion is that 'MOOSE Crossing' is a virtual meeting place where social interactions take place that are similar to 'real life'. Bruckman developed a simple programme language for 'MOOSE Crossing', which is based on colloquial English and tolerates many formal errors. And yet the textual navigation through MUD is too demanding for many children who have no knowledge of programming.

Three-dimensional visual worlds in the WWW are easier to cross – the user clicking arrows at the bottom of the screen. One example: 3DimenCity, a German-language virtual leisure-time landscape, where kids can meet kids, discover places, move into their own cyber-apartment and seek advice for their problems from their peers and even professional advisers (Huchler and Zinser 1997). 3DimenCity uses forward-looking VRML technology (Virtual Reality Markup Language). Presently this service is not yet completely set up. There are, however, some sectors of the *Kinder-und-Jugend-Fun-Stadt* (children's and young people's fun city) that can already be visited.[10]

137

## E-mail

Electronic mail is one of the most intensively used applications in Internet. This form of communication offers children the opportunity to maintain long-distance penfriend relationships – without any mail delivery intervals. The children's service offered by *EXPO 2000* is a useful assistant in the search for 'keypals'.[11] On the 'mail worm' page children can fill in an onine form, where they say something about themselves and their hobbies. All they need to do is to enter their e-mail address, to click a button, and their news appears on a list that can be read by all Internet users.

Children can also find contacts via so-called mailing lists and discuss a whole variety of topics. Mailing lists are electronic distributor lists. Anyone wanting to take part e-mails a command to the administration address of the mailing list in order to join the address list. When someone subsequently writes to the list, their message lands in the electronic mailbox of all the participants. A large number of such mailing lists for 10- to 15-year-olds is administered by the non-profitmaking, international organisation *Kidlink*,[12] which also includes a German-language Kids' Café. *Kidlink* establishes contacts between school classes from all over the world and gives them useful support in the implementation of their projects (Gehle 1997).

Another German mailing list for kids is *Kinderpost*, set up in spring 1998.[13] The list is moderated: the owners go through every single message before forwarding it to the participants. In November 1998 over 130 children were registered at *Kinderpost*, sending up to 50 e-mails a day.

Another opportunity for on-line discussion is offered by news groups. Here the participants do not have to enter their names on an address list, but can access directly via a news reader.[14] Special German-speaking news groups for kids are still the exception rather than the rule: *schule.schueler.forum*, *schule.schueler.schwatz* and *schule.schueler.kontakte* are three examples. Children younger than 10 seldom participate in the discussions, however. Most of the messages are mailed by older kids and teenagers.

Open and subject-related forums of this kind can also be found on the World Wide Web. The kids' net *Kindernetz*[15] and *Fun Online* offer a large number of notice-boards dealing with various topics.

## The child as a publisher

The example of SWR's *Kindernetz* shows that the young surfer generation particularly appreciates online services in which they can participate themselves. At Südwestrundfunk kids have their homepage in the WWW, where they can describe their hobbies and receive feedback from peers who have similar interests. The editorial office of the kids' net is literally swamped with mail. In September 1998 more than 6,000 children had their own virtual home. The average age was 13; one child in five was between 7 and 9, almost half between 10 and 12.

Another form of participation is offered by 'join-in' projects. There are countless homepages, where kids can publish their own short stories,

poems, paintings and sounds. One example is *Pixelkids*, where cock-and-bull stories and children's pictures can be found.[16] This homepage was installed upon the initiative of a small agency, and ranks as one of the best designed German-language children's pages on the Net. Another site where children can publish their writings and pictures is *Netzmatz*.[17] And on the German homepage of *CHILIAS*, a project sponsored by the European Commission and connecting children's libraries from six european countries, children can tell stories, including pictures from a virtual gallery.[18]

### Reading material in bits and bytes

The World Wide Web is by no means a mass of visual material for illiterate computer freaks. This is borne out, for example, by the exceptionally wide variety of German children's literature on the Net. Fears that the fairy godmother in cyberspace could replace the good, old book are probably groundless. Studies from the USA show that in multimedia offers children circumnavigate long texts on the screen and steer a course for visuals and sound (Oliver and Perlyzo 1992). And yet most German literature pages for young readers in the Web present themselves in the form of pure piles of text. The classic example is the fairy-tale library, which has an incredible variety but absolutely no illustrations.[19]

The most that many homepages featuring German children's stories include is static pictures, as in the case of the *Zauberer von Oz* (The Wizard of Oz), retold and illustrated by children attending primary school.[20] Interaction for the reader is restricted here to simply turning the pages. The graphic designer and children's book author Ika Bremer goes one step further and adds brief texts to the picture fairy-tales on her homepage, giving the children the opportunity to decide for themselves the way the stories continue.[21] One can search in vain for German stories with integrated video sequences, and stories for listening to are also rare. Wilhelm Busch's tale *Hans Huckebein* is certainly worth a mention; it can be found on the homepage of the German Language Institute of an American University.[22] Here children can listen to a recital of individual verses.

Reviews of children's literature can also be found at various places on the Net, many of them on publisher's pages. There are a few third party virtual libraries too – on the homepage of the *Kinderkurier*[23] for instance, the children's edition of an Austrian newspaper, or at the site of *LILIPUZ*[24], a children's radio programme of the broadcasting company Westdeutscher Rundfunk (WDR).

### News for kids

Up-to-date information on society events is rarely specially adapted for children on the Net. Today there are only a few German language news services and online magazines for children. One of them is *Sowieso*, a weekly updated online newspaper, which also includes a discussion

group.[25] This service is hosted by a small public relations agency in Berlin. *GEO lino* is a professionally designed nature and science magazine published every other month.[26] It contains reportages, connected via hyperlinks to other sites on the Net, where children can find other information. *Fun Online* offers a lifestyle magazine, reporting about topics like skating, dinosaurs and computer games. And *LILIPUZ* serves the online clicker the bulletins of the day.

## Virtual playground

The simplest online games are small Java programmes operated on a WWW page – simple positioning exercises and games of skill à la *Tetris* and *Vier gewinnt* (Four Wins). During these games the computer is connected with the Internet all the time (which results in rather high telephone charges!). Services of this kind are found, for example, on the *Pixelkids* homepage, and that of the *EXPO 2000*. Other addresses on the Net offer small shareware programmes that can be downloaded and played off-line, eg Jutta Behling's private homepage.[27] On then Internet some software companies also offer the trial version of their products in order to whet the appetite for the pricier complete version.

E-mail games are popular because of their cheapness and occasionally their complexity. They work according to the principle of letter-post games: the game leader sends instructions, and all the participants respond with written directions for the next move. Most of them are only suitable for older children, however, because of their complexity. A list of e-mail-games can be found in the *PBeM* database.[28]

Strategy games on the Net are frequently based on simple Hypertext Markup Language (HTML), the basic language of the World Wide Web. The players, who may come from different countries, enter their game instructions on forms, as in the case of the car race simulation *F1Live*.[29]

Particularly attractive are network games such as *Warcraft 2* and *Duke Nukem 3D* (Fehr and Fritz 1997). Here game scenarios are downloaded from a CD-ROM, so that graphics, sound and video sequences achieve a quality unmatched by most customary on-line presentations.[30] These games can also be hooked up to the Internet to enable several players from different locations to play against each other simultaneously. The other players are usually represented as graphic figures, with whom it is possible in some games to communicate in real time via a chat function. Fehr and Fritz conclude:

> According to present research findings the fascination for playing games is generally increasing. The human opponent is always more appealing than the computer. (...) playing together on the screen, which frequently means human co-operation in the process of solving problems, becomes a relic of the past when a data helmet is donned. (Fehr and Fritz 1997, p. 81)

## Service and leisure-time tips

Do-It-Yourself instructions, tips for calendar events and information on current television programmes – the range of online services for children is large. This does not mean that they are always up-to-date, best illustrated by the tips for a number of calendar events. One exception is the *Nix wie hin!* tips provided by the *LILIPUZ* editorial office at the WDR in Cologne, where events in North Rhine-Westphalia are announced every week.

Timeless tips for outings are usually geared to the regional clientele, eg the *Pänz Pages* (kids pages) by Köln Digital. Here children are told which playing grounds, bathing lakes and open-air swimming pools there are in the Rhine metropolis, Cologne.[31]

Children can discover tips on recommendable computer programmes at various addresses in the Net. Reviews can be found, for example, on Sylvie Jansen's private home page,[32] which also offers pictures that can be downloaded and painted. For television fans the magazine *TV Today* offers a review of all current children's programmes.[33] The youth magazine *YPS* invites the children to hunt for bargains on their virtual secondhand market.[34] And at the *Kinderinfo*-site children find a school holiday timetable for entire Germany and 'child-friendly' rules of the house for printing out and pinning up in the hallway.[35]

## Library of factual knowledge

Children thirsty for knowledge also get their money's worth, on the whole, on the Internet. Sites providing factual knowledge are, however, often not expressly conceived for children. But here exceptions prove the rule.

Information on animals is one of the main features on facts pages for children. The private homepage *Animal Links* is an infinite source of material offering many links where children can go to visit animal homes or obtain information on animal-protection organisations in Germany.[36] A visit to the virtual *ZOO* promises no end of interesting facts about native and exotic animals. Starting out from a central page children can wander through many German and international zoos.[37] And if they want to know all about wolves, they can visit *Thoddy's Wolf-Site*,[38] an ambitious homepage set up by a graphic designer as a private initiative.

Computer knowledge is presented only on a few pages for kids. Two examples: the homepage of the *Dettmer*[39] publishing house, where children can go for a stroll through the interior of a computer, and that of the *Pixelkids*, where they can learn the basic rules of the Hypertext Markup Language (HTML), the computer language for programming sites on the World Wide Web.

A particularly sophisticated English-language service, unparalleled in the German-language sphere, deserves a special mention: at *Volcano World*[40] children can watch videos of volcanic eruptions, ask vulcanologists all types of questions and, on an extra children's page, take part in a quiz on eruptions, lava and magma.

**Institutions and Associations on the Net**

Public and private institutions and associations in Germany are really mean about providing information specially adapted for children. One exception is the human rights organisations and institutions fighting for children's rights. The *Kinderhilfwerk* for instance provides two sites for children and teenagers, where they find information about children's rights, such as the UN Convention for Children's Rights, and addresses of organisations dealing with children's matters. The staff of *Kinderhilfwerk* also invite children to join them in the fight for an online world which takes into account children's interests.[41] *Terre des hommes* has a well-designed virtual kids space, too, informing children about what can do to make grown-ups respect their needs.[42]

UNICEF's *Voices of Youth* homepage is unfortunately only available in English, Spanish and French. It provides information on child labour, discrimination against girls, and child suffering in regions of war. What is more, kids can say what they think about the respective topics in a public forum.[43]

Environmental protection organisations are also quite active. *Greenpeace* has its own children's page providing information on the 'Green teams', online versions of children's brochures, a pinboard where children can contact each other and get current news on the environment.[44] The *Fritz-Kids-Umwelt-Club* (Fritz Kids Environment Club) in Bonn is represented with a similarly extensive range of services in the Web. Here children can look at a dinosaur collection book or comics and obtain information about how to celebrate a child's birthday without creating a lot of waste.[45]

Political organisations are conspicuous by their virtual absence. The political parties ignore their future voters. The German Bundesrat is the only political institution to have set up a site for kids: *Politix*.[46] Here children can learn about how legislation works in Germany.

**Conclusion**

Online media such as the Internet harbour tremendous opportunities and can enrich children's everyday media use. Does this mean serious competition for the classical media such as television, radio and video games? At the moment the Internet – at least in Germany – is (still) too chaotic, expensive and its contents too imperfect. But the success of services such as the *Kindernetz* of the Südwestrundfunk proves that there are quite a few kids out there who make use of the new medium to satisfy their own individual needs and who are eager to participate in what is happening on the data highway.

The role that the Internet plays now and will play in the future in the kids' media programme is – still – the subject of considerable speculation in Germany. Representative research findings are unavailable to date, implying a task that is just as important as it is attractive for media science.[47]

# References

Aufenanger, S. (1997). *Internet-Angebote für Kinder. Ein Streifzug durchs World Wide Web.* (Internet services for children. An excursion through the World Wide Web.) *medien praktisch,* 21(3), pp. 22-24.

Batinic, B. and Bosnjak, M. (1997). Fragebogenuntersuchungen im Internet. (Questionnaire surveys in Internet). In B. Batinic, (ed) *Internet für Psychologen.* Göttingen, pp. 221-243.

Bruckman, S.A. (1997). *MOOSE Crossing. Construction, community, and learning in a networked virtual world for kids.* Cambridge. Available on the Internet: *http://www.cc.gatech.edu/fac/Amy.Bruckman/thesis/.*

Bußmann, I. (1997). CHILIAS. Die europäische virtuelle Kinderbibliothek der Zukunft. (The European children's virtual library of the future.) *medien praktisch,* 21 (3), pp. 19-20.

Eimeren, B. van, Oehmichen, E. and Schröter, C. (1997). ARD-Online-Studie 1997: Onlinenutzung in Deutschland. Nutzung und Bewertung der Onlineangebote von Radio- und Fernsehsendern. (ARD on-line study 1997: on-line use in Germany. Use and evaluation of radio and TV broadcasters' on-line services.) *Media Perspektiven,* (10), pp. 548-557.

Fehr, W. and Fritz, J. (1997). Zur Faszinationskraft von Netzwerkspielen am Beispiel von Warcraft 2 und Duke Nukem 3D. (The fascination of network games, eg Warcraft 2 and Duke Nukem 3D.) In *Gesellschaft für Medienpädagogik und Kommunikationskultur: GMK-Rundbrief: Netzwärts – Multimedia und Internet. Neue Perspektiven für Kinder und Jugendliche.* Bielefeld, pp. 76-81.

Feierabend, S. and Klingler, W. (1997). *Jugendliche und Multimedia.* (Young people and multimedia) Report on the findings of a study commissioned by the Medienpädagogischer Forschungsverbund Südwest (Documentation – vol. 6). Baden-Baden.

Gehle, T. (1997). Der direkte Draht zwischen Kindern aus aller Welt. *Kidlink:* Online-Netzwerk für die Jüngsten. (The direct line between kids from all over the world. *Kidlink:* the on-line network for the youngest ones.) *Kölnische Rundschau of 17.6.1997.*

Gehle, T. (1998). Kinder auf Draht. Internetangebote für Kinder und Jugendliche. (Kids on a wire. Internet services for kids and young people.) *c't,* (20), pp. 88-93.

Huchler, M. and Zinser, S. (1997). 3DimenCity – Die Kinder und Jugend Fun-Stadt. (3DimenCity – the kids' and young people's fun city.) In *Gesellschaft für Medienpädagogik und Kommunikationskultur: GMK-Rundbrief: Netzwärts – Multimedia und Internet. Neue Perspektiven für Kinder und Jugendliche.* Bielefeld, pp. 36-39.

*KidsVerbraucherAnalyse 1998 (KidsVA 98).* (Kids' consumer analysis 1998) Bergisch-Gladbach/Hamburg: Bastei-Verlag, Axel Springer Verlag and Verlagsgruppe Bauer.

Oliver, R. and Perlyzo, L. (1992). An Investigation on Children's Use of a Multimedia CD-ROM Product for Information Retrieval. *Microcomputers for Information Management,* -(4), pp. 225-239.

Schindler, F. (1997). Cyberspace selbst gestalten. Virtual Worlds für Kinder. (Designing your own cyberspace. Virtual worlds for kids.) *medien praktisch,* 21(3), pp. 25-29.

Schmidt, W.C. (1997). World Wide Web Survey Research: Benefits, Potential Problems, and Solutions. *Behaviour Research Methods, Instruments & Computers,* (29), pp. 274-279.

Schumacher, B. (1997). *Multimedia-Anwendungen für Kinder und Jugendliche im Internet*. (Multimedia applications for children and young people in Internet.) Diplomarbeit im Studiengang Öffentliche Bibliotheken bei der Fachhochschule Stuttgart – Hochschule für Bibliotheks und Informationswesen. Stuttgart.

Tuominen, K. (1996). *CHILIAS. Children in Libraries: improving multimedia virtual library access and information skills. User need analysis*. Helsinki.

*Typologie der Wünsche Intermedia 98/99*. (Typology of wishes Intermedia 98/99) The data material can be analysed through a WWW interface at *http://www.tdwi.com*.

Weiler, S. (1997). Mit dem Computer durch die Kindheit. (Through childhood with the computer.) In P. Ludes and A. Werner, *Multimedia-Kommunikation. Theorien, Trends und Praxis*. Opladen: Westdeutscher Verlag, pp. 141-170.

## Notes

1  Original German version in *TelevIZIon* 10/1997/2, pp. 22-27.

2  More infomation about this survey can be found in the World Wide Web: *http://pweb.uunet.de/pr-gehle.do/kinder/* and *http://www.geocities.com/~tobias-gehle/kinder/*

3  *http://www.blinde-kuh.de*

4  *http://www.kidsworld.org*

5  *http://www.schulweb.de*

6  *http://www.langenscheidt.de/schulnet/schulnet.htm*

7  *http://www.kindernetz.de*

8  *http://www.funonline.de*

9  *http://www.cc.gatech.edu/fac/Amy.Bruckman/moose-crossing/*

10  *http://www.3DimenCity.de*

11  *http://www.expo2000.de/deutsch/kinderexpo/index.html*

12  *http://www.kidlink.org*

13  *http://minerva.sozialwiss.uni-hamburg.de/kinderpost/ml/*

14  The newsreader is usually included in the contents of the browser delivery such as Netscape Navigator or Microsoft Internet Explorer.

15  *http://www.kindernetz.de*

16  *http://www.pixelkids.de*

17  *http://members.aol.com/netzmatz/*

18  *http://www.stuttgart.de/chilias/*

19  *http://gutenberg.aol.de/maerchen/0maerch.htm*

20  *http://ourworld.compuserve.com/homepages/J_Behling/oz/index.htm*

21  *http://www.ika.com/maerchen/*

22  *http://www.fln.vcu.edu/Huckebein/h1aiff.html*

23  *http://www.kiku.at*

24  *http://www.wdr.de/radio/radio5/lilipuz/*

25  *http://www.sowieso.de*

26  *http://www.geo.de/magazin/geolino/*

27  *http://www.abc-ware.de/*

28  *http://webxxx.schlund.de/pbembase/*

29  *http://f1live.com/*

30  Trial versions of commercial network games and freeware programmes can be found at *http://www.mpogd.com/*

31  *http://www.koeln-digital.de/paenz/index.htm*

32  *http://members.aol.com/kinderecke/*

33  *http://www.tvtoday.de/TVTODAY/akt.prog/sender.haupt/hauptsender/kinder.haupt.html*

34  *http://www.yps.de*

35 *http://www.kinderinfo.de*

36 *http://privat.schlund.de/HeymelRobert/animal-links/*

37 *http://www.zoos.de/*

38 *http://www.i.de-stampe.de/wolf/wolf.html*

39 *http://www.dettmer-verlag.de/jojo/jojo.htm*

40 *http://volcano.und.nodak.edu/*

41 *http://www.kinderpolitik.de* and *http://www.kindersache.de*

42 *http://www.oneworldweb.de/tdh/kinderseiten/*

43 *http://www.unicef.org/voy/*

44 *http://www.greenpeace.de/STD_3P/KIDS/SONSTIGE/INDEX.HTM*

45 *http://www.fritz-kids-club.com/*

46 *http://www.bundesrat.de/politix/*

47 Secondary literature (approx. 300 titles) on the subject 'Children and the Internet' is available under: *http://www.geocities.com/~tobias-gehle/kinder/*

# Young people online[1]

## Michael Schmidbauer and Paul Löhr

### Preliminary remarks

The following contribution is based on the results ascertained in the study on 'Young people and the Media' that was commissioned by the IZI and the BR Media Research Department and part of which was published in an earlier issue of TelevIZIon.[2] To round off the discussion on the findings of our survey a study carried out by Feierabend and Klingler on the same subject will also be referred to.[3] The two media researchers at SWF had given us the opportunity to evaluate their material for our own purpose and to include it in this contribution (see Sections 6 and 7).

### 1. PC activity, television use and interest in politics

In the BR/IZI survey (1997) it was ascertained that 34 per cent of the young people interviewed described computer freaks as 'quite OK' and that 36 per cent of them actively use the PC daily/almost daily, or at least two to three times a week. (It should be borne in mind that, in terms of *activity*, 97.1 per cent of the young people interviewed devote the same proportion of time to watching television.)[4] The BR/IZI results, classified according to young people's gender and age, reveal the following picture (Table 1a).

Table 1a: **PC activities**
(daily/almost daily, 2-3 times a week; answers in %)

|  | all respondents | m | f | 12-13 | 14-15 | 16-17 | 18-19 |
|---|---|---|---|---|---|---|---|
| PC use | 36.0 | 51.4 | 20.2 | 38.6 | 37.6 | 34.1 | 32.3 |
| Sample (abs.) | 1060 | 539 | 521 | 280 | 327 | 267 | 186 |

Particularly striking is the great difference between young males and females with regard to their interest in the PC. The most likely explanation is that the still common opinion of male interest in, and of female aversion to, things technical creates different levels of computer appeal for the two sexes. But it should be taken into account, however, that in the younger age groups there are probably more PC-oriented girls than in the older groups. It is notable that the 12- to 15-year-olds are still more attracted to the

146

computer than the 16- to 18-year-olds, possibly linked to the boys' stronger passion for playing games (in both senses of the term).

Table 1b: **PC activities**
(daily/almost daily, 2-3 times a week, answers in %)

| Answers | Secondary modern | Secondary school | Grammar school | Em- ployed | At school | Unem- ployed | West German | East German |
|---|---|---|---|---|---|---|---|---|
| PC use | 33.1 | 32.1 | 39.2 | 30.2 | 36.5 | 39.1 | 34.4 | 41.4 |
| Sample (abs.) | 133 | 355 | 572 | 53 | 934 | 23 | 811 | 249 |

The first thing that Table 1b shows is that the *Realschule* (secondary school with a technical/economic bias) and *Hauptschule* (secondary school with a practical bias) pupils' interest in PC activities lags way behind that of their counterparts from the *Gymnasium* (secondary academic school) and *Fachoberschule* (vocational college).[5]

There also seem to be a lot of computer freaks among unemployed young people (admittedly represented by only a small number in the BR/IZI survey). The figure for those in jobs is apparently somewhat lower, on the other hand. A comparatively higher value was ascertained among young people in eastern Germany, probably mainly due to the replies from the male contingent.

It is constantly argued that the level of PC use runs parallel to a lack of interest in the television programmes. The BR/IZI study reveals that this is not necessarily quite the case (see Table 2).

Table 2: **PC activities related to TV and TV-news use**
(daily/almost daily, 2-3 times a week)

| | All respondents | TV use | | | TV-news use | | |
|---|---|---|---|---|---|---|---|
| | | Intensive | Medium | Low | Intensive | Medium | Low |
| PC use | 36.0 | 38.6 | 23.3 | 33.3 | 39.3 | 38.6 | 29.4 |
| Sample (abs.) | 1060 | 873 | 172 | 15 | 379 | 368 | 303 |

Although the previously mentioned data are only available for the young people interviewed *as a whole*, it is clear that intensive use of the PC can still coincide with intensive use of TV and TV news. This could be due to two factors: first, the general interest in the electronic media with regard to both television and the computer; second, an active interest in the computer requires similar levels of education and skills to those necessary for a specific interest in news and information programmes.

Of particular interest is the result concerning the relationship between PC use and medium TV use. This could also be evidence of two tendencies: first, that many girls, less inclined to use the computer, assigned themselves to the category of medium TV use; second, that young people tend more strongly towards this category who find contact with TV

programmes a better means of regeneration and compensation than a computer game, a CD-ROM adventure or surfing on the Internet, and this for different social or individual reasons (eg stress and failure in the family, at school and in professional training).

Moreover, the BR/IZI survey data (also based on the *total* of the young people interviewed) fail to substantiate the common argument that young people who make intensive use of the computer are not interested in political topics and discussions (see Table 3).

Table 3: **PC activities related to interest in politics**
(daily / almost daily, 2-3 times a week; answers in %)

|  | All respondents | Interest in politics | | Political discussions with friends | |
|---|---|---|---|---|---|
|  |  | High | Medium | Many | Few |
| PC use | 36.0 | 40.2 | 34.2 | 39.1 | 35.1 |
| Sample Basis (abs.) | 1060 | 311 | 749 | 281 | 772 |

On the contrary, the degree of computer utilisation is revealed to be far more pronounced in the case of young people who are politically active and interested in regular political discussions with their friends. As is suggested by BR/IZI data ascertained in another context,[6] this result is likely to be somewhat higher in the case of male, older, *Gymnasium* and *Fachoberschule* pupils and young people in jobs.

**2. Computer equipment**
With regard to PC activity one interesting point, right at the outset, is the number of young people's households equipped with at least one PC: 54 per cent of the households have at least one PC and 16 per cent have an additional appliance belonging to the young people themselves (see Table 4a). The latter comprises a good 30 per cent in terms of PC households, a value, like the first, based on the households of all the 1,060 interviewees. In the first case – the households having a PC – the households predominate in which young males live, but all the individual age groups reveal only negligible deviations from the mean value applicable to all the interviewees. In the second case – where young people have their own PC – the boys have a clear lead over the girls. The 12- to 17-year-olds correspond to the mean value, not quite reached by the 18- to 19-year-olds.

A striking result is the close connection between the PC ownership per household and the young person's educational level. Only 31 per cent of *Hauptschule* households are equipped with a PC whereas almost 63 per cent of *Gymnasium* and *Fachoberschule* pupils' households have a computer (see Table 4b).

The chances of these pupils owning their own PC are similar, according to the survey, the differences between the groups being somewhat less significant, however. It is hardly surprising that young people still

148

Table 4 a: **PC in households**

|  | All respondents | M | F | 12-13 | 14-15 | 16-17 | 18-19 |
|---|---|---|---|---|---|---|---|
| PC in household | 54.2 | 57.3 | 51.1 | 53.6 | 54.7 | 53.2 | 55.9 |
| PC in household as well as own PC | 16.4 | 23.6 | 9.0 | 17.9 | 15.9 | 17.6 | 13.4 |
| Sample (abs.) | 1060 | 539 | 521 | 280 | 327 | 267 | 186 |

Table 4b: **PC in households**

| Answers | Secondary modern | Secondary school | Grammar school | Em-ployed | At school | Unem-ployed | West German | East German |
|---|---|---|---|---|---|---|---|---|
| PC in household | 30.8 | 49.3 | 62.8 | 37.7 | 55.9 | 26.1 | 55.7 | 49.4 |
| PC in household as well as own PC | 11.2 | 14.4 | 18.9 | 9.4 | 17.7 | 8.7 | 17.4 | 13.3 |
| Sample (abs.) | 133 | 355 | 572 | 53 | 934 | 23 | 811 | 249 |

attending school reveal more favourable results than those at work and particularly those who are unemployed: at least some of the young people in employment have a computer at work as opposed to one at home. And those out of work do not have the necessary money or perhaps the necessary interest, having to cope with problems of a more existential nature. Neither can it be particularly surprising that the last two points also restrict the acquisition of a computer by young people in the eastern part of Germany, who consequently lag behind their counterparts in the west.

How are the PCs the young people use equipped? Table 5a lists the technical features of the PCs, classifying them according to the young people's gender and age.

Table 5a: **PC processing power, technical peripherals, online or Internet access** (multiple responses possible; answers in %)

|  | All respondents | M | F | 12-13 | 14-15 | 16-17 | 18-19 |
|---|---|---|---|---|---|---|---|
| 386 | 5.0 | 7.1 | 2.9 | 4.6 | 5.2 | 3.4 | 7.5 |
| 486 | 12.3 | 18.0 | 6.3 | 9.3 | 8.9 | 16.9 | 16.1 |
| Pentium | 12.1 | 18.6 | 5.4 | 9.6 | 15.6 | 13.5 | 7.5 |
| CD-ROM drive | 38.4 | 45.6 | 30.9 | 36.8 | 38.8 | 41.2 | 36.0 |
| Sound card | 30.1 | 40.4 | 19.4 | 28.6 | 30.6 | 34.8 | 24.7 |
| Modem | 10.3 | 11.3 | 9.2 | 9.3 | 7.3 | 15.4 | 9.7 |
| ISDN card | 4.2 | 5.8 | 2.7 | 3.2 | 4.3 | 4.1 | 5.9 |
| Video card | 5.5 | 9.1 | 1.7 | 3.2 | 8.6 | 6.7 | 1.6 |
| Joystick | 29.4 | 37.3 | 21.7 | 27.1 | 33.0 | 33.3 | 22.0 |
| Internet access | 3.1 | 3.7 | 2.5 | 2.9 | 1.2 | 4.1 | 5.4 |
| Young people with no PC in household | 45.1 | 42.1 | 48.2 | 45.7 | 44.3 | 46.1 | 44.1 |
| Sample (abs.) | 1060 | 539 | 521 | 280 | 327 | 267 | 186 |

Four points are striking: first, up-to-date appliances (486 PCs, Pentiums) as well as many of the latest accessories (CD-ROM drives, sound cards) are strongly represented in the case of all the PC users interviewed. Second, girls rank lower than boys on all counts – they come closest to their male counterparts in the case of modems and Internet connections. Third, the 14- to 17-year-olds have a very strong affinity to the latest technical devices on the market (including joysticks) and trail only slightly behind the 18- to 19-year-olds with regard to ISDN cards and Internet connections. Fourth, Internet access is still restricted to a small percentage of young people; as is to be expected, the group of 17- to 19-year-olds is the most active, and is more likely to be familiar with operational requirements and facilities than the younger group. The results relating to ISDN, modems and Internet – still – cover a relatively small group of people.

Table 5b: **PC processing power, technical peripherals, online or Internet access**
(multiple responses possible; answers in %)

|  | Secondary modern | Secondary school | Grammar school | Em-ployed | At school | Unem-ployed | West German | East German |
|---|---|---|---|---|---|---|---|---|
| 386 | 3.8 | 3.4 | 6.3 | 3.8 | 5.1 | 4.3 | 4.2 | 7.6 |
| 486 | 8.3 | 10.4 | 14.3 | 9.4 | 12.4 | 8.7 | 13.2 | 9.2 |
| Pentium | 3.8 | 12.4 | 13.8 | 5.7 | 13.1 | 0.0 | 13.6 | 7.2 |
| CD-ROM drive | 18.8 | 35.8 | 44.6 | 24.5 | 39.5 | 17.4 | 40.6 | 31.3 |
| Sound card | 12.8 | 27.0 | 36.0 | 13.2 | 31.6 | 17.4 | 32.6 | 22.1 |
| Modem | 4.5 | 10.1 | 11.7 | 7.5 | 10.5 | 4.3 | 11.6 | 6.0 |
| ISDN card | 1.5 | 5.6 | 4.0 | 5.7 | 4.3 | 4.3 | 4.4 | 3.6 |
| Video card | 0.8 | 4.8 | 7.0 | 1.9 | 5.9 | 4.3 | 5.5 | 5.2 |
| Joystick | 20.3 | 27.0 | 33.4 | 18.9 | 31.0 | 17.4 | 30.0 | 28.5 |
| Internet access | 0.0 | 3.7 | 3.5 | 5.8 | 2.9 | 4.3 | 3.2 | 2.8 |
| Young people with no PC in household | 69.2 | 50.4 | 36.2 | 62.3 | 43.4 | 73.9 | 43.4 | 50.6 |
| Sample (abs.) | 133 | 355 | 572 | 53 | 934 | 23 | 811 | 249 |

The fact that *Gymnasium* and *Fachoberschule* pupils overall rank higher than *Hauptschule* pupils, particularly with regard to the modern versions of the appliances and accessories, does not require a separate explanation. It should not be forgotten that only 31 per cent of *Hauptschule* pupils live in PC households (Table 5b). An interesting observation is the fact that *Realschule* pupils come much closer to *Gymnasium* and *Fachoberschule* pupils than *Hauptschule* pupils in terms of modems and Pentiums in addition to CD-ROM drives, sound cards and joysticks. The results for the items Internet connections and ISDN cards are excluded on account of the small sample. The same applies to the ISDN and Internet values ascertained for young people attending school, in jobs and out of work, although the young people in jobs reveal the highest value of the sub-groups with regard to Internet connections.

School pupils are evidently not only ahead of employed and unemployed young people in virtually every category (with the exception of ISDN and the

Internet). The last named sub-groups also constantly lie below the mean values applicable to all the interviewees. This could be due to the fact that only 38 per cent and 26 per cent of the employed and the jobless young people, respectively, live in PC households. The good position occupied by the pupils is probably due to the fact that the employed and jobless young people are moderately interested in the PC's game and entertainment qualities (CD-ROM drives, joysticks, sound cards). They may have to use a PC at work during the day and prefer watching TV in the evening. Particularly the jobless young people have to spend their money (if they have any) on other things.

Finally, it was ascertained that young people living in the western part of Germany rank higher than those in the eastern part on all counts – most consistently in the case of somewhat more expensive hardware applications and accessories (Pentiums, CD-ROM drives, sound cards, modems). But on the other hand, ISDN cards and Internet connections are still rare in the case of young people both in the west and the east.

## 3. Daily use of the PC

Utilisation values for young people frequently using the computer were ascertained on the basis of a four-week period and are documented in Tables 6a and 6b. Two points have to be considered in the interpretation of the tables: on the one hand, the values are based on all the interviewees – many live in households without a computer. On the other hand, only the results ascertained for the utilisation category 'every day/almost every day' and '2-3 times a week' have been recorded. In Table 6a the results for boys/girls and the individual age groups are presented.

Table 6a: **PC use**
(in a four-week period daily/almost daily, 2-3 times a week; answers in %)

|  | All respondents | M | F | 12-13 | 14-15 | 16-17 | 18-19 |
|---|---|---|---|---|---|---|---|
| Daily/almost daily use; 2-3 times a week | 29.6 | 39.1 | 19.8 | 29.3 | 30.9 | 31.5 | 25.3 |
| Young people with no PC at home | 45.1 | 42.1 | 48.2 | 45.7 | 44.3 | 46.1 | 44.1 |
| Basis (abs.) | 1060 | 539 | 521 | 280 | 327 | 267 | 186 |

Regarding the proportion of computer utilisation, the boys are once again shown to dominate the girls, the difference being a little lessened by the fact that the group of girls coming from households having no computer is considerably larger than that of the boys. In the case of the 12- to 17-year-olds there are no notable differences; the proportion of computer utilisation approximately amounts to the mean value ascertained for all the interviewees. The 18- to 19-year-olds group (absolutely) reach this value. This is probably due to the fact that employed young people are strongly represented in this age group who have less time and who have relatively little to do with the computer during their working day.

151

Table 6b: **PC use**
(in a four-week period daily / almost daily, 2-3 times a week; answers in %)

| Answers | Secondary modern | Secondary school | Grammar school | Em-ployed | At school | Unem-ployed | West German | East German |
|---|---|---|---|---|---|---|---|---|
| Daily /almost daily use; 2-3 times a week | 12.0 | 27.6 | 35.0 | 22.6 | 30.6 | 8.7 | 30,3 | 27.3 |
| Young people with no PC at home | 69.2 | 50.4 | 36.2 | 62.3 | 43.4 | 73.9 | 43.4 | 50.6 |
| Sample (abs.) | 133 | 355 | 572 | 53 | 934 | 23 | 811 | 249 |

The group of *Hauptschule* pupils is also affected by the availability of a PC in only 30 per cent of their households (see Table 6b). *Realschule* and particularly *Gymnasium* and *Fachoberschule* pupils, who live in 50 per cent and 74 per cent of the PC-households, respectively, consequently have a utilisation time that is over twice and in the case of *Gymnasium* and *Fachoberschule* pupils almost three times as high as *Hauptschule* pupils.

What was previously said in connection with 18- to 19-year-olds probably also applies to employed young people and their somewhat lower utilisation time. In the case of unemployed young people the already mentioned handicaps are again evident:

• first, too few households having a PC;
• secondly, too few opportunities to use the PC meaningfully (word processing – relevant for pupils and thus quite time-consuming – presumably does not play a major role for jobless young people);
• thirdly, the limited capacity of the PC to afford distraction, suspense, stress relief, and compensation – TV consumption tends to be more effective in satisfying such needs.

Finally, in terms of east and west, it is revealed that usage by young people in the eastern part – despite almost 51 per cent of their households lacking a computer – closely corresponds to their counterparts in western Germany.

## 4. Daily duration of PC use

The utilisation pattern outlined above suggests daily PC use whose duration differs enormously within the individual sub-groups of young people interviewed. In the interpretation of the Tables 7a and 7b the following should be observed: first, 45 per cent of all the young people interviewed are members of households without a computer; second, 39 per cent of the young people interviewed use the PC at least two to three times a week, which is not daily/almost daily. Third, this means conversely: the values ascertained for the daily utilisation of the PC – see the categories 'up to 2 hours', etc – thus refer to the 15.2 per cent of the interviewees that daily/almost daily use the PC. This is particularly extreme in the case of girls and 18- to 19-year-olds.

In Table 7a the daily duration of PC use is illustrated according to age groups and sex. Daily or almost daily PC users prefer to spend up to two hours at the keyboard.[7] This applies to both boys and girls as well as the

Table 7a: **Daily duration of PC use**
(in a four-week period daily/almost daily, 2-3 times a week; answers in %)

| Answers | All respondents | M | F | 12-13 | 14-15 | 16-17 | 18-19 |
|---|---|---|---|---|---|---|---|
| Young people using the PC daily/almost daily (total) | 15.2 | 21.9 | 9.5 | 15.2 | 13.4 | 16.3 | 13.6 |
| – up to 2 hrs | 11.3 | 15.6 | 6.9 | 14.1 | 11.6 | 10.8 | 7.0 |
| – up to 6 hrs | 2.8 | 4.8 | 1.0 | 1.1 | 1.5 | 3.3 | 4.4 |
| – up to 8 hrs | 1.1 | 1.5 | 0.6 | 0.0 | 0.3 | 2.2 | 2.2 |
| Young people using PC less than daily/almost daily | 38.8 | 35.6 | 42.0 | 36.4 | 39.1 | 37.8 | 43.0 |
| Young people without any PC in their household | 45.1 | 42.1 | 48.1 | 45.7 | 44.3 | 46.1 | 44.1 |
| Sample (abs.) | 1060 | 539 | 521 | 280 | 327 | 267 | 186 |

individual age groups. But considerable differences are revealed between the sub-groups with regard to the 'up to two hours' category: notably a great contrast between boys and 12- to 13-year-olds, on the one hand, and girls and 18- to 19-year-olds, on the other. The 12- to 13-year-olds possibly spent a relatively long period of time in front of the computer simply because, compared to young people older than themselves, they have to spend more time becoming familiar with it. Working on the computer for longer than three hours is rare; this only occurs somewhat more frequently in the boys' and in the 18- to 19-year-olds' groups.

Table 7b: **Daily duration of PC use**
(in a four-week period daily/almost daily, 2-3 times a week; answers in %)

| Answers | Secondary modern | Secondary school | Grammar school | Em-ployed | At school | Unem-ployed | West German | East German |
|---|---|---|---|---|---|---|---|---|
| Young people using the PC daily/almost daily (total) | 7.7 | 13.5 | 18.0 | 9.5 | 15.5 | 0.0 | 15.1 | 15.6 |
| – up to 2 hrs | 3.8 | 9.3 | 14.3 | 3.8 | 12.1 | 0.0 | 11.1 | 12.0 |
| – up to 6 hrs | 2.3 | 3.1 | 2.8 | 0.0 | 2.8 | 0.0 | 2.8 | 3.2 |
| – up to 8 hrs | 1.6 | 1.1 | 0.9 | 5.7 | 0.6 | 0.0 | 1.2 | 0.4 |
| Young people using PC less than daily/almost daily | 22.6 | 35.8 | 44.4 | 24.5 | 40.5 | 26.1 | 40.6 | 32.9 |
| Young people without any PC in their household | 69.2 | 50.4 | 36.2 | 62.3 | 43.4 | 73.9 | 43.4 | 50.6 |
| Sample (abs.) | | 355 | 572 | 53 | 934 | 23 | 811 | 249 |

The time spent by *Hauptschule, Realschule, Gymnasium* and *Fachoberschule* pupils using the PC daily/almost daily usually amounts to one to two hours, too (see Table 7b). *Hauptschule* pupils trail way behind, however. It is also astonishing that employed young people are the only sub-group to play a relatively insignificant role in the 'up to 2 hours' category, but, on the other hand, a much more important role in the 'up to

8 hours' category. The results referring to the pupils overall and young people from the eastern and western parts of Germany reveal a reduction in the differences described. The mean values applicable to all the interviewees predominate. The fact that no values were assigned to jobless young people is due to this group featuring no users who daily/almost daily use the computer.

## 5. Daily PC use, TV use, and interest in politics

The question as to the possible consequences that frequent use of the PC can have on TV use and young people's interest in politics can also be explained in detail. It has already been said that the intensive use of the computer coincides neither with young people's disinterest in TV programmes nor with an aversion towards politics and political discussions with friends. In order to arrive at a more differentiated analysis of this result and possible modifications, Table 8 illustrates the extent to which (intensive/medium/low) TV and TV-news use reaches the group considered to constitute the most intensive PC users (daily/almost daily).

Table 8: **PC use related to TV and TV-news use**
(daily/almost daily over a period of four weeks; answers in %)

| | All respondents | TV use | | | TV-news use | | |
|---|---|---|---|---|---|---|---|
| | | Intensive | Medium | Low | Intensive | Medium | Low |
| 'Daily/almost daily' PC use | 15.2 | 16.5 | 8.1 | 20.0 | 17.7 | 16.0 | 10.9 |
| Young people in households having no PC | 45.1 | 44.7 | 46.5 | 53.3 | 45.6 | 41.8 | 47.9 |
| Sample (abs.) | 1060 | 873 | 172 | 15 | 379 | 368 | 303 |

The results on the subject of 'television use' reveal the following: in the case of intensive TV consumption the value for daily/almost daily young PC users is slightly above the mean value applicable to all those interviewed, but in the case of low TV consumption the result for daily/almost daily young PC users is considerably higher than this mean value. Therefore it may be concluded that daily/almost daily young PC users comprise two categories: in the first section PC and TV are both used intensively. This probably applies particularly to boys and those younger in age (known to be relatively intensive viewers) as well as employed young people, who possibly tend to watch TV in their free time, mainly because they have to use a PC at work. The second section comprises those revealing a 'low' TV consumption accompanied by a high level of PC use. This probably applies particularly to older young people, known to be very reluctant to watch TV.[8]

Table 9: **Daily duration of PC use related to interest in politics**
(daily/almost daily over a period of four weeks; answers in %)

| | All respondents | Interest in politics Low | High | Political discussions with friends Frequently/ Sometimes | Rarely/ Never |
|---|---|---|---|---|---|
| 'Daily/almost daily' PC use | 15.2 | 19.0 | 13.6 | 13.5 | 15.9 |
| Young people in households having no PC | 45.1 | 36.0 | 48.9 | 40.2 | 46.9 |
| Sample (abs.) | 1060 | 311 | 749 | 281 | 772 |

The situation regarding TV-news use seems to be less complicated by comparison (see Table 9). Here the intensive PC use corresponds to a great interest in politics, on the one hand, an interest no doubt pursued with the assistance of the PC; on the other hand, it seems that the attempt to discuss politics with friends clearly clashes with intensive PC use, however. It has already been noted in Section 1 that the combination of intensive PC use and a great interest in politics is possibly rooted in specific cognitive qualities, more highly represented in young people keen on computers and those interested in politics. This in turn could mean that young people making intensive use of both the computer and TV are to be found particularly in the groups of *Realschule*, *Gymnasium* and *Fachoberschule* pupils in addition to young people of an older age.

In terms of the duration of daily PC use there are further modifications. Table 10 supplies the relevant data on the subject of TV and TV news use.

Table 10: **Daily duration of PC use in relation to TV and TV-news use**
(daily/almost daily over a period of four weeks, answers in %)

| | All respondents | TV use Intensive | Medium | Low | TV-news use Intensive | Medium | Low |
|---|---|---|---|---|---|---|---|
| Young people using PC daily/almost daily all: | 15.2 | 16.3 | 8.8 | 20.1 | 17.7 | 15.8 | 10.9 |
| – up to 2 hrs | 11.3 | 12.2 | 7.0 | 6.7 | 12.6 | 12.8 | 7.9 |
| – up to 4 hrs | 2.8 | 3.1 | 0.6 | 13.4 | 3.5 | 1.9 | 3.0 |
| – up to 8 hrs | 1.1 | 1.0 | 1.2 | 0.0 | 1.6 | 1.1 | 0.3 |
| Young people using PC less than daily/almost daily | 38.3 | 37.9 | 44.2 | 26.7 | 36.4 | 40.8 | 39.9 |
| Young people in households having no PC | 45.1 | 44.7 | 46.5 | 53.3 | 45.6 | 41.8 | 47.9 |
| Sample (abs.) | 1060 | 873 | 172 | 15 | 379 | 368 | 303 |

In the case of young people devoting up to two hours to using the computer daily/almost daily an intensive level of TV use was ascertained,

155

slightly higher than the mean value applicable to all the interviewees. But medium and low levels of TV use trail way behind this value. Moreover, it is particularly striking that, in the case of a daily utilisation duration of up to four hours, intensive and average levels of TV consumption are hardly possible; only a low level of TV use is possible – evidently for time reasons.

Table 11 contains the data on the items 'interest in politics' and 'political discussions with friends'. It can therefore be said, in addition to what is outlined in Section I, that young people very interested in politics reveal a higher level of PC utilisation. But at the same time it must be conceded that the extended duration of the daily use of the PC is accompanied by a reduction in the political discussions with friends. Even in the case of a daily duration of only two hours the category of 'political discussions frequently/sometimes' does not even reach the mean value characteristic of all the interviewees together.

Table 11: **Daily duration of PC use in relation to political interest;** (daily/almost daily over a period of four weeks

| | All respondents | Interest in politics Low | High | Political discussions with friends Frequently/ Sometimes | Rarely/ Never |
|---|---|---|---|---|---|
| Young people using PC daily/almost daily (total) | 15.2 | 20.8 | 14.0 | 14.8 | 17.3 |
| – up to 2 hrs | 11.3 | 14.1 | 10.1 | 9.9 | 11.9 |
| – up to 4 hrs | 2.8 | 2.9 | 1.8 | 2.1 | 3.1 |
| – up to 8 hrs | 1.1 | 3.0 | 2.1 | 2.8 | 2.3 |
| Young people using PC less than daily/almost daily | 38.3 | 44.7 | 36.3 | 45.2 | 36.3 |
| Young people in households having no PC | 45.1 | 36.0 | 48.9 | 40.2 | 46.9 |
| Sample (abs.) | 1060 | 311 | 749 | 281 | 772 |

## 6. Reasons for PC utilisation and PC activities in various fields

Feierabend and Klingler (1997) investigated the reasons for young people using the computer in their representative survey on 'Youth and Multimedia'. Unlike the BR/IZI study, they focused on the 12- to 17-year-old age group using a representative sample of 803 youngsters in the federal states Baden-Württemberg and Rhineland-Palatinate. The 690 young people using the computer rarely or more often supplied the following answers – classified according to gender and age groups (see Table 12a).

Using the computer for game purposes still appears to be the main reason (for fun, computer games, passing the time) – particularly in the case of 12- to 13-year-old boys. But the use of the PC at school and in the context of learning and everyday practical applications has been stepped up, a remarkable feature in the case of girls and 16- to 17-year-olds.

Table 12a: **Reasons for PC use of young people using the PC at least rarely or more often**
(N=690; stating 'absolutely correct' on given criteria; answers in %)

| Reasons given | Total | M | F | 12-13 | 14-15 | 16-17 |
|---|---|---|---|---|---|---|
| For fun | 71 | 62 | 79 | 78 | 72 | 62 |
| computer games | 56 | 45 | 66 | 66 | 58 | 43 |
| PC at home | 47 | 44 | 51 | 48 | 49 | 45 |
| Useful at school | 47 | 58 | 41 | 45 | 47 | 50 |
| Good for passing the time | 36 | 28 | 44 | 40 | 36 | 32 |
| Something out of the ordinary | 25 | 20 | 29 | 31 | 23 | 21 |
| Sample (abs.) | 690 | 330 | 360 | 227 | 236 | 227 |

Once the connection between the young people's educational levels and their justification of PC activities is taken into account, a striking feature is revealed (Table 12b): *Hauptschule* and *Realschule* pupils are very fun- and games-oriented but also accept the computer as a learning aid.

For *Gymnasium* pupils the PC plays a less significant role as a learning aid and as a toy, probably because particularly the older years are represented here. The same applies to vocational school students, who have even less time for playing on the computer due to their vocational activities.

Table 12b: **Reasons for PC use of young people using the PC at least rarely or more often**
(N=690; stating 'absolutely correct' on given criteria; answers in %)

| Reasons given | Pupils in | | | |
|---|---|---|---|---|
| | Hauptschule | Realschule | Gymnasium | Vocational school |
| For fun | 75 | 73 | 68 | 66 |
| Computer games | 56 | 65 | 50 | 44 |
| PC at home | 47 | 47 | 48 | 42 |
| Useful at school | 60 | 48 | 40 | 45 |
| Passing the time | 40 | 40 | 30 | 37 |
| Something out of ordinary | 35 | 28 | 17 | 19 |
| Sample | 154 | 220 | 254 | 62 |

Similar, albeit not directly comparable, results can also be found in the 1997 BR/IZI study (see Section 8, specifying the areas in which young people mainly use the PC). A look at the differences illustrated by the five categories listed in Tables 13a and 13b soon reveals that the topic 'games' is high on young people's popularity list, but that in the meantime the computer is put to other uses, such as surfing the Internet, schoolwork and learning, listening to music by means of a CD-ROM drive, and applications in the field of professional activity.

In this connection another result from the Feierabend/Klingler study is interesting: 14 per cent of young people using the PC rarely or more often

make use of a computer when it is installed in a young people's library or a youth club.[9] If this result – which generally applies to young people – is classified according to gender- and age-specific criteria, a number of supplementary differences are revealed (see Table 13a).

Table 13a: **PC use in various sections**
(daily/almost daily, 2-3 times a week over a period of four weeks; answers in %)

| Section | All respondents | M | F | 12-13 | 14-15 | 16-17 | 18-19 |
|---|---|---|---|---|---|---|---|
| Career | 3.7 | 3.9 | 3.5 | 0.7 | 0.9 | 6.4 | 9.1 |
| School, learning | 12.8 | 16.5 | 9.0 | 12.5 | 15.6 | 13.5 | 7.5 |
| Games | 24.4 | 34.7 | 13.8 | 30.7 | 28.1 | 23.2 | 10.2 |
| Listening to music | 5.5 | 8.7 | 2.1 | 5.4 | 5.5 | 6.0 | 4.8 |
| Internet | 1.8 | 2.6 | 1.0 | 0.7 | 0.9 | 3.4 | 2.7 |
| Young people without a PC in their household | 45.1 | 42.1 | 48.2 | 45.7 | 44.3 | 46,1 | 44.1 |
| Sample (abs.) | 1060 | 539 | 521 | 280 | 327 | 267 | 186 |

That boys and younger adolescents use the computer very intensively to play games is nothing new. But what is new is that the use of the PC for playing games now assumes a less predominant role, as it is used more and more for school work and learning-related activities, on the one hand, and due to the increasing popularity of surfing and navigating through the Internet, quantitatively still subject to certain limitations, however. The former applies particularly to 12- to 14-year-olds, the latter more to 16- to 19-year-olds. It should not be overlooked that girls trail way behind their male counterparts; they are by no means as keen on games.

Table 13b: **PC use in various sections**
(daily/almost daily, 2-3 times a week over a period of four weeks; answers in %)

| Section | Secondary modern | Secondary school | Grammar school | Em-ployed | At school | Unem-ployed | West German | East German |
|---|---|---|---|---|---|---|---|---|
| Career | 3.0 | 4.5 | 3.3 | 22.6 | 1.6 | 4.3 | 4.1 | 2.4 |
| School, learning | 7.5 | 13.2 | 13.8 | 0.0 | 14.6 | 0.0 | 12.8 | 12.9 |
| Games | 14.3 | 23.1 | 27.6 | 5.7 | 26.6 | 8.7 | 23.9 | 26.1 |
| Listening to music | 3.0 | 6.2 | 5.6 | 1.9 | 6.1 | 0.0 | 5.7 | 4.8 |
| Internet | 0.8 | 1.4 | 2.3 | 3.8 | 1.7 | 4.3 | 2.2 | 0.4 |
| Young people without a PC in their household | 69.2 | 50.4 | 36.2 | 62.3 | 43.4 | 73.9 | 43.4 | 50.6 |
| Sample (abs.) | 133 | 355 | 572 | 53 | 934 | 23 | 811 | 249 |

Table 13b also reveals the great interest in playing games on the PC – particularly in the case of *Realschule*, *Gymnasium* and *Fachoberschule* pupils. PC use for playing games is most intensively pursued by *Realschule*, *Gymnasium* and *Fachoberschule* pupils as well as by unemployed young

people – in both eastern and western Germany. But *Realschule, Gymnasium* and *Fachoberschule* pupils also appear at the top of the rankings of school – and learning-oriented PC use both in eastern and western Germany. Logically, PC use for professional purposes is largely restricted to the group of employed young people. Compared to the previously mentioned forms of PC use, listening to music and Internet activities account for a small percentage.

## 7. Attitudes to PC use

Young people, due to their PC-related interest and knowledge, develop a specific attitude syndrome. Tables 14a and 14b display the findings of Feierabend and Klingler (1997) based on the sample of 803 12- to 19-year-old respondents, 690 of which rarely or more often use the PC.[10]

Table 14a: **Attitudes towards the PC: age group and gender**
(N=690; stating 'absolutely correct' on given criteria; answers in %)

| Attitude | Total | F | M | 12-13 | 14-15 | 16-17 |
|---|---|---|---|---|---|---|
| At school you should be taught how to handle a computer | 79 | 78 | 80 | 73 | 81 | 82 |
| You can do a lot of interesting things with computers | 76 | 72 | 81 | 78 | 81 | 71 |
| It's fun playing with the computer | 65 | 56 | 74 | 71 | 67 | 57 |
| Computers will soon be just a part of everyday life as the telephone | 60 | 58 | 63 | 54 | 63 | 63 |
| Computers are important for finding a profession | 60 | 63 | 56 | 58 | 60 | 61 |
| The more often children and young people use the computer the less they read | 57 | 58 | 57 | 59 | 58 | 55 |
| It's fun learning with the computer | 51 | 48 | 53 | 61 | 49 | 41 |
| Computers should be used in normal lessons at school | 44 | 44 | 45 | 45 | 47 | 41 |
| The more often children and young people use the computer, the less they watch TV | 37 | 35 | 39 | 36 | 36 | 38 |
| The computer is a good way of spending your free time | 36 | 27 | 45 | 40 | 41 | 27 |
| My parents don't think computers are so important | 25 | 24 | 27 | 23 | 24 | 29 |
| I don't know exactly what you can do with a computer | 17 | 10 | 25 | 18 | 18 | 16 |
| Computers are more for boys than for girls | 8 | 7 | 10 | 13 | 7 | 6 |
| Sample (abs.) | 803 | 408 | 395 | 267 | 268 | 268 |

Table 14a clearly reveals that young people have a very positive attitude towards the PC and its opportunities for amusement and games, for effective learning and acquiring information. They particularly emphasise the use of the PC as a multi-purpose tool in their leisure time, at school and in their profession, allowing them to cater for interests and tackle tasks previously less accessible to young people. Boys and 12- to 15-year-olds are accordingly more oriented towards games and leisure-time activities than girls and 16- to 17-year-olds, although boys and 12- to 13-

159

year-olds resolutely advocate using the PC at school and in other learning contexts.

The girls evidently seem to find themselves in a slightly contradictory position: on the one hand, they stress the practical value of the computer for professional purposes; on the other, they do not feel as knowledgeable as boys about the opportunities afforded by the computer.

The statements above must be differentiated even further when the variable of school education is taken into account (see Table 14b).

Table 14b: **Attitudes towards the PC**

| Reasons given | Pupils in | | | |
| | Hauptschule | Realschule | Gymnasium | Vocational school |
|---|---|---|---|---|
| At school you should be taught how to handle a computer | 83 | 78 | 75 | 82 |
| You can do a lot of interesting things with computers | 78 | 77 | 75 | 76 |
| It's fun playing with the computer | 71 | 67 | 59 | 68 |
| Computers will soon be just a part of everyday life like the telephone | 64 | 62 | 58 | 55 |
| Computers are important for finding a profession | 63 | 62 | 57 | 54 |
| The more often children and young people use the computer the less they read | 61 | 62 | 52 | 52 |
| It's fun learning with the computer | 65 | 56 | 39 | 46 |
| Computers should be used in normal lessons at school | 51 | 46 | 40 | 44 |
| The more often children and young people use the computer, the less they watch TV | 47 | 37 | 30 | 30 |
| The computer is a good way of spending your free time | 46 | 42 | 26 | 35 |
| My parents don't think computers are so important | 34 | 27 | 18 | 28 |
| I don't know exactly what you can do with a computer | 17 | 18 | 18 | 13 |
| computers are more for boys than for girls | 11 | 11 | 6 | 4 |
| Sample (abs.) | 180 | 251 | 301 | 71 |

One striking feature is that *Hauptschule* pupils and, slightly more reservedly, vocational school pupils are interested in using the PC as a learning aid, but both groups are clearly aware of the PC's usefulness for playing games. *Gymnasium* pupils, on the other hand, are by no means as strongly represented in both the first and the second case; moreover, using the computer for fun and as a leisure-time activity is evidently limited in their case.

An interesting result is that the prejudice that the PC is something for boys rather than for girls is hardly significant; only in the case of 12- to 13-year-olds (Table 14a) and *Hauptschule* and *Realschule* pupils (Table 14b) does this play a somewhat more important role. Both tables reveal that young people – interestingly, mainly *Hauptschule* and *Realschule* pupils – also see possible dangers in using the PC: for example, a lack of interest in the print media.

160

## 8. Users of Internet and other online services

Although young people's participation in Internet and other online services (eg e-mail, data banks) is not yet very wide-spread, it still seems useful to have a closer look at this field, which will probably assume completely different dimensions in the near future. Feierabend and Klingler (1997) supply important information on this topic, featuring a systematic and representative survey on young people's Internet/online activities.[11]

It should be remembered that the data furnished by the Feierabend/Klingler survey was based on a representative sample from two federal states (Baden-Württemberg, Rhineland-Palatinate), the age group of 12- to 17-year-olds, and the answers of those 125 Internet/online users among the pupils who use the PC at least rarely or more often. This consequently limits the ability to compare the Feierabend/Klingler findings with those of the BR/IZI study:

- the results ascertained from the Baden-Württemberg/Rhineland-Palatinate sample, reviewed in the context of federal state parameters, cannot be used to project results applicable to all young people living in Germany;
- the data ascertained from the sample of 12- to 17-year-old pupils do not reflect the same as the BR/IZI study results, whose point of departure is a different one, caused by the extension of the study to cover the 18- to 19-year-old age group and employed/unemployed young people, only a part of whom come under the Feierabend/Klingler category of vocational school students.

Table 15: **Users of Internet/on-line services**
(basis: young people using the PC rarely or more often, N=690; answers in %)

| Users (rare or more often) | |
|---|---|
| Overall | 16 |
| Girls | 13 |
| Boys | 18 |
| 12-13 | 11 |
| 14-15 | 19 |
| 16-17 | 16 |
| Hauptschule pupils | 12 |
| Realschule pupils | 19 |
| Gymnasium pupils | 16 |
| Vocational school pupils | 14 |
| Basis (abs.) | 690 |

The values entered in Table 16 are based on the Internet/online use of 690 young people who make use of the PC rarely or more often. This contrasts with the BR/IZI results revealed in Table 13a on young people who use the PC at least two to three times a week and who answered only on the subject of Internet (and not on the subject of Internet/online). Once

these restrictions have been taken into account, it is possible to explain the figure, in the Feierabend / Klingler study, of 16 per cent of young PC users (rarely or more often) also ranking among Internet / online users.

If this group of young people is chosen as the point of reference, as in the Feierabend / Klingler survey, the Internet / online users are distributed in the gender, age and school type categories as follows (see Table 16). It seems that boys, 14- to 15-year-olds and *Realschule* pupils are particularly enthusiastic Internet / on-line users. On the other hand, girls, 12- to 13-year-olds *Hauptschule* pupils and vocational school students occupy a somewhat lower position.

Table 16: **Internet/online services users**
(basis: young people *actually* using Internet / online; N=125; answers in %)

| Users (actual) | |
|---|---|
| Girls | 44 |
| Boys | 56 |
| | |
| 12-13 | 23 |
| 14-15 | 42 |
| 16-17 | 35 |
| | |
| Hauptschule pupils | 16 |
| Realschule pupils | 38 |
| Gymnasium pupils | 38 |
| Vocational school pupils | 8 |
| | |
| Basis (abs.) | 125 |

On the whole, this is a result that differs to the data ascertained in the BR/IZI survey on some counts. In the BR/IZI study the weaker position of the girls, the wide margin between them and the boys, is documented in a similar way. But in the BR/IZI analysis the 14- to 15-year-olds differ, but very slightly to the 12- to 13-year-olds and the 16- to 17-year-olds, ranking not higher but just below the latter. It is true that the BR/IZI study ascertained a wide margin between *Hauptschule* and *Realschule* pupils, but (according to BR/IZI) the latter are clearly surpassed by *Gymnasium* and *Fachoberschule* pupils.

The composition of the Feierabend / Klingler sample of young people, who use the PC rarely or more often but in fact use Internet / online services (16 per cent of the whole sample – see Table 15), can be seen in Table 16: The top rankings are again occupied by boys, 14- to 15-year-olds and *Realschule* and *Gymnasium* pupils. The relatively low proportion of *Hauptschule* pupils and particularly vocational school students is more clearly illustrated here than in Table 15.[12]

## 9. Acquisition of Internet/online knowledge

As is revealed in Table 17a, the young person's friends are the most important point of reference in the acquisition of Internet / online

knowledge: this applies particularly to boys and 14- to 17-year-olds. Parents also frequently seem to be important contacts. They are particularly approached by girls and 12- to 13 -year-olds, who evidently seek and find strong support from their teachers. It is remarkable that 23 per cent of boys and 21 per cent of 12- to 13-year-olds have acquired the relevant knowledge and skills themselves. This result must be particularly stressed, since the requirements that must be met by young people in order to handle Internet/on-line services are very demanding.

Table 17 a: **Sources of information about handling Internet/on-line services**
(basis: young people actually using Internet/on-line; N=125; answers in %)

| Source of guidance | Total | F | M | 12-13 | 14-15 | 16-17 |
|---|---|---|---|---|---|---|
| Friends | 38 | 27 | 46 | 17 | 46 | 41 |
| Parents | 20 | 25 | 16 | 34 | 19 | 11 |
| Found out myself | 17 | 9 | 23 | 21 | 15 | 16 |
| Teachers | 9 | 18 | 1 | 17 | 8 | 5 |
| Relatives/acquaintances | 8 | 11 | 6 | 7 | 6 | 11 |
| Brothers/sisters | 5 | 5 | 4 | 3 | 4 | 4 |
| Internet café | 2 | 2 | 1 | 0 | 0 | 5 |
| Others (expert, etc.) | 2 | 2 | 3 | 0 | 2 | 5 |
| Basis (abs.) | 125 | 55 | 70 | 29 | 52 | 44 |

Table 17b: **Sources of information about handling Internet/online services**
(basis: young people actually using Internet/online; N=125; answers in %)

| Source of guidance | Hauptschule | Realschule | Gymnasium | Voc. school |
|---|---|---|---|---|
| Friends | 35 | 38 | 40 | 30 |
| Parents | 15 | 23 | 21 | 10 |
| Found out myself | 5 | 21 | 19 | 10 |
| Teachers | 30 | 4 | 4 | 10 |
| Relatives/acquaintances | 10 | 6 | 4 | 30 |
| Brothers/sisters | 7 | 5 | 4 | 0 |
| Internet café | 0 | 0 | 4 | 0 |
| Others (expert, etc.) | 0 | 2 | 2 | 10 |
| Basis (abs.) | 20 | 47 | 48 | 10 |

The pupils' key point of reference is their friends, as can be clearly seen in the case of those attending *Realschule* and *Gymnasium*, but they apparently still seek considerable advice from their parents (see Table 17b). Unlike *Realschule* and *Gymnasium* pupils, their counterparts from the *Hauptschule* and the vocational school complement their weaker reference to their friends with a more intensive contact with teaching staff (*Hauptschule* pupils) and

relatives/acquaintances (vocational school pupils).

The latter can be explained by the fact that only five per cent of *Hauptschule* pupils and 10 per cent of vocational school students taught themselves, as opposed to 20 per cent of *Realschule* and *Gymnasium* pupils. An interesting point is that a good proportion of vocational school students occupy the category *Others (experts, etc)*. This is probably explained by the fact that at least a few vocational school students learn how to handle a PC in their company training scheme.

## 10. Interest in Internet/online services

Evidently very many of the 125 young people have already tried out several services offered in Internet and on-line. But Table 18a also reveals that girls and boys in addition to the individual age groups feature quite different user patterns in connection with the services on offer.

Girls particularly prefer the sections 'sending e-mails', 'listening to music/sound files' and 'seeing pictures/videos'. No. 1 for the boys is the section 'listening to music/sound files', followed by the quartet 'sending e-mails', 'seeing pictures/videos', 'chatting' and 'network games'. Boys also have a great interest in the services 'downloading' and 'visiting data banks', evidently of little interest for girls. For 12- to 13-year-olds the sections 'sending e-mails', 'listening to music/sound files' and 'network games' are equally important, and 'seeing pictures/videos' just a little less. 14- to 15-year-olds also like 'sending e-mails', 'listening to music/sound files', and – not quite to the same extent – 'seeing pictures/videos'. In contrast, 16- to 17-year-olds – despite their preference for 'sending e-mails' – are particularly faithful enthusiasts of 'chatting', 'downloading' and 'data banks', ie services that, mainly due to their cognitive and technical demands – are, at best, only of average relevance for younger kids.

Table 18a: **Use of Internet/online services**
(basis: young people actually using Internet/online; N=125; frequency in %)

| Services | Total | F | M | 12-13 | 14-15 | 16-17 |
|---|---|---|---|---|---|---|
| Sending e-mails | 66 | 67 | 66 | 69 | 73 | 67 |
| Listening to music/sound files | 66 | 62 | 70 | 69 | 73 | 57 |
| Seeing pictures/videos | 62 | 56 | 66 | 66 | 62 | 59 |
| Chatting | 56 | 47 | 63 | 52 | 52 | 64 |
| Network games, MUDs | 54 | 44 | 63 | 69 | 50 | 50 |
| Downloading | 46 | 31 | 59 | 41 | 42 | 55 |
| Visiting data banks | 44 | 29 | 56 | 31 | 44 | 52 |
| Basis (abs.) | 125 | 55 | 70 | 29 | 52 | 44 |

In terms of school education, it was ascertained that *Hauptschule* pupils are only moderately interested in 'e-mailing', 'chatting', and 'visiting data banks', but show an intensive interest in 'music/sound files' and 'downloading' (see Table 18b).

164

Table 18b : **Use of Internet/online services ('occasionally')**
(basis: young people actually using Internet/online; N=125; frequency in %)

| Services | Hauptschule | Pupils in Realschule | Gymnasium | Voc. school |
|---|---|---|---|---|
| Sending e-mails | 50 | 68 | 75 | 50 |
| Listening to music/sound files | 70 | 77 | 56 | 60 |
| Seeing pictures/videos | 50 | 70 | 58 | 60 |
| Chatting | 35 | 53 | 67 | 60 |
| Network games, MUDs | 55 | 66 | 46 | 40 |
| Downloading | 55 | 43 | 46 | 50 |
| Visiting data banks | 35 | 43 | 48 | 50 |
| Basis (abs.) | 20 | 47 | 48 | 10 |

*Realschule* pupils also show a merely average interest in 'e-mailing" and 'chatting', in radical contrast to their great preference for 'music/sound files', 'pictures/videos' and 'network games'. *Gymnasium* pupils, on the other hand, set great store in 'e-mailing' and 'chatting'. This is probably the reason why they can spend less time on entertainment services ('listening to music/sound files', 'seeing pictures/videos' and 'playing network games'), 'downloading', and 'visiting data banks'.

The situation is a little different in the case of vocational school students; they are also only moderately interested in entertainment facilities, but this lack of enthusiasm is not offset by intensive 'e-mailing' and 'chatting' (although they are apparently not averse to practising the latter). Their interest focuses more on 'downloading' and 'visiting data banks'.

## 11. Reasons for using Internet/online services

Like the previously discussed attitudes towards the PC, the attitude to Internet/online services is positive. The tenor of this attitude: on the one hand, it is fun to spend one's time in Internet and online; on the other, this facility offers opportunities unavailable elsewhere for acquiring information and making contacts. Table 19a reveals that this applies to both girls and boys as well as individual age groups.

As expected, girls and boys differ regarding 'interest in things technical' and the opportunity 'to do things that not everyone does'. In both cases the girls expressed a relative reluctance. The age groups also differ: the 12- to 13-year-olds are keener on using the PC for making contacts and passing the time than the 14- to 17-year-olds. And yet the 12- to 13-year-olds stress the usefulness of Internet/online services as learning aids and as services that provide new activities and activities that are not available to everyone.

Table 19a: **Reasons for Internet/online services use**
(basis: young people actually using Internet/online; N=125; answers in %)

| Reasons for using Internet | Total | F | M | 12-13 | 14-15 | 16-17 |
|---|---|---|---|---|---|---|
| Because it's fun | 75 | 73 | 77 | 72 | 75 | 77 |
| Because I can so easily get information that interests me | 68 | 67 | 69 | 66 | 71 | 66 |
| Because you can make contacts with other people | 56 | 55 | 57 | 62 | 60 | 48 |
| Because it's a good way of passing the time | 45 | 44 | 46 | 55 | 40 | 45 |
| Because I want to keep up with the latest technological developments | 42 | 38 | 46 | 41 | 44 | 41 |
| Because I like doing things that not everyone does | 30 | 24 | 34 | 41 | 27 | 25 |
| Because it's useful for school | 22 | 22 | 21 | 38 | 15 | 18 |
| Because my friends use Internet/on-line | 18 | 18 | 19 | 21 | 19 | 16 |
| Basis (abs.) | 125 | 55 | 70 | 29 | 52 | 44 |

Table 19b: **Attitudes towards the PC**
(basis: representative sample, 12- to 17-year-olds ; N=803; answers in %)

| Reasons for using Internet | Pupils in | | | |
| | Hauptschule | Realschule | Gymnasium | Voc. school |
|---|---|---|---|---|
| Because it's fun | 80 | 77 | 73 | 70 |
| Because I can so easily get information that interests me | 85 | 72 | 58 | 60 |
| Because you can make contacts with other people | 65 | 70 | 44 | 30 |
| Because it's a good way of passing the time | 57 | 31 | 31 | 50 |
| Because I want to keep up with the latest technological developments | 60 | 47 | 27 | 60 |
| Because I like doing things that not everyone does | 45 | 34 | 19 | 30 |
| Because it's useful for school | 40 | 21 | 17 | 10 |
| Because my friends use Internet/on-line | 40 | 19 | 13 | 0 |
| Basis (abs.) | 20 | 47 | 48 | 10 |

Table 19b reveals that *Hauptschule* pupils have the most positive attitude towards Internet/online services. With regard to the entertainment and pastime, information and communication, as well as technical and learning qualities of Internet/online services *Hauptschule* pupils rank much higher than the mean values ascertained for all the interviewees. They rank significantly higher than their counterparts at the *Gymnasium* – even in areas that one would not normally suppose, namely in categories such as 'acquisition of information' 'making contacts', 'interest in things technical',

and 'effective learning'. *Realschule* pupils and vocational school students can hold their own in 'making contacts' (*Realschule* pupils) and 'interest in things technical' (vocational school pupils).

## Final remarks

The above mentioned surveys showed that the majority of young people still have little to do with PC and Internet activities, particularly compared to their counterparts in the USA. According to a survey carried out by USA TODAY, CNN and the American National Science Foundation (NSF) the motto there is: *'Techno-kids can't live without their computers'*. This is expressed in the phenomenon that 98 per cent of 12- to 18-year-olds use a computer – at home and / or at school – spending 4.4 hours a week in front of the monitor.[13]

It is more than probable that the situation here will develop in a similar, if not identical, fashion. It is therefore all the more unfortunate that youth and educational research in Germany have hardly taken into consideration what this means for most young people, ie not only for the virtual communities of computer freaks[14] or the mini-group of qualified students of computer science,[15] but also for the vast majority of young people growing up in the PC / Internet world with its promises, demands and both positive and negative opportunities.[16]

There are several references to study courses, learning and counselling projects planned and partly realised in schools and youth institutions outside school.[17] But no matter how significant, how prolific and how practical and sensible most studies and projects of this kind are, they do not adequately consider the living conditions and awareness of the majority of young people. They usually focus on the narrowly defined interests of specific young people's groups or on the equally narrowly defined notions of benevolent adult friends and helpers.[18]

But it is not possible to just cross off the scientific elucidation of the topic of youth and the PC or the Internet. Moreover, a pedagogical approach is needed in which the crucial, but possibly fateful, individual and social consequences of the emerging PC / Internet world are an essential point of reference – especially when three of the most serious problems are taken into account:

- as yet the PC and Internet box of tricks is only adapted to the interests of educationally and financially privileged members of so-called high-technology production;
- there is an intensified commercialisation and thus considerable increase in prices for PC and Internet use;
- there is a shortage of staff and funds particularly in the fields (school, training, leisure-time institutions) where young people could be systematically introduced to using the PC and the Internet and which could provide the public premises for this purpose.[19]

It must therefore be remembered that the alternating waves of public

glorification and condemnation of the PC and of Internet cannot yet fall back on a solid foundation of knowledge which can produce reliable analyses and pedagogical approaches specifically related to the situation of young people. The BR/IZI study and the Feierabend/Klingler survey therefore represent significant starting points which must be pursued very soon and very fast, however. This is the only way to create the basis for paving the way to pedagogical, practical goals, namely helping young people to proceed from the 'electronic superhighway to everyday life, from virtual communities to real friendships, from complex information to concrete issues'.[20]

## References

Baacke, D. (1997). Internet, Multimedia und neue Entwicklungsaufgaben. (Internet, multimedia and new development tasks.) *GMK-Rundbrief,* (41), pp. 3-10.

Bahl, A. (1997). *Zwischen On- und Offline. Identitaet und Selbstdarstellung im Internet.* (Between online and offline. Identity and self-portrayal in Internet.) Munich: Kopaed.

Batinic, B., Bosnjak, M. and Breiter, A. (1997). Der 'Internetler'. Empirische Ergebnisse zum Nutzungsverhalten. (The 'Internetler'. Empirical findings on use behaviour.) In L. Graef (ed), *Soziologie des Internet – Handeln im elektronischen Web-Werk.* Frankfurt am Main: Campus, pp. 196 ff.

Eimeren, B. van and Maier-Lesch, B. (1997). Die Sache mit der Politik im Fernsehen. (The thing about politics on television.) *TelevIZIon* 10 (1), pp. 9-13.

Fasching, T. (1997). *Internet und Paedagogik. Kommunikation, Bildung und Lernen im Netz.* (Internet and pedagogy. Communication, education and learning in the Net.) Munich: Kopaed.

Feierabend, S. and Klingler, W. (1997). *Ergebnisbericht: Jugendliche und Multimedia.* (Findings report: Young people and multimedia.) Baden-Baden: Medienpaedagogischer Forschungsverbund Suedwest, SWF.

Fischbach, R. (1997). Schule ans Netz? (Schools into the Net?) *Blaetter fuer deutsche und internationale Politik,* (9), pp. 1055-1059.

Fritzsche, Y. (1997). Jugendkulturen und Freizeitpraeferenzen. Rueckzug vom Politischen? (Youth cultures and leisure-time preferences. Withdrawal from politics?) In Deutsche Shell-Aktiengesellschaft, Hamburg, Jugendwerk (ed.), *Jugend '97. Zukunftsperspektiven,Gesellschaftliches Engagement, Politische Orientierungen.* Opladen: Leske u. Budrich, pp. 343-377.

Kübler, H.-D. (1997). Surfing, chatting, mailing ... Wieviel und was fuer eine Paedagogik braucht Internet? (Surfing, chatting, mailing ... How much and what kind of a pedagogical approach does the Internet need?) Teil 1 *Medien praktisch,* 21(3), pp. 4-9.

*Medien praktisch,* 21/1997/2, pp. 4-32 und 21/1997/3, pp. 4-33.

Petzold, M., Rohmann, M. and Schikorra, Sabine (1997). Computernutzung und Persoenlichkeitsmerkmale. (Computer use and personality features) *Medien und Erziehung,* 40(5), pp. 347-351.

BR/IZI-Studie (1997). *Jugend und Medien. Eine quantitative Studie.* (Youth and media. A quantitative study.) Vol.1-3. Munich: IZI (unpublished report).

Rilling, R. (1996). Enternet. In G. Ahrweiler *et al.* (eds), *Soziologische Ausfluege.* Opladen: Westdeutscher Verlag, pp. 239 ff.

Rilling, R (1997). Auf dem Weg zur Cyberdemokratie?. (Off to a cyberdemocracy?) http://staff-www.uni.de/marburg.de/(rillingr/bdweb/texte/cyberdemokratie .html (Text und Fußnoten)

Sandbothe, M. (1996). Interaktive Netze in Schule und Universitaet. Philosophische und didaktische Aspekte. (Interactive networks at school and university. Philosophical and didactic aspects.) In S. Bollmann *et al.* (eds), *Kursbuch Internet. Anschluesse an Wirtschaft und Politik, Wissenschaft und Kultur.* Mannheim: Bollmann, pp. 424-433.

Schmidbauer, M., Löehr, P. (1997). Jugendmedien und Jugendszenen. Ergebnisse einer aktuellen Untersuchung. (Youth media and youth scenes. Findings of a current survey.) *Televizion*, 10 (1), pp. 13-26.

USA TODAY Technical Report, 5.12.97. http://www.usa-today.com/life/cyber/tech/cta319.htm)

Vogelgesang, W. (1997). Virtuelle Erlebniswelten: Computer- und Netzfreaks. (Virtual worlds of experience: computer and network freaks.) *Medien praktisch*, 21(2), pp. 27-32.

## Notes

1   The German version of this article appeared in *TelevIZIon* 10/1997/2, pp. 28-40.

2   Cf. BR/IZI-Studie 1997; Schmidbauer and Löhr 1997. The basis of this survey was a representative sample (N=1,060) of 12- to 19-year-olds from all federal states of Germany.

3   Cf. Feierabend and Klingler 1997 Abschnitt 3

4   Cf. Schmidbauer and Löhr 1997; pp. 14-15.

5   Translator's note: The translations of the school types can only be approximations. Secondary modern school has been used for *Hauptschule*; secondary school for *weiterführende Schule*, or *Realschule*, which leads to the equivalent of GCSEs; grammar school for *FH-Reife, Abitur*, which lead to university entrance qualifications.

6   Cf. van Eimeren and Maier-Lesch 1997; p. 9.; chapter 6 of this volume.

7   If the values for the categories up to 2 hours etc. were not related to all the interviewees, but only to 15.2 per cent of the young people using the PC daily/almost daily, it would be revealed that 65 per cent of these 15 per cent spend 1 to 2 hours, 25 per cent 2 to 4 hours and 10 per cent 5 to 8 hours daily in front of the monitor.

8   Cf. Schmidbauer and Löhr 1997; p. 17.

9   Feierabend and Klingler 1997: p. 12

10   For a comparison with the results of the BR/IZI survey see the beginning of Section 8.

11   Unlike the BR/IZI survey, in which the subject of Internet use was only generally surveyed, Feierabend and Klingler combine the item 'Internet/on-line' Internet services and online services without any Internet use, eg data bank searches.

12   It must be taken into account that data in Tables 17, 18, 19 and 20 (both a and b) are initially based on a (sub-) sample of 125 respondents and contain very limited sub-groups; therefore only very careful and guarded statements can be made. Cf. Batinic, Bosnjak and Breiter (1997) on the current problematic and meagre research situation, not only with regard to young people.

13   Cf. USA TODAY 1997: Technical Report of 5 December 1997 (available online)

14   Cf. Vogelgesang 1997.

15   Cf. the seven-person survey in Bahl 1997 or the psychological survey of 400 students at the Universities of Düsseldorf and Cologne in Petzold, Rohmann and Schikorra 1997.

16   Cf. Fritzsche 1997; the 12th. survey of the German Shell AG *Jugend '97* reveals very little, since the young people's statements compiled there only refer to the item 'playing on the computer' and are only superficially evaluated.

17   Cf. medien praktisch 1997 and GMK circular letter 1997

18   Cf. the contributions – committed to a cautious approach and argumentation – by Baacke (1997) and Kübler (1997), and particularly the book by Fasching (1997), which contains specific information and discussions on the subject of the Internet and offers an unemotional approach and a broad range of perspectives on the subject of PC/the Internet from both the technical and structural services and utilisation points of view.

19   Cf. Rilling 1995, 1996; Fischbach 1997.

20   Cf. Sandbothe 1996, p. 433.

# 4: Television Features and Formats

# Television formats and the child's processing of visual information
## An overview and a selected bibliography[1]

*Michael Schmidbauer*

The studies presented here deal with the formal features of television. Most of them relate to US American 4- to 10-year-old children and were carried out in the 1980s. Their analysis is based on the following assumptions:

- the significant structure of the medium of television has to be sought in the formal features (camera setting, editing, montage, pace of presentation, physical movements of the actors, succession of the scenes, form of the plot and narration, the personality of the characters) with which the medium presents the respective programme content (themes);
- every event mediated by a television programme can be described with regard to these presentation forms;
- the presentation forms have a profound influence (positive or negative) on the child's attention, comprehension and handling of the programme content.

Furthermore, in analysing the results of these studies one would have to ask whether they have any importance for the design and the production of television programmes for children in Germany. It is true that the central issues of debate here – such as the role of television for the children's socialisation, the dialectic of form and content as well as the organisational-economic limits and possibilities of programme production – are only vaguely referred to in most of the studies.

Nevertheless, the studies do contain a great deal of material which should not be ignored by research into children's television here in Germany. This applies in particular to the individual formal attributes of children's programmes or of TV commercials made to appeal to them, and also to the impact that these attributes may have on the children's cognitive and emotional reactions while viewing, on their perception and processing of programmes contents and on their behaviour.

A discussion of the findings obtained for American children's relationship with their television would, however, only be meaningful if they were analysed with regard to children's and 'child-relevant' programmes and their audience here in Germany. It would thus be possible, first, to check to what extent the American findings can be transferred and considered as relevant to the circumstances of German children's television.

And, secondly, there would also be a chance to compare the procedures and findings of the American research with the analysis of formal programme features that takes place in Germany with an entirely critical intent.

Here a few studies of the connection between picture, music and text formats and the cognitive and emotional reactions of children should be mentioned (see, for example Sturm, Bauer and Grewe-Partsch, 1982); or the analyses of children's handling of the 'grammars' of film and television stories (Nieding 1989; Böhme-Dürr, 1985); the discussion on the effects that the so-called 'short-term' modes of televised presentation have on children's strategies of perception and processing has to be recalled as well (Sturm, 1975, 1977, 1987).

## 1. Overviews

Huston, A. C. and Wright, J. C. (1989). The Forms of Television and the Child Viewer. In G. Comstock (ed), *Public Communications and Behavior*. Vol. 2. New York: Academic Press, , pp. 103-158.

Huston, A. C. and Wright, J. C. (1983). Children's processing of television: The informative functions of formal features. In J. Bryant, J. and D. R. Anderson (ed), *Children's Understanding of Television. Research on Attention and Comprehension*. New York: Academic Press, pp. 35-68.

Rice, M. L., Huston, A. C. and Wright, J. C. (1983). The forms of television. Effects on children's attention, comprehension and social behavior. In M. Meyer (ed), *Children and the formal features of television*. Munich *et al.*: Saur, pp. 21-55.

Wright, J. C. and Huston, A. C. (1987). A Matter of Form: Potential of Television for Young Viewers. In: M. Grewe-Partsch, J. Groebel (ed), *Mensch und Medien*. Munich etc: Saur, , pp. 42-57.

If one looks for an overview on the knowledge that accumulated in the 80s on the subject of formal features and children's processing of television programmes, four articles would have to be mentioned in particular that reflect the work of Huston and Wright and their associates at the University of Kansas[2]

Their studies are based on the assumption that children are active viewers who turn to the programme selectively and take it in and evaluate it according to their development and experience, in particular according to their cognitive abilities and their preconceptions of television. The formal attributes of the medium, their definitions and the methods of their analysis are described and conclusions that could be drawn for structuring programmes for children are discussed. It is shown how

- the children's cognitive processing and their handling of the formal features of television are connected;
- these features affect the attention and comprehension which the children show for the programme;
- these features influence children's orientation and behaviour.

## 2. Empirical studies on particular aspects

Abelman, R. (1990). You can't get there from here: Children's understanding of time-leaps on television. *Journal of Broadcasting and Electronic Media*, 34 (4), pp. 469-475.

In this study 215 children aged three, four, six and eight were examined to see how they perceive and process the time structure of a programme and especially the time-leaps inserted into it. The result shows that the children can deal with the time structure and correctly interpret time-leaps to the same extent as they develop the capacity to follow elaborate conversations. Pre-supposing that, the quantity of television consumed by children plays an essential part.

Alwitt, L. F., Anderson, D. R., Lorch, E. P. and Levin, S. R. (1980). Preschool children's visual attention to attributes of television. *Human Communication Research*, 7(1), pp. 52-57.

The subject of the study was the way in which the visual attention in pre-school children can be influenced by simple visual and acoustic features of television programmes. The results:

- Attention comes about when the children are presented with puppets, women and children, sound changes and effects, unusual voices, movement, cutting to another shot, laughter and applause.
- No, or only slight, attention sets in when the children are confronted with male voices, slow camera tracking, camera panning, eye contact (with the persons on screen) and still pictures.
- How 'attention-positive' or 'attention-negative' the effect of these features is depends on whether they announce intelligible or unintelligible content. For example, male voices inhibit attention because the children associate 'serious' programmes with them (eg news transmissions).

Bryant, J., Zillmann, D. and Brown, D. (1983). Entertainment features in children's education television: Effects on attention and information acquisition. In J. Bryant and D. R. Anderson (eds), *Children's understanding of television. Research on attention and comprehension*. New York: Academic Press, pp. 221-240.

The study went into the question as to whether entertainment features (special effects, pace of presentation, animation, humour, background music) aroused and held the attention of 7- to 8-year-old children for education programmes (example *Sesame Street*). The results:

- Entertainment features increase both the children's visual attention and the extent to which they acquire information.
- Excessive length and intensity of the entertainment features, however, often limit the children's interest in the educational material quite considerably.

Calvert, S. L., Huston, A. C., Watkins, B A. and Wright, J. C. (1982). The relation between selective attention to television forms and children's comprehension of content. *Child Development*, 53, pp. 601-610.

This study focused on the question of how the visual attention, which pre-school and school children (3- to 5- and 7- to 9-year-olds respectively) pay to the formal features of television, influences their comprehension of the content of the respective programme (animated cartoon with a pro-social content). It emerged that both groups of children understood and remembered the programme content best – at a rapid as well as a moderate pace of presentation – that contained perceptually salient features. (Perceptually salient features were understood as the rapidity of directing, cuts, montage, fade-over, fade-down and fade-out, sound effects etc. in which the pace of presentation and the multiplicity of the scenes and players is manifested.)

The younger children were especially attentive when they heard perceptually salient sound effects. The attention of the older children was particularly pronounced when children's dialogues and a moderate pace of presentation were offered. There was no, or only very little, attention when the younger children were confronted with a male voice and the older ones with camera zooms.

Calvert, S. L., Huston, A. C. and Wright, J. C.( 1987). Effects of visual and verbal televised preplays on children's attention and comprehension. *Journal of Applied Developmental Psychology*, 8(4), pp. 329-342.

The result of this study – also involving pre-school and school children – was the same as in the study by Calvert, Huston, Watkins and Wright (1982): the attention brought about by certain perceptually salient forms ensured that the content that was made perceptually salient was best remembered and understood. The differences ascertained by Calvert *et al.* (1982) between the younger and older children was also corroborated.

Flavell, J. H., Flavell, E. R., Green, F. L. and Korfmacher, J. E. (1990). Do young children think of television images as pictures or real objects? *Journal of Broadcasting and Electronic Media*, 34(4), pp. 399-418.

In three partial studies the question was up for debate on whether 3- and 4-year-old children interpret television images as pictures of objects or as real objects that are physically present. The result: The 3-year-olds answer according to the first version, and the 4-year-olds the second, the main difficulty being for the 3-year-olds that they are not (yet) able to distinguish conceptually between television images and 'real' objects to which they can relate.

Greer, D., Potts, R., Wright, J. C. and Huston, A. C. (1982). The effects of television commercial form and placement on children's social behaviour. *Child Development*, 53, pp. 611-619.

A group of pre-school children was shown television commercials for some of which a higher and for others a lower degree of perceptually salient forms were characteristic. (see Calvert, Huston, Watkins and Wright) The children, who were distracted by toys that were on hand for the purpose, were only attentive when they were confronted with such (audible and visible) forms. Additionally, it turned out that in the play breaks after the programme had been shown, the group of children that had seen the perceptually salient commercials was significantly more aggressive than the group that had not.

Huston, A. C., Greer. D., Wright, J. C., Welch, R. and Ross, R. P. (1984). Children's comprehension of televised formal features with masculine and feminine connotations. *Developmental Psychology*, 20 (4), pp. 707-716.

The starting point was the fact – corroborated in a content analysis – that specific formal features of television are signals for specific, in this case for gender-specific, orientation. Using the example of commercials it was demonstrated that:

- products for girls and/or women are made attractive with the help of 'immediate' background music, soft fade-outs and fade-overs and a female voice;
- products for boys and/or men, however, are made attractive with the help of speed, action, rapid cuts, loud music and appropriate background noises.

Such formal features were presented within the framework of specially produced, gender-specifically 'neutral' mock-commercials to a group of 4- to 9-year-old children, and they were asked whether those features belonged to 'female' or 'male' products. The children – even the 4-year-olds – had no difficulty in identifying the formal features and assigning the relevant products to them (eg 'doll's pram' or 'truck').

Huston, A. C., Wright, J. C. and Potts, R. (1982). Fernsehspezifische Formen und kindliches Sozialverhalten. (Television-specific formats and children's social behaviour.) *Fernsehen und Bildung*, 16(1-3), pp. 128-138.

The report refers to three studies which the authors (on collaboration with other members of staff) carried out at the Center for Research on the Influence of Television on Children at the University of Kansas. The effect of perceptually salient programme formats and aggressive programme content (portraying violence) on attention and social behaviour of pre-school children were analysed. The main findings were:

- The formal aspects that were examined (see Calvert, Huston, Watkins and Wright 1983) had considerably more influence on the children than the violence shown in the programme.
- The portrayals of violence were no more attractive for the children than non-violent programmes, when the latter were also presented in perceptually salient forms.

- Although this could not be established beyond all doubt, the confrontation with the perceptually salient forms (no matter whether in the portrayal of violence or in programmes without violence) triggered in the children a diffuse excitement, which could only be specified indirectly through the interaction situation (and its 'stimuli' that influence behaviour) which the children entered after seeing the programme.

Huston, A. C., Wright, J. C., Wartella, E., Rice, M., Watkins, B. A., Campbell, T. and Potts, R. (1981). Communicating more than content: Formal features of children's television programs. *Journal of Communication*, 31(3), pp. 32-48.

This analytical study of the programme uncovers what have been labelled ever since as perceptual salient formal features. The authors distil from 137 children's programmes transmitted by US commercial television and the Public Broadcasting System (PBS) during a week in November 1977 and one week in February 1978 what in a formal regard is typical of the entertainment and educational programmes (aimed at children). The principal results were:

- The *entertainment programmes* (animated cartoon series, game and quiz shows, feature films) are characterised by perceptually salient qualities that are aimed at an intensive visual and auditive impact and by only very little spoken language (dialogue); their attributes are action (realised visually and acoustically and provided with special picture, sound and noise effects), speed and variability which express themselves in the physical movements of the characters, in the change of scenes and overall setting.

- In *educational programmes* (offered by PBS in particular) perceptual salient features (ie rapid directing, cuts, montage, fade-over, fade-off and fade-out etc) in which the above-mentioned action, speed and variability express themselves get much less of a look-in. In these an attempt is made to capture the children's attention by using both visual techniques (slow camera tracking, slow directing) and elaborate spoken plots to increase an understanding of the programme and to heighten the children's abilities to reflect.

Meadowcroft, J. M. and Reeves, B (1989). Influence of story schema development on children's attention to television. *Communication Research*, 16(3), pp. 352-374.

This study looked into the question of to what extent the attention of 5- to 8-year-old children paid to a television programme and whether their ability to remember its content depend on the way in which the narrated plot follows an intelligible story schema. It was impressively demonstrated that – mediated by such a schema – the degree of attention, the comprehension of the main content, the extent of the parts of the programme remembered and the ability to piece these parts sensibly together were considerably enhanced.

Rice, M. L. and Haight, P. L. (1986). The 'motherese' of Mr. Rogers. *Journal of Child Language*, 51, pp. 282-287.

An analysis of the linguistic forms that are characteristic of the series *Mister Rogers' Neighborhood* and *Sesame Street* was carried out. The results:

- The linguistic forms of the programmes are strongly imitative of 'motherese', the way mother and child talk with one another, and thus correspond well to the children's language abilities.
- The course of the dialogue was unhurried; words and parts of sentences were often reiterated, and sentences were explained again and again.
- The characters always spoke in whole sentences and specially accentuated the words that were important for the content.
- The subject was looked at from different angles and narrowed down in its meaning, and what was actually spoken was always illustrated by pictures.

Compared with *Mister Rogers' Neighborhood* and *Sesame Street*, commercial entertainment programmes were unintelligible to the children, confronting them with a hectic dialogue and statements that were often abstract and remained impenetrable as to their meaning.

Rice, M. L., Huston, A. C. and Wright, J. C. (1986). Replays as repetitions: Young children's interpretation of television forms. *Journal of Applied Developmental Psychology*, 7(1), pp. 61-76.

The point of departure for this study was the problem that many children's broadcasts are made up of several programme forms (eg segments in magazine programmes) which are only intelligible in themselves if they can be distinguished from one another. Moreover, before, during and after the respective broadcast commercials are transmitted, which the children should be able to clearly distinguish from the programme. To make it easier for the children to do so, special formal indicators (visual or acoustic markers) are inserted in such programmes – and generally before commercials are slotted in – in order to function as 'dividing lines'.

It now turned out in the study that the 5- to 6-year-olds interviewed are hardly capable of interpreting such markers as 'dividing lines': they have great difficulty, for example, in identifying the immediate replay of a scene that has just been transmitted as a repetition and correctly understanding its position within the overall broadcast. They find it just as difficult to infer from a visual and/or acoustic marker that the programme has switched over to advertising. In a study quoted by Rice, Huston and Wright it was discovered that the children only understand the switch-over when a 'stop sign' appears on the screen and it is stated quite unequivocally that a commercial is coming up.

Smith, R., Anderson, D. R. and Fischer, C. R. (1985). Young people's comprehension of montage. *Child Development*, 56, pp. 962-971.

In the first part of the study short video tapes were played to a group of 3- to 5-year-old children in which sequences of easily understandable events were joined together by cutting: (eg picture 1: a boy is sitting on a staircase and asks his mother if he can go out and play; picture 2: the boy is playing in the street). The children could follow the films without any effort and retell the stories presented.

In the second part of the study 4- to 7-year-old children were shown video tapes with a similar content, but presented in a more complex way: ellipsis was used (parts of the programme are omitted, but the viewer can complete the connection because of the sense), presenting strands of the plot running parallel. Both the younger and the older children could follow the spatial, temporal and personal connections without any difficulty. The children scored the best results when the events presented were simple and familiar to them, and when they not only had to say what they had understood, but when it was possible for them to reconstruct the particular film story as a whole.

Wartella, E. and Hunter, L. S. (1983). Children and the formats of television advertising. In M. Meyer (Ed.), *Children and the formal features of television*. Munich *et al.*: Saur, pp. 144-165.

As part of a very informative literature report on the subject, the authors present a study of their own. It aimed at extracting the discursive structures of television commercials, ie the pictorial and linguistic forms used to present the products. The question that was more far reaching for the authors, but remained unanswered in the study, concerned the way in which these structures are taken in and processed by the children. In the analysis of the commercials three forms of discursive structures were found: descriptive, expository and narrative structures. What is characteristic of the advertising commercials is the dominance of expository (basis: the power of persuasion) and descriptive structures (basis: product information). The task that emerges from the discursive-theoretical description of the commercials is to analyse how the discursive forms help children to gather the sense of the advertising message and by what means and how the discursive forms affect children's desire for a product.

Wright, J. C., Huston, A. C., Ross, R. P., Calvert, S. L. *et al.* (1984). Pace and continuity of television programs: Effects on children's attention and comprehension. *Developmental Psychology*, 20(4), pp. 653-666.

Primary school children were shown programmes that were either made in magazine format or in which stories were told. The perceptually salient features were largely identical in both kinds of the programmes. These were characterised by rapid or slow presentation and by short- or longer-lasting continuity of the action presented. The children were more attentive to the stories, without, however, being more strongly influenced by the pace of presentation. What seemed to be decisive was

that the children, because of their development and television experience up to then, were guided by the view that comprehending stories called for more effort than comprehending magazine programmes, because the content of the stories as a temporally structured coherence had to be grasped.

## References and further literature

Abelman, R. (1990).You can't get there from here. Children's understanding of time-leaps on television. *Journal of Broadcasting and Electronic Media*, 34(4), pp. 469-476.

Alwitt, L.F., Anderson, D.R., Lorch, E.P. and Levin, S.R. (1980). Preschool children's visual attention to attributes of television. *Human Communication Research*, 7(1), pp. 52-67.

Anderson, D.R. and Field, D.E. (1983). Children's attention to television. Implications for production. In M. Meyer (ed), *Children and the formal features of television*. Munich *et al.*: Saur, pp. 56-96.

Anderson, D.R. and Lorch, E.P. (1983). Looking at television: Action or reaction? In J. Bryant (ed), *Children's understanding of television*. New York, N.Y. *et al.*: Academic Press, pp. 1-33.

Böhme-Dürr, K. (1985). Verarbeitung von massenmedialen Informationen durch Kinder. 'Wald' oder 'Baeume'? (The processing of mass media information by children. 'Wood' or 'trees'?) In G. Bentele *et al.* (ed), *Zeichengebrauch in Massenmedien*. Tuebingen: Niemeyer, pp. 195-228.

Bryant, J., Zillmann, D. and Brown, D. (1983). Entertainment features in children's educational television: Effects on attention and information acquisition. In J. Bryant (ed), *Children's understanding of television*. New York, N.Y. *et al.*: Academic Press, pp. 221-240.

Calvert, S.L., Huston, A.C., Watkins, B.A. and Wright, J.C. (1982). The relation between selective attention to television forms and children's comprehension of content. *Child Development*, 53(-), pp. 601-610.

Calvert, S.L., Huston, A.C. and Wright, J.C. (1987). Effects of visual and verbal televised preplays on children's attention and comprehension. *Journal of Applied Developmental Psychology*, 8(4), pp. 329-342.

Collins, W.A. (1987). Fernsehen: kognitive Verarbeitungsprozesse. (Television: cognitive processing processes.) *Unterrichtswissenschaft*, 15(4), pp. 410-432.

Dorr, A. (1986). *Television and children. A special medium for a special audience.* Beverly Hills: Sage.

Dorr, A., Doubleday, C. and Kovaric, P. (1983). Emotions depicted on and stimulated by television programs. In M. Meyer (ed), *Children and the formal features of television*. Munich *et al.*: Saur, pp. 97-143.

Esslin, M. (1989). *Die Zeichen des Dramas. Theater, Film, Fernsehen.* (The symbols of drama. Theatre, Film, TV.) Reinbek: Rowohlt.

Fiske, J. (1987). *Television culture*. London *et al.*: Methuen.

Flavell, J.H. (1985). *Cognitive development.* Englewood Cliffs: Prentice-Hall (2nd edition)

Flavell, J.H., Flavell, E.R., Green, F.L. and Korfmacher, J.E. (1990). Do young children think of television images as pictures or real objects? *Journal of Broadcasting and Electronic Media*, 34(4), pp. 399-419.

Greer, D., Potts, R., Wright, J.C. and Huston, A.C. (1982). The effects of television commercial form and commercial placement on children's social behavior and attention. *Child Development*, 53(3), pp. 611-619.

Hodge, B. and Tripp, D. (1986). *Children and television. A semiotic approach*. Stanford: Stanford University Press.

Huston, A.C., Greer, D., Wright, J.C., Welch, R. and Ross, R. (1984). Children's comprehension of televised formal features with masculine and feminine connotations. *Developmental Psychology*, 20(4), pp. 707-716.

Huston, A.C. and Wright, J.C. (1983). Children's processing of television: The informative functions of formal features. In J. Bryant (ed), *Children's Understanding of Television*. New York, N.Y. *et al.*: Academic Press, pp. 35-68.

Huston, A.C. and Wright, J.C. (1989). The Forms of Television and the Child Viewer. In G. Comstock (ed), *Public communication and behavior.2*. New York, N.Y. *et al.*: Academic Press, pp. 103-158.

Huston, A.C., Wright, J.C. and Potts, R. (1982). Fernsehspezifische Formen und kindliches Sozialverhalten. (Television-specific forms and the child's social behaviour.) *Fernsehen und Bildung*, 16(1-3), pp. 128-138.

Huston, A.C., Wright, J.C., Wartella, E., Rice, M.L., Watkins, B.A. *et al.* (1981). Communicating more than content. Formal features of children's television programs. *Journal of Communication*, 31(3), pp. 32-48.

Krull, R. (1983). Children learning to watch television. In J. Bryant (ed), *Children's understanding of television*. New York, N.Y. *et al.*: Academic Press, pp. 103-123.

Leary, A., Wright, J.C. and Huston, A.C. (1989). Young children's judgements of the fictional/nonfictional status of television programming. Zit. in Huston, A.C., Wright, J.C.: *The forms of television and the child viewer*. In G. Comstock (ed.), *Public communication and behavior.2*. New York, N.Y. *et al.*: Academic Press, pp. 103-158.

Meadowcroft, J.M. and Reeves, B. (1989). Influence of story schema development on children's attention to television. *Communication Research*, 16(3), pp. 352-374.

Mielke, K.W. (1983). The educational use of production variables and formative research in programming. In M. Meyer (ed), *Children and the formal features of television*. Munich *et al.*: Saur, pp. 233-252.

Mikunda, C. (1990). Psychologie macht Dramaturgie. Ein Hoffnungsgebiet? (Psychology creates dramaturgy. An area of hope?' *Medienpsychologie*, 2(4), pp. 243-257.

Montada, L. (1982). Die geistige Entwicklung aus der Sicht Jean Piagets. (Mental development as seen by Jean Piaget.) In Oerter, Rolf *et al.* (ed), *Entwicklungspsychologie*. Munich *et al.*: Urban & Schwarzenberg, pp. 375-399.

Nessmann, K. (1988). *Gestaltung und Wirkung von Bildungsfilmen. Ergebnisse der empirischen Forschung*. (Design and effects of educational films. Empirical research findings.) Europaeische Hochschulschriften. Reihe 11,Paedagogik. p. 365. Frankfurt,Main *et al.*: Lang.

Nieding, G. (1989). *Zeitreihenanalytische Evaluation von Modellen der Aufmerksamkeitslenkung. Ein Experiment zur kindlichen Informationsverarbeitung von TV-Programmen*. (Time series analytical evaluation of attention guidance models. An experiment on the child's information processing of TV programmes.) Berlin,West,Techn.Univ.,Institut.f.Psychologie,Dipl.1989. Berlin, West: 1989.

Palmer, E.L. (1983). Formative research in the production of television for children.

In M. Meyer (ed), *Children and the formal features of television*. Munich *et al.*: Saur, pp. 253-278.

Piaget, J. (1946). *Psychologie der Intelligenz*. (Psychology of Intelligence) Zuerich: Rascher (2. Auflage)

Pretis, S. (1986). Koennen Vorschulkinder Fernsehprogramme verstehen? Die Wirkung der formalen Gestaltung von Fernsehsendungen. (Can pre-school children understand TV programmes? The effect of the formal design of TV programmes.) *Publizistik*, 31(3-4), pp. 138-146.

Rice, M.L. and Haight, P.L.(1986). The 'motherese' of Mr. Rogers. *Journal of Child Language*, 51, pp. 282-287.

Rice, M.L., Huston, A.C. and Wright, J.C.(1986). Replays as repetitions: Young children's interpretation of television forms. *Journal of Applied Developmental Psychology*, 7(1), pp. 61-76.

Rice, M.L., Huston, A.C. and Wright, J.C.(1983). The forms of television. Effects on children's attention, comprehension and social behaviour. In M. Meyer (ed), *Children and the formal features of television*. Munich *et al.*: Saur, pp. 21-55.

Rydin, I. (1983). How children understand television and learn from it. A Swedish perspective. In M. Meyer (ed), *Children and the formal features of television*. Munich *et al.*: Saur, pp. 166-187.

Salomon, G. (1983). Beyond the formats of television. The effects of student preconceptions on the experience of televiewing. In *Children and the formal features of television*. Munich *et al.*: Saur, pp. 209-229.

Salomon, G. (1983). Television watching and mental effort. A social psychological view. In M. Meyer (ed), *Children's understanding of television*. New York, N.Y. *et al.*: Academic Press, pp. 181-198.

Singer, J.L. and Singer, D.G. (1983). Implications of childhood television viewing for cognition, imagination, and emotion. In J. Bryant (ed), *Children's understanding of television*. New York, N.Y. *et al.*: Academic Press, pp. 265-295.

Smith, R., Anderson, D.R. and Fischer, C. (1985). Young children's comprehension of montage. *Child Development*, 56(4), pp. 962-971.

Sturm, H. (1975). Die kurzzeitigen Angebotsmuster des Fernsehens. (The short-term service pattern of television.) *Fernsehen und Bildung*, 9(1), pp. 39-50.

Sturm, H. (1977). Fernsehdramaturgie und Zeigarnik-Effekt. Eine Variante zu Wahrnehmung – Entwicklung – Kommunikation. (TV dramaturgy and the Zeigarnik effect. A variation on perception – development – communication.) *Fernsehen und Bildung*, 11(1-2), pp. 103-110.

Sturm, H. (1987). Medienwirkungen auf Wahrnehmung, Emotion, Kognition. Eine Grundlage fuer medienpaedagogisches Handeln. (Media effects on perception, emotion, cognition. A foundation for media-pedagogical activity.) In L.J. Ludwig J.(ed), *Medienpaedagogik im Informationszeitalter*. Weinheim: Dt. Studien-Verlag, pp. 91-115.

Sturm, H., Vitouch, P., Bauer, H. and Grewe-Partsch, M. (1982). Emotion und Erregung – Kinder als Fernsehzuschauer. Eine psychophysiologische Untersuchung. (Emotion and stimulation – children as TV viewers. A psycho-physiological investigation.) *Fernsehen und Bildung*, 16(1-3), pp. 11-114.

Waldmann, M.R. (1990). *Schema und Gedaechtnis. Das Zusammenwirken von Raum- und Ereignisschemata beim Gedaechtnis fuer Alltagssituationen*. (Schema and memory. The combination of space and event schemata in the memory for everyday situations.) Zugl.: Munich, Univ.,Diss.,1988. Heidelberg: Asanger.

Wartella, E. (1987). *What children like and why. On the psychology of successful plots.* Paper presented to the Prix Jeunesse Research Seminar, May 27-29 1987, Munich. Stiftung Prix Jeunesse (ed). Munich: Stiftung Prix Jeunesse.

Wartella, E. and Hunter, L.S. (1983). Children and the formats of television advertising. In M. Meyer (ed), *Children and the formal features of television.* Munich et al.: Saur, pp. 144-165.

Watt, J.H. and Welch, A.J. (1983). Effects of static and dynamic complexity on children's attention and recall of televised instruction. In J. Bryant (ed), *Children's understanding of television.* New York, N.Y. et al.: Academic Press, pp. 69-102.

Wright, J.C., Huston, A.C. (1987). A matter of formL: Potentials of television for Young Viewers. In M. Grewe-Partsch et al. (ed), *Mensch und Medien.* Munich et al.: Saur, pp. 42-57.

Wright, J.C., Huston, A.C., Ross, R.P. et al. (1984). Pace and continuity of television programs. Effects on children's attention and comprehension. *Developmental Psychology,* 20(4), pp. 653-666.

## Notes

1    The German version of this article appeared in *TelevIZIon* 4/1991/1, pp. 21-26.

2    Both were then co-directors of the Center for Research on the Influence of Television on Children (CRITC); Cf. especially Huston and Wright 1983; Huston and Wright 1998; Rice, Huston and Wright 1984; Wright and Huston 1987.

# Understanding – yes or no? Designing children's news on television[1]

*Paul Löhr*

The literature discussed here comprises documents on the history of television news for children (1), on programme producers' and editors' self-image (2), on programme analysis (3), on use studies (4) and assessing aspects of media education (5). As some of the texts contribute to several of the areas mentioned, please note the cross-references given at the end of some of the articles.

**1. The history of television news for children[2]**
Mattusch, U. (1991). Nachrichten für Kinder. Stationen einer Entwicklung. (News for children, stages of a development.) In H. D. Erlinger (ed), *Kinderfernsehen III* (children's television III). Essen: Die blaue Eule, pp. 73-98.

In his article Mattusch makes it clear what importance has been attached to television news programmes in the history of ARD and ZDF. Section 1 contains a table of children's television news broadcasts produced and transmitted in the period from 1970 to 1990. In Section 2 the detailed descriptions of some programmes are given: *Nachrichten des Monats* (HR, 1970); *Tagesschau auch für Kinder* (ARD, 1971); *Durchblick* (SDR, SR, SWF, 1976-1979). Section 3 is devoted to *logo,* the current ZDF children's news programme. Here the self-image of the production team responsible is outlined, together with some important results from the research accompanying *logo,* which investigated both the conception of the programme and its production as well as the reactions and attitudes of the children who watch.

**2. The self-image of the programme producers and editors[3]**
Wellershoff, I., Ammermann, A. and Müller, S. (1991). Konzeptionen konkret. Beispiele aus dem aktuellen Kinderprogramm. (Concrete conceptions. Examples from the current ZDF children's programme.) In Zweites Deutsches Fernsehen (ed), *Kinderfernsehen – Fernsehkinder.* Mainz: von Hase & Köhler, pp. 53-58.

This article presents a brief sketch of the *logo* conception and the self-image of the producers of this programme. The contribution is especially important because in it Susanne Müller, the responsible producer of *logo,* expresses her views.

## 3. Programme analyses[4]

Bourne, C. (1986). *Children's Television News as Political Communications.* Paper presented to the 2nd International Television Studies Conference, London, 10th-12th July, 1986. London: British Film Institute.

This conference paper deals with the BBC's children's news programme *Newsround.* In the light of the latter and its relation to children's interests, the possibilities of developing a political awareness in keeping with the children's processing abilities are discussed. An important finding of the study is that the established patterns of adults' news are very emphatically gaining the upper hand in children's news and thus many educational and didactic intentions with which the producers first approached children's news come to nothing. This means that children's news often brings nothing but information for adults that has been trimmed in length. The only difference then seems to be that in news for adults an insecure and dangerous world full of problems is presented, but in children's news it is more likely to be a hopeful, more secure world that respects human life.

Brand, M. and Ruhrmann, G. (1991). Zeitgeschehen à la carte. Ereignis, Nachricht und Rezipient. (Current affairs à la carte. Event, news and recipient.) Funkkolleg *Medien und Kommunikation – Konstruktionen von Wirklichkeit* (Media and communication – constructions of reality.) 14th Kollegstufe. Frankfurt am Main: Hessischer Rundfunk.

In their contribution – the manuscript for the educational radio strand *Funkkolleg* – Brand and Ruhrmann show impressively and in detail how news broadcasts come about. It becomes clear to what extent and with what consequences problems of selection and wording have to be solved here, thereby constructing a 'reality' out of news. This article is especially suitable for graphically demonstrating to children everything that has to happen before a news item reaches them via radio or television and how a world with its own reality is created from the news that they receive. But it also demonstrates what remains unpublished in the way of events and incidents because they are considered to have no 'news value' .

Foote, J.S. and Saunders, A. C. (1990). Graphic Forms in Network Television News. *Journalism Quarterly*, 67(3), pp. 501 ff.

In their investigation Foote and Saunders describe what graphic forms – symbols, films, video and photography – are used in US television news. Such graphic means are used in 78 per cent of the ABC, CBS and NBC news programmes. The description of these graphic forms by the authors contains many points that could be transferred to the concept of 'animated graphics' which was incorporated into *logo,* the ZDF children's news broadcast. The conclusions that Foote and Saunders draw regarding the reception-supported function of graphic forms (enhancement of the ability to understand and retain the news) corresponds very largely to what has been realised in the *logo* programmes.

## 4. Use studies[5]

Atkin, C. K. and Gantz, W. (1974a). *How children use television news programming. Pattern of exposure and effect.* Paper presented at the Annual Meeting of the International Communication Association (New Orleans,La., April 17-20, 1974). ERIC Educational Documents ED094431.

Atkin, C. K. and Gantz, W. (1974b). *Children's response to broadcast news. Exposure, evaluation and learning.* Paper presented at the Annual Meeting of the Association for Education in Journalism (57th, San Diego, California, August 18-21, 1974). ERIC Educational Documents ED097707.

Atkin, C. K. and Gantz, W. (1979). Wie Kinder auf Fernsehnachrichten reagieren. Nutzung, Praeferenzen, Lernen. (How children react to television news. Use, preferences, learning.) *Fernsehen und Bildung,* 13(1-2), pp. 21-32.

In 1973 Atkin and Gantz surveyed 703 kindergarten and primary school children about how they handled television news programmes for adults and children. About 50 per cent of them regularly watched the Saturday children's news and occasionally the daily news for adults. The majority of the children preferred the children's news. There was no significant difference between the news behaviour of the children and that of their parents. Boys used the news programmes more often and more intensively than girls; the stratum they belonged to had no influence on their news use. The effects of viewing news were found to be: an increase in knowledge about political and public events and persons; a greater readiness to become involved in (parent-related) conversations; an interest in further and more extensive information.

Atkin, C. K. and Miller, M. M. (1981). Parental Mediation of Children's Television News Learning. *Communications,* 7(1), pp. 85-93.

In an experiment Atkin and Miller investigated the impact that parents' behaviour has on 276 primary school children's learning by watching short news programmes. Parents and children were asked to watch a children's news programme together and to discuss it. It emerged that the encouragement given by the parents considerably stimulated the children's interest, attention and willingness to learn.

Brosius, H.-B. (1990a). Verstehbarkeit von Fernsehnachrichten. (The intelligibility of television news). In M. Kunczik and U. Weber (ed), *Fernsehen – Aspekte eines Mediums.* (Television – aspects of a medium.) Cologne: Boehlau, pp. 37-51.

Although Brosius's article does not specifically deal with problems arising from the reception and processing of news for children, it does cover three points which can also be used to analyse such programmes. Brosius gives (1) a brief but informative overview of the available literature on the subject of the intelligibility of news and thus on important findings which reveal which factors enhance or hinder intelligibility. He discusses (2)

different forms of intelligibility. He tries (3) to classify the effect of television news from the point of view of understanding or misunderstanding – the latter being of particular importance regarding the children's ability and possibility to process news.

Brosius, H.-B. (1990b). Vermittlung von Informationen durch Fernsehnachrichten. Einfluss von Gestaltungsmerkmalen und Nachrichteninhalt. (Mediating information by means of television news. The influence of design features and news content.) In K. Böhme-Dürr, J. Emig and N. M. Seel (eds), *Wissensveraenderung durch Medien. Theoretische Grundlagen und empirische Analysen*. Munich: Saur, 1990, pp. 197-214.

This study does not present child-specific findings either, but 'child-relevant' ones on the following questions: (1) What consequences do volumes of information of varying size have on the mediation of information? (2) Is detailed or simple information more suitable for mediation? (3) What influence does the nature of the information presented (event, person-related), its quantity and its wording have on information mediation? (4) What impact do pictures accompanying the information have – especially according to whether they correspond to the information or not?

Brosius, H.-B. (1991). Format Effects on Comprehension of Television News. *Journalism Quarterly*, 68(3), pp. 396-401.

In the experiment presented by Brosius – see the remarks on his article 'Mediating information...' – two findings were ascertained which probably apply to the audiences of news programmes both for children and adults: (1) News is understood all the better, the more it is supplemented by film commentaries and the more variable the formal design is. (2) News is understood worst when it is presented by only one newscaster – a man or a woman – in a formal, monotonous, unclear way without intonation.

Cairns, E. (1990). Impact of Television News Exposure to Children's Perception of Violence in Northern Ireland. *Journal of Social Psychology*, 130(4), pp. 447-452.

Cairns's study reveals how, on the one hand, the perception of violence is influenced by viewing television news and how, on the other hand, the readiness to watch television news is influenced by the perception of violence. The analysis investigates 570 Northern Ireland children whose answers about violence they had perceived – in the 'neighbourhood' – were related to place of residence, age, sex and their use of television news. It emerged, on the one hand, that viewing television news made the children more sensitive to their environment and contributed to a more precise perception of violence – and all the more so for the older children (no differences were noticed between boys and girls). And it was shown, on the other hand, that the violence perceived independently of television

(ie by seeing it) provoked the children to use television news, which, in turn, resulted in that sensitisation.

Cohen, A. A., Adoni, H. and Drori, G. (1983). Adolescents' Perception of Social Conflicts in Television News and Social Reality. *Human Communications Research*, 10(2), pp. 203-225.

This study centres on the question of whether children and adolescents (can) distinguish between social conflict that is perceived independently of television and that mediated by television news. 917 Israeli children and adolescents were surveyed. The findings reveal two points: (1) The distinction is made all the more clearly, the older the respondents are and the more familiar the conflict areas concerned are to them. (2) The older respondents are of the opinion that television news presents a distorted reality, while the younger ones tend much more to regard what is shown on television news as the 'real' reality.

Drew, D. G. and Reese, S. D. (1984). Children's Learning from a Television Newscast. *Journalism Quarterly*, 61(1), pp. 83-88.

The experiment carried out by Drew and Reese with 198 primary school children investigated how 'learning from television news' is supported by the explanation and commentary provided by picture and film material: by the children's attention being activated by film and picture material that matches the news item; and both the structure of the programme as a whole and the content of the individual news items being made clearer and more intelligible for the children by news-related picture and film material (it improves retention and memory). The experiment also impressively proved that even older children are hardly able to grasp and process news if it is not consistently adapted to the respective level of cognitive, affective and socio-moral development of the children to whom it is addressed.

Findahl, O. and Hoeijer, B. (1979). Nachrichtensendungen – wie werden sie verstanden? Ergebnisse aus einem langfristigen Untersuchungsprojekt. (News programmes – how are they understood?) *Fernsehen und Bildung*, 13(1-2), pp. 7-27.

The long-term project that Findahl and Hoijer present deals with the problem that news usually conveys fragments of events which turn up in the children's consciousness as a disconnected string of details. This situation can be mitigated by three methods: (1) by the content of the news being accentuated by visual and verbal presentation forms that make at least the core information recognisable and intelligible for the children; (2) by stressing the central causal connections and adding specific background information; and (3) by delivering the news in such a way that it is adapted to the children's way of seeing, orientating themselves and articulating.

Früh, W. (1990). Strukturierung themenbezogenen Wissens bei Massenmedien und Publikum. (Structuring subject-related knowledge for the mass media and the public.) In K. Böhme-Dürr, J. Emig and N. M. Seel (eds), *Wissensveraenderung durch Medien. Theoretische Grundlagen und empirische Analysen.* Munich: Saur, pp. 151-170.

In his article Früh discusses something that applies not only to adults but also and particularly to children: namely the fact that forgetting an item of information, of news, begins, on the one hand, very rapidly and on a broad scale, but, on the other, what is thought to be the cognitive and/or emotional core message of the information, of the news, is 'spared' at first. The difficulty in supporting the children just at this point is apparently that it is especially difficult to understand how children process these core messages and include them in the structure of knowledge, emotions and interpretations they already have. This is mainly connected with the fact that this structure and its individual 'schemata' first form in children and cannot yet be regarded as a fully developed structure of knowledge, emotions and world-view.

Graber, D. A. (1990). Seeing is remembering: How visuals contribute to learning from television News. *Journal of Communication*, 40//3, p. 134-157.

Graber's study, based on a form and content analysis of news and an experiment with 48 (albeit adult) test subjects, can be regarded as complementing the work of Drew/Reese and Foote/Saunders. On the one hand, Graber shows (see Foote/Saunders) what importance and priority the graphic forms – symbol, film, video and photography – have in US news programmes; in contrast to Foote/Saunders, Graber also makes it clear that the graphic means are scattered in the programme entirely as short-term and stereotype features. On the other hand, the author confirms the finding that Drew/Reese made – namely, that 'learning from television' and remembering and retaining the information received, proceed all the better the more emphatically the news items are explained and commented on by pictures and film material. Here Graber points out that the film material develops its effect especially when the presentations are personalised and depicted from an unusual angle.

Grimes, T. (1990). Audio-Visual Correspondence and Its Role in Attention and Memory. *Educational Technology, Research and Development*, 38(3), pp. 15-25.

Grimes's study also looks at the same problem as Drew/Reese, Foote/Saunders and Graber: the consequence that the correspondence of text and film, graphic forms and photography have for the reception of news. Grimes also observes that the recipients' attention and memory (= thematic and visual recognition) are stimulated most intensively when there is no 'gap' between text and film or picture, but when there is a large measure of agreement.

Huth, S. (1979). Verstehen und Behalten von Nachrichtensendungen. Eine ausgewaehlte Darstellung empirischer Befunde (Understanding and retaining newscasts. A selection of empirical findings.) *Fernsehen und Bildung*, 13(1-2), pp. 115-165.

This contribution presents empirical findings which refer to both the area of news and news reception generally and to the way in which children deal with news broadcasts. The general part goes into the presentation forms, language and text-picture-film-quality of news; news contents; and a sociological analysis of the recipients' education and social strata. The 'child-relevant' section, entitled 'Political socialisation by means of television news', deals with children's news use, the learning effects triggered by news and the socialising function of news. Although Huth's work is not so recent, it still always addresses problems precisely and specifically that are connected with the effects which news reception – especially news intended for adults – have on the way children think and feel.

Müller, S., Neumann, K., Six, U. *et al.* (1989). Begleitforschung zur ZDF-Nachrichtensendung fuer Kinder 'logo'. Konzeption und erste Ergebnisse. (Research accompanying *logo*, the ZDF children's news programme. Conception and first results). *Media Perspektiven*, (7), pp. 436-450.

The article constitutes an interim report on the analysis of the programme, its acceptance and the effect of ZDF's news for children programme *logo* (transmission began at the beginning of 1988). It provides information on the following complexes: 1. the (especially family) conditions that have to be taken into account during reception of (children's) news by children (based on GfK measurements); 2. the subjects, method of presentation and linguistic form which are characteristic of *logo*; 3. the acceptance and understanding that the programme enjoys by parents and children; 4. the effects the programme has on forming the children's view of the world and society. Summing up, it can be stated from the findings that were ascertained in several test stages, partly quantitative and partly qualitative: 95 per cent of the children surveyed are interested in a children's news programme; 74 per cent have watched at least one *logo* broadcast with great attention and viewing intensity; the programme was given the mark 2.9 (on a scale from 1 = very good to 6 = bad); 78 per cent of the children would like the transmission of *logo* to be continued; the majority of the children's level of knowledge improved, they saw the world more sharply and their world-view was given a positive tint.

Mundorf, N., Drew, D., Zillmann, D. and Weaver, J. (1990). Effects of Disturbing News on Recall of Subsequently Presented News. *Communication Research*, 17(5), pp. 601-615.

The authors examine the hypothesis that the reception of an emotionally charged piece of news provokes the viewers to recall

subsequently presented information only to a reduced extent. Although solely young adults were used in the test, the result can no doubt be applied to children as well without any difficulties, and is likely to be of very special importance for the way in which they handle the news. For it was ascertained that acquiring, processing and retaining information after the reception of disturbing news deteriorate and the (adult) viewer needs at least three minutes to overcome the distraction.

Neumann-Braun, K. (1991). Kinder moegen Nachrichten. Beobachtungen zur Rezeption von 'logo' in der Einfuehrungsphase der neuen ZDF-Kindernachrichten. (Children like news. Observations of the reception of *logo* in the introductory stage of the ZDF children's news.) In Zweites Deutsches Fernsehen (ed): *Kinderfernsehen – Fernsehkinder*. Mainz: von Hase & Köhler, pp. 224-233.

Neumann-Braun – a member of the team carrying out the research work for *logo* – sums up the findings that are available for the ZDF's news programme for children (see also the study by Wellershoff, Ammermann and Müller, above). The advantage of Neumann-Braun's description lies in his integrating the various analyses carried out in the research for *logo* into an argumentation context, so that he can at least indicate how the large number of individual findings can be combined with one another.

Ruhrmann, G. (1989). *Rezipient und Nachricht. Struktur und Prozess der Nachrichtenrekonstruktion*. (Recipient and news. Structure and process of news reconstruction.) Opladen: Westdeutscher Verlag.

Ruhrmann presents a research project with which the structure and process of news construction on the part of the recipients, ie the connection between television news, news reception and the effects of news, should be made transparent. The project is to be seen as a continuation of the study that was carried out by Klaus Merten – on behalf of the ARD/ZDF Media Commission – in the mid-60s on the problem of 'news reception'. Ruhrmann's study focuses on the attempt to use the findings of news theory, of the psychology of cognition and the sociology of knowledge to develop a general reception model, which will then be analysed empirically. The empirical analysis involves the questions: Which news content is received? How does the recipient process the news assimilated? What importance do social, personal and situational factors of news reconstruction have? The principal result of Ruhrmann's investigation is: the recipients of news operate with selection criteria and strategies which are determined by their social origin, education and previous knowledge. To receive 'relevant' news means for the viewer selectively assessing the up-to-date (news) events according to general and personal relevance and familiarity. This information processing is organised above all by cognitive schemata with the help of which recipients grasp, assess, store, change and, as a rule, greatly simplify the structure of the news content.

Winterhoff-Spurk, P. (1990). Wissensvermittlung durch Nachrichten? Zur Kritik der Lehrfilm-Metapher. (Mediating knowledge by means of news? On the criticism of educational film metaphor.) In K. Böhme-Dürr, J. Emig and N. M. Seel (eds), *Wissensveraenderung durch Medien. Theoretische Grundlagen und empirische Analysen.* Munich: Saur, pp. 173-184.

Winterhoff-Spurk begins with two findings from television news research: (1.) the fact that the majority of viewers, when receiving news programmes, do not watch them either continuously or undisturbed; and (2.) the fact that most of the recipients of news can neither assimilate nor understand many of the reports offered because of the quality of their content and their mode of presentation. Winterhoff-Spurk therefore pleads for a conception of news programmes that is inspired by advertising psychology. That means for him: news programmes – especially for children – should not be designed as 'educational films to transfer knowledge', but as 'spotlight' stimulants which deliberately attract the viewers' attention and provoke them to be on the look-out for further information (in other media and in conversations).

Wosnitza, A.-R. (1982). *Fernsehnachrichten fuer Kinder. Eine kritische Bestandsaufnahme.* (Television news for children – Critically taking stock.) Frankfurt am Main: Fischer.

Although Wosnitza's book was published in the early 80s, in the German-speaking countries it still constitutes the most detailed documentation and most precise commentary on the subject 'children and television news'. Wosnitza begins his introduction with a general analysis which is geared equally towards recipient and product theories and also reveals content and structure of news programmes as well as their use by the recipients. It is against this background that Wosnitza takes up the subject of 'television news for children' in the subsequent chapters by putting into concrete terms the general theses of recipient and product theories in the light of German and foreign programme productions. Then from these concrete terms – listed under the headings 'Programme conception', 'Editorial activity', 'Child audience', 'Designing the themes according to content and form' and 'Future research projects' – Wosnitza derives conceptional and educational maxims to guide the design of children's news programmes and to structure the way children deal with them.

Wright, J. C., Kunkel, D., Pinon, M. and Huston, A. C. (1989). How children reacted to televised coverage of the space shuttle disaster. *Journal of Communication,* 39(Spring), pp. 27-45.

The research group surveyed 122 9- to 12-year old primary school children on how they had taken in and processed the live transmission of the Challenger space shuttle disaster (1986). The situation to be analysed constituted for the research team a constellation in which – under

conditions that gave rise to extraordinary and therefore specific effects – it was possible to register the emotional reaction of the children to an item of television news. In addition it was especially important for the researchers that here the children were confronted by an unexpected, dramatic and violent real-life event, the reality of which they could not mistake for film fiction. The principal finding of the study was that, although the children acted outwardly as if they had cognitively and emotionally overcome the disaster without too much effort, they could only talk about the shock of the uncertainty they had suffered in stereotype phrases, which signalised fear rather than reassurance. The result suggests the conjecture that coming to terms with devastating, and especially disastrous, events is more than children can cope with without additional counselling and help in interpreting the event by persons who can intervene with explanations and reassurance.

### 5. Media education work[6]

Aufenanger, S. (1990). Kindernachrichten *logo* – Politische Bildung auf neuen Wegen. (Children's news *logo* – Political education going new ways.) *Media praktisch,* 14(3), pp. 17-19.

Aufenanger describes the structure and conception of the ZDF news programme *logo*, its acceptance and the probable educational effects. He points out that the children's interest in children's news is largely determined, firstly, by the parents' behaviour and their attitude to news, and, secondly, by the similarity of children's news to adults' news. Aufenanger sees the dilemma of the *logo* project in the fact that the programme, on the one hand, gives them a didactically edited insight into the world of politics, ecology and economics, but, on the other hand, offers them a specific variant of 'infotainment' which is questionable as far as its effect on children's awareness is concerned.

Czirr, B. and Ferenz, H. (1991). *Kick* – Nachrichten fuer Kinder. Projekt der Buergerradio- Hoerfunkwerkstatt Berlin. (*Kick* – News for children. Project of the Bürgerradio-Hörfunkwerkstatt Berlin.) *Medien praktisch,* 15(3), pp. 47-51.

This article describes a media-educational campaign in which a children's news programme on radio (*Kick*) was prepared by children (between 9 and 14 years of age) and broadcast by the SFB and the Berliner Rundfunk. With the assistance of adult helpers (*Berliner Hörfunkwerkstatt*) the children produced five  seven-minute newscasts that focused on ten main topics chosen by them (environment, improving the outskirts of the town, school, leisure etc). During the project it became quite clear that it is very easy to get children to join in and to develop considerable ability for discussing, producing and getting their way. But it also became clear that such a project can only be implemented if sensitive and continuous media-educational guidance and technicians who are interested in teaching are

available and premises for 'group' discussions and production, experts at organising and the necessary financial means are provided.

Jensen, K. and Rogge, J.-U. (1979). Das Experiment *Durchblick*. Analysiert unter dem Aspekt der politischen Bildung von Schuelern. (The *Durchblick* experiment – analysed from the point of view of political education of schoolchildren. *Fernsehen und Bildung*, 13(1-2), pp. 82-99.
The subject of the study was the children's news programme *Durchblick*, which was broadcast by SDR, SWF and SR between 1976 and 1979. In the (qualitatively designed) survey 130 schoolchildren were interviewed on the intelligibility of the programme, their knowledge mediated by news and what they wanted from children's news programmes in general and from *Durchblick* in particular. The description of the findings is introduced by two sections dealing with the situation of children's news programmes in various European countries and the importance of television as a (politically) socialising authority. From the results of their investigation the authors developed educational and didactic demands by which, on the one hand, they measure the programme *Durchblick* and from which, on the other, they derive postulates for improving this programme.

### Notes

1   The German version of this article appeared in *TelevIZIon* 6/1993/1, pp.17–23.

2   See also: Wosnitza, 1982 (p186); Jensen and Rogge 1979 (p.82 ff.).

3   See also: Brand and Ruhrmann 1991 (p.179); Müller *et al.* 1989, (p.184); Wosnitza 1982 (p.186); Jensen and Rogge 1979 (p.188).

4   See also: Müller *et al.* 1989 (p.184); Grimes 1990 (p.183); Huth 1979 (p.184); Ruhrmann 1989 (p.185)

5   See: Mattusch 1991 (p.178); Bourne 1986 (p.179); Brand and Ruhrmann 1991 (p.179); Jensen and Rogge 1979 (p.188).

6   See also: Mattusch 1991 (p.178); Bourne 1986 (p.179); Müller *et al.* 1989 (p.184); Neumann-Braun 1991 (p.185); Wosnitza 1982 (p.186).

# Not a dumping ground for sensations and catastrophes[1]

*Michael Schmidbauer*

Children as news customers have to be taken seriously. They cannot be fobbed off with a copy of adult news or pseudo child-adapted information. Now news programmes are not only expected to give children's questions and concerns a hearing but also to provide services offering explanations as to why things are the way they are and how they came to be. Does television news for children actually help them to understand the world around them?

## 1. A review of the history of news programmes for children

The early 1970s saw the beginning of the discussion at the ARD on whether a news programme for 9- to 13-year-olds could be launched and if so, how (Mattusch 1991). What triggered the discussion, subsequently joined by the ZDF, was the fact that a large group of 9- to 13-year-olds regularly watched the afternoon programme for adults. This in turn raised the question as to whether there should be a slot in the public television programme range for a news programme specifically designed for children.

### 1.1 Inland programme services

Current scientific analysis on inland news programmes for children mainly focuses on the ZDF project *logo – Neues von hier und anderswo* (*logo*[2] – news from here and elsewhere). The 8- to 10-minute *logo* programme addresses the age group of the 9- to 13-year olds and has a similar design to the ORF programme *Mini-ZiB*; it has been broadcast four times a week since the beginning of 1988 (Wellershoff, Ammermann and Müller 1991).

*logo* can be seen as a continuation of the children's news programmes introduced by the ARD and the ZDF in recent years. These programmes' lives were limited – for real and apparent staffing, financial and organisation policy reasons. This applies to *Nachrichten des Monats* (News of the Month) broadcast by the HR in 1970; to *Durchblick* (What's what) broadcast by the SDR, the SWF and the SR from 1976 to 1979; *Nachrichten für Kinder* (News for Children) on 'Children's Day at the ZDF' broadcast in 1981; and the programme *Dran – Nachrichten für Kinder* (Time for the Children's News) broadcast by the SFB in 1981 (Jensen and

Rogge 1979; Wosnitza 1982; Schmidbauer 1985; Hagenmeier 1988; Mattusch 1991).

### 1.2 Programmes abroad
The ARD/ZDF discussion centred specifically on the children's news programmes designed and realised in Denmark, England, Holland, Norway, Sweden, Australia and the USA. They were programmes – some of which are still broadcast today – such as *Children's News*/Danish Radio, John Craven's *Newsround*/BBC, *Jeugdjournaal*/Netherlands Television, *Monthly Review*/ Norwegian Television, *Barnjournaalen*/Swedish Television, *Behind the News*/Australian Broadcasting Commission, *In the News*/Columbia Broadcasting System/CBS and *Kid's News*/ Manhattan Cable Television (Wosnitza 1982).

### 1.3 Conclusions
Today the production of a children's news programme simply cannot ignore the experience gathered in the production of the programmes referred to above. In particular, it has to tackle the following problems (Barnes 1979; Craven 1987; Dielessen 1989):
- the transferability or lack of transferability of criteria applicable to news programmes for adults ('objective', 'complete', and 'up-to-date') to news programmes for children;
- the relationship between the supply of facts and the development of their awareness by means of instruction and guidelines;
- the feasible spectrum of topics and contents that can (and must) be offered to children;
- the formal features of the programme that decide the format, the visual and verbal language and the kind of presentation of the programme offered;
- the opportunity of addressing the children not only as programme consumers but also as producers, by integrating them in the design and production of the programme;
- the provision of funds and personnel as well as the integration of such news programmes in the overall context of the (news) organisation at the respective broadcasting institution.

## 2. Criteria for creating children's news programmes
Only children who have accomplished the 'phase of concrete organisation' and initiated 'abstract thinking' (Müntefering 1976, p. 1) can benefit from a news programme. They are then able to cope with the 'high level of abstraction' characteristic of 'headline news' (Hagenmaier 1988, p. 2). Consequently, the relevant target audience is the 9 to 13 age group, which, it should not be forgotten, features a wide gap between the youngest and the oldest, due to their different levels of cognitive, emotional and social-moral development.

Children must therefore be 'taken seriously' (Müller 1989, p. 144) in their role as news customers and must not be seen as a dumping ground for sensations and catastrophes (Wright *et al.* 1989). Children cannot be fobbed off with a copy of adult news or pseudo child-adapted information (Müller 1990). Moreover, children must be shown where the news items come from, how they are produced and why this and not that topic is focused on.

Children must first and foremost be afforded access to topics which they can grasp in both terms of space, location and time, which therefore 'have some connection .... with (their) environment' (Müller, *et al.* 1989, p. 437) and in whose design they can participate – in principle at least (Dielessen 1989; Czirr and Ferenz 1991). A principal task of news for children is to 'provide a hearing for their questions and concerns' and not only to explain to them why something is the way it is and how something is, but also to demonstrate to them 'what children ... can do ... to improve matters' (Müller 1989, p. 145).

But it should be borne in mind that 'attempts at explanation ... (are) always tied to values ... (and) ... events (are) ... judged according to certain standards of values and applied to wider contexts' (Hagenmaier 1988, p. 2). As such values and contexts still have to be learned by children, explanations must address both the topic in question and children's cognitive, emotional and social-moral development and consequently their development in terms of ego-identity and social integration. One of the self-evident design criteria is that children should enjoy 'their' news programme (Müller, *et al.* 1989; Dielessen 1989; Müller 1989).

## 2.1 Programme contents

Most programme designs for children's news urge that the news programme should be broadcast every day, whenever possible, and should not exceed 10 to 12 minutes. The latter permits an effective news broadcasting slot of 7 to 8 minutes per programme, accommodating three to five news items in brief. This limitation in terms of time and contents is geared to children's reception and assimilation capacities ascertained in tests (Hagenmaier 1988).

The intention is to offer the contents themselves in the form of a blend creating a balance between 'the subjective interests of the children and objective information requirements' (Wosnitza 1982, p. 190); '... the important point being the blend of topics within the individual programmes. It is necessary to include a topic from the world of news, accompanied by a topic from the children's own field of experience and one for relaxation purposes' (Mueller, *et al.* 1989, p. 437; see also Cameron, *et al.* 1991). Such a blend is intended, first, to respond to the heterogeneity of the child audience – some 9, some 13; secondly, to arouse curiosity; and, thirdly, to foster the children's willingness to understand the information offered.

The time frame of the programme and the mode of selecting the contents shown are derived from the children's limited reception capacity.

The consequence is that only a small section of the current news, and only certain topics, can be considered. The selection criterion adopted is, without exception, the child viewers' interests (generally assumed by the programme editors), which are not interpreted, however, as being solely topics from the children's environment. And yet, in the case of topics far removed from the children's environment but still of informational value for the children great emphasis is placed on providing them with access that corresponds to their realm of experience (Winterhoff-Spurk 1990).

### 2.2 Language, forms of presentation

The programme form must 'be contingent on the ability to present a news item' and always have the aim of 'better comprehensibility' (Wosnitza 1982, p. 190). The visual message must be kept simple, concrete and appropriate; the text must relate to the visual image and supply explanations. A divergence between the text and the visual message must be avoided; the text and the visual image must match in order to form optical-verbal unity guaranteeing optimal comprehension.

The following specific rules have been established (Müller, et al. 1989):
- complex and abstract factual contents made comprehensible by means of graphics and cartoon elements;
- intensive use of documentaries related concretely and consistently to the child perspective;
- inclusion of dialogue action elements suitable for illustrating different viewpoints in the depiction of controversies;
- tranquil visual sequences as opposed to 'colourful visual quilts'.

Considerable emphasis is placed on the subject of language. Every word uttered during the programme must be 'understandable' (Dielessen 1989, p. 21). Sentence constructions must not be too complex, too demanding. Syntax and lexis must be consistently geared to the children's usage. Foreign words must be explained immediately. All in all, a 'talking language' should be used that is 'also a language for listening to' (Müller, et al. 1989, p. 438).

The didactically favourable form medium of 'creating a personal atmosphere by means of one or two presenters' is recommended (Wosnitza 1982, p. 190). The presenters are supposed to act as trustworthy 'advocates', who ensure the children's emotional stability and their identification with the programme. The studio design must also be appropriate: it must radiate a matter-of-fact and yet relaxed atmosphere; it must emanate seriousness and an emotional tone banishing anxiety and promoting the children's interest (Winterhoff-Spurk 1990).

### 3. Children and news programmes for adults

In the surveys on the conditions fulfilled by adult news programmes for use and acceptance by children, it has been ascertained that the group of children who watch the news for adults relatively regularly is large.

Children's interest in news topics, the criteria determining what a news item is and what it should be like, the way the news is handled – all this is strongly influenced by the way the children relate to adult news programmes.

### 3.1 Children's use of adult news programmes

A special analysis of statistical data in Germany (GfK 1987) revealed that the average weekday viewing proportion of 8- to 13-year-olds amounts to between three and four per cent in the case of the ARD/ZDF afternoon news, seven per cent in the case of the 7 p.m. *Heute* news and eight per cent in the case of the *Tagesschau* at 8 p.m. Even *Heute Journal* (9.45 p.m.) and *Tagesthemen* (10.30 p.m.) are watched by approximately two per cent. What is more, a special analysis for a so-called 'sample day' ascertained that over 20 per cent of 8- to 13-year-olds were reached by the eight news programmes broadcast that day. In the USA 15 per cent of 8- to 13-year-olds regularly and over 30 per cent frequently join the adult news audience (Drew and Reese 1984; Drew and Reeves 1981; Huth 1979).

A survey carried out by ZDF media research (Müller, *et al.* 1989) with 650 9- to 15-year-olds was not only largely consistent with the GfK results; it also revealed several factors favourable to children's acceptance of a children's news programme. Four types of (child) 'users' and 'non-users' of adult news programmes were ascertained:

- Type A: rare user of television news, no interest in special news programmes for children (25 per cent);
- Type B: close affiliation to adult news programmes, little interest in Thildren's news programmes (20 per cent);
- Type C: little attachment to adult news programmes, special expectations of children's news programmes (30 per cent);
- Type D: intensive user of adult news programmes, high interest in children's news programmes (25 per cent).

This shows that types C and D probably represent the target audience for a children's news programme – an audience composed partly of 'news beginners' and partly of children who have different levels of 'competence ... required for the reception and understanding of news programmes' (Müller, *et al.* 1989, p. 439).

### 3.2 Do children understand adult news programmes?

To answer this question three 'indicator constellations' were developed in the previously mentioned survey (Müller, *et al.* 1989, p. 439). The children were asked about their newspaper and magazine reading, the subjects they were interested in and their knowledge of the news.

- Of the 650 9- to 15-year-olds interviewed, 30 per cent stated that they regularly read a daily newspaper; 10 per cent of the newspaper readers turn to the tabloid *Bild-Zeitung*, 3 per cent said that they regularly read a topical magazine. The *Bild-Zeitung* readers reveal the most extensive,

the readers of the topical magazines a somewhat below-average television use.

- The analysis of the subject interests reveals: 50 per cent of the interviewees perceive current political events and other social events in such a way that they can spontaneously refer to and talk about them.
- As regards the individual indicators comprising the section 'news knowledge' (familiarity with politicians, knowledge of geography, meaning of abbreviations, etc) 30 per cent of the interviewees provided correct answers. The correlation between the knowledge of the news measured here and the intensity of television news use was so high that the assumption that news contributes significantly to the children's acquisition of news competence did not seem to be unjustified, to say the least (Cairns 1990).

Whether what has been described here as competence is 'real' competence is probably debatable, however. If one considers, on the one hand, the form and the content of the news for adults (Brand and Ruhrmann 1991), and, on the other, the difficulty that these adults have in handling this television news (Brosius 1991; Brosius and Kepplinger 1990), it becomes clear that the acquisition of competence by children is probably largely impaired by the news for adults being littered with obstacles that the children can hardly be in a position to overcome (Ruhrmann 1991).

Some important examples of the difficulties involved are: ' ... the procedural obligation characteristic of the medium, the fast transitions between unrelated individual reports, the difficult vocabulary and the complex language structure, the divergence in contents between the text and the visual message as well as the demands of the news on the recipient's education' (Huth 1979, p. 146). A further obstacle to the acquisition of competence is that the news for adults places very high demands on the children's short-term memory, which amounts to three seconds in the case of 7- to 8- year-olds (six in the case of adults).

The news for adults is hardly able to take into consideration the fact that children, at least up to the age of eleven, have enormous difficulty recognising the logical consequences of statements, and in particular the connections, between them, without any background information. Nor can the news consider the fact that children lack the cognitive, affective and social-moral capacity – due to their early stage of development – required to classify the news and accomplish the mental process of interpreting it (Brosius 1990 b).

### 3.3 What should be observed in news programmes that children are supposed to understand?

It can be concluded from the previous statements that national and international politics can probably only be made palatable for children in a programme geared to the conditions and opportunities of their socialisation.

In view of children's cognitive abilities, a news programme for children, if it is to address the 9 to 13 age group, has to take the group's level of development into account (Piaget 1972; Sturm 1973). At this level children – from 9 to 10 – experience the transition from the concrete operational phase to that of formal-abstract operations and – from 11 to 13 – the extensive development of these formal-abstract operations. The 9- to 10-year-olds are thus still dependent on concrete facts, concrete ideas and therefore concrete operations, but on the other hand they are on the way to extending these operations with formal-abstract procedures. Conversely, the 11- to 13-year-olds increasingly perform such formal-abstract operations that enable them to dispense with concrete parameters and to acquire global and partial, causal-analytical and hypothetical-deductive (logical-mathematical) thinking.

Considering the children's emotional structure, which also influences the development of their cognitive abilities, two principal factors apply: first, registering the emotions they show themselves and the world, particularly what frightens and shocks them; and second, consistently taking into consideration that children do not want to experience any uncertainty in what they believe to have recognised as being 'right'. It is in this light that the children's (often extreme) wish for topics directly related to their experience, to their ability to think and to take action should be evaluated. A highly significant factor in the informational 'contact' with children, however, is that this wish on the part of the children must be seen with a critical eye, that a *sine qua non* for their development, namely extending the scope of their 'direct' environment, cannot be sacrificed to satisfy this wish.

Considering the social-moral dimension of child development, care must be taken to present children, in the information transmitted to them, with action relationships and justifying standards that they, too, can comprehend and grasp. A solely superficially informative or entertaining news programme for children must be avoided; on no account should the presentation and analysis of their own forms of commitment be excluded.

## 4. The design of children's news programmes

To date there is apparently only one extensive study available in Germany that examines news programmes for children from the viewpoint of product analysis; the form and contents analysis of the ZDF news programme *logo* (Müller, *et al.* 1989). The following sections will therefore review this survey as an example. This is also justified by the fact that the few references to other news programmes – *Barnjournaal, Het Jeugdjournaal, Newsround, Behind the News, In the News* – indicate similar tendencies with regard to contents and form (Wosnitza 1982; Barnes 1979; Bourne 1986; Craven 1987; Dielessen 1989).

## 4.1 The topics, their weighting and their blend

The results of the *logo* programme analysis reveal that topics related to national and international politics predominate in the transmissions, followed by contributions on nature and the environment and on child and adolescent situations. After these news items come curious events and phenomena, 'out-of-the-ordinary miscellanies'. According to the programme analysis the difference in adult news programmes is documented in the emergence of a 'blend of serious, difficult topics and less demanding, entertaining items taken from the events mentioned above' and, secondly, in the choice of primarily 'topics related to children and young people' (Müller, *et al.* 1989, p. 442).

In the programmes the latter is mainly borne out – in the opinion of the ZDF research group – by the extent to which children are presented with their own activities and/or express their views on the topics introduced: approximately 60 per cent of the *logo* contributions reviewed feature children and young people; in a third of the contributions they can express their own views. The strongest rapport with the children's environment is featured in contributions on school and child institutions. These fields offer children the most opportunities to voice their opinions. Children express their views on political and environmental issues far less often.

It goes without saying that the *logo* analysis – by naming the topics, by referring to the blend of these topics and the description of their rapport with the children – does not reveal very much about the actual quality of the topics and their connections with the children's everyday world and their level of development. In particular, the important question remains unanswered as to whether and how the *logo* programme – despite its sensible choice of topics, blend of topics and rapport with the child's world – differs from the news for adults in the structural sense, ie in terms of the child-specific cognitive, emotional and social-moral 'organisation' of the respective topic.

Another question that is not answered is the extent to which, during the production of *logo*, its programmes were subjected to considerable alignments with the established pattern of the adult news programme, thus ruining many good intentions – simply because of the close material and institutional connections of the editorial department for children's programmes with the news department (Hagenmaier 1988; Müntefering 1976). That this can be the case was ascertained in a pilot study on the children's news programme *Newsround*/BBC (Bourne 1986). There was little to criticise about this project's choice of topics from the point of view of their informational significance. And yet it emerged that *Newsround* usually only showed a potted version of the news for adults.

## 4.2 Visuals, text, language and presentation

In the *logo* programmes, each of which contains three items (two 'challenging' and one 'easy' one), the weather chart and 'amusing' credits,

almost all the parts of the programme are illustrated with visual material. Only a few reports are read by the presenter, which 'keep the programme together', but always with the support of inserts, however. The visuals assume the form of film reports shown at a relatively slow pace, individual graphics and animated graphic presentations (Foote and Saunders, 1990). The latter are inserted in almost 15 per cent of the contributions and referred to as 'Erklärstücke' (explanatory items; Müller, *et al.* 1989, p. 442); a similar proportion of items also contains individual graphics.

The animated graphic presentations mostly serve to elucidate background information, where it is necessary to ensure an extensive co-ordination between the visuals and the text. Although a divergence between the visuals and the text should be avoided according to the philosophy of the *logo* programme editors, not only in this context but, if possible, in every part of the programme range, a divergence between visuals and text was in fact ascertained in seven per cent of the contributions. The analysis of the language comprehensibility of the *logo* programmes specifically focused on the sentence constructions and the use of foreign words, abbreviations and terms. The research group placed particular emphasis on how such expressions are explained in the transmissions and on the language comprehensibility of the overall programme.

## 5. How children handle children's news programmes

As the results on programmes produced in Germany are mainly significant for the general situation here, in the following section particular emphasis will be attached to the results of acceptance and comprehension tests, on the one hand, and of the effects panel study, on the other, realised within the framework of the *logo* analysis (Müller, *et al.* 1989; Neumann-Braun 1991).

### 5.1 Acceptance, attentiveness and learning effects

The results of the *logo* back-up research reveal that the news programme receives a relatively high level of acceptance:

- 95 per cent of the interviewees consider a children's news programme important;
- 60 per cent saw *logo* either always or several times a week during the pilot phase;
- 75 per cent saw it on at least one occasion;
- 50 per cent award *logo* good, 30 per cent average and approximately 15 per cent bad marks.

The *logo* data fail to indicate whether the interviewed children intentionally took an interest in the news programme or just 'happened to receive' it because they were interested in the programme preceding or following *logo* (Bourne 1986). The fact that the latter almost generally applies – particularly in the case of younger children (under the age of 11)

– and does not basically change until they proceed to the adolescent phase – has already been ascertained on a number of occasions (Atkin 1978; Drew and Reese 1984).

That the overwhelming majority of the children interviewed can be described as tending to take an intentional interest in the *logo* programmes is documented, among other things, in the level of attentiveness afforded to the *logo* programmes. Contrary to the usually low degree of willingness on the part of children to show and sustain attention in a concentrated fashion (Winterhoff-Spurk 1990), the *logo* audience apparently responds to the programme with a high level of 'attentiveness' (Chaffee and Schleuder 1983, p. 102) – despite the problematic broadcasting time of 4.25 p.m., problematic in the sense of gaining children's attention at a time that is filled up with homework duties, playing, hobbies, watching entertaining children's programmes (Gunter, Jarrett and Furnham 1983). Moreover, the children perform hardly any secondary tasks while viewing.

The *logo* analysis reveals that mainly gender, school level and class differences are the decisive factors with regard to programme acceptance:

- boys award the (general, economic, cultural, technological and environmental) contributions higher marks, have a more accurate knowledge of the programme contributions and consider them to be more comprehensible than the girls do;
- pupils attending academic *Gymnasium* schools have no problem understanding the programmes, remember the contents of the programmes more accurately and show a stronger interest in the political contributions than is shared by pupils from the *Realschule* and the *Hauptschule* (secondary schools).

In all pupil groups the closer the (political) items in the programmes relate to the interviewees' everyday awareness and the more clearly and more focally the causal and motivation links and the background information are prepared in advance, the more easily these items are understood (Brosius 1990 b; Bourne 1986). The previously mentioned animated graphic representations, and the graphic explanatory items demonstrate here their special usefulness for underlining the 'significance' of news items (Brosius 1990 a, p. 211). On the other hand, precisely these political contributions could be the reason why the *logo* programme was awarded only the mark 'satisfactory'. The following points may be the reasons for this mark.

Normally a *logo* programme contains only two political contributions, which are however inherently very varied. This is expressed mainly in the constant fluctuation between 'concrete text-visual presentation' and the 'commentary promoting the process of abstraction' (Sturm 1973, p. 301), ie in a procedure that is none too remote from that adopted in the news programme for adults (Hagenmaier 1988; see also the review of BBC's *Newsround* in Bourne 1986). This makes child viewers reluctant to watch because they are constantly compelled to give up on account of the hardly

comprehensible text and visual sequences and to make do with what they already know.

The political contributions display an abundance of visual material, also reminiscent of the adult news programmes. The principal and secondary, central and detail visual sequences make it difficult for children to register the visual references that are really important for the event described (Davies, Berry and Clifford 1985). This applies not only to the 9- and 10-year-olds, who (still) have considerable difficulty – due to the level of their development – in selecting and subsequently discarding unimportant detailed information and who are dependent on the main visual information items, since they frequently cannot (yet) understand the verbal messages. This also applies to older children who are confused in their attentiveness by an intentional reception of information, who are distracted by a central tending towards a peripheral processing of visual (and text) material (Petty and Cacioppo 1988): instead of disturbance and distraction by in-between questions one of 'in-between pictures' (Bock 1990; Brosius 1990 b; Mundorf, Drew and Zillmann 1990).

Apparently the visual and verbal language deployed in the contributions has its difficulties – not only in the form of a number of excessively long sentences that are hardly comprehensible for child viewers, but also in a flood of 'irrelevant visual information' (Huth 1979, p. 147). Since such visual information is not repeatable, they demand considerable attentiveness and ability to select as the programme progresses (Bernard and Coldevin 1985).

Moreover, the causal and motivation links presented – already mentioned above – which are of eminent cognitive importance for children, frequently seem to be vaguely accentuated, and the result is that a significant 'information function' of the contribution (Drew and Reeves 1981), proven to be stimulating for learning, lacks transparency. It may therefore be assumed that, due to this form of presentation, the children's willingness to learn is not promoted and that what remains in their minds largely comprises only fragments of events (Findahl and Hoijer 1979, p. 19), details torn from the original context and background, details that the children now know, but which they now face without being able to understand them (Drew and Reese 1984).

*5.2 Acquisition of knowledge and development of a conception of the world*
The previously mentioned panel study carried out in the framework of the *logo* survey focused particularly on the question of whether and how the reception of television news for children contributes towards the acquisition of knowledge and the development of a conception of the world. By means of a first interview before and a second after the *logo* transmission (broadcasting period: the first three months in 1988) the attempt was made to ascertain which changes had come about for 672 pupils as a result of a more or less continuous interest in *logo* programmes.

## 5.3 Acquisition of knowledge

The questions testing the pupils' knowledge of the news were on politicians and political offices, geographical matters, terms such as comment, coalition and correspondent. The hardly surprising results, revealing that older children fared better than younger ones, boys better than girls, *Gymnasium* pupils better than their counterparts from the *Realschule* and the *Hauptschule*, are largely similar to those of other studies (Drew and Reese 1984; Drew and Reeves 1981). They are, according to the research group, most impressive:

> ... almost all of the above named knowledge indicators – familiarity with politicians, knowledge of political offices, geographical knowledge and terms – (reveal) in the overall random sample of the second survey higher values ... than in the first survey ...
>
> As a result of using *logo* the interviewees' level of knowledge ... significantly improved (Müller, S. *et al.* 1989, p. 449).

The problem revealed in earlier studies on the subject of correlations between the use of news programmes and the level of knowledge will not be analysed in this context. It was ascertained in those studies that there is a correlation between knowledge and television programme utilisation but not in the sense of a linear causal effect, as the level of knowledge and the type of programme utilisation are both dependent on other variables that are not surveyed in the respective study – tuition at school, discussions with parents etc. (Ballstaedt and Hinkelbein 1976).

Neither is there any reference to the relationship between the information acquired as knowledge and the information which is subsequently forgotten – the point in question being not only the retaining and forgetting of cognitive contents but also that of the emotional qualities of the programme (Müntefering 1976). As is generally known, in the case of children the process of forgetting commences very rapidly and extensively, but 'spares' – initially, at least – what they consider to be the (usually very few) cognitive and/or emotional central messages of the news (Früh 1990). It must be conceded, however, that particularly in the case of children it is very difficult to comprehend how they process these central messages and integrate them in their already existing structure of knowledge, emotions and interpretations (Graber 1984; Bock 1990).

The numerous other theses on the topic of 'forgetting' will not be the subject of discussion here: for example that:

- news items broadcast without any commentary are forgotten more quickly and more probably than (verbally and/or optically) commented news (Graber 1990; Grimes 1990);
- information 'telling no story' fades more quickly and more probably than information 'telling a story' (Müntefering 1976);
- reports which are just read fade into oblivion more quickly and more probably than those accompanied by a film (Drew and Reese 1984);
- information the reception of which is disturbed is forgotten more

rapidly and more probably than information received in an atmosphere of tranquillity and concentration (Bernard and Coldevin 1985; Bock 1990);

• news seen for entertainment purposes or while emulating parents (Bourne 1986) disappears more quickly and more probably from the memory than news which children assume they could learn something from (Drew and Reeves 1981).

The subject of the differences between the 9- to 11- and the 12- to 13-year-olds receives little attention in the *logo* backup research. The most well-known hypothesis (implicitly, at least), for example, which is also relevant for the *logo* research, is not systematically treated: that only 'concrete or personalised information contents' can be conveyed to 9- to 11-year-olds but not 'abstract connections ... such as the meaning of political parties, the structure of legislative procedures' (Huth 1979, p. 150). If this hypothesis had received due attention, another matter would have had to be consistently examined, ie the question as to whether it is at all possible to produce a news programme that can be useful for both the 9- to 11-year-olds, who are partly in, or partly close to. the development phase of concrete operational thinking, and 12- to 13-year-olds, who largely find themselves in the stage of formal-abstract thinking (Conway, Stevens and Smith 1975; s. also Böhme-Dürr 1993, p. 6 ff.).

Although, in the framework of the *logo* back-up research, a small qualitative analysis was carried out on the effects of the children's family constellation on the utilisation of the news by the children, the ZDF research group took only a passing interest in the thesis maintaining a connection between the children's class and family origins and their acquisition of knowledge (Chaffee and Tims 1977; McLeod and Brown 1979; Atkin and Miller 1981). According to this thesis, the children who acquire the most knowledge in their utilisation of children's news programmes are those in the upper middle class and consequently in families who mostly show an above-average level of interest in current events and a clear preference for news programmes (Atkin and Gantz 1979).

Furthermore, the items concerning age, class and family are also significant in this context because they can serve to categorise the age-, class- and family-specific patterns of attitudes, knowledge and emotions of children receiving the news. Consequently, it is possible to include the patterns regarded as the preliminary forms of the children's developing structures of knowledge, emotions and a conception of the world. This means that the main issue can be focused on, determining the socialisation of the children and their action-determining themes: namely, growing into a world that is dominated by the authority of adults to which the children have a very 'broken' relationship as far as their identification is concerned (Schmidbauer and Löhr 1993).

This issue is probably of particular importance for children's (meaningful) contact with news, since it may give rise to barriers that a news programme

must first of all remove before it can be effective. It must be borne in mind that the children's 'broken' relationship with parents and adults – a relationship that is self-centred but still adaptable, rejects authority and yet needs protection, that is reluctant to take decisions and yet in search of a purpose, easily offended and yet open – often makes it difficult for children:

- to accept instructions as binding;
- to accept learning requirements if they cannot be classified as directly personally relevant and gratifying;
- to come to terms with demands that can influence and alter – as is always the case with news – their whole cognitive, emotional and social-moral disposition.

### 5.4 Developing a conception of the world

The questions submitted to the pupils on the subject of a 'Weltbild' (conception of the world) address the pupils appraisals of the proportion of violent crime, the youth unemployment rate, the extent of damage to the environment and the degree of alienation/helplessness. The first survey – before the *logo* transmission – reveals that appraisals indicate a relatively small 'existence of danger' in the place of residence (the individual environment), but a not insignificant threat in the Federal Republic of Germany (the social environment). The pupils' conception of the world is thus influenced by the 'atmosphere of different viewpoints' – known to apply to a cross-section of the population. How judgements change when children refer to other countries was apparently not a subject of the *logo* survey, although television reporting with regard to the image children create of other countries plays an extremely important role (cf. Atkin and Garramone 1984).

The second survey – which took place after the *logo* transmission – shows, on the other hand, that:

… after the *logo* test phase both the individual environment and the social environment (are) regarded as less threatening than before (and) … diagnoses on general issues relating to conception of the world issues (reveal) … either no change or considerable improvements. (Müller, *et al.* 1989, p. 450)

Perhaps this is due to *logo's* great skill at dealing with children's anxieties (whatever their origin), which succeeds in reducing them somewhat – as is hoped by the *logo* research group and the *logo* programme editors (Groebel 1990; Müller 1990), but this question remains unanswered (Aufenanger 1990).

In the already mentioned survey on the *Newsround* programme there are however certain indications that do not quite correspond to the opinion of the *logo* researchers and programme editors. It ascertains that the decisive factor for the 'improvement' of the conception of the world is possibly to be found in the selection of the material offered to the children. In the comparison between news for adults and news for children it emerged that – with almost identical news material – in the news for adults

an insecure, problematic and dangerous world was presented, but in the news for children this world tended to be one of hope and security, respecting the life of the individual (Bourne 1986).

It is obvious that such a 'positive' connection between the conception of the world presented in a programme and the one forming in the children's minds can be created all the more easily the less the children know about the reality actually surrounding them (Cohen, Adoni and Drori 1983; Adoni, Cohen and Mane 1984).

## References

Adoni, H., Cohen, A.A. and Mane, S. (1984). Social reality and television news. Perceptual dimensions of social conflicts in selected life areas. *Journal of Broadcasting*, 28 (1), pp. 33-49.

Atkin, C.K. (1978). Broadcasting news programming and the child audience. *Journal of Broadcasting*, 22 (1), pp. 47 ff.

Atkin, C. and Gantz, W. (1979). Wie Kinder auf Fernsehnachrichten reagieren. Nutzung, Praeferenzen, Lernen. (How children react to TV news. Use, preferences, learning.) *Fernsehen und Bildung*, 13 (1-2), pp. 21-32.

Atkin, C.K. and Miller, M.M. (1981). Parental mediation of children's television news learning. *Communications*, 7 (1), pp. 85-93.

Atkin, C.K. and Garramone, G. (1984). The role of foreign news coverage in adolescent political socialization. *Communications*, 10 (1-3), pp. 43-61.

Aufenanger, S. (1990). Kindernachrichten *logo*. Politische Bildung auf neuen Wegen. (The children's news programme *logo*. New departures in political education.) *Medien praktisch*, (3), pp. 17-19.

Ballstaedt, S.-P. and Hinkelbein, S. (1976). Alltagsfern, oberflaechlich und unverstaendlich. (Remote from everyday life, superficial and incomprehensible.) *Psychologie heute*, 3(9), pp. 13-18.

Barnes, E. (1979). 'John Craven's Newsround'. Ein aktuelles politisches Kinderprogramm der BBC. (BBC's current political children's programme.) *Fernsehen und Bildung*, 13(1-2), pp. 41-47.

Bernard, R.M. and Coldevin, G.O. (1985). Effects of recap strategies on television news recall and retention. *Journal of Broadcasting and Electronic Media*, 29(4), pp. 407-419.

Bock, M. (1990). Wirkungen von Werbung und Nachrichten im Druckmedium und Fernsehen. Bericht über eine experimentelle Untersuchungsreihe. (Effects of advertising and news in the printing medium and on TV. Report on an experimental survey.) *Medienpsychologie*, 2(2), pp. 132-147.

Böhme-Dürr, K., Emig, J., Seel, N. M. *et al.* (1990). *Wissensveränderung durch Medien. Theoretische Grundlagen und empirische Analysen.* (The change of knowledge caused by the media. Theoretical principles and empirical analyses.). Munich *et al.*: Saur.

Böhme-Dürr, K. (1993). 'Das kenn' ich schon aus den echten Nachrichten'. Ergebnisse einer Pilotstudie. ('I know that from the real news'. Results of a pilot study.) *Televizion*, 6(1), pp. 6-8.

Bourne, C. (1986). *Children's television news as political communication.* Paper presented to the 2nd International Television Studies Conference, London, 10th-12th July,1986. London: British Film Institute.

Brand, M. and Ruhrmann, G. (1991). Zeitgeschehen à la carte. Ereignis, Nachricht und Rezipient. 14. Kollegstunde. (Current events à la carte. The event, the news and the recipient.) Funkkolleg. Hessischer Rundfunk, Frankfurt, Main, Hauptabteilung Bildung und Erziehung Hoerfunk (ed). Frankfurt, Main: HR o.J. 39 pp. (Medien und Kommunikation – Konstruktionen von Wirklichkeit.)

Brosius, H.-B. (1991). Format effects on comprehension of television news. *Journalism Quarterly*, 68(3), pp. 396-401.

Brosius, H.-B. (1990). Vermittlung von Informationen durch Fernsehnachrichten. Einfluss von Gestaltungsmerkmalen und Nachrichteninhalt. (Transmission of information by TV news. The influence of design features and news contents.) In K. Böhme-Dürr *et al.* (ed.), *Wissensveraenderung durch Medien*. Munich *et al.*: Saur; pp. 197-214.

Brosius, H.-B. (1990). Verstehbarkeit von Fernsehnachrichten. (The comprehensibility of TV news.) In M. Kunczik *et al.* (ed), *Fernsehen*. Cologne *et al.*: Böhlau; pp. 37-51.

Brosius, H.-B. and Kepplinger, H.M. (1990). The agenda-setting function of television news: Static and dynamic views. *Communication Research*, 17(2), pp. 183-211.

Cairns, E. (1990). Impact of television news exposure on children's perceptions of violence in Northern Ireland. *Journal of Social Psychology*, 130(4), pp. 447-452.

Cameron, G.T. *et al.* (1991). The role of news teasers in processing TV news and commercials. *Communication Research*, 18(5), pp. 667-684.

Chaffee, S.H. and Tims, A.R. (1977). Kommunikationsmuster und Fernsehnutzung Jugendlicher. Eine Untersuchung des Einflusses von Familie und Gleichaltrigen. (Young people's communication patterns and TV use. A survey on the influence of the family and peers.) *Fernsehen und Bildung*, 11(3), pp. 249-268.

Chaffee, S.H. and Schleuder, J. (1986). Measurement and effects of attention to media news. *Human Communication Research*, 13(1), pp. 76-107.

Cohen, A.A., Adoni, H. and Drori, G. (1983). Adolescents' perceptions of social conflicts in television news and social reality. *Human Communication Research*, 10(2), pp. 203-225.

Conway, M.M., Stevens, A.J. and Smith, R.G. (1975). The relation between media use and children's civic awareness. *Journalism Quarterly*, 52(3), pp. 531-538.

Craven, J. (1987). *Images of the world. Documentaries for children. News and current affairs*. Prix Jeunesse Seminar, Munich 27–29 May 1987. Stiftung Prix Jeunesse (ed) Munich: Stiftung Prix Jeunesse.

Czirr, B. and Ferenz, H. (1991). Kick – Nachrichten fuer Kinder. Projekt der Buergerradio-Hoerfunkwerkstatt Berlin. (Kick – news for children. The Berlin citizens' radio-radio workshop project.) *Medien praktisch*, (3), pp. 47-51.

Davies, M.M., Berry, C. and Clifford, B. (1985). Unkindest cuts? Some effects of picture editing on recall of television news information. *Journal of Educational Television*, 11(2), pp. 85-98.

Dielessen, G. (1989). The justification for a news programme for children. *EBU Review*, 40(1), pp. 20-25.

Drew, D.G. and Reese, S.D. (1984). Children's learning from a television newscast. *Journalism Quarterly*, 61(1), pp. 83-88.

Drew, D. and Reeves, B. (1981). Learning from a television news story. In G.C. Wilhoit *et al.* (ed), *Mass Communications Review Yearbook*. Beverly Hills, pp. 404-419.

Findahl, O. and Hoeijer, B. (1979). Nachrichtensendungen – wie werden sie verstanden? Ergebnisse aus einem langfristigen Untersuchungsprojekt. (News programmes – how are they understood? Results from a long-term research project.) *Fernsehen und Bildung*, 13(1-2), pp. 7-21.

Foote, J.S. and Saunders, A. C. (1990). Graphic forms in network television news. *Journalism Quarterly*, 67(3), pp. 501-507.

Früh, W. (1990). Strukturierung themenbezogenen Wissens bei Massenmedien und Publikum. (Structuring subject-related knowledge in the mass-media and the audience.) In K. Böhme-Dürr *et al.* (ed), *Wissensveraenderung durch Medien*. Munich *et al.*: Saur, pp. 151-170.

GfK (1987). *Sonderanalyse 'Kinder und Nachrichten' fuer das 1. Quartal 1987*. (Special analysis 'Children and News' for the 1st quarter 1987.) Nuremberg.

Graber, D. (1984). *Processing the news. How people tame the information tide*. New York.

Graber, D.A. (1990). Seeing is remembering. How visuals contribute to learning from television news. *Journal of Communication*, 40(3), pp. 134-157.

Grimes, T. (1990). Audio-visual correspondence and its role in attention and memory. *Educational Technology, Research and Development*, 38(3), pp. 15-25.

Groebel, J. (1990). 'Macht' das Fernsehen die Umwelt bedrohlich? Strukturelle Ergebnisse einer Laengsschnittstudie zu Fernsehwirkungen. (Does TV turn the environment into a threatening place? Structural results of a longitudinal study on the effects of TV.) In M. Kunczik *et al.* (ed), *Fernsehen. Aspekte eines Mediums*. Cologne *et al.*: Böhlau, pp. 121-138.

Gunter, B., Jarrett, J. and Furnham, A. (1983). Time of day effects on immediate memory for television news. *Human Learning*, 2(4), pp. 261-267.

Hagenmaier, M. (1988). Konstruierte Wirklichkeit. Zur ZDF-Nachrichtensendung fuer Kinder: 'Logo – Neues von hier und anderswo'. (Construed reality. The ZDF news programme for children: 'Logo – news from here and elsewhere'.) *Funk-Korrespondenz*, 36(15), pp. P1-P2.

Huth, S. (1979). Verstehen und Behalten von Nachrichtensendungen. Eine ausgewaehlte Darstellung empirischer Befunde. (Understanding and retaining news programmes. A selected presentation of empirical findings.) *Fernsehen und Bildung*, 13(1-2), pp. 115-165.

Jensen, K. and Rogge, J.-U. (1979). Das Experiment 'Durchblick'. Analysiert unter dem Aspekt der politischen Bildung von Schülern. (The 'Durchblick' experiment. Analysed from the point of view of pupils' political education.) *Fernsehen und Bildung*, 13(1-2), pp. 82-99.

MacLeod, J.M. and Brown, J.D. (1979). Familiale Kommunikationsmuster und die Fernsehnutzung Jugendlicher. (Family communication patterns and young people's TV use.) In H. Sturm *et al.* (ed) *Wie Kinder mit dem Fernsehen umgehen*. Stuttgart: Klett-Cotta, pp. 215-251.

Mattusch, U. (1991). Nachrichten fuer Kinder, Stationen einer Entwicklung. (News for children, stages in a development.) In H.-D. Erlinger *et al.* (ed) *Kinderfernsehen.3*. Essen: Verlag die Blaue Eule, pp. 73-98.

Müller, S., Neumann, K., Six, U., Winklhofer, U., Rogge, J.-U. *et al.* (1989). Begleitforschung zur ZDF-Nachrichtensendung für Kinder *logo* (1989). Konzeption und erste Ergebnisse. (Backup research on the ZDF news programme for children *logo*. Conception and first results.) *Media Perspektiven*, (7), pp. 436-450.

Müller, S. (1989). *Logo* – Kinder wollen ernstgenommen werden. (*Logo* – children

want to be taken seriously.) Zweites Deutsches Fernsehen, Mainz (ed), *ZDF Jahrbuch 1988*. Mainz: ZDF, pp. 144-147.

Müller, S. (1990). *Logo* – the ZDF's news programme for children. *EBU Review*, 41(3), pp. 15-18.

Müntefering, G.K. (1976). Nachrichten über Nachrichten für jene, für die es keine Nachrichten gibt. Zum EBU-Workshop 'Information and News for Children'. (News on news for those there is no news for. The EBU workshop 'Information and News for Children'.) *epd Kirche und Rundfunk*, (31-32), pp. 1-3.

Mundorf, N., Drew, D. and Zillmann, D. (1990). Effects of disturbing news on recall of subsequently presented news. *Communication Research*, 17(5), pp. 601-615.

Neumann, K. (1991). Kinder moegen Nachrichten. Beobachtungen zur Rezeption von *logo* in der Einfuehrungsphase der neuen ZDF-Kindernachrichten. (Children like news. Observations on the reception of *logo* in the introductory phase of the new ZDF children's news programme.) In Zweites Deutsches Fernsehen, Mainz *et al.* (ed), *Kinderfernsehen – Fernsehkinder*. Mainz: v. Hase u. Koehler, pp. 224-233.

Petty, R.T. and Cacioppo, J.T. (1988). *Communication and persuasion. Central and peripheral routes to attitude change*. New York.

Piaget, J. (1972). *Psychologie der Intelligenz*. (Psychology of Intelligence) Olten Freiburg.

Ruhrmann, G. (1989). *Rezipient und Nachricht. Struktur und Prozess der Nachrichtenrekonstruktion*. (The recipient and the news. The structure and process of news reconstruction.) Opladen: Westdt.Verl.

Schmidbauer, M. (1987). *Die Geschichte des Kinderfernsehens in der Bundesrepublik Deutschland. Eine Dokumentation*. (The history of children's news in the Federal Republic of Germany. A documentation.) Internationales Zentralinstitut fuer das Jugend- und Bildungsfernsehen, München (ed) Munich *et al.*: Saur. (Internationales Zentralinstitut fuer das Jugend- und Bildungsfernsehen, Munich. Schriftenreihe. 21)

Schmidbauer, M. and Löhr, P. (1992). *Fernsehkinder – 'neue Sozialisationstypen?' Zur sozialpsychologischen Charakterisierung des Kinderpublikums*. (TV kids – 'New socialisation types?' A socio-psychological characterisation of the child audience.) Munich: Stiftung Prix Jeunesse. (Prix Jeunesse Forschungsreihe.)

Sturm, H. (1971). Fernsehen und Entwicklung der Intelligenz. (TV and the development of intelligence.) In F. Ronneberger *et al.* (ed), *Sozialisation durch Massenkommunikation*. Stuttgart: Enke, pp. 290-304.

Wellershoff, I., Ammermann, A. and Mueller, S. (1991). Konzeptionen konkret. Beispiele aus dem aktuellen Kinderprogramm des ZDF. (Concrete conceptions. Examples from the ZDF's current children's programme.) In Zweites Deutsches Fernsehen, Mainz *et al.* (ed), *Kinderfernsehen – Fernsehkinder*. Mainz: v. Hase u.Koehler, pp. 53-58.

Winterhoff-Spurk, P. (1990). Wissensvermittlung durch Nachrichten? Zur Kritik der Lehrfilm-Metapher. (Transmitting knowledge via the news? On the criticism of the educational film metaphor.) In K. Böhme-Dürr *et al.* (ed) *Wissensveränderung durch Medien*. Munich *et al.*: Saur, pp. 173-184.

Wosnitza, A.-R. (1982). *Fernsehnachrichten für Kinder. Eine kritische Bestandsaufnahme*. (TV news for children. A critical audit.) Frankfurt, Main: R.G.Fischer.

Wright, J.C., Kunkel, D., Pinon, M. *et al.* (1989). How children reacted to televised coverage of the space shuttle disaster. *Journal of Communication*, 39(2), pp. 27-45.

## Notes

1  The German version of this article appeared in *TelevIZIon* 6/1993/1, pp. 9-17.

2  Translator's note: *logo* is current German slang for 'logisch', meaning 'logical' or 'sure thing!'.

# 'I know that already from the proper news'
## Findings from a pilot study[1]

*Karin Böhme-Dürr*

That even quite small children can distinguish between children's news and 'proper' news on television is one of the findings of this pilot study. On the new news programme *Junior Clip*, the author says, children are well-informed about important and current events – even if it is difficult to sustain the interest of young and older children in television news.

'Oh, please, can't we watch *Who is the Boss Here?* instead of that kids' stuff?' Eight-year-old Celina and her friend Steffi of the same age are showing no enthusiasm whatsoever for the fact that they are supposed to watch the new children's news on Bavarian Television as guinea pigs. The American comedy series being transmitted at the same time on RTL is a far greater attraction for them. Steffi and Celina leaf through the television guide: 'Where does it say that about the children's news?' In daily newspapers and programme magazines we find no closer references to the fact that *Junior Clip*, which will be transmitted each Tuesday at 5.25 p.m. from the middle of March, is a new news programme for children.

Before *Junior Clip* comes *Die Sendung mit der Maus*, which is only of moderate interest to the second formers Celina and Steffi ('It's something for children at Kindergarten'). After that *Fury* neighs in black and white, not a great hit with kids accustomed to action. So the programme setting for *Junior Clip*, which is meant to reach mainly the 8- to 13-year-olds, is not very suitable for these ages and interests.

### The first transmission
But not only is the slot unfavourable for the start of the new programme, but also the opening. Steffi and Celina almost missed it. Although the cuddly doll Max ('He's so sweet') makes the transition from *Käpt'n Blaubär* to *Junior Clip* with the words that now something is coming 'for all of you who otherwise only grasp half of what is happening in the world', the children complain that there is no break, no 'music', no clock or date, precisely all those typical features of 'proper' news.

Instead a boy, whom the girls find likeable (he is probably only slightly older, but to the great regret of the girls has no name), immediately reads

215

the news from his sheet. The first three items (lead stories) on the first *Junior Clip* are detailed picture reports, commentated on by a child's voice, about problems in Russia, the closures of steelworks and plans to shorten the time children have to attend school. Analogous to the Austrian *Mini-Blick*, the main news items in *Junior Clip* are followed by *Blick in die Welt* (A Look at the World). In the first programme three themes are broached: an exhibition with pictures painted by children of the Armenian earthquake, an Easter egg market and the biggest ice cream cornet in the world.

### What interests the 8-year-old children in *Junior Clip*?
The two 8-year-old girls are restless and slightly bored as they follow the lead stories ('How much longer is this going on for?'). When questioned afterwards, they can chiefly recall (surprising and concrete) details. The egg thrown by a steelworker at a speaker left a clearer impression than the (abstract) connection between the economic problems, poverty and violence in Russia.

Independently of the placing and duration of the items, the children mostly comment on and retain what relates to their life-world. During the report on shortening the time children have to attend school, they criticise that a child can be seen with a Cola can, as 'we aren't allowed to do that at our school'. And during the pictures of the Easter egg market they have a lively discussion on how many Easter eggs they have already painted.

### The children also talk about whatever moves them
The children also talk about whatever moves them. It does not have to be their own experiences. For example, they sympathise with the speaker from the steel industry who has eggs thrown at him: 'It's not his fault that the others have no work any more.' The report on the ice cream cornet is for them 'stupid because so many children are starving in Yugoslavia'. They get most excited, however, about something that was not shown, the weather. News without weather, they both agree, is not 'proper' news.

### ...and what about the older children?
How do older children interpret the same programme? Iris (10), Lucilla (12) and Sabine (13) have schemata of perception and interpretation that clearly differ form those of Celina and Steffi. Although they, too, are not curious about the programme, they concentrate their attention on the spoken contributions and pictures. They have no problem repeating the core messages. They are already familiar – from other media reports – with links which are not made clear even in *Junior Clip* (how are economic problems, poverty and violence connected in Russia?). The most frequent comment of the older girls on *Junior Clip* news items is 'I know that already from the proper news.'

From the proper news? Obviously children have a clearly formed concept of what constitutes 'proper' news, or adult news. Like Steffi and Celina, all of the ten boys and girls questioned in this pilot study point out formal features. Exact dates and times are very important criteria that are mentioned again and again. As far as content is concerned, 'proper' news consists almost entirely of politics, the children believe. As Steffi puts it: 'People read from their sheet things like where there's a war and such like.' Eleven-year-old Elias defines news as 'new things happening all over the world that you don't hear about from your friends.'

With the exception of two children (Eva and Rafael, both 8 years old), all of them stress that 'proper' news only reports bad things. It is amazing that even 8-year-olds mention such criteria, which in communication research are known as news factors. Apart from the factor 'negativism', four other news factors can be found in the children's statements: personalisation ('A lot of people who talk a lot'), references to elite persons ('Chancellor Kohl or Foreign Mister (sic) Kinkel'), surprise ('Just think of that! Ugh!') and importance ('When it concerns a lot of people').

### The acceptance and credibility of television news

All children distinguish between 'proper' news for adults and children's news. They perceive children's news as less serious and severe, and as explaining things better. As political contributions are less frequently included in children's new programmes, they are considered to be better ('It's cool that they don't talk just about presidents'). Child presenters – as in *Junior Clip* – are, it is true, more highly regarded than adult newsreaders, but acceptance and credibility are two entirely different things. Diana, almost 10 years old, rejects child presenters altogether: 'A man or woman like they have in *MiniZiB* (the Austrian children's news) simply knows how to do it better than a child.'

### 'Proper' news for adults and children's news are kept apart by all children

Although differentiating between 'proper' news and children's news suggests that children believe that the former reflects reality and the latter is constructed, subsequent investigations have shown that even 8-year-olds know that both kinds of news have their equivalents in reality. Nevertheless the children are less certain in the case of children's news. It was noticeably the older children in particular who thought that children's news is sometimes specially made and was 'not quite so real'. Whether the views about the somewhat more casual relation to reality are to be accounted for by the entertainment elements in the children's news could not be clarified in the pilot study. As the question as to what is considered to be real is of utmost importance, especially in this age of reality TV and multifarious media realities (key word: virtual reality), more research should be carried out into this question.

217

## Television news and the perception of reality

All the children were shown different children's news programmes to assess them: *MiniZiB* from ORF1, *logo* from ZDF and *Junior Clip* from BR. When all three kinds of news were transmitted on the same day, the children, especially the younger ones, were disturbed by the fact that not all the contributions were identical. Ten-year-old Iris complained, 'That's not real news. Each programme reports something different.' Is it possible that older children accept different realities more readily than younger ones? Is there a greater tendency to tolerate various realities as adulthood is approaching? The work of the media researchers Aimée Dorr and Robert Hawkins substantiates the belief that as age increases assessments of television reality become more complex. To what extent does this also apply to news?

Children (and many adults as well) are probably not clear what turns news into a news item. Who selects what when where how and why from a mass of information and what we are presented with as news? The fact that news is constructed is more difficult for children under the age of ten to grasp than for older ones. For the younger ones – this is shown by the replies – there is only the reality.

Even if the findings of the pilot studies cannot be generalised, they do provide us with indications of what should be researched. And such an indication is the observation that the orientation function of news is only mentioned by the older children. Thus Lucilla believes, 'You need news, otherwise you run around like a blind chicken.' And Elias draws on the etymological meaning: 'The point of children's news is to give children an example to follow.'

## The themes in *Junior Clip*

So does children's news contain themes for children? An analysis of the content of *Junior Clip*, *logo* and *MiniZiB* from 16th March to 4th May 1993 makes it clear that *Junior Clip* contains more relations to children (it was not counted as a 'relation to children' if a child appeared by chance or was casually mentioned – as for, example, in the fire at Waco in the USA, in which children also died). 61 per cent of *Junior Clip* items are directly addressed to children (by comparison: in the period of the study it was 37 per cent for *logo* and 33 per cent for *MiniZiB*). Direct relations to the children's immediate life-world ('home references') can also be found more frequently in *Junior Clip* (39 per cent compared with 34 per cent for *logo* and 28 per cent for *MiniZiB*).

Whereas in the more comprehensive Austrian children's news two out of three items relate to abroad, the proportion in *Junior Clip* is exactly the reverse: two-thirds of all items refer to Germany (in *logo* as much as 74 per cent). Compared with the 'real' news of the Bavarian Broadcasting Corporation (*Rundschau Clip*), *Junior Clip* makes a good showing. In spite of the time difference, all the lead stories that constitute more than

218

one item in *Rundschau Clip* can also be found in *Junior Clip*, although it has to be borne in mind that the *Rundschau Clip*, broadcast daily, generally contains twice as many items. So the children are well informed about important and on-going events by *Junior Clip*.

What the children interviewed miss most in *Junior Clip* news – apart from the weather – are animals. Steffi, whose mother is a vet, does not like *Junior Clip* more than *MiniZiB* just because more animals are shown in the Austrian news. The content analysis, however, produces no significant differences. 30 per cent of the items include animals on *MiniZiB*. In the case of *Junior Clip* it is 24 per cent. The ZDF's *logo* children's news, conceived principally for adolescents, has animals in only 3 per cent of the reports (in this calculation the weather forecasts, in which various animals are important, were, however, not considered).

After the first *Junior Clip* broadcast all the children want to see more of them, 'at least when there is nothing exciting to watch in the other programmes' (Lucilla). But the interest, which is weak anyway in the case of the lead stories, is waning more and more. During the broadcasts Steffi, Dilara and Celina are leafing through their sticker albums and swapping chewing gum balls without any inhibitions.

The girls' lack of interest is due to inadequate understanding. That is why some improvements could be made to *Junior Clip*. Thus in one report on 23rd March, the syllable 'pact' in 'solidarity pact', is, it is true, impressively explained, but not then what 'solidarity' means. So Dilara, when asked, chooses her own interpretation: 'The people stick together and send packets to those who are not so well off.' Nor can the children understand what is meant by 'general strike' (20th April). It also gets difficult when reports are not held together by a thematic clip. On 13th April, for example, at first children's accidents and child neglect are dealt with in one and the same picture report, and then there is an item on drug abuse by children and young people. Steffi is surprised: 'If you have an accident, why do people take drugs then?'

Similar mix-ups and equally difficult language constructions are also found in other children's and adults' news. Understanding depends, of course, to a great extent on previous knowledge and on viewers' prior attitude. And it is precisely that which makes it so difficult to produce news for children that is in keeping with their age and social class.

But *Junior Clip* could use appropriate programme advertising (trailers, references in magazines), a suitable programme setting and some improvements in form and content to win over far more young viewers. Perhaps that would increase the chances of the older children then saying as they watch the 'proper' news: 'I know that already from *Junior Clip*.'

# Note

1 The German version of this article appeared in *TelevIZIon* 6/1993/1, pp. 6–8.

# Cartoons in media research[1]

*Sabrina Kaufmann and Paul Löhr*

In this documentation selected literature on the subject of the animated cartoon on children's television is presented. The main questions that arise in the publications collated here can be stated as follows: Can cartoon programmes influence children's world view? What is the impact of violence in cartoons on children's behaviour? What and how can children learn from cartoons? We have therefore divided them into the following chapters: socialisation by means of cartoons (1), violence in cartoons (2) and learning from cartoons (3). These chapters also include abstracts or summaries of research findings. What follows is a selection of works which deal with the possible uses of animated cartoons for purposes of media education (4). Finally those publications are listed which go into aspects of cartoon production; these works deal basically with the questions: How are animated cartoons produced? How much financial expenditure and how much work has gone into them? What part do cartoons play in programme production for children?

## 1. Socialisation by means of cartoons
Aitken, J. E. (1986). *The Role of Gender and language in 'The Transformers': An Analysis of Messages in Cartoons for Children*. Paper presented at the Annual Meeting of the Organization for the Study of Communication, Language, and Gender.

In the 1980s new, seemingly technical animated cartoons were developed. The author believes it is possible that these new cartoons influence the behaviour and attitude of the recipients, mainly boys. The study examined in particular language, scenes of violence and characters in the cartoon film *The Transformers* (a mixture of violence, technology, space travel and galactic adventures). The protagonists in the cartoon are adapted from a toy series and can transform themselves into different figures. The aim of the study was to record information on children's perception of this programme.

*Method:*
- 34 children filled in a questionnaire on the cartoon and took part in a discussion on the film, which they generally liked.

- 37 students had the job of describing the cartoon with regard to violence, characters and language to enable the programme to be analysed.

*Results:*

The children had difficulties in understanding because of:
- the complicated technical language;
- the complexities of negative statements;
- the rough and unintelligible way of postulating good morality.

*Conclusion of the study:*

Although the toy series *The Transformers* offers the children a creative and modern kind of jigsaw puzzle, the production of a cartoon series with figures of that kind has negative concomitants.

Aufenanger, S. (1989). Zur Rezeptionssituation von Zeichentrickfilmen aus japanischer Produktion fuer Kinder in der Bundesrepublik Deutschland. (On the reception situation of animated cartoons produced in Japan for children in Germany.) In Deutsches Jugendinstitut (ed), *Kinderfernsehen und Fernsehforschung in Japan und der Bundesrepublik Deutschland.* Weinheim *et. al.*: Juventa Verlag, pp. 129-143.

In this article animated cartoon series for children produced in Japan like *Pinocchio, Marco, Nils Holgersson* and *Biene Maja*, are discussed, literary exemplars being of European origin. According to the findings of the survey, the programmes mentioned are more popular with children than broadcasts considered to be educationally valuable like *Löwenzahn, Bettkantengeschichten* or *Anderland,* and their popularity even exceeds that of American cartoon productions. The author stated that '... the animated cartoons produced in Japan and especially films like *Heidi, Marco, Pinocchio* and *Nils Holgersson* are among the most popular in Germany.'

*Typical features of Japanese productions:*
- They are, as far as the author knows, the first series on German television which had to be followed from instalment to instalment if you wanted to keep up with the story (suspense factor). ...Cartoon series of Japanese production are distinguished by four formal elements:
  - graphic design: the figures seem to be very simply structured (childish schema);
  - structuring the animation sequence: only one part of the movement is drawn (partial animation);
  - picture design: observer's perspective;
  - perspective when people come and go: distorted by partial animation.
- The scenes of the animated cartoon series are very long, the cuts not too short. There are only very few special visual effects.

*Effect of the formal design:*
- Because of the formal presentation (childish schema) regressive forms of experiencing television result.
- As the series are on a lower level of intelligibility, the cartoons may be too undemanding for the children.
- The figures arouse sympathy.
- On account of the above-mentioned structural elements, parents rate Japanese productions higher than American ones; moreover, many parents are familiar with the content from their own childhood.

Baggaley, J. P. (1985). Design of a TV Character with Visual Appeal for Pre-school Children. *Journal of Educational Television*, 11(1), pp. 41-48.

The aim of this study was to ascertain the visual appeal of a number of cartoon figures in the current educational programme for pre-school children. Then a cartoon figure was to be worked out for an anti-smoking campaign on television. An experiment was carried out with 108 pre-school children from a rural district and an urban district of Quebec in which the children had to say whether they liked or disliked eight cartoon figures from educational programmes.

*Method:*
An electronic measuring device was used on which the children had two buttons to express their negative or positive reactions to the figures presented. Additionally, after the presentation the children were asked orally about their reactions.

*Results:*
- The two most popular figures were similar in four ways:
  - the two figures were animal animation (the only ones);
  - they were very colourful with hard contours;
  - both were described by the children as very active and entertaining;
  - both figures possessed one outstanding comic feature (ears/teeth) that the children found especially striking.
- The figures that prompted the most negative reactions were, on the other hand, those whose colours were drab and who were less active. The children could not remember these figures so well either.
- It was also noticed that the children from rural areas were less keen on answering and were less systematic in their replies than the children from the town, although by and large they preferred similar and/or the same characters.

Dobkins, D. H., Aitken, J. E. and Jacobs, R. (1987). *The Communicative Response Repertoire of Children's Television Cartoon Characters.* Paper presented at the Annual Meeting of the Popular Culture/American Culture Association in the South; October 1987. (ERIC Educational Document ED 293183)

How do children perceive the content of continually repeated statements made by female figures in animated cartoons? Is children's perception comparable to that of the researchers? Do cartoons provide role models which children can adopt into their behaviour repertoire? If so, to what extent?

Dobkins *et al.* asked themselves these questions so that they could ascertain *one* effect of children's television programmes. The test subjects for their study were 61 children in the fourth and fifth grades of a primary school in Louisiana. The material used for the experiment was six of the ten most popular animated cartoons in the Saturday morning programme.

*A partial finding:*
Considerable differences were ascertained between the children's and the researchers' perception. The children were more balanced and flexible in their perception of the characters. The researchers sum up by saying that the data seem to prove that children's perception of statements spoken by cartoon figures is neither uniform nor identical to adults' perception.

Forge, K.L.S. and Phemister, S. (1987). Effect of Pro-social Cartoons on Pre-school Children. 1982. *Child Study Journal*, 17(2); pp. 83-88.

This study deals with the question of whether the reception of pro-social cartoons has the same effect regarding the support of prosocial behaviour in preschoolers as the reception of pro-social children's programmes with human actors (eg *Sesame Street, Mister Rogers' Neighborhood*). Altogether 40 boys and girls of pre-school age were each shown one of four 15-minute film sequences. The film sequences were the following:

● a cartoon film on the subject of friendship;
● a second cartoon film with a neutral content (how to take part in a motorcycle race);
● another pro-social film also on the subject of friendship, with human actors;
● finally a neutral film showing whales and dolphins being fed – again with human actors.

After viewing their sequences the children were observed at free play for 30 minutes. During this time the number of pro-social behavioural acts was recorded.

*The most important findings:*
● As the researchers had assumed, the reception of the pro-social animated cartoon was just as effective as the pro-social film with human actors, both sequences giving rise to the same extent of pro-social behaviour.
● The children who had seen the pro-social films displayed more pro-social behaviour than the children who had seen the neutral films.

Jennings, C. M. and Gillis-Olion, M. (1979). *The Impact of Television Cartoons on Child Behavior*. Paper presented at the Annual Meeting of the National Association for the Education of Young Children; Atlanta, GA, November 8-11 1979. (ERIC Educational Document ED194184)

In this study the observations made of a group of children by kindergarten teachers and researchers were used to examine the effects on children's free play of animated cartoons shown on television. Sixty-five kindergarten children (pre-school children) and their teachers (N = 18) took part in the experiment.

*The method:*
Each child was asked the following questions:
1. Which television programmes do you like best?
2. Which cartoons do you like best?
3. Which television figures do you like best?
4. Why do you like these figures?

After watching their children engaged in free play the teachers were asked:
1. What do you see in the classroom that reflects an effect of cartoons an the children's behaviour?
2. Do you know the children's preferences for certain television programmes?

*Results:*
- Animated cartoons were the most popular genre with the children.
- Programmes transmitted in the afternoon were named by the children most frequently.
- The children usually watched television together with other children or with adults.
- The children did not like news, feature films and frightening pictures.
- In the teachers' opinion, cartoons did have an effect on children's behaviour in the classroom.
- Behaviour patterns adopted from television that could be observed in the children seemed, however, to be stimulated by adventure shows with human actors more frequently than by animated cartoons.
- Many of the cartoons that the children preferred to watch were unknown to the teachers.
- The teachers usually knew only the programmes that were transmitted on Saturday mornings.

Kodaira, S. I. and Akiyama, T. (1988). *With Mother and Its Viewers: Behavior Monitoring of 2- and 3-year-olds*. Japan Broadcasting Corp., Tokyo: NHK Broadcasting Culture Research Institute.

This study examined the reception behaviour of 277 2- to 3-year-old children who were observed by their mothers while watching the television programme *With Mother*. The programme consists of several

parts: actors appearing disguised as animals, songs, games, exercises, an animated cartoon entitled *Kids like us* and films on everyday life. Some of the children were given a monthly magazine with stories about the eight figures to be seen in the series *Kids like us* to investigate possible effects of an interplay of several media (media-mix).

The researchers were especially interested in finding out:

- how much time the children spent in front of the television;
- whether the mothers watched television with their children;
- at which age the children began to watch the television programme;
- to what extent the children imitated the exercises shown and processed the programme in imitative role play;
- to what extent the children understood the programme and learnt something from it;
- what attitude the children had towards the individual parts of the programme;
- what reactions the children showed to the cartoon film part;
- what impact the magazines had on the children's viewing behaviour.

*Results:*

- Three-year-old children understood more than the two-year-olds.
- Although the programme was generally popular, *Kids like us* produced different reactions in the children to the various characters.

Mayes, S. L. and Valentine, K. B. (1979). Sex Role Stereotyping in Saturday Morning Cartoon Shows. *Journal of Broadcasting*, 23(1), pp. 41-50.

Do children perceive sex role stereotyping on television? What part do stereotype presentations of sex roles, ie the presentation of 'mainly male' and 'mainly female' behaviour patterns, play in Saturday morning cartoon programmes for the development of an understanding of sex roles in children? Thirty 8- to 13-year-old boys and girls were each shown two episodes from four cartoons in the Saturday morning programme. Afterwards the children answered questions on the personality traits of the main figures.

*The aim of the study:*

1. to ascertain, by analysing the content, to what extent animated cartoon figures of either sex display selected personality features (aggressiveness, independence, intelligence, vanity etc.) which are regarded as either *especially* 'male' or *especially* 'female';
2. to register whether and how far the perception of these personality traits differs in boys and girls.

*Results:*

- The children realised that the cartoon figures had shown stereotype male or female behaviour patterns.
- Boys and girls do not differ significantly in their responses.

*Conclusion:*
The authors fear that children are restricted by the unbalanced presentation of role clichés on television in their ability to register and thus to learn behaviour patterns detached from the stereotype 'television image'.

Rice, M. (1980). *What Children Talk About While They Watch Television.* Paper presented at the Biennial Meeting of the Southwestern Society for Research in Human Development; Lawrence, Kans., March 1980. (ERIC Educational Document ED 194046)

This study examined what children talk about when they watch television and to what extent these statements are connected with the presentation form. For this purpose pre-school children and children in the third grade were shown four animated cartoons which differed in the amount of dialogue they contained (a lot – little – none).

What the children said was recorded in writing and the content coded into 13 categories for statements that were connected with the content of the cartoons, and 8 categories for statements that had no connection with the events.

*Main findings:*
- During the programme without dialogue the children had altogether talked more and spoken about the plot more frequently.
- The statements on the programmes without dialogue were qualitatively different from the statements on the programmes with dialogue.

The effect of the programme without dialogue, the researchers conjecture, can be put down to familiarity with and the simple structure of the content.

Schorb, B., Petersen, D. and Swoboda, W. H. (1992). *Wenig Lust auf starke Kämpfer. Zeichentrickserien und Kinder.* (Not in the mood for tough fighters. Cartoon series and children.) München: Institut Jugend Film Fernsehen. (BLM-Schriftenreihe 19)

This reception study tries to answer the following questions on the basis of combined written and oral interviews of about 1000 4- to 6-year-old children from kindergartens, secondary modern schools and grammar schools in Bavaria: What fascinates children about cartoon series on television? To which elements of content, scripting and aesthetics do children direct their attention? How do children perceive the portrayal of violence they are presented with and how do they come to terms with it? How are the identification potential of the cartoon figures and the plot patterns to be assessed? What importance do cartoons have for children's everyday life? Do children of various ages, sex and social background differ in their orientation by cartoon programmes?

*Findings:*

- The children clearly name preferences and aversions, differentiated according to age and sex.
- The prime-time broadcasts for cartoon series are the children's prime-time viewing times.
- Opinions are divided on the *Smurfs*. Cartoons with humour are popular; the *Rescuers of the World* is rejected.
- Children look for proximity to their own world in cartoons. Space wars are hardly in demand.
- Figures must have character to become the children's favourites.
- Conquering the world with humour and not with violence. The children's favourite types are like themselves: nice and a bit chaotic.
- The heroes of cartoon programmes are the children's constant companions: in video films, audio cassettes or comics, but also on clothing and as toys.

## 2. Violence in the cartoon programme

Becker, B., Janssen, S., Rullmann, A. and Schneider, B. (1992). Die neuen Zeichentrickserien – immer wieder Action (The new cartoon series: Non-stop action.) In I. Paus-Haase (ed), *Neue Helden für die Kleinen*. Münster: Lit, pp. 152-198.

The study is part of a research project which analysed a selection of action series and action cartoons. The study focuses on the series *He-Man and the Masters of the Universe*, which according to a survey of children is the most popular among the action-packed cartoon series. It is excellently discussed to illustrate the steps of the analysis.

*Main points of the detailed analysis:*

- The *basic conflict* in action cartoons: it takes place, as in real action series, '... in the area of tension between good and evil'.
- *Structure of the plot* and scripting: formal structure and plot are described, for example direction of the plot (parallel direction of the plot), pace of the narrative and editing elements (snippet scripting). The effects of these production elements on the children's reception are given.
- *Plausibility* of the series: space and time are relative in action cartoons. The authors sum up: 'The setting is a fantasy world, which is determined by fairy tales, saga elements and/or science fiction.'
- Description of *the protagonists*: the appearance of the protagonists reflects their character; thus, for example, bright, friendly colours are the feature of the 'goodies', while the 'baddies' appear in dark, drab colours. The heroes distinguish themselves from the group by special skills.
- *Suspense* in action cartoons: the content and form as a means of producing suspense (danger, menacing or forceful music, camera setting) and reducing tension (overcoming a danger, music) are made use of in almost every scene. The suspense sequence is similar in most of the action cartoons.

- *Humour* in the series: humorous episodes which 'are developed from the drawing and from the animation' are rare; verbal humorous insertions prevail.
- *Violence* in action cartoons: violence serves to produce suspense; it is a means of resolving conflict, but is mainly used against objects. In general violent scenes are not presented in much detail; violence is divided into violence against good and violence against evil, violence against the bad figures being apparently legitimate in itself.
- *The picture of the world* in action cartoons is completely static. At the beginning and end of each instalment you can find an 'intact world', which, although it is disturbed by the bad figures in the course of the series, is restored by the good figures.

*Reasons for the popularity of action cartoons with children:*
- The formal and scripting elements of the series (eg avoiding time leaps, episodic narrative structure) and the clear division between good and evil make concessions to the children's reception.
- Especially heroes, but other figures as well, constitute an offer of identification which children can use individually for their different requirements (problems in everyday life).
- The opportunities for consumption provided by multimedia – there are toys representing the figures of the series, T-shirts with pictures printed on them, audio cassettes and comics to go with the series – constitute an additional incentive for the children to involve themselves in the television series.

Hapkiewicz, W. G. (1977). *Cartoon Violence and Children's Aggression: A Critical Review.* Paper presented at the Annual Meeting of the American Psychological Association. San Francisco, Ca, August 1977. 17 pp. (ERIC Educational Document ED 147008)

In this article ten studies on the effect of violence in cartoons on the aggressive behaviour of children are reviewed and possible reasons for inconsistent findings are discussed. The methods and results of field and laboratory tests are compared, and the limits of the two test designs are examined. The effects of cartoons were considered in the ten studies under two aspects:
- Do animated cartoon figures which represent people have a different effect on children's aggressive behaviour from cartoons which represent animals with human behaviour patterns and characteristics?
- Is there any difference in the effect between cartoon film and 'real' film?

*The results of the studies:*
- In four of the studies the anti-social effect of films containing violence that had been predicted could not be confirmed.
- For the remaining studies, which claim their data confirm an anti-social effect of cartoons containing violence, it is shown that plausible

alternatives to the interpretations suggested by the researchers are possible.

In conclusion problems are discussed which arise in interpreting studies on the effect of violence in cartoons on children's behaviour.

Haynes, R. B. (1978). Children's Perceptions of 'Comic' and 'Authentic' Cartoon Violence. *Journal of Broadcasting*, 22(1), pp. 63-70.

Do children perceive violence in realistic animated cartoons differently, or more negatively, than in so-called 'comic', unrealistic cartoons like *Tom and Jerry*? Do girls perceive violence in 'comic' cartoons more strongly than boys? 120 children in the fifth and sixth grades at school were shown either a cartoon with realistic content (*Dick Tracy*) or with comic content (*Pink Panther*). Both cartoons contained the same amount of violence. (Six adults had determined the violence contained in the cartoons on the basis of a definition of a 'violent act'.) After that the children were asked about their feelings during reception.

*Findings:*
- Boys and girls perceived violence in the same way in the two cartoons.
- The data support the assumption that children have more negative feelings about violence in a 'comic' cartoon than in a realistic one.
- Children who had seen the 'comic' cartoon perceived the violence as unacceptable; children who had seen the realistic cartoon, on the other hand, felt the violence presented was acceptable or justified.

*Conclusion of the study:*
Children recognise violence even with, or despite, a comic background and do not regard this violence as merely humorous.

Hesse, P. and Mack, J. E. (1990): Feindbilder im amerikanischen Kinderfernsehen. (Concepts of the enemy in American children's television.) *Psychosozial*, 13(4), pp. 7-23.

'An enemy is someone who kills people and steals jewels. I've seen it on telly.' Leigh, the girl who said that, is five years old. An enemy, 'that is Skeletor. That is the bad guy in *He-Man*. He tries to catch He-Man and to lock him up...' explains Jai, six years old. The author concludes from these statements that they ' ... suggested the hypothesis that children's concepts of enemies can be influenced by television programmes.' In a qualitative analysis of eight cartoon series in the children's programme 'the concepts of enemies and political and ideological content' mediated in the series were examined.

*Some of the findings:*
- The enemy is an animal.
- The main enemy or 'leader' of the enemies is never an animal.
- The enemy looks 'different' or 'alien', has a foreign accent.

230

- The enemy is thoroughly bad.
- The enemy is a dictator; he combines Nazi and Communist features.
- The enemy is a threat to identity and existence.
- Heroes are, following the idea of seeing everything in terms of black and white, the exact opposite of the enemies: they are completely good.
- The plot is similar in all eight of the cartoons:
  In the beginning, paradise. – Then the paradise is lost (eg following a surprise attack by the enemy – Reason for the aggression: greed, thirst for power, wickedness. War (where modern military technology plays a big part). – The flight of the enemy and there's no end to it.

In conclusion, the effect of ideas of enemies or generally of violence in children's programmes on children's behaviour and attitude is discussed on the basis of some of the pertinent studies.

Kunczik, M. (1983). Wirkungen von Gewaltdarstellungen in Zeichentrickfilmen (The effects of depicting violence in cartoons.) *Media Perspektiven* -(5), pp. 338-342.

In this article the effect of violence in animated cartoons on children's aggressiveness is dealt with. The researcher discusses and at the same time criticises relevant studies on the effect of violence shown on television. It can be concluded from the studies examined:

- 'Humorous violence' in cartoons is generally not regarded as violence.
- Rating the degree of violence by the recipients does not depend on the number of acts of violence shown.
- Rating the degree of violence differs in different film genres.
- Children perceive violence in cartoons differently from adults – they mostly look upon violence in cartoons as amusing.

Because of the inconsistencies and unpredictability of how violence is perceived the author demands that a 'functional content analysis' should precede studies on the effect of violence. That means that the studies should be based on the perception of violence by the recipients.

*The author's résumé:*
- Experiments with cartoons only allow conclusions to be drawn on short-term effects.
- Fictitious violence in cartoon films does not have negative effects on children.

### 3. Learning from animated cartoons
Akiyama, T. and Kodaira, S. I. (1987). *Children and Television: A Study of New TV Programs for Children Based on the Pilot of an Animated Production.* Tokyo: NHK Broadcasting Culture Research Institute.

The study was carried out as part of a project of the Japanese public broadcasting station Nippon Hoso Kyokai (NHK) and the NHK Broadcasting Culture Research Institute.

The *aim* of the study was the development and examination of educational programmes for infants. The reactions of 96 2- and 4-year-old Japanese children to two pilot films were investigated. The pilot films were two animated cartoons, *Yadoman* (the dissatisfied child) and *Tazura* (the gloating child), whose main figures obviously represented negative children's behaviour. (The production of these pilot films is described in detail.) It was the aim to get the children to perceive the behaviour patterns shown as negative and therefore not to display them any longer themselves.

The *method* of the experiment: each child was led with its mother into a room with two television sets. One of the televisions showed the interesting test programme, and the other a very colourful animated film with a lot of movement but no sound, in order to distract the child. The idea of this distraction was to ascertain the 'true interest' in the test programme. The researchers had two video cameras so that they could monitor the children's behaviour (especially laughter) and facial expressions (eye movements to television set 1 or 2) during reception. Additionally, all utterances were recorded with a microphone. After that the children were interviewed to find out if they had understood and retained the plot. Also, the interview was used to ascertain what and how much the children had remembered, especially of the characters of the figures.

*The main findings:*
• A high degree of attention by the children was recorded for both pilot films.
• About 30 per cent of the 2-year-olds and around 50 per cent of the 4-year-olds were able to answer questions on the plot. They could even reply to some questions with concrete details and thus showed that they had understood the personal traits of the characters.
• It was, however, realised that some of the drawings were too complicated, especially for the 2-year-olds, and therefore they had to be improved. Changes were also to be made to the content and plot to ensure that the 2-year-olds understood the message correctly.

Four more films with similar content were added to the two pilot films. The six cartoons were broadcast in six instalments, each as part of the children's series *With Mother* from September 1986.

Knowles, A. and Nixon, M. (1983). Young children's understanding of emotional states as depicted by television cartoon characters. In S. Kent, M. Nixon, A. Knowles *et al.* (eds), *Television and Children: Comprehension of Programs*. Clayton, Victoria: Monash University, pp. 49-60.
The *aim* of this Australian study was:
• to ascertain how far 5- to 9-year-old children understand or register emotions as depicted by animated cartoons;

- to compare Selman's development stages of the feeling of jealousy with age, with the ability to cognitively express views and with other person-related features of the test subjects. (Selman divides the development of children's feeling of jealousy into three phases: (1) from the age of three to six – children feel no jealousy towards other people, but towards what other people do or what they play with; (2) from the age of five to nine – children are still jealous of objects or deeds, although they now have an understanding of other people's thoughts or feelings; (3) from the age of seven to 12 – children can recognise the feelings of other people, put themselves into their position and are jealous of interpersonal relations.)

Eighty 5- to 9-year-old children watched a short cartoon film about the jealousy of a boy whose dog preferred to play with another child. Then the children individually answered three parts of a test: first, they assessed the emotional state of an animated figure on the basis of eight colour photos of pictures from the cartoon they had just seen; then the children answered open-ended questions on the boy's feelings and on jealousy; finally two psychological tests were carried out which, among other things, looked at the children's ability to express views on emotions cognitively. The children's teachers had to describe each child's temperament in a further psychological test.

*The most important results:*
- Age and the ability to express themselves verbally significantly agreed with Selman's division (according to age levels) on feeling jealousy.
- The ability to recognise emotional states from pictures was connected with age, but not with the ability to express views cognitively or with the children's temperament. This study provides the first information on children's ability to perceive emotions presented by television figures and on the development of how children feel jealousy.

Quarfoth, J. (1979). Children's understanding of the nature of television characters. *Journal of Communication*, 29(3), pp. 210-218.

When does a child begin to recognise the features which distinguish between people as television characters in animated cartoons and puppets as television characters? Each of 118 3- to 10-year-old children were shown 20 pictures of people, puppets and drawn figures for the children to assign to groups of the same kind. Using multiple choice questions and open-ended questions, a test was carried out to see to what extent the children understood the different natures of people, puppets and drawn figures.

*Results:*
- In the test to arrange the pictures into groups, the percentage of children, (correctly) ordering them into three groups (people, drawn figures and puppets) rose systematically as age increased.
- It was only in the third and fourth school grade that the children

realised that 'being alive' and the ability to move alone (autonomously) is characteristic of people as television characters and not of drawn figures and puppets.

- A large number of the children in the second, third and fourth grades at school did not understand how the animated figures and puppets functioned.
- The children understood the features peculiar to television characters all the better, the older they were. Their understanding increased, especially in children in the early school years.

*Conclusion of the study:*
Most of the children are not in a position up to about the age of seven to distinguish between real film and animation.

Rydin, I. (1979). *Children's understanding of television. From seed to telephone pole. With moving pictures or stills?* Stockholm: Swedish Broadcasting Corporation

This study carried out in Stockholm with 149 5-year-old and 126 7-year-old children examines how children perceive educational content on television that was mediated partly by still pictures and partly by moving (animated) pictures. How far details and digressions from the main subject, inessential for the clarity of the content, influence comprehension and retention was also discussed.

To do this six versions of a film sequence were produced with the same content: three of them with stills – with or without details and digressions by the speaker off screen – and three with moving pictures – with or without details and digressions by the speaker off screen. Groups of four to five children each saw one version and were questioned individually afterwards, top priority being given to the children's understanding and retention performances.

*Some of the findings:*
- There was a difference in the retention performance when the two versions were compared (with stills and moving pictures) the content of which was restricted to the bare facts.
- Moving pictures only rarely contributed to a better understanding of the content, as had been predicted.
- In the case of the versions that showed not only the facts but also additional details that were not necessary for the clarity of the content, moving pictures had a stimulating effect. They backed up an understanding of what was essential.
- The 5-year-olds perceived the content more attentively when details were presented on the facts.
- In the case of the 7-year-olds it was observed that the content could be better understood and retained if they were shown moving pictures.

## References

Bachmair, B. (1980). 'Mit eigenen Augen sehen'. Der Versuch, Fernsehen didaktisch zu zähmen. ('Seeing with your own eyes'. The attempt to tame television didactically.) *Medien und Erziehung*, 24(4), pp. 194-204.

Careless, J. (1990). Canada's Soft Sell. *Television Business International.* Focus: Children's television grows up, -(7), p. 40.

Caron, A.H., Every, E. van and Croteau, S.C. (1991). *Children's television in Canada and Europe*. An analysis of Canadian children's programming and preferences. Examples of children's television programming in Europe. Montreal, Quebec: CYMS.

Dœlker-Tobler, V. (1983). Zeichentrickfilm und Comics aus medienpädagogischer Sicht. (Cartoons and comics from a media pedagogical perspective.) *Communications*, 9(2-3), pp. 221-226.

Evans, R. (1990). European animators team up to compete. *Television Business International*. Focus: Children's television grows up, (7), pp. 44-47.

Evans, R. (1990). The day of the jackpot. The biggest money of all is made off-screen, and that has drawn some of TV's biggest players to the gaming table. *Television Business International*. Focus: Children's television grows up, (7), pp. 35-36.

Friedman, A.J. (1989). Goodbye hard times, hello soft 'toons'. *TV World*, 12(3), pp. 12-14.

Fuchs, W.F. (1973). Schweinchen Dick und seine Freunde. Comics im Fernsehen. (Schweinchen Dick and his friends. Comics on TV.) *Medium*, 3(2), pp. 4-7.

Gronegger, H. (1990). Bessi & Bingo. Eine bewegte Geschichte. Die neuen SWF-Werbefiguren oder Wie ein Zeichentrickfilm entsteht. (Bessi & Bino. A moving story. The new Südwestfunk advertising figures or how a cartoon comes about.) *SWF-Journal*, 165(-), pp. 12-19.

Haley, K. (1989). On a clear day you can see quality kids' TV. . . A showdown is imminent on kids´ television. The trend towards 'soft' animation has already slowed the slump in syndicated TV revenues, while cable's kiddie income has trebled. Kathy Haley reports on the syndicators' scramble for quality. *TV World*, 12(7), pp.26-29.

Hayes, D.S. and Birnbaum, D.W. (1980). Pre-schooler's retention of televised events. Is a picture worth a thousand words? *Developmental Psychology*. 16(5), pp. 410-416.

Hirschkorn, A. (1989). *Der deutsche Zeichentrickfilm für Kinder. Produktion – gegenwärtiger Stand und zukünftige Entwicklungen,* (German cartoons for children. Production – the current state of the art and future developments.) (Diplomarbeit). Hanover: Hochschule für Musik und Theater.

Huston, A.C. *et al.* (1981). Communicating more than content: Formal features of children's television programs. *Journal of Communication*, 31(3), pp. 32-48.

Jakob, S. (1990). Einfach märchenhaft. Animation und Information im Prix Jeunesse (1990). (Simply fabulous. Animation and information in the Prix Jeunesse.) *epd Kirche und Rundfunk*, (48), pp. 8-12.

Jung, F. (1987/1988). Der Animationsfilm (I-V). Film und Videos zur Medienkunde. (The animated film (I-V). Film and videos on media studies.) *Medien praktisch*, 1987(March)/1988(Jan).

Kent, S. (1983). Presentation medium and story, comprehension in young children. In *Television and children: Comprehension of programs*. Clayton, Victoria: Monash

Univ. pp. 28-48.

Kline, S. (1991). Let's make a deal: Merchandising im US-Kinderfernsehen. *Media Perspektiven*, (4), pp. 220-234.

March, R. (1989). Science fiction or 'good old days'. *TV World*, 12(3), pp. 18-19.

*Medien Concret* (1990). Zeichentrick- und Animationsfilm. -(3), (Cartoon and animated film) 95 pp.

O'Bryan. K.G. (1975). *Eye movements as an index of television viewing strategies.* Paper presented at the Biennial Meeting of the Society for Research in Child Developnent. Denver,Col., April 10-13, 1975.

Production, modernisation, training and information. Cartoon goes all out for European animation (1991). *Media*, (7), pp. 12-15.

Rogge, J.U. (1990). Am Samstagmorgen ist die Welt noch in Ordnung. (It's Saturday morning and the world is still in order.) *Medien Concret*, -(3), pp. 49-56.

Schilling, M. (1990). Japan faces some unfavorable trends. *Television Business International*. Focus: Children's Television Grows Up. (7), p. 48.

Schmid Ospach, M. (1973). Vorschule für Konsumenten. Die Mainzelmännchen. Das »ungeheuer erfolgreiche« ZDF-Vehikel für die Werbung. (Pre-school for consumers. The 'monstrously successful' ZDF vehicle for advertising.) *Medium*, 3(2), pp. 2-3.

Stötzel, D.U. (1990). *Das Magazin 'Die Sendung mit der Maus'.* Analyse einer Redaktions- und Sendungskonzeption. (The magazine 'The programme with the mouse'. Analysis of an editorial and programme conception.) Wiesbaden: Harrassowitz.

Strobel, R. (1987). *Die »Peanuts« – Verbreitung und ästhetische Formen. Ein Comicbestseller im Medienverbund.* ('Peanuts' – propagation and aesthetic forms. A comic best-seller in the media.) Heidelberg: Winter.

Stuart, J. and Schilling, M. (1989). Animation producers draw gently together. *Television Business International*, 2(7), pp. 38-42.

Thiele, J. (1981). *Trickfilm-Serien im Fernsehen. Eine Untersuchung zur Didaktik der Ästhetischen Erziehung.* (Cartoon series on TV. A survey on the didactics of aesthetic education.) Oldenburg: Isensee.

Thierney, J., Hardy, P., Kindred, J., Williams, M. and Kruger, D. *et al.*(1990). Animation. *Animation*, -(5), pp. 55-70.

Tobin, B. (1990). Renaissance humour. After years in the doldrums, animation has regained its classic style – heroic, cool and, above all, funny. *TV World*, 13(7), pp. 12-14.

TV World (1989). *Animation special.* 12(3).

U.S. animation boom draws the big guns (1990). *Television Business International.* Focus: Children's Television Grows Up. (37), p. 38.

Woolery, G.W.(1983). *Children's television. The first thirty-five years.* 1946-1981 Vol.. 1. Animated cartoon series. Metuchen, N.J. *et al.*: Scarecrow Press. XVII, 386 pp.

Woolery, G.W. (1985). *Children's television. The first thirty-five years.* 1946-1981 Vol. 2. Live, film, and tape series. Metuchen, N.J. *et al.*: Scarecrow Press. XXI, 788 pp.

Zapletal, A. (1990). Jenseits von Walt Disney. Zur Situation des europäischen Animationsfilms. (Beyond Walt Disney. The situation of European animated film.) *Medien Concret*, -(3), pp. 27-33.

## Note

1   The German version of this article appeared in *TelevIZIon* 5/1992/1, pp. 22-29.

# Children and TV advertising: Research findings 1988–1993[1]

*Paul Löhr*

The following documentation contains analyses and studies that have been published between 1988 and 1993.[2] There are two exception to this: the study by Böckelmann, Huber and Middelmann (1979) is considered as a 'classic' in German research on television advertising; the commentary by Haase (1987) offers an assessment of the international and national effects research in the field of children and commercial television that is still valid today.[3]

## 1. A German 'classic'

Böckelmann, F., Huber, J. and Middelmann A. (1979). *Werbefernsehkinder. Fernsehwerbung von und mit Kindern in der Bundesrepublik Deutschland.* (Children of commercial television. Television advertising by and with children in the Federal Republic of Germany.) Berlin West: Spiess.

This study, which was carried out as part of the Munich *Arbeitsgemeinschaft für Kommunikationsforschung* (Working Party for Communication Research – AfK) in 1977/78, comprises a content analysis of the 3,201 television commercials and an experimental study on the effect of television advertising carried out with 260 6- to 14-year-olds. What follows is a summary of the results:

- The commercials aimed at children and cast with child actors consist to a very great extent of conservative family arrangements and follow the axiom: 'Possession guarantees attention and recognition'.
- Role models from the upper middle and upper class and infantile satisfaction patterns are presented to the children.
- The product descriptions made in the commercials lack 'hard facts'; they speculate on the children's passion for collecting and hopes of winning something.
- Advertising is for children a phenomenon that is both inescapable and haphazard and not pursued with any specific intention.
- As their age increases, children's attitude to advertising and commercial television becomes more ambivalent and negative.
- As their age increases, children's doubt about the credibility of TV commercials grows.

- More important for the buying behaviour of the children than the claims of commercials is what parents and peers say.
- If children appear as actors in TV commercials, they can stimulate the children's willingness to pay attention to the commercial.
- From the age of 6, at the earliest, children can distinguish between a commercial and a regular programme.
- Whether commercial television influences children's buying behaviour could not be proved.

## 2. Current synopses on the subject of children and television advertising

### 2.1 The expert opinion for the Government

Baacke, D., Sander, U. and Vollbrecht, R. (1992). *Kinder und Werbung*. Gutachten für das Bundesministerium für Frauen und Jugend der Bundesrepublik Deutschland (Children and advertising. An expert opinion for the (German) Federal Ministry for Women and Young People.) Bielfeld (unpubl. manuscript). 259 pp.

The volume contains an extensive treatment of the subject of children and television advertising. Well-founded data on the development of the German advertising market, on the production of advertising, on forms of advertising, on advertising on children's television, on the effect of television advertising, and on children as consumers can be found, as well as references to the quality of sociological studies hitherto available. In the final chapter the approach to a theoretical conception is presented in which the modern industrial and service society is outlined as an advertising society mediated in principle by very different forms of advertising.[4]

### 2.2 General Overviews

Comstock, G. and Paik, H. (eds). (1991). *Television and the American Child*. San Diego et al.: Academic Press. (Chapter on 'Advertising' pp. 188-233.)

Haase, H. (1987). Die Wirkung des Werbefernsehens auf Kinder und Jugendliche. (The effects of television advertising on children and young people.) In M. Grewe-Partsch et al. (ed), *Menschen und Medien*. Munich: Saur, pp. 152 ff.

Huston, A.C., Donnerstein, E., Fairchild, H., Feshbach, N. D., Katz, P.A. et al. (1992). *Big World, Small Screen. The Role of Television in American Society*. Lincoln, Neb.: University of Nebraska Press. (Chapter on 'Advertising' pp. 69-76.)

Signorielli, N. (1991). *A Sourcebook on Children and Television*. New York, N.Y.: Greenwood Press. (Chapter 'Children and Advertising' pp. 99-112.)

These four texts are similar in many ways; the most extensive documentation is the one by Comstock and Paik (1991), while that by

Huston *et al* (1992) is short but very concise. In the summary of the current research situation the authors begin with the debates that led to the question in the USA at the end of the eighties of whether advertising that is directly aimed at children can be politically justified. They then present the most important findings of more recent studies and try to show that it is particularly younger children who should be confronted by television advertising as little as possible.

All authors offer useful overviews – with a lot of data clearly arranged – on the studies that have been carried out in the last decades, especially with regard to the following problems:

- How can the attributes of the form and content of TV commercials be described?
- How do children understand television advertising?
- What makes it possible – or impossible – for children to recognise in 'real life' the products praised in TV commercials?
- How do the children assess the advertising messages?
- What are the consequences for the parent-child relationship arising from children watching commercials?

Assessments are also given of the current discussion on advertising policies, and it becomes obvious that as far as those responsible for social and television policies are concerned few concessions are made towards dealing with the subject of children and TV advertising in an educationally appropriate way.

Haase (1987) attaches particular importance to drawing conclusions for the research situation in Germany from the debate about the American findings. He offers a very subtle assessment of the research findings available hitherto, criticises the German research findings and suggests where research projects should begin.[5]

Pauser, B. (1990). *Werbefernsehkinder? Zum Stellenwert der Fernsehwerbung und ihrer Werbewirkung auf das Konsumverhalten bei Kindern im Vorschulalter.* (Children of Television Advertising? The role of television advertising and its advertising effect on consumer behaviour in children of pre-school age.) Vienna: Grund-u. Integrativwissenschaftl. Fakultät (M.A. dissertation).

An even more comprehensive treatment of the subject 'children and television advertising' is to be found in Pauser's dissertation. The author also refers to the research results obtained in recent years, but she tries to shift the emphasis of her analysis more towards the situation here in Germany – in particular the situation in Austria and in former West Germany. As she, however, can only fall back on very few Austrian and German studies, she does not go beyond the question as to whether and how far the findings, mainly from US studies, can be applied to conditions in Germany. In Pauser's work reference is made not only to the economic, technical, legal and political circumstances of television advertising (and

239

other advertising practices in the media) but also to the problems connected with the form and content of television advertising and its influence on primary school children.

Six, U. (1990). *Kinder und Werbung. Ausgewählte Thesen und Forschungsergebnisse.* (Children and advertising. Selected theses and research findings.) Munich: Deutsches Jugendinstitut.

Six collates mainly US research results that seem to be applicable to the relationship between children and television advertising in Germany, in particular to how it is influenced by the way commercial television is implemented. She first sketches the importance of the advertising market and its connection to children. She also shows how much space commercials take up on public-service (ARD, ZDF) and commercial television and how the latter has an ever growing impact on children as a target group. In the second part of her argumentation Six explains the reasons why commercials seem to attract children and the influence they have on them. Here she distinguishes between intentional effects (ie tied up with the advertising brief) and casual, unintentional ones. She emphatically points out that such effects can only be ascertained correctly if they are distilled from the context in which children's experiences of television, the media and other everyday events take place.

The author stresses in particular that the consumption of television advertising by the children may result in their experiencing a shortcoming and polarisation: on the one hand, expectations that cannot be fulfilled are aroused and heightened in a large group of the young audience, and, on the other, the children who think they can afford the products advertised are set apart from those who have to make do without fulfilling such wishes.

### 2.3 Advertising, commercial television and children's everyday life-world[6]

Kübler, H.-D. (1991). Werbung in der Lebenswelt von Kindern heute. Einige Thesen und Forschungsergebnisse. (Advertising in children's life-world. Some theses and research findings.) In A. Buskotte, R. Wiebusch, Buersch, M. *et al.* (eds). *Dokumentation des Expertenforums 'Kinder und Werbung'.*(Documentation from the experts' forum 'Children and Advertising'.) Munich: Deutsches Kinderhilfswerk; pp. 11-35.

Kübler first points out current impulses and trends to introduce his treatment of the subject of children and television advertising, focusing on the situation of the children, developments on the product and media market and the role of commercial television. He then takes an example to illustrate what is to be understood today by advertising, in particular advertising relevant to children.[7] Kübler then asks what the effects are that television commercials have on children and which consequences these

programmes have for children's buying behaviour, for the development of their cognitive and affective abilities and for the formation of their concepts of world and society.

Kübler is guided by the study by Böckelmann, Huber and Middelmann (1979), arguing that otherwise no studies were available that were useful for analysing conditions here in Germany. He emphasises that any clarification of the relationship of children and commercial television depends very considerably on how precisely the function of commercial television in children's everyday life can be brought out. In the final section he discusses the question as to whether the problems associated with the subject of children and commercial television can be tackled by using prescriptions and proscriptions which are directed against the advertisers. He does not believe that it is possible to intervene in this way in favour of the children. He tends to support endowing the children with abilities which turn them into perhaps resistant, at any rate not entirely compliant and manipulable, consumers.

### 2.4 Towards a theory based on developmental and cognitive psychology

Young, B. M. ( 1990). *Television Advertising and Children*. New York, N.Y.: Oxford University Press.

Young presents a series of empirical studies which he has carried out himself and which are built up on approaches of cognitive and developmental psychology as well as on theories of linguistics and discourse analysis. He places three questions in the centre of his study:

- How do children understand television advertising?
- What do the effects of television commercials on children look like?
- Which abilities do children need to possess what Young calls *'advertisement literacy'*?

The author looks into these questions by dealing with both the relevant and the more unusual literature published by psychologists and linguists in the last 20 years. He presents the results of his own studies of which the hypotheses have been obtained from evaluating that literature. Young offers an in-depth overview of the current state of research and its development in the last few years. Taking his own projects as examples, he demonstrates how the horizons of empirical studies can be considerably extended by including modern qualitative methods of analysis, as compared to methods of traditional research into effects.

Young's interest is mainly directed towards formulating a psychological theory of literacy development, in which there is no longer room for the common formula of 'advertising as seducer' and 'child as innocent'. He argues in favour of a conception centred on children's (learnable) competence to interpret and see through commercials so that they can be neither manipulated nor deceived by them.[8]

## 3. Media and consumption

Ehapa Verlag (1992). *Frühe Markenpositionierung. Neues über Kinder und Marken.* (Early Brand Positioning. New findings about children and brands.) Stuttgart: Ehapa.

Verlagsgruppe Bauer, Media Marketing/Forschung (1993). *Kinder- und Programmzeitschriften. Medien- und Konsumdaten von 6-14 jährigen Kindern.* Eine repräsentative Studie. (Children and TV Guides. Media and consumption data of 6- to 14-year-old children.) Hamburg: Bauer-Verlag.

These two studies contain a collection of child-related data on important aspects of the relationship between children and commercial television. The Bauer report is based on a representative omnibus survey of 1,614 children aged between 6 and 14 years from former West German and the 'new' East German *Länder*. It deals chiefly with the following issues: pocket money, possession of a savings book, the family's influence on purchasing decisions, interest in and the acquisition of sweets, soft drinks and toys.

The Ehapa survey constitutes a good complement to that of the Bauer publishing company. It is, for the most part, devoted to the 8- to 12-year-olds' awareness of car brands and comprises an experiment with 45 9- to 12-year-old subjects and a representative survey of 502 8- to 12-year-olds. The Ehapa study is an example to illustrate;

- how on the part of the children the world of products praised by advertising (including television advertising) turns into a brand market;
- which 'order functions' such brands avail themselves of;
- which personality and socially-relevant features are allotted to the brands and to the companions they represent; and
- how children apply their knowledge of brands to their parents' purchasing decisions and the individually and socially made assessment of the brand owners.[9]

## 4. Analyses of advertising programmes

### 4.1 General programme analyses

Heinrichs, M., Mohr, I., Schmid, T., Smits, R., and Sutor, S. (1992). *Kinder und Werbung. Programmanalyse der privaten TV-Veranstalter RTL plus, SAT.1, Tele 5 und PRO 7*. Eine Analyse der Werbepraxis im Hinblick auf die Werbung für und mit Kindern. (Children and Advertising. A programme analysis of the private TV companies *RTL plus; SAT 1, TELE 5* and *PRO 7*. An analysis of the advertising practice with regard to advertising for and with children.) *epd Kirche und Rundfunk*, (72), pp. 3-19.

Krüger, U.M. (1993). *Kontinuität und Wandel im Programmangebot.* Programmstrukturelle Trends bei ARD, ZDF, SAT 1 und RTL 1986 bis 1992.

(Continuity and change in the programmes output. Trends in the programme structure of ARD, ZDF, SAT 1 and RTL from 1986 to 1992.) *Media Perspektiven*, (6), pp. 246-266.

The study by the team led by Heinrichs[10] is the only one in which the advertising programme broadcast by the several commercial stations is broken down into categories and subjected to a content and form analysis.[11] Particular attention was paid to advertising within the framework of the programmes presented officially as children's programmes by the (then) leading commercial broadcasters in Germany.

Although not all the findings of the programme analysis are still transferable to the current situation, the data on the whole do provide an informative insight into the way in which the commercial companies tailor their advertising programme and adapt it to the young viewers. The major issues on which the analysis furnished data graphically presented in detail are:

- the daily advertising quantity of the commercial stations:[12]
- the characteristics of the various forms of advertising offered by the commercial stations, the classic commercial being the dominant one;
- the direct and indirect relation of advertising to children;
- the part played by child actors in advertising;
- the placement of commercials in the vicinity of and as an interruption to the 'official' children's programmes (see above);
- the especially children-friendly advertising in the afternoon and on Saturday and Sunday mornings;
- the types of products most frequently advertised.

The authors close their study by emphasising children's need for protection against the 'power of advertising' that is clearly revealed.[13]

## 4.2 The 'gender specifics' of advertising programmes

Kolbe, R.H. (1990). Gender Roles in Children's Television Advertising. A Longitudinal Content Analysis. In J. H. Leigh. C. R. Martin, Jr. (eds). *Current Issues and Research in Advertising.* Ann Arbor, Mich.: Graduate School of Business Administration, University of Michigan; pp. 180 ff.

As a continuation of studies most of which were carried out by working groups led by Aletha C. Huston at the end of the 70s and beginning of the 80s, Kolbe has made a content analysis to reveal and show the 'gender specifics' of commercials which help to give them a 'female' or 'male' emphasis. Using for the most part advertising for toys, he demonstrates that commercials contain a female accent by calm direction, gentle background music and soft, often blurred pictures, and a male accent by active and aggressive behaviour with the toys, technical effects and loud music. That these formal features apparently fit the stereotype of femaleness and maleness acquired by the children through socialisation

can be seen from the fact that the children – both boys and girls – describe the programme with female accents as female and the programme with male accents as male.[14]

### 4.3 Children as actors in television commercial

Aufenanger, S. (1993). *Kinder im Fernsehen – Familien beim Fernsehen.* (Children on television – Families watching television.) München: Saur. (Schriftenreihe IZI. 26.) (Chapter *Kinder in Werbesendungen* [Children in Commercials] pp. 82 ff.).

Aufenanger presents a brief study on how often and in which roles children appear in television commercials. He has analysed 272 commercials broadcast by *ARD, ZDF, SAT 1* and *RTL* in a typical weekday (February 1-11, 1992) and 72 commercials from the Saturday and Sunday morning programme of *SAT 1* and *RTL* (March 2-3, 1992). It emerges that:

- the rate of child actors is smaller in the weekday commercials than at the weekend (23 per cent to 40 per cent);
- children play a leading role especially in commercials that are aimed more or less directly at children as customers;
- with the help of child actors the commercials are given a lasting gender-specific tinge;
- the commercials in which children are given a leading role are repeated most frequently.

In two brief qualitative sketches Aufenanger shows from commercials for *Barbie, Kaba* and *R+V Versicherung* (insurance) which effects advertising messages can have on children's thinking and feeling as well as on their consumption habits and social behaviour.[15]

### 5. Children's relationship to television advertising and age differences

Riecken, G. and Yavas, U. (1990). Children's General, Product, and Brand-Specific Attitudes Towards Television Commercials: Implications for Public Policy and Advertising Strategy. *International Journal of Advertising,* 9, pp. 136-148.

The authors take as their starting point the following questions: How do children relate to television advertising? What attitude do they adopt to it by reason of their level of cognitive, affective and motivational abilities? What effect does the consumption of television advertising have on the above abilities which themselves have to be regarded as essential variables intervening in the children's relation to advertising messages? In their study they measured the attitudes of 152 school pupils to product brands and individual products – both in their general quality and when confronted by advertising messages.

Van Evra, J. (1990). *Television and Child Development.* Hillsdale, N.Y.: Erlbaum. (Chapter 7: Television Advertising and Behavior, pp. 133-149).

Van Evra collates the findings of psychological and sociological research on the problem of advertising and children's development. She takes as the guideline the thesis that the children turn to advertising and television commercials and develop specific attitudes towards them according to their age and level of development. She describes the variables resulting from developmental stages (the children's cognitive and affective capacities) which determine their attention towards and willingness to view the content and form of television commercials. In this connection she shows how it is precisely the formal features that contribute to the children's attention being aroused and sustained. She also points out which attitudes the children develop towards the advertising messages and whether – and if so, how – these attitudes have an effect on the children's consumer behaviour. Finally she sketches the particular qualities of content and form that are meant to bond children to the advertising messages and their 'positive appeal'.

Van Raaji, W. F. (1990). Cognitive and Affective Effects of TV Advertising on Children. In S. Ward, T. Robertson, R. Brown (ed). *Commercial Television and European Children. An International Digest.* Aldershot, Hants.: Avebury, pp. 99-109.

Van Raaji presents a model in which the variables resulting from age and developmental stage through which children's relationship to advertising messages materialises are collated and – in relation to one another – are explained. Van Raaji demonstrates how and through what means the children's reactions to the advertising messages arise. He also makes clear which abilities the children must have to be neither deceived nor manipulated by the messages they receive, and that these abilities cannot be acquired at any particular time, but that they form as a factor of age and level of development. He breaks down the factors relevant to future research into 'commercial' variables (content and form, attention value of the advertising message), 'antecedent' variables (eg involvement of the children, processing time, situational distractions) and 'processing' variables (the manner in which children treat the information) and shows how these variables interact with one another.

Ward, S. (1990). How children understand with age. In S. Ward, T. Robertson and R. Brown (eds). *Commercial Television and European Children. An International Research Digest.* Aldershot, Hants.: Avebury, pp. 33-53.

Ward also presents a compilation of findings on the subject of children and commercial television – however, only of studies and papers which were carried out and ascertained solely on the basis of theories of cognitive psychology. He states as essential points:
- Younger children are not 'confused' by watching advertising messages, but are cognitively overtaxed, because they are unable to understand what distinguishes advertising.
- Older children (from the age of eight) have to be quite differently

assessed from younger children because they have no difficulty in grasping the basic intentions contained in the advertising messages (namely, to praise something 'persuasively' in order to sell it).

- The aversion to the persuasion mechanism begins chiefly from the age of 10, because children are then, first, cognitively capable of dealing with advertising messages and, secondly, have gathered practical experience to enable them to assess accordingly and qualify the recommendations made by advertising.

The so-called heavy viewers, even with increasing age and cognitive capacity, remain far more 'vulnerable' to advertising messages than 'normal viewers'.[16]

## 6. Methods of praising products and influencing children

Kunkel, D. (1988). Children and the Host-Selling Commercial. *Communication Research*, 15, 1, pp. 71 ff.

The author describes how children of six to seven years of age have difficulty in distinguishing between advertising and programming; that means, in separating the meaning level of one from that of the other programme item. This situation is also aggravated by the extreme proximity of commercials and other programmes, which allows one kind of programme to turn into the other unnoticed by children. How this weakness of the children in differentiating is taken into account in the make-up of commercials is shown by the so-called host-selling method, which is based on consistently merging commercials and programming. The principal feature of the host-selling format is that in commercials products are endorsed by presenters, actors, puppets, and toy figures that are known as leading figures in children's television programmes and are popular with children: the celebrity appearing in the commercial (Alperstein, 1991) is meant to make the relationship that has formed between him or her and the children have the effect of a transmission belt through which the children are conveyed to the recommended product.[17]

## 7. The problem of effect

Goldberg, M. E. (1990). A Quasi-Experiment Assessing the Effectiveness of TV Advertising Directed to Children. *Journal of Marketing Research*, 27, p. 445-454.

Goldberg's study was carried out in Montreal. The starting point for his study is the fact that the Quebec television stations, which broadcast in French, are not allowed to transmit any advertising that is directed to children and that French-speaking children who watch the Quebec stations' children's programmes almost exclusively are confronted far less by advertising than the English-speaking children, who insist on watching the programmes from the USA. As was confirmed in the study the English

speaking children showed a far greater knowledge about advertised toys and breakfast cereals than the French-speaking children. Goldberg demonstrates that television commercials undoubtedly have an immediate impact on children. This, however, does not furnish any important information on the influence of television advertising on the children's thinking, feeling and behaviour. Such information is only possible if:

- it is shown from which situation the effect on children takes place;
- it is revealed what the advertising message triggers off in the children;
- the way in which children deal with what the advertising message has brought about in them is followed up.

Heining, R. and Haupt, K. (1988). Die Wirkung des Werbefernsehens auf Kinder. (The Effect of Television Advertising on Children.) *planung und analyse*, pp. 343 ff.

This study is based on a non-representative sample of 5- to 10-year-olds and their parents. The data and findings relate to:

- the role function of parents with regard to evaluating advertising messages;
- the fascination exerted by the advertising messages;
- the significance of advertising and products that are targeted directly at children;
- the discrepancy between children's actual 'advertising knowledge' and that presumed by the parents;
- the creation of wishes through advertising;
- the attractiveness of advertising messages and their impact on the children's buying wishes.[18]

## 8. International comparative studies

Collins, J., Seip Toennessen, E., Barry, A. M, Yeates, H. (1992). Who's Afraid of the Big Bad Box? Children and TV Advertising in Four Countries. *Educational Media International*, 29,4, pp. 254-260.

Robertson, T. S., Ward, S., Gatignon, H., Klees, D. M. (1989). Advertising and Children. A Cross-cultural Study. *Communication Research*, 16(4), p. 459-485.

Both studies revolve round the question of the way in which television advertising influences children's orientation and behaviour. Collins *et al.* (1992) interviewed children from Australia, Ireland, Norway and the USA; Robertson *et al.* (1989) children from Britain, Japan and the USA. The findings show that the children – independent of their nationality – develop a similar relationship to the form and content of television advertising, to its attractiveness and ability to manipulate, to its relevance to information and entertainment.

Here the statements and reactions of the 'western' children are almost indistinguishable, whereas in some cases significant differences emerge between children from Japan and those from Britain and the USA. Thus the

Japanese children were very much more strongly bound by rules of family life, displayed a clear – related to the family – we-feeling, occupied themselves far less with television and its advertising, called on their parents much more rarely to buy things than the children from British and American families. In conclusion Robertson's research team notes:

- The more 'egocentrically' the children relate to themselves and their environment, the greater is the television (advertising) consumption, the more demands are made on the parents (to make purchases) and the deeper is the conflict between child and parents.

- The greater the television (advertising) consumption, the more demands are made on the parents (to make purchases) and the deeper is the conflict between child and parents.[19]

## 9. Children, television advertising and the free market economy

Kerkmann, D., Kunkel, D., Huston, A. C., Wright, J. C., Pinon, M. F. (1990). Children's Television Programming and the 'Free Market Solution'. *Journalism Quarterly*, 67 (1), pp. 147-156.

Kunkel, D. and Gantz, W. (1992). Children's Television Advertising in the Multichannel Environment. *Journal of Communication*, 42 (3), pp. 134-152.

Kunkel, D. and Roberts, D. (1991). Young Minds and Marketplace Values: Issues in Children's Television Advertising. *Journal of Social Issues,* 47(1), pp. 57-72.

The studies are based on the assertion of the US Federal Communications Commission that a high-quality children's television programme will prevail if the market forces are allowed to take effect without any interference. In large-scale studies the research groups show that that is out of the question. Instead two things become clear:

- In the multi-channel television market, from the economic viewpoints of advertising, those children's television programmes that are preferred are precisely those whose forms and content direct the children to an extreme extent to the commercials.

- Under the competitive conditions of this market the children are quite deliberately targeted with such commercials as operate with manipulations and deceptions and which, above all, try to exploit the vulnerability of the younger children to insidious influences.

In the studies it is explicitly disclosed that confidence in the free development of market forces prevents the research findings on the relationship between children and television advertising from being treated in a way which is politically and educationally responsible. It is argued that in the meantime numerous reliable research findings, especially for younger children, are available, which make their need for protection against rampant television advertising and its unchecked effects on the non-commercial part of the programming crystal clear. On account

of the prevailing balance of the economic forces of television it cannot be expected, in the authors' opinion, however, that in the USA those responsible for social and communication policies will draw conclusions for educational policies which are in the interests of protecting children.[20]

## References

Alperstein, N. M.( 1991). Imaginary social relationships with celebrities appearing in television commercials. *Journal of Broadcasting and Electronic Media*, 35,1, pp. 43-58.

Aufenanger, S. (1993). *Kinder im Fernsehen – Familien beim Fernsehen.* (Children on television – Families watching television.) Munich: Saur. (Schriftenreihe IZI. 26.) (Chapter *Kinder in Werbesendungen* [Children in Commercials] pp. 82 ff.).

Baacke, D., Sander, U. and Vollbrecht, R. (1992). *Kinder und Werbung.* Gutachten für das Bundesministerium für Frauen und Jugend der Bundesrepublik Deutschland (Children and advertising. An expert opinion for the (German) Federal Ministry for Women and Young People.) Bielfeld (unpubl. manuscript). 259 pp.

Böckelmann, F., Huber, J. and Middelmann A. (1979). *Werbefernsehkinder. Fernsehwerbung von und mit Kindern in der Bundesrepublik Deutschland.* (Children of commercial television. Television advertising by and with children in the Federal Republic of Germany.) Berlin West: Spiess.

Collins, J., Seip Toennessen, E., Barry, A. M, Yeates, H. (1992). Who's Afraid of the Big Bad Box? Children and TV Advertising in Four Countries. *Educational Media International*, 29,4, pp. 254-260.

Comstock, G. and Paik, H. (eds). (1991). *Television and the American Child.* San Diego et al.: Academic Press. (Chapter on 'Advertising' pp. 188-233.)

Ehapa Verlag (1992). *Frühe Markenpositionierung. Neues über Kinder und Marken.* (Early Brand Positioning. New findings about children and brands.) Stuttgart: Ehapa.

Goldberg, M. E. (1990). A Quasi-Experiment Assessing the Effectiveness of TV Advertising Directed to Children. *Journal of Marketing Research*, 27, p. 445-454.

Haase, H. (1987). Die Wirkung des Werbefernsehens auf Kinder und Jugendliche. (The effects of television advertising on children and young people.) In M. Grewe-Partsch *et al.* (ed), *Menschen und Medien.* Munich: Saur, , pp. 152 ff.

Heining, R. and Haupt, K. (1988). Die Wirkung des Werbefernsehens auf Kinder. (The Effect of Television Advertising on Children.) *planung und analyse*, pp. 343 ff.

Heinrichs, M., Mohr, I., Schmid, T., Smits, R., Sutor, S. (1992). *Kinder und Werbung. Programmanalyse der privaten TV-Veranstalter RTL plus, SAT.1, Tele 5 und PRO 7.* Eine Analyse der Werbepraxis im Hinblick auf die Werbung fuer und mit Kindern. (Children and Advertising. A programme analysis of the private TV companies RTL plus; SAT 1, TELE 5 and PRO 7. An analysis of the advertising practice with regard to advertising for and with children.) *epd Kirche und Rundfunk*, (72), pp. 3-19.

Huston, A.C., Donnerstein, E., Fairchild, H., Feshbach, N. D., Katz, P.A. *et al.* (1992). *Big World, Small Screen. The Role of Television in American Society.* Lincoln, Neb.: University of Nebraska Press. (Chapter on 'Advertising' pp. 69-76.)

Kerkmann, D., Kunkel, D., Huston, A. C., Wright, J. C., Pinon, M. F. (1990).

Children's Television Programming and the 'Free Market Solution'. *Journalism Quarterly*, 67 (1), pp. 147-156.

Kolbe, R. H. (1990). Gender Roles in Children's Television Advertising. A Longitudinal Content Analysis. In J. H. Leigh. C. R. Martin, Jr. (eds). *Current Issues and Research in Advertising*. Ann Arbor, Mich.: Graduate School of Business Administration, University of Michigan; pp. 180 ff.

Krüger, U. M. (1993). *Kontinuität und Wandel im Programmangebot. Programmstrukturelle Trends bei ARD, ZDF, SAT 1 und RTL 1986 bis 1992.* (Continuity and change in the programmes output. Trends in the programme structure of ARD, ZDF, SAT 1 and RTL from 1986 to 1992.) *Media Perspektiven*, (6), pp. 246-266.

Kübler, H.-D. (1991). Werbung in der Lebenswelt von Kindern heute. Einige Thesen und Forschungsergebnisse. (Advertising in children's life-world. Some theses and research findings.) In A. Buskotte, R. Wiebusch, Buersch, M. *et al.* (eds). *Dokumentation des Expertenforums 'Kinder und Werbung'.*(Documentation from the experts' forum 'Children and Advertising'.) Munich: Deutsches Kinderhilfswerk; pp. 11-35.

Kunkel, D. (1988). Children and the Host-Selling Commercial. *Communication Research*, 15, 1, pp. 71 ff.

Kunkel, D. and Gantz, W. (1992). Children's Television Advertising in the Multichannel Environment. *Journal of Communication*, 42 (3), pp. 134-152.

Kunkel, D. and Roberts, D. (1991). Young Minds and Marketplace Values: Issues in Children's Television Advertising. *Journal of Social Issues*, 47(1), pp. 57-72.

Pauser, B. (1990). *Werbefernsehkinder? Zum Stellenwert der Fernsehwerbung und ihrer Werbewirkung auf das Konsumverhalten bei Kindern im Vorschulalter.* (Children of Television Advertising? The role of television advertising and its advertising effect on consumer behaviour in children of pre-school age.) Vienna: Grund- u. Integrativwissenschaftl. Fakultät (M.A. dissertation).

Riecken, G. and Yavas, U. (1990). Children's General, Product, and Brand-Specific Attitudes Towards Television Commercials: Implications for Public Policy and Advertising Strategy. *International Journal of Advertising*, 9, pp. 136-148.

Robertson, T. S., Ward, S., Gatignon, H., Klees, D. M. (1989). Advertising and Children. A Cross-cultural Study. In. *Communication Research*, 16(4), p. 459-485.

Signorielli, N. (1991). *A Sourcebook on Children and Television.* New York, N.Y.: Greenwood Press. (Chapter 'Children and Advertising' pp. 99-112.)

Six, U. (1990). *Kinder und Werbung. Ausgewählte Thesen und Forschungsergebnisse.* (Children and advertising. Selected theses and research findings.) Munich: Deutsches Jugendinstitut.

Van Evra, J. (1990). *Television and Child Development.* Hillsdale, N.Y.: Erlbaum. (Chapter 7: Television Advertising and Behavior, pp. 133-149).

Van Raaji, W. F. (1990). Cognitive and Affective Effects of TV Advertising on Children. In S. Ward, T. Robertson, R. Brown (eds). *Commercial Television and European Children. An International Digest.* Aldershot, Hants.: Avebury, pp. 99-109.

Verlagsgruppe Bauer, Media Marketing/Forschung (1993). *Kinder- und Programmzeitschriften. Medien- und Konsumdaten von 6-14 jährigen Kindern. Eine repräsentative Studie.* (Children and TV Guides. Media and consumption data of 6- to 14-year-old children.) Hamburg: Bauer-Verlag.

Ward, S. (1990). How children understand with age. In S. Ward, T. Robertson and R. Brown (eds). *Commercial Television and European Children. An International Research Digest.* Aldershot, Hants.: Avebury; pp. 33-53.

Young, B. M. (1990). *Television Advertising and Children.* New York, N.Y.: Oxford University Press.

## Notes

1   The German version of this article appeared in *TelevIZIon* 6/1993/2, pp. 28-35.

2   This was the time when the public discussion about the effects of television advertising on children was heated up in Germany due to the emergence of commercial or 'private' broadcasting in Germany and its successes among the child audience

3   Unless otherwise stated, the studies documented here all refer to the age group of the 5- to 13- year-olds. They are arranged under different subject headings. As many texts contain contributions on several aspects, cross-references are given in the footnotes.

4   Cf. Kerkmann *et al.*1990.

5   Cf. the overviews by Van Evra, 1990 and Ward, 1990.

6   Cf. Haase, 1987; Huston, *et al.* 1992; Signorielli, 1991; Six 1990

7   The example he takes is the children's programme of the commercial station *Tele 5* (which is no longer transmitting) and the advertising incorporated into it.

8   Cf. Van Raaji, 1990; Ward, 1990; Haase, 1987.

9   Cf. Baacke, Sander and Vollbrecht, 1992; Pauser, 1990

10   The team included experts from the media control bodies in Bavaria, Bremen, North Rhine-Westphalia, Rhineland-Palatinate and Schleswig-Holstein.

11   Included in the analysis were the advertising programmes (i.e. all the programme elements designated as 'advertising' by the commercial stations) that were broadcast by PRO 7, RTL plus, SAT 1 and TELE 5 from 29th July to 4th August 1991.

12   For a comparison with the respective findings for ARD, ZDF, SAT 1 and RTL see Krüger 1993.

13   Cf. Aufenanger, 1993; Baacke, Sander and Vollbrecht, 1992; Böckelmann, Huber and Middelmann, 1979; Kolbe, 1990.

14   Cf. Huston, *et al.* 1992; Signorielli, 1991; Van Evra, 1990.

15   Cf. Baacke, Sander and Vollbrecht, 1992; Böckelmann, Huber and Middelmann, 1979; Heinrichs *et al.* 1992.

16   Cf. Baacke, Sander and Vollbrecht, 1992; Comstock and Paik 1991; Haase, 1987; Six, 1990; Young, 1990.

17   Cf. Alperstein, 1991; Baacke, Sander and Vollbrecht, 1992; Böckelmann, Huber and Middelmann, 1979; Huston, *et al.* 1992; Signorielli, 1991; Van Evra, 1990.

18   Cf. Baacke, Sander and Vollbrecht, 1992; Böckelmann, Huber and Middelmann, 1979; Collins, *et al.* 1992; Comstock and Paik, 1991; Haase, 1987; Kunkel and Gantz, 1992; Pauser, 1990; Robertson, Ward, Gatignon and Klees, 1989; Van Raaji, 1990; Young, 1990.

19   Cf. Haase, 1987; Pauser, 1990; Young, 1990

20   Cf. Baacke, Sander and Vollbrecht, 1992; Haase, 1987; Huston, *et al.* 1992; Kübler, 1991; Pauser, 1990.

# 5: The Violence Issue

# 'Terrific scenes'

## A study of children's reactions to violence on the screen[1]

*Helga Theunert and Bernd Schorb*

*κ fanta.../*

Once I saw a crime thriller; it was brutal. Then I switched over to another channel where the news was on. And in the thriller a person had been murdered; he was lying on the floor dead. And in the news a lot of people were also lying in the street murdered; there were tanks everywhere. That's why I woke up in the middle of the night. I was afraid ...

This is how an 8-year-old boy explains why the 'terrific scenes' on the news upset him. He is not the only one to be scared by gruesome reality shown on television. Portrayals of real-life violence trigger intense emotions in children.

A study on children's reception of portrayals of violence was the subject of a survey carried out by the *Institut Jugend Film Fernsehen* (JFF) and commissioned by the *Hamburgische Anstalt für neue Medien* (HAM) and the *Bayerische Landeszentrale für neue Medien* (BLM), two regional control authorities for private broadcasting.

### The survey in brief

Included in the survey were 100 children aged between 8 and 13 from different social environments in Hamburg and Munich. By means of interviews and play an investigation was carried out into the circumstances in which these children watch information programmes on television, which portrayals of violence they perceive there and how they react rationally as well as emotionally. Individual studies were also carried out on 12-year-old children and their parents. The findings on child reception were reviewed against the background of a previous contents analysis of the information programmes shown on ARD, ZDF, RTL, SAT.1 and PRO 7. This procedure made it clear which programmes and which elements go down well with children and are assimilated.

### Some findings

Children know that the violence – regardless of the type – they see in news programmes comes from real life. They react primarily to three components.

*1. Recognisable suffering of the victims*
When children see that people are suffering physically or psychically their basic reaction is generally one of pity provided that the portrayal contains no elements that disguise the victim. In the event of the latter the children's feelings of pity turn into other feelings, into disgust or fear.

*2. Extremely violent pictures*
If the violent episodes are shown as gory pictures, children all react with disgust. The plainer the pictures, the more intense their feelings are. Children cannot digest such pictures, and many show their indignation, as in the case of a 9-year-old boy: 'There's blood everywhere, and young kids like us have to look at it.'

Extremely violent pictures also arouse anxiety. Another element in this constellation, which does not derive from television, is the children's imagination. When violence is shown in contexts the children evaluate as close and menacing, they put themselves in the situation and thus activate existing anxieties.

*3. 'Reality TV': fictional enactments of reality*
Many children relish 'reality TV' with a thirst for experiencing anxiety and excitement. They react to dramatic compositions they are familiar with in fictional genres, they get a kick out of the climax and the last-minute rescue. In 'reality TV' they have no pity for the victims. When watching portrayals of real-life violence children's emotional reactions come to the fore. Only a few achieve a rational approach, which is also erased when extremely violent pictures flash across the screen.

• A child's reactions to television information is dependent on the home environment. The information consumed and appraised by the parents is also viewed and appreciated by the children. The importance attached by the parents to the information shown on television for their view of the world and their own lives also applies to their children.

Children from intellectually oriented or liberal parents begin at an early age to extend their horizons beyond the immediate environment and endeavour to respond to reality with a critical eye. They largely succeed in drawing a line between above-board information and sensationalism. Particularly children in less stimulating environments, whose parents understand 'reality TV' as a reproduction of the real world, have difficulty achieving this.

Many parents believe in the proclaimed educational value of the programmes, which they in turn wish to pass on to their children. The children's (and parents') perspective is restricted to allegedly ubiquitous dangers. Not only a closer look at reality but also the ability to distinguish reality from its transmission in the media are impaired as a result. The children's feelings of uncertainty associated with unfathomable, threatening reality – as conveyed by their parents – are intensified by
• television.

## Consequences

Children are inquisitive about the world around them; they have eyes and ears for what is going on and want to understand things. Both television and pedagogy could help them in this process. In pedagogical terms particularly, education for parents is called for, which may assist them in preparing their children for the outside world and appropriately coping with the way it is transmitted via the media. Educational institutions must do justice to the child's thirst for knowledge. One particular service they must render is assistance in coping with the burdens and anxieties arising from our reality.

Television is called upon to show responsibility towards children. Information services are watched by children and cause them problems. At the same time children also want to be informed. It should be television's obligation to cater for this need. Hence the following demands:

● *Information services for children:*
News and magazine programmes must explain relevant information to children in an appropriate form and in context, at times when children can be reached. Moreover, care must be taken not to make information intended for adults unnecessarily difficult for child viewers to understand.

● *Renunciation of extremely violent pictures:*
Detailed portrayals of dead and injured people, blood and injuries and artificially dramatised gruesome pictures are repulsive for children and arouse anxiety. They even destroy what they are meant to elicit according to the programme makers, namely pity. Violence against human beings is a part of this world and must not be concealed; neither must it degenerate into cheap sensationalism.

● *Reality TV must not assume the guise of information:*
Many children – and parents – think that they can learn important, even meaningful, things via these programmes. This is not least due to direct or indirect claims of informational value by programmes that say they inform about dangers and appropriate behaviour. These programmes are however aided and abetted by anxious conceptions of reality that are not very beneficial for children. As long as children classify 'reality TV' as being informative, they are hardly in a position to distinguish information from sensationalism.

## Note

1   The German version of this article appeared in *TelevIZIon* 8/1995/1, p. 232-24. For the completed study and its results cf. Theunert, H. and Schorb, B. (1995). *'Mordsbilder'. Kinder und Fernsehinformation. Eine Untersuchung zum Umgang von Kindern mit realen Gewaltdarstellungen und Reality TV*. Berlin: Vistas Verlag. (Schriftenreihe der Hamburgischen Anstalt für neue Medien, Vol. 13).

# How do children observe and come to terms with violence on TV?[1]

*Michael Schmidbauer*

## 1. Initial question

It is generally known that the discussion on the possible effects of portrayals of violence on children's emotions, thinking and behaviour has become a constant topic of sociological, and socio-psychological mass-communication research.[2] Particularly since the introduction of commercial television, reputed – rightly or wrongly – to offer a programme range 'full of violence', the question as to the effects that violent programme output may possibly have on child viewers has again become the centre of public attention.[3]

This question is currently not only of special interest because of the implied nature of the commercial TV channels, but also remains the subject of continuous debate, raised in the context of national and international circumstances, which many parents and teachers evidently experience as extremely violent.[4] It should not be forgotten that such experiences are largely acquired from information supplied by the media – first and foremost from television news – in which violence is presented as crime, political terror and war.[5]

A glance a few years back reveals that the decisive impulse for the intensive sociological analysis of the subject 'television – violence – children' came in the early 1960s. Admittedly, Himmelweit and Schramm and their teams had been active in this field of research from the mid-1950s,[6] but research into violence did not receive a vital boost until the scientific achievements of Bandura and Walters, who published their theory of observation learning in 1963. Their basic theory was: social behaviour – ie both socially desirable and undesirable – is learnt by means of observing models.[7]

Bandura and his colleagues carried out a series of socio-psychological laboratory experiments intended to investigate this thesis; they set out to prove that the child subjects of the experiments emulate aggressive modes of behaviour observable in real people or television and film actors (including comic figures), and to illustrate the means by which they do so. The experiments produced very meagre results, however. On the one hand, it emerged that the (presumed) link between the film shown in the experiment and the child's behaviour was not very strong. On the other, it

was evident that the only reason for this link was the *artificial nature* of the laboratory situation – a link that was by no means discernible in real everyday television life.

And yet the conclusions Bandura and his colleagues drew from their experiments were indiscriminately transferred to the children's everyday situation television. Back then it was contended – and such arguments are still constantly heard even nowadays – that the aggressive, violent behavioural patterns featured in the television and film programmes are directly transferred into real actions by child viewers.[8] This in turn gave rise to the constant concern – existing, as it has been said, even today – that the viewing of violent scenes portrayed in the programmes leads to a direct increase in the children's violence, brutalisation and 'criminalisation'.[9]

The above 'invalid conclusion' (Merten, 1994) is still drawn by many parents, teachers and broadcasters responsible for the programmes, although media scientific research into violence, carried out for 30 years now, has indeed produced one clear finding: a linear cause-and-effect relationship between violent programmes and aggressive, violent actions and reactions by children can admittedly be induced on an experimental basis – although only under very restricted conditions – but in everyday television life it very clearly cannot be ascertained.[10] In this respect, the stimulation, catharsis, inhibition, habituation and imitation theses – constantly submitted in public, pedagogical and family discussions on the subject – by no means constitute 'real life assumptions', but are all assumptions that cannot be proved or substantiated.[11]

## 2. Current research procedures on the effects of violence

The above-mentioned theses and their analyses are primarily founded on the linear, cause-and-effect argumentation principle according to which a stimulus (portrayal of violence) coming to the child from the outside is said to trigger off a response (aggressive behaviour). This principle has been turned upside down.

### 2.1 A new argumentation principle

The criticism of this mechanistic viewpoint paved the way for a procedure that insisted on neither the direct effect of a certain cause nor the behavioural reaction of a passive recipient exposed to stimuli. This form of procedure endeavours to deduce the aggressive, violent behaviour (feared in the children) not from *one* factor but from a combination of factors.[12]

More precisely, the focus is not on one isolated cause – the received portrayal of violence in the television programme – assumed to have a direct effect on the children viewing. The analysis rather focuses on a *constellation* of reasons – the received portrayal of violence, the reception situation, the cognitive, emotive and social-moral capacities of the children, their relationships with their parents and friends, their experience of confrontations with real violence etc – ie the combination of factors in

which the (feared) aggressive, violent behaviour of the children is to be understood. It is of vital importance that two points should be included in this investigation procedure:

1. the way children themselves relate their needs and interests, their thoughts, feelings and actions, to these institutional, psychic, mental conditions, referred to above as behaviour-determining factors;

2. the way children define themselves and their everyday situation in these conditions and thus define the real reason for their attention to, reception of and influence by portrayals of violence. [13]

It should be borne in mind that in both cases the media and particularly television, of which the far-reaching socialising quality is by no means attached to the transmission of violent programme content alone. Neither should it be overlooked that an analysis of the subject 'children and portrayals of violence' can only provide reliable results if occurrences described and classified as aggressive and violent are accurately adjusted to the children's comprehension, assimilation and accommodation capacities. This means that every form of bias must be avoided that is created by numerous 'experts' and 'well-meaning people' when they attribute to children an understanding of aggression and violence equivalent to that of adults.

Currently virtually all existing research projects on the subject of children and television violence are founded on the following, previously mentioned, definition of aggressive, violent behaviour: such behaviour is understood to be a (re)action – expressed in deeds and/or words, taking place in the framework of a perpetrator-victim relationship in the form of intended (physical and/or psychological) detriment to persons, other living creatures and property.[14]

In this connection the concept of violence employed is seen in a relatively narrow way, and that of the harm in relatively broad terms:

- Violence is expressed as a deed or verbal act, carried out intentionally and consciously (albeit not necessarily planned).
- Harm means all the modes of behaviour that physically and psychically injure and/or destroy other people, animals and property to such an extent that their psychological and physical well-being, their function or their appearance are impaired. In the case of people this 'impairment' can range from an insult to death, in the case of animals from being chased away to being slaughtered, and in the case of property from a scratch on a car's paintwork to an A-bomb explosion.

This form of definition, when related to the knowledge potential and different interpretation possibilities on the part of the children, raises an important problem. It suggests the ability on the children's part to grasp the perpetrator-victim relationship, which allows them to appreciate the intentions of the perpetrators and the suffering of the victims, ie an understanding that enables them to perceive the *direct* framework of the aggressive, violent activity and the damage or detriment incurred.[15]

This assumption does, however, imply two difficulties of equal relevance in terms of theoretical approach and practical research. First, it must be taken into consideration that this understanding is significantly restricted by the fact that the overwhelming majority of the children – particularly the 6- to 10- and 11-year-olds – cannot grasp (or can only very vaguely grasp) what the perpetrator-victim relationship involves in terms of psychological and socio-structural, societal-institutional violence.[16] Secondly, it must also be considered that the children's ability to understand varies according to the age group, resulting in different ways of understanding.

If the theory of the development of moral discernment is applied, which says that actions can be judged by their actual results as well as by their underlying intentions, a factor of crucial significance is revealed, concerning 6- to 13-year-olds in particular, the main group under study in this exposé:

- Up to the age of 8-9, children judge the aggressiveness of an action according to the extent of the damage caused by the action;
- From 10-11, children are able to interpret their own and others' actions as *intentional* and to evaluate this intention as a 'cause' of the possible aggressiveness of the behaviour in question.[17]

Consequently, reliable and valid data can only be ascertained on the (possible) influence of portrayals of violence on the child's psyche if the children's evaluation and judgement capacity is consistently taken into account and if what they generally assimilate is thus clearly illustrated and what they can integrate into their thinking, feeling and behaviour – depending on their cognitive, emotional and social-moral level of development.

This again shows that a competent focus on the relationship between portrayals of violence in television programmes and children's reactions is possible only if two elements are included in the analysis:

- Portrayals of violence in television programmes must be understood as those having an effect only when conveyed via variables intervening in the relationship between these portrayals of violence and children's aggressive, violent behaviour (possibly) triggered as a result. These factors – ie the conditions of children's reception, their needs and their abilities, their family environment, the situation at school, the children's relationships with friends and teachers, their games and leisure-time activities etc – constitute the fundament, as it were, which determines the development of the specific form characterising the relationship between the violence presented in the programmes and the (possible) expression of aggressive, violent behaviour on the part of the children.
- The portrayals of violence must be seen in the light of the perceptions and conceptions, needs and interests, intentions and plans that children revise in the everyday circumstances they are confronted with (including the influence of the media in general and of television in

particular). After all, this is what children use to create the motivation framework in which these portrayals of violence first become relevant for them and from which they go on to address such portrayals of violence, with specific reasons and specific modes of reception. [18]

It is known that for 6- to 13-year-old children violence is largely relevant as a *person-related* quality. It is also known that children still have considerable difficulty seeing 'behind' the violence manifested in people (expressed physically and/or verbally) to discover its psychic substructure or even recognising psychic violence for what it is.

Another known fact is that children – at least the 6- to 11-year-olds – face similar difficulties when it comes to registering 'structural violence' (Krebs, 1994, S. 358), ie comprehending the disparity, incorporated in social circumstances, between power and life opportunities.[19] Children (still) particularly lack the ability to comprehend the dependence of personal violence on structural violence and to understand violence in a *generalised* sense, as a relationship in which people are restricted in their personal and social development; they are unable to see any intentional detriment – inflicted and suffered by people.

### 2.2 Three illustrative investigations on two key conceptions[20]

The above-outlined procedural model for research into the effects of violence was elaborated particularly in the course of the (further) development of the habituation thesis and the thesis of modelling.[21] These theses have meanwhile been incorporated in a number of research investigations. The latter were carried out in the form of multi-level analyses, ie they relate to the communicators and their institutional parameters, to the programme presentation of aggressive actions/verbal acts as well as to the recipients and their socio-psychic circumstances – and operate accordingly on the lines of a multivariate design.[22]

The problems arising from the previously outlined methodological-theoretical criteria for planning and realising an empirical investigation are however quite considerable. Particularly the isolation and operationalisation of variables localised on different levels, on the one hand, and the inclusion of the mutual dependency of these levels and variables, on the other, place enormous demands on these projects. Unfortunately, these projects opted not to include the three dimensions of violence – the physical, the psychic and socio-structural aspects – to an equal and to an equally systematic extent. They rather focus on the topic of physical violence, which only sporadically relates to the levels of 'psychic and structural violence'. It goes without saying that this is a serious deficiency. Psychic and structural violence are not necessarily manifested in physical acts of violence, but, on the other hand, physical acts of violence are constantly linked to aspects of psychic and structural violence.

This brings up the question as to whether the results of these projects actually prove that acts of violence presented in TV programmes trigger

aggressive, violent behaviour in children and young people. Two approaches will be presented as illustrative examples.

### 2.2.1 The de-sensitisation thesis

Following on from the habituation thesis, the de-sensitisation thesis was developed. The research project designed by Belson (1978) to scrutinise this thesis, involving a sample of 1,500 11- to 15-year-old children/young people and proceeding on the basis of the arguments outlined above, hinged on three assumptions:

1. A high consumption of television violence is linked to the child viewers' biographical involvement in a violent environment.
2. Child viewers in turn accept the presentation of violent scenarios as a means of asserting their own interests if two conditions are fulfilled: when the violence presented is embedded in personal and family relationships that the children can relate to their own situation and when the violence presented serves a 'good' cause.
3. Particularly in the case of adolescents, the interest shown in portrayals of violence is dependent on the respective programme genre; especially portrayals of violence in cartoons, shows, science fiction films and sports programmes have little effect on the child viewers.

Belson's work, carried out highly systematically and with considerable attention to detail – albeit basically restricted to the subject of 'physical violence' – only weakly substantiated the first hypothesis. The data ascertained failed to provide any positive or negative (statistically relevant) evidence of the other two statements.[23]

### 2.2.2 Modelling or observational learning

In current research into the effects of violence the desensitisation hypothesis does, however, play a much less significant role than the (further developed) concept of modelling or observational learning – especially as many considerations based on the desensitisation concept have been adapted from this approach to a learning theory.[24] The modern version of this approach to the study of learning and cognition is based on the fundamental assumption that social modes of behaviour are learned from the observation of models in reality or film.

Unlike 'learning by imitating', which postulates the direct emulation of the behaviour observed, 'modelling' constitutes a mechanism that leads to a concealed adoption of behavioural patterns. This means that the patterns of behaviour observed are not translated into visible behaviour on the part of the learner, but are stored in his or her memory, 'adapted' according to previous experience and – in this altered, thus 're-patterned' form – 'retrieved' when needed.

On the assumption of these criteria a new dividing line is drawn between the acquisition and the *execution* of an observed pattern of behaviour in the learning and cognition theory concept. When it is applied

to the relationship between the television programmes and the child viewers two *basic assumptions* arise:

- On the one hand, it can be assumed that the way child viewers acquire a pattern of behaviour presented in a broadcast is dependent on the observation processes and the subsequent attributions of meaning and relevance with which the children respond to the programme.
- On the other, it can be assumed that the execution of the acquired behaviour pattern is linked to the prediction of the consequences that the child viewers associate with the behaviour observed and its effects on themselves and their situation.[25]

Especially the latter must be taken into account, since it is seen particularly in aggressive modes of behaviour that their execution and utilisation are subject to considerable inhibitions – the social norms in force, fear of punishment, feelings of guilt and anxiety, for example. Moreover, psychological surveys have revealed that acts of aggression do not represent constant modes of behaviour but tend to arise from the situation at hand and should therefore usually be seen and evaluated as being situation-linked.[26]

This apparently also applies to the lowering of inhibitions in aggressive behaviour. A reduction in inhibitions is more likely to come about when the following conditions coincide:

- when the child viewers are encouraged to perform (their own) acts of aggression prior to the reception of a portrayal of violence;
- when positive aspects of the received portrayal of violence and rewards for the aggressive behaviour shown come to the fore; and
- when the creation of feelings of guilt and fear is prevented by the denial of any personal responsibility in the violence shown and when the victims are characterised as alleged monsters.[27]

This implies, however, that the processing and possible aggressive use of observed violent patterns of behaviour in TV programmes really follow on from, and within the framework of, the consequences of the already mentioned internal processes taking place in the children.[28] In this respect, the 'effects' of violence presented on television – presuming that they actually exist – probably depend on various factors such as:

- how the children judge the portrayals with regard to their own abilities, opportunities and circumstances;
- how justified they consider the observed pattern of behaviour to be;
- how they bring the behaviour shown into line with their own moral concepts, their previous experiences, their fear of feelings of guilt;
- how intensively they feel their emotions aroused by the portrayals of violence on account of their own personal-social situation; and
- how intensively they feel involved in them (identification with the actors).[29]

The outlined hypothesis framework was formulated with the utmost precision and tested with considerable methodological effort (including a

panel survey) in the two studies referred to: the study of Milhavsky *et al.* (1988) was based on a sample of 2,400 7- to 12-year-old boys and girls, and that of Huesman and Eron (1986) on representative samples in the USA, Australia, Israel and Poland. (It should not be forgotten that the studies systematically focused only on physical violence.)

Nevertheless, it was not possible to corroborate the assumption that portrayals of violence shown on television and in film have a negative effect (of aggression arousal) or a positive effect (aggression reduction) on children's behaviour.[30] The closing remarks on the Milhavsky project states this extremely clearly:

> Our conclusion was that any effect of watching television violence on children's aggression either did not really exist or was very small... (Our) judgement was that it was somewhat more likely that the effect was zero rather than it was small. (Milhavsky 1988, p. 165)

### 2.3 Recent findings

In the meantime numerous studies – experts estimate approximately 5,000 to date – have been carried out on the subject of 'media portrayals of violence', most of them based on the arguments of learning, cognition and emotion theory. Many of these studies focusing on the child audience relate to the above quoted findings.[31]

Nevertheless, several items in the collection of data and statements compiled to date must not be allowed to pass unheeded (even though virtually only the subject of physical violence plays the most important role in these data and statements). It must be particularly stressed that even if it is not possible to ascertain a monocausal – aggression-inductive or aggression-reductive – relationship between the portrayals of violence in television programmes and the patterns of behaviour on the part of the children studied, the *risk* of negative consequences for child viewers in their contact with such portrayals cannot be excluded:

- First, within the context of individual and social factors television programmes may assume an important role in the production or reduction of aggression. They may serve as a store of patterns for behaviour, argumentation and legitimisation, as the transmission of new, otherwise inaccessible experiences, as the depiction of a world view and a view of mankind.[32]
- Secondly, it must be borne in mind that the results of the studies quoted are statistically processed mean values and relate to children who have experienced a 'normal' process of socialisation. This means that any specific and 'precarious' problems of reception, assimilation and effects, which (may) occur in the case of children who are particularly at risk on account of their extreme psychic weakness and social deprivation, are largely excluded. But it is known, however, that it is quite possible to ascertain in such cases relatively direct links

between the nature of the television programmes received and the way the children concerned subsequently react.[33]

- Thirdly, the studies quoted focus only on a certain point in time or a short-term period. This means that the long-term effect processes were not included in the research. The possibility that the reception and assimilation of portrayals of violence bear 'fruit' as the result of a gradual process was disregarded because the consequences become apparent only in the course of continuous development and orientation processes, in conjunction with later experiences and events.[34]

But who can justifiably contest the idea that children's *constant* confrontation with portrayals of violence *in the long term* (regardless of how they are transmitted in conjunction with other factors) does in fact contribute to the development of aggressive and/or anxious appraisals of oneself and one's environment – that, at the very least, it promotes an increase in consumption of violent media features in particular (especially when they are wrapped and presented in the corresponding 'attractive' package)?[35]

Who can simply push to one side the danger – possibly looming 'only' in the long term – of portrayals of violence in television programmes contributing to the stimulation and promotion of anti-social behaviour, aggressive world images and acts of violence – particularly in the case of children whose personality structure and everyday situation increase their receptivity to them?[36]

Doubtless both questions (and their pedagogical policy implications) cannot be trivialised, requiring even more urgent attention especially when systematic research (into their effects) focuses on the television presentation of not only physical but also of psychic and structural violence. The possible danger potential of portrayals of violence in television programmes therefore has to be consistently taken into account – irrespective of the fact that the research findings to date only relate to *statistically* irrelevant connections.[37]

### 3. The subject of children and violence in German television research

The following section will present and discuss the conceptions and results of a few studies that focused on the topic of portrayals of violence and their effects on children with reference to the programmes broadcast by the German public service companies ARD and ZDF and the commercial TV channels.

### 3.1 General remarks on the data situation

To begin with, a data deficit must be pointed out, illustrated by the fact that until 1995 no theoretically and methodologically elaborated project has been carried out in which this topic was tackled from the standpoint of both programme *and* child audience analysis.[38] The exception was a study

by Theunert and Schorb (1995) that claimed to tackle these two aspects. With regard to our context here, however, its findings must be seen with some reservation: first, the study relates to a fairly small, non-representative sample (101 8- to 13-year-olds from Hamburg and Munich), and the evaluation of the interviews and group discussions – although qualitatively oriented – is based on a rather coarse interpretation framework, compared to the sophisticated analytical interpretation techniques of objective hermeneutics. Second, the study is based on the analysis of programme formats and contents that focuses only on a small section of the programme range, ie on news, information magazines and 'reality TV' programmes.

That some progress was made in the research field was born out by the research of Grimm (1995 a; 1995 b) and Früh (1995) whose projects have produced very useful contributions to a theoretically well-founded and methodically acceptable programme and audience analysis. But both studies are directed primarily at the adult population. In Grimm's work the subject of children – in this case 11- to 15-year-olds – represents a relatively minor aspect of the survey, especially since it is mainly oriented towards the 'feature film' (television plays a role only with regard to violence in the news and assumes the form of an artificial, construed TV-news programme).[39]

Two extensive programme analyses have been carried out by Groebel and Gleich (1993) and by Merten (1993). They provide a quantifying perspective and classification of portrayals of violence found on ARD and ZDF channels, on the one hand, and some commercial television channels on the other.[40] Both programme analyses are based on a concept of violence, in which the dimension of 'physical violence' dominates and consequently aspects of psychic and structural violence are often only treated as secondary aspects.

The programme genres are the items under investigation in the analyses, with the result that it is not possible to draw any conclusions about individual programmes (and their *possible* violence potential). Moreover, the qualitative analyses carried out in the studies only skim the surface of the programmes investigated: neither the dramaturgy and the internal structure of the portrayals of violence nor the contents of the messages and the meanings they convey were intensively examined and analysed.[41]

Another shortcoming of the programme analyses mentioned is that they were carried out without any particular focus on the way children handle portrayals of violence. A psychological-sociological, longitudinal study analysing the child audience was conducted almost 20 years ago; from today's perspective it can no longer be considered to be suitable.[42]

This description of the current data situation can be rounded off by mentioning several somewhat qualitative-essayistic studies in which

children were interviewed or observed in connection with specific programme content.[43] Some of them reveal at least one clear disadvantage: they endorse the children's statements, the contents of the programmes and the physical, psychic and structural dimension of violence, but they are by no means representative, and there is a long way to go before they can contribute to the systematic establishment of a theory.

As the amount of data related to audience analysis findings is rather scarce, the author has attempted to boost the supply a little by means of a special assessment – specifically designed for this exposé – carried out by *GfK Fernsehforschung*, one of the leading research companies in Germany that furnishes the broadcasting stations with the audience ratings. Their evaluation was based on a representative sample of 6- to 13-year-olds; it records their reception of portrayals of violence – during the week 18.9.-24.9.95.

### 3.2 Portrayals of violence on ARD/ZDF and the commercial television channels

In the following section, the range of portrayals of violence broadcast on ARD/ZDF and the commercial television channels will be outlined. References will be made to the most important points compiled from the previously mentioned material and to studies and secondary analyses closely related to this topic.[44]

*3.2.1 Quantitative aspects*

First, a word to describe the extent and the nature of portrayals of violence shown on ARD/ZDF and the commercial television channels. In this connection, the findings of the above-mentioned programme analyses by Groebel and Gleich (1993; the LfR study) and Merten (1993; the RTL study) will be quoted. The limited range of problems considered in the studies – ie the focus on the television presentation of physical violence – has already been mentioned.

Both studies relate to the general range of programmes offered by ARD, Pro 7, RTL, SAT.1 and ZDF and the portrayals of violence featured. The LfR survey also included the Tele 5 range of programmes broadcast in 1991 but which has meanwhile been discontinued. To allow a correct appraisal of the values given in this survey the data on Tele 5 are quoted in the following analysis but are not evaluated any further.[45]

In the evaluation of the studies it should be particularly taken into account that one survey refers to the range of programmes broadcast in the middle of 1991 (LfR study) and the other to that of November 1992 (RTL study). This must be emphasised, since the time difference in the compilation of the data was probably the main reason for the divergences recorded between the findings of the two projects. (One main reason for the results diverging so dramatically on some points is doubtless due to the changes experienced by the range of programmes between 1991 and 1992 – particularly in the case of Pro 7 and RTL.)

Presuming that (both physical and verbal) violent acts are to be understood as those in which one or several persons intentionally do recognisable physical and/or psychic harm to one or several persons, an animal or property, it is ascertainable that violence is a component of the programme that can by no means be ignored. The weekly range of ARD, Pro 7, RTL, SAT.1, Tele 5 and ZDF programmes surveyed comprises 1,219 (LfR study) and 1,291 programmes (RTL study), respectively, 47.5 per cent and 59.9 per cent of which contain aggressive, violent sequences. This amounts to 2,745 violence sequences in the LfR study and 3,417 violent sequences in the RTL study. The word *sequence* means the extended context within which aggressive, violent actions or violent verbal acts occur (the latter, for example, in form of a threat or a violent item in the news).

The LfR study distinguished between such sequences and individual aggressive actions or verbal acts. According to this study the 2,745 violent sequences contain 3,632 aggressive, violent actions/verbal acts. It is interesting that the duration of these actions/verbal acts varies considerably on the various channels: in the ARD and the ARD/ZDF morning programme they last 29 seconds, on Pro 7 18 sec., on RTL and on SAT.1 23 sec. and on ZDF 32 sec.[46] As no difference between sequence and action/verbal act was made in the RTL study, the following analysis – for *comparative* reasons – will be based on the 'sequence' category.

The (2,745 or 3,417) violent sequences refer to both *intentional* (premeditated) and *non-intentional* violence (negligence, accidents, disasters). The latter was excluded in both studies, which meant that 2,428 sequences (LfR study) and 2,826 sequences of intentional violence (RTL study) were left as material for investigation. The frameworks of the events in which these sequences of intentional violence (= aggressive actions/verbal acts) occur are attributable, in the LfR study, particularly to the areas of crime/delinquency (37 per cent of the sequences), science fiction/the supernatural (14 per cent), comedy (11 per cent), everyday life/family/marriage relationships (11 per cent), war (7 per cent), political controversies (7 per cent), youth/games (2 per cent) and terrorism (1 per cent).[47]

The *status* of the violence sequences in the programme of the individual German television companies can be recognised by comparing the time span occupied by the sequences in the weekly programme surveyed with the overall *broadcasting time* of this weekly programme (including the range of intentional and non-intentional violence). By means of this comparison it is possible to calculate the proportion of intentional violence in the weekly programme of the television companies (see Table 1).[48]

Table 1 reveals some important points. First, the proportion of intentional violence in the overall weekly programme of the channels surveyed is relatively small, although particularly in terms of aggression and violence very limited conclusions can be drawn on their effects from their time and spatial volume. Scenes creating a shock that last only a few seconds are frequently registered more intensively and recalled more

vividly than stories narrated in considerable breadth and detail. Second, as regards the individual channel's programme, the ARD/ZDF reveal a low and the commercial television channels a much higher proportion of intentional violence. A further striking feature is that the RTL programme comes off particularly well in the RTL study – not that any suspicion is implied on this score.

Table 1: **Proportion of time occupied by intentional violence sequences**

| Channel | LfR study (1991) | RTL study (1992) |
|---------|------------------|------------------|
| ARD | 6.7 | 2.3 |
| ARD/ZDF(a.m.). | 2.1 | - |
| Pro 7 | 12.7 | 9.5 |
| RTL | 10.7 | 2.4 |
| SAT.1 | 7.3 | 4.3 |
| Tele 5 | 11.7 | - |
| ZDF | 7.2 | 2.6 |

It is not only important to ascertain the proportion of intentional violence in the television programme range but also the degree of cruelty suggested in the presentation of the violence in question. For this purpose an index was designed for the RTL study to record the degree of cruelty shown. It is presumed that the level of cruelty is linked to the expression of specific parameters, eg the duration of the violent sequences, the perpetrator's actions, the nature and the severity of the violence, the type of victim and the harm done to him or her, etc. On this ground it is possible to work out a corresponding 'cruelty index' for the television programmes containing intentional violence, which in each case – see Table 2 – incorporates the sum of all the products taken from 'the duration of the portrayal of violence – the mean level of the cruelty shown'.[49]

Table 2: **Indices for intentional violence sequences (RTL study)**

| Channel | Cruelty/Violence Index |
|---------|------------------------|
| ARD | 0.52 |
| Pro 7 | 2.96 |
| RTL | 0.68 |
| SAT.1 | 1.31 |
| ZDF | 0.62 |

The violence indices again reveal the high position of the commercial channels Pro 7 and SAT.1 with regard to violent content, as compared to the relative restraint practised by ARD/ZDF and RTL (who had commissioned the study!).

In the LfR study (Groebel and Gleich 1993) there is no comparable data. Here, however, one finds another item of particular interest: the representation of the violent sequences in the individual programme genres offered by the various channels. The strongest representation of

violent sequences is to be found in cartoons – particularly on Tele 5, Pro 7 and SAT.1; in feature films – particularly on Tele 5 and ZDF; and in the news – particularly on RTL and SAT.1. The proportion of violent sequences in the field of 'information/documentaries' (info/docu) and 'series' on RTL and Pro 7 should not be overlooked.[50] The tables 3 and 4 sum up the results of the LfR study. [51]

Table 3: **Proportion of intentional violence in individual programme genres** (as a %; LfR study)

| Genres | ARD | ARD/ZDF (a.m.) | Pro 7 | RTL | SAT.1 | Tele 5 | ZDF |
|---|---|---|---|---|---|---|---|
| News | 8.1 | 9.7 | 10.2 | 15.4 | 12.3 | 9.4 | 11.3 |
| Info/Docu | 5.8 | 1.0 | 13.5 | 2.0 | 3.8 | 2.8 | 4.1 |
| Feature films | 15.8 | - | 11.4 | 16.0 | 11.4 | 23.5 | 20.8 |
| Series | 3.4 | 3.8 | 11.9 | 12.4 | 9.3 | 6.8 | 3.8 |
| Cartoons | 8.6 | - | 21.5 | 14.9 | 21.3 | 21.6 | 12.3 |

If a dividing line is drawn between the scenes featuring intentional *physical* violence and those containing aggression in a verbal form, the picture illustrated by Table 4 is revealed.

Table 4: **Proportion of physical violence sequences in individual programme genres** (as a %; LfR study)

| Genres | ARD | ARD/ZDF (a.m.) | Pro 7 | RTL | SAT.1 | Tele 5 | ZDF |
|---|---|---|---|---|---|---|---|
| News | 1.4 | 1.3 | 2.6 | 7.6 | 2.5 | 0.3 | 0.7 |
| Info/Docu | 0.5 | 0.1 | - | 1.9 | 2.7 | 1.4 | 1.3 |
| Feature films | 7.6 | - | 5.5 | 8.4 | 3.8 | 8.6 | 5.6 |
| Series | 1.5 | 1.8 | 4.6 | 4.3 | 3.4 | 2.6 | 1.8 |
| Cartoons | 4.3 | - | 9.0 | 4.0 | 5.5 | 5.5 | 7.9 |

In this case feature films also lead the field – particularly on Tele 5, RTL and ARD, joined by cartoons – particularly on Pro 7 and ZDF. In the news programmes only the RTL programmes reveal a clearly higher violence potential.

So-called murder scenes play a significant role regarding sequences featuring physical violence. In the RTL study it was ascertained that ARD shows a dead victim every 154 min., ZDF every 143 min., RTL every 111 min., SAT.1 every 102 min., and Pro 7 every 52 min..[52] The LfR study reveals that on Pro 7 20 murder scenes can be viewed daily, on Tele 5 and RTL 13, on SAT.1 9, on ZDF 7, on ARD 6 and in the ARD/ZDF morning programme 2.[53]

It can be said that murder, which in most portrayals has no consequences for the murderer/murderess,[54] constitutes an absolutely self-evident element in the range of violence shown in the channels' programmes – likewise the fact that over 70 per cent of the portrayals of physical and other violence are of an illegal nature.[55]

This phenomenon is best explained by the fact that the originators of violence usually assume the role of 'bad' characters, who usually appear as 'killers', psychopaths, sex criminals or political-military 'murder and terror specialists'.[56] This particularly applies to the portrayals of violence shown in the commercial broadcasters' programme: according to the RTL study 40 per cent of the scenes featuring psychopaths/sex criminals can be assigned to SAT.1 and 24 per cent of the killer scenes to Pro 7. But 23 per cent of the scenes featuring political-military assassins can be seen on ZDF – as a 'compensation', so to speak, for the scenes shown there featuring 'people like you and me'-criminals (23 per cent; on ARD 19 per cent).

Conversely, it is this category of 'people like you and me' that supplies most of the victims shown in the portrayals of violence on both the ARD/ZDF and the commercial channels.[57] 40 per cent of the victims are subjected to slight and grievous bodily harm, 24 per cent incur damage to property, 15 per cent experience a murder attempt and 14 per cent a brawl. The result of these threats: approximately 62 per cent of all the victims shown are either harmed or killed in the (physical/material) acts of violence.[58]

The final item in this section is Table 5, which documents the distribution of the sequences featuring physical violence in the individual sections of the channels' daily schedule.

Table 5: **Distribution of intentional physical violence sequences in the individual broadcasting slots** (as a %; LfR study)

| Time | ARD | ARD/ZDF (a.m.) | Pro 7 | RTL | SAT.1 | Tele 5 | ZDF | Total (abs.) |
|---|---|---|---|---|---|---|---|---|
| 6 – 14 | 4.8 | 3.8 | 29.3 | 22.8 | 15.2 | 22.8 | 1.4 | 290 |
| 14 – 18 | 17.3 | 0 | 28.1 | 15.7 | 13.5 | 15.7 | 9.7 | 185 |
| 18 – 20 | 7.9 | 0 | 52.0 | 22.8 | 3.9 | 7.9 | 5.5 | 127 |
| 20 – 22 | 11.0 | 0 | 21.1 | 18.3 | 23.9 | 15.6 | 10.1 | 109 |
| 22 – 23 | 8.6 | 0 | 32.9 | 20.0 | 0 | 34.3 | 4.3 | 70 |
| 23 – 5 | 2.8 | 0 | 37.2 | 21.7 | 5.0 | 23.9 | 9.4 | 180 |
| Total (abs.) | 79 | 11 | 316 | 197 | 109 | 189 | 60 | 961 |

This means that the largest proportion of the 961 sequences of physical violence shown daily is attributable to Pro 7 and RTL. The intense concentration of aggression and violence in the 6 p.m. – 8 p.m. time slot is particularly striking, ie peak viewing time for large sections of the child audience. Here again Pro 7 and RTL lead the field: ARD/ZDF generally exercise considerable restraint, particularly between 6 p.m. and 8 p.m. (the latter also applies to SAT.1 and Tele 5).[59]

*3.2.2 Qualitative aspects*
If the previously mentioned results are supplemented by those revealed on the qualitative description of the violence and aggression potential

(actions/verbal acts), it is possible to discern further characteristics of the television presentation of violence. The latter are mainly found in the field of '(fictional) entertainment', both on the ARD/ZDF and the commercial channels. There are also some programme analysis references to the way in which violence is presented in news programmes and in the 'reality TV' genre, a point that will be reviewed later.

But first the 'entertainment' sector, ie feature films, action series and animated cartoon series. On the basis of the material ascertained in more or less valid (qualitative) programme analyses it has been possible to compile a list of features that characterise the portrayal of violence in television entertainment programmes. A little coarsely painted, the following picture emerges:[60]

- The most common form of violence featured is that performed on a victim by a more powerful assailant (by inflicting harm, wielding superior power and killing).
- Violence is in nearly all cases male violence. The perpetrators of the violence are usually adults, 30- to 45-year-old dynamic-aggressive males. The use of violence is clearly a male domain; the role of the (murder) victim, on the other hand, is a female domain.
- In most cases violence is practised for its own sake and almost always staged as an inevitable event.
- The patterns of behaviour featuring violence hardly ever arise from the plot presented and are rarely based on concrete circumstances.
- Portrayals of violence on television are frequently unrealistic, particularly the representations of suffering, pain, injuries and torment. The latter seem to be directed at preventing any empathy for the victims' suffering and emotions.
- When violence is practised, the authors' emotionally relevant qualities are excluded; at most they assume the form of cynicism, anger and fear.
- The portrayal of violence often takes place in a ritualised and aestheticised form; it is staged and arranged like a show.
- Violence tends to occur between strangers – aggression practised by women usually takes place in the private sphere, aggression practised by men usually in the traditional arenas of war and crime.
- Violence is often embodied in what seem to be omnipotent heroes who suggest superiority and (moral) inviolateness.
- The use of violence is justified by 'success' and 'reward'. It is rarely punished.
- Those using violence for a 'good cause' usually act without any feelings of guilt. Thus the use of violence is offered mainly as an efficient way of settling conflicts.
- The portrayal of violence is person-oriented. Conditions embedded in the social structure, promoting success or failure, the quality of life and disadvantage – ie the factors that come under the category of 'structural violence' are hardly ever focused on.

- Violent behaviour on the part of males is often based on material considerations and political-ideological aims; violent behaviour on the part of women, however, is primarily ascribable to psychological reasons.
- In animated/cartoon series the incidence of extreme physical acts of violence and murders is relatively low; in feature films and series, however, death and murder play a major dramaturgical role.
- The action series mainly focus on the motoric practise of violence, on the development of the attack; the victim and his or her suffering only put in a cursory appearance, if any, playing the whole thing down.

To sum up, the following can be said about the subject of 'portrayals of violence in fictional-entertainment contributions': the violence in the programmes is usually visualised and verbalised as actions depicted as a normal, everyday behavioural strategy resorted to not only by criminally active people, but also by people of moral integrity. Behavioural models are shown that demonstrate how to realise legitimately recognised aims (affluence, power, prestige) by means of illegitimate (violent) means, which intentionally create sacrifice and suffering – and frequently in the haze of comradely 'humour'.[61]

It has quite rightly been pointed out that children watch not only entertainment programmes but also information, reality TV, and news programmes.[62] The frequency and intensity of the use of such programmes are far lower than those ascertained in connection with entertainment programmes. But the way information, reality TV, and news magazines present the topic of 'violence' to child viewers cannot be treated with indifference. A survey by Krüger (1994) on the subject of information and news programmes on the ARD, RTL, SAT.1 and ZDF and the 'reality TV' of RTL and SAT.1 clearly revealed the contents of Table 6: SAT.1 contains slightly more, and RTL far more portrayals of violence in the already named genres than ARD/ZDF.[63]

Table 6: **Incidence of violence in information/news/'reality TV'**

| TV company | Basis in minutes | Portrayals of violence (%) |
|---|---|---|
| ARD | 1.649 | 6.8 |
| RTL | 1.100 | 17.6 |
| SAT.1 | 795 | 9.3 |
| ZDF | 2.176 | 6.2 |
| Total | 5.730 | 9.0 |

The study by Theunert and Schorb (1995) mentioned above describes the areas that the portrayals of violence, presented in the genres named, originate from. Table 7 presents the findings of this study, which also apply to the channel Pro 7.[64]

Table 7: **Subject areas relating to the portrayals of violence in information, 'reality TV' and news magazines** (as a %;)

| Subject area | information, news and 'reality TV' programmes (in %) |
|---|---|
| War | 30.0 |
| Crime | 27.5 |
| Accidents | 11.5 |
| Catastrophes | 9.0 |
| Personal fate | 5.2 |
| Political disputes | 4.8 |
| Abuse / maltreatment | 2.7 |
| Other | 9.3 |

The strong position occupied by the subject 'war' is due to the news programmes, particularly ARD's *Tagesschau* and ZDF's *Heute*, which in recent years have devoted almost half of their news-time to military conflicts.[65] However, the subjects of 'crime', 'accidents', 'catastrophes', 'personal fate' and 'abuse/maltreatment' receive preferential treatment in RTL and SAT.1 magazine programmes and particularly in 'reality TV'.

It should be taken into account that in 'reality TV' it is not reality that is reported (as in the news or – at least partially – in the magazine programmes) but a re-enactment of reality, a usually effective reproduction.[66] 'Reality TV' can therefore also be assigned to the category of '(informative-entertaining) fiction'. Whether children (are able to) see the differences indicated here will be discussed at a later stage.

But despite the differences between the three genres they do in fact reveal a number of similarities, which may be summed up as follows:

- Primarily, sequences of physical violence are shown. The focus is on the suffering of the victims, who are often children.
- The presentation of violent sequences is seldom endowed with a comprehensible and intelligible explanatory context. Violence is often staged as a ubiquitous threat.
- Whereas in 'reality TV' and the information magazine programmes the threat comes from concrete perpetrators and is practised on concrete victims, on the news (see war reports) anonymous perpetrators and personified weapons are the protagonists. As a result, the presentation of violence is removed from the context of concrete human activity.
- The presentation of violent sequences is dictated by the images. This is expressed by both the fictional dramatisations and horror-creations of 'reality TV' and the desperate scenes reporting gruesome death and atrocious mutilation, not only in the context of war reports.[67]

### 3.3 How children deal with portrayals of violence
A glance back at the previously mentioned results of the programme analyses makes one thing clear: the domain of direct and indirect physical

violence (manifest in threats and other gestural-verbal forms, for example) is not only the main subject of the programme analysis; it also seems to be the one that is most emphatically expressed in the presentation of violent sequences in terms of both extent and intensity. In the list of harm and injury cases occurring in the violent sequences presented – involving 2,428 violent events evaluated in the LfR study – the category of 'psychological harm' assumes a rather low position (see Table 8).[68]

Table 8: **Forms of harm characteristic of violence sequences**

| Form of harm | Number of incidents | % |
|---|---|---|
| Threat of danger | 654 | 23.8 |
| Slight injury | 554 | 20.2 |
| Death | 489 | 18.5 |
| Material damage | 427 | 15.6 |
| Severe injury | 237 | 8.6 |
| Psychological injury | 36 | 1.3 |
| Harmed animals | 13 | 0.5 |
| Combination | 167 | 6.1 |
| Not identifiable | 148 | 5.4 |

The question cannot be answered here as to whether the predominance of physical violence is due to the portrayals of violence shown on television featuring more physical violence than its psychic variant; neither is it possible to say now whether it predominates because the 'violent nature' of psychic violence, which can range from a straightforward restriction in communication to subtle verbal torture, is often extremely difficult to discern.[69] A further question that remains unanswered is whether research into the effects of violence, particularly in connection with the child audience, is not characterised by an unacceptable lacuna because of the scant elucidation of the topic 'psychic violence' (see below).

*3.3.1 Children's preferences for programmes containing violence*
What violence potential previously described do children assimilate? In the evaluation of regular GfK audience research data mentioned earlier, taken from a representative sample of 6- to 9-year-olds and 10- to 13-year-olds, the children's particular preference for programmes broadcast during one week was listed.[70]

A synopsis of the data combined with the focus on the criterion of *intentional violence* (presented in the programmes chosen) allows only one possible conclusion: the programmes featuring a varying degree of intentional physical violence – expressed either concretely or verbally – occupy a rather modest position in the range of the programmes preferred by children.

The violence contained in the first 10 of the preferred programmes ranged from a kick in the shin (*Fußball*/ZDF) to mass murder (*Explosiv*/RTL), from a fictional animated scenario (*Power Rangers*/RTL) to

war, annihilation and destruction documented from reality (*Heute*/ZDF, *Tagesschau*/ARD)

A further point is the fact that children – both the 6- to 9-year-olds and the 10- to 13-year-olds – take a very low interest in portrayals of violence (apparently behaving differently to their peers in the USA).[71] The programmes analysed in the evaluation of the GfK data that can be classified as extremely *radical* (both verbally and action-wise) on account of their physical violence potential were therefore *Power Rangers* (RTL), according to the 6- to 9-year-olds and *Beverly Hills Cop* (Pro 7), *Explosiv* (RTL) and *Faust*, (ZDF) according to the 10- to 13-year-olds. It must not be forgotten, however, that children represent a kind of mass audience for *Beverly Hills Cop* and to a somewhat lesser extent *Power Rangers* – unlike information magazines interspersed with violence (*Explosiv*/RTL), news programmes (*Heute*/ZDF, *Tagesschau*/ARD) or largely ignored 'reality TV' programmes.[72]

The results presented in a study by Janssen (1995) illustrate the contents of such 'Cop' and 'Rangers' series and films in terms of violence potential. Their programme analysis focused on the series broadcast by both the ARD/ZDF and several commercial television companies: *A-Team*, *Airwolf*, *He-Man* and *Knight Rider*. As is generally known, these series – as well as *Beverly Hills Cop* and *Power Rangers* – are based on a 'well-balanced' and usually – with regard to the visuals – expertly 'dynamised' mixture of aggression and action. The analysis points out that each (30- to 40-minute) episode in the series shows between 11 and 15 acts of intentional physical violence (actions/verbal acts): *A Team* 14, *Airwolf* 11, *He-Man* 15, and *Knight Rider* 11.[73]

Unfortunately there are no data available from the GfK data that register the differences in programme use by girls and boys. However, it may be concluded from indications gathered from several studies that girls largely avoid programmes in which 'hard' (and direct) violence is celebrated. Consequently they are probably less inclined towards *Power Rangers* and *Beverly Hills Cop*, and more towards *Prinz Eisenherz* (6- to 9-year-olds) and *Lindenstrasse* (10- to 13-year-olds).[74]

It should also be remembered that the previous remarks applied to the television presentation of (intentional) *physical* violence. This does not consider the fact that children are also confronted with aspects of psychic and structural violence in the programmes they view – and not only in the programmes previously mentioned (including the news programmes) but also, albeit frequently concealed, in ordinary entertainment series.

It is true that the overwhelming majority of children will not recognise the aspects of psychic and structural violence presented on television as such, for they – at least in the case of 6- to 11-year-olds and certainly many older children – are able to develop only a vague understanding of the individual psychic and social structural processes that take place behind the causes and effects of actions featured or behind the visible and audible perpetrator-victim relationship.

And yet the possible effects of the reception of such aspects of (largely unrecognised) psychic and structural violence by the children in a subcutaneous sense, as it were, – imperceptibly influencing and forming the self-image and the conception of the world – must by no means be underestimated.

Unfortunately only a few reliable references to this problem can be found in the surveys and studies referred to here. Hence it is not possible to answer the question as to whether the main problem for the children does not in fact lie in their confrontation not with physical, but with psychic and structural, violence – usually imperceptible for most child viewers.

### 3.3.2 Which conception of violence do children have?

• To emphasis the situation once again: children's conception of violence – ie their interpretation of what violence is, what they perceive as violence – is not at all identical and comparable to an adult's: whether their parents', their teachers' or the researchers'.

• For children, violence is first and foremost physical violence; they regard it and evaluate it as negative in every respect, particularly for the victims, especially when the act of violence features particular intensity, has detrimental, even fatal, consequences and is not justified by a 'good' cause.[75]

In this connection, the boys only consider severe and existential physical injury to be violence whereas girls experience even harmless brawls as violent. It is interesting that for quite a few girls and boys even verbal disputes, staged with the corresponding severity and existential threat, assume the quality of physical violence (not of *psychic* violence). It is quite clear that verbal disputes are often experienced much more intensively in terms of violence than brawls, for example -- the point at issue being not the problem of psychic violence but the interpretation of verbal disputes as physical violence expressed in words and gestures.[76]

This is probably due to the fact that verbal disputes are more a part of their 'real' everyday life, their own individual world, rather than flying fists, drawn revolvers and flashing knives, which are consequently classified by most children as aspects of the 'extraordinary' world of television.[77]

What is decisive for the child's conception of violence is the child's everyday environment and what he or she experiences there. That children prefer to see violence from the perspective of the victims is a reflection of their real experience.[78] They are themselves often the weaker ones and thus often assume the role of the victim. Admittedly they are rarely subjected to physical, but mainly to psychic, violence, which they often do not recognise and understand as such – just as they fail to comprehend structural violence linked to the world of politics.[79]

Nevertheless, they are quite familiar with relationships like 'the perpetrator and the victim', 'the stronger one against the weaker one' and

278

the feeling of powerlessness on the part of the weaker one, usually the victim. And they are moved by this relationship even when they cannot understand the overall context of the perpetrator-victim relationship – as in the case of psychic and structural violence.

The children's everyday situation also explains why the boys have a much narrower conception of violence than the girls have. In the everyday activities of the boys, playful fighting and boasting is a 'normal' event – especially as the model of 'being a man' expected of them constantly suggests that they should be strong and superior, victorious and successful. Girls do not 'have to prove themselves physically' in everyday situations, since it is not part of their obligatory stereotype of 'being a woman'. In their particular case violence starts with just little squabbles. Moreover, particularly for older girls, is the subject of 'psychic violence' is an explicit problem relevant at an earlier age than for the boys, possibly because the girls are more strongly subjected to psychic violence in their socialisation than the boys.[80]

### 3.3.3 The motives that prompt children to take an interest in portrayals of violence

Despite considerable and frequently wild speculation, there is no precise evidence on the reasons and motives prompting a relatively large group of children to take a specific interest in portrayals of violence. But the assumption is probably none too spurious that such an interest is determined by factors arising from the children's environment: that is, first and foremost, from their everyday socialisation situation.[81] It is here that they begin to experience the existence, the evaluation and the consequences of physical and psychic violence. They experience, in particular, how violence is linked to making decisions whenever those who want to, or have to, decide are not able or willing to settle disagreements and conflicts non-violently: that is, on the basis of discussion and argumentation.

How the children receive and digest such manifestations of violence and hence the portrayals of violence on television depends on the intensity and the extent of the threat with which they actually experience violent behaviour in real life and are affected by it. The closer they come into contact with violent behaviour in their real experience and the more they are themselves harmed there by violent behaviour, the more they will turn to portrayals of violence to possibly use them for coming to terms with and compensating for their own distress – in both the positive or in the negative sense of the term, which is largely dependent on the quality of their everyday environment, particularly of their family situation.[82]

The fascination that portrayals of violence can have for children is the consequence of not only the problem just mentioned, however. Children can relate to portrayals of violence to satisfy completely 'normal' needs arising from their development. Children subject themselves to such

portrayals, for example, in order to venture into and prove themselves in situations where they have to endure suspense and overcome feelings of anxiety. Such a 'thirst for fear' (*Angst-Lust*; Michael Balint), such willingness to take risks and to enter emotionally stressful experiences, have to be considered as important principles that help children form their identity and provide guidelines for coping with reality.[83]

Further reasons and motives for the children may arise from the way portrayals of violence are presented; from the fact that children, when watching portrayals of violence, feel they are 'grown-up'; or from the notion that only those who can talk about portrayals of violence (particularly ones that adults condemn) is really 'somebody' among friends of the same age.

*3.3.4 What do children actually receive as portrayals of violence?*
In the perception and appraisal of portrayals of physical violence children introduce their conception of violence as a kind of threshold from which they decide whether they will turn to or turn away from such portrayals. Many comments, especially in qualitative studies, maintain that children prefer to view programmes 'laced with violence' where the violence presented does not cross this threshold, ie the act of violence is neither presented with particular intensity, nor with detrimental or fatal consequences nor deprived of a 'good' cause to justify it.[84]

This in turn leads to the conclusion that the reception of portrayals of physical violence is unproblematic for children when these portrayals present physical violence as a fictional event without any consequences, in which there are no victims and hence no suffering to be viewed, as it is the case in cartoon series like *Prince Eisenherz, Bugs Bunny* and *The Flintstones*, or in action series such as *Knight Rider* and *A-Team*.

What is more, verbal aggression in such series, which assumes the form of threats and insults, is structured in such a way that it does not impair the generally friendly atmosphere of the series. This is in turn interpreted as an opportunity for children to comprehend the fictional context of such series and to view the portrayals of violence as amusing matters, whose possible seriousness is additionally pushed aside by means of many gags, magic tricks, athletic-grotesque acrobatics, technological gadgets and humour.[85]

The fact that children may be endangered by the portrayal of such super-clean violence is not contested in the surveys quoted. This danger is mainly ascribed to the fact that the portrayals of violence just described run under the basic principle of being easy for the children to grasp, but this is not unproblematic: the danger comes from the 'baddies', and the 'goodies' have to defend themselves against it. So the model of the 'good' hero who overcomes 'evil' is presented to the children, which at the same time imposes on them the formula that the good purpose justifies the bad means, a self-evident and often inevitable recipe for settling conflicts of

every possible kind. The children are consequently deprived of the opportunity to recognise violence as the (concealed and hence imperceptibly justified) fangs of 'goodness' and, in the final analysis, as its very negation.[86]

Children watch not only such 'harmless' cartoon and action series but also programmes of which the violence content lies above the level of their 'normally' accepted violence threshold, ie 'hard' animation and action series such as *Power Rangers*, *Faust*, *Beverly Hills Cop* or the *Galaxy Rangers*, not forgetting the repeatedly shown *Airwolf* and *Starsky+Hutch* machinations.

Children seem to react differently to the latter, namely with anxiety, uncertainty and fear. For most children the previously described 'threshold' is quite clearly crossed in such series and films, despite all the wrappings of technology, fun and brashness. This may be due to the fact that:

- the acts of violence are linked to drastic, visible consequences;
- children can comprehend the victims' situation and can suffer with them;
- children, if only as a vague suspicion, can create a relationship between the acts of violence and their own circumstances, thus losing the opportunity to interpret the programme as fiction;
- the acts of violence are embedded in mysterious, unclear, incomprehensible contexts.[87]

As children are hardly in a position to know in advance what kind of violence presentation they will be confronted with, they can only avoid the previously described features of the portrayal of violence if they immediately shun this form, either due to a lack of interest or for fear of the scenes that may follow.

As a rule, they do not do this, however. This gives rise to the danger that the shock suffered by the reception of 'hard' violence cannot be digested by the children, that it is suppressed, possibly emerging in individual behaviour when everyday conditions (in the family, at school) provoke and impel, as it were, the transformation – in whatever form assumed – of what was suppressed into specific emotional, mental and behavioural patterns.

The above-mentioned problem – that children cannot cope with portrayals of violence embedded in (what seem to them to be) mysterious, opaque, incomprehensible contexts – will probably also appear in the case of presentations of psychic and (social) structural violence. Children not only have considerable difficulty assimilating and digesting these portrayals; in some cases they are totally deprived of the opportunity to assimilate and digest this process when they face relatively subtle, usually well concealed forms of psychic and structural violence, as in family dramas and comedies. Or when they – as in news and information programmes – are confronted with very far-reaching contexts, totally

different and thus unrelatable to their everyday circumstances, and with a shocking event like war, in which the conditions and effects of psychic and structural violence are rooted.[88]

*3.3.5 Which effects of violence portrayals can be assumed?*
If shocking events featuring violence are excluded, especially those which are for children incomprehensible and the source of disgust and horror (war, terror, cruelty to animals), and if special problems affecting children psychically at risk are also disregarded, the least that may be said about what children 'normally' receive as portrayals of violence on television is the following: children's preoccupation with portrayals of violence can subsequently have effects on their thinking, feeling and behaviour if there is a 'resound board', as it were, furnished by the socially determined and individually embedded conditions that the children contribute to the handling of such portrayals.[89]

As the results ascertained in analyses of the so-called 'double dose' hypothesis[90] show, it seems possible to assume one thing with a relatively high level of certainty: children – younger rather than older – may be stimulated into aggressive, violent thinking, feeling and behaviour by the portrayal of violence on television only if, on the one hand, they repeatedly experience real-life violence in the family, at school or in the peer group and if, on the other, they are confronted with *comparable* (and possibly justified) acts of violence on the screen.

This combination may result in the following:

• children – due to their everyday experience and the everyday nature of the violent events enacted – see the world as inherently violent and regard acts of aggression as the only possible means of asserting individual interests and settling conflicts;

• children tend to be less inhibited about violent behaviour;

• children, if made uncertain and anxious by the reception of portrayals of violence, are not only encouraged to increase their consumption of portrayals of violence to ease their feelings of uncertainty and fear but also resort to aggressive behaviour in an attempt to compensate for their uncertainty and fear.[91]

*3.4 Consequences for a programme policy responsible towards children*
The risk that the reception of portrayals of violence may entail negative consequences for child viewers should urge programme planners to constantly insist on a 'disarmament of violence' (Schmidt 1991, p. 8;).[92] This demand is not only directed at public service broadcasters ARD and ZDF whose general programme offers relatively few portrayals of violence: it is also aimed at the commercial television companies who forget now and again – especially in the organisation of their entertainment programme – that children are in a 'protected age' (Ganz-Blättler 1995, p. 39). Besides, this demand for 'disarmament' is already laid down in the German

broadcasting legislation, in the statutes of the regional broadcasting control authorities of the *Länder* and in the guidelines of the EBU.[93]

Television broadcasters – particularly the commercial companies – did not seriously respond to this demand until a wide-scale parents' campaign created a big stir, until the *Power Rangers* debate triggered another commotion and an intervention by higher authorities was considered.[94] As a result, ARD and ZDF made it clear that in their programme planning they would always practise caution and restraint concerning portrayals of violence, keeping the latter particularly low in number in public television programmes by such measures as:

- taking care to exclude excessive portrayals of violence that glorify or play things down in programme production and programme acquisition;
- taking into consideration possible dangers, particularly for young viewers in programme placement;
- not selecting facts destined for reports in news and information programmes on the basis of their sensational value and violence content;
- taking care that in entertainment programmes violence is not extolled either as a means of settling conflicts or as a means of degrading human beings or discriminating against minorities.[95]

German commercial broadcasting companies have also commendably nailed their colours to the mast by establishing a body for 'voluntary self-restraint' (*Freiwillige Selbstkontrolle Fernsehen*, FSF), joined by DSF/Deutsches Sportfernsehen, Kabel 1, n-tv, Premiere, Pro 7, RTL, RTL 2, SAT.1 and VOX. According to the statutes it is the duty of this body to limit the portrayal of violence and sexuality to such an extent that children and young people are not harmed in their psychological, mental and moral development.

There is no doubt that the targets named by the ARD/ZDF and the commercial television companies must be supported. How they can be achieved in practice is certainly a question that would be really worth answering on an empirical basis.[96] Then it would be possible to decide whether this type of attempt to reduce the violence potential implanted in television programmes is more effective than installing a computer chip in the TV set by means of which violence and sex scenes could be banned from the screen by the parents pressing a button.[97]

## References

Anfang, G. and Schorb, B. (1995). *Nie hat es so viel Spaß gemacht. Gewalt in den Medien.* (Never had so much fun. Violence in the media.) Munich: KoPäd. (2nd version; 1st version 1987: Theunert, Helga; Müller-Hilmer, Rita)

ARD/ZDF-Medienkommission (1990). Stellungnahme zu den Ausführungen der Gewaltdarstellungen in den Massenmedien im Gutachten der Unabhängigen Regierungskommission zur Verhinderung und Bekämpfung von Gewalt (Gewaltkommission). (Statement on representations of violence exposés in the mass media in the Independent Government Commission's report on the

prevention of and fight against violence (Violence Commission). *Media Perspektiven Dokumentation*, (II), pp. 91-98.

Aufenanger, S. (1993). Actionserien und ihre Helden. Warum Kinder sie lieben und Erzieher sie fürchten. (Action series and their heroes. Why children love them and educators fear them.) In Landesanstalt für Rundfunk/LfR (ed), *Gewalt im Fernsehen. (K)ein Thema für Kindergarten und Schule.* Düsseldorf: LfR-Referat Presse- und Öffentlichkeitsarbeit, pp. 36-49. (2nd edition)

Bachmair, B. (1989). Wie, in welchen Zusammenhängen und mit welchen Konsequenzen verarbeiten Kinder Fernseherlebnisse? Pädagogische Perspektiven zum alltäglichen Fernsehen. (How, in which contexts and with which consequences do children come to terms with TV experiences? Pedagogical perspectives on everyday television.) In Landesanstalt für Rundfunk/LfR (ed), *Medienerziehung im Kindergarten. Neue Herausforderungen durch private Programme.* Düsseldorf: LfR, pp. 35-46.

Bachmair, B. (1995). Spiel mit der Gewalt – Zur Bedeutung von Wrestling-Sendungen für Kinder und Jugendliche. (The game with violence – the meaning of wrestling programmes for children and youth.) *medien praktisch*, 19(3), pp. 23-27.

Bandura, A. (1979). *Sozial-kognitive Lerntheorie.* (Social-cognitive learning theory.) Stuttgart: Klett.

Bandura, A. and Walters, R.H. (1963). *Social learning and personality development.* New York *et al.*: Holt, Rinehart u. Winston.

Becker, B., Janssen, S., Rullmann, A. and Schneider, B. (1990). Die neuen Zeichentrickserien. Immer wieder Action. (The new cartoon series. Action time and again.) In I. Paus-Haase (ed), *Neue Helden für die Kleinen. Das (un)heimliche Kinderprogramm des Fernsehens.* Münster: Lit, pp. 152-198.

Belson, W.A. (1978). *Television violence and the adolescent boy.* Westmead *et al.*: Saxon House, Teakfield.

Bonfadelli, H. (1995). Mediengewalt als Forschungsgegenstand. (Media violence as a subject of research.) *ZOOM Kommunikation & Medien,* (5-6) (Gewalt und Gewalt), pp. 96-97.

Brosius, H.-B. (1987). Auswirkungen der Rezeption von Horror-Videos auf die Legitimation von aggressiven Handlungen. (The effects of the reception of horror videos on the legitimacy of aggressive actions.) *Rundfunk und Fernsehen,* 35(1), pp. 71-91.

Calliess, J. (1993). Gewaltverständnis und Gewaltaufklärung. (Comprehending and clarifying violence.) In Institut Jugend Film Fernsehen (ed), *Eine Gesellschaft unter Druck.* Munich: KoPäd, pp. 9 ff.

Charlton, M. and Neumann-Braun, K. (1992). Komplexe Kausalmodelle der Medien-Rezipienten-Beziehung (am Beispiel von Untersuchungen zur Auswirkung von Gewaltdarstellungen in Medien). (Complex causal models of the media recipient relationship – with reference to surveys on the effects of representations of violence in the media). In M. Charlton, K. Neumann-Braun (eds), *Medienkindheit – Medienjugend. Eine Einführung in die aktuelle kommunikationswissenschaftliche Forschung.* Munich: Quintessenz, pp. 39-45.

Czaja, D. (1995). 'Wir haben schon sehr viel bewegt!' ('We've changed a lot!') *TeleImages. Das Fachmagazin für Fernsehwerbung,* (2), pp. 46-47.

Egbringhoff, V., Gehrke, G. and Hohlfeld, R. (1990). Was guckt ihr denn so? Eine

Befragung von Kindern. (What do you watch then? A children's survey.) In I. Paus-Haase (ed), *Neue Helden für die Kleinen*. Münster: Lit, pp. 36-55.

Eimeren, B. van and Löhr, P. (1991). Kinderfernsehen und gesellschaftliche Verantwortung. (Children's television and social responsibility.) *Media Perspektiven*, -(10), pp. 649-660.

Feshbach, S. (1989). Fernsehen und antisoziales Verhalten. Perspektiven für Forschung und Gesellschaft. (Television and anti-social behaviour. Perspectives for research and society.) In J. Groebel, P. Winterhoff-Spurk (eds.), *Empirische Medienpsychologie*. Munich: Psychologie Verlags Union; pp. 65-76.

Feshbach, S. and Singer, R.D. (1971). *Television and aggression: An experiment field study*. San Francisco, Ca.: Jossey-Bass XVIII,186 pp.

Friedrich, L.K. and Stein, A.C. (1975). Pro social television and young children. *Child Development*, 46(1), pp. 27-38.

Früh, W. (1995). Die Rezeption von Fernsehgewalt. (The reception of television violence.) *Media Perspektiven*, (4), pp. 172-185.

Gangloff, T.P. (1995). Invasion der Gewalt. (The invasion of violence.) *journalist – Das deutsche Medienmagazin*, (6), pp. 12 ff.

Ganz-Blättler, U. (1995). Fernsehserien unter Anklage. (TV series under fire.) *ZOOM Kommunikation & Medien*, (5-6) (Gewalt und Gewalt), pp. 35-39.

Gauntlett, D. (1995). *Moving experiences. Understanding television's influences and effects*. London: Libbey VIII, 148 pp.

Geraint, S.-J. and Kündig, U. (1991). Gewalt im Fernsehen. Die Richtlinien der EBU. Violence on television. The EBU guidelines.) *epd Kirche und Rundfunk*, (56), pp. 17-19.

Gerbner, G. (1988). *Violence and terror in the mass media*. Paris: Unesco, 45 pp.

Glogauer, W. (1991). *Kriminalisierung von Kindern und Jugendlichen durch Medien*. (The criminalisation of children and young people by the media.) Baden-Baden: Nomos, 144 pp.

Grimm, J. (1995). *Wirkungen von Mediengewalt*. (Effects of media violence.) Opladen: Westdeutscher Verlag.

Grimm, J. (1995). Wirkungen von Fernsehgewalt – Zwischen Imitation und Erregung. (Effects of television violence – between imitation and stimulation.) *medien praktisch*, 19(3), pp. 14-23.

Groebel, J. (1982). Fernsehen und Angst. Macht das Fernsehen die Umwelt bedrohlich? (Television and Fear. Does television make the environment threatening.) *Publizistik*, 27(1), pp. 152 ff.

Groebel, J. (1988). Sozialisation durch Fernsehgewalt. Ergebnisse einer kulturvergleichenden Studie. (Socialisation by television violence. Results of a comparative cultural study.) *Publizistik*, 33(2-3), pp. 468-480.

Groebel, J. (1990). Wechsel – Risiko – Spiele. (Change – Risk – Games.) *epd Kirche und Rundfunk*, (94), pp. 3-7.

Groebel, J. (1993). Gewalt im deutschen Fernsehen. Ergebnisse einer vergleichenden Untersuchung der Gewaltprofile öffentlich-rechtlicher und privater Fernsehprogramme. (Violence on German television. Results of a comparative survey of violence profiles of public and commercial TV channels.) In Landesanstalt für Rundfunk/LfR (ed), *Gewalt im Fernsehen. (K)ein Thema für Kindergarten und Schule*. Düsseldorf: LfR-Referat Presse- und Öffentlichkeitsarbeit; pp. 24-35.(2nd edition)

Groebel, J. and Gleich, U. (1993). *Gewaltprofil des deutschen Fernsehprogramms. Eine Analyse des Angebots privater und öffentlich-rechtlicher Sender*. (Violence profile of

the German television broadcasting service. An analysis of the programme services offered by commercial and public broadcasters.) Opladen: Leske and Budrich 174 pp.

Heath, L., Kruttschnitt, C. and Ward, D. (1986). Television and violent criminal behavior. Beyond the bobo doll. *Violence and Victims*, (1),pp. 177 ff.

Heitmeyer, W. (1995). Freigesetzte Gewalt. Gewalt als Bearbeitungsform einer neuen Unübersichtlichkeit. (Unleashed violence. Violence as a form of processing a new complexity.) In Arbeitsgemeinschaft Kinder- und Jugendschutz Landesstelle Nordrhein-Westfalen (ed), *Materialien zum Thema 'Gewalt und Gewaltprävention'*. Essen: Drei-W-Verlag; pp. 42 ff.

Heitmeyer, W., Collmann, B., Conrads, J., Kaul, D., Kühnel, W. *et al.* (1995). *Gewalt – Schattenseiten der Individualisierung bei Jugendlichen aus unterschiedlichen Milieus*. (Violence – the dark sides of the individualisation of young people from different social environments.) Weinheim *et al.*: Juventa, 478 pp.

Heitmeyer, W., Conrads, J., Kaul, D., Möller, R. and Ulbrich-Hermann, M. (1995). Gewalt in sozialen Milieus. Darstellung eines differenzierten Ursachenkonzepts. (Violence in social environments. The presentation of a discriminate concept of the causes.) *Zeitschrift für Sozialisationsforschung und Erziehungssoziologie (ZSE)*, 15(2), pp. 145 ff.

Hermann, I. (1986). Erleuchtet oder überdüngt? Fernsehgewalt: Was bewegt Verantwortliche und Macher. (Enlightened or over-fertilised? Television violence: what moves those responsible and the producers?) *epd Kirche und Rundfunk*, (79), pp. 5-7.

Hesse, P. and Mack, J.E. (1990). Feindbilder im amerikanischen Kinderfernsehen. (Enemy images on American children's television.) *Psychosozial*, 13(4), pp. 7-23.

Himmelweit, H.T., Oppenheim, A.N. and Vince, P. (1958). *Television and the child. An empirical study of the effect of television on the young*. London: Oxford University Press.

Hipfl, B. (1991). Gewaltdarstellungen im Fernsehen und ihre Bedeutung für die Entwicklung der Kinder: (Portrayals of violence on television and their meaning for children's development.) In S. Aufenanger (ed), *Neue Medien – Neue Pädagogik? Ein Lese- und Arbeitsbuch zur Medienerziehung in Kindergarten und Grundschule*. Bonn: Bundeszentrale für politische Bildung, pp. 122-135.

Hoeistad, G. (1991). How vulnerable are children to electronic images? *Media Development*, 38(4), pp. 60-61,63-64.

Höfer, G. (1995). Gewaltstrukturen in den Zeichentrickprogrammen der privaten Kanäle. (Violence structures on the commercial channels' cartoon programmes.) In G. Hoefer and S.R. Janssen, *Gewalt als Unterhaltung im Kinderfernsehen?* Coppengrave: Coppi, pp. 234-295.

Hüsman, L.R. and Eron, L.D. (1986). The development of aggression in American children as a consequence of television violence viewing. In L.R. Hüsman and L.D. Eron (eds), *Television and the aggressive child. A cross national comparison*. Hillsdale, N. J.: Erlbaum, pp. 45 ff.

Institut Jugend Film Fernsehen (ed). Videokassette *'Gewalt hat viele Gesichter'*. ('Violence has many faces'). Munich: KoPäd o. J.

Jablonski, C.K. and Zillmann, D. (1995). Humor's role in the trivialization of violence. *Medienpsychologie – Zeitschrift für Individual- und Massenkommunikation*, 7(2), pp. 25 ff.

Janssen, S.R. (1995). Action, Bedrohung, Konflikt und Gewalt – Typologie und Analyse spannungserzeugender Strategien im Fernsehen. (Action, threats, conflicts and violence – a typology and analysis of excitement-arousing strategies on television.) In G. Hoefer and S.R. Janssen, *Gewalt als Unterhaltung im Kinderfernsehen?* (Violence as entertainment on children's television?) Coppengrave: Coppi, pp. 15 ff.

Kalkofe, O., Raschke, P., Schröder, B. and Welke, O. (1990). Action-Serien – Anatomie eines Genres – Von Cowboys, Cops und Detektiven. Wie die Action auf den Bildschirm kam. (Action series – Anatomy of a genre – Of cowboys, cops and detectives. How action came on to the screen.) In I. Paus-Haase (ed), *Neue Helden für die Kleinen.* Münster: Lit, pp. 87 ff.

Kepplinger, H.M. (1995). Wirkungen von Gewaltdarstellungen in Massenmedien. (The effects of represenations of violence in the mass media.) In E. Noelle-Neumann, W. Schulz and J. Wilke, *Publizistik Massenkommunikation (Fischer Lexikon).* Frankfurt am Main: Fischer, pp. 571 ff.

Krebs, D. (1994). Gewalt und Pornographie im Fernsehen. Verführung oder Therapie? (Violence and pornography on television. Seduction or therapy?) In K. Merten, S.J. Schmidt and S. Weischenberg (eds), *Die Wirklichkeit der Medien.* Opladen: Westdeutscher Verlag, pp. 352 ff.

Krebs, D. and Groebel, J. (1980). *Die Wirkungen von Gewaltdarstellungen im Fernsehen auf die Einstellung zur Gewalt und auf die Angst bei Kindern und Jugendlichen.* (The effects of television representations of violence on attitudes towards violence and on children's and young people's fears.) Aachen: Technische Hochschule.

Krüger, U.M. (1994). Gewalt in Informationssendungen und Reality TV. (Violence in information programmes and reality TV.) *Media Perspektiven,* (2), pp. 72 ff.

Kühnel, W. (1995). Die Bedeutung von sozialen Netzwerken und Peer-group-Beziehungen für Gewalt im Jugendalter. (The meaning of social networks and peer-group relationships for violence in adolescence.) *Zeitschrift für Sozialisationsforschung und Erziehungssoziologie (ZSE),* 15(2), pp. 122 ff.

Kunczik, M. (1993). Gewalt im Fernsehen. Stand der Wirkungsforschung und neue Befunde. (Violence on television. Current levels of effect research and new findings.) *Media Perspektiven,* -(3), pp. 98 ff.

Kunczik, M. (1994). *Gewalt und Medien.* (Violence and the media.) Wien: Böhlau. (2nd revised edition)

Kunczik, M., Bleh, W. and Maritzen, S. (1993). Audiovisuelle Gewalt und ihre Auswirkungen auf Kinder und Jugendliche. (Audio-visual violence and its effects on children and young people.) *Medienpsychologie,* 5(1), pp. 3 ff.

Loretan, M. (1995). Ethische Leitlinien zur Mediengewalt. (Ethical guidelines for media violence.) *ZOOM Kommunikation & Medien,* (5-6), pp. 4 ff.

Lukesch, H. and Schauf, M. (1990). Können Filme stellvertretende Aggressionskatharsis bewirken? (Can films effect a substitutional aggression catharsis?) *Psychologie in Erziehung und Unterricht,* 37(1), pp. 38 ff.

Merten, K. (1993). *Darstellung von Gewalt im Fernsehen. Inhaltsanalyse 11.-17.11.92 – Abschlußbericht.* (Presentation of violence on television. Contents analysis 11.-17.11.92 – final report.) Münster: COMDAT-Medienforschung GmbH.

Merten, K. (1994). Unvalider Schluß. Kritische Anmerkungen zur aktuellen TV-Gewaltdiskussion. (Invalid conclusion. Critical notes on the current TV violence discussion.) *epd Kirche und Rundfunk,* (18), pp. 3 ff.

Milhavsky, J.R. (1988). Television and aggression once again. In S. Oskamp (ed.), *Television as a social issue. Applied Social Psychology Annual no. 8.* Newbury Park, Ca.: Sage, pp. 141 ff.

Milavsky, J.R., Kessler, R.C., Stipp, H.H. and Rubens, W.S. (1982). Television and aggression. Results of a panel study. In D. Pearl (ed), *Television and behavior.* 2. Rockville, Md.: National Institute of Mental Health, pp. 138 ff.

Mustonen, A. and Pulkkinen, L. (1993). Aggression in television programmes in Finland. *Aggressive Behavior,* 19(-), pp. 175 ff.

*Neue Zürcher Zeitung* v. 12.11.93 ('Genug ist genug!' Amerikanische Veranstalter unter politischem Druck) ('Enough's enough!' American broadcasters under political pressure.)

*Neue Zürcher Zeitung* v. 10.12.93 (Freiwillige Selbstkontrolle institutionell verankert. Vereinbarung unter den Privatsendern Deutschlands) (Voluntary self-restraint institutionally established. Agreement between commercial broadcasters in Germany.)

Paus-Haase, I. (1991). Zur Faszination von Action-Serien und Action-Cartoons für Kindergarten- und Grundschulkinder. (The fascination of action series and action cartoons for kindergarten and primary school children.) *Media Perspektiven,* -(10), pp. 672 ff.

Rogge, J.-U. (1990). *Medial inszenierte Gewalt am Beispiel von Zeichentrick- und Kriminalserien sowie von Aktions-Spielzeug. Masters of the Universe und Barbie Puppen.* (Violence staged in the media with reference to cartoon and crime series as well as action toys. Masters of the Universe and Barbie dolls.) Hannover: Niedersächsisches Kultusministerium.

Rogge, J.-U. (1993). Geschlechtsgebundene Tendenzen im Umgang mit medial inszenierter Realität. (Gender-related tendencies in dealing with reality staged in the media.) In Landesanstalt für Rundfunk/LfR (ed), *Gewalt im Fernsehen. (K)ein Thema für Kindergarten und Schule.* Düsseldorf: LfR-Referat Presse- und Öffentlichkeitsarbeit, pp. 50 ff. (2nd edition)

Schell, F., Gerke, G. and Stolzenburg, E. (1995). *An jeder Ecke ... Gewalt im Alltag.* (On every corner ... Everyday violence.) Munich: KoPäd.

Schmidbauer, M. and Löhr, P. (1991). *Fernsehformen und kindliche Programmverarbeitung.* Zum Diskussionsstand in der amerikanischen Fernsehforschung (Television forms and the child's processing of programmes.) Munich: IZI (unpublished manuscript)

Schmidbauer, M. and Löhr, P. (1992). *Fernsehkinder – 'Neue Sozialisationstypen'?* (TV kids – 'New socialisation types'?) Munich: Stiftung Prix Jeunesse.

Schmidbauer, M. and Löhr, P. (1994). Was 'fernsehen' Kinder tatsächlich? (What do kids actually 'tv'?) *TelevIZIon,* 7(2), pp. 7 ff.

Schmidt, C. (1991). *Zur Debatte 'Gewalt im Fernsehen'.* (On the debate 'Violence on television'.) Cologne: WDR. (unpublished manuscript)

Scholz, R. and Joseph, P. (1993). *Gewalt- und Sexdarstellungen im Fernsehen. Systematischer Problemaufriß mit Rechtsgrundlagen und Materialien.* (Violence and sex portrayals on television. Systematic problem outline with legal principles and materials.) Bonn Bad Godesberg: Forum.

Schorb, B., Petersen, D. and Swoboda, W.H. (1992). *Wenig Lust auf starke Kämpfer. Zeichentrickserien und Kinder.* (Not much interest in strong fighters. Cartoon series and children.) Munich: R. Fischer.

Schorb, B. and Swoboda, W.H. (eds) (1991). *Medienpädagogen kommentieren populäre Thesen über die Wirkungen der Darstellungen von Gewalt und Sexualität im Fernsehen*

*auf Kinder und Jugendliche. Dokumentation einer bundesweiten Experten-Befragung.* (Media educationists comment on popular theses about the effects of portrayals of violence and sexuality on television on children and young people. Documentation of a country-wide experts' survey.) Munich: GMK. (2nd edition)

Schramm, W.S., Lyle, J. and Parker, E.B. (1961). *Television in the lives of our children.* Stanford, Ca.: Stanford University Press.

Selg, H. (1990). Gewaltdarstellungen in Medien und ihre Auswirkungen auf Kinder und Jugendliche. (Portrayals of violence in the media and their effects on children and young people.) *Zeitschrift für Kinder- und Jugendpsychiatrie,* 18(3), pp. 152 ff.

Selman, R.L. and Byrne, D.F. (1980). Stufen der Rollenübernahme in der mittleren Kindheit – eine entwicklungspsychologische Analyse. (Levels of role adoption in the middle of childhood – a development psychology analysis.) In R. Döbert, J. Habermas, G. Nunner-Winkler (eds), *Entwicklung des Ich.* Königstein, Ts.: Verlagsgruppe Athenäum Hain Scriptor Hanstein, pp. 109 ff.

Stadik, M. (1995). Die Angst vor dem eigenen Spiegelbild. (The fear of one's own reflection.) *TeleImages. Das Fachmagazin für Fernsehwerbung,* (2), pp. 42 ff.

Stolzenburg, E. (1995). *Bloß 'ne Rippe. Gewalt gegen Frauen.* (Just a rib. Violence against women.) Munich: KoPäd.

*Süddeutsche Zeitung* v. 27.1.94 (Nicht das Was, sondern das Wie ist entscheidend) (Not 'what' but 'how' is important)

*Süddeutsche Zeitung,* 17.2.94 (Gewaltfilme als Vorbild) (Violence films as a model)

*Süddeutsche Zeitung,* 6.4.94 (Aggressionssteigerung) (The escalation of violence)

*Süddeutsche Zeitung,* 25.4.94 (Wenn Angst die Oberhand gewinnt) (When fear gains the upper hand)

*Süddeutsche Zeitung,* 22.6.94 (Protestbriefe gegen Gewalt im Fernsehen) (Protest letters against violence on television)

*Süddeutsche Zeitung,* 19.1.95 (Gemeinsamer Kampf gegen Alpträume) (Common fight against nightmares)

*Süddeutsche Zeitung,* 12.5.95 (Kindliche Angst und kindliche Argumente) (The child's fear and the child's arguments)

*Süddeutsche Zeitung,* 15.7.95 (Mit einem Chip gegen die Gewalt) (A chip against violence)

Swoboda, W.H. (1994). Abseits oder Anstoß? (Off-side or kick-off?) In R. Kübert, H. Neumann, J. Hüther, W. H. Swoboda, *Fußball, Medien und Gewalt. Medienpädagogische Beiträge zur Fußballfan-Forschung.* Munich: KoPäd; pp. 51 ff.

Theunert, H. (1987). *Gewalt in den Medien – Gewalt in der Realität. Gesellschaftliche Zusammenhänge und pädagogisches Handeln.* (Violence in the media – violence in reality. Social connections and pedagogical activity.) Opladen: Leske and Budrich.

Theunert, H. (1995). *Die Sache mit der Gewalt. Informationen und Einstiegsanregungen zu Gewalt im Alltag und in den Medien.* (The violence issue. Information and introductory suggestions on violence in everyday life and the media.) Munich: KoPäd.

Theunert, H., Pescher, R., Best, P. and Schorb, B. (1992). *Zwischen Vergnügen und Angst – Fernsehen im Alltag von Kindern. Eine Untersuchung zur Wahrnehmung und Verarbeitung von Fernsehinhalten durch Kinder aus unterschiedlichen soziokulturellen Milieus in Hamburg.* (Between fun and fear – TV in children's everyday lives. An investigation into the perception and processing of television contents by children from different socio-cultural environments in Hamburg.) Berlin: Vistas.

Theunert, H., Lenssen, M. and Schorb, B. (1995). *'Wir gucken besser fern als Ihr!'* – *Fernsehen für Kinder.* ('We watch TV better than you do!' – TV for children.) Munich: KoPäd. (Edition TelevIZIon)

Theunert, H. and Schorb, B. (in cooperation with Best, P., Basic, N. and Petersen, D.) (1995). *Mordsbilder. Kinder und Fernsehinformation.* (Terrific scenes. Children and TV information.) Berlin: Vistas.

Tulodziecki, G. (1989). Mediennutzung von Kindern als bedürfnisbezogene Handlung. (Children's media use as a needs-related activity.) In H.D. Erlinger (ed), *Kinderfernsehen II.* Essen: Die blaue Eule; pp. 143 ff.

Winterhoff-Spurk, P. (1994). Gewalt in Fernsehnachrichten. (Violence in TV news.) In M. Jäckel and P. Winterhoff-Spurk (eds), *Politik und Medien. Analysen zur Entwicklung der politischen Kommunikation.* Berlin: Vistas, pp. 55 ff.

## Notes

1    The German version of this article appeared in *TelevIZIon* 8/1995/2, pp. 4-24.

2    In the subsequent analyses we focus on the field of sociological and socio-psychological mass communication research. Mainly empirical (primary) studies are considered, ie the type of research that claims to provide results that are representative for 6- to 13-year-old children. Consequently, individualistic (psychological) analyses are largely excluded.

Two remarks on the subject of 'portrayals of violence in television programmes': 'portrayal' means both fiction and factual programmes (eg news); 'violence' is understood to be a perpetrator-victim relationship implying the intended harm of human beings, other living creatures and property (by human beings).

3    In the present context it is not possible to consider the important role of the propagation of action and horror videos in the stimulation of the media/violence discussion (cf. Brosius 1987, pp. 71 ff.). Particularly the murder of the 2-year-old James Bulger (Liverpool) by two 10-year-olds and the murder of the 15-year-old Sandro Beyer (Sonderhausen) by a clique of peers caused a big stir, as the perpetrators of these crimes were said to have indulged a specific consumption of videos (cf. Grimm 1995 b, p. 14)

4    Cf. Bonfadelli, 1995; Anfang and Schorb, 1995; Schell, Gerke and Stolzenburg, 1995; Stolzenburg, 1995; Theunert, 1995.

5    Cf. Loretan, 1995, p. 6.

6    Cf. Himmelweit, Oppenheim and Vince, 1958; Schramm, Lyle and Parker, 1961.

7    Cf. Bandura and Walters, 1963; Bandura, 1979

8    Cf. Gangloff, 1995, p. 13

9    Cf. Glogauer, 1991

10   Cf. Kunczik, Bleh and Maritzen, 1993, pp. 3 ff.; Lukesch and Schauf, 1990, pp. 38 ff. The so-called field experiments, ie the surveys which took place in the framework of everyday reality but in an experimentally prepared variation of the same, and which have hardly anything in common with 'genuine' everyday (television) situations must also be evaluated in the same way (cf. Feshbach and Singer, 1971; Friedrich and Stein, 1975, p. 27 ff.; Gauntlett, 1995, pp. 21 ff.).

11   Cf. the complex 'portrayal of violence' in note 2 and the following: Groebel and Gleich, 1993, p. 21 ff.; Hipfl, 1991, p. 122 ff.; Kepplinger, 1994, p. 578 ff.; Krebs, 1994, p. 363 ff. Kunczik, 1994, p. 53 ff.; Merten, 1993, p. 18 f.; Scholz and Joseph, 1993, p. 154 ff.

12   Cf. Kepplinger, 1994, pp. 578 ff.; Merten, 1993, pp. 11 ff..

13   Cf. Bachmair, 1989, pp. 35 ff.; Krebs, 1994, pp. 374 ff.

14   Cf. Groebel, 1993, p. 28; Groebel and Gleich, 1993, pp. 41 f.; Früh, 1995, p. 174. See also. the video-film documentation on 'violence', 'damage' and 'harm' produced by the *Institut Jugend Film Fernsehen* in Munich.

15   Cf. Krebs, 1994, pp. 357 f.

16   Psychic violence is understood to be a form of influence based on manipulation, deceit, intimidation etc. of the 'victim' by the 'perpetrator', who seeks to assert his or her aim without resorting to (direct or indirect) physical violence. Structural violence, on the other hand, means a consequence arising from a certain arrangement of societal conditions expressed in an unequal distribution of power and opportunity, and in its influence on individual thought, emotion and behaviour (see further below).

17   Cf. Selman and Byrne, 1980, pp. 110 ff.; Theunert, Lenssen and Schorb, 1995, pp. 54 ff..

18  Cf. Schorb and Swoboda, 1991.

19  Cf. Calliess, 1993, pp. 12 ff.; Theunert, 1987; Theunert, 1995, pp. 12 ff.; Krüger, 1994, pp. 73 ff..

20  Cf. for the following studies by Belson, 1978, Milavsky et al. 1982; Hüsman and Eron, 1986.

21  Cf. Kepplinger, 1995, pp. 578 ff.

22  Cf. Merten, 1993, pp. 16 f..

23  Cf. Gauntlett, 1995, pp. 39 ff.; Charlton and Neumann-Braun, 1992, p. 42 ff.; Kunczik, 1993, p. 98 ff.; Kunczik, 1994, pp 100 ff.

24  Cf. the comments by Charlton and Neumann-Braun, 1992, p. 42 ff.; Kunczik, 1993, p. 98 ff.; and Kunczik, 1994, p. 150 ff.

25  Cf. Hüsman and Eron, 1986, pp. 45 ff.

26  Cf. Milavsky et al., 1982, pp. 138 ff.

27  Cf. Brosius, 1987, pp. 71 ff.

28  Cf. Grimm, 1995 (b), pp. 16 ff.; Schmidbauer and Löhr, 1994, pp. 40 ff.

29  Cf. Swoboda, 1994, pp. 57 f.

30  Cf. Gauntlett, 1995, pp. 31 ff.

31  Cf. Gauntlett, 1995, pp. 26 ff.; Charlton and Neumann-Braun, 1992, pp. 40 ff.; Kunczik, 1994, pp. 53 ff.

32  Cf. Groebel, 1993, pp. 25 f.; Loretan, 1995, p. 8

33  Cf. Kunczik, Bleh and Maritzen, 1993, pp. 3 ff.; and Kunczik, 1994, pp. 157 ff.

34  Cf. Gerbner, 1988, Grimm, 1995 (b), pp. 15 f., Groebel, 1982, pp. 152 ff.

35  Cf. Gerbner, 1988; Groebel, 1990, pp. 3 ff.; Schmidbauer and Löhr, 1990.

36  Cf. Feshbach, 1989, pp. 65 ff.; Hesse and Mack, 1990, pp. 7 ff.; Groebel, 1988, pp. 468 ff.; and for the conceptualisation of the topic 'violence by children and young people' Heitmeyer et al., 1995, pp. 145 ff.

37  Cf. Hoeistad, 1991, pp. 60 ff.

38  Cf. Bonfadelli, 1995, p. 97

39  Cf. Grimm, 1995b, pp. 14 ff..

40  The study by Groebel and Gleich (1993), commonly and in the following refered to as 'the LfR study' was commissioned by the Landesanstalt für Rundfunk (LfR), the broadcasting controll authority of North Rhine-Westphalia; the work of Merten (1993), 'the RTL study' was commissioned by the commercial station RTL. A brief summary of the Groebel and Gleich study can be found in Groebel, 1993, p. 24 ff..

41  Cf. Kepplinger, 1993, pp. 573 f.

42  Cf. Krebs and Groebel, 1980; for examples of various evaluations of the results see, for instance, Groebel, 1982, p. 152 ff. and Groebel, 1988, p. 468 ff.

43  Cf. Becker et al., 1990, pp. 152 ff.; Egbringhoff, Gehrke and Hohlfeld, 1990, pp. 36 ff.; Kalkofe et al., 1990, pp. 87 ff.; Theunert et al., 1992; Schorb, Petersen and Swoboda, 1992.

44  Früh, 1995, pp. 172 ff.; Grimm, 1995 (a), Grimm, 1995 (b), pp. 14 ff.; Krebs, 1994, pp. 352 ff.; Krüger, 1994, pp. 72 ff.; and Kunczik, 1994

45  For the LfR study (Groebel and Gleich, 1993) the programme section analysed was broadcast from 17 June to 11 August 1991 and examined in the form of an 'artificially composed' but representative weekly programme – without any commercials. The programme section analysed in the RTL study (Merten 1993) was broadcast from 11 to 17 November 1992 and examined in the form of an 'original' weekly programme. The evaluation of the trailer analysis carried out by Groebel/Gleich and Merten will not be presented here for reasons of space.

46  Cf. Groebel and Gleich, 1993, p. 70

47  Cf. Groebel and Gleich, 1993, pp. 63 ff.; Merten, 1993, p. 3

48  Cf. for Table 1 Groebel and Gleich, 1993, p. 68; Merten, 1993, p. 31.

49  Cf. Merten, 1993, p. 32. The disadvantage of the Merten construct of a violence index consists in the fact that there is no explicit content definition of what is understood to be violence (see Merten 1993, pp. 26 ff.).

50  The violence potential contained in news and some information/documentary programmes should be evaluated differently to the violence potential in fictional programmes, for example: the latter is intentional in two ways, so to speak: intentional with regard to the perpetrator, but also intentional with regard to the broadcaster that intentionally shows a portrayal of violence in its programme (as opposed to the portrayal of violence in news and information programmes, in which violence as a part of a necessary description has to be reported). For the sector of 'reality TV', which describes

posed, staged reality, cf. Krüger, 1994, p. 76 ff.

51 Cf. Groebel and Gleich, 1993, p. 76.

52 Cf. Merten, 1993, p. 4

53 Cf. Groebel and Gleich, 1993, p. 73.

54 Cf. Groebel and Gleich, 1993, p. 119

55 Cf. Merten, 1993, p. 68

56 Cf. Merten, 1993, pp. 66 f

57 Cf. Groebel and Gleich, 1993, pp. 67 und 85.

58 Cf. Merten, 1993, pp. 54 ff.. The threat of danger by means of various forms of psychic harm is excluded here.

59 Cf.. Groebel and Gleich, 1993, p. 81.

60 Cf. Becker et al., 1990, pp. 152 ff.; Groebel and Gleich, 1993, pp. 83 ff.; Höfer, 1995, pp. 234 ff.; Janssen, 1995, pp. 65 ff.; Kalkofe et al., 1990, pp. 87 ff.; Kunczik, 1994, pp. 40 ff.; Merten, 1993, pp. 74 ff.; Scholz and Joseph, pp. 161 ff.; Theunert et al., 1992.

61 Cf. Jablonski and Zillmann, 1995, pp. 25 ff.; Früh, 1995, pp. 181 ff.

62 Cf. Theunert and Schorb, 1995, p. 11.

63 Cf. Krüger, 1994, p. 76. The survey is based on the evaluation of the general programme broadcast between 5 p.m. and 11 p.m. in the periods 1.3.-7.3.93 and 21.6.-27.6.93.

64 The Theunert and Schorb study (so-called IFF study) is based on the evaluation of programme material broadcast on 7 days in July and 2 days in August 1993 (Monday – Thursday: 12 a.m. – 9 p.m., Friday: 12 a.m. – 11 p.m., Saturday: 9 a.m. – 11 p.m., Sunday; 9 a.m. – 9 p.m.) and combined to create an artificial weekly programme. The sample included: 89 news programmes containing 366 items of violence, 66 information magazine programmes containing 184 items, and 12 reality TV programmes containing 74 items (Cf. Theunert and Schorb, 1995, p. 233 ff.).

65 Cf. Groebel and Gleich, 1993, pp. 101 ff.; Merten, 1993, pp. 74 ff..

66 The reference to the 'report character' of the news is not intended to cast any doubt on the news being produced – the production takes place, however, in a different context to that of fictional programmes.

67 Cf. Theunert and Schorb, 1995, pp. 238 ff

68 Cf. Groebel and Gleich, 1993, p. 66

69 It must be pointed out, however, that the exclusion of the category 'psychological damage' raises several questions – for example, the question why the table contains 236 'severe injuries' but only 13 'cases' of 'psychological damage'.

70 Cf. Tables 9 ff. the GfK evaluation mentioned earlier (representative sample of 6- to 13-year-olds and their overall programme use during the period 18.9.-24.9.95). Children in the Federal Republic of Germany ( as a point of reference for the number of child viewers): are currently approx. 6.5 million 6- to 13-year-olds, of whom 3.3 million are 6- to 9- year-olds and 3.2 million 10- to 13-year-olds.

71 Cf. Milavsky, 1988, pp. 141 ff.

72 Cf. Theunert and Schorb, 1995, p. 13.

73 Cf. Janssen, 1995, p. 149.

74 Cf. Schorb, Petersen and Swoboda, 1992; Theunert et al., 1992.

75 Cf. Theunert and Schorb, 1995, pp. 129 ff..

76 Cf. Früh, 1995, p. 172.

77 Cf. Theunert and Schorb, 1995, pp. 92 ff..

78 Cf. Heitmeyer et al., 1995, pp. 145 ff..

79 Cf. Theunert and Schorb, 1995, pp. 109 ff..

80 Cf. Rogge, 1992, pp. 56 ff..

81 Cf. Heitmeyer, 1994, pp. 42 ff.

82 Cf. Theunert and Schorb, 1995, pp. 117 ff.; Aufenanger, 1992, pp. 46 ff.; Rogge, 1990.

83 Cf. Groebel, 1988, pp. 468 ff.; Hipfl, 1991, pp. 122 ff.; Winterhoff-Spurk, 1994, pp. 62 ff..

84 Cf. Becker et al., 1990, pp. 152 ff.; Kalkofe et al., 1990, pp. 87 ff.; Theunert et al., 1992; Schorb; Petersen and Swoboda, 1992.

85 Cf. Paus-Haase, 1991, pp 672 ff.; Jablonski and Zillmann, 1995, pp. 25 ff.. Athletic-grotesque acrobatics are, for example, transmissions of wrestling bouts on some sports channels that are, however, received by children with considerable reserve (cf. Bachmair, 1995, pp. 23 ff.).

86 Cf. Scholz and Joseph, 1993, pp. 163 ff. and – albeit in the context of a somewhat different form of

argumentational framework – Bachmair, 1995, p. 26.

87 Cf. Theunert and Schorb, 1995, pp. 117 ff.; Aufenanger, 1992, pp. 46 ff.; Theunert, Lenssen and Schorb, 1995, p. 50 ff..

88 Cf. Winterhoff-Spurk, 1994, pp. 55 ff.

89 Cf. Kunczik, Bleh and Maritzen, 1993, pp. 3 ff.; Kunczik, 1994, pp. 157 ff.; Selg, 1990, pp. 152 ff..

90 Cf. Heath, Kruttschnitt and Ward, 1986, pp. 177 ff.

91 Cf. Scholz and Joseph, 1993, pp. 162 ff.

92 Cf. also Gangloff, 1995, p. 15

93 Cf. Scholz and Joseph, 1993, pp. 131 ff.; for the EBU guidelines see Geraint 1991, pp. 17 ff..

94 Gangloff, 1995, p. 15; cf. 22.6.94 and 19.1.95 issues of the *Süddeutsche Zeitung* for 'Parents' Campaigns'; cf. 12.11. 93 issue of the *Neue Zürcher Zeitung* for 'Anti-TV Violence Campaign' in the USA.

95 Cf. Hermann, 1986, pp. 5 ff.

96 Cf. Stadik, 1995, pp. 42 ff.; and Czaja, 1995, pp. 46 f.

97 Cf. Groebel and Gleich, 1993, pp. 130 f., and their appeal for a 'non-technical' solution of the problem.

# Media violence and media education

## How adolescents handle action films[1]

*Maria Borcsa and Michael Charlton*

In the early 1990s portrayals of action, violence and horror on German television had increased to such an extent that a fresh discussion of the subject was felt necessary, a discussion that in previous years had quietened down: namely, the effect of media violence on – usually young – viewers. According to current research findings there does exist a proven, albeit not very strong, connection between young people's inclination towards violence and the level of violence consumed on television. The ascertained intensity of this relationship clearly depends on the viewers' living conditions (eg the nature of their upbringing, alternatively of their neglect, in the home). Cultural comparisons also reveal clear differences.

Is there anything new to say about this subject? Is there any hope, with over 5,000 surveys published to date, of extending our current knowledge on the subject? In our opinion there has been particularly a lack of research into the individual and cultural anomalies ascertained. We hardly know anything about the processes responsible for the great differences in the viewers' reactions.

Individual variations in reception are not only of scientific interest. It will not be possible to plan a suitable media pedagogy approach until we know more about the reception strategies that can be adopted by young viewers watching violence on the media.

It should then be possible on the basis of this knowledge to devise for young people a socially responsible approach towards television and video offers, or to appeal for a ban on the broadcasting of a film which, by its very nature, clearly does not allow children and young people to shoulder this responsibility. Those who believe right from the start that media messages are omnipotent determinants need not bother about a media educational strategy. Media pedagogy means broadening the individual's scope of opportunities *vis-à-vis* the media system.

### What are effects of the media?
The concept of media effects as applied in science, politics and everyday life does suggest, however, that the media should be seen as a physical-

chemical substance that has an effect on the human nervous system without the viewers having a chance of eluding its influences. This viewpoint is certainly not completely wrong. It is quite possible for the rapid fluctuation of pictures in computer games to trigger epileptic fits in people prone to such pathological reactions and for the formal properties of media presentations (editing sequence, colour change) to bring about an increase in viewers' excitation. But we should be aware that the 'effect' of an advertising message or the 'effect' of media violence is meant as a *cultural* occurrence rather than one dictated by a law of nature. Just as the human language triggers reflexes that are hard to predict, media messages can also be received and responded to quite individually.

## Media reception – a mixture of individual and mass communication

The reception of the media takes place in two ways. First, the individual takes a more or less direct interest in certain media contents and relates the media messages to already existing knowledge and convictions. In the framework of cognitive reception research, process models are currently being developed that reflect the individual stages in the processing of media contents.[2] Viewers use various models (eg models for media-specific modes of portrayal, characters and roles, scene progressions and reception contexts) to attribute a meaning to the world of pictures and words shown.

Second, there is more and more evidence that the comprehension of media messages is not attained by the individual viewer or reader alone. Since the beginning of electoral research we have known that so-called 'opinion leaders' can alter the audience's perception of media messages, but not until the more recent papers on ethnographic communication research has it been possible to recognise how closely mass and individual communication are in fact intertwined in everyday life.[3]

## Individual strategies of violence reception

The objective of our study on individual strategies of violence reception was to investigate the possible 'effects' of portrayals of violence on television against the background of an active recipient.[4] It was assumed that young viewers already deploy *cognitive* and *social* strategies to safeguard their own individual autonomy and to protect themselves against undesirable media influences.[5]

Previous mainstream research on media effects had hardly investigated such processes – largely considered to be social processes. Even methodologically outstanding longitudinal studies like that of Milavsky *et al.* (1982) endeavoured to eliminate methodologically (partial out) the influence of friends so as to ascertain the media effect cleared of social strategies, ie the media effect which consequently bypasses the environment of the individual recipient.

The survey under consideration focused on the following:

295

- habits of media use and handling media experiences in everyday life;
- the cognitive processes in the selection of a film and the identification tendency during the viewing of an action film;
- the communicative processing of the contents of the viewing in the form of letters and reproductions of the story.

In view of the given budget and time situation it was not possible to carry out more complex procedures such as a discourse analysis of young people's everyday communication on the media. But we did endeavour to apply several, currently less usual, methods in order to test their effectiveness in the context of the effect of audio-visual portrayals of violence.

**Review of study results:**

Altogether four studies were carried out on four different phases of the reception process (see Table 1).

Table 1: **Process characteristics of the reception of TV violence**
(before, during and after reception; measuring instruments and variables)

| | Reception conditions | Before reception | During reception | After reception |
|---|---|---|---|---|
| **Process** | Socio-demographic features and long-term modes of behaviour | Expectations before reception | Identification with protagonists | Communication on media story in letter and reproduction of story |
| **Measuring instruments** | Questionnaire (n=153) | Sorting of programme announcements according to similarity (n=64) | Stop technique and individual interview (n=30) | Form and content analysis (n=121) |
| **Variables** | Gender Social stratum Viewing habits (TV, video, film) Social behaviour (tendency towards aggression) | Undifferentiated vs. differentiated knowledge of genres | Illusive-equating vs. inclusive-differentiating | Self-related vs. object-related violence treatment is evaluated: <br> • – in a meta perspective <br> • – as an overstatement <br> • – as an understatement <br> • – inconsistently |

*Study I: Individual reception conditions*

In a random sample of 153 pupils from a secondary school *(Realschule)* aged between 12 and 15, the inclination towards aggression and long-term use preferences and habits regarding the television medium were ascertained by means of a questionnaire. The connections between the viewing duration on individual days of the week and the self-reported inclination towards violence were very significant; depending on the questionnaire used, gender-specific information on the aggression value was also revealed.[6]

296

As is already known, a correlation says little about the background, let alone the causes. Our hypotheses were derived from the following questions:

- Does frequent viewing make the recipient aggressive (effect)?
- Do aggressive young people watch television more often (selection)?
- Are the viewing duration and aggression dependent on third-party variables, eg the social stratum?

We were able to exclude statistically the third hypothesis. Both the effect hypothesis and the selection hypothesis ascertain only one fact without explaining it psychologically. Particularly a media pedagogical study involving young people inclined to violence would be totally dependent on such explanations. Only an understanding of the previously discussed cognitive and social strategies for handling television violence will make it possible to develop measures, with any chance of success, intended to afford young people more competence in dealing with media stories.

### Study II: Knowledge prior to reception

On the assumption that television consumption is a process, whose prior, parallel and subsequent conditions control perception processing, the second study provides information about personal categorisations taking effect *prior to* reception (cognitive formats). Previous expectations of a film are mainly influenced by the recipient's personal knowledge of the genre.

Sixty-four children each sorted out 50 programme announcements of feature films to create several piles of films that they subjectively considered to be of a similar or kindred type. Young people with a high propensity towards violence proved to be a relatively homogeneous group with a rather differentiated knowledge of film genres, ie these children know what they want to see and what to expect.

The group of rather heavy viewers revealed a completely different picture. Their genre knowledge is much lower and inconsistent. Viewers prone to violence are therefore by no means 'naïve' media users. In terms of media education it may be concluded from this result that particularly children and young people inclined to violence are not as vulnerable to media violence as might be suggested by a mechanistic effect theory. These recipients are hardly surprised by violence on television films: it must be left open at this point whether they take a specific interest in them (see selection hypothesis above).

### Study III: Identification processes during reception

The film *Terminator 2* (featuring Arnold Schwarzenegger) was used as a concrete model for this study and the one to follow. The reason for choosing this film was that it shows both male and female individuals performing acts of violence, but with very different justifications. The film

story focuses on the boy John, his mother and two non-human creatures, the Terminators. Twenty boys and 10 girls saw the first half of the film. The film screening was stopped at three fixed intervals and the children were asked about their viewing experiences in individual discussions. The intervals were specially chosen so that the preceding scenes gave sufficient opportunity for the interviewees to have an intensive look at one of the film characters' behaviour.

The children's replies revealed clear *gender-specific differences* in perceptual processing. The girls seemed to be more strongly affected than the boys, referring more frequently to emotions and associations triggered in themselves by the film. Their para-social relationship with the young protagonist John was often expressed by their assumption of a helper role whereas some of the boys could imagine themselves living like John. These boys with a relatively high propensity towards violence considered the figure of John to be on the whole rather ambivalent, but partly positive, and they examined his living situation more intensively. On the other hand, boys less inclined towards violence categorically rejected the child protagonist's living situation in the questionnaire.

*During* the viewing of an action film different assimilation processes take place in boys and girls, on the one hand, and in young people with higher/lower aggression values, on the other. It is striking that girls see the film story as relatively remote from their own lives, while boys more frequently construct a relationship between their own situation and the film story and – inspired by the story – consider their own future. This point is of particular interest for a media pedagogical approach, as it reveals that the aggression/identification propensity constellation can be conveyed via subjects of personal concern.

*Study IV: Communication on media experiences after reception*
The fourth sub-division of the research project centred on communication processes taking place *after* the film showing: 55 children were asked to write a reproduction of the above-mentioned film story, and 66 others were given the task of writing a fictive letter to a good friend about their viewing experience. The communication situation closer to everyday reality of the 'letter' led to an overall greater variety of messages.

With regard to the violence theme it was possible to discern four types in the two tasks assigned:

- One group proved to be 'realists', whose reports on violent scenes corresponded to their level of gravity.
- The 'toners-down' played down the degree of violence portrayed.
- The 'meta-type' we called young people tending to write in a reflective way on the film.
- Finally there was a 'mixed type', who used all categories of writing style.

There was evidence of a connection between the writing style and the degree of television consumption, eg relatively frequent viewers had a

realistic attitude to the subject of violence, but it was not possible to prove a connection with tendencies towards violence in those writing.

Although we could not supply evidence by means of the method chosen that the meaning of media experiences is acquired not only individually but mainly in the social reference group, we consider it to be extremely important to continue scientific research in this direction. We hope for further findings from ethnographic and discourse-analysis research, which is admittedly very time-consuming. Here the conversations of young people are recorded in as natural everyday circumstances as possible and subsequently analysed to find out how and for which social purpose media experiences are focused on and evaluated.

## Conclusions

It may be said in conclusion that it was possible by means of the methods chosen to find evidence of different cognitive and social strategies in the reception of violent films. Both the individual handling of the theme during the film and the effects of post-receptive communication reveal opportunities for a media educational approach.

There seem to be good prospects of developing in future surveys methods of media education that tune into the different reception modes and processing forms of aggression-inclined and less aggressive viewers, with the aim of affording children and young people a self-determined and socially responsible way of dealing with the television medium.

## References

Belson, W.A. (1978). *Television violence and the adolescent boy*. Westmead *et al.*: Saxon House,Teakfield.

Charlton, M., Barth, M. (1995). *Interdisziplinäre Rezeptionsforschung. Ein Literaturüberblick*. (Interdisciplinary reception research. A literature review.) Freiburg i. Br.: Universität Freiburg.

Charlton, M., Borcsa, M., Mayer, G., Haaf, B., Kleis, G. (1996). *Zugänge zur Mediengewalt. Untersuchungen zu individuellen Strategien der Rezeption von Gewaltdarstellungen im frühen Jugendalter*. (Access to media violence. Studies on adolescents' individual strategies in the reception of representations of violence.) Villingen-Schwenningen: Neckar-Verl. 1996. (Schriftenreihe der LfK. 7).

Charlton, M., Neumann, K. (1990). *Medienrezeption und Identitätsbildung. Kulturpsychologische und kultursoziologische Befunde zum Gebrauch von Massenmedien im Vorschulalter*. (Media reception and identity development. Cultural-psychological and cultural-sociological findings on the use of the mass media in preschool age.) Tübingen: Narr.

Holly, W., Püschel, U., Charlton, M., Ayass, R. Bachmair, B. *et al.* (1993). *Medienrezeption als Aneignung. Methoden und Perspektiven qualitativer Medienforschung*. (Media reception as an acquisition. Methods and perspectives of qualititave media research.) Opladen: Westdeutscher Verlag.

Jud-Krepper, H., Lattewitz, F. (1996). *Kinder und Medien. Praxisheft zur Sendereihe*. (Children and the media. Practical supplement to the broadcasting series.) Baden-Baden: SWF.

Lukesch, H., Kischkel, K.-H., Amann, A., Birner, S., Hirte, M. *et al.* (1989). *Jugendmedienstudie. Verbreitung, Nutzung und ausgewählte Wirkungen von Massenmedien bei Kindern und Jugendlichen.* (Youth media study. Propagation, use and selected effects of mass media on children and young people.) Regensburg: Roderer.

Milavsky, J.R., Kessler, R., Stipp, H., Rubens, W. S. (1982). *Television and aggression.* Results of a panel study. New York: Academic Press

Ohler, P. (1994). *Kognitive Filmpsychologie. Verarbeitung und mentale Repräsentation narrativer Filme.* (Cognitive film psychology. Propagation and mental representation of narrative films.) Münster: MAKS.

Petermann, F., Petermann, U. (1980). EAS – *Erfassungsbogen für aggressive Verhalten in konkreten Situationen.* (EAS – statistical questionnaire on aggressive behaviour in concrete situations.) Braunschweig: Westermann.

## Notes

1   The German version of this article appeared in *TelevIZIon* 8/1995/2, pp. 36-39.

2   For a general review see Charlton and Barth, 1995; Ohler, 1994.

3   Cf. Holly and Püschel *et al.*, 1993; Keppler, 1994.

4   This study was sponsored by the *Landesanstalt für Kommunikation* in Baden-Württemberg. The results have been published in an extensive research report (Charlton M. *et al.* 1996). Examples of media pedagogical application can be found in the television series *Kinder und Medien* broadcast by Südwestfunk in spring 1996 or in the corresponding textbook (Jud-Krepper, H. and Lattewitz, F., 1996).

5   Cf. Charlton and Neumann, 1990.

6   In order to include possible gender-dependent effects related to the propensity towards violence two aggression questionnaires were used. To allow a better comparison of the two studies, one was a questionnaire used by Lukesch et. al. (1989) in the 'Jugendmedienstudie' (youth media study), primarily geared to boys' pranks, however, and the other was a section from a genuinely psychological questionnaire designed to register aggressive behaviour, available in two forms, one for girls and one for boys (Petermann and Petermann, 1980).

# Chaos and fun knock out *He-Man* [1]

## *Helga Theunert and Bernd Schorb*

Children see cartoons as their very own programme, as a 'children's programme'. As a 9-year-old put it: 'I like TELE 5 best because it has the most programmes for kids', and a 10-year-old girl adds: 'On Saturdays and Sundays I watch the telly when I get up, about eight. Then you can watch films for children.' Films and programmes for children – these are the cartoon series broadcast in the television programmes from early morning to early evening.

The young TV generation's opinion that cartoons are programmes for children is also corroborated by programme broadcasters. There is hardly any children's programme selection that does not include a cartoon series or use cartoon features, as in the case of *Sendung mit der Maus* (the programme with the mouse) on the ARD, a programme based not only on the animated cartoon: public television institutions generally do set great store in factual films, documentaries, information and useful knowledge in their children's programmes.

The private television companies' motto is usually 'cartoons non-stop'. RTLplus and SAT.1 do not even structure their cartoon series by means of presentation slots. In *Trick 7* on PRO 7 the two ravens just introduce the next cartoon. The children's programme *Bim Bam Bino* is in fact TELE 5's cartoon slot. The intermezzos by the mouse Bino basically just fill the gap until the next cartoon is shown. Children thus equate *Bim Bam Bino* with the cartoon series it features. At the outside children under the age of 10 find the mouse Bino funny, their interest aroused by Bino's chats with experts and by the tips on how to make things. Older kids' comments on the magazine sections, however, are critical: 'I find it boring, a bit stupid, when they chatter away with Bino', says a 10-year-old boy.

The private television companies generally put on a string of various cartoon series as their children's programme, and they are successful. The young television generation goes for the private channels, particularly TELE 5.[2] But RTLplus and PRO 7 are also high on their list, with the public television institutions trailing behind. Children love cartoons and cannot see enough of them – clearly a reason for these channel preferences, another being children's viewing times.

## Cartoon transmission times are children's peak viewing times

Most children watch television in the afternoon and in the early evening the whole week. The morning block also plays a very significant role for infants at pre-school age, which is only important for school kids at the weekend. Between two thirds and half of 4- to 10-year-old children watch television in the early morning at the weekend. Those above the age of 10, on the other hand, prefer the late-afternoon and evening programme throughout the week. The times when the majority of children sit in front of the TV set are also the peak time-slots for the cartoons, particularly on the private channels.

At peak viewing times the private channels in particular offer the kids a 'full supply' of cartoons. It is hardly surprising that children understand these offers to be 'their' programme. Not only does this programme tune into the children's preferences, the fixed time-slot for cartoons ties the kids to the private channels.

'I don't look at the TV mag. I don't want to read that much', an 8-year-old said. Like him, children rarely use a TV magazine to select a programme. They know the times of 'their' programmes by heart, they know exactly when the cartoons are shown on the various channels and usually which cartoon series to expect. If they do not know the broadcasting times most children zap through the channels. 'I simply zap around until I find something good', admitted a girl of 10.

In their search for 'good' programmes they usually stay tuned to familiar stories and heroes. The private channels, which offer the same cartoon series every day – sometimes several times – also cater for children's wishes in this respect. The fact that all the private channels have fixed time-slots for their cartoon programme, broadcasting daily the same series, corresponds to the children's reception structures. The process of fixing the children on the private channels is promoted by the regularity of the programmes offered and easy recognition of the content patterns and the main characters.

The public television institutions have tailed the field for some time now. Their time-slots for children's programmes lack this daily regularity, and frequently have to give way to other, supposedly more important programmes, for example live sports broadcasts – a phenomenon that quite rightly makes many kids angry. This programme policy overlooks the fact that children hinge their esteem for a channel on the way it handles 'their' programme and that the children of today are the adult viewers of tomorrow. A 12-year-old girl sums up her evaluation of the various television channels: 'The most wonderful films are on SAT.1, PRO 7, RTL and ZDF. And someone who has only got ARD, ZDF and BR can't watch the most wonderful films. That's really mean.'

## Children love exciting entertainment

The cartoon series that combine the three elements comedy, excitement and heroes are highly popular with kids. Fantasy and fiction worlds are also

expected, and a happy ending for the heroes they admire is a must. 'Everything that's very funny and very exciting and where there's a hero' – this answer from an 11-year-old boy is typical when children are asked what they like to watch on TV. The cartoon series offer all three elements:

- *Fun*
  It is funny when the talking baby Fantastic Max, equipped with nappies and a dummy in his teat bottle, flits through space and swaggers: 'Here comes fantastic Capt'n Poohy-Pants'. The chaotic Simpson Family, 'a close resemblance of the worse half of humanity', also has them in stitches. Teddy Monster – a cuddly toy as long as it is wearing hand-cuffs and a good-natured monster when released – is sure to give the kids a lot of fun because it 'is somebody who gets up to a lot of mischief and frightens people'. Then there is Biester, who wants to bring the Teddy Monster back into the monster kingdom and tries to hunt him down, only to be gloated at when 'Biester himself falls into the black hole'.

- *Excitement*
  The chase is of course also exciting, as are the evil sorcerer Gargamel's attempts to lure the Smurfs into his cauldron and to turn them into gold. It is even more thrilling when strong fighters are at large: the fight between good and evil guarantees action and excitement – whether the Star Sheriffs in *Saber Rider* with their futuristic weapons and 'cool patter' will thwart the Outriders' occupation attempts, whether He-Man will once again defeat Skeletor with his magic sword, or whether the Ghostbusters will again succeed in bagging some gruesome ghost.

- *Heroes*
  The protagonists in the cartoons are all heroes. The strong fighters intrepidly rescue others from danger, courageously fight against evil, unselfishly set about saving the world or other planets from doom. By means of magic, fantastic weapons and unflagging physical strength they maintain law and order. Astuteness, wit, and sophistication help those who cannot rely on physical strength and weapons to achieve their aim. They, too, overcome all obstacles and help others in distress – 'just the way heroes do'.

### Children take hardly any notice of violence in cartoon series

Providing the blend of comedy, action and heroes is right, the kids are not put out by the violence featured in many cartoons. Violence is a part of the stories and represents the action, especially in the case of a fight between good and bad. 'Action for me is when He-Man fights against Skeletor with his sword', explains a 10-year-old boy.

Acts of violence in cartoons never have any consequences. The animated figures can be struck by laser beams or blown up, they can fall from inconceivable altitudes, they can be steamrollered, but there are no visible traces of injury. 'Clean violence' is shown in cartoons, without any bruises, blood or death. The children's violence threshold – their

individual yardstick of what portrayals of violence they can stand and which ones disturb or make them anxious – is not crossed by these portrayals. A 9-year-old explains this. According to his understanding of violence everything that does not end in death is only 'half violence'. Thus he does not find his favourite cartoon, the *Ghostbusters*, particularly violent. The 'proton ray gun ... (used) to suck in the ghost ... only hurts a little bit, it only gets a shock, no more than that. Some electric current is also produced, but not the type to kill a person, no!'

There is always a legitimate reason for the acts of violence. The good guys are attacked by the bad guys and have to defend themselves, help others or fight back on behalf of a 'noble cause'. The children welcome these legitimisation models, which permit them to unreservedly enjoy their heroes and their actions, even when things get a little rough. An 8-year-old justifies his preference for the *Lone Ranger* with the argument that he 'always rescues people from the bad guys', and a 10-year-old describes the content of *He-Man* in a nutshell: 'He-Man is a good guy and Skeletor is a bad guy and he and his gang take care of Skeletor.'

An 11-year-old, who only tolerates the use of violence in defence, explains this with the example of the old war-horse Strong Smurf: 'Actually, he's a nice guy ... he's got muscles, he's strong, he's only bad to Gargamel, who always wants to eat Smurfs. He doesn't attack any other people, but defends all of those in the village. One for all.'

Due to the fictional context of the cartoons and the legitimate portrayal of acts of violence without any consequences children hardly notice the violence shown. The portrayals of violence are not taken seriously and are pushed into the background by their fascination with the heroes and their actions. The situation changes, however, when the acts of violence get out of control and represent the only contents as in the case of some fighting series, and when the other elements, particularly comedy, are neglected. Then follows a parting of the ways, with many children rejecting cartoon series that focus solely on violent clashes.

**Not all kids like the same**
When kids are asked which cartoon series they like and which they do not, they state the preferences they have just at that moment, thinking of current shows. Figures 1 and 2 provide a snapshot of 7- to 14-year-old children's preferences and dislikes, accumulating 883 answers on the kids' favourite series, and 806 on their least liked series; other titles were named less than 15 and 18 times, respectively.[3]

The two rankings clearly illustrate that children have different opinions. Some cartoon series such as the *Smurfs* or *Saber Rider* are very popular with many children, but are rejected by others. Mainly two elements influence children in forming a positive or negative opinion of cartoon series: the stories, and even more strongly the figures featuring in these stories.

Figure 1: **Ranking of favourite cartoon series**

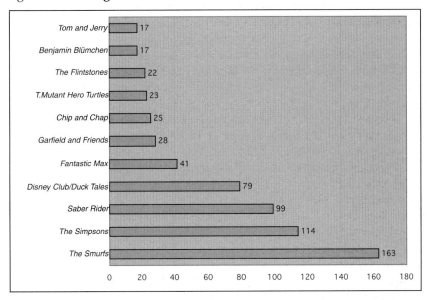

Figure 2: **Ranking of disliked cartoon series**

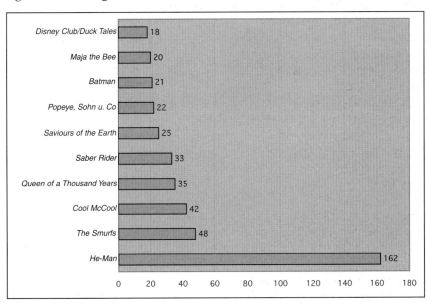

reject depends on their age and their sex. Roughly speaking, girls and boys can be said to have different preferences and dislikes, but girls and boys in the same age group do have similar preferences and dislikes. By means of

a few examples of series and figure types we would like to explain the criteria the children's preferences and dislikes are based on.

**Children seek in cartoons a rapport with their everyday life**
The most popular cartoons for all children are those that tell stories about the 'everyday ups and downs' of families or larger communities. The main subject in these series is everyday co-existence with all its blessings and curses, as organised by their members or determined by external events. One series of this type is the *Smurfs*, whose large village community always provides sufficient material for variety and disputes or finds itself in a turmoil caused by its adversary Gargamel. Another example of this type is *The Simpsons*, with their chaotic family life, in which every member only pursues his or her own interests. *Garfield*, the greedy cat, and *The Flintstones* come under this category.

Figure 3: **Evaluation of 'family' series: by girls and boys**
(659 answers on popular, 615 on unpopular types).

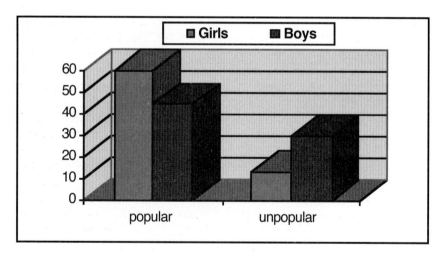

This type of series is particularly popular with the girls whereas a large number of boys raise objections. If the criterion of the children's age is also considered, it is revealed that particularly older girls are fans of this kind of series. But the boys also become increasingly enthusiastic about this type of story when they grow older. The growing rejection of this type particularly by older children has something to do with the individual cartoons.

The two most popular cartoon series of this type are *The Simpsons* and *The Smurfs*. Older children like the former and reject the latter, whereas the 7- to 10-year-olds are the main fans of the Smurfs. They love their Smurfs because they are 'so sweet' and are 'always cheerful' and because 'each of them has its own special ways', like the Baking Smurf, for example, 'who

always wants to eat cake'. They are happy to see 'the Smurfs pulling the wool over Gargamel's eyes', 'who is always so stupid', and find the 'catching and rescuing of the Smurfs' particularly exciting. The simple, straightforward stories, the proximity to fabulous and fairy-tale creatures, and probably the fact that the 'Smurfs' can be seen several times a day seem to be particularly appealing for young kids.

Older children reject *The Smurfs* for these very reasons, describing them as 'boring' and as a 'real baby series'. They prefer the chaotic family life of *The Simpsons* all the more. Evidently, the children recognise themselves in this series, as is borne out by the following extracts: a 12-year-old judges the series to be 'a little exaggerated' but 'some scenes are like real life', and a boy of the same age particularly appreciates the fact that 'all problems are overcome with some gag or other'. A 14-year-old finds it absolutely fantastic 'that the parents are always shown as idiots'. The proximity to their own everyday life, the witty dialogues and the somewhat more demanding complexities in the plot clearly thrill older children.

On the whole cartoons that focus on everyday matters in the broadest sense and that are in the form of amusing and exciting stories are particularly popular with the children, the girls having an even stronger preference for these stories than the boys. The two examples of *The Smurfs* and *The Simpsons* clearly illustrate that children take an interest in different cartoon series of a certain type in accordance with their age and corresponding cognitive development. The older the children, the higher their demands on the contents of the series. Only the younger ones are content with simple stories.

Children submit a devastating appraisal of cartoons centered round 'justified fights' between good and evil, regularly resolved in favour of the heroic representatives of the good side. The heroes of these series possess superhuman physical strength, occasionally magic powers and are usually supported by extremely modern weapon and space technology. This type of series includes all the cartoons in which heroic fighters keep terrestrial and extra-terrestrial assailants in check, either alone – as in *He-Man, Flash Gordon, Batman* or the *Königin der 1000 Jahre* (Queen of a Thousand Years), or in groups – as in the *Star Sheriffs,* the *Retter der Erde* (Rescuer of the Earth), the *Ghostbusters* or the *Teenage Mutant Hero Turtles.*

How few children like series of this type is illustrated by Figure 4, which represents 659 answers on popular, 615 on unpopular types. Almost all the children share an aversion towards cartoon series of this type; in all age groups they express more rejection than acceptance. The girls in particular show a categorical aversion with over two-thirds evaluating these series as bad. The only real fans of cartoons of this type are boys aged 7 to 10, although over half of them also award bad marks.

Many cartoons receive a whole range of appraisals. By far the most unpopular series on justified fights is *He-Man*, awarded bad marks by all the children.[4] A popular fighting series, on the other hand, is *'Saber Rider'*, loved most by 7- to 10-year-old boys.

Figure 4: **Evaluation of 'family' series**
(659 answers on popular, 615 on unpopular types)

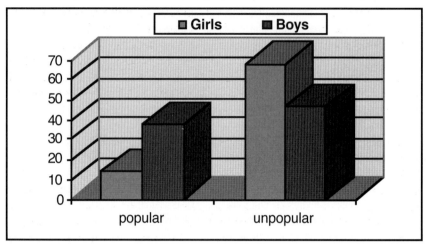

Young boys enjoy battles in outer space, straight with no trimmings, as featured in *Saber Rider*, mainly because of the technical gadgets and tricks: there is 'a robot capable of completely changing its appearance, super rays and warrior robots' and much, much more in this direction. A 7-year-old particularly likes the Star Sheriffs 'protecting other people from the Outriders' and an 11-year-old thinks it is therefore alright 'that the humans want to despatch the Outriders into the Phantom Zone and to free their planet of these creatures'.

There is plenty of humour, too, says a 9-year-old, for even when threatened by the most perilous situations, the Star Sheriffs always have 'the right phrases up their sleeves'. The simple structure of the plot, the fantastic technical sophistication, the fast and astute action, the cool gestures of the heroes – young boys find this combination in *Saber Rider* exciting and enjoyable. But they are not particularly thrilled by other series of this type.

No series triggers as much revulsion as *He-Man*. This heroic muscle-man's eternal struggle with Skeletor, the fundamentally evil skeleton, 'is simply too boring', says a 7-year-old who objects to the 'stupid fighting'. Children do not agree with the constant acts of violence in this series: 'Utter fantasy, brutal, too much war and weapons that don't exist', explains a 12-year-old. A 13-year-old proclaims quite categorically: 'Always the same rubbish, the others are killed with machines.' The fact that at the end 'the moralising starts' is simply 'gross', according to one 13-year-old.

Apart from the fact that children can simply have enough of the long runner *He-Man*, their criticism is mainly levelled at the primitive structure of the plot, at the stereotype of the eternally victorious fighter and at the persistently brutal fighting scenes. Cartoons based on a plain good-against-bad

pattern, in which heroes with bulging muscles always emerge victorious from their battles against evil, are extremely unpopular with children. If they have any fans at all, they are only young boys, but they, too, prefer series featuring not only fighting but some humour at least and heroes with a few human traits. But most children turn down flat the hero stereotype à la *He-Man*.

For children the stories are more important than the characters in their appraisal of cartoons, ie acceptance or rejection. It is their personal qualities and their behaviour that either unleash the children's criticism or spark their fascination. Their appraisals of cartoon protagonists very clearly reflect their evaluations of cartoon series.

### Children prefer witty and sly figures to the fighters and their unfortunate adversaries.

He-Man, the protagonist in the series with the same name, has fired his last shot with the kids. Irrespective of age and gender they reject this blond hero, even more so than his adversary Skeletor. The kids have no use for such constantly victorious, perfect and violent muscle men, as illustrated by the following statements: 'The guy's amazingly arrogant and conceited, he thinks he's absolutely great' and 'There's nothing he can't do, he's stupid' according to two girls aged 12 and 13. Even a 9-year-old boy cannot stand 'his thinking he's so fantastic and his being so violent' and 'He-Man's constant winning ... gets on my nerves' says a 13-year-old girl.

The distinguishing feature of the 'supreme rescuers', of whom He-Man is one, is that they constantly and victoriously put evil in its place by means of physical strength, magic and futuristic weapons. They are the most unpopular for all children. If children are to like them at all, then they must have more to offer than just winning and must feature somewhat more sophisticated character traits, like Fireball in the *Saber Rider* series. He is the fourth most popular figure for the kids.

Fireball is the youngest of the Star Sheriffs and the prototype of a young daredevil, impulsive and dynamic, with tousled hair. He's a glib talker and loves daring adventures, fast cars and his female colleague April a little. He is not at the top of the Star Sheriffs hierarchy but is respected by his colleagues for his reliability.

Apart from the fact that Fireball 'can fight well' and 'helps others', the kids appreciate this figure's astuteness and his 'witty patter'. The girls like him because he is 'good-looking'. The boys, on the other hand, are taken with his car and enjoy the 'Fireball car races'. Fireball's popularity with the kids is probably due to the mixture of helpfulness, appearance and boldness he represents.

The 'constant losers' featured as anti-figures, particularly in the fighting series, are not as unpopular as the 'supreme rescuers', but are accepted by most children as anti-figures. The 'constant losers' assume the appearance of small, sheepish characters at the end of each episode, despite their having tried so hard and having been so successful in

between. Examples of their genre are Gargamel, who despite his magic tricks and his cunning never succeeds in catching a Smurf, and Skeletor, who can be as mean and brutal as he wants but never has a chance against He-Man. Skeletor's constant brutality is also a reason why the kids so categorically reject the *He-Man* series.

The little sly devils know what's what, they always have a trick or two up their sleeves, never lose command of the situation and distribute their little pearls of wisdom to all and sundry. Papa Smurf, Biene Maja (Maya the Bee) and Mickey Mouse are examples of this genre.

These types of figures are primarily loved by the under-10s. They clearly enjoy the idea of having someone in the cartoons, like in real life, who knows what to do. One 7-year-old said that he liked Papa Smurf because he 'always knows exactly what he has to do when the Smurfs are in danger'. Older children, however, reject him as being a 'know-all'.

### The children's favourite figures are like themselves: lovable and a little bit chaotic

The children's real favourites are the 'lovable chaotic figures'. They are amiable and cause trouble and confusion wherever they go. They never really mean to be naughty, and there is always a happy end. 'Lovable chaotic figures' mainly feature in series of the 'everyday ups and downs' genre, as in the case of Bart Simpson, who ruins the nerves of those around him with his inexhaustible repertoire of inspirations. Whereas Bart Simpson is the older kids' favourite, the 7- to 10-year-olds have another favourite in this genre: Fantastic Max.

Fantastic Max is a baby with a red punk hairstyle and thick nappies, who can speak, think clearly and act independently. His family knows nothing about it because he experiences his adventures at night-time. Accompanied by A. B. Sitter and Fidibus he races through outer space with his teat bottle. He and his friends often get into dangerous situations. But Max solves all his problems with his astuteness and by convincing his adversaries – without violence.

Young children are particularly thrilled by Fantastic Max being such an extraordinary baby, who 'can speak', has a 'punk hairstyle' and 'flies with his bottle through space to other planets and meets other creatures there'. What is more, he knows 'such good tricks and cool things to say'. Two 10-year-olds put it in a nutshell: 'Max is funny' and he has 'thrills and excitement'. Fantastic Max combines the features of a lovable baby with the abilities of a crafty prankster, a mixture that kids would probably like to have as their own personal features.

Fantastic Max for young kids is what Bart Simpson represents for the older ones. Bart Simpson is 'like reality' for kids. What goes on in his home is 'just like real life'; one 12-year-old particularly likes viewing 'the problems of a naughty boy at school'. Another thing is that Bart 'does not put up with everything his Dad says and contradicts'; according to an 11-

year-old and a 13-year-old, he is 'no coward'. His 'witty patter', his 'great ideas' and 'that he always does what he wants' clinch the kids' excitement about this character.

Bart Simpson is a lousy pupil that his teachers unsuccessfully try to knock some discipline into. His flops at school don't bother him that much: 'I'm a failure, but I'm proud of it.' Bart constantly has ideas, which keep those around him on tenterhooks. Pranks and bold ventures are all part of the game. Bart refuses to get bored, and defiantly goes his own way. But he is never mean or bad, just a little selfish and rash – basically a nice guy.

Crafty Bart Simpson, as indicated in this description, has patterns of behaviour that the kids can grasp. This rough-hewn young lad, just like themselves, creates a lot of confusion in adults' lives, but never means any harm. The kids' wish that their own pranks come off just as successfully and are just as funny as Bart's partly explains this character's popularity.

The popularity of these 'lovable chaotic figures' with the kids highlights the fact that in cartoons they seek a close reference to their everyday situation. Evidently, children like not only stories from everyday life but also figures who have things in common with themselves, who play tricks that they would like to play themselves, who sometimes come a cropper but who get off lightly, who love and are loved by their environment. These 'lovable chaotic figures' are closest to the children's world, down to the level of their language. The older the children are, the more they turn to these characters.

Children, as is revealed by their preferences for stories about the 'ups and downs' of everyday life, very well know that they need shrewdness and wit rather than simple-mindedness and strength. Only young kids are content with simply structured stories and simple figure stereotypes. When they grow older, they become more demanding and turn to more sophisticated stories and figures with character, offering them close contact with their own reality and with themselves. The material battles in space, with their straightforward good-and-bad cliché, their factory-made but perfect winner types and their action only based on acts of violence, have hardly any fans among young viewers. The few young boys who generally prefer fighting scenes turn to those in which the heroes are not 100 per cent perfect and who spice their fights with at least a few witty comments.

Broadcasters do not seem to be aware of this. They continue to put their money on series in which insuperable heroes engage in extensive material battles in space or elsewhere with absurd technology. This genre appears in most of the various types of cartoon series offered. It is constantly maintained that heroic, victorious fighters are part and parcel of children's dream-worlds and must therefore not be denied them, but way over half of the children contradict this justification. It only remains to pass on a 9-year-old girl's message to the programme planners responsible, which arrived at the wrong address when sent to us:

Dear Tem. Please get rid off He-man, Mister T, Superman and Spyderman. They're only rubbish and full of fighting and I don't like fighting!

## References

Schorb, B., Petersen, D., Swoboda, W.H., Theunert, H., and Best, P. (1992). *Wenig Lust auf starke Kämpfer. Zeichentrickserien und Kinder.* (Little enthusiam for strong fighters. Cartoon series and children.) Institut Jugend Film Fernsehen; Bayerische Landeszentrale für neue Medien (eds). Munich: R.Fischer.

Theunert, H., Pescher, R., Best, P., Schorb, B. *et al.* (1992). *Zwischen Vergnügen und Angst – Fernsehen im Alltag von Kindern.* (Between fun and fear – television in children's everyday life.) Hamburgische Anstalt für neue Medien (ed). Berlin: Vistas.

Theunert, H. and Schorb, B. (eds) (1996).*Begleiter der Kindheit. Zeichentrick und ihre Rezeption durch Kinder.* (Companions of childhood. Cartoons and their reception by children.) Munich: R. Fischer. (BLM-Schriftenreihe Vol. 37)

## Notes

1 The following contribution is based on two projects: in the survey *Kinder und Cartoons* (children and cartoons) at the end of 1991 over 1,000 children aged between 4 and 14 were interviewed on their consumption of cartoons, their preferences and dislikes. The following refers mainly to the results on the 7 to 14 age group (cf.: Schorb *et al.* 1992). In autumn 1990 100 8- to 13-year-old children from Hamburg were examined on the perception and processing of television contents. Game methods and individual case studies were used in addition to the questionnaire (cf.: Theunert *et al.* 1992). The German version of this article appeared in *TelevIZIon* 5/1992/1, pp. 6-12.

2 *Tele 5* ceased to exist in 1992.

3 These rankings come from the survey carried out in 1991. In 1990 the *Smurfs* were at the top of the list of favourites. *Fantastic Max* came second. In 1990 *He-Man* still occupied position three in the favourite series chart.

4 This result comes from the survey carried out in 1991. In 1990 *He-Man* was still relatively often named as the favourite cartoon. But the positive statements originated mainly from young boys; the opinion of the girls was negative in almost every case.

# 6: Adolescents and their Media Worlds

# Youth media and youth scenes:
## Results of a recent survey[1]

*Michael Schmidbauer and Paul Löhr*

## 1. Life's prospects

When young people are asked about their life's prospects they give an answer in which views typical of the adult world play a central part. As can be seen in Table 1a, what the young people hope for are: fun and (financial) success at work, a family of their own, which, however, they must be able to reconcile with their work, especially in the case of girls and young women; and sufficient free time to make life easier and provide relaxation. The fact that male adolescents' interest in work is bound up with hope of financial advantages is not surprising. Nor is the fact that an orientation of this kind is to be found far less frequently among female adolescents. Instead, it is here the thought of a job 'in which I can be of help to others' that clearly stands out. The male adolescents are apparently not very interested in an occupation that focuses on social and charitable work. They are strongly interested – no doubt stimulated by the current economic and socio-political situation (unemployment, cuts in benefits) – in success at work, earnings to match it and enough leisure-time to make life easier. That greater importance attaches to the latter and also the relation to the family, above all among the 12- to 13-year-olds, can probably be explained by the distance they (still) have from the 'serious side of life' and by being tied down into family constellations.

The break-down into specific educational standards carried out in the table shows that all the answers are all the more pronounced, the lower the adolescents' educational level. Here it is particularly noticeable that the pupils at the secondary modern school are, on the one hand, quite emphatically aiming for success at work and the financial gains this brings and, on the other, are very family-orientated and interested in jobs 'in which I can be of help to others'.

Here it must be borne in mind that respondents with a lower level of school education frequently tend towards an extreme assessment. For adolescents at grammar school these subjects, rated highly by the youngsters at the secondary modern schools, are apparently of less importance – possibly because the economic constraints in the families

they come from are less pronounced, hope of common family interests plays less of a role, while competitive thinking an all the greater one.

Table 1a: **Life's prospects**
('fully applies'; selection: ratings 1-7, answers in %)

| Answers | All | m | f | 12-13 | 14-15 | 16-17 | 18-19 |
|---|---|---|---|---|---|---|---|
| Fun at my job | 75.4 | 72.0 | 77.9 | 71.1 | 76.1 | 77.5 | 77.4 |
| My own family | 60.8 | 60.3 | 61.4 | 63.6 | 58.4 | 59.2 | 63.4 |
| Success at work | 47.2 | 52.9 | 41.3 | 48.6 | 50.5 | 43.8 | 44.1 |
| Fun and leisure | 44.1 | 49.0 | 39.0 | 56.1 | 44.3 | 36.3 | 36.6 |
| Earn a lot of money | 40.4 | 45.1 | 35.5 | 40.4 | 43.1 | 39.3 | 37.1 |
| Family more important than my work | 39.0 | 43.4 | 34.4 | 49.6 | 35.5 | 34.8 | 34.9 |
| A job in which I can be of help to others | 32.3 | 21.7 | 43.2 | 38.6 | 28.4 | 31.1 | 31.2 |
| Sample (abs) | 1060 | 539 | 521 | 280 | 327 | 267 | 186 |

The result outlined above can be described in more precise terms if it is first related to the criterion 'school education' (see Table 1b).

Table 1b: **Leisure /media activities preferred**
('daily/almost daily', '2-3 times a week'; Selection: ratings 1-7, answers in %)

| Answers | Secondary modern school[2] | Secondary school | Grammar school | Em- ployed | At school | Unem- ployed | West German | East German |
|---|---|---|---|---|---|---|---|---|
| Fun at my job | 82.0 | 77.2 | 72.7 | 83.0 | 75.4 | 73.9 | 75.6 | 74.7 |
| My own family | 70.7 | 63.7 | 56.8 | 75.5 | 60.2 | 47.8 | 60.8 | 61.0 |
| Success at work | 63.9 | 51.8 | 40.4 | 45.3 | 47.8 | 39.1 | 45.0 | 54.2 |
| Fun and leisure | 53.4 | 46.8 | 40.2 | 45.3 | 44.5 | 39.1 | 45.1 | 40.6 |
| Earn a lot of money | 57.1 | 44.2 | 34.1 | 45.3 | 39.7 | 52.2 | 39.2 | 44.2 |
| Family more important than my work | 52.6 | 41.4 | 34.3 | 35.8 | 39.1 | 39.1 | 42.7 | 26.9 |
| A job in which I can be of help to others | 44.4 | 35.5 | 27.4 | 43.4 | 32.1 | 34.8 | 30.9 | 36.5 |
| Sample (abs) | 133 | 355 | 572 | 53 | 934 | 23 | 811 | 249 |

If the adolescents of school age, those out of work and those in work are compared with one another, three points emerge:

- First, the values for the schoolboys and -girls agree quite closely with the results that apply to the whole group of respondents.
- Secondly, those in work attach particular importance to 'fun at work', an intact family life that, however, does not restrict their work, and social and charitable activities – the latter perhaps because they feel at work how important such services are.
- Thirdly, the unemployed adolescents make it clear that they are less interested in success at work and leisure than in acceptable earnings, without which starting up their own family, for example, is hardly possible.

That the east German adolescents express similar ideas to those of the unemployed young people cannot surprise us. For the pronounced job- and reward-orientation of the east German adolescents and the fear that a family life of their own and an extensive leisure life could stand in the way of this orientation can be easily explained by the fact that they are constantly and in an extreme way exposed to the problems of unemployment and an insecure future. It is noteworthy in this connection that the young east Germans are far more prepared than the west Germans to also get involved in working activities that put social service first and not their individual career.

In summary it can be inferred from the results dealt with so far: the overwhelming majority of the young people interviewed apparently seem to set store by a working and leisure-time existence, which strongly conforms to society and is bound by the prevailing rules, stimulated above all by fears of a work-related economic and political kind and by the rigorously expanding fixation on competition and money. That the young people do not sink or swim in their endeavours to achieve such an existence can be seen from their desire for fun and leisure. But it should be added that their interest in leisure ranks fairly far behind their wish for development and success at work. To this extent, the adolescents today – that means under the present economic and political circumstances – can be described as a 'leisure generation' only with some reservations.

## 2. Leisure-time and media activities and media equipment

Below, the adolescents' leisure behaviour and especially their media behaviour will be dealt with in more detail. In doing so it should always be borne in mind that this behaviour concerns only one dimension of the young people's life prospects. The leisure-time activities together with the work- and school-related ones constitute the main area of what shapes the course of a young person's day: thus, on the one hand, 98 per cent of the adolescents interviewed are occupied with school or work for more than two hours a day; on the other, however, 88 per cent of them devote themselves to over two hours of leisure activities a day. The latter are characterised by an intensive preoccupation with the media, especially with television, sound carriers and radio. Table 2a documents this first with regard to gender- and age-specific considerations.

Heading the list of favourite leisure-time pursuits – and well ahead of the other activities – is the occupation with TV programmes. That applies – if we take Table 2b as well – to all the groups of adolescents presented here to an almost identical extent. Much the same applies to listening to records, cassettes and CDs, although here the girls and older adolescents are involved somewhat more intensively. There are noticeable differences in the case of listening to the radio, above all between female and male as well as between the older and the younger adolescents, and in the case of reading newspapers and magazines, which is found more frequently among the older and less among the younger respondents.

317

Table 2a: **Leisure /media activities preferred**
('daily/almost daily', '2-3 times a week'; selection: ratings 1-7, answers in %)

| Answers | All | M | F | 12-13 | 14-15 | 16-17 | 18-19 |
|---|---|---|---|---|---|---|---|
| Watching television | 97.1 | 97.0 | 97.1 | 96.8 | 98.2 | 96.6 | 96.2 |
| Listening to records/ cassettes/CDs | 89.6 | 87.8 | 91.6 | 84.6 | 89.3 | 94.4 | 90.9 |
| Being together with friends | 85.7 | 85.7 | 85.6 | 82.1 | 85.6 | 88.0 | 87.6 |
| Listening to the radio | 80.7 | 77.9 | 83.5 | 77.5 | 77.4 | 83.9 | 86.6 |
| Doing sport | 71.4 | 77.0 | 65.6 | 80.4 | 72.5 | 71.5 | 55.9 |
| Doing nothing, dreaming | 68.3 | 62.9 | 73.9 | 69.6 | 69.7 | 63.3 | 71.0 |
| Reading newspapers/ magazines | 62.8 | 63.8 | 61.8 | 53.2 | 62.4 | 66.3 | 73.1 |
| [11th rating: using the computer] | 36.0 | 51.4 | 20,2 | 38,6 | 37.6 | 34.1 | 32.3 |
| Sample (abs) | 1060 | 539 | 521 | 280 | 327 | 267 | 186 |

The fact, however, that the boys, especially those who are older, go in for considerably more sport than the girls, who are well ahead when it comes to 'dreaming', though, is not surprising in view of the traditional idea of masculinity and femininity that still exists. The differing attractiveness of dealing with computers can probably be explained in a similar way – although here it has to be taken into consideration that there are possibly more computer-orientated girls to be found among the younger than the older ones.

Table 2b: **Leisure /media activities preferred**
('daily/almost daily', '2-3 times a week'; selection: ratings 1-7, answers in %)

| Answers | Secondary modern | Secondary school | Grammar school | Em- ployed | At school | Unem- ployed | West German | East German |
|---|---|---|---|---|---|---|---|---|
| Watching television | 97.0 | 96.6 | 97.4 | 96.2 | 97.3 | 95.7 | 96.9 | 97.6 |
| Listening to records /cassettes/CDs | 92.5 | 89.0 | 89.3 | 96.2 | 89.0 | 100.0 | 89.0 | 91.6 |
| Being together with friends | 86.5 | 87.9 | 84.1 | 77.4 | 86.0 | 91.3 | 85.8 | 85.1 |
| Listening to the radio | 78.2 | 82.3 | 80.2 | 86.8 | 79.8 | 91.3 | 79.2 | 85.9 |
| Doing sport | 64.7 | 69.9 | 74.0 | 43.4 | 74.4 | 52.2 | 71.3 | 71.9 |
| Doing nothing, dreaming | 63.2 | 67.6 | 69.9 | 64.2 | 67.9 | 69.6 | 67.8 | 69.9 |
| Reading newspapers/ magazines | 53.4 | 61.4 | 65.9 | 58.5 | 62.1 | 91.3 | 63.1 | 61.8 |
| [11th rating: using the computer] | 33.1 | 32.1 | 39.2 | 30.2 | 36.5 | 39.1 | 34.4 | 41.4 |
| Sample (abs) | 133 | 355 | 572 | 53 | 934 | 23 | 811 | 249 |

From Table 2b it can first be seen that those at secondary modern school develop a strong relationship to sound-carrier products, while their interest in newspapers and magazines is less pronounced. Their involvement in computer-related activities remains behind that of the grammar school children as well.

The tendency to take part in sports is also developed below average in the case of the secondary modern school children, although they also tend towards 'doing nothing' and 'dreaming' only to a limited extent. At least they do so to a much lesser degree than the grammar school children, amongst whom sporting activities are nevertheless represented above average. As evidence: 52 per cent of the young people interviewed belong to a sports club or fitness club – of these to an above-average extent the males (45 per cent), the 12- to 13-year-olds (61.8 per cent), the grammar school pupils (53.6 per cent) and the West German adolescents (56.4 per cent). On the other hand, 6 per cent of all the respondents are members of a socially – or environmentally-orientated society.

It should also be noted that the working adolescents devote themselves to sound carrier products and radio programmes intensively and young unemployed people very intensively, but they are not so keen on sporting activities. It is also noticeable to what extent the unemployed adolescents seek conversations with friends of both sexes and guidance in newspapers and magazines – quite unlike the working adolescents, who remain far below the average in their communicative activities and reading newspapers and magazines. What is more, there appear to be very many computer freaks among the unemployed adolescents. The same applies to the young east Germans, who otherwise differ from the West Germans only by their greater use of the radio.

It is interesting that the adolescents, although sporting activities come only fifth in their leisure-time pursuits, appreciate those among the current youth-scene groups who either do sport themselves (rollerbladers, skaters) or feel close to sport (football fans). In Table 3a first the gender- and age-specific preferences are put together.

Table 3a: **Assessment of the scene groups**
('think it's good'; Selection: ratings 1-6; answers in %)

| Answers | All | M | F | 12-13 | 14-15 | 16-17 | 18-19 |
|---|---|---|---|---|---|---|---|
| Rollerbladers | 62.0 | 55.7 | 68.5 | 75.0 | 64.5 | 58.4 | 43.0 |
| Skaters | 54.0 | 49.0 | 59.1 | 60.7 | 63.9 | 50.6 | 31.2 |
| Football fans | 50.7 | 58.1 | 43.0 | 63.6 | 53.8 | 47.3 | 30.6 |
| Rappers (rap/hiphop) | 47.6 | 46.2 | 49.1 | 45.4 | 51.1 | 50.9 | 40.3 |
| Ravers | 34.2 | 34.3 | 34.0 | 29.3 | 33.9 | 41.2 | 31.7 |
| Computer-Freaks | 33.8 | 45.6 | 21.3 | 42.9 | 33.0 | 30.0 | 26.9 |
| Sample (abs.) | 1060 | 539 | 521 | 280 | 327 | 267 | 186 |

It is not difficult to recognise that as far as rollerbladers and skaters are concerned it is especially the female and the younger adolescents who stand out – the football fans are preferred mainly by the male and also by the younger adolescents. On the next ranks of the scale the ravers and rappers are to be found, who are quite obviously favoured by the (14- to 17-year-old) girls and boys in equal measure.

Table 3b: **Assessment of the scene groups**
('think it's good'; Selection: ratings 1-6; answers in %)

| Answers | Secondary modern | Secondary school | Grammar school | Em- ployed | At school | Unem- ployed | West German | East German |
|---|---|---|---|---|---|---|---|---|
| Rollerbladers | 64.7 | 66.2 | 58.7 | 47.2 | 64.0 | 47.8 | 61.0 | 65.1 |
| Skaters | 57.9 | 57.5 | 50.9 | 28.3 | 57.0 | 34.8 | 53.6 | 55.0 |
| Football fans | 60.9 | 60.0 | 42.5 | 50.9 | 52.2 | 30.4 | 49.9 | 53.0 |
| Rappers (Rap/hip hop) | 54.9 | 45.6 | 47.2 | 34.0 | 49.3 | 43.5 | 47.1 | 49.4 |
| Ravers | 40.6 | 41.4 | 28.1 | 37.7 | 33.8 | 43.5 | 32.7 | 39.0 |
| Computer-Freaks | 30.8 | 34.6 | 33.9 | 20.8 | 35.2 | 21.7 | 32.3 | 38.6 |
| Sample (abs.) | 133 | 355 | 572 | 53 | 934 | 23 | 811 | 249 |

In assessing the computer freaks, the greatest differences emerge between male and female as well as younger and older adolescents. It is noteworthy that the 18- to 19-year-olds apparently feel too 'old' to have much affinity with the computer freaks. Altogether the 18- to 19-year-olds, not only here but also in relation to all the scene groups, reach a – no doubt also 'age-dependent' – below average level as well. The findings in Table 3b make it clear that the grammar school pupils are not very keen on what the secondary modern pupils like: neither rollerbladers and skaters nor football fans and ravers.

The working and unemployed adolescents dissociate themselves even more clearly from the rollerbladers, skaters and football fans – and from the computer freaks as well. The ravers, on the other hand, are accepted to an above average extent by the unemployed adolescents. If the young people in west Germany are compared with those in the east, it emerges that the two groups only differ with regard to ravers and computer freaks: to both of them the east German adolescents seem to be closer than the west Germans of the same age.

Another finding is also important which is not included in Tables 3a and 3b because of its 'unimportance': the skinheads do not seem to stand much of a chance with the adolescents, only 2.2 per cent of them finding this grouping 'good'; however, the secondary modern school pupils with 3.8 per cent and the east Germans with 4.4 per cent do not deviate appreciably from this mean value.

Returning to the fact that handling the media plays a decisive part in the young people's leisure-time pursuits, the obvious thing to do is to ask about the media equipment they possess. The findings are brought together in Tables 4a and 4b. They reveal that the households in which young people live are very well fitted out with such equipment.

Regarding sex and age most results are scattered only slightly around the average figure. Exceptions are the female adolescents, for whom record players and CD players are more and PCs less important than for the male adolescents; the 16- to 17-year-olds, who are very intensively preoccupied with the CD player; and the 18- to 19-year-olds, for whom the record player seems to be something they still enjoying using.

Table 4a: **Media technical equipment**
(available 'in the household'; Selection: ratings 1 – 7; answers in %)

| Answers | All | M | F | 12-13 | 14-15 | 16-17 | 18-19 |
|---|---|---|---|---|---|---|---|
| Radio | 98.5 | 97.8 | 99.2 | 98.9 | 97.2 | 99.6 | 98.4 |
| Television | 98.2 | 98.0 | 98.5 | 98.2 | 97.6 | 98.9 | 98.4 |
| Cassette recorder | 94.4 | 93.7 | 95.2 | 95.7 | 93.3 | 95.5 | 93.0 |
| CD player | 88.5 | 86.1 | 91.0 | 88.6 | 86.5 | 92.1 | 86.6 |
| Video recorder | 83.6 | 83.3 | 84.3 | 81.8 | 86.5 | 85.0 | 80.1 |
| Record player | 67.2 | 64.0 | 70.4 | 67.1 | 65.1 | 66.3 | 72.0 |
| PC | 54.2 | 57.3 | 51.1 | 53.6 | 54.7 | 53.2 | 55.9 |
| Sample (abs.) | 1060 | 539 | 521 | 280 | 327 | 267 | 186 |

Table 4b: **Media technical equipment**
(available 'in the household'; selection: ratings 1-7; answers in %)

| Answers | Secondary modern | Secondary school | Grammar school | Em- ployed | At school | Unem- ployed | West German | East German |
|---|---|---|---|---|---|---|---|---|
| Radio | 98.5 | 97.7 | 99.0 | 100.0 | 98.5 | 95.7 | 98.6 | 98.0 |
| Television | 99.2 | 97.7 | 98.3 | 98.1 | 98.2 | 95.7 | 98.2 | 98.4 |
| Cassette recorder | 91.7 | 94.1 | 95.3 | 96.2 | 94.8 | 82.6 | 95.3 | 91.6 |
| CD player | 82.7 | 87.3 | 90.6 | 92.5 | 88.9 | 56.5 | 89.4 | 85.5 |
| Video recorder | 85.7 | 82.8 | 83.9 | 79.2 | 84.5 | 78.3 | 84.1 | 82.7 |
| Record player | 49.6 | 65.6 | 72.2 | 71.7 | 66.8 | 73.9 | 69.4 | 59.8 |
| PC | 30.8 | 49.3 | 62.8 | 37.7 | 55.9 | 26.1 | 55.7 | 49.4 |
| Sample (abs.) | 133 | 355 | 572 | 53 | 934 | 23 | 811 | 249 |

If the criterion of school education is brought into the equation, there are, it is true, no appreciable differences between secondary modern and grammar school pupils for the 'radio', 'television' and 'cassette recorder', but certainly for CD players, record players and PCs. The latter are – see Table 4b – especially to be found in households in which young people live who attend secondary and grammar schools.

Three things attract attention:

- The figures for the adolescents of school age come very close to those that apply to the respondents as a whole.
- Regarding the ownership of radio and television sets, there are no striking differences between the education-related, activity-related and geography-specific groupings.
- The only exception is the unemployed adolescents, who in the case of television sets and radios lag somewhat behind and of cassette and video recorders quite considerably.

That the young working people are also relatively poorly provided with PCs is likely to have reasons which have little in common with those of the young unemployed people. Instead this can be explained by the fact that many adolescents who work use a PC for long periods at their place of employment and therefore do without a home PC. (The study shows that 22.6 per cent of the young people who work use a PC in the workplace.)

Apart from that, Table 4b shows that having a cassette recorder, CD player, record player and PC clearly correlates with education-specific factors. There are far fewer cassette recorders, CD players and record players in the households of secondary modern school children – though video recorders are an exception – than in those of grammar school pupils. A similar result emerges if the young west and east Germans are compared. The latter lag somewhat behind with cassette recorders and CD players and considerably with record players and PCs.

## 3. The use of television

Judging by the time the adolescents spend in front of the television screen each week and day they can quite definitely be described as very interested in television. Taking the weekly use time the male and the 14- to 15-year-olds clearly rank highest (see Table 5a).

If the criterion of daily use time is included, it can be seen that the female adolescents, if they watch television, spend about as long doing so as their male counterparts. It is also just as obvious that the 18- to 19-year-olds use television less than the other age groups – both daily and weekly. They differ mainly from the 16- to 17-year-olds, who, although their daily use is only just below the average for the respondents as a whole, are well ahead of the other age groups as far as their daily viewing time is concerned.

Table 5a: **Frequency of television use per week and per day**
('on 6-7 days a week'; 'up to 2/up to 4 hours a day'; answers in %)

| Answers | All | M | F | 12-13 | 14-15 | 16-17 | 18-19 |
|---|---|---|---|---|---|---|---|
| 6 – 7 days a week | 69.2 | 71.6 | 66.8 | 66.8 | 73.1 | 68.5 | 67.2 |
| Up to 2 hours a day | 65.3 | 63.7 | 67.0 | 74.3 | 64.8 | 57.7 | 63.4 |
| Up to 4 hours a day | 94.9 | 95.1 | 94.9 | 94.7 | 94.5 | 97.4 | 92.4 |
| Sample (abs.) | 1060 | 539 | 521 | 280 | 327 | 267 | 186 |

Table 5b: **Frequency of television use per week and per day**
('on 6-7 days a week', 'up to 2/up to 4 hours a day'; answers in %)

| Answers | Secondary modern | Secondary school | Grammar school | Em-ployed | At school | Unem-ployed | West German | East German |
|---|---|---|---|---|---|---|---|---|
| 6 – 7 days a week | 71.4 | 71.5 | 67.3 | 77.4 | 69.1 | 60.9 | 67.9 | 73.5 |
| Up to 2 hours a day | 52.6 | 62.0 | 70.3 | 54.6 | 65.8 | 56.5 | 68.0 | 56.7 |
| Up to 4 hours a day | 91.7 | 94.4 | 96 | 94.3 | 95.1 | 82.6 | 95.2 | 93.6 |
| Sample (abs.) | 133 | 355 | 572 | 53 | 934 | 23 | 811 | 249 |

What is noticeable at first about the figures collated in Table 5b is that – the higher the school level – the less the weekly use time and the greater the daily viewing time. The latter only applies, however, to the category 'up to 2 hours'; in the category 'up to 4 hours', on the other hand, the

secondary modern school pupils are more numerously represented than the secondary school or even the grammar school pupils.

It can also be seen that the weekly use time in which the working adolescents are engaged in watching TV programmes is quite considerably above that of all other groupings, especially that of the young unemployed, who are a long way behind their working contemporaries both in the weekly and the daily use time. Although the two groups are noticeably closer in their daily use time, this is only the case in the category 'up to 2 hours'. When we look at the more extensive viewing times, those who work are again well ahead.

It is known that the young east Germans watch television more each week and longer each day (see category 'up to 4 hours') than the west Germans, and this is also understandable on account of the connection of adverse living conditions and the wish for an, at least imaginary, easier life. This lead applies, however, only to the weekly use time; in their daily use the east German adolescents almost come up to the time of the west Germans.

### 4. Programme preferences and music styles

It is nothing new that news, cartoons and sports transmissions are regarded as a 'men's matter' rather than a 'women's matter' on account of the prevailing femininity ideology (see Table 6a). It is also just as well documented that – regarding the most favoured programmes – the series audiences are clearly determined by the female and the interest in feature films just as clearly by the male adolescents. It is likely to be less well known that the female push the male adolescents into the background not only in the case of talk shows and programmes specially for young people but also of music programmes.

Table 6a: **Use of television programmes**
('daily/almost daily', 'at least 2-3 times per week'; ratings 1-8; answers in %)

| Answers | All | M | F | 12-13 | 14-15 | 16-17 | 18-19 |
|---|---|---|---|---|---|---|---|
| Series (sitcom, crime, etc) | 74.1 | 69.6 | 78.7 | 72.1 | 75.2 | 75.7 | 72.6 |
| Feature films | 65.0 | 68.5 | 61.4 | 62.1 | 65.1 | 66.3 | 67.2 |
| News broadcasts | 59.4 | 67.0 | 51.6 | 42.9 | 59.6 | 65.9 | 74.7 |
| Music programmes | 58.6 | 57.1 | 60.1 | 58.9 | 60.6 | 64.8 | 45.7 |
| Cartoons | 38.6 | 43.6 | 33.4 | 50.7 | 34.6 | 36.0 | 31.2 |
| Sports broadcasts | 38.1 | 56.2 | 19.4 | 43.6 | 40.1 | 39.3 | 24.7 |
| Talk shows | 34.3 | 28.0 | 40.9 | 31.4 | 39.8 | 33.7 | 30.1 |
| Young people's programmes | 28.7 | 23.4 | 34.2 | 34.3 | 34.6 | 24.7 | 15.6 |
| Sample (abs.) | 1060 | 539 | 521 | 280 | 327 | 267 | 186 |

Table 6b: **Use of television programmes**
('daily/almost daily', 'at least 2 – 3 times per week'; ratings 1-8; answers in %)

| Answers | Secondary modern | Secondary school | Grammar school | Em- ployed | At school | Unem- ployed | West German | East German |
|---|---|---|---|---|---|---|---|---|
| Series | | | | | | | | |
| (sitcom, crime, etc) | 77.4 | 74.4 | 73.1 | 81.1 | 73.6 | 82.6 | 73.5 | 75.9 |
| Feature films | 68.4 | 65.6 | 63.8 | 75.5 | 64.7 | 73.9 | 63.6 | 69.5 |
| News broadcasts | 55.6 | 55.2 | 62.9 | 69.8 | 57.9 | 82.6 | 58.3 | 63.1 |
| Music programmes | 63.2 | 62.5 | 55.1 | 50.9 | 59.4 | 56.5 | 56.5 | 65.5 |
| Cartoons | 37.6 | 44.5 | 35.2 | 26.4 | 39.3 | 43.6 | 37.0 | 43.8 |
| Sports broadcasts | 49.6 | 42.0 | 33.0 | 30.2 | 39.0 | 21.7 | 37.0 | 41.8 |
| Talk shows | 30.8 | 37.2 | 33.4 | 17.0 | 36.1 | 21.7 | 33.0 | 38.6 |
| Young people's | | | | | | | | |
| programmes | 36.8 | 32.7 | 24.3 | 17.0 | 30.0 | 26.1 | 25.6 | 38.6 |
| Sample (abs.) | 133 | 355 | 572 | 53 | 934 | 23 | 811 | 249 |

Related to the age groups it is not possible to see any appreciable differences between the age groups in the matter of 'series' and 'feature films' – although it cannot be overlooked either that the older ones can get more out of feature films than the younger. For all other programme categories, however, in some cases considerable use differences between the various age groups can be discerned. Thus in the case of the 12- to 13-year-olds, television news broadcasts drops back to sixth place, while the 18- to 19-year-olds say that they are the programmes they watch most. And so the interest of the 12- to 13-year-olds up to the 15- to 16-year-olds in music broadcasts seems to be continually on the increase, only to drop off rather abruptly in the 18- to 19-year-old group.

That cartoons, sports broadcasts and programmes specially for young people are used less and less as age increases has already been ascertained quite often in the available studies: cartoons because they are too 'childish', sports broadcasts because they are too 'boring', and programmes for young people because they are geared too much to younger age groups.

Why the 14- to 15-year-olds show such a pronounced interest in talk shows is probably due to the fact that at this age it is important to become acquainted with persons whom they can relate to and who can provide them with guidance to prepare them for the inevitable entry into the adult world – and that in a positive as well as negative sense.

The education-based breakdown of the findings carried out in Table 6b confirms that the use of series, feature films, music and sports programmes as well as broadcasts specially for adolescents gradually declines with increasing (formal) education. The fact that grammar school pupils have a stronger interest in information and politics than the other groups is also substantiated.

If a comparison is made between those of school age and the adolescents at work and unemployed the use behaviour of the first group moves along the line which applies to the respondents as a whole. On the other hand, the young people at work and unemployed show a much

stronger interest in series, feature films, but also in news broadcasts (here especially the figure for the unemployed is striking). Whereas the working adolescents often fall far behind the young people of school age regarding all the other programme categories, this is expressed in the case of the young unemployed people only for the sports broadcasts and talk shows, but hardly for cartoons, music programmes and special programmes for young people.

It should also be mentioned that the East German adolescents use all programmes more intensively than the West Germans of the same age; that applies in particular to cartoons, music programmes and broadcasts for young people. The East German adolescents apparently seem to find the latter especially attractive.

In conclusion one more point should be added which refers to the category 'music broadcasts'. That young people appreciate music is not only indicated by the place they gave it in the list of preferences (rank 4 in Tables 6a and 6b). It is also expressed in the fact that the music and choir clubs are the second most attractive societies: 17.3 per cent of the respondents say they are members of such clubs; in the case of the most popular, 'sport/fitness club', it is 52.6 per cent. From that point of view the following remarks on the subject of 'taste in music' are likely to be of interest.

Table 7a makes it clear that disco, rap/hip hop, techno and pop are the most important kinds of music for young people. A breakdown into sex and age shows, however, two things: firstly, that disco and pop (as the 'softer' kinds) are preferred by the female adolescents, while rap/hip hop and techno (as the 'more aggressive' kinds) by the males. And, secondly, that as the adolescents grow older, the four kinds of music lose some of their attraction.

Here it should not be overlooked that the 'softer' kinds (disco, pop) are especially appreciated by the 12- to 13-year-olds, while the older adolescents tend to have more of an ear for 'harder' ones: punk among the 14- to 15-year-olds; house – a techno variant – among the 16- to 17-year-olds; rock among the 18- to 19-year-olds.

Table 7a: **Assessment of types of music**
('I like it very much/a lot'; ranks 1-7; answers in %)

| Answers | All | M | F | 12-13 | 14-15 | 16-17 | 18-19 |
|---|---|---|---|---|---|---|---|
| Disco | 33.8 | 27.8 | 39.9 | 40.7 | 33.0 | 33.7 | 24.7 |
| Rap/hip hop | 32.1 | 33.6 | 30.5 | 32.5 | 33.0 | 35.6 | 24.7 |
| Techno | 25.6 | 27.8 | 23.2 | 26.8 | 25.1 | 27.0 | 22.6 |
| Pop | 18.3 | 11.3 | 25.5 | 27.9 | 17.1 | 13.5 | 12.9 |
| House | 13.7 | 14.7 | 12.7 | 9.6 | 10.4 | 19.1 | 17.7 |
| Rock | 13.3 | 13.2 | 13.4 | 14.3 | 10.7 | 13.1 | 16.7 |
| Punk | 11.0 | 11.7 | 10.4 | 9.6 | 14.4 | 9.0 | 10.2 |
| Sample (abs.) | 1060 | 539 | 521 | 280 | 327 | 267 | 186 |

Table 7b: **Assessment of types of music**
('I like it very much/a lot'; ratings 1-7; answers in %)

| Answers | Secondary modern | Secondary school | Grammar school | Em- ployed | At school | Unem- ployed | West German | East German |
|---|---|---|---|---|---|---|---|---|
| Disco | 48.1 | 40.3 | 26.4 | 37.7 | 34.5 | 21.7 | 30.6 | 44.2 |
| Rap/hip hop | 42.1 | 33.2 | 29.0 | 20.8 | 33.0 | 30.4 | 32.7 | 30.1 |
| Techno | 47.4 | 33.0 | 15.9 | 28.3 | 25.6 | 21.7 | 23.2 | 32.9 |
| Pop | 23.3 | 20.6 | 15.7 | 13.2 | 19.2 | 8.7 | 16.6 | 23.7 |
| House | 18.0 | 16.9 | 10.7 | 24.5 | 13.0 | 8.7 | 12.5 | 17.7 |
| Rock | 15.8 | 14.1 | 12.2 | 15.1 | 12.8 | 13.0 | 12.9 | 14.5 |
| Punk | 10.5 | 11.5 | 10.8 | 15.1 | 11.1 | 8.7 | 10.9 | 11.6 |
| Sample (abs.) | 133 | 355 | 572 | 53 | 934 | 23 | 811 | 249 |

It can be seen from the findings compiled in Table 7b that as the young people's educational qualifications improve, the different kinds of music – with the exception of punk – lose some of their importance, in some cases, for example, disco and techno, rather rapidly.

Similarly striking differences also emerge when the young working people are compared with the young unemployed. (The adolescents of school age agree in their reactions to a very great extent with those that apply to the respondents as a whole.) Those who have a job turn more to disco, techno and punk, while the unemployed of the same age dissociate themselves both from these types of music and from the others – except for rap/hip hop, which in its aggressiveness apparently appeals to them much more than to the adolescents with a job.

In the same way as the adolescents of school age, the young west Germans deviate only slightly from the results that were ascertained for the respondents as a whole. The young people in east Germany present themselves, on the other hand, as decided fans of disco, pop, techno and house; they are apparently not particularly interested in unruly and rebellious sounds and words (rap/hip hop).

**5. The most popular news broadcasts and the lack of interest in TV news**
In Tables 7a and 7b it has been made clear that a relatively large number of adolescents not only use television news, but some sub-groups (males, 16 to 19-year-olds, both those in work and unemployed) often quite considerably exceed the average of all the respondents, too. But although the use of the news by adolescents is by no means as moderate as is always assumed, it is nevertheless probably useful to search for the reasons that provoke the lack of interest in the news that still exists.

If we start with the respondents who 'seldom/never' watch TV news, that is therefore those who are *not* to be counted among the groups that watch TV news 'daily/almost daily', '2-3 times a week', 'about once a week' or 'every 14 days', it can be noticed that there are essentially four reasons for the lack of interest in news broadcasts (see Table 8a).

Table 8a: **Reasons for the lack of interest in television news**
('fully applies', 'applies in most cases'; ratings 1–4; answers in %)

| Answers | All | M | F | 12-13 | 14-15 | 16-17 | 18-19 |
|---|---|---|---|---|---|---|---|
| News is presented in a fairly boring way | 18.6 | 14.1 | 23.0 | 32.5 | 20.8 | 10,1 | 5.9 |
| When the news comes I usually switch over | 18.5 | 14.1 | 23.0 | 30.0 | 20.2 | 12.0 | 7.5 |
| What they bring in the news generally does not interest me | 12.8 | 9.8 | 15.9 | 22.5 | 13.8 | 7.9 | 3.8 |
| I inform myself about these things in other media | 12.1 | 7.4 | 16.9 | 17.1 | 14.1 | 8.2 | 6.5 |
| Adolescents who do not watch TV news[3] | 74.7 | 80.8 | 69.3 | 56.4 | 73.4 | 85.0 | 89.8 |
| Sample (abs.) | 1060 | 539 | 521 | 280 | 327 | 267 | 186 |

Table 8b: **Reasons for the lack of interest in television news**
('fully applies', 'applies in most cases'; ratings 1–4; answers in %)

| Answers | Secondary modern school | Secondary school | Grammar school | Em- ployed | At school | Unem- ployed | West German | East German |
|---|---|---|---|---|---|---|---|---|
| News is presented in a fairly boring way | 22.6 | 19.7 | 17.0 | 1.9 | 20.1 | 13.0 | 18.5 | 18.9 |
| When the news comes I usually switch over | 25.6 | 19.4 | 16.3 | 1.9 | 19.8 | 13.0 | 18.1 | 19.7 |
| What they bring in the news generally does not interest me | 18.8 | 15.8 | 9.6 | 1.9 | 13.7 | 13.0 | 12.3 | 14.5 |
| I inform myself about these things in other media | 12.8 | 13.0 | 11.4 | 3.8 | 12.8 | 8.7 | 11.1 | 15.3 |
| Adolescents who do not watch TV news[4] | 67.7 | 74.1 | 76.7 | 94.3 | 72,7 | 82,6 | 74.5 | 73.5 |
| Sample (abs.) | 133 | 355 | 572 | 53 | 934 | 23 | 811 | 249 |

The reservations regarding TV news are to be found most clearly among the female adolescents and the 12- to 15-year-olds. That the female and 12- to 13-year-old adolescents react with particular aversion is, in the first case, probably rooted in 'femininity ideology' – see above – and, in the second case, results from the (age-dependent) level of development of the affective and cognitive capacities. Evidence for the latter is also furnished by the fact that the 16- to-19-year-olds react with much greater reservation, 'education-conventionally' so to speak.

If we take our bearings from the educational levels to which the adolescents have been assigned, Table 10b shows that the values for secondary modern pupils go well beyond the rates that apply to the 'uninterested' respondents as a whole – especially with regard to the willingness not to watch news programmes at all. The secondary school pupils come close to the average rates; and the grammar school pupils deviate from these rates, in some cases quite considerably.

While the adolescents of school age, on the other hand, move on the line that reflects the respondents' reactions as a whole, among the young unemployed the points of criticism of TV news are less pronounced and can be hardly found among the working adolescents. Like those of school age, the young west Germans only deviate slightly in their assessments from the overall distribution. But the young east Germans criticise the TV news all the more emphatically and point out that there is also news in other forms (newspapers, conversations, books).

### 6. The interest – or lack of it – in informational programmes
Compared with the TV news, the informational programmes are watched less frequently by adolescents. Accordingly, such informational programmes, or magazines, do not rank among the first eight frequently watched broadcasts (Tables 7a and 7b). Moreover, basically only two informational programmes are particularly appreciated by young people in Germany: *Explosiv – Das Magazin* (RTL) and *taff* (Pro 7), both programmes containing a mixture of information, reality TV, show and sensation (usually with a female presenter).

That *Explosiv* and *taff* are the young people's favourites is probably due to their positively rated features, which apparently distinguish them from other magazines. What these features might be can be seen as a mirror-image, so to speak, from the reasons given by the young people to justify their lack of interest in informational programmes. We begin – as previously with the subject of TV news – with the adolescents who watch informational programmes 'more rarely/never', ie those who do not belong to the groups who watch informational programmes 'once a week and more often', '2-3 times a month' or 'about once a month'. According to Table 9a, the main reservations relate to the fact that informational programmes are 'boring', 'long-winded' and that they ignore what interests adolescents – as far as the subjects are concerned.

This is mainly what emerges from what the female and the 12- to 15-year-old adolescents say; it is, however, also put forward – in a somewhat weaker form – by the male and the 16- to 19-year-old adolescents. It is quite obvious that, as age increases, the lack of appreciation for informational programmes often suddenly diminishes, so that the negative assessment of informational programmes is probably largely due to the level of the young people's cognitive capacities.

The influence exerted by the level reached at school by the adolescents seems – according to Table 9b – to be only moderate. That is similarly expressed by the young people of school age and those from west and east Germany. On the other hand, having a job and being unemployed have a considerably stronger effect. In the case of the working adolescents, that only concerns the fact that they are apparently closer to the TV programmes than the two other groups, ie they show little inclination to inform themselves in alternative ways.

Table 9a: **Reasons for the lack of interest in information programmes** ('fully applies'; ratings 1-4; answers in %)

| Answers | All | M | F | 12-13 | 14-15 | 16-17 | 18-19 |
|---|---|---|---|---|---|---|---|
| Most informational programmes are presented in a rather dull way | 20.2 | 16.9 | 23.6 | 22.1 | 22.6 | 18.7 | 15.1 |
| The contributions are mostly too long-winded for me | 16.7 | 13.4 | 20.2 | 22.5 | 19.3 | 12.4 | 9.7 |
| What they bring generally does not interest me | 12.8 | 11.5 | 14.2 | 16.8 | 14.1 | 9.7 | 9.1 |
| I inform myself about these things in other media | 9.3 | 7.8 | 10.9 | 10.0 | 10.7 | 9.0 | 6.5 |
| Adolescents who do not watch informational programmes[5] | 37.5 | 43.2 | 31.7 | 24.3 | 31.8 | 45.3 | 56.5 |
| Sample (abs.) | 1060 | 539 | 521 | 280 | 327 | 267 | 186 |

Table 9b: **Reasons for the lack of interest in information programmes** ('fully applies'; ratings 1-4; answers in %)

| Answers | All | Secondary modern | Secondary school | Grammar school | Em-ployed | At school | Unem-ployed | West German | East German |
|---|---|---|---|---|---|---|---|---|---|
| Most informational programmes are presented in a rather dull way | 20.2 | 18.8 | 23.9 | 18.2 | 22.6 | 20.1 | 13.0 | 20.1 | 20.5 |
| The contributions are mostly too long-winded for me | 16.7 | 14.3 | 18.6 | 16.1 | 13.2 | 17.1 | 8.7 | 16.3 | 18.1 |
| What they bring generally does not interest me | 12.8 | 14.3 | 14.6 | 11.4 | 11.3 | 12.8 | 13.0 | 13.1 | 12.0 |
| I inform myself about these things in other media | 9.3 | 10.5 | 9.0 | 9.3 | 3.8 | 9.6 | 8.7 | 8.6 | 11.6 |
| Adolescents who do not watch informational programmes | 37.5 | 34.6 | 34.6 | 40.0 | 43.4 | 36.4 | 56.5 | 37.9 | 36.5 |
| Sample (abs.) | 1060 | 133 | 355 | 572 | 53 | 934 | 23 | 811 | 249 |

The unemployed adolescents reveal two other things: first, they contain – together with the 18- to 19-year-olds – the smallest section of those who watch informational broadcasts 'more rarely' or 'never'. And, secondly, they emphasise their negative estimation of TV information programmes less clearly than the young people in work and of school age (see 'boring' and 'dull' presentation).

## 7. Television – the favourite medium

Despite the reservations expressed by an often small, but sometimes also larger, group of adolescents, television – measured against other media – is

nevertheless looked upon as the most attractive medium, and this applies right across all sections (see Table 10a). It applies more to the male than the female adolescents, and more to the 14- to 15-year-olds than the other age groups.

The latter occupy themselves instead more with sound carriers (12-13), with radio programmes (16-17) and with reading books and newspapers (18-19), while the female adolescents show a marked interest in listening to the radio and reading books. It can also be seen that the 12- to 13-year-olds show the highest figures within the totality of the age groups not only under 'reading newspapers/magazines' – here it is likely to be comics and magazines – but also under 'watching video'.

Table 10a: **The most important media** (answers in %)

| Answers | All | M | F | 12-13 | 14-15 | 16-17 | 18-19 |
|---|---|---|---|---|---|---|---|
| Television | 35.4 | 40.8 | 29.8 | 31.4 | 38.2 | 36.0 | 35.5 |
| Cassettes/CDs/records | 23.2 | 23.7 | 22.6 | 26.1 | 26.3 | 22.8 | 14.0 |
| Radio | 20.8 | 17.1 | 24.8 | 16.1 | 19.9 | 25.8 | 22.6 |
| Books | 9.7 | 6.1 | 13.4 | 11.4 | 5.8 | 7.1 | 17.7 |
| Newspapers/magazines | 8.4 | 8.5 | 8.3 | 10.4 | 7.3 | 6.7 | 9.7 |
| Video | 2.5 | 3.7 | 1.2 | 4.6 | 2.4 | 1.5 | 0.5 |
| Sample (abs.) | 1060 | 539 | 521 | 280 | 327 | 267 | 186 |

Table 10b: **The most important technical media** (answers in %)

| Answers | Secondary modern | Secondary school | Grammar school | Employed | At school | Unemployed | West German | East German |
|---|---|---|---|---|---|---|---|---|
| Television | 33.8 | 38.0 | 34.1 | 35.8 | 35.3 | 39.1 | 36.3 | 32.5 |
| Cassettes/CDs/ records | 32.3 | 25.4 | 19.8 | 17.0 | 23.7 | 21.7 | 23.8 | 21.3 |
| Radio | 18.8 | 20.6 | 21.5 | 35.8 | 20.0 | 8.7 | 20.2 | 22.9 |
| Books | 3.8 | 6.2 | 13.2 | 5.7 | 9.7 | 21.7 | 10.1 | 8.4 |
| Newspapers/ magazines | 6.0 | 8.2 | 9.1 | 5.7 | 8.6 | 8.7 | 7.3 | 12.0 |
| Video | 5.3 | 1.7 | 2.3 | 0.0 | 2.7 | 0.0 | 2.3 | 2.8 |
| Sample (abs.) | 133 | 355 | 572 | 53 | 934 | 23 | 811 | 249 |

From education-specific points of view the trend sketched out above also applies: television is the favourite medium (see Table 10b). Here the secondary modern school pupils are conspicuous for their extensive use of sound carriers and video – unlike the grammar school children, who seem to concentrate more on reading newspapers/magazines and books.

That the unemployed adolescents rate television higher than those who work and are of school age can probably be explained from the amount of time they involuntarily and of necessity have to 'kill'. That seems to be something that involvement with radio programmes does not bring about, but apparently involvement with books does. (Whether these books are their own or are borrowed, high-quality reading or light fiction, will have to remain an unanswered question.)

The opposite is the case with the working adolescents: they are less orientated to books and newspapers/magazines, yet instead they place radio, which can be carried along without much effort, on the same level as television – which makes life easier. It is rather surprising that the east German adolescents do not give television such a high priority as the west Germans. For them the radio and – in some cases no doubt because of the after-effects of their socialisation under the former communist East German regime – newspapers and magazines are still important.

It is known that the adolescents – like all the other age groups as well – insist on being entertained by television programmes. That is also expressed here in the respondents' reactions. For three of the main motives named in Table 11a which induce the adolescents (relatively independently of sex and age) to watch television refer to its entertainment-orientation (see the answers in 1, 3 and 4 in Table 11a).

The male adolescents compared with the female take centre stage and the younger compared with the older ones. The 12- to 13-year-olds react with rather more reservation compared with the answer in the first position by all respondents. This is, however, compensated for in two ways:

• by their being more intensively interested in 'action and excitement' than the other groups of respondents; and
• by their distancing themselves extremely far away from all the other groupings regarding the use of television for communicative purposes.

In the older age groups the interest in entertainment clearly decreases and in information just as clearly increases – which apparently applies to the female adolescents only to a limited extent.

Table 11a: **Reasons for watching television programmes**
('fully applies', 'mainly applies'; the first 5 rankings; answers in %)

| Answers | All | M | F | 12-13 | 14-15 | 16-17 | 18-19 |
|---|---|---|---|---|---|---|---|
| I mainly watch TV to be entertained | 65.6 | 70.7 | 60.3 | 59.6 | 66.1 | 70.8 | 66.1 |
| I mainly watch TV to be informed | 54.2 | 57.0 | 51.2 | 48.6 | 52.3 | 56.2 | 62.9 |
| I watch TV because I have nothing better to do | 47.8 | 50.1 | 45.5 | 47.5 | 47.7 | 50.9 | 44.1 |
| I would like action and excitement | 47.3 | 58.6 | 35.5 | 50.4 | 51.7 | 47.6 | 34.4 |
| I want to be able to join in conversations with friends about TV | 44.7 | 46.9 | 42.4 | 61.1 | 48.6 | 37.8 | 23.1 |
| Sample (abs.) | 1060 | 539 | 521 | 280 | 327 | 267 | 186 |

It is remarkable that all schoolchildren look to television for its entertainment quality – the grammar school and secondary school children somewhat more than the secondary modern pupils. Even more remarkable is the fact that the secondary modern pupils seem to be far more information-orientated than the other groups of schoolchildren (especially

the grammar school pupils). It also has to be taken into account, however, that the secondary modern pupils watch television far more frequently because they have 'nothing better' to do and feel a strong urge for action and excitement.

Table 11b: **Reasons for watching television programmes**
('fully applies', 'mainly applies'; the first 5 rankings; answers in %)

| Answers | Secondary modern | Secondary school | Grammar school | Em-ployed | At school | Unem-ployed | West German | East German |
|---|---|---|---|---|---|---|---|---|
| I mainly watch TV to be entertained | 63.2 | 66.5 | 65.6 | 69.8 | 65.1 | 78.3 | 65.1 | 67.1 |
| I mainly watch TV to be informed | 62.4 | 55.5 | 51.4 | 60.4 | 53.9 | 60.9 | 52.7 | 59.0 |
| I watch TV because I have nothing better to do | 57.1 | 49.9 | 44.4 | 35.8 | 48.8 | 43.5 | 47.6 | 48.6 |
| I would like action and excitement | 60.9 | 54.1 | 39.9 | 47.2 | 47.6 | 52.2 | 48.1 | 44.6 |
| I want to be able to join in con-versations with friends about TV | 45.1 | 50.7 | 40.9 | 34.0 | 46.8 | 26.1 | 44.3 | 46.2 |
| Sample (abs.) | 133 | 355 | 572 | 53 | 934 | 23 | 811 | 249 |

That the strongest fixation on entertainment is to be found among the working and jobless adolescents can hardly be a surprise in view of their desire to compensate for everyday strains and stress (see particularly the answers 1 and 4 for the unemployed and the answer 1 for the working adolescents). It is just as important that both groups have a tremendous interest in information.

Besides that, it is also quite clear that in the conversations that working and unemployed adolescents hold with friends of both sexes the medium of television plays a relatively minor part – in contrast to the young people of school age, who follow the average trend with regard to these as well as other answers. It should also be noted that although the east Germans are more entertainment-orientated than the west German adolescents (except for their desire for 'action and excitement'), they are instead more emphatically out for information.

## 8. Conversation ranks ahead of television and radio
It is true that the dominating position television takes up in the youth culture scene cannot be overlooked. But it must be considered here that the adolescents are not only attached to the media drip, ie subject to a technically organised transmitter/receiver device, but also have opportunities to express themselves in face-to-face communication, holding 'conversations with others' (friends, parents, teachers etc).

Table 12a: **The most important media for current information**
(Comparison of *television, radio* and *conversations with others;* answers in %)

| Answers | All | M | F | 12-13 | 14-15 | 16-17 | 18-19 |
|---|---|---|---|---|---|---|---|
| Conversations with others | 38.9 | 34.9 | 43.0 | 36.4 | 41.0 | 37.5 | 40.9 |
| Television | 26.3 | 30.2 | 22.3 | 19.6 | 27.5 | 29.6 | 29.6 |
| Radio | 26.8 | 23.6 | 30.1 | 22.9 | 27.2 | 30.3 | 26.9 |
| Sample (abs.) | 1060 | 539 | 521 | 280 | 327 | 267 | 186 |

Table 12b: **The most important media for current information**
(Comparison of *television, radio* and *conversations with others;* answers in %)

| Answers | Secondary modern | Secondary school | Grammar school | Em- ployed | At school | Unem- ployed | West German | East German |
|---|---|---|---|---|---|---|---|---|
| Conversations with others | 38.3 | 39.2 | 38.8 | 34.0 | 39.0 | 39.1 | 38.5 | 40.2 |
| Television | 28.6 | 26.5 | 25.7 | 20.8 | 26.3 | 26.1 | 26.6 | 25.3 |
| Radio | 29.3 | 25.4 | 27.1 | 26.4 | 26.6 | 26.1 | 26.0 | 29.3 |
| Sample (abs.) | 133 | 355 | 572 | 53 | 934 | 23 | 811 | 249 |

Tables 12a and 12b reveal what an extraordinary significance this form of communication has for young people. And they also reveal that although the medium of television is the front runner among the technical means of communication in the case of the specific subject 'information', television has often had to exchange its role with that of radio. (Weekly newspapers, regional and national 'dailies' and young people's magazines – far less valued by the young people – have been incorporated into the constellation of answers relevant to Tables 12a and 12b.)

It can be seen from the results that 'conversations with others' constitutes the medium that is clearly preferred over the technical means of communication television and radio. This applies in a very pronounced way to the older, the female and the east German adolescents; and it shows, too, that accordingly the time of youth is not just media time, especially not television time, either, and media time is not simply tantamount to the time of youth.

It is the time in which intensive conversations – certainly related again and again to experiences mediated by the technical media – and interactive situations are sought, above all when it is a question of understanding discussions on central themes: for example, on assimilating and processing current information – political, economic, cultural and quite everyday-related information.

Here the exchange not only with persons of the same age but also with adults to relate to is involved. The latter should therefore not try to avoid conversing with young people by referring to an all-powerful domination of the media, especially of television, that allegedly no longer allows a

readiness and ability to converse, especially on the part of young people, to flourish. It would be better to accept the clear invitation to engage in conversation.

## Notes

1   All the findings described below are taken from a representative survey carried out by IZI in conjunction with the media research departments of the *Bayerischer Rundfunk* and the *Südwestfunk*. Cf. the article by B. van Eimeren and B. Maier-Lesch (in this chapter). The German version of this article appeared in *TelevIZIon* 10/1997/1, pp. 13-26.

2   Translator's note: The translations of the school types can only be approximations. Secondary modern school has been used for *Hauptschule*; secondary school for *weiterführende Schule*, or *Realschule*, which leads to the equivalent of GCSEs; grammar school or *FH-Reife, Abitur*, which lead to university entrance qualifications.

3   The questions were not put to the adolescents who do *not* watch news programmes (answer: 'more rarely/never'). These were 792 respondents = 74.7 per cent of the sample.

4   As footnote 3

5   The questions were not put to those adolescents who do *not* watch political broadcasts/magazines (answer: 'more rarely/never'); 398 respomdents = 37.5 per cent of the sample.

# Adolescent media behaviour: Scenes, styles, competence[1]

*Waldemar Vogelgesang*

**1. The pervasion of the adolescent's everyday life by the media**

The age of youth is the age of the media, and youth scenes are to an increasing extent media scenes. A merely superficial examination of the relation between the everyday world and media everyday life gives us some indication of how deeply the media have changed the socio-cultural environment and how much they have become the epitome of universally available consumer and cultural goods. There are television sets, radios, record players, magazines, books, cinemas everywhere, and the so-called new media are inexorably conquering the adolescents' leisure area.

What individual, societal and cultural impact will this media boom have? It is certain that the dominant media of a culture shape communicative exchange and thus exert a formative influence on the modes of perception, the nature of knowledge and the content of the culture concerned, as is borne out by studies of the media and cultural history.[2] Nor will anybody dispute that for children and adolescents today the mass media constitute an extremely important source of material that is relevant for socialisation and everyday life.

But in the individual case it is tremendously difficult to empirically uncover any lasting effect of the various roles and norms they offer as far as perception, feeling, thinking and behaviour are concerned, since the way in which socialisation occurs is – especially in the media age – too multi-faceted to make it clearly possible to exclude and thus to objectivise the individual factors at work here. Michael Kunczik (1988) puts the dilemma of effect research in a nutshell when he states:

> In view of the complex questions raised that are at present being examined by effect research, unequivocal, indubitable proof cannot be expected, because the fringe conditions under which the media have their effect are far too complex to be brought together in a consistent set of hypotheses. (Kunczik 1988, p. 10)

Of course, this statement does not imply a recourse to the repeatedly expressed thesis of the ineffectiveness of the mass media, but it does make it clear that tracking down the effects of the media is, theoretically and empirically, a difficult business. For practical research this means that

media research must develop a high degree of sensibility for life-world and biographical contexts if it undertakes to make the subjects of discussion not only processes that shape everyday life but also the influence of the media on the formation of adolescent-specific behaviour patterns and reception settings.

In work over several years the Trier research group *Medienkultur und Lebensformen* (media culture and life forms)[3] has tried, by combining quantitative and qualitative research strategies, to produce the necessary realism in order to disclose the forms and motives of adolescents' occupation with the media as well as their appropriation styles and processing modes. The central perspective guiding research is here based on the premise that media do not exist in themselves, but always only for themselves, ie in social and individual, commercial and cultural, biographical and current interpretation connections. People use them, learn to use them or teach how they are to be used.

People shape their daily routine, their leisure time, with them. In the same way fantasies, feelings, wishes and also personal relations are changed in interaction with the media. This kind of understanding of the media is not aimed at a causal-analytical interpretation ('What do the media do with young people?'), but is more a question of reconstructing the realities in which media become significant for the recipients ('What do young people do with the media?').

In this connection it can be seen that the wide range of possible uses and codings which the media open up can lead to forming specialised personal identities and scenes and special cultures peculiar to adolescents.

## 2. Media and youth scenes – in retrospect

Since the 50s a development has been emerging among young people in which media of every complexion are increasingly becoming crystallisation points of youth scenes. Here the leading medium was (and is) the radio, the leading environment the rock and pop scene. It arose in the USA in the 50s, and its aesthetic means of expression, rock 'n' roll, gained in world-wide popularity within a few years, indeed it became the musical label of a whole generation. The German rock singer Udo Lindenberg recalls:

At that time, 1957, I was eleven, Elvis Presley shot out of the radio with 'Tutti Frutti', and the first beats banished my favourite songs up to then ... from my greenhorn heart from one minute to the next. I didn't understand what it was all about, but this hiccuping singing and the electrifying music rocked right through me. ... Elvis Presley had lit me up, and I thought to myself, 'Now here's an earthquake'.[4]

Rock music continues a long tradition of young people's enthusiasm for music. Thus in the famous Middletown Study in America back in the 20s listening to the radio was at the top of adolescents' list of interests.[5]

336

Later, however, it marked a radical turning point in their taste in music. Conventional dancing and light music are replaced by a new kind of music peculiar to young people which allows them to let out their feelings at the moment and their needs for self-projection, but also to draw a clear-cut line between young people and adults. This was something that it was impossible not to hear and, through the accoutrements (clothing, language, dancing style etc), not to see too.

The young people found in rock music a symbolic medium of expression that brings out the independence and immediacy of the lifestyle desired with special emphasis. It opened up a world to counter the restorative-consumptive routines and structures of everyday life which – for example, in the atmosphere of discotheques and festivals – made it possible to demonstratively display their 'otherness'. In the same way, in these contexts a re-acquisition of sensuality, the testing of an erotic radiance and attractiveness, the flaunting of belonging to a scene and a dissociating of oneself from middle-class everyday life occurred.

Rock is more than just music, it is a philosophy of life and an attitude to style with a pronounced character that creates identity and togetherness. Even commercialisation, puffing up and temporising the stylistic devices of the rock culture were unable to change this. On the contrary, they stimulated the development and self-transformation of the scenes. One only needs to call to mind the splitting off of the various rock derivatives (for example, cog, punk, New Wave, heavy metal), the various dancing styles (like the twist, hully-gully, the waddle, breakdance) or the creation of new style-forming items (such as the motor cycle and leather clothing for rockers or the Mohican-look and the safety-pins for punks).

Within the scenes, too, there is a tremendous dynamism, as Diedrich Diedrichsen points out from the example of punk culture: 'Indeed, the trends and the areas of resorts in the first few years after punk changed almost every month. The music industry once again felt unsure of itself, and, up to 1982, the climax and end of this period, hardly any successful artist danced longer than one summer.'(Diedrichsen 1985, p. 91)

But not only the music genres popularised world-wide on the basis of auditive media led to the formation of youth-specific sub-worlds, but also – although not to the same extent – the medium of the film.[6] What is noticeable here is the close connection, extending up into the present, between rock music and film in the form of a multi-media arrangement, which has cultivated a new style of perception and expression in the so-called video clips or music videos.[7]

This is due, on the one hand, to the way in which aesthetic signals and accents are being set and – besides the aesthetic gains – at the same time a re-mythologising and re-enchantment of reality is taking place. On the other hand, they symbolise for many young people – analogous to the rock-cultural manifestation of freedom, self-assertion and resistance – an affront to the everyday world's culture of taste, which,

for its part, only catches a glimpse of merely superficial and stimulating goods in the clips.

Apart from the music-centred youth-worlds, the cinema film, however, inspired and initiated quite a number of other special cultures. They range from the Western and Red Indian clubs and the deportment forms of the adolescent bodybuilders and dirty dancers to the fan clubs grouped around a star or an individual film.

In this connection the *Rocky Horror Picture Show* can be regarded as a scene-generating cult film and communicative cinema event *per se*. Since this film spectacle was first performed in 1976 uncountable fan communities have formed that are organised into a kind of umbrella association (the International Rocky Horror Fan Club) and publish several fan magazines (eg *The Transylvanian*).

The regular audiences – relevant American media studies[8] also talk in this connection about 'veterans' or 'regulars' – usually come in small cliques to the late or night shows, well equipped with various utensils such as rice, water pistols, newspapers, toilet paper and sparklers, which then have to be used at certain points in the film. It is therefore not watching the film that is the actual experience but – some of the fans have dressed up to look like the film's protagonists – the total involvement and the constant repetition of camp ritual. Camp is 'an unnatural way of experiencing. The quintessence of camp is the love of the unnatural: of the trick and exaggeration. And camp is esoteric – a kind of secret code, the badge of small urban groups' (Sonntag 1968, p. 268).

Cult films, too, therefore constitute youth scenes, which in an ironical-eccentric manner not only crusade against the patterns of established film criticism, but also make it possible to try out and experience unconventional ideas of personality by means of an extraordinary stylisation. This is also the finding of a study in which, well backed up by research and close to the scenes, the coming into being and reproduction of two current special film worlds are described which have formed around the pop and film star Madonna and the US series *Star Trek*.[9]

The author found out for himself at a Star Trek party at the Advanced Technical College in Trier that it is precisely the Trekkies who can be counted among the most colourful youth scenes of the present time. The dense atmosphere and the – at times – carnival-like goings-on of the youthful fan community is well reproduced in the following description:

> The refectory offers an unusual scene. Coloured spotlights and floodlights immerse the functional room in an unreal light, converting it into a bridge of the spaceship Enterprise. The guests who go onto the 'bridge' have to pass through a thick skittering fog behind the pay desk. From the back of the room the Star Trek film music can be heard, still subdued. On huge screens loom the heads of Captain Kirk, Mr Spock, Scotty and Doc. ... Guido Hertl was also among the guests that evening. He is the founder of the Star Trek fan club *Utopia Planitia Trier*.

In Germany, he reports, there are at present some 20 Star Trek fan clubs with about 6,000 members. ... Hertl and his Trekkies have taken on quite a job for the future. A Star Trek film night is planned in which all six of the cinema films made so far are to be shown. In addition they want to make their own film parody and bring out a club magazine. ... 11.00 p.m. on the dot: sharply focused beams of light suddenly cut through the room. A piercing sound pounds from the spherical depths. Star time, twenty-three hundred hours: the party has begun – and the uniformed galactic voyagers seem to have found their true home.[10]

## 3. Youth cultures mediated by the media: Examples of current research

### 3.1 Video cliques

We have also made comparable observations in young people's video cliques.[11] What is meant here are certain groups of young people who watch hard (ie mostly banned) action and horror films more or less regularly. For these young people, their film sessions, as they call their meetings, are a kind of extension of the cinema setting in the privacy of the home and represent a special situation compared with everyday routines.

Here they can give free rein to their spontaneity, their need for activity and representation without having to fear any strong objections from their parents. Here they can satisfy their wishes for adventure and action, horror and thrills, which are hardly allowed in normal everyday life. So videos ignore everyday life, and they create a kind of exceptional situation in which the present-day social suspension of the body and disciplining one's feelings are eliminated.

How it is precisely that the contemporary horror film – assuming a suitable setting – can so easily offer a forum to the general trend of a policy of having fun and carnivalising everyday life is also documented by the following observation:

The visitor to a Festival of the Fantastic Film in Paris, which has been held annually since 1972, was one of the climaxes of our exploration into the horror fan's social world. The unconventional spectacle which took place in the auditorium was strongly reminiscent of Bachtin's description of carnival as a form of popular amusement. Its distinguishing features are laughter and physical sensations, nonsense and parodies, eccentricity and exaggeration. From that point of view it represents a kind of resistance (in the literal sense of the word) to sense, subjectivity and responsibility.

Thus the sense conveyed by the language was less important for the fans than the threat staged by the spectacle of images, and in the same way no one in the auditorium could escape the carnival-like goings-on. ... The festival participants – most of them covered in flour – exposed to the noise and images were part of the collective happening in which conventional

339

distances between people were put into perspective, thus building up a counterworld to everyday life. (Vogelgesang and Winter 1990, p. 42)

But it is obviously not only the brief escapes from the monotony of everyday life that constitute the appeal of videos, it is also the chance of coping with frustrations and aggressive impulses while watching them. During the viewing the young film fan lives out internally what he cannot show externally because aggressive styles of behaviour are strongly disapproved of in everyday life. This form of media sublimation or drying out aggressiveness can thus also be interpreted as a form of valve for morals. Seen in this way, the acquisition of videos packed with thrills and action is a functional equivalent of carnival, sports events or of other festivities that for a time cancel out everyday life.

The media adventure and the exceptional situation that videos are able to stimulate are closely linked to the development of specific film competencies, and that was not necessarily to be expected. While the fans are primarily motivated by a voyeuristic curiosity at the beginning of their video career, in the course of time they develop more subtle viewing practices on the basis of film experience and film knowledge, which allow them to experience even the most spectacular film scenes in carefully measured quantities. In doing so the youthful video freaks realise at all times that the action and horror scenarios are pure fantasy worlds, and, what is more, the difference between fictionality and reality practically constitutes their forms of experience.

Young video fans are therefore by no means degenerate 'videots', as they are often said to be. This applies at any rate to the type we studied. On the contrary, they do not – in the sense of an all-powerful effect doctrine – succumb to the shock pictures that are present in such profusion in many video films, they do not turn into media marionettes, but they competently acquire their means of dramaturgical production and theatrical scenarios.

It cannot be ruled out, however, that there are circumstances under which the consumption of hard video films can also be problematic. Thus the film *The Warriors*, for example, has become a cult film for aggressive bands of adolescents. Research ought to be carried out into the effect of, for instance, films like *Rambo* in right-wing extremist groups. What certainly appears to be possible here is a tendency to confirm and intensify. For in these films – on account of their closeness to everyday life – identification figures and plot patterns are offered that over and beyond the fictional framework of the film can be connected to existing group ideology and a readiness to use violence.[12]

### 3.2 The Lindenstrasse fans

Anyone thinking of the fans and constant viewers of *Lindenstrasse* is as a rule likely to imagine middle-aged or elderly housewives – maybe gentlemen of a more advanced age – who switch on their television at 6.40 p.m. every Sunday and are carried off into a serial world with prototypical

dramatisations of everyday and family life in Germany. One would hardly suspect adolescents and young adults of being among the consumers of this series. But the enthusiasm for most series – and here in particular for *Lindenstrasse* – does not fit in with any rigid pattern of target groups. It is, rather, the age groups between 20 and 30 in the fan clubs that we interviewed who class themselves as heavy viewers and display a strong link with the series.[13]

An important motive for the communal *Lindenstrasse* experience is based on the communicative structure and the dense atmosphere of the meetings. Conviviality, high spirits and lack of constraint are the order of the day, and this by no means just in the latest Sunday instalment of the series: a group that has existed since 1992 writes to us from Wuppertal: 'The aim of our fan club is to meet as often as possible and simply to have fun together.' A similar view was expressed by a fan club from Velbert: 'We have a whale of a time watching the individual instalments with friends, laughing and quarrelling together, and forgetting everything else for a while.'

Occasionally the descriptions even recall youthful flip practices with a markedly expressive character: 'Sometimes you'd think you were on a cabaret stage, only it's much more chaotic. Jokes are made, people fool around, dirty stories are told, almost like at carnival' (Hanover Fan Club). Or as a fan club in Zweibrücken put it so graphically: 'You enter into the everyday life of *Lindenstrasse* to leave real everyday life.' In addition to dramatising and transcending everyday life, it is above all the media competence of the *Lindenstrasse* fans that is so impressive.

They are not only familiar with the diversity of themes and the ensemble of actors, but it also obviously gives them pleasure to decode the narrative structure of the series. A fairly long passage from a letter from the Munich Cult Community is quoted here as an example to make it equally clear how elaborate the achievements of the fans to understand and interpret are and what productivity and creativity they develop in their cultural arena:

> So why do we watch *Lindenstrasse*? Chiefly just because it is possible to watch and discuss it on different levels, from different points of view. The superficial level of the plot differs for many unnoticeably or not at all from other series. My grandma, for example, probably watches *Lindenstrasse* just like *Forsthaus Falkenau* or whatever. Perhaps she is also aware of the second level: the *Lindenstrasse* as a long-term series.
>
> We have the characters accompanying us as constant companions, they grow old with us, celebrate, vote, go to work or school. Everything just the same as it is for those sitting in front of the television. On a third level, the pure plot is sub-divided into confrontations with various social issues: illness, death, pregnancy, drugs, marriage crisis, homosexuality, child abuse, puberty, sex, right-wing extremism etc.
>
> Now you can quarrel about whether these subjects are

appropriately presented, but the fact that they are brought up at all is in itself remarkable. In which series would a gay, for example, have been imaginable as the protagonist before *Lindenstrasse*? Here is a chance to confront the viewers with subjects of which they claim complete innocence.

As I said, it may be questionable how far this succeeds. And there is even another fourth level to discover: that of self-irony and running gags. Where could you find this sort of thing? Else Kling is satire in its highest form, Matthias ('Am I disturbing?') an unparalleled hate figure, and the series that takes place inside the series in the form of conversations or fan articles is the finest self-irony. As far as I'm concerned these components could, without, however, degenerating into slapstick, be increased many times over.

The subtlety and consideration in analysing *Lindenstrasse* shows how little its fans have in common with the stereotype of the viewer without any detachment. Mixing up their own world with the media world that is so often imputed to them also lacks any relevance for them. It is true, the adolescent fans ascribe real-life character to the individual instalments, but the closeness to everyday life presented is at the same time seen as an achievement of fiction, as a particular theatrical achievement. So in their eyes *Lindenstrasse* is by no means filmed social studies or the stringing together of an educational programme, but a source of themes which allows a soft link-up with their own biography and life-world:

They are, it is true, everyday stories with changing interpersonal situations and relationships, in other words themes and events as in real life. But even if you grow older with the actors or see how the children in 'Lindenstrasse' grow up, it is and remains a film town made up of sets. Although not a phantom town, it is something fictitious and constructed, a media world and not reality (Braunschweig Fan Club).

It is important for the fans that the episodes of the plot in the series are stories, fictions and constructions, ie a form of artistically condensed reality and not simply the duplication or extension of their own experience – and life-world. Tourism to the filming locations, repeatedly interpreted as a confirmation of the dwindling distance between the series' appearance and everyday reality, tends to be tantamount to a disenchantment in which the fans are confronted with the character of the art product and how it is made.

It is precisely the realisation of the difference between the world of the series and everyday life that turns *Lindenstrasse* into a pleasure for them to watch. They are, so to speak, wanderers between the worlds, the distinction between fiction and reality becoming a constitutive motive of their forms of acquisition and experience. Or as Angela Keppler put it so aptly:

The interest in the fictitious reality of the series is accompanied by an interest in the artificiality of the fictitiousness – and even in the play

between both elements. ... The viewer of the series seeks and finds in the series of his choice a 'countergame' to the form of his own existence. Life with a series, however closely the latter may be set on the appearance of closeness to real life, is a life in the tension between life and the series. This example ... (of the *Lindenstrasse* fans) shows that those who would be blind to the laws of a television series could not enjoy it in the least. (Keppler 1994, p. 33 f.)

### 3.3 Computer Games

The appearance of the so-called 'electronic playing fields' has also contributed to the formation of social worlds in youth cultures. Tele-games, video and computer games are conquering adolescents' leisure-time to an ever greater degree. Originally invented by professional programmers to brighten up their work, in a short time this development quite naturally resulted in a tremendous profusion of games equipment and programmes. In the meantime – not least as a consequence of the advancing spread of the computer – gimmicks and simulations, strategy and sports games, adventures and erotica, have become a fixed play quantity in the leisure budget, whose possibilities of graphic art, sound engineering and creativity represent a fascinating phenomenon for young people – and for adults as well to an ever greater extent.[14]

What is indisputable in these modern games paradises is a concentration on the secluded world of the game framework and on one's own abilities to observe, not, however, in the sense of an individualistic culture, but in the form of a group-sport confrontation with other game players. Although in exceptional cases it may well lead to cutting oneself off and self-isolation, the picture of the computer player sitting in his room and giving vent to his perverse fantasies behind shuttered windows is a myth.

Reality reveals to us instead a differentiated fan culture with its own strategies of recruiting and creating hierarchies and with norms, rituals and matters that are taken for granted and shared in common, and the game novice in many cases can look them up in self-help books and manuals for computer game players. If then one day the game enthusiast manages by practising and training his perception and memory to advance into the master class, new worlds of meaning and reference open up to the game enthusiast which – whether in a competitive performance comparison or in pleasurable-autonomous penetration of fantasy spheres believed to be unattainable – mean not only the expansion of individual free spaces for self-projection and self-definition but also a growing experience-orientated re-charging of everyday life.

This is also the finding of a study carried out by Fritz and Fehr (1995), the Cologne media educationists who point out:

Games are fascinating because they are needed by the players to get 'good feelings'. The game computer is coveted as 'Mr Feel Good'

because it can give rise to positive emotions: it can result in pleasure, fun and enjoyment, mediate feelings of achievement and competence and create distance to one's life-world. ... The emotional experience while doing so should be as 'dense' and 'intensive' as possible. A fascinating game mediates a 'feeling of reality', thus bringing about an enhancement of emotional experience. The more realistic the virtual world, ... the greater the density of the experience.

Penetrating virtual game worlds and concentrating on the action of the game provide great excitement – and relaxation as well. Playing diverts from everyday life and at times even becomes a therapy. It is especially the so-called 'shooting games' that offer a chance to work out aggressive impulses. Above all in the case of male adolescents, we repeatedly observed how negative feelings resulting from everyday experiences, such as fear or rage, are absorbed by certain types of games and practices. It is not the game that produces aversive moods and feelings – at least we have found no indications to that effect – but frustrations experienced outside the game are taken over into the framework of the game and reduced while playing.

The fact that the tele-game enthusiasts satisfy their hunger for experiences to an increasing extent in the numerous computer networks, too, is, however, also a reason for many a critical comment. For it is chiefly banned or even confiscated games, like, for example, *Mortal Combat*, that the freaks use to communicate with each other over the network: 'The world-wide community of players possesses whole libraries of books in which all the key sequences discovered are recorded. Innumerable mail boxes offer notice boards on which the players discuss the combinatorics of double grips and sit-backs. An abundance of teaching material is stored on the Internet as well.'[15]

That this development is a cause of concern to the authorities for the protection of children and young people is only too understandable. Thus the chairperson of the German Office for Inspecting Publications Harmful to Young People, Elke Monssen-Engberding, rightly points out that appropriate control measures can no longer be a national matter, but that an international agreement must be found. However, no jointly acceptable solution is emerging on this point between the opponents and supporters of measures for intervening, which sometimes extend as far as extremely stringent demands for censorship.[16]

### 3.4 Computer and network scenes

The core of the so-called new media – the computer – has become an ideal starting point for the social worlds of youth culture. We have shown in several studies that the computer has become firmly established in the younger generation's activities.[17] What is here characteristic of most of the adolescent users – much the same as with adults – is an instrumental

orientation: they use the computer as a tool so that they can cope with certain kinds of everyday work or functions more elegantly and faster, ie their use profile is chiefly based on routine and making life easier. But this conventional user type will not be treated in greater detail below.

The analysis will centre instead on the group of adolescents whose occupation with the computer in their leisure time is particularly intensive and specialised. For this circle of people – referred to below as computer freaks – the use of the computer is not only a central hobby, but its different forms of acquisition and use are bound together in a complex mesh of knowledge, experience and (sub-)cultural interpretation patterns.

Whether hacker or programmer, cracker or mail box fan, the way they handle the computer is characterised by a high degree of professionalism and competence. They acquire – very often as autodidacts – a specialised knowledge in the field of hardware and software that brings them prestige, recognition and in some cases admiration in the differently developed scenes of the social world of computer users as well as in circles of experienced, academically qualified information scientists. Although there is no clear dividing line between the scenes, basically every grouping defines itself by an exclusive way of handling the computer, although differentiation processes within the scenes are constantly resulting in the formation of new sub-groupings.

For the freaks the computer is always a special challenge which they take up, sometimes enthusiastically. This is another central element of their use profile, for the computer allows them to create, discover and develop something new. Problems they have created or sought for themselves become incentives to mobilise their reserves of fantasy and achievement, to venture forward into 'new dimensions'. For the freaks the computer is therefore not only a tool, but also a kind of time-machine that enables them to go on trips into different worlds.

All the more surprising and disconcerting is the feeling of uneasiness that is reiterated in discussions and publications: working at the computer deprives one of the opportunity for first-hand experience. Thus we find, for example, the statement in Joseph Wandl (1985): 'While school is anyway a place where the 'world' is mediated second or third hand, now there is a risk in the future that computer images or computer simulations might to a growing extent be regarded as reality.'

Irrespective of the empirical content of such statements, it is a sociological platitude that in modern societies people only have primary contact to a small part of reality. Whether these other – media or virtual – realities represent a form of 'reduced reality' or even 'a loss of reality', as is repeatedly claimed, is extremely doubtful from a sociological point of view. For to construct out of the shift from original to mediated experience a relationship of setting something above or below something else, of valuable and second-rate, of good and dangerous, is to establish norms and it is not an anthropological constant. Instead we have to imagine both

forms of experiencing the world as being on the same level and complementing one another.

Over and beyond all the sub-scenes and specialisations, it is characteristic of computer freaks that activities at the computer are for them always expressively coded, ie they go beyond purely instrumental use. On the one hand, they are closely bound up with feelings, rituals, a certain identity and to a greater extent with a language of their own, but, on the other hand, they serve the purpose of cultivating their self-projection, of demonstrating competence and demarcating scenes.

While in the workplace and very often in everyday life the computer is a mere working tool, a means to an end, for the freaks it turns into an end in itself. Its multi-functionality permits forms of activities on their own and of creativity which strongly stimulate the production and exploration of other spaces and realities. In addition, computer communication by no means becomes for them a substitute for personal and social communication processes, but instead the dialogue potential of the computer provokes and intensifies the formation of the scenes' own new forms of interaction and sociability.[18]

Another example of the emergence of new special cultures in the environment of the computer and its networked use are the so-called 'cyberpunks', who in a way continue the culture of the hackers from the 80s. Even if the term 'cyberpunk' is used excessively and unspecifically in the media, behind it there does exist a scene that has formed around the digital world of cyberspace. An elusive mixture of enthusiasm for technology, preferences for science fiction (especially the novels of William Gibson) and elements of so-called underground cultures, like punk, for example, constitutes the framework of orientation for their handling of computer networks. This kind of style mixture, or style *bricolage*, is vividly documented in the cult magazine *Mondo 2000*.

The Japanese 'computer otakus' represent a comparable scene. Volker Grassmuck describes the otaku freaks as follows:

Otakus loathe physical contact and love media, technology and the realm of reproduction and simulation in general. They do not talk to one another, they 'communicate'. They are enthusiastic collectors and processors of useless artefacts and information. They are an underground culture, but not opponents of the system. They change, manipulate and undermine the system of ready-made products, and at the same time they are the apotheosis of consumer culture. ... They are the children of the media. (Grassmuck 1994, p. 270.)

The use of technology in such scenes is characterised by complex aesthetic and expressive codings. The opening up of new forms of perception and experience is also important to the cyberpunks. By synthesising elements from the area of games, pop and computer art they want to venture into new cultural and unconventional areas. The cyber

346

freaks see themselves as a kind of avant-garde of what is virtual and pioneers of the global village, in which intensive experiences of competence, excitement and the community are possible. Rainer Winter makes very similar observations in his ethnography of the cyberpunk scene:

> The cyberpunks share with normal freaks the preoccupation with the computer, life in the electronic networks, which are experienced as more realistic than the rest of the world, and an enthusiastic examination of techno culture. But the word punk also signalises an oppositional dissociation from the dominant lifestyles in the present time that is recognisable externally. Thus cyberspace style is a conspicuous, wild-looking fashion that carries on from the shock aesthetics of the punks. 'Industrial waste' is recycled, linked up with the black gear of the rockers and pepped up with new technological gadgets. Their appearance is refined with connections to the vampire and apocalyptic catastrophe film, which are also expressed by make-up and hairstyle. ... Global, unrestricted communication in the gigantic computer networks is condensed for many cyberpunks to form a mythical vision of becoming one with a community of like-minded people. (Winter 1996, p. 20)

### 3.5 The techno scene

Today the techno scene is unquestionably one of the most colourful youth cultures. In the meantime, however, it has split up into so many different styles and sub-groupings that even insiders talk about a 'motley collection of scenes, styles and fashions'[19] that is difficult to understand. Following the example of the original venues where the music originated, the clubs in Chicago, Detroit and New York, in which disc jockeys (DJs) turned playing records into a new art form, this music trend also caught on in Germany in the 90s.

Sustained by a permanent presence on radio and television – and here especially on the music channels VIVA and MTV – and supported by the scene's own means of communication like flyers (artistically designed handbills), fan magazines (eg *Frontpage, Groove, Dizko 2000* etc.) and a historically unique marketing of the youth scene, techno quickly became a mainstream youth culture whose followers are estimated to number about two million by now.[20] While record companies like Low Spirit or Eye Q and clubs like Omen (Frankfurt) or Tresor (Berlin) were known to only a few people half a decade ago, today they possess cult status and are dominated by cult figures, like, for example, the DJs Sven Väth, Dr Motte or Westbam, who can send a whole generation of young people into ecstasies.

But what is decisive for the dissemination and public attention of the techno scene were and are also the forms that their functions take, because the trend-setters realised early on that the classical discotheque and party setting does not do justice to the popularity that this music enjoys among

young people. Large-scale functions, the so-called events or raves lasting from 12 hours to several days, were institutionalised as fully commercialised alternatives. The Maydays in the Dortmund Westfalenhalle or the Love Parades on the Kurfürstendamm in Berlin are in the meantime just as normal meeting points for the scene as the big discos in all parts of Germany. What extreme emotional situations can arise at these 'locations' by a scene-specific combination of music, room design and dancing is expressed very vividly in the following description by Jörg Hunold and Baschar Al-Frangi:[21]

On 7th and 8th December 1996 we visited as part of our research seminar a two-day techno party that took place in the Frankfurt disco Dorian Gray to mark the birthday of the DJ Marc Spoon. The following report records our subjective experience and impressions we gathered at this event in which between 6,000 and 7,000 German and foreign ravers took part. ...

The Gray had been decorated for the occasion by the Cologne artist Siegbert Heil. You passed through a long, unusually illuminated cloth tunnel to come right to the centre of the happening, which was concentrated on three dance floors, if we ignore the chill-out and VIP area. Each of the three different 'rave rooms' marked another musical zone. Thus in Hall 1 mainly dances like jungle, breakbeat, ragamuffin and dub were being played. In Hall 2, on the other hand, a quieter beat, based on the classical house sound, mixed with soul and funk elements. Really fast, loud and furious sounds assailed you from Hall 3; here gabber and hardcore were being played and, at 180 bpm (beats per minute), most of the dancing and sweating was done. ...

As soon as you entered this hall you were met by an ear-splitting noise which seemed to press the air out of your lungs and immediately seized your whole body with vibrating movements. The entire room – from the bar to the dance floor – was populated by a euphoric, ecstatic mass of people who, seeming to have lost their willpower, abandoned themselves to the music and were completely at the DJ's mercy. It was quite obvious that the DJs had not just come to put on records, but in the truest sense of the word were celebrating music and were at times frenetically acclaimed by the dancers. Every DJ was received on his arrival with enthusiastic applause from the crowd, and the same occurred when he had finished; every transition, every change in the rhythm and beat was accompanied by a concert of whistling from the sweating ravers. ... The classic separation of the bar area, which affords a view of the bustle on the dance floor, and the dance area had completely disappeared: people were dancing everywhere, on the bar, on boxes, on loudspeakers and in recesses and corridors.

The intensity of the dancing depended entirely on the speed of the music played. During the slow and melodious sounds, which were sometimes reminiscent of whales' singing and usually marked the

transitions to other styles of music, the people seemed to be standing almost still. With their eyes often closed, they moved their heads to and fro, and their bodies adapted to the slow rhythms with swaying movements. As if in a trance, they were awaiting the next heavy beats, which the DJ announced with a drum roll that seemed to last an eternity. When the long-awaited, thundering bass began, there was no stopping the dancers: the strength that had been built up in the break erupted in a loud shout, which sometimes even drowned out the music. With the first hammer blow of the bass the dancers 'awoke' from their trance and transformed the music into explosive movements. The dance itself was not performed by everyone together, there was no movement up and down together; everyone danced on his own and created his own style. And yet you could see that the dancers were watching one another and included the movements of the others in their own dancing style. ...

It was also noticeable that many of the dancers consciously displayed their bodies, which in some cases were almost bare. Men and women enjoyed showing their bodies, observing and being observed. Gleaming sweat on naked skin and the rhythmical movements that seized the whole body added not only an ecstatic touch to the dance but also an erotic one. ... Couples and groups that were obviously dancing together also formed. But within these couples the partners were constantly changing, and the groups dissolved and joined up again somewhere else. Irrespective of their sex, others joined them or went on dancing alone again. Whether you knew the people or not, whether heteros danced with gays or *vice versa*, the principle was: Everything that's fun and everyone after his own fashion.

But it is not only the sensual-ecstatic physical and joint experience that is characteristic of the techno fans, but also a special form of aesthetics and stylisation. Although every youth culture develops its own theatricality and its own system of symbolic behavioural forms, which constitute group-specific internal and external circumstances in a kind of dialectic of classification and demarcation, the techno scene has radicalised the most important principle of style formation in youth culture, the *bricolage*. By this is meant a tinkering mentality that encompasses all stylistic elements and whose aesthetic mark – analogous to the cut-up technique in literature or the collage in art – redesigns existing cultural artefacts. The range of activities for stylistically moulding oneself and scenes covers music, dance, outfit and communication media and patterns.

It can be seen in this connection that the techno style producers wage their 'semiotic guerrilla war' (Eco) on two levels: by acquiring special knowledge typical of the scene and by processing general knowledge. The former is the case, for example, in record reviews, party reports and Internet discussions, in which techno fans strategically employ music-

specific puns, quotations from records, parodied band names and the like, which can only be understood by insiders, in order to make certain attitudes and aesthetic preferences known. The latter applies especially to false logos. These are alienated variations of commercial brand names whose linguistic-visual forms are given new content – *Dash* becomes *hash*, *Aral* becomes *anal* – which then convey new messages as stickers or T-shirt prints.[22]

But not only advertising and the world of products become a source for merging techno-specific stylistic elements, but also philosophy (eg Gilles Deleuze), art (eg dadaism, pop art), literature (eg Arno Schmitt) and music (eg Karl-Heinz Stockhausen) become a sort of textual and cultural quarry from which the style creators of the techno scene help themselves in an anarchic manner to produce original and unmistakable emblems and style language for their scene. For techno fans nothing is sacred in their stylisation and staging, least of all what is (culturally) sacred. The rave generation that samples and reshapes everything is, as Ralf Vollbrecht put it, 'the first post-modern youth culture ... that seeks nothing less than obligatory content'.[23]

But the fact that playfully tinkering with style and sense and the ecstatic dancing experience go hand in hand with a growing drug consumption is often overlooked. Scene-typical language games and expressions for the use of ecstasy, amphetamines or speed serve to cover up and play down the drug problem rather than shed light on it and assess it realistically.[24]

## 4. Adolescent media cultures as fields of experience and staging

The loosely structured arrangement of cliques, clubs and scenes generated and intensified by the media does not claim to be complete.[25] It has become visible, however, that the trend towards separation and segregation from homogeneously aged groups, especially emphasised and adequately proved in youth and leisure-time sociology as increasingly important informal socialisation authorities, finds its continuation and style-bound intensification in the special media cultures studied. On the one hand, they represent 'identity markets' where adolescents, free from the routine and demand character of their other role obligations, can test and practise strategies for self-projection and make sure of their personal and social identity in group play and a group mirror, so to speak. On the other hand, however, they are also 'competence markets' at which a specific socialisation and the formation of media use takes place.

It is above all the media- and scene-experienced adolescents who show an astonishing productivity and creativity in handling the media and their content. In doing so, their participation in the collectively shared spectrum of knowledge and in the cosmos of meaning deepens and consolidates a genre-specific media competence and a degree of specialisation that extends far beyond the everyday knowledge provided by the media.

In the styles of media use of the music, film, computer and network freaks who were researched not only a particular media competence and decoding practice manifests itself – here one could also speak of the adolescents' own form of incorporated cultural capital, as Pierre Bourdieu[26] put it – but they also create effective alliances and experience forms that are typical of the scene. Their festivals, happenings and sessions mark (from the perspective of civilisation theory) an overstepping of the limits of everyday order and a greater need for stimuli.

At the same time the media they prefer take over the function of impulse senders and transformers. They constitute a special situation, in which disciplining emotions caused by civilisation can be broken open and – at least temporarily – overcome. Jan-Uwe Rogge (1988) explains the vehemence with which adolescents make use of the range of experiences offered by the media-culture as the expression of a fundamental disorder in the civilisation process. It seems more appropriate to us to talk of the civilisation process splitting up into parts in view of the way in which adolescents' media and emotion cultures have become more diverse and numerous.

The media freaks and their practices that transcend everyday life are examples of the fact that under (post)modern conditions of life and existential circumstances the integration of emotions and experience is taking place less and less throughout society, but rather in special cultures and restricted space zones. What counts today is managing the emotions in a way that is adapted to the situation. 'Framing' and 'modulating' in the sense of Erving Goffman (1977) determine in each case what is admissible and/or required. General controls of emotions are being replaced by learning situational definitions and separation rules.

Here lies, of course, an explosive charge, as the acquisition of the appropriate competencies is a process full of prerequisites, because not absolute rules but tricky conditional programmes have to be internalised. The media fans we examined possess this script knowledge, although not from the outset. It is more the result and final stage of a specific reception and media career. It is especially the freaks, ie the group of adolescents who are rooted most deeply in their particular special culture, who develop an astounding virtuosity while functionalising external (determined by the media) circumstances for internal (emotional) states. They are in the end prototypical representatives of the increasing dominance of experience rationality diagnosed for present-day society.[27]

## 5. Media produce a distinction between youth cultures

If an attempt is made to consider the findings of our study from a perspective that places more emphasis on the sociology of culture and differentiation, it can be noted that the multiplicity of possible uses and codings opened up by the media leads to the emergence of new special cultures – and this by no means just among adolescents. Combined with

that is an intensification of self-chosen and self-defined life. Personal identity is increasingly consolidated through media specialisations and groupings. New forms of distinction tied up with the media and scenes establish themselves beyond status, class and social strata.

These findings clearly contradict the conviction still widely held in certain circles of the critique of culture that the communication media are the great cultural egalitarians or even the producers of a colourless and one-dimensional homogeneous culture. Analogous to Dahrendorf's idea of a 'levelled middle-class society' from the 60s, here – on a global scale, however, – it is claimed that there is a 'levelled world culture', one. That is meant to cover the developments and consequences of transcultural media communication that contribute to internationally standardised interaction patterns, values, norms and needs.

In this connection Siegfried Schmidt (1994) talks about 'de-differentiation' phenomena which are expressed in such slogans – usually with a negative connotation – as growing anonymity, Americanisation or also commercialisation. So what is meant by de-differentiation is that mass media – and television in particular here – lead to worldwide standardisations. Barbara Sichtermann recently put this in a nutshell in a television review in the newspaper *Die Zeit*: 'There's still no remedy for the Americanisation of German – and not only German – TV entertainment.' [28]

The adaptation processes that go hand in hand with the world-wide marketing of media products represent, however, only one aspect of the effect. Our research findings provide clear evidence of the fact that processes of differentiation have also been set in motion that cannot be overlooked. Thus the various media and programme genres not only make possible new opportunities for choice, but also open up greater room for manoeuvre and thus contribute to an increase in the numbers of social worlds and worlds of meaning. Borne by the media and the forms they offer, new patterns of action and attribution as well as specialised communities thus begin to develop their own distinctive features with their own forms of style and communication.

This growth in numbers can be elucidated in two areas. First, cultural forms of practice are 'dehierarchised', which means that the once firmly established distinctions of a hierarchically structured advanced culture, which knows only advanced and primitive culture, essential and superficial things, good and bad taste, are replaced by special cultures that vie with one another and develop specific forms of media use and patterns of everyday aesthetics and interpretation.

Secondly, the horizontal differentiation process, which is documented in ever new and increasingly specialised elective proximities, also reduces the notional range of sub-culture concepts, insofar as they still take as their point of departure a hierarchical relationship between culture and partial culture. We use the term special culture to try to take account of these transformations. This applies to a

great extent to adolescent media cultures. They are not sub- or countercultural drafts, but they combine the traditional, hegemonic culture with very different partial cultures. But the media do not displace the other realities, they increase their numbers.

## 6. Youth scenes as places of self-determined and creative media activities

It can be shown in the light of the cultural orientations and aesthetic practices of the media freaks we studied to what a great extent the dynamics of the market and its progressive differentiation is always producing new scenes with their own patterns of expression. The different media and their differential modes of appropriation can thus be interpreted as an integral component of a process whose time-diagnostic key terms – individualisation, erosion of tradition, a growth in the numbers of lifestyles – signalise that modern times are undergoing a fundamental change.

What is being talked about is the successive detachment from (and dissolution of) collectively binding norms and relations. Categories like origin, gender roles, family, neighbourhood and religion are losing their formative power in present-day society. That means life plans that were originally socially marked out are becoming individually available and entering the realm of the individual to an increasing extent.

Like no one else, Hans Magnus Enzensberger (1991) has vividly described the increase in self-determination and exclusivity of style, namely as a form of the 'exoticism of everyday life', which is where our research work is also positioned. Whether adolescent video cliques or the *Lindenstrasse* fan groups, whether techno fans or the computer and network scenes that are splitting up into more and more sub-groupings, what is becoming visible here are small life-worlds in whose scenic frameworks the insiders, on the one hand, appear as independent designers of everyday relations and orders, but, on the other, carry out a movement of visible and explicit demarcation and withdrawal on a socio-cultural level.

Their adolescent protagonists announce style communities, which in a smooth transition adapt to the colourful, pluralistic world of contemporary youth formations. What applies to the latter is pointed out by Baacke and Ferchhoff (1988, p. 318): 'The principally leisure-related scenes and youth cultures strengthen a tendency in which young people are no longer available for conventional ideas of development and personality, for they choose ... their own values of achieving their motives in a sensitive reaction to the conditions of the entire culture and what it has to offer.'

How do the young people deal with the lack of limitations to their options? It can be stated that, under conditions of increasing opportunities to choose from, life does not become simpler, nor simply happier, as the expanding demands may not be met and disorientation and loss of stability may result.

In view of the large number of possibilities and almost incalculable societal developments there are growing doubts as to whether the choice made does not constitute a commitment which allows what is real and better to be missed. The contrast between being culturally released, on the one hand, and the standardisations in the workplace, on the other, is also experienced as especially crisis-prone. This tense situation emerges most clearly in the case of work preferences and the great demands made on people at their job. Here the young people learn often quite soon (and clearly, too,) how restricted the limits of what is feasible can be; disappointment and bitterness are then often the consequence. (Vogelgesang 1994, p.26)[29]

What effects the experiences of a restrictive, contradictory and segmented everyday world have on the person-forming process and individual identity is at present one of the most explosive questions in the discussion about adolescents. Phrases such as 'patchwork identities'[30], 'collage-self'[31], 'individually tinkering with sense'[32] and 'reflexive self'[33] indicate the direction being taken by a new conceptualisation of the notion of identity in which creative strategies of self-organisation are considered possible.

Perhaps the disposition of the media freaks can be regarded as, so to speak, prototypical of the fact that young people in the maelstrom of modernity do not by any means have to go under, are not necessarily overwhelmed by overpowering media-determined circumstances of existence in which 'pictures of the world ... (have been) replaced by worlds of pictures'.[34] Instead, the scene becomes a social and media anchoring ground where competence is acquired under one's own direct control. One comes to an arrangement with the challenges of the media and information society, not passively and painfully, but productively and creatively.

The adolescents' cognitive and cultural mobility turns them into a sort of nomads in the 'multi-option society' (Gross 1994) who feel equally at home on real-life and fictitious paths. Perhaps their walks are occasionally tightrope walks, but they are not experienced as a threat, but rather as a 'neo-tribal form of life' (Maffesoli 1988) they take for granted.

In the end it is precisely perception and playing with the difference between real life and imagination, reality and mediality or virtuality that, as it were, constitute their media competence and their forms of experience. By no means do they lose contact with everyday reality, nor do they make permutations as in the sense of the graffito: 'Life is xerox, we are just a copy'. But, rather, they are competent commuters between social and media worlds, and that not rarely with a matter-of-factnesss and self-assurance which is reminiscent of Woody Allen's film *The Purple Rose of Cairo*, in which he lets his hero step out of the screen and his heroine dive into the imaginary world of the cinematic game.

# References

Altrogge, M. and Amann, R. (1991). *Videoclips – die geheimen Verführer der Jugend?*. (Video clips – the hidden persuaders of young people?) Berlin.

Androutsopoulos, J.K. (1997). *Jugendsprache und Textsorten der Jugendkultur* (Youth language and the kinds of texts of youth culture). Heidelberg (Diss.).

Anz, P. and Walder, P. (eds) (1995). *Techno*. Zürich.

Assmann, A. and Assman, J. (1994). Das Gestern im Heute. Medien und soziales Gedächtnis (What was yesterday today). In K. Merten, S.J. Schmidt and S. Weischenberg (eds) *Die Wirklichkeit der Medien* (The reality of the media). Opladen; pp. 114-140;

Austin, B.P. (1981). Portrait of a cult film audience: The Rocky Horror Picture Show. *Journal of Communications*, 31(2), pp. 43-54.

Baacke, D. and Ferchhoff, W. (1988). Jugend, Kultur und Freizeit (Youth, culture and leisure time). In H.-H. Krüger (ed) *Handbuch der Jugendforschung* (Handbook of youth research). Opladen; pp. 318.

Behne, K.-E. and Müller, R. (1996). Rezeption von Videoclips – Musikrezeption (The reception of video clips – music reception.) *Rundfunk und Fernsehen*, 44(1996) 3, pp. 365-380.

Böpple, F. and Knüfer, R. (1996). *Generation XTC. Techno und Ekstase* (The XTC generation and Ecstasy). Berlin.

Bourdieu, P. (1983). *Die feinen Unterschiede* (The subtle distinctions). Frankfurt/Main.

Bundeszentrale für gesundheitliche Aufklärung (German Federal Agency for Health Education)(ed). *Ecstasy*. Cologne.

Diedrichsen, D. (1985). *Sexbeat*. Cologne.

Dworschak, M. (1996). Digital Born Killers. *Die Zeit* 19 January 1996, pp. 74

Eckert, R., Vogelgesang, W., Wetzstein, T.A. and Winter, R. (1990). *Grauen und Lust – Die Inszenierung der Affekte. Eine Studie zum abweichenden Videokonsum* (Horror and desire – The staging of emotions. A study of divergent video consumption). Pfaffenweiler.

Eckert, R., Vogelgesang, W., Wetzstein, T.A. and Winter, R. (1991). *Auf digitalen Pfaden. Die Kulturen von Hackern, Crackern, Programmierern und Spielern* (On digital paths. The cultures of hackers, crackers, programmers and players). Opladen.

Engel, C. (1996). Inhaltskontrollen im Internet. (Contents contoll in the Internet.) *Archiv für Presserecht* (Archives for press legislation), 27(3), pp. 220-227.

Enzensberger, H.M. (1991). *Mittelmaß und Wahn* (Mediocrity and madness). Frankfurt/Main.

Ernst, T. (Red.). (1993). *Computerspiele – Bunte Welt im grauen Alltag* (Computer games – a bright world in dull lives). Rötzer, F. (ed) (1995). *Schöne neue Welten? Auf dem Weg zu einen neuen Spielkultur*. Munich.

Ferchhoff, W., Sander, U. and Vollbrecht, R. (eds) (1995). *Jugendkulturen – Faszination und Ambivalenz* (Youth cultures – fascination and ambivalence). Munich, Weinheim.

Flichy, P. (1994). Tele: *Geschichte der modernen Kommunikation* (The history of modern communication). Frankfurt/Main.

Friedrichsen, M. and Vowe, G. (eds) (1995). *Gewaltdarstellungen in den Medien* (Depictions of violence in the media). Opladen. Kunczik, M. (1993). *Medien und Gewalt*. Cologne – Vienna.

Fritz, J. and Fehr, W. (1995). Im Sog der Computer- und Videospiele. (In the vortex of computer and video games). *Medien Praktisch*, 19 (2), pp. 21.

Goffman, E. (1977). *Rahmen-Analyse* (A framework analysis). Frankfurt/Main.

Grassmuck, V. (1994). 'Allein, aber nicht einsam' – die otaku-Generation. Zu einigen neuen Trends in der japanischen Populär- und Medienkultur. In N. Bolz *et al.* (eds) *Computer als Medium*. Munich; pp. 270.

Gross, P. (1994). *Die Multioptionsgesellschaft* (A multioptional society). Frankfurt/Main.

Hartmann, H.A. and Haubl, R. (Anm. 12), Homfeldt, H.G. (ed) (1993). *Erlebnispädagogik* (Experience pedagogics). Hohengehren. Schulze, G. (1992). *Die Erlebnisgesellschaft*. Frankfurt/Main.

Helsper, W. (1991). Das imaginäre Selbst der Adoleszenz: Der Jugendliche zwischen Subjektentfaltung und dem Ende des Selbst (The imaginary self of adolescence. The young person between subject development and the end of self). In W. Helsper (ed) *Jugend zwischen Moderne und Postmoderne* (Youth between modernity and postmodernity). Opladen; pp. 74.

Hitzler, R. (1991). Der banale Proteus. Eine 'postmoderne' Metapher (The banal Proteus. A 'post-modern' metaphor). In H. Kuzmics and I. Mörth (eds) *Der unendliche Prozeß der Zivilisation*. Frankfurt/Main – New York: pp. 223.

Hoffmann, R. (1981). *Rockstory. Drei Jahrzehnte Rock & Pop Music von Presley bis Punk* (Rock story. Three decades of rock & pop music from Presley to punk). Frankfurt/Main.

Höhn, M., Rößler, B. and Vogelgesang, W. (1997). *Techno: Design als Sein. Ein Forschungsbeitrag zur Ästhetisierung und Instrumentalisierung von Werbung in Jugendszenen* (Techno: design as existence. A research contribution to aesthetising and instrumentalising advertising in youth scenes). Trier (Ms.).

Janke, K. and Niehues, S. (1995). *Echt abgedreht. Die Jugend der 90er Jahre* (Cool. The youth of the 90s). Munich.

Jugendschutz im Internet unmöglich (Protecting young people in the Internet impossible). *Trierischer Volksfreund* vom 3–4 January 1996, pp. 1.

Keppler, A. (1994). *Wirklicher als die Wirklichkeit? Das neue Realitätsprinzip der Fernsehunterhaltung* (More real than reality? The new reality principle of television entertainment). Frankfurt/Main.

Keupp, H. (1990). Lebensbewältigung im Jugendalter aus der Perspektive der Gemeindepsychologie (Coping with life in adolescence from the perspective of community psychology). In Ders. (ed) *Risiken des Heranwachsens. Materialien zum 8. Jugendbericht, Bd. 3*. Weinheim – Munich; pp. 25.

Klinger, J. and Schmiedke-Rindt, C. (1996). Fantome einer fremden Welt. Über subkulturellen Eigensinn (Phantoms of an alien world. On subcultural stubborness). In H.A. Hartmann and R. Haubl (eds) *Freizeit in der Erlebnisgesellschaft* Opladen; pp. 147-166.

Kunczik, M. (1988). Medien, Kommunikation, Kultur. *Bertelsmann Briefe*, -(123), pp. 10.

Lau, T. (1995). Rave New World. Ethnographische Notizen zur Kultur der 'Technos' (Ethnographical notes on the culture of the 'technos'). In H. Knoblauch (ed) *Kommunikative Lebenswelten*. Konstanz: pp. 245-259.

Lohaus, P. (1995). *Moderne Identität und Gesellschaft* (Modern identity and society). Opladen.

Luhmann, N. (1981). Veränderungen im System gesellschaftlicher Kommunikation und die Massenmedien (Changes in the system of social

communication and the mass media). In Luhmann. *Soziologische Aufklärung 3.* Opladen; pp. 309-320.

Lynd, R.S. (1929). *Middletown: A study in American culture.* New York.

Maffesoli, M. (1988). *Le temps des tribus* (The time of tribes). Paris.

Mittelstrass, J. (1996). Kommt eine neue Kultur? Auf der Suche nach Wirklichkeit im Informationszeitalter (Is a new culture on the way? In search of reality in the information age), *Universitas*, 6, pp. 537.

Müller, S. (1997). Techno lebt! (Techno lives!). *Frankfurter Rundschau*, 15 February 1997, pp. 35.

Münch, T. and Boehnke, K. (1996). Rundfunk sozialisationstheoretisch begreifen – Hörfunkaneignung als Entwicklungshilfe im Jugendalter (Understanding radio from a socialisation viewpoint –radio acquisition as a development aid in adolescence). *Rundfunk und Fernsehen* (Radio and television), 44 (4), pp. 548-561.

Pette, C. and Charlton, M. (1997). Videosessions – ritualisierter Rahmen zur Konstruktion von Gefühlen (Video sessions – a ritualised setting for constructing feelings). In M. Charlton and S. Schneider (eds) *Rezeptionsforschung.* Opladen; pp. 219-240.

Redhead, S. (ed) (1993). *Rave off. Politics and deviance in contemporary youth culture.* Aldershot *et al.* Saunders, N. and Walder, P. (eds) (1994). *Ecstasy.* Zürich.

Richard, B. (1995). Love, peace and unity. Techno – Jugendkultur oder Marketing Konzept? (Techno – youth culture of marketing concept). *Deutsche Jugend*, 43 (7-8), pp. 316-324.

Richard, B. and Krüger, H.-H. (1995). Vom 'Zitterkäfer' (Rock'n'Roll) zum 'Hamster im Laufrädchen' (Techno)(From the 'shaking beetle' (rock 'n' roll) to the 'hamster in the running wheel' (techno)). In W. Ferchhoff, U. Sander and R. Vollbrecht (eds) *Jugendkulturen – Faszination und Ambivalenz.* Weinheim: Munich; pp. 93-109.

Rogge, J.-U. (1988). *Gefühl, Verunsicherung und sinnliche Erfahrung* (Feeling, uneasiness and sensual experience). *Publizistik*, 33 (2-3), pp. 243-263.

Schmid, C. (1994). *Glücksspiel* (Game of chance). Opladen.

Schmidt, S.J. (1994). *Kognitive Autonomie und soziale Orientierung* (Cognitive autonomy and social orientation). Frankfurt/Main.

Sichtermann, B. (1997). Löschen heißer Ladung (Off-loading hot freight). *Die Zeit* 16 January 1997, pp. 47.

Sonntag, S. (1968). Anmerkungen zu 'Camp' (Comments on 'camp'). In Dies. *Kunst und Antikunst. 24 literarische Analysen k.* Reinbek; pp. 268.

Spohr, B. (1996). Techno – Party – Drogen. *Info-Dienst der Landesstelle Jugendschutz Niedersachsen* (Information Service of the Lower Saxony Agency for Children and Young Persons), -(2), pp. 4-9.

Tenbruck, F.H. (1989). *Die kulturellen Grundlagen der Gesellschaft* (The cultural bases of society). Opladen.

Vogelgesang, W. (1991). *Jugendliche Video-Cliquen* (Adolescent video-cliques). Opladen. ders. (1994). Jugend- und Medienkulturen (Youth and media cultures). *Kölner Zeitschrift für Soziologie und Sozialpsychologie*, 46(4), pp. 464-491.

Vogelgesang, W. (1994). *Jugendliche Lebenswelten im Wandel* (Changing adolescent life-worlds). Trier.

Vogelgesang, W. (1994). *Mediale und nicht-mediale Erfahrungen der Wirklichkeit*

357

(Media and non-media experiences of reality). Trier (Ms.)...

Vogelgesang, W. (1995). Jugendliches Medien-Fantum. Die Anhänger der 'Lindenstraße' im Reigen medienvermittelter Jugendwelten (Adolescent media fandom. The supporters of 'Lindenstrasse' in the various youth-worlds conveyed by the media). In M. Jurga (ed) *Lindenstraße*. Opladen; pp. 175-192.

Vogelgesang, W. (1995). *Medien und Gewalt: Fakten und Meinungen im Widerstreit* (Media and violence: the clash of facts and opinions). *Psychosozial*, -(1), pp. 99-110.

Vogelgesang, W. (1997). *Jugend, Medien, Szenen* (Youth, media, scenes). Opladen.

Vogelgesang, W. and Wetzstein, T.A. (1993). *Die Vervielfältigung der Kommunikation in Computerkulturen* (The duplication of communication in computer cultures). *Widersprüche* (Contradictions), -(4), pp. 35-44.

Vogelgesang, W. and Winter, R. (1990). *Die Lust am Grauen – Zur Sozialwelt der erwachsenen und jugendlichen Horrorfans* (The pleasure of horror. The adult and adolescent horror fans' social world). *Psychosozial*, -(4), pp. 42

Vollbrecht, R. (1997). Jugendkulturelle Selbstinszenierungen (Youth cultural self-projections). *Medien und Erziehung*, 41(1), pp. 13 f.

Walther, J.B. (1996). Computer-mediated communication: Impersonal, interpersonal, and hyperpersonal interaction. *Communication Research*, 23(1), pp. 3-43.

Wandl, J. (1985). *Computer und Lernen* (Computers and learning). Munich.

Wetzstein, T.A., Dahm, H., Steinmetz, L., Lentes, A., Schampaul, S. and Eckert, R. (1995). *Datenreisende. Die Kultur der Netze* (Data voyagers. The culture of the networks) Opladen.

Winter, R. (1995). *Der produktive Zuschauer* (The productive viewer). Munich. Baacke, D., Schäfer, H. and Vollbrecht, R. (1994). *Treffpunkt Kino*. Weinheim – Munich.

Winter, R. (1996). Punks im Cyberspace (Punks in cyberspace). *Medien Praktisch*, 20(1), pp. 20.

## Notes

1   This contribution to *TelevIZIon* 10/1997/1 (pp. 27–39) is a slightly abridged version of an article in the supplement *Aus Politik und Zeitgeschichte* B19-20/97 of the weekly newspaper *Das Parlament*.

2   In this connection the following works, for example, are of fundamental importance: Assmann and Assmann 1994; Flichy 1994; Luhmann 1981; Tenbruck 1989.

3   The *Forschungsgruppe Medienkultur und Lebensformen* is an interdisciplinary team that has been working empirically in the field of sociological media and culture research since 1985. Apart from quantitative-representative surveys, more qualitative research has been carried out in recent years. Here themes focused on the electronic media (video, tele-games and computers). At present the group is examining the cultural aspects of the growing telecommunicative networking. In 1993 the research group changed its name to '*Arbeitsgemeinschaft sozialwissenschaftliche Forschung und Weiterbildung*' at the University of Trier. The major research findings are published in: Eckert et al 1990; Eckert et al 1991; Vogelgesang 1991; Vogelgesang 1994; Vogelgesang 1997; Wetzstein *et al.* 1995.

4   Quoted in Hoffmann 1981, p. 24.

5   Cf. Lynd 1929. Otherwise still valid up until the present is the observation that for young people music is 'ringing time', as it were, and an expression of a socio-cultural feeling of identity. On their enthusiasm for music and distinguishing music-determined youth scenes cf. Richard and Krüger 1995; Münch and Boehnke 1996.

6   What productivity and creativity adolescent film fans display and with how much selectivity and specialisation films are connected to individual or scene-typical activities is shown, for example, in the studies by Winter 1995; Baacke, Schäfer, and Vollbrecht 1994.

7   Characteristic of the video clips are the camera angles which often last only fractions of a second and consist of a profusion of quotations and allusions. They work with surrealistic elements, radicalise the

principle of montage and thus produce a world which is (seemingly) diametrically opposed to what can commonly be recognised and interpreted. That conventional seeing and hearing and proven deciphering codes come up against limitations in the music video in view of the flood of pictures and sounds is obvious, since only against the background of perception blockages are labels like 'terror aesthetics' or 'mincemeat cinema' intelligible for these cultural products of the new media. In well-researched empirical works, however, it has been possible to furnish evidence not only of the existence of a media ethno-centrism but also of a specific media literalness, for with the enjoyment of a rapid change of pictures a refined sensorium for aesthetic processes also develops in the young viewers: cf. Altrogge and Amann 1991; Behne and Müller 1996. The traces of self-determined media socialisation that emerge here may announce a shift in the socially prevailing mode of perception away from the 'dominance of the conceptual', typical of adults, to a 'dominance of the visually symbolical' that is typical of adolescents (cf. Vogelgesang 1994).

8    Cf. Austin 1981.

9    Cf. Klinger and Schmiedke-Rindt 1996.

10   Cf. *Trierischer Volksfreund* 31 October1994, p. 7. That the Trier Trekkies are not inactive can also – under the heading 'Together with Kirk' – be gathered from the following press release (Trierischer Volksfreund of 27 June 1996, p. 10): 'At present all *Star Trek* fans can appear arm in arm with Kirk, Scotty, Spock and Doc in the Trier Municipal Library. The great heroes of the cult series *Raumschiff Enterprise* and the *Star Trek* series are standing as cardboard comrades in the centre of a great exhibition. The Trier fan club ... has brought together numerous glass cases brim-full with exhibition material: posters, books, videos and magazines as well as uniforms and other fan articles. To open the exhibition the short film produced under the direction of the club 'Enterprise Goes Alliance' was shown.'

11   The empirical data are based on a combination of quantitative (n=660) and qualitative (n=35) interviews with young people aged from 14 to 18. A detailed presentation of the findings can be found in: Vogelgesang (1997). Our findings were recently confirmed by Pette and Charlton 1997.

12   On the (still ongoing) controversy with regard to the effect on children and young people of presentations of violence in the media cf. Friedrichsen and Vowe 1995; Kunczik 1993; Vogelgesang 1995.

13   Cf. Vogelgesang 1995.

14   Cf. Ernst 1993; Rötzer 1995. That the use behaviour in the case of slot machines is completely different should be explicitly stated here (cf. Schmid 1994).

15   Manfred Dworschak in *Die Zeit;* 19 January 1996, p. 74.

16   Cf. Engel 1996, and the article 'Jugendschutz im Internet unmöglich' in *Trierischer Volksfreund,*3–4 January 1996, p. 1.

17   Eckert *et al.* 1990, 1991; Wetzstein *et al.* 1995.

18   Cf. Vogelgesang and Wetzstein 1993; Walther 1996.

19   Stefan Müller in *Frankfurter Rundschau ;* 15 February 1997, p. 35.

20   On the size, structure and dynamics of the techno scene cf. Anz and Walder 1995; Böpple and Knüfer 1996; Lau 1995; Richard 1995.

21   Jörg Hunold and Baschar Al-Frangi were participants in the research seminar I held in the 1996/97 winter semester 'Kultische Milieus: Techno'. I owe them and the other students a sincere debt of gratitude for their intensive and meticulous research and analyses of the scene.

22   Cf. Androutsopoulos 1997; Höhn, Rößler and Vogelgesang 1997.

23   Vollbrecht 1997, p. 13 f.

24   Cf. Bundeszentrale für gesundheitliche Aufklärung (no date); Spohr 1996; Redhead 1993; Saunders and Walder 1994.

25   The work of the following also provide information on the growing numbers, forms and transience of youth and media cultures: Ferchhoff, Sander, and Vollbrecht 1995; Janke and Niehues 1995.

26   Bourdieu 1983, p. 186 f.

27   On the importance of experience worlds and experience cf. Hartmann and Homfeldt (1993); Schulze 1992.

28   Barbara Sichtermann in *Die Zeit ,* 16 January 1997, p. 47.

29   Vogelgesang 1994, p. 26.

30   Keupp 1990; p. 25.

31   Helsper 1991, p. 74.

32   Hitzler 1991, p. 223.

33   Lohaus 1995, p. 193.

34   Mittelstraß 1996, p. 537.

# Adolescents and politics on television[1]

*Birgit van Eimeren and Brigitte Maier-Lesch*

## 1. Media use by adolescents

Today's 14- to 19-year-old adolescents have grown up into a society in which to a great extent the media set the tone of everyday life. They are the first generation to be confronted from childhood by the so-called 'dual system', ie a broadcasting system that is served by both public service and commercial or private programme providers, and that means an exposure to a large number of television and radio channels and programmes round the clock. Accordingly, having grown up in the media age means that children's and adolescents' world of experience has been conveyed to them by the media. The media are taking over the functions of the family as a socialisation authority more and more frequently by presenting role models and thus implicitly conveying values and norms.

Communication in the peer group is initiated through, with and via the media. This can be seen in the case of the so-called new media, for instance, which have established themselves in the adolescents' leisure-world in the form of computer and video games. But it can also be seen in the adolescents' everyday life, because media, on account of their comprehensive availability and their possibilities for multiple use, are integrated into the young people's daily routine as a matter of course.

In the following, an overview of the media equipment owned by adolescents in a time comparison will be given first; then a description of the use frequency will show how media use has developed in recent years and what 14- to 19-year olds' main areas of interest in the media are.[2]

### 1.1 Equipment owned by adolescents

The availability of electronic media in households in which at least one 14- to 19-year-old lives has grown very considerably in the last two decades. Over four-fifths of young people in German households today have access to a stereo/hi-fi set, to cassette recorders and CD players. Whereas in 1980 only 5 per cent of the young people could use the feature films offered by the video libraries, today 83 per cent of the 14- to 19-year-olds can avail themselves of these videos because of the enormous increase in video cassette recorders (see Table 1).[3]

360

Table 1: **Equipment owned by adolescents**
(in a comparison of 1980, 1994 and 1996; in %)

| Equipment owned or available | 1980 | 1994 | 1996 |
|---|---|---|---|
| Television – black & white or colour | 99 | 99 | 99 |
| Video cassette recorder | 5 | 70 | 83 |
| Videotext reception | -* | 54 | 70 |
| Stereo/hi-fi set | 58 | 86 | 91 |
| Radio (stationary) | 59 | 84 | 49 |
| Cassette recorder (audio tape) | 77 | 83 | 89 |
| CD player | -* | 71 | 85 |

* Not surveyed

*1.2 Television use according to coverage, viewing duration and market shares*

Watching television is right at the top of the adolescents' list of priorities for leisure-time activities: 93.7 per cent of the young people between 14- and 19- years of age representatively interviewed as part of the Media Analysis (MA) 96 watch television 'several times a week'. (The study conducted by the BR and ZDF 'Youth and the Media' yields comparable results.)

The daily viewing duration of the 14- to 19-year-old age group increased from an average of 80 minutes to 112 minutes between 1990 and 1996. As Table 2 shows, the proportion of 14- to 19-year-olds watching television on an average day and the intensity of their television use is, however, far lower than in the case of adults.

Table 2: **Television use by age groups**

| Age in years | % reached | | | Viewing time in minutes | | |
|---|---|---|---|---|---|---|
| | 1990* | 1993* | 1996** | 1990* | 1993* | 1996** |
| 14-19 years old | 51 | 55 | 56 | 80 | 93 | 112 |
| 20-29 years old | 48 | 55 | 61 | 92 | 118 | 143 |
| 30-39 years old | 68 | 71 | 71 | 138 | 161 | 179 |
| 40-49 years old | 71 | 73 | 74 | 158 | 174 | 198 |
| 50-64 years old | 78 | 78 | 77 | 187 | 205 | 218 |
| From 65 years | 82 | 83 | 81 | 226 | 242 | 253 |

* Mon – Sun, 6.00 am – 6.00 am – whole of Germany
** Mon – Sun, 3.00 am – 3.00 am – whole of Germany

The young people's television use differs not only quantitatively from that of adult viewers. Also with regard to the range of the programme genres that interest them obvious differences emerge: In contrast to the totality of viewers, they distribute their preferences over fewer programmes and genres. In 1996 the young people's favourite programmes – RTL with a 19.7 per cent and Pro 7 with a 17.6 per cent market share – ranked well above the ARD (8.7 per cent), ZDF (6.7 per cent) and the (regional) Third Programmes (5.3 per cent).

As Figure 1 on the ARD use according to programme genres shows, the predominant interest of the 14- to 29-year-olds is in the genre feature films, which they very disproportionately avail themselves of both in comparison with the overall population and with the volume of programmes offered. Another main area of interest is the sports broadcasts. This genre is also used disproportionately in comparison with what is offered. On the other hand, the genre information shows a clear lack of use. Correspondingly, the top one hundred broadcasts viewed most by adolescents in 1996 consist almost exclusively of feature films and football transmissions.

Figure 1: **Programme genres offered within the general programme of the ARD and their use by 14- to 29-year-olds compared with the total audience**
(Mon–Sun, 3.00 am–3.00pm, whole of Germany, in %)

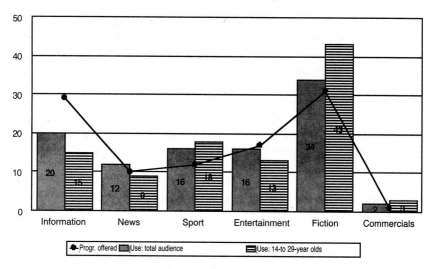

### 1.3 Audio, video and radio use

In the case of the current affairs media radio and daily newspaper the adolescents are clearly underrepresented. Conversely, they use audio recording media to a greater extent. However, the time they devote to the recording media, too, reaches far too low a level for it to compensate for the little use made of classic mass media (see Table 3).

Table 3: **Use duration per day in minutes (Mon – Sun)[4]**

| Radio | Daily newspaper | Video | CDs, audio cassettes etc | |
|---|---|---|---|---|
| 14-19 years | 117 | 13 | 6 | 35 |
| Adults from 14 years | 173 | 33 | 3 | 11 |

Compared with the whole population adolescents show a rather low use of the classic media television, radio and daily newspapers. In view of their preference for entertainment-oriented television programme genres and a simultaneous increase in their use of recording media, the question is raised as to how far these lines of development are connected with a decline in adolescents' interest in information in general and in political information in particular.

## 2. Adolescents' political interest and their use of current affairs programmes

Politics is certainly one of the adolescents' areas of life which have only little importance within their world of experience. This finding is not new, nor is the declining interest in politics within the population a youth-specific phenomenon. This is shown, for example, by the ARD/ZDF long-term study *Massenkommunikation*, which has been updated at five-year intervals since 1964.[5] According to the latest of these studies conducted in 1995, 25 per cent of the 14- to 19-year-old Germans are politically interested, whereas 43 per cent of the overall German adult population can be classified as politically interested.

### 2.1 The political understanding of adolescents

Within a representative survey conducted by the IZI, the Bayerischer Rundfunk (BR) and the Südwestfunk (SWF) at the beginning of 1997,[6] 29 per cent of the German adolescents between 12 and 19 years of age are interested in politics. A greater political interest – as other studies have previously shown – is to be found among the male and older adolescents and among young people with a higher level of formal education (see Tables 4 and 5).

Table 4: **Interest of adolescents in politics**
(answers in %; 'interested' or 'very interested')

| Whole of Germany | West Germany | East Germany | 12-13 years | 14-15 years | 16-17 years | 18-19 years |
|---|---|---|---|---|---|---|
| 29 | 29 | 24 | 12 | 26 | 37 | 51 |

Table 5: **Interests of adolescents in politics**
(answers in %; 'interested' or 'very interested')

| All | Boys | Girls | Secondary modern (GCSE) | Secondary | 'Abitur' |
|---|---|---|---|---|---|
| 29 | 34 | 25 | 18 | 22 | 36 |

According to our 1997 study the adolescents have very mixed attitudes towards politics. Its importance, since it determines the future, is at least

recognised by one in two adolescents. An equally large group, however, regards politics as too complicated to be understood. The job profile of the politician probably has the worst image of all: for 59.6 per cent of the 12- to 19-year-olds politicians are 'mainly interested in power, not in the people's problems'. There is only agreement among the adolescents that 'politics does not pay enough attention to the concerns of young people' (82 per cent).

Accordingly politics is seldom the subject of conversation with their peers: only six per cent of the 12- to 19-year-olds talk 'frequently' about current political events; politics is on the list of conversation subjects of a further 20 per cent at least 'sometimes'. A generally low interest in current political and social events corresponds with this: only 29 per cent of the German adolescents classify themselves as '(very) interested in current affairs'.

### 2.2 Contact with current information

The little importance attached to current political events by young people has a serious effect on the use of the current affairs media television, radio and print. According to long-term analyses from the study *Massenkommunikation*, in 1990 12 per cent of West German adolescents were still being reached by political information through all three current affairs media, but in 1995 only seven per cent. Of the whole population the proportion of 'fully supplied' dropped from 28 per cent to 23 per cent. In the same period, the coverage of political information on television dropped from 65 per cent to 59 per cent. In 1995 only one in three of the adolescents came into contact with political information on television every day (42 per cent in 1990).

The coverage of current affairs information, of the news therefore, dropped very sharply in the case of adolescents: while, in 1990, 44 per cent of West German adolescents said they watched the news every day, in 1995 it was only 34 per cent.

The IZI/BR/SWF study showed parallel results: the proportion of daily/almost daily news viewers among the German 12- to 19-year-olds is 36 per cent. Conversely, the proportion of adolescents who come into contact with news only every 14 days or more rarely is 28.6 per cent.

Reasons given for not or rarely using news are above all the boring form of presentation and the lack of interest in news contents, which in the case of most who do not watch the news results in their switching to another programme when the news comes on.

However, even among the young people who regularly see the news it cannot necessarily be assumed that they are very interested in current affairs. Many of them just carry on watching the news on the programme that they happen to be viewing. Accordingly, the favourite news of the young adults is frequently current affairs programmes on their favourite commercial channels (ie *Pro 7 Nachrichten* and *RTL News*). However, 16.8

per cent of them also say their favourite news broadcast is the *Tagesschau*, nationwide the most successful of its kind, which places it just behind *RTL News* (17.5 per cent) and ahead of the *Pro 7 Nachrichten* (15.2 per cent), as is shown in Table 6.

Table 6: **The favourite news broadcasts of the German 12- to 19-year-olds** (open answers in %; only answers over 2%)

|  | All | Secondary modern school | Secondary school (GCSE) | 'Abitur' |
|---|---|---|---|---|
| RTL aktuell (6.45 p.m.) | 17.5 | 17.3 | 22.3 | 14.7 |
| Tagesschau (ARD, 8.00 p.m.) | 16.8 | 6.8 | 9.9 | 23.4 |
| PRO 7 Nachrichten (7.30 p.m.) | 15.2 | 23.3 | 18.3 | 11.4 |
| heute (ZDF, 7.00 p.m.) | 3.6 | 2.3 | 3.1 | 4.2 |
| 18.30 (Sat 1, 6.30 p.m.) | 3.1 | 3.0 | 2.5 | 3.5 |
| Tagesthemen (ARD, 10.30 p.m.) | 2.7 | 0.8 | 2.0 | 3.7 |

To check the validity of these responses a special analysis was carried out which contrasts the adolescents' verbal assessments with their actual behaviour. To do this the number of contacts and the contact frequency of the young adolescents with the news transmitted by the German television channels were calculated. According to the listings used for the regularly assessed audience ratings (in Germany carried out by *GfK Fernsehforschung GmbH*) for November 1996, altogether no fewer than 1,600 news broadcasts were transmitted by the stations that are members of the *Arbeitsgemeinschaft Fernsehforschung* (Television research working group).

During the period of the analysis, 90.1 per cent of all German adults saw at least one news broadcast. On average every adult had contact with 20.7 news broadcasts. In the use of the news an obvious 'age differential' emerged: whereas the segment of the over 50-year-olds is practically 'fully supplied' with an average news coverage of almost 97 per cent and an average contact density of 32.8 per cent, the regular coverage of the young people with current information is significantly lower: although they, too, cannot avoid seeing news programmes in view of the large number of them transmitted, the adolescents who view at least one news broadcast a month (= 79.8 per cent) see on average only 6.7 per cent in that period (see Table 7).

## 2.3 *Interest in political magazine programmes*
While a surprisingly good result emerges for the ARD *Tagesschau* in the adolescents' favour, the political magazine programmes in general, and those of the public service corporations ARD and ZDF in particular,

meet with little interest among the adolescents: 62.5 per cent of them hardly ever watch a political magazine programme. As the causes of this lack of interest among young people, first, their generally low level of interest in politics can be mentioned, which results in a low interest in the relevant formats on television. Secondly, other forms of communication and programme formats are valid for adolescents in order to interest them in political and social information.

Table 7: **Frequency of contact with news broadcasts and the number of contacts**
(German adults over 14 years of age; November 1996)

| | At least one news broadcast seen, in % | Average number of contacts |
|---|---|---|
| Adults from age 14 | 90.1 | 20.7 |
| 14 – 19 years old | 79.8 | 6.7 |
| 20 – 29 years old | 82.8 | 10.9 |
| 30 – 39 years old | 92.8 | 14.9 |
| 50+ years old | 96.7 | 32.8 |

For adolescents the media are not the major source of politically and socially relevant information, but conversations with acquaintances, friends and relatives: 86 per cent of them name individual communication as an important vehicle of information to keep up with current events. Television is described by 78 per cent, radio by 71 per cent and the regional daily newspapers by 42 per cent as relevant sources of information. The Internet is used by only 0.9 per cent of the adolescents for acquiring up-to-date information.

The low level of interest among adolescents in the political magazine programmes of public service channels can also be inferred from the discrepancy between the contents of the magazine programmes and the contents the adolescents prefer: politics in the magazines of ARD, ZDF and the (regional) Third Programmes is often imparted in a way that is more closely related to things than people, more abstract than concrete and personalised and edited from an overall social, journalistic point of view rather than as tabloid infotainment.

It is precisely the tabloid-like presentation and personalised and easily intelligible form of information that is preferred by young people, and this is the policy consistently pursued by magazines like *Explosiv* (RTL) and *Taff* (PRO 7): seen by 59.6 per cent and 49.8 per cent respectively ('at least once a week'), they are among the magazine programmes most used by adolescents.

Their preference for what is personalised, intelligible and taken from their own world of ideas also becomes clear from the subjects that interest them. In order to find out their current interests, the adolescents interviewed were confronted with 15 headlines and asked to give their degree of interest. Hard political themes such as 'Old age pensions at risk',

'Kurds protest against arms supplies to Turkey', 'Human rights violations in China', 'Introduction of university fees for long-term students' etc interested at best one in two of them. Conversely, they were far more interested in stories like 'Girl (7) victim of sex crime' (79.7 per cent), 'The latest from the music scene' (75.3 per cent) and 'Police uncovers toxic waste scandal' (66.8 per cent) – subjects which are the standard daily routine of tabloid TV magazines like *Brisant* and *Explosiv*.

## Notes

1 The original German version appeared in TelevIZIon 10/1997/1, pp. 9-13.

2 The comments are in the main based on the findings of a representative survey of 1,000 German adolescents aged between 12 and 19 which the IZI and the media research departments of the Bayerischer Rundfunk and the Südwestfunk commissioned the Institute Result, Cologne, to conduct. In the period from 11th December 1996 to 21st February 1997 – leaving out the Christmas holidays – 1,060 telephone interviews from the target group mentioned were carried out throughout Germany. The purpose of the survey was to describe the connection between leisure-time behaviour, youth cultures, adolescents' life-worlds and their media use. Because news and political magazines are to an increasing extent failing to reach young people, special importance was attached to their interest in current social and political events and how these are reflected in the programmes offered by the media.

3 Sources: MA 81, MA 94, MA 96

4 Data compiled from MA 96 and *Massenkommunikation 1995* (s. footnote 4)

5 Cf. Berg, K. and Kiefer, M.-L. (eds) (1992): *Massenkommunikation. Eine Langzeitstudie zur Mediennutzung und Medienbewertung 1964-1990.* (Mass communication. A long-term study of media use and appreciation 1964-1990.) Vol. 4. Baden-Baden: Nomos. (Schriftenreihe *Media Perspektiven.* 12).

6 Cf. M. Schmidbauer and P. Löhr: Youth media and youth scenes (this volume, pp.306ff.).

# 7: Music on Television

# Back in the days of rock, pop and youth[1]

*Arne Willander*

### From the beginning ...

Once it was so simple. There were these young people and they didn't have much of a say. There was a kind of music which acted as their mouthpiece. There was a singer called Elvis Presley. And there was a generation struggle, which only ran between two parties: on the one side were the old people, most of these were the parents, and the others were the young people, the sons and daughters of the old people.

In the 50s rock 'n' roll came to Germany from America like so many other things, but unlike so many other things it didn't stabilise relations, didn't unite people and was not welcomed as a blessing. Rock 'n' roll was thought to be subversive, it helped give youth a genuine voice, and it promised a new era. Pop culture came into being, only a little later in Germany than in the USA; it was also called youth culture, and it has remained woolly, amorphous and indefinable. For rock 'n' roll and pop are also genre-terms, musical styles, on which there is only vague agreement, such as, rock is hard, the original thing, you don't joke with a rocker; pop, on the other hand, means fun, is fleecy and ironic and on the whole expresses a positive feeling for life.

### ... to Woodstock

The youth fought for it. It rehearsed it in rock 'n' roll cellars and in beat joints, it gradually conquered the radio in the good old days when the new tones came out of Hilversum and later on television, when *Beat Club* and *Disco* became societal consensus, when the *Rockpalast* with concert broadcasts lasting for hours carried the atmosphere of the events directly into the living room. By pure chance the young people mounted an unforgettable spectacle, which is notorious today as 'Woodstock' and acted as an idea that sparked everything off. In those times the pop culture was seen as a 'counter-culture' to what existed, opposed to what was elitist about the 'high culture', to adults, to what had been handed down.

Woodstock seemed to unite the youth of the world in a mild revolt which had arisen from the chaotic imponderables of a badly organised festival: the counter-culture consisted of masses of people, a lack of

hygiene, naked bodies and a lot of mud. Rock groups played on the stage, but who was actually playing didn't really matter. This sort of spirit of improvisation was called 'happenings'. Something happened somewhere, you felt you had to join in somehow, but the motive and reason could be generously ignored.

Surrounding all this were a few key words and slogans, 'Love and Peace' was the central motto, only seemingly political, since the protest against the Vietnam War, which ran parallel to the general buoyancy of the libertarian youth culture, did not, of course, lead to the end of that war – it was more of a code for the old conflict from the simple days: between the young and the old, rebellion and preservation, offensive and defensive. A war by all means – but to end with a stalemate.

## The year Elvis died

So pop culture had to become so old that the young of earlier times themselves were able to become the old of the present, and this happened, of course, in the 70s and 80s. The demarcation line between the generations was biologically eliminated, and time healed many a wound. There was a general agreement on Elvis Presley, who died in 1977 and with whom the founding generation was buried.

There was also agreement on the great dead of rock 'n' roll, the martyrs and sect founders, the men of pain and women of suffering: Jim Morrison, Jimi Hendrix, Janis Joplin, and later many others as well. And gradually there was agreement that rock music and pop music and youth culture mainly served entertainment, that there was no place in them for ideology and that a 50-year-old could still belong to them – smiled at, it is true, a relict, but tolerated.

## From the 'old' rock 'n' roll to punk

That is roughly the state of affairs in the 90s: rock'n'roll itself looks pretty old; it is an antiquated form which is repeatedly filled with new life, varied, revived – but never re-invented. A new hero is only rarely added to the list, who then dies like Kurt Cobain a few years ago, which was good as a beacon and for discussion about star fame and drug consumption – for that is what the American musician died of. His downfall had an archaic effect, indeed mythical, against the foil of the general secularisation of pop culture, in which cult had always been more important than culture, the sign more important than the substance, the act more important than the message.

In the 70s 'No future!' was the slogan of punk, the first counter-movement to rock 'n' roll – a movement that raged against the satiety of the fathers and lasted hardly a few years. Punk was integrated, became a social term and finally an image: that of the punker in the pedestrian precinct, who really ought to have been called 'punk', but is rightly given the wrong name because he lacks subversive potential and the faintest idea of what punk had

once meant. On the other hand, it admittedly didn't mean much except 'No future!', and the punks were not right in the end either.

The future came every day, and today the Sex Pistols, who launched punk twenty years ago, are going on a re-unification tour on which they deride the ghosts of the movement. Punk is self-contempt as cynicism, the last ugly face of the industrial age, surrender to what exists. 'I've seen the future,' announced the wise old man Leonard Cohen at the end of the 80s, 'it is murder.'

### What the young people want: rave and techno

The youth of the 90s countered the resignation of pop culture, as we still knew it, with a carefree attitude which is often called hedonism. It is, however, different from the hedonism of the decades before, because youth still means hedonism, how could it be otherwise? One could also term the development of young people in these years as a withdrawal into privacy, into a compartmentalised existence, into the leisure society.

'Tribalising' is what the pop thinkers call the splintering and fraying of young people themselves, who no longer dissociate themselves from the old people and the others as they once did, but seem to be worn to shreds and disintegrated among themselves. Good and bad, even if they are creations, can no longer be recognised, and society has written off the young people. They take advantage of the progress that still presents itself, they are responsible in private and have thoroughly learnt the lessons of ecology and information sciences.

But music does not unite them, it does not reach out beyond itself, and the youth has withdrawn into its shell and remained there. The concert of earlier times (which still exists, of course,) was replaced as the focal point by the so-called rave, which can take place in the discotheque, on the street, in a field or in a quarry.

Rave is an end in itself and hermetic, it only serves movement, pure consumption, it often organises thousands of people and is nevertheless a more or less autistic phenomenon. It needs no stars, at best representatives, and its signs and emblems refer only to itself. 'Move!' is now one of the slogans. The 'camel move', for example, is the name for nothing else but the marketing strategy of a cigarette manufacturer which funds organised parties at which it praises its products.

The music for movement is techno, which usually sounds like bubbles, bangs and whimpers – gentler variants are called acid house, dub, ambient or trip-hop, which is not really important, because – unlike in jazz, blues, folk and heavy metal earlier on – it is hardly possible to find any exegetists to sort out the confusion of terms. Techno is egalitarian, devoted to movement and appearance, and the drugs that accompany it – the best known is Ecstasy – are, on the one hand, part of techno folklore, and, on the other, guarantee the necessary stimulation for dance operations that last for hours.

373

## The youth dances ...

The central event of an otherwise diffuse 'scene' is the Love Parade in Berlin, which registered a new record for visitors in 1996: at least 500,000 people moved along the streets between vehicles and stalls. When it began six years ago, the organisers were still announcing their obviously senseless spectacle as a 'political demonstration'; today, as no one any longer doubts the blaring procession's lack of direction, it does not matter how it is described. The Love Parade is indeed a political event as a mass amusement and diversion for the people; the town council clears away the rubbish and provides the police. It is all peaceful, of course, and only accidents resulting from exhaustion, fainting and dehydration are reported. The youth dances, and it is carnival-time.

## ... and television keeps pace

But as a medium it is too slow, too indirect, too educational. The traditional broadcasting stations missed the boat in the 80s: not only the programmes showing video-clips and the live transmissions from the *Rockpalast* were discontinued, but new formats were not established. MTV filled the gap and expanded it. VIVA managed to establish a counterpart to it in Germany, and both channels are consistently viewed. It is the video-clips that today determine the popular music market, and commercial success depends on showing them. Even radio is almost obsolete compared with the panic-stricken aesthetics of the music videos, which today are almost solely responsible for generating the hits.

The youth uses the medium either directly for consumption or as a source of information and a catalogue from which what is wanted is confidently selected. It has become easier to filter what is suitable out of the confusing mass on offer: the programmes of the video channels carry out a pre-selection according to genre. But what is especially relevant is the 'heavy rotation' which indicates the frequency with which a clip is shown. What rotates in this way is the viewers' greatest possible consensus. As a result that is what gains acceptance.

## Where has the scene gone?

On the other hand, the traditional 'club culture' is a matter for minorities, and young people are another minority within this minority. In the small concert clubs the majority are those who have just got their youth over with, who, although according to their age are not far away from what is happening, according to their interest are detached from it. They are no longer part of a 'scene', whether it be determined by clothing, attitude or age. They have a taste or a preference, but a concert now does not create a feeling of belonging together or identity any more than an evening at the theatre. The young people dismissed them finally when they could no longer master the jargon, no longer find the tone of the time and the spirit of the age.

Globalisation involves young people all over the world being able to understand each other and to communicate via the Internet – they are as alien and incomprehensible to their elders as they ever were. Pop culture, however, is neither a transmission belt nor a distinguishing feature; it is arbitrary and a club for all. It dominates the post-modern principle of possibility, of general compatibility. The codes of the techno society do not have to be interpreted, because they say nothing. The codes of pop culture have become humdrum.

And recently, at a concert given by famous Neil Young, it seemed to the author as if all the pop generations were gathered together. Only the youth, the phantom, was again not present. It was at the Love Parade in Berlin (see above).

## Note

1   The original German version appeared in *TelevIZIon* 9/1996/2, pp. 4-6

# 'I'm crazy about techno'

## An interview with Daniela (15), Philipp (16) and Christian (16)[1]

*Paul Löhr*

The three Munich schoolchildren are very fond of watching or even just listening to music broadcasts on television, as they help to develop their taste and are part of adolescent communication. Sexist and violent videos are not taken very seriously.

*IZI:*      Which music or groups are you especially interested in?

*Daniela:*   I like listening to *trance* and *rave* and *house*. I don't go in for any particular bands or groups.

*Christian:*  It's the same with me actually. *Techno*, especially *rave, acid* is all right, too, *trance* as well now and again. That's about it. I don't specialise either. If I like something then I listen to it, and buy it as well. But there aren't actually any groups I go for really.

*Philipp:*   I'm also into *techno*. But I listen more to the harder *techno* things, like *hardcore, rave* as well, and *trance*, too, to calm me down. And groups, there aren't any I'm especially fond of, either. Actually I don't listen to them. Only when I happen to hear on radio or television that there's a good group on, then I either listen to it or buy it if it's any good – or I don't buy it.

<center>* * *</center>

*IZI:*      How then is a special taste developed?

*Christian:*  At first I used to listen to everything, I loved it all. That is, everything that was played on the radio. Then I switched to *dancefloor*, because I sort of liked it. I thought it was more modern somehow and I could identify with it better. And then after some time it changed to *techno* almost without noticing it. At first fringe groups like *house* and *trance*, and now I've stuck with that kind of thing.

*Philipp:*   With me it was just the opposite. Until I was twelve I really had no proper taste in music. I listened to everything that was played on the radio. Then – I was always a bit behind Christian – I also switched to *dancefloor, Two Unlimited, Ace of Base* and that sort of thing. And then I found out what Christian was listening to and I changed. And now, for about 18 months or so, I'm really into *techno*, you might say.

<center>376</center>

| | |
|---|---|
| *Christian:* | Both of us already have quite a big collection of CDs of it, a music case full of them, that's about 140 CDs. |
| *IZI:* | Have you also bought CDs, or do you prefer music on the radio? |
| *Daniela:* | There's not so much *trance* or *house* on the radio, more *Britpop* or *dancefloor*. Now and again perhaps *Green Days*, that's *grunge* or something like that, or the *Kelly Family*. When I hear a good song on MTV or Viva I like, then I buy the record of it or I borrow something from my sister, she listens to that sort of thing, or from friends, or I get someone to record it for me. |

\* \* \*

| | |
|---|---|
| *IZI:* | So you watch MTV? |
| *Daniela:* | Yes, certainly I watch it sometimes. |
| *IZI:* | And you? |
| *Christian:* | Yes and no. Well, I have done at Philipp's place, he had cable television before I did and I often visited him and we watched MTV and VIVA together. I thought it was quite good actually, because whenever the commercials came on we switched over to VIVA. Then I got cable television as well. And I must say I don't watch MTV that often, because MTV brings everything there is in the way of music, including underground. It has everything actually. And VIVA has concentrated a lot on *dancefloor* and *techno* as well as boy groups and girl groups. I mean, OK, I don't enjoy listening to boy and girl groups; so then I have to put up with it. But otherwise I much prefer to listen to VIVA because it usually has what I want to hear. |
| *IZI:* | You have a different opinion, Daniela? |
| *Daniela:* | Well, I like MTV much more, because you don't have to make any effort at all with VIVA, because it's a German channel, and so you sort of just expose yourself to endless music, and the presenters aren't all that super. I find that on MTV they put it over better somehow, and they don't put on the *Kelly Family* or *Backstreet Boys* and things like that all the time, and the presenters in my opinion have a better way of getting it over. |
| *Christian:* | Well, as far as the presenters are concerned, I have to agree with you. On VIVA they're really rather bad, but for example I much prefer the music on VIVA, because MTV plays, I don't know, very little *techno* and that's why I like VIVA much better. VIVA also has a special programme for *techno*. Although it's only one hour a week, but that's why I think VIVA's much better because they play my taste more. |

\* \* \*

| | |
|---|---|
| *IZI:* | Isn't MTV more international than VIVA? |
| *Christian:* | Yes, that's right. MTV's in English, but if I want an English programme then I switch to NBC or CNN. |
| *IZI:* | So a German channel is better after all, is it? |

377

*Philipp:* Not for me, because on VIVA there are actually only commercial things. Sometimes MTV does have some song that's been vegetating around in the underground, and then they bring it out into the open. So for me the difference between MTV and VIVA is that MTV doesn't just play commercial things, but also things outside the usual run of programmes that are on every week. And VIVA only does that very seldom.

\* \* \*

*IZI:* Commercial is, as you say, what is well known, and is apparently typical of music channels?

*Philipp:* Absolutely. What I wanted to say on the question before: on VIVA you also notice clearly that it's a German station and so they play and promote a lot of German groups. Though I have to say as well that VIVA does put on some things from the German underground as well, if you can call it that. MTV is really more international and shows what appeals to international taste, and VIVA has what appeals to German taste.

\* \* \*

*IZI:* ...and on the public service corporations?

*Daniela:* I don't know. I'm not familiar with all that many music programmes apart from MTV and VIVA. Only on Bayern 3, and I can't watch that so very often because I'm at school then. I think they put it on a bit too early.

*IZI:* And on the programme *Schlachthof*?

*Daniela:* Yes. Now and then I watch it, but not every time.

\* \* \*

*IZI:* The ZDF also does something, doesn't it?

*Philipp:* OK. The ZDF programme is relatively new, I believe. *Chart Attack – Just the Best*, I think it's called. I saw it last Saturday or Sunday, and I found it pretty ... bad. That really isn't my taste, and they have a lot more commercial things than VIVA. *Backstreet Boys, Caught in the Act* and the *Kelly Family* all the time over and over again, that's really not my cup of tea. I like *Hit-Clip* much better, but only one hour a day, that's really not very much. All right, you can sort of watch it on the side, when there's nothing any good on VIVA, but otherwise I think the public stations are really lagging behind quite a bit.

\* \* \*

*IZI:* The programme *Weiss der Geier* is broadcast on the ARD every two weeks at 3 o'clock in the morning. Are you still awake at that time?

*Christian:* Still up – yes. Sometimes. At least there was a time when I was always up then, because *Hit FM* was on at the same time, something from Riem Airport. It was called *Technodrome*, and it

378

carried on from midnight to six in the morning. I always used to listen to it for three hours, and now it's been taken off. I don't watch the telly any more unless a film lasts that long, or when there's a good programme on VIVA.

\* \* \*

IZI: You don't get together with friends to watch?

Daniela: Of course, you can do it with friends as well. But actually I listen to the radio all the time, and cassette recorder or CD player, while I'm doing my homework usually, and Walkman when I go by Underground.

Philipp: Well, it's not so much that you get together then and sit around the goggle box or watch VIVA. I don't think anyone really watches VIVA anyway. I don't think anybody sits down on the couch, switches on the television and then watches VIVA for an hour. I let VIVA run while I do my homework, much the same as Daniela, or when I'm sitting at the computer. I leave VIVA on for two or three hours at home and listen to the music. Now and again I also listen to CDs, of course. Put one in the player, press down 'play' and turn the volume up to loud and listen to CDs when there's nothing worth looking at on VIVA.

Christian: Yes, it's the same with me. You can say that you don't watch VIVA, or *VIVA Vision*, that happens to be the name of a programme on VIVA. You listen to VIVA actually. You register that someone or other is talking and the music is being played. If the video is good, then you take a look at it. But usually I sit around, eat on the side or telephone, or do something else. I sometimes give Philipp a call, for example when a good song comes on he doesn't know yet, but which I find good.

Philipp: ...which you think I don't know.

Christian: Yes, then I call him up and say, 'Hey, turn VIVA on, there's a good song on at the moment.' Otherwise, when I really listen to CDs, I put on my headphones, turn up my hi-fi almost as far as it'll go and...

\* \* \*

IZI: Mum jumps out of the window.

Christian: No, no, you can still hear it through the loudspeakers, but it's not loud. Although if I pulled out the headphones my mother would shriek her head off.

Daniela: But I would say that with VIVA you can really fetch something to eat from the kitchen while it carries on in the background. On MTV it might happen that, say, *Herzblatt* is shown in English, and then you can watch it. I find that sort of thing really funny, that there's something different for a change, not just music. Or there's a live broadcast from Ibiza or a party, that's what I find more interesting, and that's what I miss on VIVA.

\* \* \*

*IZI:*       Coming back to the commercial programmes. Don't they get on your nerves?

*Daniela:*    Well, I think that at a certain age, say from 12, you are influenced pretty strongly by friends, by what they listen to and that then you listen to everything that's commercial. But at any rate I manage to ignore it. I mean, when *Backstreet Boys* are on, I go into the kitchen and eat something or whatever. But I think it's really better to listen to something that not many people know. Then, in my opinion, you begin to develop a taste of your own and live your own life somehow and don't let others live it for you.

\* \* \*

*IZI:*       Young people are supposed to buy things as well.

*Christian:*  I don't actually have the feeling that when a video clip is running I then think they want to offer me something and that I'm bound to buy it. Because in most of the videos that interest us you can't see the musicians at all. For example, in *Experience* by *RMB* you can only see two little children. But if you take *Blümchen*, for example, that's a 16-year-old singer, they've really only done her up for commercial reasons. Whereas the other bands do that because they have fun doing it. They have found themselves, they've said, 'Come on, let's do something.' But with *Blümchen* it was like this: a firm made an inquiry, did a casting, and then they chose her. And they needed someone beautiful, someone nice, someone sporting, so that they can sell their things. OK, I mean who doesn't want to be commercial? If you're commercial, you make money. That's what they did with her. I really do sometimes have the impression that they think, 'She's good-looking – I'll buy her.' And sometimes I also have the impression with videos that the message behind it all is 'Buy, buy...'

*Philipp:*    The temptation is very strong as well.

\* \* \*

*IZI:*       The temptation to do what?

*Philipp:*    To buy the CD. Everything is perfectly organised. A super marketing tour, she sweeps through all the music stations. She's interviewed here, she's interviewed there. Then she says, 'If I could award a prize I would give it to my mummy' and all sorts of things like that. I find that awful, that's what I can't stand about commerce. Or all the groups are an even better example. With *Caught in the Act* there's casting as well. We need five good-looking boys who can also sing and dance a bit...

*Christian:*  But in most cases singing isn't even necessary. Take *Milli Vanilli*, for example.

*Philipp:* We'll take those who can perhaps sing and dance well, and it really does things to all the little 12-year-old girls, and they scream and squeal and almost kill themselves when they split up. That's the bad side to commerce. What is not bad about commerce is when two just join up – something we also intended to do once – produce music and then simply send their stuff in to the music stations. They play it, they like it, and the people who hear it like it. Then a video is produced and people buy it, and like that commerce is OK. But when a record company thinks, 'Now we need a new group,' and they do casting, then I think commerce is dreadful.

\* \* \*

*IZI:* And the commercials?

*Christian:* I would say that advertising is always involved, on every station, because no station can exist without revenue.

*Daniela:* Well, what I've noticed is that MTV and VIVA definitely don't have advertising for Persil or Wash-and-Go, but for music and CDs.

*Christian:* Exactly. And that's why they have to have commercial breaks. I know that they try to put on the advertising breaks at the best possible times. But I can't imagine television without advertising.

\* \* \*

*IZI:* Do you actually play music yourselves?

*Philipp:* Let's put it like this: we would really like to play music ourselves, like *techno, house* and suchlike.

\* \* \*

*IZI:* But you play instruments, don't you?

*Philipp:* Both of us play the keyboard. At the moment I can only play one song on the keyboard, because I haven't played for three years. But if we had the equipment we need for it, which costs around five thousand marks, then I would begin to play more – and so would he, of course.

*Christian:* We would really enjoy doing it, but all the equipment you need for *techno* – sound expander, synthesiser and a really good PC, mixer and all the accessories – is simply too expensive for us. That's why that will probably more or less remain a dream, I'm afraid.

\* \* \*

*IZI:* With music videos pictures are also shown which contain a lot of sex, violence and consumer stimuli. Does that sort of thing appeal to young people?

*Christian:* No, no, it's not like that at all. I personally am hardly ever interested in the pictures, only in the music. When something comes, then, for example, like *Falco* and *Naked* or whatever,

381

then I naturally watch the video, or the *Spice Girls* as well, so girl groups – not *TicTacToe* now – then I naturally watch it because you want to see something beautiful as well, and they don't look bad. But I know very few videos in which there is violence or any kind of conflict. Well, yes, conflict maybe, but violence...

Daniela: Well, what I find a bit off-putting is, for example, with *Captain Jack* I've noticed that it's all pretty perverse, because the little 10-year-old kids watch it, and there are half-naked women prancing around. I think that's a bit overdone. For sure, there's nothing to be said against seeing a beautiful chest with stomach muscles, OK, but I think it's a bit overdone.

Philipp: It might well be that they also want to lure young people with it, with something like *Captain Jack* or *Spice Girls* or *Naked*, and the girls now with *Peter Andre* or oily chests like *Caught in the Act*, it's quite likely – that's what I wanted to say about the sexist side of it. And now to the violence, you mustn't take it so seriously. There's certainly some violence in the videos, but it's definitely no more or no less than in any crime thriller, than in, say, *Tatort*, or anything else.

Christian: That's quite right. But when you watch television you see houses exploding everywhere, a few people are butchered, and you really can't complain about the music videos, because the producers take care that there isn't too much violence in them. And if I could just quickly mention an example of what was called 'luring': *Naked*, that's a song I like. I enjoy watching the video, but I wouldn't buy it just because half-naked women are dancing around. I have to be one hundred per cent convinced by the song to buy it. Because otherwise it would really be a pure waste of money if after some time I went off it.

Philipp: Something else has just occurred to me about often taking violence and all that on the music channels too seriously. In *Zehn kleine Jägermeister* by the *Tote Hosen*, you see, for example, in the video when they smoke a joint, or you see drawings of women's naked chests and pistols and all that kind of thing. On VIVA the video is played quite normally, as I said it's all animated drawings, but on MTV in the afternoon a black bar is put over all these scenes with 'Censored' written across it, and that probably has something to do with the British mentality, that everything is thought to be harmful to young people, and I think all that is often taken too seriously.

Christian: It's just the same with *Shy Guys*, the pistols in it are also blotted out, although every youngster, every person, knows what is underneath. So I really think that's stupid that they blot out these pictures, because that attracts the young people's

attention, they want to know what they're missing, what it really looks like. And so they'll probably buy the song, because their curiosity has been aroused. So like this they tend to make people want to buy it, rather than putting them off.

*Daniela:* It was just the same with the *Tote Hosen*, in *Bonny and Clyde*, when someone reported them to the police because they had sung that they had killed off a couple of cops. That was going a bit too far.

\* \* \*

*IZI:* Then it's only the adults that have problems?

*Christian:* That's quite easy to explain. They were brought up in a conservative way, and the times were different, and they haven't lost that. And we are growing up in times when you can walk along the street practically naked, and perhaps a few people look at you, but that's all. I think we are growing up in a time in which everything is natural. In which violence is natural, unfortunately, and in which sex is as natural as our daily bread or whatever. And that's why the older people get excited about everything that's shown, though for us it's quite normal.

*IZI:* Is it important that a video was expensive to make?

*Christian:* Yes and no. It's easy to tell whether a video was made with a home video camera, with a camcorder or professionally. But you don't pay much attention to whether it was an expensive production. What both of us are fond of is, for example, when videos contain good computer graphics, not that they cost all that much. And all those expensive Michael Jackson videos, in which tens of thousands of Brazilians from the slums dance around, I don't go for that very much.

*Philipp:* Well, that was a video that wasn't so expensive, it didn't cost so much. But when you see *Stranger in Moscow* it simply fascinates me how you can do that with the computer nowadays in good videos. That, for example, you see a hornet beautifully fluttering its wings, or how a ball flies through a window, you see all the details, that really fascinates me. But then I watch the video and don't listen to the song any more. That's how it is with me, the technology fascinates me but not the song.

\* \* \*

*IZI:* Do the music channels play a part when you talk about music?

*Philipp:* Yes, certainly. We might say at school, for example, 'Have you seen this or that new video? The song is really good and they've also made a good job of the video.' To that extent they do. But I think that that is hardly the main thing in life.

*Christian:* Well, with me it's like this: 'Do you know the new song?' I'm usually asked, and I say, 'No, I haven't seen it yet.' Then the

other one asks, 'Why *seen*?' It's usually not taken for granted that you look at it on VIVA. It's often happened to me that someone's heard it on the radio, but then didn't know what the song was called, so he asked me what it was called and hummed the tune to me. And I said, 'That's called so and so.' I could easily remember it because through the video on VIVA you can take in a certain sequence in the song, by taking suitable pictures and then adding them to the piece. So it's not so necessary to know songs when you only watch VIVA or MTV.

<p style="text-align:center">* * *</p>

IZI: Do you also talk about your music to your teachers at school?

Philipp: Well, as it happens, only yesterday our music teacher quite unexpectedly played a video in class, and it was *Zehn kleine Jägermeister* by the *Tote Hosen*. And then we had to analyse which consumers it was intended for, who produces something like that, what intentions were behind it and so on. That's really up-to-date. That's certainly brought up in the music lesson as well.

Christian: Well, it's not like that with us, I'm sorry to say. We're just dealing with *blues* or heavens knows what it is, *blues* and *black music*, and that doesn't appeal to me at all, but it doesn't matter, I listen to it in class all the same. But if I ask when we're going to do *techno* or *dancefloor* or something in the charts, the teacher says; 'Yes, some time perhaps we'll find a lesson for it.' So we don't really go into it, but maybe it comes up on the side. 'Well, then, that's that, and next lesson we'll do something quite different.'

Daniela: At our school it doesn't happen that the teachers deal with current music. We listen to something by Handel and then have to decide on the recitative. It's absolutely uninteresting. Last year it was quite good, then we had a different teacher and were allowed to give a talk on our own type of music, and that was quite good. But at the moment, I'm sorry, but that doesn't interest me at all.

<p style="text-align:center">* * *</p>

IZI: Will *techno* survive?

Christian: Well, some time ago people were talking about the *techno* wave, everyone's into *techno*, they said. Then it died down. Then it was being said that *techno* was out, no one listened to *techno* any more. But if you look at the top hundred, there were twice as many *techno* records as before. And now the situation is more or less that up to one quarter in the top hundred are dominated by *techno*. The *techno* wave itself is over. But *techno* is firmly established. It will stay. It will stay for the future. There will

<p style="text-align:center">384</p>

always be people who listen to it, like us. And I for my part I hope that I stick to this kind of music. I've already spent about 300 marks on *techno* CDs, and it would be really silly to change to another music style now, because then I would have to start from square one and buy everything new. That's why I'm trying to stick to it.

Daniela: I think I'll stay with it as well and that it will all expand even further. As far as I have heard, there are only two people in my class who listen to that sort of thing at all – Philipp and me. The rest listen to things like *Britpop* or the *Kelly Family* or *hip hop*, and I don't think that *techno* really dominates our times. I think that *hip hop* is pretty popular at the moment and that *techno* will really set in as time goes on.

\* \* \*

IZI: Do you also go to concerts?

Philipp: You can't really say concerts as far as *techno* is concerned. There aren't any proper *techno* concerts, only by very successful groups like, for example, *The Prodigy*; they were in the Zenith Hall, I think it was, here in Munich recently on a Saturday. Otherwise, though, you can't really say that there are concerts. At present we go to the Raving Afternoon at the Babylon Club in the East Art Park. We go there and our favourite DJs play the music we like best.

Christian: As was said before, you can't say concerts, but you can say performances. Like, for example, when Marusha is the disc jockey; it was like that at the airport and in the Coat of Arms Hall she was the DJ. That was then a performance, but not a concert, because a concert is something that lasts a long time. OK, that lasted quite a long time as well, but a concert is something sung live like *pop* and *rock*, but with *techno* you can only talk about a performance and not a concert.

\* \* \*

IZI: ...which brings together and unites young people.

Daniela: Exactly. For example, in Munich the Union Move or the Love Parade in Berlin or on the Move cruise liner, where only *rave* and *techno* and suchlike are played all the time for a whole week. So I do think that music unites people, there's no doubt about it.

IZI: Even the apparently young-at-heart 50-year-olds go to the Love Parade. Does that bother you?

Philipp: That doesn't bother us in the least. Now and again I find that quite amusing. For example, what occurs to me quite spontaneously: at the last Union Move, that is practically the Munich Love Parade – a bit smaller, though, but it's good all the same – there was a 70-year-old right beside us who was

385

'raving' around wearing a headband and a gaudy T-shirt. That really surprised me, but I think it's good that there are also older people who enjoy it. I have nothing against that at all.

*Christian:* I can actually only agree with Philipp, and I think it's good that the older people also support our music, because then those who are a bit younger say, 'Well, it can't be all that bad then if my father listens to it as well.'

**Note**

1    The German version of this interview (conducted by Paul Löhr) appeared in *TelevIZIon* 9/1996/2.

# Channels for young people: Music videos on MTV Europe and VIVA[1]

*Michael Schmidbauer and Paul Löhr*

## Preliminary remarks

First, the authors freely admit that they have no ambitions of approaching the subject of 'music videos on pop music channels' on the (precariously) high level of 'post-modern theory'. This deserves special emphasis, as this is the direction followed – at times inordinately – by a number of analyses, particularly those on MTV submitted in the framework of US communication research.[2] It is clear that the name Jean Baudrillard, the champion of this approach, must be alluded to.[3] It is his concept of 'hyper-reality' that portrays pop and rock videos as 'incalculable areas of association, of a playful association between apparently irreconcilable particles of reality' (Kemper 1995, p. 20).

The following exposition, on the other hand, should be seen only as an audit of the current situation. It is borne by the hope that it may offer a few explanations, sufficient to answer the question fairly satisfactorily as to whether the above quoted 'post-modern' interpretation is justified, should be rejected, or at least classified as an exaggerated stylisation.

## 1. Youth and the pop music channel

The following does not discuss individual programmes presenting pop music or stories on pop music on television, such as ARD's *Musikladen*, RTL's *Formel Eins*, ARD's *Rockpalast* or 3Sat/-ARTE's series *Lost in Music* (Müller 1994, p. 48 ff.). The subject under review here is the channels offering a quilt of video clips (intermingled with commercials) around the clock, whose main ingredients are music videos. 'Video clips are three- to five-minute video films, in which an entertainment composition (pop and rock music in all its varieties) is presented by a solo artist or a group, containing various visual elements' (Winter and Kagelmann 1994, p. 208).

The clip quilt is designed to appear as a continuous 'cascade of colours, forms and tones', in which 'the visuals and performance scenes (merge) ... to form a kaleidoscope' (Kemper 1995, p. 19)[4] and which the viewer can join or leave whenever he or she wants. As early as the middle and late 80s KMP's music box and Tele 5 invested (albeit not very successfully) in the

production of this clip quilt in this country: nowadays MTV Europe and VIVA lead the field, and will clearly continue to occupy centre stage in the future.[5] The great success of VIVA and MTV very clearly illustrates the importance of rock and pop music in young people's lives. Music videos, in particular, offer young people today good vibes, lifestyle and ready-to-buy products all at the same time.

## 1.1 Fears about 'Generation X'

In the controversy surrounding the quality of this music quilt (and the quality of the channels broadcasting them) one issue is now very much in the public eye: namely the idea that these channels and their combination of pop music and commercial clips inundate young people with a flood of 'bad images and dirty words' (*Süddeutsche Zeitung*, 9.8.1996) bent on 'exploiting their life feeling'(*Süddeutsche Zeitung*, 15.12.1994) and which can only be interpreted as a 'threat' (Mohn 1988, p. 137). There is no denying that this view stems from well-meaning parents, teachers and politicians. But it is equally indisputable that adults voicing such opinions are in terms of age so far removed from what is going on in (adolescent) pop music culture that their verdict cannot be accepted as being unbiased and, more important, cannot correspond to what young people themselves say on the subject of pop music channels (Hertneck 1995, p. 42).

The thesis currently read time and again in many papers claiming to be scientific states that young people behave like the mysterious 'Generation X', a 'hill of headstrong, colourful ants', marked by 'spontaneous directness, consumer-oriented tendencies, life in a world of clothes and media, ...(as well as by) ... a 'defective' language',[6] shows the value-judgements that can be generated by such a distance. It is hardly surprising that the observer who embarks on a 60-hour individual experiment with the channel VIVA, for example, can at best only come up with a 'list of the food and drink items he consumes and a few unsystematic comments' (Barth and Neumann-Braun 1996, p. 251).

## 1.2 Pop music and the everyday adolescent world

There is, however, a series of essayistic reflections and sociological analyses that endeavour to elucidate the criteria governing the understanding and evaluation of pop music culture, the function of pop music in young people's everyday life and their relationship with pop music presented via television and other means.[7] The starting point of these considerations is the thesis that the subject of 'pop music and pop music channels' can only be correctly interpreted within the framework of the current socialisation and living conditions of young people. This means that pop/rock music can be interpreted as a background that adolescents relate to during their development and the stabilisation of their personal and social identity,

which they use not only for fun, but as a vehicle for purposes of self-realisation, demarcation and socialisation.

### 1.3 Pop music culture as a commercial event

It is clear that young people can only relate to pop music and the opportunities it offers for identification, if they yield to the commercial qualities of pop music culture, which means the 'media production of a consumption-oriented youth culture' (Barth and Neumann-Braun 1996, p. 255). Anyone who wants to be 'in' must therefore adhere to the principle of 'to buy and to belong' (Aufderheide 1986, p. 57). To actually acquire what they hope to find in pop music culture, young people must accept that they are customers in a market selling records, cassettes, CDs, music videos, where the customer's interests and needs are only ever relevant if they correspond to the ruling business conditions of the day.

Especially in Germany, one of the world's largest sound media and video markets, these business conditions permit only an extremely narrow leeway.[8] Obviously, this has a lasting effect on the music channels operating in this country, which can quite rightly be described as customer acquisition agencies. Particularly when it is taken into account that, in their own interests and those of their financial sponsors from the sound media, music video and other consumer goods branches, the channels are obliged to reach an adolescent audience, who are, outwardly, fans of pop music, but who (unlike the situation in the US, for example) show a clear propensity towards TV fustiness.[9]

## 2. The music channels MTV Europe and VIVA

Up to 1993 MTV Europe was the only full-scale pop music channel, an offshoot of MTV USA, that could be received in Germany. On 15 October 1993 a competitor threw down the gauntlet: it is well-established in Germany but almost exclusively run by groups of companies from the USA, the Netherlands and Japan. The name of the enterprise: VIVA.

### 2.1 MTV USA

MTV USA was founded in 1981 in the US by the Warner Amex Satellite Company, an amalgamation of Warner Bros. and American Express; the launch costs were around $20 million (Gorman 1992, p. 26). The MTV launch was based on the music industry's vested interest (partly represented by Warner) in creating an advertising forum for sound media, whose range and intensity stretch far beyond the music presentation focus on sound by local radio stations, its primary feature being US-wide access to young people via a special film/sound medium.[10]

To achieve this goal, the music industry produces video clips to accompany its sound media, which then need a broadcasting facility. This function is assumed by MTV, which addresses mainly this young audience

by means of a round-the-clock music programme, sponsored by advertising. MTV's early commercial advertising success induced Warner Amex in 1984 to launch a second music channel: VH-1, directed at the over-25 age group.

In 1986 MTV and VH-1 – together with the children's channel Nickelodeon – were sold to the US group Viacom. Viacom expanded the MTV project by setting up a series of branches across the globe between 1987 and 1991. The following data on the technical coverage applies to 1992: MTV Internacional (Central and South America with the exception of Brazil: 13 million households, MTV Brazil (7.5 million households), MTV Asia (1.8 million households) and MTV Europe (36 million households).

The surveys on the subject constantly emphasise that the establishment and expansion of MTV are mainly determined by its successful attempt to show to the large music industry groups and a number of financially very powerful advertising customers the opportunities available on MTV to open up sales areas and primarily to mobilise young consumer groups and to push music and other products onto the market. In this respect, the designation of MTV as a 'non-stop advertising channel' is absolutely justified (Roe and Cammaer 1993, p. 169; see also Schlattmann and Phillips 1991, pp. 19 ff.). This guiding principle should be borne in mind if one wants to understand the following brief outline of MTV's development:[11]

1. In the first phase (1981-83) of creating a channel designed to stimulate the audience's interest, mainly so-called 'promotional videos' are shown, largely imported from England, mixed with commercials and somehow nailed together to form a complete programme. The latter comprises music videos, celebrating the then virulent 'synthetic pop' (Duran Duran, ABC, Culture Club) and promoting the sales of their records. In this initial period white musicians dominate all down the line in MTV programmes, prompting charges of racism against MTV. The MTV direction can be ascribed to the then predominant attitude in the US music industry that interpreted pop and rock as 'non-black' forms of music.

2. The second phase in MTV's development from 1983 to 1985 is founded on a clearly different music and programme concept. Now MTV looks for its audience not only in the centres of the cities but also on the East and West coast as well as in the Midwest; it has to satisfy the taste in music dominating in these areas, which mainly focuses on heavy metal. This effects the structure of the channel: in the first phase a kind of imitation of the American music radio principle is staged, setting out to arrange an unstructured, anti-realistic, anti-narrative 'flow' of sounds and visuals, of the same artificiality as the 'synth pop' presented; MTV takes on the form of 'visualised radio' (Barth and Neumann-Braun 1996, p. 257). In the second development phase, however, the focus is placed on – besides consumer goods commercials and MTV's own advertisements –

(staggered blocks of) sequences of 'performances', in which the heavy metal protagonists present their songs.

3. From 1986, the beginning of the third development phase, now under the direction of Viacom, MTV foregoes its preference for heavy metal to offer a wider range of different types of pop and rock music, in which, first and foremost, the somewhat softened 'rebellion appeal' of heavy metal (and subsequent grunge music) are skilfully combined with the glamorous sex appeal of disco and dancefloor music. Moreover, concrete steps are taken to combat the racism accusation. The ensuing success is due less to MTV's efforts than to the mass appeal of Michael Jackson and Prince, on the one hand, and of rap, hip hop, reggae, raggamuffin and acid jazz, on the other, the latter being a clearly visible 'cross-over' of 'black' and 'white' forms of music.[12]

## 2.2 MTV Europe

This MTV position is then assumed by MTV Europe – with one significant exception: MTV Europe largely adheres to the programme form adopted by MTV USA, but the European offshoot is far more decisive about using the new computer-assisted video and animation techniques. And more important, it includes, as far as possible, in its programme contents only 'the elements which blend smoothly in with the European scene' (Reetze 1993, p. 214).

### 2.2.1 Coverage

The station has had its headquarters in London since 1987; in 1996 it had 110 staff and could access some 45 million households in Europe by means of cable TV and satellite technology, 17 million of which (technical coverage) were in Germany (Reetze 1993, p. 214; *Werben und Verkaufen* 20.9.1996). From London it also broadcasts its (English language) 'non-stop TV format for video clips' (Kemper 1995, p. 19)[13] also to Germany – via cable TV and since 1995 in coded form for individual direct satellite reception via Astra.[14]

Viacom co-operated with British Telecom and Maxwell Communications Inc. to set up MTV Europe and enter operations (the latter has meanwhile withdrawn, however). Since 1991/92 the company joint venture has been trying to considerably enlarge its field of operations by MTV Europe's setting up a MTV Russia and a MTV Africa. Since last year Central Europe, including Germany, has had its head office, MTV Networks Central Europe, in Hamburg. It is not involved in programme transmission but does play an important role in a regionally-oriented music video selection or 'playlist' (*Werben und Verkaufen*, 20.9.1996).

### 2.2.2 The programme

MTV Europe broadcasts its mixture of advertising and its own commercials, (channel recognition) jingles, music videos and 'interactive'

audience participation, pop and fashion news, tour venues and movie tips as an alternative to the traditional television range on the basis of the following arguments:

- First, the channel adheres to strictly maintained video clip aesthetic standards.

- Secondly, the channel assumes the role of an 'electronic friend' (Kemper 1995, p. 19) on call day and night, quick to visit and quick to leave.

- Thirdly, the channel programme is geared almost exclusively to the interests of young people – also of those who see themselves as outsiders – eager to form a 'generation community' (Schultze *et al.* 1991, p. 198).

- Fourthly, the channel's main task is to create a 'positive atmosphere' – according to the earlier MTV slogan: 'MTV is an atmosphere, not a show'.

### 2.2.3 Commercial fun and non-stop advertising

But even if MTV's self-image contains the nice and friendly idea that young people's interests and their lifestyle, in simple terms 'youth culture', could be expressed in the atmosphere it creates, one important point remains: due to the advertising, market-oriented purpose that MTV is 'in principle' committed to, such an idea can only come to bear if it obeys the rules of commercial entertainment, which in the final analysis means working to establish 'consumer identities' (Schultze *et al.* 1991, p. 189). In this respect, it must proceed on the basis of treating 'youth interests as market interests' and youth programmes must be envisaged as the 'integration of entertainment and consumer guidance' (Frith 1993, p. 74). MTV Europe in its role as a media companion aims to be

> ... (a) mediator between a special young people's market influenced by its own offers and special advertisers. This go-between function consists ... of promoting and improving the viewers' mood, which means generating a positively perceived world with the music and the purchasable lifestyle of a youth culture at its hub. (Barth and Neumann-Braun 1996, p. 258)

This principle is not only established as a giant-scale product placement in the music videos: it is also documented mainly in the fact that hardly any difference can be observed between the form and content of the music clips, the channel's own advertising and the consumer goods commercials. Are the Coca Cola, the Pepsi and the Mustang shows commercials or music videos? How can the famous video clip featuring Grace Jones – *Slave to the Rhythm* – be classified, being used as a music video as well as a car ad?[15]

## 2.2.4 Broadcasting concepts

The founding of MTV Europe, MTV Asia, MTV Brazil etc. was not only aimed at starting up an extended coverage but also at clarifying the question of how 'international' a pop music channel can be when expected to be well received on different continents and in different countries. The answer to this question is already revealed in 1982 when MTV USA tries for the first time to conquer the European market. The coup fails because the MTV management expected young people in Europe, Asia and South America to be just as enthusiastic about the MTV channel as their peers in New York.

It is not until the contents of the MTV channel are adjusted to the qualities and attitudes young people appreciate in the regions of Europe, Asia and South America that the MTV expansion shows the first signs of success – particularly when (as is now the case with MTV) the channel is conceived not only on a continental plane but trimmed to the needs of the specific country. The renowned *Süddeutsche Zeitung* pointed out:

> Whereas the 'Toten Hosen' or techno is 'in' in Germany, young people in Argentina love their form of punk music and rock music mixed with salsa and reggae. From May 1 the European offshoot of MTV ... will relinquish its uniform broadcasting concept: the continent will be divided into Northern Europe (Britain, France, Scandinavia, the Benelux countries), Central Europe (Germany, Switzerland, Austria, the CIS, Poland, former Yugoslavia) and Southern Europe (Italy and Spain), and their head offices permitted to participate in the decisions on their channel. (*Süddeutsche Zeitung*, 23 April 1996)

MTV Europe's strong 'anti-Maastricht' stance – according to the ironical words of the *Süddeutsche Zeitung* of 25 August 1994 – is mainly due to the current tendency of broadcasting stations setting up shop in various parts of Europe that intend to relieve MTV Europe of its work (and market segments) by offering pop music programmes of international and country-specific calibre, with a presentation in the language of the country.

## 2.3 VIVA

### 2.3.1 Foundation

One of these broadcasting channels is VIVA – a project predicted as late as the middle of 1993 to 'flit across the scene' with virtually no chance of success (Reetze 1993, p. 195). Since its actual 'stage entrance' on 1 December 1993 VIVA has become a firmly positioned, financially secure and profitable institution. With its round-the-clock programme and 'flow' of 250 to 300 music videos (excluding the commercials time-slot for advertisers and its own advertising) VIVA follows the same line as MTV, but it is marked by a number of regional qualities, striking for both eyes and ears, expressed in the mode of presentation, the inclusion of German

pop and rock, the strong integration of the audience and a clearly recognisable structure in the transmission schedule, ie between 18 and 20 programmes a day.[16]

The initiative to found VIVA came from the initiators of POPKOMM in early 1993, an annual pop music fair held in Cologne, and the video producers Rudolf Dolezal and Hannes Rossacher. The project is enthusiastically and resolutely pursued by the (music) company groups *Warner Music, PolyGram, Sony* and *Thorn EMI*, which see in VIVA a welcome channel for playing their sound media for which they also produce the video clips themselves (*Der Spiegel* 7/1995, p. 199).

*Warner, PolyGram, Sony* and *EMI* control – with *BMG* (Bertelsmann-Musik Gesellschaft) Ariola – the German recording media market and thus the pop music market. Besides the 'big guys', there are a number of so-called 'independent/indie labels' – particularly in the pop music sector – which have strong links with the music insider scene, Rough Trade, for example, the largest, with DM 35 million sales turnover in 1993. On the German recording media market a total of approx. 160 million CDs, records and cassettes were sold in 1993, 48 of the 552 best-selling items having nothing to do with pop music (Janke and Niehues 1995, p. 64).

The three groups (and Frank Otto of the mail-order company Otto Versand) each have a holding of 19.8 per cent in VIVA at launch: 1 per cent is held by VIVA Medien GmbH (Dolezal/Rossacher), who leave in 1995, however, passing on their share to the other partners.[17] The company, with its head office in Cologne and clearly well equipped with its manager Dieter Gorny, employs 144 staff, including 18 presenters, reaping substantial profits since late 1995: overall costs currently amount to DM 42 million (DM 19 million for company-specific production), and the net advertising income comes to DM 48 million; advertising revenue for 1996 is forecast at DM 70 million.[18] An important point to be included in the calculation is the fact that 'children and adolescents, the primary users of video clips, ... spend a monthly average of DM 47.00 in Germany, approx. DM 5.4 bn overall p.a.' (*Werben und Verkaufen* 20.9.1996).

Moreover, VIVA – in addition to its co-operation with the youngest German clip channel ONYX TV – pursues intensive merchandising activities: both in the clothing, recording media and fashion branch as well as in the food and catering trade: three VIVA soft drinks in co-operation with Pepsi Cola were launched. Only the magazine VIVA has been unlucky so far; a fresh attempt is to be ventured with Gruner + Jahr. But everything else is profitable – including another project that the VIVA partners have realised, along the same lines as MTV and its offshoot VH-1 (which can be received in Germany), namely the profitable establishment of a pop music channel for middle-aged people: VIVA 2, founded in 1995, furnished with a new concept in 1996, financed with DM 13 million at launch from VIVA's profits.[19]

## 2.3.2 *The self-image*

In October 1995 the *Süddeutsche Zeitung* characterised VIVA as follows: ' ... music videos round the clock, gangling-unsophisticated presenters ... producing a hullaballoo round and about music: interviews, reports and documentaries, chart shows, and *Interaktiv*, a live show for young viewers who can ask the presenter for advice in any situation' (*Süddeutsche Zeitung*, 31 October 1995). Only someone ignoring VIVA's self-image and its exquisite language design would be capable of such a plain description (Hertneck 1995, p. 43). To pay tribute to both these features, two rather long quotes that reflect the self-image of VIVA are useful:

> In the 90s pop culture has long acted as the key communicative user interface for conveying to the relevant target groups cultural identities, lifestyle and the closely-linked consumer goods messages ... VIVA has advanced to become an image-bearing, trend-setting quality trademark, particularly because of its ideal mixture of a wide-scale effect in the pop music field and simultaneously its intensive trend-scouting ... The video clip is more than the mere visualisation of the sound medium, it is a logical stage further in the development of a complete medium, promoting pop music to an established audio-visual synthesis of art. This synthesis of art comprises youthfulness, emotionality and a trend-setting ability, thus formulating a societal status quo. VIVA, in its role as a pop culture transmitter, not only reproduces this status quo. Its programme has turned the channel into a pop culture 'opinion leader' exerting an active influence. VIVA conveys not only trends, emotions and lifestyle, but also creates, changes and influences, in close dialogue with its viewers. VIVA fuses culture, lifestyle and the product with its own specific aesthetic quality to form a communication platform designed to convey messages and to stimulate public discussions – not only on pop music and pop culture. (VIVA Fernsehen 1996, press release.)

It is obvious that such grandiose slogans ('consumer goods messages', 'image', 'trend', 'product', 'lifestyle' etc.) are not meant for the viewers, ie for young people. These slogans are directed rather at potential advertisers of music and other products on VIVA. Hence the following message primarily directed at the advertising consumer goods branch:

> The clip rhythm governing the VIVA channel generates an extraordinary programme flow. Your commercial is embedded in a magazine-like environment consisting of video clips, brief target-group-oriented contributions, presentations, programme and channel promotion features. So your clip becomes an info clip; zapping is superfluous. With VIVA your message is guaranteed high attention levels, a low degree of oversaturation and a strong advertising reinforcement ... Pop is therefore a perfect social 'mind cart', enjoying on an emotional and fractal plane the highest multiplication and

communication factor, forging the closest links between culture, lifestyle, the product and advertising. (VIVA Fernsehen: Fernsehen & Leistung 1995.)

Is it possible to express this in more 'empathetic' (and more 'appropriate') terms? This question will be considered at the end of this section.

### 2.3.3 Acceptance

In autumn 1996, VIVA is able to access some 19 million German cable TV households, 1.2 million in Switzerland and 500,000 in Austria in addition to 3.7 million households via individual satellite reception from Eutelsat. (It should be borne in mind that these figures refer to the 'technically' feasible coverage.)[20] The preferred age group is the 14- to 29-year-old group, with a clear focus on the 14- to 19-year-olds. In the battle with its competitor MTV Europe VIVA has led the field since 1995 – mainly because MTV Europe, although it offers its programmes uncoded in the cable TV network, transmits to the customer with an individual satellite dish its programme in coded form, requiring an expensive decoder.[21]

A representative survey, carried out in 1995, of 6.6 million 14- to 29-year-olds living in a so-called 'Telekom cable TV household' revealed an actual (not technical!) daily coverage of 16.2 per cent (old German *Länder*) and 15.6 per cent (new German *Länder*) for VIVA, and for MTV Europe one of 8.7 per cent (old German *Länder*) and 10.7 per cent (new German *Länder*). This means that VIVA reached 943,000 viewers daily; MTV Europe reached 504,000. VIVA can clearly hold its own in the competition with other TV channels broadcast in Germany: the actual coverage between 1 p.m. and 12 p.m. amounted to 15 per cent of 14- to 29-year-olds, ie 875,000 viewers. Unfortunately, data for the 14- to 19-year-olds were not available.[22]

In a representative survey in 1996[23] devoted solely to the VIVA audience, a larger (actual) coverage was ascertained. The 14- to 29-year-olds in cable TV households (7.1 million) amount to 25.7 per cent, the 14- to 29-year-olds living in Germany (14.2 million) amounting to 15.4 per cent. In fact, it was ascertained that VIVA is watched daily by 1.04 million 14- to 19-year-olds and by 1.15 million 20- to 29-year-olds).

There are three reasons in particular for VIVA's success:

- First, for a reasonable price VIVA can avail itself of the stars that Warner, PolyGram, Sony and Thorn EMI have under contract and the clips they make for their sound media products; conversely, the channel is obliged to provide publicity for them at an equally reasonable price.[24]
- Secondly, VIVA represents an attractive advertising forum for the consumer goods industry.
- Thirdly, the audience ('VIVA loves you,' according to one slogan) seems to respond very well to the provision of a German-language

channel clearly adapted to German pop and rock music. 'German musicians such as 'Die Prinzen', Marius Müller Westerhagen and the 'Toten Hosen' represent one third of the clips'.[25]

The public response is apparently so great that VIVA seems to be able to draw on a large stock of video clips: the record companies send 40 to 50 clips to Cologne every week. Even if only 10 of them enter the weekly rotation comprising about 100 labels, VIVA does actually suggest it is constantly offering something new, 'something never heard or seen before', that VIVA is the real generator of hits (*Süddeutsche Zeitung* , 13 February, 1996). This, in turn, creates the impression that 'the channel ... presents today ... the bands that won't be in fashion until tomorrow...' And referring to the advertising for other goods: '(The) presenter (is wearing) today the brand of sports shoes that will conquer the school playgrounds tomorrow' (*Handelsblatt*, 3 June 1996).

### 2.3.4 VIVA, young people and the market

This information again illustrates how exactly the VIVA makers' self-image discussed above, once it has been stripped of all the presumptuousness, pseudo-scientific explanations and marketing big talk, does in fact correspond to what the channel VIVA seeks to achieve. The following quote says it all in a nutshell, precisely and convincingly:

> From the media-makers' viewpoint the public represented by young people is nothing but a market; their only real task is to lure youth into it. The proven means to this end is to constantly arouse young people's attention. The symbols are the record single and the video clip. Their brevity not only corresponds to economic considerations such as low production costs and guarantees of high turnover figures but also expresses the suppliers' specific interpretation of the reception ... Both the single and the video clip require only momentary concentration and brief attention on the part of the recipients, probably sufficient to stimulate them in the posture of distraction ascribed to them by the producers. Moreover, the swift succession of such miniatures ensures that constantly something 'new', something unknown as well as something familiar that the recipients already appreciate is transmitted. These ... permutations mean there is a chance that the recipients will remain loyal to the channel, 'zap' less and constantly be accessible to its offers. (Barth and Neumann-Braun 1996, p. 258)

## 3. The hub of the music channels: the music videos

The following considerations focus on the subject of music videos. The main question is how the videos – the key elements of any music channel programme – can be described both as a genre and in their function as a commercial product.[26]

## 3.1 Music videos in the music channel programme

The following assumes that the main components of pop channels are music videos. However, it is a thesis that may only be maintained if certain modifications and the 'peripheral' nature of some other programme areas in this analysis are taken into account.

- The *first* modification arises from the fact that the sector 'music videos' does not represent the whole 'surface' (Münch 1993, p. 56) of the MTV and VIVA programme selection: as mentioned above, there are many other elements featured partly in video programmes and partly in their 'general programme framework': channel recognition devices (jingles, logo presentations, the channel's own advertising), 'interactive' audience participation (chat shows, programme selection, quiz competitions), pop news, fashion and travel news, tour dates, movie tips, interview programmes, etc..[27]

- *Secondly,* a significant part of the overall programme consists of the advertisers' commercials – 12 to 15 minutes per hour, as is generally known. Besides those from the textile, cosmetics, car and alcohol branches, for example, the advertisers are first and foremost the recording media companies that advertise their stars and recording media not only in music videos but also in spots for movies, videos and CDs, for festivals and tours, for fashion and magazines.

- *Thirdly,* the music channels are not only interested in the mere addition but in a specific fusion – in programming and industrial terms – of the previously mentioned aspects. Consequently, the emphasis of a certain aspect – for example of music videos – must always be related back to this overall context (Frith 1993, p. 53 ff.).

- *Fourthly,* in this fusion it is evident that the individual aspects are not only interwoven. It also becomes apparent that it is difficult, if at all possible, to distinguish between these aspects in the characteristics of their form and contents (the structure of their clip aesthetic quality, their symbolic content). Music videos and spots for Coca Cola, movies or sports shoes follow the same design principles; accordingly, the aesthetic quality of the channel recognition devices (jingles) is largely identical to that of the videos and the commercials (Schultze *et al.* 1991, pp. 191 f.)

## 3.2 The music video as a genre and as a commercial product

The four modifications above apply to the area of music videos, which does seem justified considering that music videos constitute some 70 per cent of the whole programme range. Furthermore, the strategy of MTV and VIVA-related company groups is not to allow any restriction of their advertising platform. This is clearly demonstrated by the response of the representatives from Warner, PolyGram, Sony and Thorn EMI to the

suggestion made in this direction by the VIVA editors in early 1996. VIVA was told to slightly reduce the share of overall broadcasting time reserved for music videos (*Süddeutsche Zeitung*, 13 February, 1996).

### 3.2.1 *Worlds of sounds and images*

If the music video is seen as a genre, it is striking that in this form – due to the previous production of the music composition (ie before the video) – the relationship between the visuals and the music is different from that on television or film.[28] The designation of the music video, therefore, as a 'three-minute feature' (Janke and Niehues 1995, p. 114) or as 'video mini-movies' (*People*, 17 October 1983) is not quite accurate. In a video the function of the visualisation is to propagate the music, to allow the 'sound to be seen' (Kemper 1995, p. 20). It boils down to the following: in the video there is ' ... a 'visual track' to accompany the sound rather than a 'sound track' to accompany the visuals' (Lull 1988 a, p. 25).

This connection is quite straightforward in the case of 'performance videos', which simply document the performance of a composition by a musician or a group. On the other hand, the music-image relationship is not quite as transparent in the case of 'concept videos' (Sherman and Dominick 1986, p. 80), providing a visual interpretation of the music – on the basis of a script. Of course concept videos also contain a performance part – very often small, however – since ' ... according to a record industry principle ... the musician or singer should perform for at least fifteen seconds' (Kemper 1995, p. 20). The following section mainly considers concept videos, as they represent the main part of the music channel's programme.[29]

### 3.2.1.1 'Sound and vision'[30]

'The information value of the visuals cannot be explained by their contents but by the liaisons created between the individual scenes in the musical context' (Altrogge and Amann 1991, p. 173). This does not imply that the visualisation constitutes a 'fixed link' (Mattusch 1995, p. 364) with the musical sequence, that the visual language has to be an extension of the musical idiom, as it were. The visualisation process can also come to the fore by behaving asynchronously, perhaps as a contrast to the music, or by assuming a completely different form (Mattusch 1991, p. 118). Moreover, it is obvious that the music video represents a synthesis of various popular art forms:

> Music videos ... involve not only a visual conceptualisation of the song and its performance but also dance, choreography, storytelling, fashion, costuming, lighting, acting, visual techniques (including digital effects and animation) ... (Lull 1988 a, p. 27).

Computer-assisted design facilities, in particular, decisively influence the music video and its dramaturgical and optical quality – often profusely.

This is documented not only by the videos themselves but especially by the channel recognition jingles and commercials. 'All the stops of the paintbox, the Harry[31] and digital effect appliances are pulled, to the point of excess. Cutting frequencies of half-seconds and less are nothing exceptional' (Reetze 1993, p. 187). An important role is played by computer-controlled film editing using the SMPTE technique, which can allot an image to every millisecond in the music (so-called Mickey Mousing). The latter technique is instrumental in creating a uniform aesthetic quality in the clip, pervading all the programme areas.[32]

This does not mean that for different directions of music there do not exist different aesthetic forms, particularly visual aesthetic forms. 'It is possible to demonstrate that, of necessity, a heavy-metal clip produces a different visual aesthetic quality to a rap/hip hop or (mainstream) pop clip (Altrogge 1994, p. 201). However, some common features can be pinpointed that do in fact permit a general characterisation of the aesthetic form of the video clip: namely a specific 'visual grammar' with a specific 'visual rhythm and tempo' and a specific 'non-linear syntax' (Snow 1987, pp. 341 f.). This aesthetic quality has little in common with the conventional type establishing a connection between music and vision on the basis of a continuous structure and a consistent narrative form – although the composition itself is incorporated into the video in an absolutely conventional manner.[33]

This means that, on the one hand, the structure of the composition corresponds to the clear and simple pattern of verse, refrain, transition, repeated to the rhythm of 8, 16, 24 or 32 beats. On the other, the melody and harmony of the composition do not exceed what might be termed a standard pop form. And yet the 'static' component of the composition is considerably decreased by the conventional continuously progressing music that structures the (frequently discontinuous) visuals, the latter simultaneously accentuating and thus setting off the individual musical aspects. 'The sequence and development of a composition is accordingly superseded by the simultaneity of the sound pattern, intensifying even further the emotion expressed in the music' (Barth and Neumann-Braun 1996, p. 261).

3.2.1.2 'The Look of the Sound'[34]

The factors outlined above give rise to what is referred to as video-characteristic, dynamic, audio-visual 'worlds of sound and visuals located at the interface of pop music, television and film' (Winter and Kagelmann 1994, p. 209). But a music video does not represent a sum of music plus television:

... but a unique audio/video combination, both in form and content ... Videos present a flow of highly impressionistic, at times random or illogical, sequences and juxtapositions of audio/video imagery. (Christenson 1992, p. 64)

Music videos 'imitate dreams or manufactured fantasies' (Aufderheide 1986, p. 65), and they do so not only by means of music, lyrics and visuals but also by way of highly sophisticated digital technology. It is worth noting that music videos do not reproduce any reality but create new 'realities' – but often by using well-known scenes from films, paintings, comics and fashion etc, by borrowing equally known elements of musical styles and trends. The music video ' ... pillages all existing art forms, cultural history and literature, uses all forms of cinema, contains comics, stories, dramas, jokes, condensed into a simultaneous collection of visuals' (Kemper 1995, p. 20). Or put even more bluntly:

> In every aspect of (their) appearance, ranging from the cloak of sound to the lighting design, (they) hardly ever refer to reality but to the history of the media. Music videos do not claim to be music and vision but time and again joyfully allude to the notion that they are images of images we all know from the history of the media, to the idea that they are echoes of tones almost all of us have heard in the past. (Weibel 1987, p. 275).

The music video can therefore be described as a *bricolage* – as 'a rearrangement and re-contextualisation of objects with the intention of communicating new meanings' (Baacke 1996, p. 201). Usually the *bricolage* in the videos is transformed into a *pastiche*, – into a form characterised by the 'art of imitations whose original has disappeared' (Jameson 1986, p. 61). It is self-evident that this borrowing of known elements involves 'forgery with no holds barred' (Reetze 1993, p. 189 f.), which becomes crystal clear when one watches MTV and VIVA for some time.

### 3.2.1.3 The Playfulness[35]

Most striking is the (constantly accelerated) pace at which these images are linked in the videos and combined in rapid takes. 'Breakneck editing technology generates extremely fast moving frames ... At an average editing sequence of approx. 2.2 sec. a three-and-a-half minute clip contains 100 frames. The associative image switching ... induces 'perception shocks' ...' (Winter and Kagelmann 1994, p. 210) It goes without saying that the 'suggestive character' (Altrogge and Amann 1991, p. 172) of the video is based on this kind of music-image combination, in which particularly the synchronisation of the rhythm of the music, the rhythm of the camera work and the editing rhythm play a key role.

This type of camera and editing technology allows very many elements to be compressed together in an extremely brief period, ie a host of heterogeneous, disparate and contradictory aspects – in terms of both form and content. Classic examples to illustrate this point are: Michael Jackson's *Thriller* and *Bad*, Madonna's *Material Girl* and *Take a Bow*, Prince's *Alphabet Street* and the acclaimed videos produced by Rudi Dolezal and Hannes

Rossacher for Queen, David Bowie, the Rolling Stones and Michael Jackson.[36]

The vast majority of the videos presented on the music channels cannot be compared to such concept productions, whose creation is based on an ambitious story, script and editing plan in film technology terms. The latter, however, clearly demonstrate what the others show initial signs of.

> Here apparently random documentary material is combined with studio recordings, cartoon films, trick films and computer visuals, fused or contrasted and superimposed with scenes from old films or visual material handed down during the history of art in addition to mythical settings, all racing by at a breathtaking speed and a breakneck editing tempo. (Barth and Neumann-Braun 1996, p. 260)

Naturally, it should not be forgotten that not only concept videos are shown on the music channels. Just to name a few examples: 'performance videos' are still in evidence, eg the video now in circulation *I can't help myself* by the Kelly Family. Mixtures of the 'performance video' and a simple form of the concept video are also presented, eg *Più bella cosa* by Eros Ramazotti or *Vamonos* by the group García. They are joined by a series of videos in which a relatively long or short story is told in true linear fashion, fairly closely linked to the song lyrics, eg the Toten Hosen with their *10 Kleine Jägermeister*, Bürger Lars Dietrich with '*Sexy Eis*' and Stefan Raab with his jubilee song for the *Sendung mit der Maus*.

Back to concept videos. Particularly striking is their constant propensity towards association and momentariness, which in turn fashions the presentation of sense (or nonsense). However, it should not be implied at this juncture that the videos mostly tell, meaningful albeit brief, stories. First and foremost, the video channel seeks to offer an appealing, stimulating range of contact opportunities, which seems to contain nothing but 'fun, carefreeness, exuberance, rebellion, spontaneity, modernity, sensuousness, incalculability and irreverence'(Kemper 1995, p. 23).

Finally, another salient feature is the non-stop presentation of the music videos throughout the programme, the constant scattering of the clips suggesting a 'timeless here and now', thus working towards a possible 'de-historisation of experience'(Winter and Kagelmann 1994, p. 211), tantamount to an abolition of history ' ... offering in its place a set of aids to nostalgia' (Aufderheide 1986, p. 71).

This is particularly the case when the music videos lean more towards the form of 'dream-like structures', the inevitable product of 'masses of images, frame editing, duplications, inserts, fade-in and fade-out effects, superpositions, freeze frames, colorations etc. often repeated in one clip, frequently without any visual narrative' (Barth and Neumann-Braun 1996, p. 260). It remains to be seen whether these three arguments will legitimately classify videos as either 'raging monstrosities, visual atrocities

on the rubbish dump of cultural history' (Kemper 1995, p. 20) or a cultural phenomenon, whose 'symbols and iconographs' ... (conceal) ... social myths and opportunities for experience' (Mikos 1993, p. 18).

It is however correct to say that the main principle now controlling the form and contents of the videos is the (afore-mentioned) high degree of playfulness, which can quite rightly be criticised if it has nothing more to offer than the 'shallowness of being', although the 'greed for fun' only becomes really embarrassing when the allegedly relevant social problems are packed into them, which is unfortunately often the case.[37]

It is also probably right to say that the frequently (over-) intensive use of computer-assisted production methods often leads to a hodgepodge of visual bubbles, which are neither atrocious nor worthy of any cultural award. They purely and simply block the view: the observer is denied the opportunity to 'let his gaze and thoughts wander' (Behne 1986, p. 101) and thus any real chance of appraisal.

### 3.2.2 Production form and production costs

It was said previously that the production costs for a video amount to DM 300,000 on average. This does not exclude the possibility of some videos costing DM 50,000, others DM 500,000 and a few considerably more: for example, the Michael Jackson videos *Thriller* (14 mins., directed by John Landis) and *Black or White* (6 mins., directed by John Landis), are reported to have cost 3 and 15 million Deutschmarks, respectively. Whether these figures are accurate or were just announced for sales promotion reasons cannot be ascertained. In any event, the production of videos seems to be more expensive than the manufacture of the actual recording media, an investment amounting nowadays to an average of DM 200,000 (once the music stars have been paid for).

Normally, the recording media companies do not manufacture the clips themselves. For this purpose they hire – with the assistance of their specially appointed 'video agent' – studios and/or an advertising agency. As the production of the videos generally does not get off the ground until four weeks before the market launch of the recording media (usually CDs), little time is left for the overall production (conception of the story-board, decor, the actual shooting, post-production). Particularly post-production, ie editing the visuals to match the music, the programming and creation of visual effects, is extremely time-consuming, although the procedure nowadays is fairly straightforward. Computer technology provides the solution, to be more precise: the previously referred to SMPTE visual and audio editing technique, applied for storing synchronisation impulses on both the music composition tape and on the previously shot video and film material, so that the sound and the vision can be easily edited to match the music, down to one twenty-fifth of a second (Reetze 1993, p. 184).

### 3.2.3 *The advertising function*

The videos, in terms of form and technology, may be extremely sophisticated and brilliantly conceived with regard to their lyrics and visual structure, but they are not programmes alone; they are programmes that have the specific role of mass marketing for popular songs (Aufderheide 1986, p. 59).[38] This means two things: on the one hand, the separation of the programme and the advertising does not apply to the music video, on the other, the programme must be evaluated according to the effectiveness of its advertising function, demonstrating that the music, lyrics and visual quality incorporated and the symbolism and 'mood' produced actually fulfil this function.[39]

In this way, an 'advertising nature' is imposed on the music video, which in turn becomes a 'promotional tool' (Abt 1988, p. 102) used today by the company-controlled CD propaganda. Ironically, the fusion of the music programme and advertising is based on the visualisation of a music form whose formerly hard, but today constantly eroded, softened core is rock 'n' roll, which at least in the early days of its career always rallied to the fore in the fight against commercialisation.[40]

Music videos, however, are not only commercials in themselves, they must also act as a useful setting for the commercials of other advertisers. This leads to clear adjustments between the two sectors. On the one hand, the commercials contain the same formal design approaches and content elements as the videos: on the other, many videos contain consumption-oriented presentations and product placements, which – as indicated above – could equally stem from commercials. As Kemper (1995) points out:

> The latest surveys in the USA have revealed that almost thirty per cent of all music clips contain some reference to a brand article, that almost seventy per cent show the consumption of certain products – from cigarettes and drinks to chewing-gum ... The genres with the most distinct evidence of commercial design are dancefloor (techno) and soft-pop videos. Particularly videos from the 'mainstream-pop' sector mainly operate with pleasant visuals, where good-looking, happy people, quite often in erotic situations, create the right atmosphere. This is then transmitted to the next commercial by means of the 'priming effect'. This means that the cognitive categories, most important for the perception and evaluation of the clip, are also applied to the perception of the advertised products. (Kemper 1995, p. 22)

This relationship must also be realised the other way round – ie from the commercial across to the music video (Aufderheide 1986, p. 62). If this were not the case, it would imply a clear rebuttal of the *ultima ratio* in advertising. The maxim, that is the famous slogan: 'Don't confuse the customer!', assumes that the viewers' minds can only assimilate the programme's buying and sales-promoting intentions including the

commercial information when confusion is excluded and when the 'ambiguity and complexity' of the advertising environment does not differ too much from that of the commercial.[41]

This reciprocal adjustment between music videos and commercials therefore makes it seem legitimate to describe the programme offered by the music channels referred to (including the other programme sectors previously mentioned) as a continuous advertising flow, in which the only differences are the different acts of advertising (Schultze *et al.* 1991, p. 189). In the midst of this the music protagonists, who are supposed to perform for at least fifteen seconds per video (Kemper 1995, p. 20), are relegated to the role of commercial characters. In the very apt words of an advertising executive referring to Madonna: 'She is a commercial character. She's changed her persona three or four times in her career already, from the vamp ingenue to the punk, to the techno girl and to who knows what, and I think Pepsi's done the same' (quoted by Savan 1993, p. 90).

It was probably not very realistic to hope that the advertising function of the music videos (with reference to the commercials) would be somewhat limited by the fact that the 'mediator' in the commercial is a (later obtainable) product whereas in the music video a subject is presented as the 'mediator', who, with his or her (acted) problems and conflicts, offers him or herself as a directly accessible identification and projection figure (Morse 1986, p. 24). It could consequently be assumed that, due to the video-characteristic mode of presentation, the subjects featuring in the videos also come over as 'products', who are not registered as identification and projection figures but as mere accessories purchasable with the product.

By no means can it be concluded from the previous arguments that the music videos are pure advertising messages. It would be more accurate to see always the music videos in their double role, as a programme and as a commercial. The programme side of things includes such tendencies, expectations, conventions and interpretations designed to achieve their particular goal.[42] Hence the crucial point is that the two sides of this double role mutually determine each other and that they generate the music videos' quality as a specific 'form of communication and a symbolic sphere of culture' (Lull 1988 b, p.171).

### 3.3 The music forms presented in videos

Before music videos as a conglomerate of music, lyrics and vision are analysed further, it is probably wise to review briefly the forms of the music on offer in music videos. It is self-evident that the 'pop and rock music context' represents the 'aesthetic quality of the music video' (Schenkewitz 1988, p. 108). But it should be borne in mind, however, that the 'rock element' of this context refers to two things. On the one hand, it alludes to rock 'n' roll in its original form (of the 50s and 60s). On the other,

it denotes the most significant component of modern pop music – a component in which rock 'n' roll disintegrates into several variants, far more diluted than its original form.[43]

### 3.3.1 From rock 'n' roll to commercialised pop

The rock 'n' roll of the 50s consciously and consistently tugs at the taboos and restraints of a conservative society. It resolutely turns against the parent generation of the teenagers at that time, enabling them to dissociate themselves from their parents and to devote their energy to 'scandalous things such as teenager love, body-oriented dancing, staying out late and ... outrageous ducktail haircuts' (Bill Haley & The Comets, Elvis Presley, the early Beatles).

In the 60s the main issue is no longer rebelling against parents. The key issues are now political interests (the campaigns against Vietnam, against capitalism), expressed in varying degrees of clarity and personified by the 1968 generation and the hippies at Woodstock (Jefferson Airplane, Jimi Hendrix, Janis Joplin, the Rolling Stones, The Who). 'Significant is the solidaristic character of pop music, it (is) the banner under which youth (gathers) to join battle' (Janke and Niehues 1995, pp. 54 f.).

Precisely this solidarity collapses in the late 70s, the early 80s. What then wins the day is the break-up into a mosaic of different youth scenes (mainly spurred on by commercial interests): the grand age of mainstream pop, which – as the 'smallest common denominator of the drifting apart (youth) scenes' – is directed at every single one of them. Then comes the pluralism period, ie a diversification of music sub-cultures linked to individual youth scenes that they serve as status symbols. These sub-cultures (and their stars) are mostly very clearly defined according to market and consumption criteria (see below: dancefloor, acid jazz, country rock, techno/house and, partly at least, rap/hip hop, hard rock and soul). And yet there are still a few sub-cultures (see below: punk, heavy metal, reggae/ragamuffin, cross-over, alternative rock), which are quite rebellious in character and more interested in the idea of individual and social problems than in commercial objectives.[44]

It is essential to draw the right conclusions from the situation just described: only when the three outlined aspects (mainstream, commercially adjusted and rebellious music sub-cultures) are seen collectively is it clear which functions music videos fulfil for young people – functions that can range from release from everyday pressures and failures to the development of personal and social (group) identity.[45] This issue will be discussed more extensively later.

### 3.3.2 The most important styles

To describe in more detail against this background the music videos presented on the music channels, a wise starting point is the individual

styles the videos belong to:

- *Mainstream Pop/Rock*: the music of the – rather traditional – 'taste of the majority' (Phil Collins, Marius Müller-Westernhagen, Meat Loaf);

- *Mainstream Dancefloor*: the music of the big discos; a combination of – frequently computer-rhythmized – danceable songs and catchy melodies; music fresh from the studio laboratory, aimed at short-term success in the hit parade (Culture Club, Dr. Alban);

- *Classical Rock*: 'contemporary' edition of the classical form of rock from the 50s and 60s (Eric Clapton, Sting/Police, Bruce Springsteen, Tracey Chapman) with partly modernistic format (REM, U2, Prince);

- *Country Rock*: rock 'n' roll, hill-billy and grassroots music featuring a usually superficial connection with rock (Roseanne Cash, Holly Dunn, Clint Black);

- *Hard Rock/Heavy Metal*: markedly masculine hard rock with metal guitar riffs; mostly aggressive forms; speed and thrash metal (Metallica, Sepultura, Scorpions); in fierce competition with grunge and alternative rock;

- *Punk*: music form consciously committed to instrumental amateurism and anti-establishment ideology; combination of 'hostile lyrics' (Lull 1988 b, p. 166) and rattling hard rock (Sex Pistols, The Clash);

- *Rap/Hip Hop*: music of the Afro-American minorities in the USA: combination of rap (speech-song) with hard, usually synthetic rhythms; the lyrics relate to topics such as 'violence', 'sex' – not as themes generally, but as everyday reality in the ghettos (Ice-T, L. L. Cool J.);

- *Techno/House*: computer-generated form of music solely designed for dancing to; constant repetitions of motif, allegedly creating a trance-like state; little singing, little star cult; house is less hard and abrupt than techno; necessary to differentiate between ultra-hard gabber techno and tranquil-meditative trance, ambiente, or chill-out techno (main performers in Germany: Westbam, Marusha, Sven Väth);

- *Grunge*: the slovenly-dressed kids' or neo-hippies' rock; anti-consumerism; raw guitar sound (Nirvana/Kurt Cobain);

- *Reggae/Ragamuffin*: music from Jamaica and hub of the Rastafarian scene; developed further to ragamuffin – to a mixture of hip hop, reggae and toasting (Jamaican speech-song), with (often chauvinistic) lyrics, featuring in particular violence, are the subject (Chaka Demus & Pliers, Shaggy);

- *Dancefloor Jazz/Acid Jazz*: jazzy music geared to dancing, in which swing, soul, funk, hip hop and dancefloor are combined into a modernistic arrangement (Brand New Heavies, U3);

- *Independent Music*: underground music, released by so-called

407

independent record companies; unconventional, guitar rock usually directed at an insider audience at least (Einstürzende Neubauten, Pavement);

- *Jungle*: also called breakbeat; a mixture of techno, hip hop, and ragamuffin with muffled-fast, percussion-generated rhythms (General Levy, M-Beat);

- *Cross-Over/Experimental Rock*: mixture of all (not only pop) styles with a rock-rhythm base and avant-garde format; intensive use of music appliances (samplers); lyrics fluctuate between the documentation of senselessness, radicalism, withdrawal into introspection and puns;

- *Alternative Rock*: combination of grunge, heavy metal, cross-over and hardcore; aggressive music with critical, radical lyrics on social politics (Henry Rollins, Rage Against The Machine, Soundgarden; German artists: Selig, Rausch, Das Auge Gottes).

Watching the channel VIVA soon reveals which of the enumerated music forms are currently more in demand and which less so. To sum up these observations:

1. It becomes clear that there are several programmes intended to present the 'breadth' of current pop/rock music culture and hence a mixture of all the styles described above. Some examples are *VIVA Wecker, Video mit VJ, Neu bei VIVA, Freunde der Nacht* and *Nachtexpress*.

2. It can be seen that mainstream pop/rock/dancefloor – seen as a single style – occupies a strong position, (which is hardly surprising). On VIVA at least 6 to 7 hours a day are scheduled for the presentation of this predominant performance style. This is evident not only in the programmes already mentioned (*VIVA Wecker, Freunde der Nacht*) but also in programmes such as *Jam, Top 100* and *Charts*.

3. It can also be observed that especially the following styles have an established time-slot in the programme range – hip hop/rap in the programme *Word Cup*, house/techno in the programmes *House TV* and *Trance*, classical rock in *Clip Klassiker* and *On the Rocks*, heavy metal in *On the Rocks* and *Metalla*, cross over in *Bits and Pieces* and alternative rock in *Wah Wah*.

4. On VIVA a wide-ranging block of domestic pop music culture is represented, eg in the programmes *Top 100* (the charts of the German sales hit parade), *Jam, Neu bei VIVA, Interaktiv* and *Freunde der Nacht*.

On MTV (in this case MTV USA) the spread is different, according to a programme analysis done in 1994 alternative rock predominates, mainstream pop occupying a lesser position. The analysis of 161 MTV, VH-1, TNN and BET[46] videos revealed that the various styles occupy the following shares in the respective programme range (the range is probably comparable to the MTV Europe version: this survey did not allocate the respective percentages to individual shows): alternative rock 29 per cent,

rap 23 per cent, heavy metal 21 per cent, pop mainstream 16 per cent, classical rock 9 per cent, country 0 per cent and others 2 per cent (Tapper, Thorson and Black 1994, pp. 110 f.).

An additional feature applicable to MTV Europe is that British pop/rock music is very well represented in the channel's programmes. This is easy to explain, for the British audience is MTV Europe's most important customer, but the – previously very low – proportion of German pop/rock music presented on MTV Europe has increased significantly in the past few months (*Süddeutsche Zeitung*, 23 April 1996).

### 3.4. *General trends in lyrics and visuals: consumerism, sexism, violence*

Any intention to classify more precisely the narrative content of the music videos – which is, as already known, non-linear or features at least so many insertions, interruptions and digressions that a linear narration becomes impossible – will have to face one enormous restriction or lacuna.

### *3.4.1 Lacuna*

This restriction consists of the phenomenon that any explanation of the contents of music videos can only relate to the song lyrics and the visuals, but not to the form of the music. The reason is that existing scientific, essayistic and journalistic treatments of what occurs in music videos shed little light on the music dimension, on which the lyrics and visuals are based, as it were.[47] And yet an analysis of the music forms could furnish some important findings which would then have to be combined with those arising from lyrics and visuals analyses in order to show what the contents of the music videos actually have to offer.

One notable feature is the aggressive-invasive character common to almost all videos – excluding so-called soft pop – with which the music cascades from the screen, best observed in rap/hip hop, techno and heavy metal. Another is the extremely accentuated stamping and tramping rhythm in rap/hip hop, techno and heavy metal, but also in alternative rock, cross-over, grunge and jungle, which – obstinately, unwaveringly – often seizes the role of a converting, conforming whip, of a subjugating machine, as it were.

Finally, an important feature is the wrapping of the music composition in the corset of a simple melody setting and an equally simple harmony, whose conventionality contrasts dramatically with the sophistication of the applied film and computer technology. At present it is not possible to answer the question as to whether it is justified to review such factors so critically: they first require individual analysis and to date no reliable research findings exist on the subject (nor on the question of how these factors actually affect the recipients – see below).

The following discussion will therefore be based on material arising from the analysis of lyrics and visuals, of which there is no abundance and which mainly applies to MTV USA. This is not particularly problematic, since the findings can probably be transferred to MTV Europe and VIVA because of the similarity of the videos broadcast. The discussion will focus on the subjects destined for long-term debate in view of the videos' subject matter, as they are said to be conducive to consumerism, sexism and violence.

### 3.4.2 Consumerism

It can hardly be ignored that in the music videos, consumer worlds are created – which explains why they are such a useful setting for the commercials of other advertisers. The glamour of these consumer worlds is due to the overall 'mood' of the videos, to the performers, ie musicians and actors, to the reality and virtual reality sets and the numerous accessories offered at all levels of project activity.

First of all, this is demonstrated by the great care taken to achieve perfect 'styling'. In this way the video and (consequently) the song to be sold are equipped with an unmistakable, highly promising brand image embracing the 'extraordinary life and drive' celebrated in the video and alluding to a special feel-good mood which can be bought with the CD. This is clearly seen in the (self-)presentation of the pop and rock stars. Vollbrecht (1987) observed:

> The non-music stylistic devices such as appearance, clothing and accessories must be 'just right', when the high priests of rock and pop set out to present their own image in a credible fashion – regardless of the type of presentation: whether it be the coolness exuded by *Victor Lazlo, Sade* or *Annie Lennox*, the clean eroticism radiated by *Whitney Houston* or 'boy toy' *Madonna* or the veteran sex symbol *Tina Turner*, the androgynous get-up of *David Bowie* or *Boy George*, the rebellious wildness of the leather-and-stud gear of the hard rock and heavy metal bands, the aggressive outfits of the punks or the militant rig-out of the skinheads, the garishness of *Fuzzbox* and *Cyndi Lauper*, the notoriety displayed by the sinful black of *Marc Almond & The Willing Sinners*, the body cult practised by *Grace Jones*, the Yuppie ambience of *Heaven 17*, the black-magic touch of *The Mission and Blue Oystercult*. (Vollbrecht 1987, p. 91 f.)

Someone who buys a CD by one of these stars buys and acquires at the same time the whole mood associated with their presentation as well as all the inherent elements. Especially the latter enables the recipient to become a star-like figure – by mimicry, copying the body language, the gestures and the language, by acquiring the clothing and the ambience.

The music video facade geared to consumerism is also borne out, as previously mentioned, by the music videos containing a constant variety of

'consumption-oriented presentations, which could have been taken from commercial clips. Branded articles are shown either directly or their use is incorporated into the video scenes' (Kemper 1995, p. 22). The range stretches from cars, motorbikes and entertainment electronics to designer furniture, from clothing and jewellery to chewing gum, cocktails and baseball caps. Here it is not only a question of offering products but of creating a favourable atmosphere conducive to the purchase of both the music and these products.

It is clear that in both cases probably almost all music videos act as 'marketing instrument(s) of pop culture' and therefore – sometimes persistently, sometimes less intrusively – as the 'branded articles of television fun culture' (Kemper 1995, p. 22). The hope placed in MTV USA in the early days – that the music videos presented there must admittedly be of a commercial nature, but that a part of them could still be 'responsible, socially conscious, satire- and parody-based' (Goodwin 1993, p. 63) – has not been fulfilled. Hence there is some justification in the thesis that a primary function of the videos consists of providing their young audience with a thoroughly merchandise-based, ie consumeristic response to their interests in developing a personal and social identity (Vollbrecht 1987, p. 92).

### 3.4.3 Sexism and violence

The second criticism that can be levelled at music videos is that the lyrics and visual stories are mainly littered with clichés. According to Kemper (1995), the visuals range

> ... from beautiful African women to good-looking Japanese men, from heavy motorbikes to snazzy cabriolets, from black leather jackets to red mini-skirts. Time and again loom the same grey cliffs from the blue sea. Smoke, mist and lightning almost always put in an appearance ... Frequently the iconographic repertoire of pop videos is restricted to ponderous, meaningful symbols, alluding in the final analysis to sex and death. (Kemper 1995, p. 20)

The crux of the problem, however, lies less in the cliché nature of the world of vision than in the phenomenon that 'garishness and colour' (Schorb 1988, p. 133) are all too often infested with sexual or anti-social elements,[48] to be more precise, with sexism and violence. It goes without saying that the visuals express and propagate far more than the actual song lyrics, to which neither the songwriter-performer nor the audience attach much importance (see below).[49]

### 3.4.3.1 Sexism

There is the general view, elicited by the 'everyday run of things' on the music channels, that music videos are wrapped in an all-pervading atmosphere of sexuality. Unfortunately, there is no general analysis providing objective information about the quality and the significance of sexuality depicted in the

411

videos. In the (few) relevant surveys carried out to date the subject of interest was narrowed down to individual aspects, the findings of which have provided few conclusions – particularly concerning the question as to whether the video-characteristic portrayal of sexuality is to be classified as sexist or not. Now follow a few findings furnished by these surveys before the 'general topic' of sexuality is resumed.

The starting point of the surveys is that a tendency towards sexism can be perceived in the gender of musician and actor personnel performing in the videos. The findings of the afore-mentioned contents analysis by Tapper, Thorson and Black (1994) have ascertained a clear predominance of men in almost all styles: 100 per cent of the protagonists in classical rock, 100 per cent in heavy metal, 88 per cent in rap/hip hop, 79 per cent in country, 77 per cent in alternative rock, 68 per cent in mainstream pop and 56 per cent in soul videos.[50] The proportion of 'black' men in rap/hip hop videos amounts to 88 per cent and to 56 per cent in soul videos: the proportion of 'white' men in classical rock amounts to 100 per cent, to 92 per cent in heavy metal, 79 per cent in country and 69 per cent in alternative rock videos.[51]

Other analyses have shown that the incidence of sexist trends – ie the 'male gaze' (Kaplan 1987, p. 55) and other patterns of behaviour portraying men as virile 'sex subjects' and women as acquiescent 'sex objects' – is higher in certain styles (Signorielli, McLeod and Healy 194, p. 91 ff.) Rap/hip hop, soul, mainstream pop and alternative rock videos, for example, are 'high in sex appeal' (Tapper, Thorson and Black 1994, pp. 111 f.). Heavy metal, country and classical rock videos are relatively unobtrusive, however.

Further findings from another survey have revealed that the video-characteristic women's image coincides with the (numerically) weak position of women (Seidman 1992, p. 209 ff.). This image portrays women as sexually provocative, emotional, dependent, compassionate, acquiescent and submissive figures. Men, on the other hand, are characterised by a thirst for adventure, claims to power, obsession with technology, aggressive and violent behaviour (see, for example, *Fast Love* by George Michael, *Laila* by Blue System [Dieter Bohlen], *Move Your Ass* by Scooter and *Killing me Softly* by the Fugees).

The question as to whether such a description is contradicted when stars such as David Bowie, Boy George, and particularly Michael Jackson hide behind a 'mask' (Mercer 1993, p. 102) of feminine qualities will not be dwelt upon here. Perhaps according to 'post-modern' criteria the video-characteristic women's and men's image is not called into question by this mask but is actually re-confirmed in a rather profound way.

The situation looks somewhat different in the case of Madonna and the already-mentioned Cyndi Lauper. Both refuse to accept the role traits accorded to women and illustrate in their songs how to waylay, how to

treat these traits with irony and ridicule, how to fool men in an absolutely non-male way (Lewis 1993, p. 143 ff.). And yet a young female viewer, who sees that one of her own identity problems is addressed, cannot always rely on such help. This is borne out by Madonna's video made in 1995 (*Take a Bow*), which celebrates the submission of a woman to a man in the example of a bull-fight – although the bull, as is generally known, is male and 'the Andalusian bull-fight ... tells the story ... of the triumph of civilisation over what is male and brutish, of the art of sublimation' (Hertneck 1995, p. 44).

Someone who watches videos as an everyday practice will soon be confronted with the fact that sexuality, sexual poses and sexual practices (sometimes as an illusion, sometimes as virtual rape) are constantly evident and peddled in a way that is literally overpowering (Schorb 1988, p. 133). In the case of most videos it does in fact seem typical that 'the body (is) at the centre of the visual whirl, the beautiful jerking, winding body' (Kemper 1995, p. 20), and a glamorous wide-screen carpet of 'seductive' sexual stimuli is unfurled, irrespective of whether the song lyrics require it or not: see completely different video variations such as *You to me are everything* by the group Flip da Scrip, the gay *Laila* by the group Blue System and the extremely accentuated top-and-bottom edition of *Sexy Eis* by Bürger Lars Dietrich.

This can have undesirable consequences: first, the magnitude of the sexual or sexually tinged performances can lead to an inflationary repetition of the same and always the same, presenting something that was never intended, namely the de-sexualisation of the videos induced by constant sexualisation. Secondly, the persistent reduction of eroticism to the level of object-like, backdrop ornaments will ensure that sexuality and the inherent relationship become exhibits bereft of any psychological and social quality. Thirdly, sexuality, being largely integrated into (advertising) commercial practices, assumes the guise of a superficial relationship – for the subjects involved – transmitted via goods and other commercial attributes, losing all substance in the absence of any real reference to it.

Many music videos can thus be described as peep shows, beckoning to the voyeuristic would-be consumption of 'fast love (food)' – see the above-mentioned George Michael title *Fast Love*. Moreover, they are peep shows obviously featuring a relapse into 'bygones', although their frequently sugar-coated artificiality and the title of 'brilliant achievement' in terms of film and computer technology endeavour to conceal this fact. For much of what is staged in their worlds of lyrics and visuals is probably old hat by now for the modern relationship between the sexes: for example the depiction of women as willing 'boy toys', the stylisation of men as exhibitionistic, cool sex dandies – occasionally endowed with a sado-masochistic touch.[52]

### 3.4.3.2 Violence

The extent of the 'violent trends' (Abt 1988, p. 209) represented in music videos does not seem as great as that ascertained in the presentation of

sexuality (Tapper, Thorson and Black 1994, p. 112). There are several serious reservations, nevertheless. They are difficult to identify and specify, as, on the one hand, there is little relevant material available and, on the other, the category 'violence' is restricted to narrowly defined elements and applied indiscriminately; that is, without any differentiation between physical, psychological and (societal) structural violence.[53]

First, it is criticised that in virtually half the concept videos 'nihilistic images such as sacrifices, murders, self-destruction, brutality, theft, drug use, and skin punctures' (Schultze *et al.* 1991, p. 209) are portrayed. The main characters featured in these acts of violence, mainly 'hand-to-hand combats' (Sherman and Dominick 1986, p. 87) whose outcome (bloody or otherwise) is rarely shown, are mostly 30-year-old white males.

A review of the findings on the channels MTV Europe and VIVA apparently reveals a certain divergence from the above. Hand-to-hand combats rarely come about, it seems. And yet the violence often seems to be couched in the threatening atmosphere of the cities, the indifference shown by technology, by the misanthropy of the military machinery, by the gloom of catastrophes and raging destruction.

The afore-mentioned predominance of men applies to both the category of the delinquents and to the category of the victims: 84 per cent of the delinquents are men, 16 per cent are women and 92 per cent white; 81 per cent of the victims are men, 19 per cent are women and 88 per cent white.[54] Another finding from a different survey has revealed that the subjects of sexuality and the confrontation between the younger and older generation play a key role in 80 per cent of the 'violent acts' recorded (Abt 1988, p. 101).

Unfortunately, with regard to the latter phenomenon no consistent dividing line was drawn between the level of violence and that of actions and circumstances arising from the rejection of authority. The latter level would reveal considerable material for analysis, since a great many rock bands, particularly from Germany, refer to this subject – see *Du bist Scheiße* (You're a bastard!) by the zany young-girl trio 'TicTacToe', the lament *Die Welt kann mich nicht mehr verstehen* (The world no longer understands me) by the 'Tocotrinics' and *Friedenspanzer* (Peace tanks) by the 'Ärzte', the ballad about a quarrel – proclaiming the toilet to be the best purgative device.

Just a word about the group Ärzte. In the discussion on violence hard rock, heavy metal and punk rock (including grunge) are often ascribed the role of the 'baddies, to all intents and purposes'. These styles till the field in which (allegedly) violence and especially the struggle against the social and parental establishment, thrive.

Some hard rock, heavy metal and punk rock titles can therefore be described as 'aggressive music' (Schorb 1988, p. 133). Just now several

414

numbers (partly of the pseudo type, however) from this genre are being shown on MTV Europe and VIVA: *Mission Impossible* by Adam Clayton and Larry Mullen, *Move your Ass* by Scooter, *The Crossroads* by 'Bone Thugs 'n' Harmony' and *Rising High* by the punk team 'H-Blockx'. Such 'acts of violence' are justified by both the musicians and the video-makers and well-disposed critics by the argument that the violent, anarchical acts in most videos clearly focus on the confrontation between the younger and the older generation.[55]

One vindication, they claim, is that they are an expression of juvenile genuineness and concern, ie of young people's anti-affirmative, critical attitude. There may be some truth in this – particularly in the case of the younger speed, thrash and death metal bands. As far as the older heavy metal bands are concerned, however, a lyrics and visuals analysis has revealed that they ' ... (are) far more affirmative than generally thought' and ' ... behind an idiom of thoroughly ritualised gestures they exhibit a system of values whose dichotomous social images and traditional gender-specific roles, in principle, comply with conventional views' (Altrogge and Amann 1991, p. 173).

The position of the younger generation of hard metal bands is somewhat different. They combine 'their radicalised social-critical expression, which not only points an accusing finger at social distress but actually documents it visually, using highly unconventional 'non-filmic' visual means of presentation' (Altrogge and Amann 1991, p. 174). But this cannot justify any form of a 'call to violence'. However, the way the two groups position violence in their videos (and lyrics) must be judged differently.

With the exception of heavy metal, punk and alternative rock, in which violence has a political status, as it were, violent behaviour is staged in the other styles as briefly flashing trimmings, set in sex and fantasy scenes and at times toned down. Some examples can be found in the numerous rap/hip hop and reggae/ragamuffin, gabber techno and jungle videos. But as violence and violent behaviour are always kept in the dark, concerning their psychological and social implications, violence often seems to be a playful, often very artificial or feigned, situation that immediately vanishes amidst the cascade of images.

It must not be overlooked that such a brief presentation is set in a highly intense sequence of visuals and usually accompanied by persistent musical reinforcement – the result of editing to produce an emphatic song beat. Consequently, the whole video can be tinged with just a short highlight of violence and thus converted into a programme with an aggressive and violent slant. No conclusive and reliable material is currently available to confirm or refute such a thesis.

## 3.5 Presentation

It is not possible to discuss extensively the topic of presentation in this context, which would in fact be difficult, as hardly any information and studies can be found on this subject, either. Now follow a few brief pointers, however, which refer solely to the presentation incorporated in the individual music video programmes. The prime objective of the presentation is to create time and again the channel identity (Hertneck 1995, p. 44), to forge an audience-channel relationship that ensures a positive viewer commitment to the music videos – and to the rest of MTV/VIVA broadcasting and its commercials.

The presenters (the vee jays = VJs = video jockeys) are therefore 'part and parcel of the channel design' (Reetze 1993, p. 215). In 1996 VIVA, for example, had 8 female and 10 male presenters. Each one represented a certain type of music and fashion, was normally responsible for two programme series, and embodied a style of presentation stringently geared to the target group, particularly the 14- to 19-year-olds, blending in with the style of the music presented, and located somewhere between the categories: good-humoured and down-to-earth, unsophisticated-silly, seductive-flirtatious, and athletic-dynamic (Reetze 1993, p. 216).

This still applies to both VIVA and MTV. Moreover, they appear as a team originating from different European countries, a team that is multi-cultural, or at least creating the impression of the same. The presenters are allotted only brief appearances; on average they appear (in the music video programmes) up to five times every programme hour. Normally they announce the titles – and smile, smile, smile. In the so-called 'inter-active' programmes, during which the viewers 'report back' via phone, fax or e-mail and can more or less participate directly in what is going on, they have to come up with a bit more – sufficient to be accepted as a 'personalised low-key companion' (Morse 1986, p. 25), who is a person like you and me and at least able to pretend that he or she is in a constant dialogue with the viewers.

It is clear that this comes off more successfully with the German audience on VIVA than for MTV, the simple reason being that the MTV presentation language is English. But this 'disadvantage' should not be overestimated, as the message is just as easy to understand in English as it is in German. The presenters therefore serve a decorative purpose and as 'doormen welcoming to the scene' (Hertneck 1995, s. 45). What is more, they establish an important channel-related identification interface, intended to offer the viewers a home they enjoy returning to.

## 4. The music channels' and music videos' young audience

The question as to the nature of the audience can only be answered provisionally. First, the 'public' material available for analysis is sparse, and secondly, the market and opinion research findings, which MTV and

VIVA no doubt have stacked away somewhere, are either kept under wraps (MTV Europe) or disclosed in very small doses of what is more or less ready-made commercial propaganda (VIVA). But it is possible to come up with a few results which provide a rough outline at least.[56]

Particularly interesting is the group of 14- to 19-year-olds, apparently the most important customers for MTV and VIVA. As the channels cannot allow themselves to target only this group but have to embrace the general cohort of 14- to 29-year-olds, it is often necessary in the case of the channels' own data to be content with results applicable to this broader cohort. Another deficiency should be noted: there are hardly any gender- and class-related findings. Consequently, the justified demand that the young people's reception modes should be interpreted in the context of the everyday 'social context ... and the experience and emotional sphere embedded (therein) ... ' (Winter and Kagelmann 1993, p. 216)[57] can only be partly met in the following discussion.

### 4.1 Coverage, viewing duration, social structure

First, some information should be provided on young people's media, particularly TV, consumption:

- In 1995 14.23 million 14- to 29-year-olds, including 4.42 million 14- to 19-year-olds – 2.14 million females and 2.28 million males – lived in Germany, east and west.[58]

- In 1994 the percentage of 14- to 19-year-olds tuning into the media 'several times a month' amounted to 97 per cent for television, 95 per cent for radio, 93 per cent for sound media and 68 per cent for video cassettes.[59]

- In 1994 56 per cent of this age group is accessed by television every day, with a daily viewing time of 96 minutes. The statistics for these young people fall far behind those of the other age groups in the population above the age of 14, excluding the group of 20- to 29-year-olds, who also reveal a daily coverage value of 56 per cent, but a daily viewing period of 117 minutes.[60]

- In 1994 the percentage of 14- to 19-year-olds who found watching TV programmes 'very enjoyable/enjoyable' came to 92.1 per cent for feature films, 85.8 per cent for music videos and 72.1 per cent for TV series.[61] In this connection young people's interest in music videos, almost exclusively pop and rock videos, is particularly remarkable.[62] Incidentally, this is a result ascertained before MTV Europe and VIVA were founded.[63]

- In 1995 the 14- to 19-year-olds gave the following ranking for their 'favourite channels': RTL (28.5 per cent), Pro 7 (20.0 per cent). MTV Europe (13.2 per cent), VIVA (12.8 per cent), and ARD (9.4 per cent).[64]

As indicated above, the data available for the music channels MTV Europe and VIVA are sparse. There is little to say about the music channels

MTV Europe and VIVA regarding coverage and use, and, only on the basis of a survey which its competitor VIVA commissioned the opinion research institute BIK (Hamburg) to carry out. The findings of this survey were challenged in a massive 'wrangle' (*Süddeutsche Zeitung*, 17 February 1995), which MTV Europe intensively participated in. The reason for the ensuing attacks is that the data collected in the eastern part of Germany was not sufficiently representative, which was, however, explicitly conceded in the information material published by VIVA.[65]

Many of the following results come from this study. Any evaluation must take into account that these statistics were collected from the 14- to 29-year-olds and apply exclusively to cable TV and satellite households. This data is supplemented by results derived from a representative analysis done by the Allensbach Institute[66] and from a qualitative, non-representative survey carried out in the winter of 1994, based on 252 14- to 29-year-old and 281 20- to 29-year-old MTV and VIVA viewers from North Rhine-Westphalia (NRW survey).[67]

According to the VIVA/BIK survey, in 1994 MTV Europe and VIVA reached an (actual) coverage of 5 per cent (MTV) and 11 per cent (VIVA). In 1995 this value rose to 10 per cent (MTV) and 16 per cent (VIVA).[68] The broadest coverage is revealed by VIVA between 1 p.m. and 12 p.m.; 15 per cent of the 14- to 29-year-olds was tuned in then; 3.1 per cent tuned in between 6 a.m. and 1 p.m.; 2.4 per cent between 12 p.m. and 6 a.m. The AWA analysis showed a VIVA coverage of 15.4 per cent for 14- to 29-year-olds in German households overall and 25.7 per cent in cable TV households.[69]

This means: VIVA reached 2.19 million (FRG overall) and 1.82 million viewers (cable TV households) daily; the 2.19 million comprised 1.04 million 14- to 19-year-olds and 1.15 million 20- to 29-year-olds. Evidently, the MTV and VIVA channels were relatively intensively used by 14- to 29-year-olds.

In the VIVA/BIK survey 60 per cent of the MTV Europe and 72 per cent of the VIVA audience stated that they tune in on between four and seven days a week. The 'non-stop' viewing period was correspondingly long. For example, almost 50 per cent of the VIVA audience (BIK survey) remained tuned in for one hour or longer per viewing session. The NRW survey revealed similar results: the 14- to 19-year-olds and 20- to 29-year-olds tuned in 'non-stop' for one hour or longer amount to 31 per cent and 32.8 per cent in the case of MTV Europe, and 44.1 per cent and 38.1 per cent in the case of VIVA, respectively.[70]

The NRW survey contains two more important findings: on the one hand, it reveals some information on the social structure of the young MTV/VIVA audience (see Table 1); on the other hand, the video and sound media that the MTV/VIVA audience is equipped with is also documented (see Table 2).[71]

Table 1: **Social structure of the young MTV/VIVA audience**
(in % NRW study)

|  | 14- to 19-year-olds | 20- to 29- year-olds |
|---|---|---|
| *Sex* | | |
| female | 46 | 45 |
| male | 54 | 56 |
| *Education* | | |
| elementary school | 23 | 25 |
| post-elementary school without *Abitur* | 29 | 27 |
| secondary academic school (Gymnasium) | 41 | 9 |
| *Abitur*, university studies | 5 | 35 |
| *Home situation* | | |
| with parents | 96 | 25 |
| own accommodation | 4 | 75 |

Table 2: **MTV-VIVA audience's visual and audio equipment**
(in %; NRW study)

|  | 14- to 19-year-olds (household) | 14- to 19-year-olds (own room) | 20- to 29-year-olds (household) |
|---|---|---|---|
| Radio | 97.6 | 83.7 | 95.0 |
| TV | 97.6 | 61.6 | 96.1 |
| Cassette recorder | 97.2 | 88.1 | 95.0 |
| CD Player | 96.8 | 85.3 | 90.4 |
| Portable stereo | 88.9 | 79.8 | 96.1 |
| Videorecorder | 81.3 | 25.0 | 77.6 |
| Record player | 78.2 | 43.2 | 64.8 |
| Computer | 61.6 | 34.5 | 46.3 |
| Game boy | 39.3 | 27.4 | 17.1 |
| Video games | 31.3 | 18.3 | 15.3 |
| Video camera | 31.3 | 3.6 | 16.7 |
| Portable CD player | 19.8 | 16.3 | 11.4 |

The selected coverage and use data reveals the significance of music – ie pop/rock music – for young people. 'The intensity of the use of television music programmes confirms the paramount importance of music as the focal point in the young people's worlds' (Altrogge and Amann 1991, p. 175). Gender-specific differences seem to be negligible. But one striking feature is that music is clearly most important for those on the upper rungs of the education ladder, and most likely for those financially better-off, too. The latter would probably also explain the availability and acquisition of media appliances.

A further interesting point is that the frequent use of music videos hardly affects the time budget young people have at their disposal for leisure-time activities. In fact, it does seem that frequent video users have a particular preference for certain specific leisure-time activities. In a non-representative survey of 527 Berlin pupils Altrogge and Amann (1991) observed that 'books are read less frequently, but daily newspapers more often. Other leisure-time activities in social situations such as 'meeting friends', 'just walking round town', going to the cinema and to concerts are also more frequent. More time is spent on hobbies ... Generally, music fans and intensive video users seem to pursue social, 'extrovert' activities more frequently than others do'... (Altrogge and Amann 1991, p. 176).

### 4.2 Preferences

How do young people evaluate the music channels and their programme services? The fact that the channels broadcasting music programmes occupy a favourable position has already been ascertained. It has also been mentioned that in 1995 the position for MTV Europe and VIVA, regarding the 14- to 19-year-olds, was more or less level pegging, with MTV Europe slightly ahead. But the latter's advantage dwindles, with VIVA going ahead, if not the 14- to 19-year-olds but the 14- to 29-year-olds are included. This is at least indicated by the VIVA/BIK survey (see above). It will be necessary to refer to this survey again, for it is the only analysis containing representative statements relevant to the whole of Germany on the 14- to 29-year-olds' evaluations.

#### 4.2.1 Programme quality

In the VIVA/BIK survey, not only is VIVA's 'leading position' confirmed, but it is also revealed that, according to 14- to 29-year-olds, VIVA has the better programme quality in 1995 (see Table 3).[72]

#### 4.2.2 Relationship with the presenters

The fact that VIVA is ascribed the better presentation and obviously the better presenters is probably due to their using the German language. Replying to the question as to whether they preferred MTV Europe's 'English' or VIVA's 'German' presentation, 17.4 per cent of the 14- to 29-

year-olds (interviewed in the VIVA/BIK survey) said they favoured MTV Europe and 68.6 per cent VIVA (with 14 per cent undecided).[74]

Table 3: **Channel quality according to 14- to 19-year-olds** (1995, in %)

| | MTV Europe | VIVA |
|---|---|---|
| Has better choice of music | 38.9 | 61.1 |
| Has better blend of music | 35.3 | 64.7 |
| Has better programmes | 33.8 | 66.2 |
| Has better presenters | 36.0 | 63.0 |

The NRW survey with its 1994 data reveals a similar result. It is clearly visible that the 14- to 19-year-olds – tipping the scales in favour of VIVA – award better marks than the 20- to 29-year-olds (see Table 4).[73]

Table 4: **Support for the criterion 'high agreement'** (1994, in %)

| | 14- to 19-year-olds | | 20- to 29-year-olds | |
|---|---|---|---|---|
| | MTV Europe | VIVA | MTV Europe | VIVA |
| Choice of music | 25.8 | 42.1 | 15.1 | 30.7 |
| English/German language | 24.0 | 61.4 | 24.5 | 59.2 |
| Reports/documentaries | 21.4 | 32.1 | 13.3 | 15.1 |
| Studio decor | 28.4 | 29.2 | 21.5 | 17.9 |
| Presentation | 34.9 | 40.1 | 32.5 | 28.9 |

There is no doubt that the 14- to 19-year-olds' special interests are expressed in their high acceptance of the VIVA presentation, a finding at least suggested by their judgement of the presentation, which is higher up the scale. For it can certainly be assumed that particularly this age group develops a strong preference for 'media identification figures', acting as models in both consumer behaviour and 'real' life (AWA '96.). The 'everyday aesthetic style' of the presenters as well as their self-portrayal 'are used ... as a guide', particularly in the development of specific music preferences and of 'social identity' (Six, Roters and Gimmler 1995, p. 44).

### 4.2.3 Feature profile of MTV Europe and VIVA

In the VIVA/BIK survey (1995 data) the 14- to 29-year-olds were requested to undertake another programme evaluation by awarding marks for different qualities, ranging from 1 (absolutely correct) to 7 (incorrect) (see Table 5).[75]

Table 5: **Evaluation of various qualities**
(marks ranging from 1 = "absolutely correct" to 7 = "incorrect")

|  | MTV Europe | VIVA |
|---|---|---|
| ... is young | 2.77 | 1.75 |
| ... is in a good mood | 2.71 | 2.10 |
| ... is likeable | 2.80 | 2.41 |
| ... is 'in' | 2.98 | 2.40 |
| ... is witty | 3.01 | 2.67 |
| ... is cool | 3.14 | 2.83 |
| ... is cheeky | 3.33 | 2.86 |
| ... is unconventional | 2.90 | 2.43 |

The NRW survey reveals similar findings. However, the interviewees here evaluated not only the individual programme ranges but the MTV/VIVA programme range as a whole. The only difference revealed in the evaluation findings of the VIVA/BIK survey was that 30 per cent of the 20- to 29-year-olds consider the MTV/VIVA programme range to be 'too hectic'.[76]

This is consequently reflected in the answers to the question as to whether VIVA provides acceptable entertainment. Again according to a scale of 1 to 7, VIVA receives high marks for playing 'my hits' (1.95) and 'creating a good mood' (1.70). But VIVA's ability to create the 'right' relaxation clearly receives a somewhat reserved judgement – equally the ability to create the 'right' mixture of music videos and other types of broadcasting: 56.7 per cent of the 14- to 29-year-olds interviewed agree with the description of 'just the right mixture'.[77]

Both themes, however, – the 'right' relaxation and the 'right' mixture of music videos and other informative reports and documentaries – seem to be very important gauges for young people to judge whether the channel appeals to them or not. Similar results have been ascertained for MTV (in this case in the USA): the top position was occupied by statements like 'to hear the music', 'to relax', 'to relieve boredom' (Roe and Cammaer 1993, p. 172) – or according to another survey: 'entertainment', 'enjoyment', 'music and visual appreciation', 'pass time' (Sun and Lull 1986, p. 120). Second came the wish for 'information/social learning' and 'information/social interaction' (Sun and Lull 1986, p. 119), enabling them to be and speak with friends – not only about music, but about the whole youth culture scene.

*4.2.4 Evaluation of the qualities of music videos*

Unfortunately, neither the VIVA/BIK survey nor the NRW survey contains any statements about how young people evaluate the individual qualities of the music videos. A tentative answer to this question is revealed by a US and a German survey. The latter, based on a non-representative interview of 160 Berlin pupils, reports that only 20 per cent of the young people interviewed show no interest in music videos. Mainstream pop videos are appreciated most by music video fans (78 per cent), followed by different varieties of rock music performances (34 per cent), rap/house (20 per cent) and soul/funk (16 per cent).[78]

The US survey inquires into the reasons for young people taking an interest in music videos.[79] The answers given are mainly (multiple responses possible) 'listening to music and lyrics' (36 per cent), 'watching visual elements' (35 per cent), '(visual) interpretation of the songs understandable' (30 per cent) and 'following the audio-visual combination' (8 per cent). Moreover, in the survey the thesis is advocated that young people like taking an interest in music videos, but they still prefer to listen to pop/rock music 'straight'. With regard to the music videos the features listed in Table 6 are especially preferred by young people.

Table 6: **Qualities of music videos particularly favoured by young people** (USA, 1989 data, in %)

| | |
|---|---|
| visuals match music composition lyrics | 56 |
| erotically tinged scenes | 41 |
| good choreography and dance scenes | 39 |
| clear, comprehensible story | 38 |
| harmonious atmosphere (even at the expense of comprehensible story) | 38 |
| illustration of the music via the visuals, with no 'life of their own' | 37 |

Another US survey indicates that music videos often receive the mark 'good' when they appear as a 'cluster', in which (in the order of items given) 'happiness', 'excitement', 'confidence', 'love', 'hope', 'delight' and 'passion' are combined (Wells and Hakanen 1991, p. 450). It is hardly surprising that the subject of 'sexuality' plays an eminent role in this constellation, considering the importance of this issue in young people's development. But one conspicuous result is that they apparently show little desire for portrayals of violence.[80]

This is contradicted by the findings of a recently published German survey: it corroborates at least a discernible interest on the part of young people in portrayals of violence in music videos. It is not clarified in the survey whether there is an 'aesthetic' or a moral basis to this interest, ie whether portrayals of violence are approved aesthetically, but rejected morally (Altrogge and Amann 1991, p. 181). In addition, the only possible evaluation of these findings is one of an assumption verified by unreliable evidence, since the survey is based on a non-representative sample of 154 14-year-old pupils from Hanover (see below).[81]

### 4.3 Modes of reception: for 'understanding' the videos

At first, several important hypotheses will be outlined on the subject of the reception of music videos. This outline will then be followed by several sections discussing specific problems, illustrated by individual surveys and critical analyses linked to these hypotheses.

#### 4.3.1 A few fundamental hypotheses

A summary of the most significant findings ascertained mainly in a large number of US surveys, based on many radically different methodological levels, points to the following hypotheses:[82]

1.  Various physiological assumptions imply that the recipients devote more attention to visual than to audio information. Such assumptions are contested, however; it is argued that the recipient occupied with the music video experiences a permanent competition between his or her perception channels. What actually predominates – the music experience or the visual perception – depends on the video material and the viewing and reception situation. The alignment or lack of alignment between the audio and the visual level plays a very important role here: an extreme divergence between them impairs the assimilation process, thus creating confusion as to the content of the music video – in turn boosted by the fact that music videos are assimilated on the emotional rather than on the cognitive level.

2.  Preoccupation with music videos suppresses the imaginative powers of the recipients. This reproach is levelled mainly at 'narrative' videos that prevent the viewers from imagining alternative images. This is contradicted. The criticism is levelled against the suggestion that imaginative powers are influenced solely by the discrepancy between music transmitted by audio and visual means. It is conceded that the associations generated by the recipients are directed by the clips, but at the same time it is argued that the imagination does not incur any severe limitation. Moreover, critics contend that activity of the imagination is largely determined by video-external, individually and socially created conditions and reception 'backgrounds'.

3. The viewers are manoeuvred by the combination of visual and audio stimuli into positive high arousal conditions, which as a result of their 'priming effects'[83] are more intensive and insistent than conditions achieved by the assimilation of an 'only music' situation. The reason for the high arousal quality of the video is ascribed by most recipients to the music and not to its visualisation. Moreover, the visual content of the video is regarded to be pleasant, the music video apparently creating feelings of a euphoric nature.

4. The repeatedly postulated thesis (and hypothesis in several studies) that the violent and sexist portrayals in music videos ideologically influence and 'brutalise' young people cannot be empirically corroborated to date. And yet the question remains as to whether it is in fact unnecessary to include indirect and unobservable consequences in the analysis even though no direct effect of this nature can be ascertained. The patterns offered in the music videos and their accompanying presentation for emotion, cognition and attitudes, for modes of thought and action and, last but not least, for lifestyles may well be viewed as possible stimulants.

5. The influences of music videos mainly hinge on the understanding of the – usually foreign language – song lyrics. US surveys have revealed that many young people do not even precisely understand the lyrics in their own language, particularly in the case of heavy metal and punk performances.[84] Of course, this does not exclude the possibility of lyrics not understood being learnt by heart. In any event numerous texts are misinterpreted. This means that the young people concerned construe their 'own' meaning, sometimes on the basis of fragments of lyrics they have understood, sometimes totally removed from the actual content of the lyrics. The problem which constantly arose in the surveys but which has not been investigated to date is the lack of any clarity as to the effects of such individual interpretations on the attitudes that young people already have or actually develop on this basis towards partnership, love, sexuality, loneliness and anxiety.

### 4.3.2 Forms of reception modes

Several of the previously mentioned studies point out that three factors determine the way in which the reception takes place: the formal and content quality of the music videos received; the conditions of the actual reception situation; the individual-social factors externally affecting the reception situation. Although this thesis is strongly advocated, the surveys contain but few initiatives to take the necessary methodological consequences of this thesis. There is, for example, no typology of specific forms subjected to a precisely structured operation procedure and empirically tested, in which the concrete reception modes – based on the previously outlined 'dependencies' – are put into practice.[85]

A provisional study supplied a few indications, available since the late 80s but which have so far evidently not been investigated by the appropriate research (at least there is nothing of any relevance to be found in the bibliographies of available texts and material). Hypothetically the following modes of reception are distinguished:[86]

- *Subcutaneous reception*: The clip is received without any specific attention and without any attempt to achieve conscious assimilation. Individual scenes and segments of scenes are stored and (possibly) activated in later situations, without the origin of the recalled scenes and segments of scenes being accounted for (incidental reception).

- *Selective reception*: Here – also without much intensive awareness – scenes are selected relating to the recipients' memories, wishes and anxieties and supplying the setting in which the clip is then individually composed. In the memory euphoric, tranquillising and frightening scenes are associated with the music.

- *Appreciative reception*: The clip is consciously received in terms of both music and image for what it is: a more or less structured combination of audio and visual aspects. The individual combination and composition elements as well as the interplay between them are perceived. Appreciative reception hinges on intellectual, repeated viewing and listening including access to the music and the visuals.

- *Neutralising reception*: The recipients reject the audio and visual stimuli, as their perception capacity is too strongly taxed by their brevity, vagueness and (partial) contradiction. The stimuli cannot be related back to audio, visual or emotional memories. The fragmented presentation form elicits rejection – particularly on the part of those who are watching a clip of this kind for the first time or who (want to) have no access to the music and the visuals.

- *Disorienting reception*: Due to the diverging contents – pervading the video – the recipients are unable to find their orientation; they cannot clearly decipher the lyrics and the visuals. The video becomes a quest for a meaning, or several set pieces are borrowed that (apparently) comply with the person's own 'real' evaluation and behaviour structures.

- *Sedative reception*: The clip is consumed 'like a drug', as it were, and used for submerging into and drifting away on the sound and vision. It is hardly a question of reflection and detachment in this case but more or less deliberately intended escapism.

The theses referred to should be seen only as hypothetical constructs, whose contents are not likely to be detected in a 'pure state'. A more precise translation into an operational procedure directed at real situations could however offer opportunities for clarifying the question as to whether a modified typology of this kind is able to embrace and illustrate diverging

modes of reception as well as the question as to how they are distributed across the (gender-, education- and class-specific) group of 14- to 19- year-olds and 20- to 29-year-olds.

### 4.3.3 Behavioural approaches to video clips

Recently the findings summarising the survey results of interviews with 154 14-year-old pupils from Hanover (an unsystematic random selection) were published. These findings were then compared with the answers provided by a survey of 248 students (*Pädagogische Hochschule Ludwigsburg,* average age 24, likewise an unsystematic random selection).[87]

In this study the main issue is to review two hypotheses. On the one hand, it is intended to ascertain whether the reception of video clips is determined by the way young people relate to music. On the other, it is intended to clarify whether in these clips young people look for guidelines related to lifestyle and opportunities for identification, ideas for acquiring social competence and/or changes in their disposition.

Table 7 shows the ranking order of the answers (first five positions) to the incomplete sentence 'When I see video clips ...' on a scale from 1 (= highest approval) to 5 (= highest disapproval).[88]

Table 7: **Answers to the partial sentence 'When I see video clips ...'** (First five positions)

| Girls (n = 75) | | Boys (n = 79) | |
|---|---|---|---|
| ... I sing or hum to the music | 1.63 | ... I sing or hum to the music | 2.37 |
| ... I feel tempted to buy the CD or tape | 2.64 | ... I am fascinated by the computer, tricks and visual effects | 2.68 |
| ... I am wide awake | 2.78 | ... I am disturbed by others wanting to talk to me | 2.79 |
| ... I feel really good | 2.82 | ... I am wide awake | 2.83 |
| ... I am thrilled by the costumes, stage design and the scenery | 2.96 | ... I feel ... I have to buy the CD or tape | 2.83 |

If the results for the other (in toto 27) items are added, two clearly distinguishable gender-specific forms of reception become apparent: watching videos for the girls tends to be a social and casual activity, from which something can also be learnt for other fields of experience and behaviour. The boys, on the other hand, take a more intensive interest in the videos, particularly the portrayals of sexual, violent and 'cool' scenes.

In a second stage the factors that characterise the way young people deal with videos are gleaned from the approval/rejection responses to the

above-mentioned items. The result is five factors: music orientation, music video orientation, involved-escapist reception, sex and violence orientation and lifestyle orientation:

1. *Music orientation*: The most important role is played first by the orientation towards the music (presented in the clips) and second by the orientation towards the changes in the person's disposition. However, the two orientations, which clearly diverge, materialise as inter-related procedures: in the case of video clips being perceived and used for reasons of music orientation, the obvious pre-condition is that music has often succeeded in changing the person's disposition.

2. *Music video orientation*: Here young people focus on the interaction between the music and the visuals, the visualisation of the musical performance and the visualisation of the music itself. An essential prerequisite of the music video orientation is the music experience factor: the stronger the importance of the music video orientation, the greater the intensity of music experience.

3. *Involved-escapist reception*: The main point here is that the music and the visuals are received with a high level of intensity. But the intensity is not to be found in the style of the music and/or the content of the video but in the wish of the recipient to achieve a specific state of mind – ie deep immersion into the deluge of music and visuals.

4. *Sex and violence orientation*: one interesting aspect is that the sex and violence orientations do not come to the fore, but are represented to an equally strong degree. This form of orientation, clearly associated with such components of music experience that reveal 'violent' features, is described as stimulating.

5. *Lifestyle orientation*: Mainly the elements of dance, fashion and body language expression reveal indications of lifestyle, illustrated by the acquisition of dance steps, for instance, 'cool' modes of behaviour, knowledge of fashion, or ideas about how to behave as a video performer.

### 4.3.4 Thematic connection or single shot selection?

In the survey outlined above a connection was implied between the intensity of the music video orientation and that of the music experience. But another interesting point is the question of whether and, if so, how the music influences the perception of the visuals. A useful source of data is a study in which reception-characteristic reactions of 700 West Berlin pupils (13 to 20 years of age, a non-systematic, random sample) were evaluated.[89] To put it bluntly, the disadvantage of the study is the fact that the category 'music' is not particularly transparent, ie with regard to 'music' no dividing line is drawn between the melodic/harmonic/rhythmical level, on the one hand, and that of the lyrics, on the other. The result is that

frequently 'music' is referred to, meaning 'lyrics' and something which is not elucidated any further.

In the survey the underlying thesis is that the structure of the visuals arrangement follows the structure of the music – and that this also applies to the reception of the visuals. This inplies an either/or hypothesis about the mode of reception:

- either individual visuals are extracted from the video – under the impression of the music presented – recallable as single shots (*single shot perception*);
- alternatively, the single shots are set in a thematic context – overlapping these single shots – at which the memory can be directed without any permanent recourse to concrete image perception (*generalisation*).

With regard to the hypothesis the statements made by the young people interviewed have been classified in two ways: first, according to whether the responses indicate single shots/iconographic patterns or whether they thematise the clip in a more general form, which is not directly linked to the single shots; secondly, according to how the influence of the music, as indicated in the responses, reflects the tendency towards single shot perception or towards generalisation. The study itself is based on the comparative statements made by the interviewees on an audio/visual version, an 'only sound' version and an 'only visual' version of various clips.

The first result reveals that the overwhelming majority of the interviewees practise single shot perception – with or without music. In the case of the audio/visual version 78 per cent said they practised this procedure and in the case of the 'only visual' version as many as 82 per cent. It is also evident that the influence of music significantly raises the generalisation approach to videos from 17.9 per cent to 22.3 per cent (see Table 8).[90]

Table 8: **The ratio between 'generalisation' and 'single shot perception'** (in the data supplied by 700 13- to 20-year-olds; in %)

|                        | Clips with music | Clips without music |
|------------------------|------------------|---------------------|
| Generalisation         | 22.3             | 17.9                |
| Single shot perception | 77.7             | 82.1                |

The question is whether this ratio is confirmed when different styles of music are taken into consideration (here: heavy metal and mainstream pop). The result, as illustrated in Table 9, is that the audio/visual versions in mainstream pop reveal no significant divergence from the above-mentioned ratio, but heavy metal audio/visual versions reveal a higher

percentage of responses reflecting generalisation than in the case of mainstream pop videos (25.4 : 20.4 per cent). Only visual versions reveal similar values for heavy metal and mainstream pop (16.8 : 18.6 per cent).[91]

Table 9: **The ratio between 'generalisation' and 'single shot perception'** (in the data supplied by 700 13- to 20-year-olds; in %)

|  | Metal with music | Metal without music |
|---|---|---|
| Generalisation | 25.4 | 16.8 |
| Single shot perception | 74.6 | 83.2 |
|  | Pop with music | Pop without music |
| Generalisation | 20.4 | 18.6 |
| Single shot perception | 79.6 | 81.4 |

In the survey this is explained by the fact that in the heavy metal clips the category of the 'meaning of life' plays an important role from beginning to end and therefore single shot forms are relatively insignificant, ie the general context reveals itself as the crucial factor. This means that young people tend to adopt a generalising attitude in the case of heavy metal clips.

In the case of such reception behaviour there must be at least some indication that – parallel to the music – the other visual aspects in these clips in fact tend towards a general context or that they can at least be interwoven on the basis of a video-external attribution of a meaning – for example by referring back to specific youth cultures and traditions. This seems to apply to heavy metal videos rather than to mainstream pop videos.

It has been established in a further stage that the tendency towards either generalisation or single shot perception is dependent on the degree to which the clips are known or not known. As illustrated by Table 10, unknown clips tend to elicit 'generalising' responses – but only in the audio/visual versions (25.8 per cent). Known audio/visual versions, on the other hand, produce a higher degree of single shot perception, evidently boosted by the presence of the music (81.9 : 84 per cent).[92]

If various styles of music are included, several differences must be taken into account (see Table 11).[93] The tendency towards generalisation in the case of known and unknown heavy metal clips in the audio/visual version is more or less equal (27.7 : 24.9 per cent). In the only visual versions the single shot perception value is twice as high in the case of unknown clips as in that of known clips (18.9 : 7.1 per cent). A possible explanation for this strong inclination towards single shot perception is that in the case of known heavy metal clips, served without any music, a generalisation is hardly required, since their stimulation lies in the –

absence of – music and the youth culture linked to it (see above: 'meaning of life'). On the other hand, the growing tendency towards generalisation in known heavy metal clips equipped with music (27.7 per cent) is probably the result of more time for concentration on the narrated 'meaning of life' story, due to already existing familiarity with the visuals (containing little scope for generalisation).

Table 10: **The ratio between 'generalisation' and 'single shot perception'** (in the data supplied by 700 13- to 20-year-olds; in %)

|  | Known clips with music | Known clips without music |
|---|---|---|
| Generalisation | 16.0 | 18.1 |
| Single shot perception | 84.0 | 81.9 |
|  | **Unknown clips with music** | **Unknown clips without music** |
| Generalisation | 25.8 | 18,8 |
| Single shot perception | 74.2 | 81.2 |

Table 11: **The ratio between 'generalisation' and 'single shot perception'** (in the data supplied by 700 13- to 20-year-olds; in %)

|  | Known metal with music | Known metal without music |
|---|---|---|
| Generalisation | 27.7 | 7.1 |
| Single shot perception | 72.3 | 92.9 |
|  | **Unknown metal with music** | **Unknown metal without music** |
| Generalisation | 24.9 | 18.9 |
| Single shot perception | 75.1 | 81.1 |
|  | **Known pop with music** | **Known pop without music** |
| Generalisation | 13.5 | 20.4 |
| Single shot perception | 86.5 | 79.6 |
|  | **Unknown pop with music** | **Unknown pop without music** |
| Generalisation | 26.8 | 16.8 |
| Single shot perception | 73.2 | 83.2 |

In the case of mainstream pop clips the situation looks different. The low value scored by known pop clips with music compared to known pop clips without music (13.5 : 20.4 per cent) could be due to the fact that the tendency towards single shot perception is increased – because the familiarity of the music lowers even further its (already very restricted) generalisation capacity. Conversely, the high value recorded for unknown pop clips presented with music compared to unknown pop clips without music (26.6 per cent : 16.8 per cent) is probably derived from the

phenomenon that a lack of familiarity with the sound and vision and particularly the presence of (unknown) music cause so much irritation that thematic connections are sought – to lower the tension, as it were.

## 4.4 Motives

The results on coverage, use and reception modes point to the question as to which motives prompt young people to take an interest in music channels and music videos in the way described. This question can be answered – at least to begin with – in two stages of argumentation. In the first stage the motives or motive constellations are listed, describing young people's interest in pop/rock and music videos in a relatively abstract way. In the second an attempt is made to describe this interest, referring to motives and motive constellations but at the same time taking into account the specific characteristics of the social situation in which motives and interests are formed.

Just a brief reminder: the following argumentation is also obliged – because of the previously explained data situation – to restrict itself to describing what are relatively concrete, but still general trends. First, insufficient surveys have been carried out in this country to analyse the links between young people's use and reception modes, on the one hand, and individual music styles and their translation in music videos (consequently in specific visual aesthetic forms), on the other.[94]

Secondly, as has been criticised several times above, there is a real lack of material based on gender, class or environment differences. This means that only the general characteristics of young people's social and individual situation can be outlined, eliminating the possibility of any detailed description, ie without any reference to the different situations of boys and girls, the varying 'parameters' of the upper, middle and lower classes and the different conditions of training and working environments.[95]

### 4.4.1 Models

Such motives and motive constellations have been systematically classified in the framework of various models. These attempts to provide a systematic structure, partly inter-related and partly autonomous, can be summarised as follows:[96]

- *Music as a means of self-realisation:*
  What is meant here is that music assumes a decisive role in the development of 'self-concept' (Lull 1988 b, p. 153); young people take an active interest in music especially to express their emotions and to acquire points of reference for their personal development.

- *Music for the creation and the management of a mood:*
  The creation, intensification and management of a mood are generally

432

considered to be primary motives. Young people clearly use music to 'set a mood' (Thompson 1993, p. 413). Two functions ascribed to pop/rock music are expressed in the motives: the symbolic and the affective-emotional function. What is understood by the symbolic function is that music acts as an expression of hopes, wishes and a specifically young life feeling. The affective-emotional function (sometimes termed 'psychic') is referred to when music is used for reasons described with catchwords such as 'distraction' (music as a background), 'escapism' (music used to flee the world) and/or 'compensation' (music used to compensate for failures).[97]

- *Music as an important component of social relationships:*
  Music constitutes a kind of instrument used to both put an end to (withdrawal, separation) and establish social relationships – demarcation, detachment, socialisation. The latter in particular can be realised by means of establishing contacts, by common discussion material, by exhibiting a personal knowledge of music, by the development of a group identity. 'Adolescents' involvement with popular music ... is often a group phenomenon. Music is a useful agent of social utility; unifying social collectives; teaching norms and creating new symbols and identities' (Feilitzen and Roe 1992, p. 228). Conversely, participation in music-oriented group life depends on young people's knowledge of music and their ability to submit appraisals and judgements that can stand up to criticism.[98]

- *Music as a means of breaking loose, of provocation:*
  Music is regarded as an opportunity of displaying a symbolic counterpole to the ruling everyday culture and adult world. This thesis is directed particularly at styles that oppositional youth sub-cultures are closely linked to.[99] This applies to classical rock 'n' roll and current forms such as punk, heavy metal, rap, ragamuffin, reggae, cross-over and alternative rock.[100]

This concept of motive categories, applied to the present relationship between pop/rock music and young people, can serve to provide a clear outline of this relationship. But it is necessary, however, to lower the barriers between the previously mentioned motive categories, thus reducing their status as clearly defined statistical models. The closer the empirical reality of the pop/rock music-youth relationship draws, the more specifically these categories must be reviewed as reciprocally supplementing, overlapping and coinciding interpretation tools. Consequently, an intrinsic feature of the following theses is that they are rarely directed at individual, mutually exclusive motives but usually try to consider several motive categories simultaneously. As the theses clearly reveal which motives and motive constellations are addressed, specific reference to the one under consideration is omitted.

433

## 4.4.2 Situation analysis

The decisive condition determining the socialisation of young people today is the fact that this socialisation takes place in a process governing the whole of society, which promotes the 'devaluation of the previous attraction of traditional values, parental lifestyle and future prospects ... , in whose wake the socialisation function of traditional authorities is decreasing in significance' (Vollbrecht 1988, p. 87). Against this backdrop particularly the youth media and especially pop/rock music offer orientation, support and relief in the development and consolidation of personal and social identity. In this process the pop and particularly the various forms of rock music seem to assume the function of propagating a 'counter-world of emotional security', which in view of the weakness and instability of traditional socialisation agencies (family, school, training/career) promise an 'emotional assurance of identity via an aesthetic presentation'. (Vollbrecht 1988, p. 87 f.)[101]

Pop/rock music in particular clearly offer young people the opportunity of attaching themselves to a certain style which does not only express an affiliation and belonging to a group and detachment from the adult generation. It also signals 'a certain behaviour and lifestyle to which these groups feel committed ... An individual's style therefore indicates not only who is 'who' or who is 'what', but also who is 'who' for whom in which situation' (Soeffner 1986, p. 318). The attraction of the style in question is enhanced even further particularly by its being presented in its capacity to rule the world, by its claim as 'world beat' music (Lull 1988 a, p. 32) to be not just a local but a global phenomenon, equally valid in Los Angeles, Mexico City, Munich and Tokyo.[102]

Confronted with the difficulty of no longer being able to hope for a fixed and hence conclusively valid 'biographical continuity' (Vollbrecht 1988, p. 92), young people evidently use the media and particularly television in order to avail themselves of help, and relief, in the realisation of personality conceptions and social relationships. It is self-evident that the development of identity is based on lifestyles – in this case on music forms – of a transitory and in most cases short-lived nature. It appears that identity (not always, but certainly very often) comes about as the result of an individual design, in which permanently changeable and interchangeable lifestyles are combined with each other. 'For many teenagers identity still seems to be conceivable only as a fragment' (Kemper 1995, p. 23).

The expression of such fragmentary identity assumes two forms. First, it is documented in the demarcation between teenagers and older people, especially their parents. This by no means applies only to so-called rebellious adolescents, who express their wish to break away via a tendency towards hard heavy metal and punk rock – in an exaggerated way, according to some; in a restrained way, according to others.[103] It is not

possible to ' ... trace any signs of acceptance of violence and rape in the recipients' reactions to the tested video clips' (Altrogge and Amann 1991, p. 181). This is certainly not only due to the fact that heavy metal and punk fans often have difficulty in understanding the lyrics presented.[104]

Secondly, the development of this fragmentary identity is closely linked to ties with a young person's own 'generational community' (Schultze et al. 1991, p. 198) with which he or she shares the symbols of a common (usually class- and education-specific) youth and adolescent music culture. As Vollbrecht (1988) points out:

> To a *Prince* concert flock many little princes today, the fans in the *Eurythmics* audience imitate the black leather and dyed hair of *Annie Lennox* and *Dave Stewart*. Agreement and unity are expressed not only via musical preferences, but also via fashion styling. 'We belong together'. Via their outward appearance the fans seek the security of the reference group and try to show to the outside who they really are. (Vollbrecht 1988, p. 92)

This is by no means just a question of superficial appearances; on the contrary, this music '... speaks to youth's very personal quest for identity, intimacy, and meaning ... at times (proffering) comfort, joy, and hope' (Schultze et al. 1991, p. 177). This not only concerns young people's relations with sexuality and aggression, important for their development. It also concerns a series of other subjects, some of which are highly relevant: overcoming 'fears, disappointments and the break-up of the first friendship'; dealing with the 'competition between each other, pressure at school and in their leisure time'; the 'regulation of proximity and distance to others'; the experience of 'feelings of familiarity and security' (Sander 1993, p. 14 ff.), and finally 'young people's yearning for special perceptual experiences and fantastic sensations' (Barth and Neumann-Braun 1996, p. 262).

It goes without saying that in the case of members of the lower classes and the upper classes, for example, these topics assume a different form and relate to different styles of music. A young person from the lower classes seems more attracted to heavy metal and punk because of his or her depressing 'quality of life' than a young person from a middle-class, 'white-collar' family, who is more likely to prefer techno and house.

That comparable differences between girls and boys come to light in the review of the overall situation is hardly surprising. Girls react differently to the volume and beat of the music, preferring a more subdued presentation.[105] Moreover, girls are hardly in a position and rarely want to identify with the 'typically male exhibitionism' and 'father-son conflicts' (Altrogge and Amann 1991, p. 179) presented in many videos – particularly in those of the heavy metal, punk and rap sectors. Differences are also reflected in their evaluation of and access to the videos directly addressing young women – such as those by Madonna and Cyndi Lauper – and

embracing their questions on sexual and erotic, emancipatory and developmental relations.[106]

## 5. Final remarks

The above reflections have clearly revealed that the relationship between the broadcasting range of music videos and the interests of the young audience is not only widespread but is also most significant for young people's everyday lives. These reflections are also a reminder of the lack of reliable and empirically controlled data on this important subject in research, especially on the domestic scene. That this does not have to be the case, and that this is a source of great pleasure, for particularly the somewhat more aged friends of young people (eg the author), to delve into the subject of young people's everyday needs should not be forgotten.

## References
Abt, D. (1988). Music Video: Impact of the Visual Dimension. In J. Lull (ed), *Popular Music and Communication*. Newbury Park, Cal.: Sage; pp. 96 ff. (2nd edition)

Altrogge, M. (1994a). Alphabet Street. Prince oder die Kunst der Rede-Konstruktion. (Prince or the art of speech construction.) In J. Paech (ed.), *Film, Fernsehen, Video und die Künste. Strategien der Intermedialität.* Stuttgart: Metzler; pp. 239 ff.

Altrogge, M. (1994b). Das Genre der Musikvideos: Der Einfluß von Musik auf die Wahrnehmung der Bilder. Selektions- und Generalisierungsprozesse der Bildwahrnehmung in Videoclips. (The music video genre: the influence of music on the perception of visuals. Selection and generalisation processes of image perception in video clips.) In L. Bosshart and W. Hoffmann-Riehl (eds), *Medienlust und Mediennutz. Unterhaltung als öffentliche Kommunikation.* Munich: Ölschläger, pp. 196 ff.

Altrogge, M. and Amann, R. (1991). *Videoclips – Die geheimen Verführer der Jugend? Ein Gutachten zur Struktur, Nutzung und Bewertung von Heavy Metal Videoclips – erstellt im Auftrag der Landesmedienanstalten* (Video clips – the hidden persuaders of young people? A report on the structure, use and evaluation of heavy metal video clips.) Berlin: Vistas. *(Schriften der Landesmedienanstalten. Band 2).*

Aufderheide, P. (1986). Music Videos: The Look of the Sound. *Journal of Communication,* 36(1), pp. 57 ff.

AWA '96 *(Allensbacher Werbe-Analyse)* (Allensbach advertising analysis), Cologne 1996

Baacke, D. (1996). Die Welt als Clip? Jugendstile und Medien. (The world as a clip? Youth styles and media.) In B. Schorb and H.-J. Stiehler (eds), *Medienlust – Medienlast. Was bringt die Rezipientenforschung den Rezipienten?* Munich: KoPäd; pp. 193 ff.

Barth, M. and Neumann-Braun, K. (1996). Augenmusik. Musikprogramme im deutschen Fernsehen – am Beispiel von MTV. (Music for the eyes. Music channels on German television with reference to MTV.) In Landesanstalt für Kommunikation Baden-Württemberg (ed): *Fernseh- und Radiowelt für Kinder und Jugendliche.* Stuttgart: Neckar-Verlag, pp.249 ff.

Bastian, H.G. (1986). *Musik im Fernsehen. Funktion und Wirkung bei Kindern und Jugendlichen.* (Music on television. The function and effect on children and young people.) Wilhelmshaven: Noetzel.

Baudrillard, J. (1983). 'The ecstasy of communication'. In H. Foster (ed), *The Anti-Aesthetic: Essays in Postmodern Culture*. Port Townsend: Bay Press.

Behne, K.-E. (1990). Musik im Fernsehen – Leiden oder Lernen? Auditives und audiovisuelles Musikerleben im experimentellen Vergleich. (Music on television – suffering or learning? Audio and audivisual music experience in an experimental comparison.) *Rundfunk und Fernsehen*, 38(2), pp. 222 ff.

Behne, K.-E. (1985). Vier Thesen zur Musik im Fernsehen. (Four theses on music on television.) In W. Hoffmann-Riem, W. Teichert (eds), *Musik in den Medien. Programmgestaltung im Spannungsfeld von Dramaturgie, Industrie und Publikum.* Hamburg: Hans Bredow-Institut, pp. 99 ff.

Behne, K.-E. and Müller, R. (1996). Rezeption von Videoclips – Musikrezeption. Eine vergleichende Pilotstudie zur musikalischen Sozialisation. (The reception of video clips – music reception. A comparative pilot study on musical socialisation.) *Rundfunk und Fernsehen*, 44(3), pp. 365 ff.

Berland, J. (1993). Sound, Image and Social Space: Music Video and Media Reconstruction. In S. Frith, A. Goodwin and L. Grossberg (eds), *Sound and Vision. The Music Video Reader*. London et al.: Routledge, pp. 25 ff.

Bleich, S., Zillmann, D. and Weaver, J. (1991). *Does Rebellious Rock Engross Rebellious Youths? Paper for the International Communication Association Meeting*. Chicago, Ill.

Christenson, P. (1992). Preadolescents Perceptions' and Interpretations of Music Videos. *Popular Music and Society*, 16(3), pp. 63 ff.

*Der Spiegel* (1995). Clip mit Haudruff (Clip with a punch), -(7), p. 199.

*Der Spiegel* (1995). Neues Idol für Teenies, (New idol for teenies) -(16), pp. 118

*Der Spiegel* (1995). Pop-art für Sozialdemokraten, (Pop art for Social Democrats) -(33), pp. 148 ff.

*Der Spiegel* (1996). 'Drei Löffel Kunst' (Spiegel-Gespräch mit Rudolf Dolezal und Hanns Rossacher) (Three spoonfuls of art – Spiegel discussion with Rudolf Dolezal and Hanns Rossacher), -(36), pp. 238 ff.

*Der Spiegel* (1996). Türsteher für Talente (Doormen for talents), -(36), p. 139.

Eimeren, B. van and Klingler, W. (1995). Elektronische Medien im Tagesablauf von Jugendlichen. (Electronic media in the young people's day.) *Media Perspektiven*, -(5), pp. 210 ff.

Feilitzen, C. von and Roe, K.P. (1992). Eavesdropping on Adolescence: An Exploratory Study of Music Listening among Children. *Communications*, 17(2), pp. 225 ff.

Fenster, M. (1993). Genre and Form: The Development of the Country Music Video. In S. Frith, A. Goodwin and L. Grossberg (eds), *Sound and Vision. The Music Video Reader*. London et al.: Routledge, pp. 109 ff.

Frielingsdorf, B. and Haas, S. (1995). Fernsehen zum Musikhören. Stellenwert und Nutzung von MTV und VIVA beim jungen Publikum in Nordrhein-Westfalen. (Television for music listening. The significance and use of MTV and VIVA by the young audience in North Rhine-Westphalia.) *Media Perspektiven*, -(7), pp. 331 ff.

Frith, S. (1988). The Industrialization of Popular Music. In J. Lull (ed), *Popular Music and Communication*. Newbury Park, Cal.: Sage; pp. 53 ff. (2nd edition)

Frith, S. (1993). Youth/Music/Television. In S. Frith, A. Goodwin and L. Grossberg (eds), *Sound and Vision. The Music Video Reader*. London et al.: Routledge, pp. 67 ff.

*Funk-Korrespondenz* (1996). Musikfernsehsender VIVA 2 mit neuem Konzept (Music television channel VIVA 2 with a new concept.), 44(23), p.7.

Goldberg, M.E., Chattopadhyay, A., Gorn, G.J. and Rosenblatt, J. (1993). Music, Music Videos, and Wear Out. *Psychology & Marketing*, 10(1), pp. 1 ff.

Goodwin, A. (1993). Fatal Distractions: MTV meets Postmodern Theory. In S. Frith, A. Goodwin and L. Grossberg (eds), *Sound and Vision. The Music Video Reader.* London *et al.*: Routledge, pp. 45 ff.

Gorman, P. (1992). MTV: Sex and Rebellion? *Intermedia*, 20(5-6), pp. 26 ff.

Greenfield, P.M., Bruzzone, L., Koyamatsu, K., Satuloff, W., Nixon, K., Brodie, M. and Kingsdale, D. (1987). What is Rock Music doing to the Minds of our Youth? A First Experimental Look at the Effects of Rock Music Lyrics and Music Videos. *Journal of Early Adolescence*, 7(3), pp. 315 ff.

Greeson, L.E. (1991). Recognition and Ratings of Television Music Videos: Age, Gender, and Sociocultural Effects. *Journal of Applied Social Psychology*, 21(-), pp. 1908 ff.

Grossberg, L. (1993). The Media Economy of Rock Culture. Cinema, Postmodernity and Authenticity. In S. Frith, A. Goodwin and L. Grossberg (eds), *Sound and Vision. The Music Video Reader.* London *et al.*: Routledge, pp. 185 ff.

Hall Hansen, C. and Hansen, R.D. (1991). Constructing Personality and Social Reality through Music: Individual Differences among Fans of Punk and Heavy Metal Music. *Journal of Broadcasting and Electronic Media*, 35(3), pp. 335-350.

Hall Hansen, C. and Krygowski, W. (1994). Arousal-Augmented Priming Effects: Rock Music Videos and Sex Object Schemas. *Communication Research*, 21(1), pp. 24 ff.

*Handelsblatt*, 3.6.1996: Heute bereits den Trend von morgen präsentieren. (Presenting today the trends of tomorrow.)

Hertneck, M. (1995). Frohe Botschaften. (Glad tidings.) VIVA und MTV. *Medium*, 25(3), pp. 42 ff.

Hitchon, J., Duckler, P. and Thorson, E. (1994). Effects of Ambiguity and Complexity on Consumer Response to Music Video Commercials. *Journal of Broadcasting and Electronic Media*, 38(3), pp. 289 ff.

Jameson, F.A. (1986). Postmoderne – zur Logik der Kultur im Spätkapitalismus. (Postmodernity – the logic of culture in late capitalism.) In A. Huyssen and K.R. Scherpe (eds), *Postmoderne. Zeichen eines kulturellen Wandels*. Reinbek: Rowohlt, pp. 45 ff.

Janke, K. and Niehues, S. (1995). *Echt abgedreht. Die Jugend der 90er Jahre.* (Completely turned off. The youth of the 90s.) Munich: Beck. (3rd edition)

Kaplan, E. A. (1987). *Rocking around the Clock. Music Television, Postmodernism, and Consumer Culture.* New York: Methuen.

Kellaris, J.J. and Rice, R.C. (1993). The Influence of Tempo, Loudness, and Gender of Listeners on Responses to Music. *Psychology & Marketing*, 10(1), pp. 15 ff.

Kemper, P. (1995). Weltfernsehen MTV – ein Clip zielt ins Herz, nicht ins Hirn. (World television MTV – a clip aims at the heart, not at the brain.) *Frankfurter Allgemeine Magazin*, -(823), pp. 18 ff.

Kleinen, G. (1985). Der Zielgruppenbezug als Bewertungskriterium für Musik in Hörfunk und Fernsehen. (The target group reference as an evaluation criterion for music on the radio and television.) In W. Hoffmann-Riem and W. Teichert (eds), *Musik in den Medien. Programmgestaltung im Spannungsfeld von Dramaturgie, Industrie und Publikum.* Hamburg: Hans-Bredow-Institut, pp. 126 ff.

Klingler, W. (1994). Was Kinder hören. (What children listen to.) *Media Perspektiven*, -(1), pp. 14 ff.

Klingler, W. and Windgasse, T. (1994). Was Kinder sehen. (What children watch.) *Media Perspektiven*, -(1), pp. 2 ff.

Lewis, G.H. (1988). Patterns of Meaning and Choice: Taste Cultures in Popular Music. In J. Lull (ed), *Popular Music and Communication*. Newbury Park, Cal.: Sage, pp. 198 ff. (2nd edition)

Lewis, L.A. (1993). Being Discovered? The Emergence of Female Address on MTV. In S. Frith, A. Goodwin and L. Grossberg (eds), *Sound and Vision. The Music Video Reader*. London *et al.*: Routledge, pp. 129 ff.

Lull, J. (1988 a). Popular Music and Communication: An Introduction. In J. Lull (ed), *Popular Music and Communication*. Newbury Park, Cal.: Sage, pp. 10 ff. (2nd edition)

Lull, J. (1988 b). Listeners' Communicative Uses of Popular Music. In J. Lull (ed), *Popular Music and Communication*. Newbury Park, Cal.: Sage, pp. 140 ff. (2nd edition)

Mattusch, U. (1994). 'You've got the Power – nichts ist unmöglich.' Musik im Kinderrahmenprogramm. ('You've got the power – nothing's impossible'. Music in the children's programme slot.) In H.D. Erlinger (ed), *Kinderfernsehen und Markt*. Berlin: Spiess, pp. 163 ff.

Mattusch, U. (1991). Die Musik spielt im Film eine Hauptrolle. Bedeutung und dramaturgische Funktion der Filmmusik in der Serie Janna. (Music plays a major role in the film. The significance and dramaturgical function of film music in the series Janna.) In H.D. Erlinger (ed), *Erzählen im Kinderfernsehen*. Heidelberg. Winter, pp. 111 ff.

Mattusch, U. (1995). Musik im Kinderfernsehen. (Music on children's television.) In H.D. Erlinger (ed), *Handbuch des Kinderfernsehens*. Konstanz: UVK Medien/Ölschläger, pp. 363 ff.

*Media Perspektiven, Daten zur Mediensituation 1995*. (Data on the situation in the media 1995.) Frankfurt am Main: Arbeitsgemeinschaft der ARD-Werbegesellschaften 1995.

Meiners, F. (1993). *Musik im Fernsehen: Rezeptionsfähigkeiten im Grundschulalter*. (Music on television: reception abilities at primary school age.) Hanover: Zulassungsarbeit zur künstlerischen Fachprüfung für das Lehramt an Gymnasien im Fach Musik in Niedersachsen.

Mercer, K. (1993). Monster Metaphors: Notes on Michael Jackson's *Thriller*. In S. Frith, A. Goodwin and L. Grossberg (eds), *Sound and Vision. The Music Video Reader*. London *et al.*: Routledge, pp. 93 ff.

Mikos, L. (1993). Selbstreflexive Bilderflut. Zur kulturellen Bedeutung des Musikkanals MTV. (Self-reflective deluge of visuals. The cultural significance of the music channel MTV.) *Medien Praktisch*, -(4), pp. 17 ff.

Mohn, E. (1988). Videoclips – eine Bedrohung für die Medienpädagogik? (Video clips – a threat to media pedagogy?) *Medien & Erziehung*, 32(3), pp. 137 ff.

Morse, M. (1986). Postsynchronising Rock Music and Television. *Journal of Communication Inquiry*, 10(3), pp. 15 ff.

Müller, S. (1994). 'Lost in Music' und 'VIVA'. Zwei Beispiele für Popmusik im Fernsehen. ('Lost in Music' and 'VIVA'. Two examples of pop music on television.) *Medium*, 24(1), pp. 48 ff.

Münch, M. (1993). Nutzeroberfläche Pop. Musiksender VIVA: MTV-Konkurrenz aus NRW? (The user interface of pop music. Music channel VIVA: MTV competition from North Rhine-Westphalia?) *Agenda*, -(3-4), pp. 56 ff.

Neale, S. (1980). *Genre*. London: British Film Institute.

*People* v. 17.10.1983: Rock 'n' Roll Video: MTV's Music Revolution.

439

Reetze, J. (1993). MTV Europe. In J. Reetze, *Medienwelten: Schein und Wirklichkeit in Bild und Ton*. Berlin *et al.*: Springer, pp. 213 ff.

Reetze, J. (1989). Videoclips im Meinungsbild von Schülern. Ergebnisse einer Befragung in Hamburg. (Video clips in the opinion of pupils. Results of a survey in Hamburg.) *Media Perspektiven*, -(2), pp. 99 ff.

Reetze, J. (1993). Videoclips. In J. Reetze, *Medienwelten: Schein und Wirklichkeit in Bild und Ton*. Berlin *et al.*: Springer, pp. 179 ff.

Roe, K. (1988). The School and Music in Adolescent Socialization. In J. Lull (ed), *Popular Music and Communication*. Newbury Park, Cal.: Sage, pp. 212 ff. (2nd edition)

Roe, K. and Cammaer, G. (1993). Delivering the Young Audience to Advertisers: Music Television and Flemish Youth. *Communications*, 18(2), pp. 169 ff.

Sander, E. (1993). Laut und lebendig. Kinder, Jugendliche und ihre Popmusik. (Loud and lively. Children, young people and their pop music.) *Sozial Extra*, -(4), pp. 14 ff.

Savan, L. (1993). Commercials go Rock. In S. Frith, A. Goodwin and L. Grossberg (eds), *Sound and Vision. The Music Video Reader*. London *et al.*: Routledge, pp. 85 ff.

Schenkewitz, J. (1988). Videopop. Musik als strukturbildendes Element einer Gattung. (Video pop. Music as the structural element of a genre.) *TheaterZeitSchrift*, 26(1), pp. 102 ff.

Schlattmann, T. and Phillips, D.D. (1991). MTV and the New Artist: Bullet, Breaker, or Bust. *Popular Music and Society*, 15(4), pp. 15 ff.

Schmidt, C. (1995). Fernsehverhalten und politisches Interesse Jugendlicher und junger Erwachsener.(Television behaviour and political interest of youth and adults.) *Media Perspektiven*, -(5), pp. 220 ff.

Schmidt, H.-C. (1993). Fernsehen. (Television.) In H. Bruhn, R. Oerter and H. Rösing (eds): *Musikpsychologie. Ein Handbuch*. Reinbek: Rowohlt, pp. 195 ff.

Schmuck, F. (1992). Zur Problematik der Standardmusik für Fernsehserien. (The problem of standard music for TV series.) *Beiträge zur Film- und Fernsehwissenschaft*, 33(43), pp.79 ff.

Schorb, B. (1988). Videoclips kommen gewaltig. Von den mannigfachen Gewaltaspekten in Videoclips. (Video clips are coming strong. The many aspects of violence in video clips.) *Medien und Erziehung*, 32(3), pp. 132 ff.

Schultze, Q.J., Anker, R.A., Bratt, J.A., Romanowski, W.D., Worst, J.W. and Zuidervaart, L. (1991). Rocking to Images: The Music Television Revolution. In Q.J. Schultze, R.A. Anker, J.A. Bratt, W.D. Romanowski, J.W. Worst, L. Zuidervaart (eds), *Dancing in the Dark. Youth, Popular Culture and the Electronic Media*. Grand Rapids, Mich.: Eerdmans, pp. 178 ff.

Seidman, S.A. (1992). An Investigation of Sexrole Stereotyping in Music Videos. *Journal of Broadcasting and Electronic Media*, 36(2), pp. 209 ff.

Sherman, B.L. and Dominick, J.R. (1986). Violence and Sex Music Videos. TV and Rock 'n' Roll. *Journal of Communication*, 36(1), pp. 79 ff.

Signorielli, N., McLeod, D. and Healy, E. (1994). Gender Stereotypes in MTV Commercials: The Beat goes on. *Journal for Broadcasting and Electronic Media*, 38(1), pp. 91 ff.

Six, U., Roters, G. and Gimmler, R. (1995). *Hörmedien. Eine Analyse zur Hörkultur Jugendlicher*. (Audio media. An analysis of young people's listening culture.) Landau: Knecht.

Snow, R.P. (1987). Youth, Rock 'n' Roll, and Electronic Media. *Youth and Society*, 18(4), pp. 326 ff.

Soeffner, H.-G. (1986). Stil und Stilisierung. Punk oder die Überhöhung des Alltags. (Style and Stylisation. Punk or the excess of everyday life.) In H.U. Gumbrecht

and K.L. Pfeiffer, (eds), *Stil, Geschichte und Funktion eines kulturwissenschaftlichen Diskurselements*. Frankfurt am Main: Suhrkamp, pp. 317 ff.

Stout, P., Leckenby, J.D. and Hecker, S. (1990). Viewer Reactions to Music in Television Commercials. *Journalism Quarterly*, 67(4), pp. 887 ff.

Straw, ...... (1993). Popular Music and Postmodernism in the 1980s. In: S. Frith, A. Goodwin and L. Grossberg (eds), *Sound and Vision. The Music Video Reader*. London et al.: Routledge, pp. 3 ff.

*Süddeutsche Zeitung.* 25.8.1994: MTV contra Maastricht (MTV vs. Maastricht).

*Süddeutsche Zeitung.* 10.10.1994: Musiksender VIVA verkauft Mode und baut Cafés (Music channel VIVA sells fashion and builds cafés).

*Süddeutsche Zeitung.* 26.11.1994: Die Posaunen von MTV (The fanfares of MTV).

*Süddeutsche Zeitung.* 15.12.1994: Ein Lebensgefühl wird ausgeschlachtet (A life feeling is being capitalised on.).

*Süddeutsche Zeitung.* 24.1.1995: Beim Clipkanal VIVA spielt die Musik (Music is played on clip channel VIVA.)

*Süddeutsche Zeitung.* 17.2.1995: Hickhack um die Zahlen (Bickering over the ratings).

*Süddeutsche Zeitung.* 12.4.1995: Verschlüsselt in der Schüssel (Coded in the dish).

*Süddeutsche Zeitung.* 18.4.1995: Prinzip Hoffnung beim Spartenkanal VIVA 2 (The principle of hope on thematic channel VIVA 2).

*Süddeutsche Zeitung.* 23.4.1995: Tote Hosen statt Madonna (Tote Hosen instead of Madonna).

*Süddeutsche Zeitung.* 3.7.1995: Die digitale Zukunft läßt grüßen. Warum MTV via Satellit nur noch verschlüsselt sendet (The digital future is on its way. Why MTV broadcasts its programmes only decoded via satellite).

*Süddeutsche Zeitung.* 19.8.1995: Und sie schießen wie Pilze aus dem Boden (And they are mushrooming everywhere).

*Süddeutsche Zeitung.* 30.10.1995: Schrilles, Clips und Kummerkasten (Zany features, clips and suggestions boxes).

*Süddeutsche Zeitung.* 22.12.1995: Musiksender VIVA spielt Gewinn ein (Music channel VIVA makes a profit)

*Süddeutsche Zeitung.* 13.2.1996: Singen statt Schnattern (Singing instead of chattering).

*Süddeutsche Zeitung.* 9.8.1996: Die Entjungferung der Augen. (The defloration of the eyes).

Sun, S.-W. and Lull, J. (1986). The Adolescent Audience for Music Videos and why they watch. *Journal of Communication*, 36(1), pp. 115 ff.

Tapper, J., Thorson, E. and Black, D. (1994). Variations in Music Videos as a Function of their Musical Genre. *Journal of Broadcasting and Electronic Media*, 38(1), pp. 103 ff.

Thompson, K.P. (1993). Media, Music, and Adolescents. In R.M. Lerner (ed), *Early Adolescence – Perspectives on Research, Policy, and Intervention*. Hillsdale, N.J.: Erlbaum, pp. 407 ff.

VIVA Fernsehen GmbH & Co KG (1996). *Daten & Fakten. Die BIK-Studie 1995.* (Data & Facts. The BIK study 1995.) Munich.

VIVA Fernsehen GmbH & Co KG (1995). *Fernsehen and Leistung.* (Television and Performance.) Munich.

VIVA Fernsehen GmbH & Co KG (1996). *Musik? Fernsehen? VIVA ZWEI.* (Music? Television? VIVA 2.) Munich.

VIVA Fernsehen GmbH & Co KG (1996). *presse info.* (press release) Munich.

Vollbrecht, R. (1988). Rock und Pop – Versuche der Wiederverzauberung von Welt. Individualisierungstendenzen im Medienkonsum und ihre Konsequenzen für Sinnstiftung und Identitätsbildung im Jugendalter. (Attempts to conjure up worldly feelings again. Individualisation tendencies in media consumption and their consequences for conveying a meaning and developing identity in youth.) In M. Radde (ed), *Jugendzeit – Medienzeit*. Weinheim: Juventa, pp. 72 ff.

Walker, J.R. (1987). The Context of MTV. Adolescent Entertainment Media Use and Music Television. *Popular Music and Society*, 11(3), pp. 1 ff.

Walser, R. (1993). Foregoing Masculinity: Heavy-Metal Sounds and Images of Gender. In S. Frith, A. Goodwin and L. Grossberg (eds), *Sound and Vision. The Music Video Reader*. London et al.: Routledge pp. 153 ff.

Weibel, P. (1987). Was ist ein Video-Clip? (What is a music clip?) In V. B Gender. In S. Frith, A. (ed.), *Clip, Klapp, Bum. Von der visuellen Musik zum Musikvideo*. Cologne: DuMont, pp. 274 f.

Wells, A. and Hakanen, E.A. (1991). The Emotional Use of Popular Music by Adolescents. *Journalism Quarterley*, 68(3), pp. 445 ff.

*Werben und Verkaufen*, 20.9.1996

Winter, R. and Kagelmann, H.J. (1993). Videoclip. In H. Bruhn, R. Oerter and H. Rösing (eds), *Musikpsychologie. Ein Handbuch*. Reinbek: Rowohlt, pp. 208 ff.

Zillmann, D. and Mundorf, N. (1986). *Effects of Sexual and Violent Images in Rock-Music Videos on Music Appreciation*. Paper given at the 31st Annual Convention of the Broadcast Education Association. Dallas, Tex.

## Notes

1 Original version of this article: Schmidbauer, M. and Löhr P.: *Das Programm für Jugendliche: Musikvideos in MTV Europe and VIVA*. In: TelevIZIon 9/1996/2, pp. 6-32. For an updated and edited version see Neumann-Braun, K. (ed.): *VIVA MTV! Popmusik im Fernsehen*. Edition Suhrkamp 1999.

2 See, among others, Berland 1993, pp. 25 ff.; Goodwin 1993, pp. 45 ff.; Lewis 1993, pp. 129 ff.; Straw 1993, pp. 3 ff..

3 Baudrillard 1983.

4 See also Janke and Niehues 1995, p. 41.

5 Cf. Reetze 1993, pp. 194 f.

6 Cf. the critical viewpoint taken by Barth and Neumann-Braun 1996, pp. 249 f.

7 Cf. Thompson 1993, pp. 407 f.

8 Cf. Müller 1988, p. 49; Reetze 1993, p. 189.

9 Cf. Barth and Neumann-Braun 1996, p. 253; Thompson 1993, pp. 409 f.

10 Cf. Reetze 1993, p. 181; Straw 1993, p. 8.

11 Cf. Goodwin 1993, p. 48 ff.; Gorman 1992, pp. 26 f.; Schultze *et al.* 1991, pp. 178 ff.

12 For the individual music directions see for example: Beastie Boys, Run DMC, Fat Boys, Ice-T, Chaka Demus & Pliers, Shaggy, Jamiroquai, and US 3.

13 See also Barth and Neumann-Braun 1996, p. 255.

14 Cf. *Süddeutsche Zeitung*, 12.4.1995 and 3.7.1995.

15 Cf. Savan 1993, p. 90; Janke and Niehues 1995, pp. 50 f.; Reetze 1993, p. 186.

16 Cf. VIVA broadcasting sequence and the VIVA programme model in: *VIVA Fernsehen 1996* (press release).

17 Cf. VIVA Fernsehen 1996 (press release); see also *Der Spiegel* -16/1995, p. 118.

18 Cf. *Süddeutsche Zeitung*, 22.1295, 24.1.95, 13.2.96; *Der Spiegel* -33/1995, p. 148 f.

19 Cf. VIVA Fernsehen: VIVA ZWEI (press release), 1996, *Funk-Korrespondenz* 44/1996/23, p. 7.

20 VIVA Fernsehen 1996 (press release); no pp.; *Werben und Verkaufen*, 20.9.96.

21 VIVA Fernsehen 1996: *Daten & Fakten*; (Dates & Facts). In this connection, it is noteworthy that VIVA was prepared to disclose its data whereas MTV Europe supplied no material.

22 Cf. *Süddeutsche Zeitung*, 17.2.95; dto., 3.7.95.

23 *Allensbacher Werbe-Analyse* (Allensbach advertising analysis) 1996 (s. AWA '96).

24 Cf. the 10-year contract that Warner concluded with the pop group REM for $ 80 million. The average cost of a music video is $ 150,000; see also Reetze 1993, pp. 184 f.

25 Cf. *Süddeutsche Zeitung*, 31.10.95.; *Der Spiegel* 36/1996, p. 139: 'In Germany ... the percentage of self-produced best-seller hits has risen from 27.5 to 41.3 per cent'.

26 Subsequently referred to music video examples all come from MTV and VIVA programmes; as the same or comparable videos are broadcast by both MTV and VIVA, 'their' channel will not be specified.

27 Cf. the 24-hour programme schedule for Monday to Friday and Saturday/Sunday in: VIVA Fernsehen 1996 (press info), no pp.

28 Cf. Schmuck 1992, pp. 79 ff. for the sector 'television'; Mattusch 1991, pp. 111 ff. and Mattusch 1995, pp. 363 ff. for the sector 'children's TV'.

29 Cf. Altrogge 1994, p. 200; footnote 5.

30 Cf. Barth and Neumann-Braun 1996, p. 259.

31 Harry: a digitisation instrument (editor's note).

32 See, for example, the series 'Miami Vice', the short programme preview trailers, some programmes for young people, commercials etc. (cf. Schmuck 1992, pp. 79 ff.).

33 Cf. Schmidt 1993, p. 198; Berland 1993, pp. 39 f..

34 Cf. Aufderheide 1986, p. 57.

35 Cf. Goodwin 1993, p. 62.

36 Cf. *Der Spiegel* -36/1996, p. 238 ff.; and the analysis of the Prince video in Altrogge 1994(a), pp. 239 ff.

37 See. for instance, the somewhat older Phil Collins video 'Another Day in Paradise' and the songs 'Friedenspanzer' by the Ärzte and 'The Crossroads' by Bone, Thugs and Harmony (cf. Reetze 1993. pp. 188 f).

38 Cf. also Frith 1993, pp. 70 ff..

39 Cf. Barth and Neumann-Braun 1996; p. 259; Mattusch 1994, p. 165.

40 Cf. Abt 1988, p. 102 f.; Grossberg 1993, pp. 185 f..

41 Hitchon, Duckler and Thorson 1994, pp. 300 ff.; see also Stout, Leckenby and Hecker 1990, p. 887.

42 Cf. Fenster 1993, pp. 125 f.; Neale 1980, p. 19, 54.

43 Cf. Mikos 1993, pp.17 ff.

44 Cf. Vollbrecht 1988, pp. 91 f.; see also the 'unplugged' concept 'Zurück zur Natur, zur neuen Einfachheit und optischen Askese' (Back to nature, to the new simplicity and optical asceticism), Kemper 1995, p. 21).

45 Cf. Lull (b) 1993, pp. 165 ff.; Walser 1993, pp. 153 ff.

46 TNN and BET are American cable TV companies

47 An exception is Schmuck (1992) with his analysis of the introductory music to Miami Vice.

48 Cf. Christenson 1992, p. 64; see also Abt 1988, p. 101.

49 Cf. Barth and Neumann-Braun 1996, pp. 260 f.; Greenfield *et al.* 1987, pp. 318 ff.

50 Cf. Tapper, Thorson and Black 1994, p. 109; see also Sherman and Dominick 1986, pp. 85 f..

51 Cf. Sherman and Dominick 1986, pp. 85 f. (About 5 per cent of the bands are women's bands, 18 per cent are mixed groups.)

52 Cf. Kaplan 1987; Winter and Kagelmann 1994.

53 Cf. Kaplan 1987, p. 55; Winter and Kagelmann 1994, pp. 212 f.

54 Cf. Sherman and Dominick 1986, p. 87.

55 Cf. Walser 1993, p. 153 ff.; Lull 1993, p. 165 ff.

56 None of the non-commercial 'German-origin' studies on the subject of the 'music video' is based on a representative sample with sufficient gender-, class- and education-specific differentiation: see Altrogge 1994; Altrogge and Amann 1991; Bastian 1986; Behne and Müller 1996; Frielingsdorf and Haas 1995; Reetze 1989.

57 See also Thompson 1993, p. 407 ff.

58 Cf. *Media Perspektiven* 1995, p. 84; AWA '96.

59 Cf. van Eimeren and Klingler 1995, p. 219.

60 Cf. van Eimeren and Klingler 1995, p. 212.

61 Cf. Schmidt 1995, p. 221. Frielingsdorf and Haas (1995, p. 335) also arrive at similar results; in a survey of young people carried out in North Rhine-Westphalia, of clear limitations concerning its representative nature (see below).

62 Cf. Klingler and Windgasse 1994, pp. 4, 15, 18 and 19. Their study documents the intensive interest on the part of 10- to 13-year-olds in pop music, pop music programmes and music videos (cf. Feilitzen and Roe 1992, p. 225 ff), and it provides an outline of the situation of Swedish children (9 to 14 years of age). The fact that particularly during this age the children's great 'openness' towards music (usually without the children having the opportunity to take an interest in other types of music) is very quickly fixed on the 'pop/rock music' genre should not be overlooked (cf. Meiners 1993, p. 116 ff.; for US children cf. Christenson 1992, p.70 ff., and for Swedish children Feilitzen and Roe 1992, p. 233).

63 Cf. Behne 1986, p. 100; Altrogge and Amann 1991, pp. 175 f.

64 Cf. Schmidt 1995, p. 221. 'Daten & Fakten 1996' by VIVA Fernsehen (the so-called VIVA/BIK study) reveals a slightly different picture: Pro 7 is way in front, VIVA in third position and MTV Europe trailing behind. The difference is probably mainly due to the fact that the BIK opinion research survey focuses on the 14- to 29-year-old age group.

65 Cf. VIVA Fernsehen: Daten & Fakten, 1996. (VIVA/BIK study).

66 Allensbacher Werbe-Analyse (Allensbach advertising analysis) 1996 (s. AWA '96). The AWA analysis is based, as mentioned above, only on the 14- to 19-year-old and the 14- to 29-year-old VIVA viewers, but does consider both cable TV and the TV households overall. As the quoted VIVA/BIK and AWA material contains no references to pages, the source of the quoted passages will subsequently not be named.

67 For the so-called NRW survey cf. Frielingsdorf and Haas 1995, pp. 331 ff.

68 As to the coverage of MTV USA, incomparably larger than that of MTV Europe and VIVA, cf. Thompson 1993, pp. 409 f..

69 Total no. of households = 14.23 million, with 7.1 million 14- to 29-year-olds.

70 Cf. Frielingsdorf and Haas 1995, pp. 331 ff.

71 Frielingsdorf and Haas 1995, p. 332.

72 Cf. VIVA Fernsehen: Daten & Fakten, 1996, no pp.

73 Cf. Frielingsdorf; Haas 1995, p. 338 (Table 4 shows a selection from the programme factors supplied by Frielingsdorf and Haas).

74 Cf. VIVA Fernsehen: Daten & Fakten, 1996, no pp. (VIVA/BIK study; 1995 data).

75 Cf. VIVA Fernsehen: Daten & Fakten, 1996, no pp. (VIVA/BIK study; 1995 data).

76 Cf. Frielingsdorf and Haas 1995, p. 337; see also Roe and Cammaer 1993, p. 173.

77 Cf. VIVA Fernsehen: Daten & Fakten, 1996, no pp. (VIVA/BIK study; 1995 data).

78 Cf. Reetze 1989, pp. 100 ff.

79 Cf. Christenson 1992, p. 63 ff. (non-representative survey of 100 US pupils from Oregon).

80 Cf. Zillmann and Munford 1986, p. 2; Walker 1987, p. 7.

81 Cf. Behne and Müller 1996, pp. 374, 377.

82 Cf. Six, Roters and Gimmler 1995, pp. 80 ff.

83 Hall Hansen and Krygowski 1994, p. 24; see also Bastian 1986, p. 158 ff., Behne 1990, p. 235; Goldberg et al. 1993, p. 10 ff.

84 Cf. Greenfield et al. 1987, pp. 314 ff.

85 The conclusion that video viewing enthusiasts mainly come from the 'lower classes', that they are 'regular video viewers' and conspicuous 'non-church goers' (Greeson 1991, p. 1908), is rather inadequate.

86 Cf. Schorb 1988, pp. 135 f.

87 Cf. Behne and Müller 1996, pp. 365 ff. Any discussion of comparative data and arguments is dispensed with in the following.

88 Behne and Müller 1996, p. 371.

89 Cf. Altrogge 1994, pp. 196 ff.

90 Altrogge 1994, p. 203.

91 Altrogge 1994, p. 205.

92 Altrogge 1994, p. 208.

93 Altrogge 1994, p. 209.

94 The sole exception (Altrogge and Amann 1991) relates to heavy metal and its fans.

95 Cf. Schorb 1988, p. 134; Winter and Kagelmann 1995, p. 215.

96 Cf. Six, Roters and Gimmler 1995, pp. 42 ff.; Bastian 1986, pp. 148 ff.; Kleinen 1986, p. 134; Thompson 1993, pp. 411 ff..

97 Cf. Kleinen 1986, p. 134.

98 Cf. Thompson 1993, p. 411.

99 Cf. Thompson 1993, p. 415.

100 Cf. Altrogge and Amann 1991, pp. 177 ff.; 1988 b, pp. 165 ff.; Schultze *et al.* 1991, pp. 167 ff.

101 Cf. also Mikos 1993, p. 17.

102 Cf. Janke and Niehues 1995, p. 35.

103 For the first view see Hall Hansen and Hansen 1991, pp. 335 ff., for the second see Bleich, Zillmann and Weaver 1991, pp. 3 and 10; Altrogge and Amann 1991, pp. 177 ff.

104 Cf. Altrogge and Amann 1991, p. 176 f.; Greenfield *et al.* 1987, pp. 318 ff.; Thompson 1993, p. 314.

105 Cf. Kellaris and Rice 1993, pp. 15 und 25.

106 Cf. Lewis 1993, pp. 140 ff.; Winter and Kagelmann 1995, pp. 217 f.

# The Authors

**Ben Bachmair**, PhD, born in 1943, is Professor of Education, Media Pedagogics and Media Didactics at the Education and Humanities Faculty I of Kassel University.

**Bruno Bettelheim**, PhD, 1903 – 1990, was Professor of Developmental Psychology at the University of Chicago. He founded and directed the Chicago-based Orthogenic School. Among his most famous books were *Love is not enough* (1950), *Truants from life* (1955), *The informed heart* (1960), *The empty fortress* (1967), *A home for the heart* (1974) and *The uses of enchantment* (1976).

**Karin Böhme-Dürr**, PhD, born in 1949, is Professor and holds the Chair of the Institute of Media and Communication Research at the University of Düsseldorf.

**Maria Borcsa**, born in 1967, has a degree in psychology and is a Member of Staff of the Institute of Psychology at the University of Freiburg Breisgau.

**Moira Bovill**, PhD, born in 1938, is Project Officer at the Department of Social Psychology at the London School of Economics and Political Science.

**Michael Charlton**, PhD, born in 1943, is Professor of Psychology at the Institute of Psychology (Clinical and Developmental Psychology) at the University of Freiburg/Breisgau.

**Birgit van Eimeren**, born in 1960, has a degree in psychology and is Head of the Media Research Department of the Bayerischer Rundfunk (BR – Bavarian Broadcasting Corp.), Munich.

**George Gaskell**, PhD., born in 1948, is Reader in Social Psychology and Director of The Methodology Institute at the London School of Economics and Political Science.

**Tobias Gehle**, born in 1971, has a degree in journalism and is working as a journalist in the field of children's media, living in Dortmund.

**Jo Groebel**, PhD, born in 1950, is Director General of the European Institute of the Media, Düsseldorf, and was Professor of Media Psychology at the University of Utrecht, Netherlands.

**Sabrina Kaufmann**, born in 1969, has a degree in communication sciences and lives in Leipzig.

**Friedrich Krotz**, born in 1950, PhD, has a degree in mathematics and sociology. He is Scientific Collaborator of the Hans-Bredow-Institute for Media Research at the University of Hamburg.

**Sonia Livingstone**, PhD, born in 1960, is Senior Lecturer in Social Psychology at the London School of Economics and Political Science.

**Paul Löhr**, born in 1938, is an educationist and Head of the Internationales Zentralinstitut für das Jugend- und Bildungsfernsehen (IZI) at the Bayerischer Rundfunk, Munich.

**Brigitte Maier-Lesch**, born in 1955, has a degree in sociology and is a Member of Staff of BR's Media Research Department, Munich.

**Jan-Uwe Rogge**, PhD, born in 1947, is a freelance scientist in the field of cultural studies as well as a family counsellor, living in Bargteheide near Hamburg.

**Michael Schmidbauer**, PhD, born in 1940, is a social psychologist and freelance Scientific Author, living in Wuppertal.

**Bernd Schorb**, PhD, born in 1947, is Professor of Media Pedagogics and Further Education at the Centre for Media and Communication (ZMK) at the University of Leipzig.

**Helga Theunert**, PhD, born in 1951, is an educationist and research Director of the Institut Jugend Film Fernsehen (JFF), Munich.

**Waldemar Vogelgesang**, PhD, born in 1952, is an academic employee in the Department of Sociology at the University of Trier.

**Stefan Weiler**, PhD, born in 1965, is a scientific collaborator of the Institute for Media and Communication Sciences at the University of Mannheim and Collaborator at the Media Institute in Ludwigshafen.

**Arne Willander**, born in 1970, studied German language and literature and is the Music Editor of the magazine 'Rolling Stone' in Hamburg.